토마토 토익
중급 RC

지은이	NE능률 영어교육연구소
선임 연구원	이보영
연구원	한윤희 정혜란 채민정
영문 교열	Danielle Josset
감수	YBM 어학원 종로 이미영 강사
디자인	강주현 송현아 오솔길 민유화
맥편집	허문희
영업	김민석 최낙선 유성석
마케팅	김영일 김송이 남경진 김혜림
제작	한성일 김동훈 심현보

First Published

Copyright © 2019 by NE Neungyule, Inc.

서문

토익 입문서의 스테디셀러인 토마토 BASIC 교재로 유명한 NE능률 영어 교육연구소에서 **토마토 토익 중급**을 선보입니다. 단기간에 효율적으로 목표를 달성할 수 있도록 토익 전문가들이 치열하게 고민하여 만든 **토마토 토익 중급**은 750점 돌파를 위해 매일매일 꾸준히 할 수 있는 현실적인 학습 커리큘럼을 제시합니다.

본 교재는 최근 몇 년간의 출제 경향을 철저히 분석하여 핵심이 되는 출제 포인트와 출제 원리만을 제시함으로써 단기간 학습으로도 목표 점수를 달성할 수 있도록 얇게 구성했습니다. 특히 '출제 포인트+실전 문제'의 구성으로 이론과 실전을 한 번에 해결할 수 있기에 짧은 시간에 보다 효율적으로 공부할 수 있습니다.

자주 출제되지 않는 어려운 내용까지 공부해서 토익 목표 점수를 달성하는 길은 길고 어려울 수밖에 없습니다. 하지만 **토마토 토익 중급**과 함께 하루에 3개의 출제 포인트를 30일간 학습하여 출제 포인트와 출제 원리를 확실히 이해하고 실전 문제를 풀다 보면 얼마든지 목표를 달성할 수 있으리라 자부합니다. 여러분들의 그 여정이 외롭지 않도록 토마토 토익이 든든한 벗이 되어 돕겠습니다.

목차

책의 구성 및 특징

1. 문법편: 단기간에 학습 효과를 극대화시키는 문제를 통한 출제 원리 학습

기본 개념 노트 & SELF-TEST
문법 요소별 기본 개념을 간단하게 살펴보고, 그 기본 개념이 적용 된 빈출 문제를 풀어보며 자신의 실력을 확인할 수 있습니다.

문법 출제 POINT 및 출제 원리
Part 5&6의 출제 POINT별로 분류된 SELF-TEST 문제의 정답 및 해설을 확인하고 각 문제의 출제 원리를 학습함으로써 학습 효과를 극대화시킬 수 있습니다.

FINAL TEST
최신 경향을 반영한 실전 문제를 풀어보며 앞에서 학습한 내용을 점검해 보고 문제 응용력을 향상시킬 수 있습니다.

2. 독해편: 속독 스킬과 효율적인 문제 해결 전략 제시

독해 출제 POINT 및 풀이 전략
질문 유형별 풀이 전략뿐만 아니라 지문 유형별 분석을
다루어 빠르고 효율적인 문제 풀이를 도와줍니다. 또한
패러프레이징의 원리도 충실히 다루어 실용적인 독해
학습이 가능합니다.

FINAL TEST
최신 경향을 반영한 실전 문제를 풀어보며 앞에서 학습
한 내용을 점검해 보고 문제 응용력을 향상시킬 수 있습
니다.

3. 어휘편: DAY별 토익 핵심 어휘 학습

빈출 랭킹 순위별 어휘편
시험에 빈출된 어휘들이 DAY별로 구성되어있어 매일
토익 핵심 어휘를 암기할 수 있습니다.

학습 스케줄러

30일 기본 완성 코스

1일차 (월 일)	2일차 (월 일)	3일차 (월 일)	4일차 (월 일)	5일차 (월 일)
DAY 01	DAY 02	DAY 03	DAY 04	DAY 05
6일차 (월 일)	7일차 (월 일)	8일차 (월 일)	9일차 (월 일)	10일차 (월 일)
DAY 06	DAY 07	DAY 08	DAY 09	DAY 10
11일차 (월 일)	12일차 (월 일)	13일차 (월 일)	14일차 (월 일)	15일차 (월 일)
DAY 11	DAY 12	DAY 13	DAY 14	DAY 15
16일차 (월 일)	17일차 (월 일)	18일차 (월 일)	19일차 (월 일)	20일차 (월 일)
DAY 16	DAY 17	DAY 18	DAY 19	DAY 20
21일차 (월 일)	22일차 (월 일)	23일차 (월 일)	24일차 (월 일)	25일차 (월 일)
DAY 21	DAY 22	DAY 23	DAY 24	DAY 25
26일차 (월 일)	27일차 (월 일)	28일차 (월 일)	29일차 (월 일)	30일차 (월 일)
DAY 26	DAY 27	DAY 28	DAY 29	DAY 30, 실전 모의고사

15일 집중 완성 코스

1일차 (월 일)	2일차 (월 일)	3일차 (월 일)	4일차 (월 일)	5일차 (월 일)
DAY 01, 02	DAY 03, 04	DAY 05, 06	DAY 07, 08	DAY 09, 10
6일차 (월 일)	7일차 (월 일)	8일차 (월 일)	9일차 (월 일)	10일차 (월 일)
DAY 11, 12	DAY 13, 14	DAY 15, 16	DAY 17, 18	DAY 19, 20
11일차 (월 일)	12일차 (월 일)	13일차 (월 일)	14일차 (월 일)	15일차 (월 일)
DAY 21, 22	DAY 23, 24	DAY 25, 26	DAY 27, 28	DAY 29, 30, 실전 모의고사

토익 정보

토익(TOEIC)은 Test of English for International Communication의 약자로, 영어가 모국어가 아닌 사람들을 대상으로 의사소통에 중점을 두고 일상 생활 또는 국제 업무에 필요한 실용 영어 능력을 평가하는 시험입니다.

시험 구성

구성	Part	내용		문항 수	시간	배점	
Listening Comprehension	1	사진 묘사		6			
	2	질의응답		25			
	3	짧은 대화		39	100	45분	495점
	4	짧은 담화		30			
Reading Comprehension	5	단문 공란 메우기 (문법/어휘)		30			
	6	장문 공란 메우기		16	100	75분	495점
	7	독해	단일 지문	29			
			이중 지문	10			
			삼중 지문	15			
Total	7 Parts			200문항	120분	990점	

접수 방법

TOEIC 접수는 한국 토익 위원회 사이트(www.toeic.co.kr)에서 온라인으로만 접수가 가능합니다.

시험 준비물

- **신분증** 규정 신분증만 가능
 (주민등록증, 운전면허증, 기간 만료 전의 여권, 공무원증 등)
- **필기구** 연필, 지우개 (컴퓨터용 사인펜이나 볼펜은 사용 금지)

성적 확인

한국 토익 위원회 사이트에 안내된 일자에 인터넷과 ARS(060-800-0515)를 통해 성적이 발표됩니다. 성적표는 우편이나 온라인으로 발급받을 수 있으며, 우편 발급의 경우 성적 발표 후 약 일주일이 소요되고 온라인 발급은 성적 유효기간인 2년 안에 홈페이지에서 1회에 한해 무료로 출력할 수 있습니다.

RC 최신 경향 및 풀이 전략

최근 토익 RC는 문맥 파악과 논리적 사고를 요하는 문제 유형이 증가하고 어휘 문제가 까다로워짐에 따라 전반적인 체감 난이도가 높아졌습니다. 또한, Part 7에 삼중 지문까지 출제되어 읽어야 할 지문이 많아 시간 관리도 매우 중요해졌습니다.

PART 5 단문 공란 메우기 (30문항)

빈칸이 포함된 단문이 주어지고, 4개의 선택지 중 빈칸에 알맞은 답을 고르는 파트

READING TEST

In the Reading test, you will read a variety of texts and answer several different types of reading comprehension questions. The entire Reading test will last 75 minutes. There are three parts, and directions are given for each part. You are encouraged to answer as many questions as possible within the time allowed.

You must mark your answers on the separate answer sheet. Do not write your answers in your test book.

PART 5

Directions: A word or phrase is missing in each of the sentences below. Four answer choices are given below each sentence. Select the best answer to complete the sentence. Then mark the letter (A), (B), (C), or (D) on your answer sheet.

101. If the team director isn't available, you will interview the final two candidates by -------.

(A) you
(B) your
(C) yourself
(D) yours

102. Workers at Winny's Burger cannot accept any meal coupons ------- drive-through windows.

(A) in
(B) on
(C) by
(D) at

103. Mr. Hudson is the most ------- accountant involved in the project.

(A) knowledgeable
(B) approved
(C) enhanced
(D) accustomed

105. Ranath Industries ------- hard work from its staff members by giving out generous monthly bonuses.

(A) establishes
(B) rejects
(C) endures
(D) recognizes

106. Please board through the closest ------- to your seat when you get on the train.

(A) entry
(B) entrance
(C) enter
(D) entering

107. It is Mr. Marino's job to create a safe working ------- for all laboratory workers.

(A) environment
(B) foundation
(C) equipment
(D) capacity

풀이 전략

- Part 5는 Part 7의 독해 시간 확보를 위해 15분 내에 풀어야 합니다.
- 시간 절약을 위해 선택지를 먼저 보고 문제 유형에 따라 풀이 전략을 다르게 적용합니다.
- 구조 문제는 해석하지 말고 문장의 구조를 먼저 파악하고 오답부터 제거하며 정답을 찾습니다.
- 문법 문제는 빈출되는 문법 POINT 위주로 암기해 두고 해당 내용을 적용해서 풀어야 합니다.
- 어휘 문제는 개별 어휘를 암기하기보다는 함께 쓰이는 어휘들을 같이 암기해 두면 문제 풀이 시간을 줄일 수 있습니다. 뉘앙스나 어법을 묻는 고난도 문제도 출제되므로 예문을 통해 어휘를 암기하세요.

4개의 문제가 포함된 지문이 주어지고, 4개의 선택지 중 빈칸에 알맞은 답을 고르는 파트

PART 6

Directions: Read the texts that follow. A word, phrase, or sentence is missing in parts of each text. Four answer choices for each question are given below the text. Select the best answer to complete the text. Then mark the letter (A), (B), (C), or (D) on your answer sheet.

Questions 131-134 refer to the following information.

Residents of any unit in the Carson Corp. apartment complex are required to purchase parking permits, which are issued by the main offices in the lobby of each building. ------, residents **131.** must renew these every year. Expired passes are not acceptable. ------. Building managers are **132.** responsible for ------ these policies and ticket any vehicle that does not have a visible valid **133.** permit. Owners of unauthorized vehicles ------ large fines. **134.**

131. (A) Similarly
(B) In fact
(C) In addition
(D) However

132. (A) There are no underground parking spots available.
(B) Therefore, residents are not able to choose their spot numbers.
(C) Moreover, permits must be displayed visibly to avoid tickets.
(D) Guest parking spots are limited to four hours at a time.

133. (A) inserting
(B) enforcing
(C) eliminating
(D) verifying

134. (A) have charged
(B) are charging
(C) are charged
(D) to charge

풀이 전략

- Part 6에서 한 지문에 딸린 4문제 중 3문제는 Part 5와 유사하게 구조, 문법, 어휘 지식을 묻는 문제입니다. 단, 문맥을 파악해야 풀 수 있는 경우도 있으므로 지문의 전반적인 흐름을 파악하는 것이 중요합니다.

- 지문당 한 문제씩 출제되는 알맞은 문장 고르기 문제는 문맥 파악과 논리적 흐름 이해가 중요합니다. 빈칸 앞뒤에 있는 지시어 및 대명사를 단서로 활용하거나 연결어를 단서로 활용하여 단락의 구조와 논리적 흐름을 파악해서 문맥에 알맞은 선택지를 고릅니다.

- 알맞은 문장 고르기 문제의 경우, 문제의 위치가 단서가 될 수 있으므로 지문 구조에 들어가는 내용을 미리 알아 두고 그 구조에 알맞은 내용의 선택지를 고릅니다.

PART 7 독해 (54문항)

지문을 읽고, 문제에 대한 단서를 찾아 알맞은 답을 고르는 파트

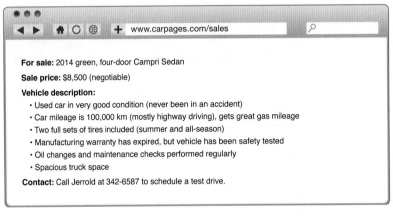

PART 7

Directions: In this part, you will read a selection of texts, such as magazine and newspaper articles, e-mails, and instant messages. Each text or set of texts is followed by several questions. Select the best answer for each question and mark the letter (A), (B), (C), or (D) on your answer sheet.

Questions 147-148 refer to the following Web page.

www.carpages.com/sales

For sale: 2014 green, four-door Campri Sedan

Sale price: $8,500 (negotiable)

Vehicle description:
- Used car in very good condition (never been in an accident)
- Car mileage is 100,000 km (mostly highway driving), gets great gas mileage
- Two full sets of tires included (summer and all-season)
- Manufacturing warranty has expired, but vehicle has been safety tested
- Oil changes and maintenance checks performed regularly
- Spacious truck space

Contact: Call Jerrold at 342-6587 to schedule a test drive.

147. What is suggested about the seller?

(A) He has only owned one vehicle.
(B) He performs his own oil changes.
(C) He is willing to lower the posted price.
(D) He pays a lot for fuel.

148. What is NOT true about the vehicle?

(A) It has time remaining on the warranty.
(B) It has passed official safety checks.
(C) It was driven on the highway regularly.
(D) It comes with an additional set of tires.

지문 종류 및 문항 수

지문 종류	지문 수	지문당 문항 수	전체 문항 수
단일 지문	10개	2~4문항	29문항
이중 지문	2개	5문항	10문항
삼중 지문	3개	5문항	15문항

지문 종류

1) 단일 지문: 이메일, 편지, 공지, 메모, 광고, 기사, 설명서 등 다양한 유형의 지문이 등장합니다. 일상생활에서 많이 이용되는 문자 메시지나 온라인 채팅과 같은 SNS 대화문도 나오므로 구어체에도 익숙해져야 합니다.

2) 이중 지문: 공지나 메모에 대한 문의, 편지나 이메일에 대한 답신, 공지문과 청구 내역 등 서로 연관된 지문들이 등장합니다.

3) 삼중 지문: 이중 지문에서 지문이 하나 더 추가된, 내용상 서로 연계된 세 개의 지문이 등장합니다. 세 개의 지문이라고 해서 복잡하다고 생각하지 말고 이중의 지문 형태와 마찬가지라고 생각해야 합니다.

문제 유형

1) 일반적 문제: 글의 주제나 목적, 글의 대상 또는 출처 등을 묻는 문제로, 글의 전반적인 내용을 묻는 문제 유형입니다.

2) 세부 정보 문제: 특정 정보를 확인해야 하는 시간이나 방법, 이유 등을 묻는 문제와 진위 여부를 묻는 문제, 추론 문제 등이 나옵니다. 그리고 특수한 유형으로 화자의 의도를 묻는 문제와 문장의 적절한 위치를 찾는 유형은 각각 문제를 푸는 훈련이 필요합니다.

풀이 전략

- Part 7은 지문이 길고 딸려 있는 문제 수가 많아 시간 관리가 무엇보다 중요합니다. 모든 지문을 정독하지 말고 문제를 먼저 읽고 키워드를 파악하여 지문에서 필요한 정보를 빠르게 찾아 읽는 연습을 하세요.

- 삼중 지문의 경우 대부분 지문의 길이가 길지 않고 문제의 순서에 따라 단서도 지문에서 순서대로 등장하므로 어렵게 생각하지 말고 문제 유형별 단서를 찾는 연습을 꾸준히 하세요.

- 화자의 의도 파악 문제를 위해 행간의 의미를 파악하는 연습과 구어체 표현을 익혀두세요.

- 문장 위치 찾기 문제는 제시된 문장을 각 위치에 대입하며 앞뒤 문장과 논리적 흐름이 자연스러운 위치를 찾는 연습을 하세요.

- 패러프레이징에 대비해 패러프레이징의 유형을 미리 숙지해 두고 많은 문제를 풀어보세요.

CHAPTER

1

-

문장 구조편

DAY 01
문장 구조

기본 개념 노트

본 학습에 들어가기 전에 기본 문법 개념의 틀을 잡아보자.

❶ 주어

주어란 동작이나 상태의 주체로 주어 자리에는 명사류(명사, 대명사, to부정사, 동명사, 명사절)가 온다.
① **Our team** has regular meetings every month.

❷ 동사

동사란 주어의 동작이나 상태를 나타내는 말이다. 뒤에 목적어가 없는 동사인 자동사, 목적어가 있는 동사인 타동사로 크게 나뉘며, 동사 뒤에 오는 문장 성분의 종류에 따라 5가지 문형으로 나뉜다.

1문형	go(가다), arrive(도착하다), fall(떨어지다) 등 완전자동사가 쓰이는 〈주어＋동사(＋부사구)〉 구조 ② The subway **arrives** at Henley Station at exactly 8:05 A.M.
2문형	be(~이다), become(~이 되다) 등 불완전자동사가 쓰이는 〈주어＋동사＋주격 보어〉 구조 ③ Angrino Park **has become** a popular place for family outgoings.
3문형	eat(먹다), attend(참석하다) 등 대부분의 동사가 취하는 〈주어＋동사＋목적어〉 구조 ④ Employees **attended** an awards banquet on Friday night.
4문형	give(주다), send(보내주다), offer(제공하다), show(보여주다) 등 목적어를 두 개 가지는 수여동사가 쓰인 〈주어＋동사＋간접목적어＋직접목적어〉 구조 ⑤ H&C Travel Agency **offers** loyal customers free tickets to the museum.
5문형	keep(~한 상태로 유지하다), leave(~한 상태로 두다) 등 목적어 뒤에 목적어의 의미를 보충하는 목적격 보어가 붙은 〈주어＋동사＋목적어＋목적격 보어〉 구조 ⑥ She **left** the children unattended in the backyard.

❸ 목적어

동작이 행해지는 대상을 나타내는 것으로, 주로 타동사와 전치사 뒤에 위치한다. 목적어로는 명사류인 명사, 대명사, to부정사, 동명사, 명사절이 쓰인다.
⑦ They built **factories** in the suburban areas.

❹ 보어

주어 또는 목적어를 보충 설명하는 문장 성분으로, 주로 명사 또는 형용사가 보어로 쓰인다.
⑧ The weather in the north is turning **cold** these days.

① 우리 팀은 매달 정기 회의를 한다. ② 지하철은 헨리 역에 정확히 오전 8시 5분에 도착한다. ③ 앵그리노 공원은 가족 야유회 장소로 유명해졌다. ④ 직원들은 금요일 밤에 시상식 연회에 참석했다. ⑤ 에이치앤씨 여행사는 단골 고객들에게 박물관 무료 입장권을 제공한다. ⑥ 그녀는 아이들을 뒤뜰에 돌보는 사람 없이 방치했다. ⑦ 그들은 교외 지역에 공장들을 세웠다. ⑧ 최근 북부 날씨가 추워지고 있다.

SELF-TEST

기본 개념이 토익에는 어떻게 출제되는지 알아보자. ⏱ 제한시간 03:00

다음 핵심 포인트를 참고하여
정답이 되는 이유를 적어보자. **NOTE**

1. The ------- between Meteor Motors and Vladys Designs created hundreds of jobs for the community.

 (A) cooperatively (B) cooperated
 (C) cooperation (D) cooperate

2. There is increasing ------- about the central topic of the president's upcoming speech.

 (A) to speculate (B) speculation
 (C) speculated (D) speculates

3. The temporary employee's contract ------- from July 4 until July 3 of next year.

 (A) extensively (B) extending
 (C) extensive (D) extends

4. Please ------- Clark Inc.'s updated calendar of events with all department heads.

 (A) sharing (B) shared
 (C) to share (D) share

5. Ms. Burns received ------- for her proposal to open a new branch.

 (A) approved (B) approval
 (C) approves (D) approve

6. IDs are ------- as long as members do not give their passwords to other people.

 (A) securities (B) secure
 (C) securely (D) security

1. 주어 자리

2. ⟨there + be동사 + 주어⟩ 구문

3. 동사 자리

4. 명령문

5. 목적어 자리

6. 주격 보어 자리

문제별 출제 **POINT** ▶ 다음 페이지에서 확인하기

주어 자리

주어는 모든 문장의 기본이 되는 요소로, 주어 자리를 묻는 문제가 빈출된다. 동사만 파악하면 주어 자리는 쉽게 판별이 가능하므로 동사를 찾는 연습을 충분히 해야 한다.

The **cooperation** between Meteor Motors and Vladys Designs created hundreds of jobs for the community.

(A) cooperatively (B) cooperated

(C) **cooperation** (D) cooperate

동사 created 앞에 있는 전치사구 between Meteor Motors and Vladys Designs는 수식어이므로 주어가 될 수 없다. 따라서 문장 내 주어가 없으므로 빈칸이 주어 자리이고, 선택지 중 주어 자리에 올 수 있는 것은 명사인 cooperation뿐이므로 정답은 (C).

해석 | 메테오르 자동차 사와 블라디스 디자인 사의 협력은 지역 사회에 수백 개의 일자리를 창출했다.

1. 주어 자리에 오는 명사 상당어구

주어는 주로 문장이나 절의 맨 앞에 위치하며 우리말의 '~은, ~는, ~이, ~가'에 해당된다. 주어 자리에는 주로 명사나 대명사가 오고, 동명사구, to부정사구 또는 명사절이 올 수 있지만, 동사, 형용사, 부사는 주어 자리에 올 수 없다.

명사(구)	**Attendance** to the training workshop is mandatory. ~~Attend, Attentive, Attentively~~ 연수 워크숍의 참석은 의무이다.
대명사	**You** have to be good with numbers as an accountant. 회계사로서 당신은 숫자를 잘 알아야 한다.
동명사구	**Satisfying its clients** is the company's main objective. 고객을 만족시키는 것이 그 회사의 주요 목적이다.
to부정사구	**To hire new employees** is a difficult task. 신입 사원을 고용하는 것은 어려운 일이다.
명사절	**Whether I'll be promoted** is up to my supervisor. 내가 승진하게 될지는 나의 상사에게 달려 있다.

There is increasing **speculation** about the central topic of the president's upcoming speech.

(A) to speculate (B) **speculation**

(C) speculated (D) speculates

⟨there is[are]⟩ 구문에서는 동사 뒤에 진짜 주어가 위치한다. 빈칸 앞의 increasing은 명사를 수식하는 분사로 주어 역할을 할 수 없으므로 빈칸이 주어 자리이다. 따라서 주어 자리에 올 수 있는 명사 (B) speculation이 정답.

해석 | 다가오는 대통령 연설의 중심 주제에 대한 추측이 많아지고 있다.

2. 특이한 주어 자리: ⟨there+동사+주어⟩ 구문

⟨주어+동사⟩ 어순의 일반적인 문장 구조와 달리 ⟨there is[are]⟩ 구문은 주어가 동사 뒤에 위치한다. 이때 주어가 단수이면 동사는 is, 복수이면 are를 쓴다. be동사 이외에도 remain, exist 등이 올 수 있다.

<u>There are</u> **some applicants** for the managerial position. 관리직에 지원한 사람들이 몇 명 있다.

3. 특이한 주어 형태: 가주어 it

to부정사구나 that절과 같이 주어가 길어지는 복잡함을 해소하기 위해 가주어 it을 앞에 내세운다. 이때 it을 가주어, 긴 주어를 진주어라고 한다. 진주어 자리에 동사원형이나 동명사는 올 수 없다.

To establish a loyal customer base is critical. 충성 고객 기반을 마련하는 것은 중요하다.

주어
→ **It** is critical **to establish a loyal customer base**.

가주어 ~~establish, establishing~~ 진주어

출제 POINT 02

동사 자리

모든 문장은 동사를 수반해야 하며 동사는 보통 주어와 가깝게 위치한다. 동사는 주로 수, 시제, 태와 결합하여 복잡하게 출제되지만 문장이 간단한 형태부터 살펴보자.

SELF-TEST 3

The temporary employee's contract **extends** from July 4 until July 3 of next year.

(A) extensively (B) extending
(C) extensive **(D) extends**

주어 The temporary employee's contract에 대한 동사가 없으므로 빈칸은 동사 자리이다. 따라서 정답은 동사 (D) extends. 주어가 3인칭 단수이므로 단수 동사인 extends가 왔다. 부사나, 동명사, 형용사는 문장의 동사가 될 수 없으므로 (A), (B), (C) 모두 오답.

해석 | 계약 직원의 계약은 7월 4일부터 내년 7월 3일까지 계속된다.

출제원리

1. 주어 뒤 동사 자리

동사란 주어의 상태나 동작을 나타내는 말로, 절이나 문장에서 주로 주어 뒤에 위치하며 '~이다, ~하다'로 해석된다. 동사 자리에는 〈(조동사)+동사원형〉이나 주어의 수, 시제, 태에 따른 다양한 형태의 동사가 오고, to부정사나 동명사는 올 수 없다.

기본 문장	The factory **can produce** a wide range of building materials. ~~to produce, producing~~ 그 공장은 다양한 건축 재료를 생산할 수 있다. Dr. Raymond recently **published** his paper in the journal. ~~to publish, publishing~~ 레이몬드 박사가 최근 그의 논문을 학술지에 게재했다.
접속사로 연결된 두 개의 절	After Mr. Bailey **resigned**, he **started** his own company. 접속사　　~~to resign, resigning~~ 베일리 씨는 퇴사 후 직접 회사를 창업했다. The washer **makes** a loud beep when the laundry **is** done. 　　　　　　　　　　　접속사　　　~~to be, being~~ 세탁이 다 되면 그 세탁기에서는 '삐' 소리가 크게 난다.

SELF-TEST 4

Please **share** Clark Inc.'s updated calendar of events with all department heads.

(A) sharing (B) shared
(C) to share **(D) share**

주어 없이 Please로 문장이 시작되고 있으므로 명령문임을 알 수 있다. 명령문은 동사원형으로 시작하거나 동사 앞에 please를 붙이므로 정답은 동사원형인 (D) share.

해석 | 클라크 사의 최신 행사 달력을 모든 부서장들과 공유해 주십시오.

출제원리

2. 항상 동사원형을 써야 하는 자리

조동사 뒤 동사 자리와 명령문의 동사 자리에는 항상 동사원형을 쓴다. 특히 명령문은 주어 없이 동사원형으로 시작되거나 please를 동사 앞에 붙여 공손함을 나타내기도 한다. 앞에 부사절이 와서 복잡해진 형태의 명령문도 출제되니 다양한 형태에 익숙해지도록 하자.

조동사 뒤	The sales team must **attend** a conference next week. 　　　　　　　　　　~~attending, attendance~~　영업팀은 다음 주 회의에 참석해야 한다.
명령문	Please **confirm** your reservation at least three days before traveling. 　　　~~confirmation, confirming~~　최소한 여행 3일 전에 예약을 확정해 주십시오. When you give a speech, **avoid** looking down at your notes often. 　　　　　　　　　　　~~to avoid, avoiding~~　연설을 할 때, 원고를 자주 내려다보지 마십시오.

목적어와 보어 자리

목적어 자리에 올 수 있는 명사 상당어구를 고르는 문제가 주로 나온다. 또한, 보어 자리에는 명사 또는 형용사가 오는데 그중에서도 형용사 보어 자리를 빈칸으로 묻는 문제가 많이 출제된다.

SELF-TEST 5

Ms. Burns received **approval** for her proposal to open a new branch.

(A) approved (B) **approval**
(C) approves (D) approve

빈칸은 타동사 received의 목적어 자리이다. 선택지 중에서 목적어 자리에 올 수 있는 것은 명사 approval뿐이므로 정답은 (B).

해석 | 번즈 씨는 새로운 지점을 열겠다는 그녀의 제안에 대해 승인을 받았다.

1. 목적어 자리

목적어는 주로 타동사나 전치사 뒤에 위치한다. 타동사 뒤의 목적어 자리에는 명사(구), 대명사 이외에도 동명사구, to부정사구, 명사절이 올 수 있고, 전치사 뒤 목적어 자리에는 명사(구), 대명사, 동명사구, 명사절이 올 수 있다. 그러나 목적어 자리에 형용사나 부사는 올 수 없다.

타동사 + 목적어	Mr. Palmer makes **contributions** to local charities every year.
	~~contribute, contributable~~ 파머 씨는 지역 자선단체에 매년 기부한다.
전치사 + 목적어	Under the new **regulations**, spending on office equipment will be reduced.
	~~regular, regularly~~ 새로운 규정 하에서는 사무실 장비에 대한 지출이 줄어들 것이다.

SELF-TEST 6

IDs are **secure** as long as members do not give their passwords to other people.

(A) securities (B) **secure**
(C) securely (D) security

빈칸은 be동사 are의 주격 보어 자리이므로 명사 (A)와 (D), 형용사 (B)가 정답 후보이다. 문맥상 '아이디가 안전하다'라는 상태의 의미가 적절하므로 정답은 형용사인 (B) secure.

해석 | 회원들이 자신의 비밀번호를 다른 사람들에게 주지 않는 한 아이디는 안전하다.

2. 주격 보어 자리

주어를 보충 설명해 주는 말을 주격 보어라고 한다. 보어로 명사가 오면 주어와 동격 관계를, 형용사가 오면 주어의 성질이나 상태의 변화를 서술해준다. 단, 부사는 보어 자리에 올 수 없다. 토익 대표 2문형 동사들은 꼭 알아두자.

주격 보어를 취하는 동사	become, get ~이 되다 stay, remain ~상태를 유지하다 grow, go, turn ~상태로 변하다	feel ~처럼 느끼다 sound ~처럼 들리다 seem, appear, look ~처럼 보이다
명사 보어	Brandon is **an accountant** at the Ashmore Foundation. [동격 관계]	
	브랜든 씨는 애시모어 재단의 회계사이다.	
형용사 보어	The sales projections for January seem **optimistic**. [서술 관계]	
	1월의 판매 예상치는 낙관적으로 보인다. ~~optimism, optimistically~~	

3. 목적격 보어 자리

목적어를 보충 설명해 주는 말을 목적격 보어라고 한다. 목적격 보어 자리에는 명사류인 명사, 대명사, to부정사와 형용사류인 형용사, 분사가 주로 온다.

to부정사구 보어	The system permits customers **to compare** the costs of products.
	그 시스템은 고객들이 제품 가격을 비교할 수 있게 해준다.
과거분사 보어	You can find an application form **enclosed** with this letter.
	이 편지에 동봉된 지원서를 확인하실 수 있습니다.

FINAL TEST

1. From speaking to singing, presenters and performers can use this powerful microphone for any -------.

 (A) occasionally (B) occasion
 (C) occasional (D) occasioned

2. Users must ------- the terms and conditions of the Web site to sign up for a membership.

 (A) accepted (B) are accepting
 (C) accept (D) accepting

3. The camera was -------, so the customer returned it to the store and asked for an exchange.

 (A) faulty (B) faults
 (C) fault (D) faultless

4. Economists ------- that the rate of unemployment will decrease in the next quarter.

 (A) predictably (B) predicting
 (C) predict (D) predictable

5. When you prepare for your hike, please ------- yourself with the map of the mountain and surrounding areas.

 (A) familiarize (B) familiarizes
 (C) familiarity (D) familiarizing

6. All candidates must wait in the hallway until the personnel manager ------- them into the interview.

 (A) calling (B) to calling
 (C) calls (D) to call

7. The fact that a majority of middle-class workers got a raise this year is an ------- of the economy's recovery.

 (A) indications (B) indication
 (C) indicates (D) indicating

8. The ------- of the automobile industry motivated many corporations to invest in car manufacturing plants.

 (A) grow (B) grown
 (C) growth (D) growingly

9. A guide from A&C Travels will greet you at the airport and provide ------- to the hotel.

 (A) directs (B) directly
 (C) direct (D) directions

10. Crown University's latest research shows that ------- are diverse endangered species living in the jungle of eastern Brazil.

 (A) where (B) it
 (C) and (D) there

11. Mr. Simmons finds hands-on marketing workshops very ------- and tries to organize one every month.

 (A) information (B) informally
 (C) informer (D) informative

12. Several older staff members were in ------- at the event even though the seminar was originally intended for new employees.

 (A) absence (B) evidence
 (C) attendance (D) objective

13. The construction manager mentioned that ------- of the new building would be delayed due to unforeseen circumstances.

 (A) completion (B) completed
 (C) completely (D) completes

14. It is one of Mr. Thompson's responsibilities ------- department reports before the monthly meeting.

 (A) to review (B) reviewing
 (C) is reviewing (D) is to review

정답 및 해설 2쪽

CHAPTER
2

-

명사편

DAY 02
명사

—

기본 개념 노트

본 학습에 들어가기 전에 기본 문법 개념의 틀을 잡아보자.

❶ 개념

명사란 사람이나 사물, 추상적 개념의 이름을 나타내는 말이다.

man, manager, cup, boat, tree, computer, book, truth, knowledge, ...

❷ 역할

명사는 문장에서 주어, 목적어, 보어로 쓰인다.

주어	① **Companies** often <u>give</u> stock options to their employees.
목적어	② The factory <u>has removed</u> outdated **equipment**.
보어	③ <u>Bruce</u> is the **CEO** of H&B Motors.

❸ 종류

명사는 셀 수 있는 가산명사(단수 또는 복수)와 셀 수 없는 불가산명사로 나뉜다.

가산명사	employee, plan, teacher, police, committee, product, ...
불가산명사	information, news, equipment, Earth, Seoul, John, water, paper, milk, ...

❹ 한정사

한정사란 명사 앞에서 명사의 의미를 더욱 분명하게 한정해 주는 것으로 관사와 소유격이 대표적이다.

부정관사	a, an	불특정한 하나의 대상을 가리키며 단수 가산명사 앞에 붙는다. ④ She opened **an** <u>account</u> with TB Bank.
정관사	the	특정한 대상을 가리키며 가산명사와 불가산명사 앞에 붙는다. ⑤ **The** <u>subject</u> was changed to **the** <u>importance</u> of marketing.
소유격	his, its, Maggie's, ...	소유의 의미를 나타내며 인칭, 수, 성에 따라 형태가 달라진다. ⑥ Because he was sick, Andrew could not finish **his** <u>reports</u>.

① 회사들은 종종 직원들에게 스톡 옵션을 제공한다. ② 그 공장은 오래된 설비를 제거했다. ③ 브루스 씨는 에이치앤비 자동차 사의 대표이사이다. ④ 그녀는 티비 은행 계좌를 개설했다. ⑤ 주제가 마케팅의 중요성으로 변경되었다. ⑥ 아팠기 때문에 앤드류 씨는 그의 보고서를 끝내지 못했다.

SELF-TEST

기본 개념이 토익에는 어떻게 출제되는지 알아보자.

⏱ 제한시간 03:00

다음 핵심 포인트를 참고하여
정답이 되는 이유를 적어보자. **NOTE**

1. Mr. Smith's executive assistant took the ------- of planning the employee orientation.

(A) responsive (B) responsible

(C) responsibly (D) responsibility

1. 타동사의 목적어 자리

2. Holding a video conference was a preferable ------- to traveling to Europe for the sales meeting.

(A) alter (B) alternative

(C) alternatively (D) alternated

2. <관사 + 형용사 + ------->

3. The government library launched an online catalog to increase public ------- to its book collection.

(A) accessible (B) accesses

(C) access (D) accessing

3. 가산명사 vs. 불가산명사

4. The mechanical problem resulted in a ------- in the delivery of canned goods to the retailers.

(A) delayed (B) delays

(C) delay (D) delaying

4. 한정사와 명사의 수일치

5. Queensland Resort Hotel has hired an ------- to redesign its beachfront pool.

(A) architectural (B) architecturally

(C) architecture (D) architect

5. 사람명사 vs. 사물/추상명사

6. Ms. Reilley declined a job ------- from *Leisure* magazine because the position requires frequent business travels.

(A) offerings (B) offer

(C) offered (D) offers

6. 복합명사

문제별 출제 **POINT** ▶ 다음 페이지에서 확인하기

명사 자리

명사 자리 문제 중 최다 빈출 유형은 타동사의 목적어로 쓰인 명사를 묻는 문제이다. 그러나 명사는 단독으로 오기보다 다양한 품사의 수식을 받는 경우가 많으므로 다양한 구조에 익숙해지도록 하자.

SELF-TEST 1

Mr. Smith's executive assistant took the **responsibility** of planning the employee orientation.

(A) responsive (B) responsible
(C) responsibly **(D) responsibility**

타동사 took의 목적어 자리에 들어갈 수 있는 품사를 묻고 있다. 선택지 중에서 목적어로 쓰일 수 있는 것은 명사인 responsibility뿐이므로 정답은 (D). 명사는 대부분 구를 이뤄 문장 속에서 주어, 목적어, 보어 역할을 한다는 것을 기억하자.

해석 | 스미스 씨의 수석 비서는 직원 오리엔테이션을 기획하는 책임을 맡았다.

출제원리

1. 명사의 역할

명사는 문장 안에서 주어, 타동사의 목적어, 전치사의 목적어, 주격 보어, 목적격 보어의 역할을 한다.

주어		**Security** is the top priority for airport police. ~~Secure, Securely~~ 보안은 공항 경찰의 최우선 과제이다.
목적어	타동사의 목적어	Vacation requests normally <u>require</u> the **approval** of a supervisor. 휴가 신청은 보통 상관의 승인을 필요로 한다. ~~approved, approvingly~~
	전치사의 목적어	Several homes were <u>without</u> **electricity** due to a damaged power line. ~~electrical, electrically~~ 손상된 송전선 때문에 여러 가구의 전기가 나갔다.
보어	주격 보어	These are **products** that are designed to help software developers. 이것들은 소프트웨어 개발자들을 돕기 위해 기획된 상품이다.
	목적격 보어	Management wants to make <u>Ms. Barnes</u> **department head**. 경영진은 반즈 씨를 부서장으로 앉히려고 한다.

SELF-TEST 2

Holding a video conference was a preferable **alternative** to traveling to Europe for the sales meeting.

(A) alter **(B) alternative**
(C) alternatively (D) alternated

빈칸은 주격 보어이면서 형용사 preferable의 수식을 받는 명사 자리이므로 명사인 (B) alternative가 정답이다. 명사는 단독으로 쓰이기보다 대부분 구를 이뤄 쓰이기 때문에 명사 앞에 올 수 있는 품사들을 정리해 두면 빈칸이 명사 자리임을 파악하는 데 도움이 된다.

해석 | 화상 회의를 하는 것이 영업 회의를 위해 유럽에 가는 것보다 나은 대안이었다.

출제원리

2. 명사를 수식하는 품사

명사 앞에는 관사 a[an], the와 소유격 his, her 등과 같은 한정사나 형용사가 올 수 있다. 한정사나 형용사는 특별한 경우를 제외하고는 반드시 명사 앞에 와야 한다.

관사 + 명사	Mr. Bennett went to the town hall to attend a **fundraiser**. 베넷 씨는 모금 행사에 참여하기 위해 시청에 갔다.
소유격 + 명사	The merger is still awaiting the <u>CEO's</u> **confirmation**. 합병 건은 아직 대표이사의 승인을 기다리고 있다.
형용사 + (형용사) + 명사	The <u>tentative</u> **conclusion** is that we should expand our plant. 잠정적인 결론은 우리가 공장을 확장해야 한다는 것이다.
관사 + 부사 + 형용사 + 명사	The <u>newly hired</u> **intern** has experience in finance. 새로 채용된 인턴 사원은 재무 분야의 경험이 있다.

가산명사 vs. 불가산명사

명사 자리 문제는 명사의 수와 결합해 출제되기도 한다. 따라서 가산명사와 불가산명사를 구별할 수 있어야 하는데, 불가산명사의 경우 토익에 자주 출제되는 어휘가 있으므로 해당 어휘만 암기하면 된다.

SELF-TEST 3

The government library launched an online catalog to increase public **access** to its book collection.

(A) accessible (B) accesses
(C) access (D) accessing

빈칸은 to부정사인 to increase의 목적어 자리로, 목적어 역할을 할 수 있는 명사 (B)와 (C)가 정답 후보. access는 불가산명사로 복수형이 없으므로 정답은 (C).

해석 | 정부 도서관은 소장한 책에 대한 일반인의 열람권을 개선하기 위해 온라인 도서 목록을 출간했다.

출제원리

1. 가산명사

가산명사는 단수일 경우 a[an], the, 소유격과 같은 한정사가 반드시 앞에 와야 하며, 복수일 경우 끝에 -(e)s를 붙이고 the 또는 소유격과 함께 쓰거나 관사 없이 쓸 수 있다.

an approach 접근법	a discount 할인	an increase 증가	a price 가격	a refund 환불
a circumstance 환경	an estimate 견적서	an intention 의도	a recommendation 추천	a sale 판매

Helen came up with <u>a</u> new **approach** for the slogan. 헬렌 씨는 구호에 대한 새로운 접근법을 생각했다.

2. 불가산명사

불가산명사는 수의 구분이 없으므로 단수 표현인 부정관사 a[an]과 함께 쓰일 수 없으며, 끝에 -(e)s를 붙일 수 없다. 단, 소유격이나 지시형용사, 수량형용사와는 함께 쓸 수 있으며 관사 없이도 사용 가능하다.

in *one's* **absence** ~의 부재중에	written **authorization** 서면 허가
have **access** to ~에 접근할 수 있다	give **consent** for ~에 동의하다
give **advice** on ~에 대해 조언하다	a budget on **equipment** 기계 예산
obtain **approval** for ~에 대한 승인을 얻다	do **research** on ~에 대해 연구하다

We should repair <u>that</u> **equipment** as soon as possible. 저 기계를 가능한 한 빨리 수리해야 한다.

SELF-TEST 4

The mechanical problem resulted in a **delay** in the delivery of canned goods to the retailers.

(A) delayed (B) delays
(C) delay (D) delaying

빈칸은 부정관사 a의 수식을 받으면서 전치사 in의 목적어가 되는 명사 자리이다. 부정관사 a는 항상 가산명사의 단수 형태와 쓰이므로 정답은 (C) delay.

해석 | 기계상의 문제가 소매업자들에게 통조림 제품을 배송하는 데 있어서 지연을 초래하였다.

출제원리

3. 한정사와 명사의 수일치

한정사란 명사 앞에서 명사의 의미를 한정시켜 주는 품사로, 관사와 소유격이 대표적이다. 이러한 한정사는 뒤의 명사와 수일치를 이뤄야 하기 때문에 명사의 단수, 복수를 구별하는 데 도움이 된다.

관사 a[an], the	▶ 부정관사 a[an]은 가산명사 단수형에, 정관사 the는 모든 명사에 쓰일 수 있다. She stopped by **the** <u>bank</u> to make **a** <u>deposit</u>. 그녀는 예금하기 위해 그 은행에 들렀다.
소유격	▶ 소유격은 모든 명사 앞에 쓰이며, 소유격이 대신하는 명사의 성과 수를 일치시켜야 한다. **Employees** must have **their** <u>identification cards</u>. 직원들은 본인의 신분증을 가지고 다녀야 한다.
지시형용사	▶ this와 that은 단수 가산명사나 불가산명사와, 복수형 these, those는 복수 가산명사와 쓴다. Please take **these** <u>packages</u> to the mail room. 우편실로 이 소포들을 가져가세요. <center>package</center>

의미를 구분해야 하는 명사

사람명사와 사물/추상명사의 의미를 구분하여 문맥에 맞는 명사를 고르는 문제가 자주 출제된다. 또한 복합명사를 이용해 〈명사+빈칸〉 또는 〈빈칸+명사〉 형태의 문제도 출제된다.

SELF-TEST 5

Queensland Resort Hotel has hired an **architect** to redesign its beachfront pool.

(A) architectural (B) architecturally
(C) architecture **(D) architect**

빈칸은 동사 has hired의 목적어 자리로 목적어 역할을 하는 명사 (C) architecture(건축)와 (D) architect(건축가)가 정답 후보. 문맥상 '건축가를 고용했다'는 것이 자연스러우므로 정답은 (D).

해석 | 퀸즐랜드 리조트 호텔은 해변에 있는 수영장을 재설계하기 위해 건축가를 고용했다.

출제원리

1. 사람명사 vs. 사물/추상명사

사람명사와 사물/추상명사는 그 형태가 비슷하고 둘 다 명사 자리에 올 수 있기 때문에 해석을 통해 판단해야 한다. 사람명사는 주로 끝에 -er, -or, -ee, -st가 붙는다는 것도 참고로 알아두자.

사람명사	사물/추상명사	사람명사	사물/추상명사
accountant 회계사	accounting 회계	graduate 졸업생	graduation 졸업
advisor 고문, 조언자	advice 조언, 충고	inspector 조사관, 감독관	inspection 점검
assistant 보조자, 비서	assistance 지원, 도움	instructor 강사	instruction 설명, 지시
competitor 경쟁자	competition 경쟁	negotiator 협상가	negotiation 협상
consultant 상담가	consultation 협의, 상담	performer 연기자	performance 공연, 실적
correspondent 기자, 특파원	correspondence 편지	purchaser 구매자	purchase 구입, 구매
director 임원, 책임자	direction 방향, 지시	resident 거주자	residence 주택, 거주지
distributor 판매 업체	distribution 분배	supervisor 관리자, 상사	supervision 감독, 관리
employee 직원 / employer 고용주	employment 고용	supplier 공급업자	supplies 물품 / supply 공급

The magazine can be sent to my personal **residence**. 잡지는 제 개인 주택으로 보내도 됩니다.
~~resident~~

SELF-TEST 6

Ms. Reilley declined a job **offer** from *Leisure* magazine because the position requires frequent business travels.

(A) offerings **(B) offer**
(C) offered (D) offers

빈칸에는 앞에 있는 명사 job과 어울려 동사 declined의 목적어가 되는 명사가 필요하다. 명사 job과 함께 '일자리 제의'라는 뜻의 복합명사를 만드는 명사 (B)와 (D)가 정답 후보인데 앞에 관사 a가 있으므로 단수 명사인 (B) offer가 정답.

해석 | 라일리 씨는 그 직책이 잦은 출장을 요구하기 때문에 〈여가〉 지의 일자리 제의를 거절했다.

출제원리

2. 복합명사

두 개 이상의 명사가 어우러져 하나의 명사처럼 쓰이는 것을 복합명사라고 한다. 복합명사를 구성하는 두 명사 중 앞에 나오는 명사를 형용사나 분사로 바꿔 쓸 수 없다는 점에 주의하자.

account number 계좌번호	consumer survey 소비자 설문 조사	job applicant 구직자
application form 신청서	customer inquiry 고객 문의	job offer 일자리 제의
assembly line 조립 라인	customer satisfaction 고객 만족	performance review 업무 평가
awards ceremony 시상식	exchange rate 환율	product description 제품 설명
budget decision 예산 결정	expiration date 만기일	quality control 품질 관리
building permit 건축 허가	facility regulation 시설 규정	safety inspection 안전 점검
business proposal 사업 제안	fuel cost 연료비	travel reimbursement 출장비 환급

Please submit your **performance reviews** in person on the fifth floor.
~~performing, performed~~
5층으로 직접 오셔서 업무 평가서를 제출해 주세요.

FINAL TEST

1. ------- to the Khartoum Film Festival must be submitted before the end of the month.

 (A) Entered
 (B) Entrances
 (C) Entries
 (D) To enter

2. Dr. Watson's ------- helps him overcome challenges that everyone in the medical field faces each day.

 (A) enthuse
 (B) enthusiasm
 (C) enthusiastic
 (D) enthusiastically

3. The retailer offered the customer a voucher as ------- for the late delivery.

 (A) compensation
 (B) compensated
 (C) compensates
 (D) compensatory

4. If you have any questions about your itinerary, please contact Ms. Palafox for -------.

 (A) assistance
 (B) assists
 (C) assistant
 (D) assisted

5. As part of the expansion plan, administration will order additional office ------- next month.

 (A) equip
 (B) equipped
 (C) to equip
 (D) equipment

6. The clients have given their ------- to change the color of their living room walls.

 (A) consented
 (B) consents
 (C) consent
 (D) consenting

7. To replace the printer's ink cartridge properly, please follow the detailed ------- in the user guide.

 (A) instructors
 (B) instructional
 (C) instructions
 (D) instructs

8. Please be reminded that the awards ------- for the Young Entrepreneurs of the Year is on Friday at 7 P.M.

 (A) winner
 (B) ceremony
 (C) selection
 (D) presenter

9. Davis Inc. decided to stop manufacturing printers, as ------- products are the company's worst-selling items.

 (A) theirs
 (B) these
 (C) them
 (D) this

10. Employees must apply for travel ------- at the finance department immediately after they return from any business trip.

 (A) reimbursement
 (B) reimburse
 (C) reimbursing
 (D) reimbursed

11. The executive chef suggested acquiring cooking ingredients and other ------- from local shops to save on costs.

 (A) necessity
 (B) necessities
 (C) necessitating
 (D) necessitated

12. The chief safety officer visited the factory to discuss the scheduled ------- of machinery.

 (A) inspections
 (B) inspector
 (C) inspects
 (D) inspect

13. All marketing managers need to ------- several trade shows a year to expand their client base.

 (A) examine
 (B) attend
 (C) consider
 (D) participate

14. You may hire a licensed broker to assess the value of your ------- so that it may be sold at the best price.

 (A) reside
 (B) resident
 (C) residence
 (D) residential

Glam.com Refund Policy

Starting August 1, Glam.com will ------ refunds within seven days of receiving notification instead
 15.
of fourteen days. This change is in response to a request raised by many shoppers in our last
customer service survey.

------. However, they found our refund process to be too long. To provide customers with a
16.
convenient shopping ------, our management team has decided to shorten the refund process. If
 17.
you request a refund after making a ------ on our Web site, it will now be handled within a week.
 18.
For further information, please contact our customer service center.

Christine Tirumala
Customer Relations Director
Glam.com

15. (A) issues
 (B) to issue
 (C) issue
 (D) issuing

17. (A) experience
 (B) permission
 (C) familiarity
 (D) behavior

16. (A) The survey was conducted to rate our
 summer fashion collection.
 (B) We are planning to offer a wider selection
 of products.
 (C) Based on their feedback, our Web site is
 not user-friendly.
 (D) According to the results, most shoppers
 are happy with our ordering system.

18. (A) purchase
 (B) purchases
 (C) purchased
 (D) purchasing

Questions 19-22 refer to the following letter.

December 2

Roger Williams
Lancelot Boutique Hotel
829 Old Dear Lane
New York, NY 10005

Dear Mr. Williams,

Thank you for writing to express your interest in our company's services. Walters has been a leading

------ of cleaning products in New York for over a decade. In addition to selling our goods at retail
19.

stores, we supply products directly to hospitals, major restaurants, and shopping centers. To continue

being a successful organization, we ------ our business last year by offering cleaning services to
20.

corporate clients.

While we are relatively new to this field, we are ------ that we can provide high-quality services. We offer
21.

professional window washing, carpet vacuuming, and floor polishing to hotels like yours. ------.
22.

For details on these services, please call 555-1011. Thank you.

Sincerely,

Shannon Cole
Client Representative, Walters

19. (A) distribute
 (B) distribution
 (C) distributor
 (D) distributing

20. (A) accepted
 (B) arrived
 (C) conducted
 (D) expanded

21. (A) confidence
 (B) confident
 (C) confidently
 (D) confidences

22. (A) We can also meet any special needs you may have.
 (B) We have recently opened a new branch in another city.
 (C) However, our services are also available on weekends.
 (D) Thank you for being a loyal patron of Walters cleaning.

정답 및 해설 5쪽

CHAPTER

2

-

명사편

DAY 03
대명사

기본 개념 노트

본 학습에 들어가기 전에 기본 문법 개념의 틀을 잡아보자.

❶ 개념 및 역할

대명사는 같은 명사의 반복을 피하기 위해 쓰이는 품사로 주어, 목적어, 보어의 역할을 한다.

주어	① Sharon and I discovered that **we** attended the same university.
목적어	② Everyone respected Ryan, so the manager chose **him** as the team leader.
보어	③ Stephanie is the **one** with the plant on her desk.

❷ 종류

대명사는 크게 인칭대명사, 지시대명사, 부정대명사로 나뉜다.

인칭대명사	자신이나 상대방, 제 3자를 구별함 (I, you, he, she 등) ④ **We** must collect feedback from **our** customers.
지시대명사	사람이나 사물 등 특정한 대상을 가리킴 (this, these, that, those) ⑤ **This** is the championship trophy that the team won.
부정대명사	정해지지 않은 불특정 대상을 대신함 (one, another, others, the others, some, any 등) ⑥ These files have some errors but **the others** are correct.

❸ 형태

인칭대명사의 형태는 격에 따라 바뀐다.

인칭	격	주격	소유격	목적격	소유대명사	재귀대명사
1 인칭	나	I	my	me	mine	myself
	우리	we	our	us	ours	ourselves
2 인칭	당신	you	your	you	yours	yourself
	당신들	you	your	you	yours	yourselves
3 인칭	그	he	his	him	his	himself
	그녀	she	her	her	hers	herself
	그것	it	its	it	-	itself
	그들, 그것들	they	their	them	theirs	themselves

① 샤론 씨와 나는 우리가 같은 대학교에 다녔다는 것을 알게 되었다. ② 모든 사람들이 라이언 씨를 존경해서 경영자는 그를 팀장으로 선택했다. ③ 스테파니 씨는 자신의 책상 위에 화분을 둔 사람이다. ④ 우리는 고객들의 의견을 취합해야 한다. ⑤ 이것은 그 팀이 받은 우승 트로피이다. ⑥ 이 파일들에는 오류가 일부 있지만 나머지 다른 파일들은 정확하다.

SELF-TEST

기본 개념이 토익에는 어떻게 출제되는지 알아보자.　🕐 제한시간 03:00

1. We will ship the packages to ------- apartment unit tomorrow morning.

 (A) you　　　　　　(B) your
 (C) yourself　　　　(D) yours

 1. 명사구 수식

2. Ms. Stanford was able to successfully organize the product launch -------.

 (A) herself　　　　(B) hers
 (C) her　　　　　　(D) she

 2. 빈칸 앞 완전한 문장

3. ------- who are participating in the tree planting activity are advised to wear comfortable clothing.

 (A) That　　　　　(B) This
 (C) Anybody　　　(D) Those

 3. 지시대명사

4. Use a strong password to prevent ------- from accessing your online bank account.

 (A) others　　　　(B) nobody
 (C) ones　　　　　(D) another

 4. 부정대명사

5. The Vitaplus cereal bars come in a variety of flavors, but ------- of them are sugar free.

 (A) not　　　　　(B) no
 (C) none　　　　(D) nothing

 5. 부정대명사 vs. 형용사

6. Although some tenants disagree with setting quiet hours, ------- of them are in favor of it.

 (A) almost　　　　(B) much
 (C) most　　　　　(D) any

 6. 부정대명사 vs. 부사

문제별 출제 **POINT** ▶ 다음 페이지에서 확인하기

인칭대명사의 격 & 재귀대명사

인칭대명사 문제는 빈칸이 가리키는 명사가 무엇인지 먼저 파악한 후 그것의 인칭, 성, 수와 대명사의 역할에 따라 격에 맞는 것을 선택해야 한다. 재귀대명사는 자리 문제와 관용표현을 묻는 문제가 출제된다.

SELF-TEST 1

We will ship the packages to **your** apartment unit tomorrow morning.

(A) you　　　　　　(B) your
(C) yourself　　　　(D) yours

빈칸은 뒤에 오는 명사 apartment unit을 수식해 주는 한정사 역할을 한다. 소유격 인칭대명사 your가 명사 앞에서 한정사 역할을 하므로 정답은 (B). 〈전치사+빈칸+명사〉는 대표적인 소유격 자리이다.

해석 | 내일 아침에 귀하의 아파트로 소포를 배송해드리겠습니다.

출제원리

1. 인칭대명사의 격
인칭대명사는 사람이나 사물을 가리키는 말로 문장 내 역할에 따라 주격, 소유격, 목적격으로 나뉜다.

〈주격+동사〉	▶ 주격은 문장의 주어로 쓰이며, 동사와 수일치를 시켜야 한다. As a statistician, **he** is skilled at analysis. 통계학자로서 그는 분석에 능숙하다.
〈소유격+명사〉	▶ 소유격은 한정사이므로 항상 명사 앞에 위치한다. Workers are afraid of losing **their** jobs. 직원들은 일자리를 잃는 것을 두려워한다.
〈타동사+목적격〉	▶ 목적격은 타동사나 전치사 뒤에 와서 목적어 역할을 한다. Management expects **us** to arrive early. 경영진은 우리가 일찍 출근하기를 기대한다.
〈전치사+목적격〉	Please submit all the forms to **her**. 그녀에게 모든 서식들을 제출하십시오.

2. 소유대명사
소유대명사는 〈소유격+명사〉의 의미로 그 자체가 명사 역할을 하며, 문장에서 주어, 목적어, 보어로 쓰인다.

After Jack made a great profit on his motorcycle, Jen decided to sell **hers**.
잭 씨가 그의 오토바이로 엄청난 수익을 거두자, 젠 씨는 자신의 것을 팔기로 결심했다.　　　　=her motorcycle

SELF-TEST 2

Ms. Stanford was able to successfully organize the product launch **herself**.

(A) herself　　　　(B) hers
(C) her　　　　　　(D) she

빈칸 앞이 완전한 문장이므로 생략이 가능한 강조용법으로 쓰인 재귀대명사 (A) herself가 정답. 재귀대명사는 재귀용법과 강조용법으로 쓰이는데, 그 쓰임과 생략 가능 여부를 통해 구분할 수 있어야 한다.

해석 | 스탠포드 씨는 직접 상품 출시를 성공적으로 준비할 수 있었다.

출제원리

3. 재귀대명사의 용법
인칭대명사의 목적격이나 소유격에 -self(단수), -selves(복수)를 붙인 것으로 재귀용법 또는 강조용법으로 쓰인다.

재귀용법	▶ 동사의 주어와 목적어가 동일한 경우, 목적어 자리(타동사 뒤, 전치사 뒤)에 재귀대명사를 쓴다. 이때 재귀대명사는 주어를 보고 인칭과 성, 수를 결정하며, 목적어에 해당하므로 생략이 불가능하다. Eric was proud of **himself** for signing the new client. [Eric=himself] 에릭 씨는 신규 고객과 계약을 맺은 것에 대해 스스로가 자랑스러웠다.
강조용법	▶ 주어, 목적어, 보어를 강조하기 위해 보통 강조하는 말 뒤나 문장 끝에 오며 생략할 수 있다. Mr. Johnson will interview the applicants **himself**. 존슨 씨가 직접 지원자들 면접을 볼 것이다.

4. 재귀대명사의 관용표현
전치사와 재귀대명사가 함께 쓰여 특정한 뜻을 나타내기도 한다. 다음 관용표현을 한 단어처럼 암기해 두자.

by *oneself* 혼자서(=alone), 혼자 힘으로	of itself 그것 자체로

Mark has lived **by himself** for five years. 마크 씨는 5년 동안 혼자 살았다.

지시대명사 & 부정대명사

지시대명사와 부정대명사는 그 종류가 다양하고 쓰임이 제한되어 있어서 까다로운 고난도 유형에 속한다.
하지만 토익에 자주 출제되는 유형은 정해져 있으니 빈출 유형 중심으로 학습해 보자.

Those who are participating in the tree planting activity are advised to wear comfortable clothing.

(A) That (B) This
(C) Anybody (D) Those

빈칸 뒤 who부터 activity까지가 빈칸을 수식하는 절이라는 것을 파악해야 한다. who가 이끄는 관계사절의 수식을 받으면서 복수 동사 are advised와 수일치 되는 것은 (D) Those뿐이다. those는 who가 이끄는 관계사절과 함께 쓰여 '~하는 사람들'이란 의미로 자주 쓰인다.

해석 | 나무 심기 활동에 참여하는 사람들은 편한 옷을 입도록 권장된다.

1. those who

지시대명사 those는 관계대명사 who가 이끄는 관계사절의 수식을 받아 '~하는 사람들'이라는 의미로 쓰인다. 이 경우에는 단수형 that이나 다른 인칭대명사가 those 대신 쓰일 수 없다. 관계대명사 who 뒤에는 복수 동사가 와야 하며 〈who+be동사〉는 생략되기도 한다. those는 전치사구 또는 분사의 수식도 받을 수 있다.

those who ~하는 사람들	**Those** (**who** <u>are</u>) assigned to cleaning tasks should wear rubber gloves. ~~That, They~~ 청소 업무를 배정받은 사람들은 고무장갑을 착용해야만 한다.

2. 지시대명사 that과 those

한 문장에서 앞에 나온 명사가 반복될 경우 단수 명사는 that을, 복수 명사는 those를 써서 이를 대신한다.

The opinions in this newspaper are **those** of the individual writers. [those=the opinions]
이 신문의 의견들은 개별 작가들의 의견이다.

Use a strong password to prevent **others** from accessing your online bank account.

(A) others (B) nobody
(C) ones (D) another

문맥상 '정해지지 않은 전체 중, 일부 사람들이' 접근하지 못하게 한다는 의미이므로 정답은 (A) others. (B) nobody는 '아무도'라는 뜻으로 문맥상 어색하며, (C) ones나 (D) another는 앞에서 언급된 명사인 '비밀번호(들)'의 접근을 막는다는 것을 의미하여 문맥에 맞지 않아 오답.

해석 | 다른 사람들이 귀하의 온라인 은행 계좌에 접근하지 못하도록 강력한 비밀번호를 사용하세요.

3. 부정대명사

부정대명사는 정해지지 않은 막연한 대상을 가리킬 때 쓰는 대명사이다.

one	▶ '정해지지 않은 막연한 어떤 것(하나)'을 가리키거나 일반인(we)을 나타낼 수 있다. Those tickets sell out so quickly that it's difficult to get **one**. [one=a ticket] 그 표는 너무 빨리 팔려서 하나를 구하는 것이 어렵다.
another	▶ '앞에서 언급한 것 이외의 또 다른 하나'를 의미한다. I had to transfer from one train to **another** in order to get to City Hall. 나는 시청에 가기 위해 한 기차에서 다른 기차로 갈아타야 했다.
other	▶ 대명사일 때 세 형태 중 하나로만 쓰이며 other 자체로는 대명사 역할을 할 수 없다.

	the other	others	the others
other	(둘 중) 나머지 하나	(정해지지 않은 전체 중) 나머지 일부	(정해진 전체 중) 나머지 전부

Some people believed his excuse, but **others** didn't.
몇몇 사람들은 그의 변명을 믿었지만, 다른 사람들은 믿지 않았다.

주의해야 할 부정대명사

부정대명사를 묻는 문제는 빈칸이 의미상 가리키는 대상이 무엇인지 파악하여 답을 고르는 것이 중요하다. 의미나 형태가 비슷하지만 쓰임이 다른 부정대명사는 따로 정리하여 알아두자.

The Vitaplus cereal bars come in a variety of flavors, but **none** of them are sugar free.

(A) not (B) no
(C) **none** (D) nothing

문맥상 '그것들 중 아무것도 무가당이 아니다'라고 하는 것이 알맞으므로 대명사 (C) none이 정답이다. 부사 (A) not과 형용사 (B) no는 주어 자리에 올 수 없으므로 오답. (D) nothing은 항상 단수 취급하는 대명사로 복수 동사 are와 수가 일치하지 않으므로 오답이다.

해석 | 비타플러스 시리얼 바는 다양한 맛으로 나오는데, 그것들 중 무가당인 것은 아무것도 없다.

1. none(대명사) / no(형용사)

none과 no 모두 부정의 의미를 나타내지만, none은 대명사이므로 단독으로 쓰이며, no는 형용사이므로 반드시 뒤에 명사가 와야 한다.

Turbulence was expected during the flight, but there was **none**.
비행 중에 난기류가 예상되었지만 아무 일도 없었다.

The manager had **no** idea of how to handle the matter. 부장은 그 문제를 어떻게 해결할지에 대해 아무런 생각이 없었다.

2. some / any

some과 any는 둘 다 부정대명사 또는 부정형용사로 쓰이며 '몇몇, 조금'이라는 뜻을 가진다. 그러나 some은 주로 긍정문, any는 주로 부정문, 조건문, 의문문에 쓰인다는 점에서 다르다. 또한, any는 긍정문에서 '어떤 ~라도'의 뜻으로도 쓰인다.

Some of the stockholders were upset about the previous quarter's performance.
몇몇 주주들은 지난 분기의 실적에 당황했다.

This voucher can be used on **any** airline you choose. 이 상품권은 당신이 선택한 어떤 항공사에서도 이용할 수 있다.

Although some tenants disagree with setting quiet hours, **most** of them are in favor of it.

(A) almost (B) much
(C) **most** (D) any

빈칸 뒤의 of와 함께 쓰여 '대부분'이란 의미로 쓰이는 것은 대명사인 (C) most이다. (A) almost는 부사이므로 대명사로 쓸 수 없다. 비슷한 의미를 가진 대명사 most와 부사 almost의 쓰임을 구별해 두자.

해석 | 비록 일부 세입자들이 소음 없는 시간을 만드는 것에 반대하긴 하지만, 대부분의 세입자들은 그것에 찬성한다.

3. most (대명사, 한정사) / almost (부사)

most는 대명사이기도 하지만 한정사로 뒤에 명사가 오기도 한다. almost는 부사이므로 바로 뒤에 명사가 올 수 없다.

Most of the pollution in the city is caused by vehicles. 도시 오염의 대부분은 차량에 의해 발생된다.
~~Almost~~

Almost all merchandise at the store is on sale today. 그 상점에 있는 거의 모든 제품들이 오늘 할인된다.

4. each (대명사, 형용사) / every (형용사)

each와 every는 둘 다 부정형용사로서 단수 명사를 수식하며 '모두의'라는 의미를 가진다. 그러나 each는 대명사로 쓰이는 반면, every는 대명사로 쓸 수 없다는 차이가 있다.

Each of the ambassadors was given a small welcome gift. 모든 대사들은 작은 환영 선물을 받았다.
~~Every~~

Every room comes furnished with a king-size bed. 모든 방은 킹사이즈 침대가 갖춰져 있다.

FINAL TEST

1. During the training, the manager reminded all of the supervisors to update ------- progress charts every week.

(A) they (B) their
(C) themselves (D) them

2. We are out of stock of Decibel headphones as the last ------- on the shelf was sold yesterday.

(A) that (B) one
(C) other (D) another

3. Most motorists avoid the Abenson Boulevard after office hours to keep ------- from getting caught in heavy traffic.

(A) yourselves (B) themselves
(C) itself (D) ourselves

4. A security officer checked the passports and boarding passes of ------- in line at the boarding gate.

(A) another (B) his own
(C) other (D) everyone

5. Theater enthusiasts may buy the complete soundtrack of the musical *Evergreen* at ------- Beats & Lyrics outlet.

(A) any (B) much
(C) many (D) all

6. According to the Labor Department's survey, ------- who work from home are mostly married women with young children.

(A) those (B) that
(C) ours (D) theirs

7. The Chamber of Commerce hosts monthly gatherings to give an opportunity for members to get to know -------.

(A) one another (B) another
(C) other (D) anybody

8. Mr. Stevens has turned in his vacation request form to the human resources office, but Ms. Clark has yet to fill out -------.

(A) herself (B) she
(C) hers (D) her

9. ------- is allowed to stay in the physics laboratory beyond office hours except authorized engineers.

(A) No one (B) Each other
(C) Someone (D) Others

10. Because of our advanced equipment, several museums contact ------- to request assistance with moving delicate sculptures.

(A) we (B) us
(C) ours (D) ourselves

11. To encourage more people to come to the fundraiser, the host entered ------- of the guests in a raffle for a trip to Europe.

(A) every (B) each
(C) someone (D) others

12. ------- all of the delegates are coming from overseas, but there are a few local representatives as well.

(A) Most (B) Much
(C) Any (D) Almost

13. Since the secretary was sick for a week, Mr. Clements had to prepare the documents for the client meetings -------.

(A) he (B) his
(C) himself (D) his own

14. Before ordering vaccines, the doctors must determine the amount of supplies that ------- need for the estimated number of patients.

(A) their (B) them
(C) they (D) themselves

정답 및 해설 10쪽

CHAPTER
3

-

동사편

DAY 04
수일치

—

기본 개념 노트

본 학습에 들어가기 전에 기본 문법 개념의 틀을 잡아보자.

❶ 개념

수일치란 주어의 수에 따라 동사를 일치시키는 것을 말한다. 즉, 주어가 단수이면 단수에 맞는 동사를, 주어가 복수이면 복수에 맞는 동사의 형태를 써야 한다.

단수 주어 + 단수 동사	① Our software **is** ideal for small business owners.
복수 주어 + 복수 동사	② Economists **assume** that property prices are going to fall.

❷ 형태

동사의 기본 형태를 변형하여 단수 동사와 복수 동사를 만들 수 있다.

단수 동사 (3인칭 단수 주어) 현재시제	일반동사 → -(e)s be동사 → is do동사 → does have동사 → has	③ The river **divides** the city into two parts. ~~divide~~ ④ This model **has** various features. ~~have~~
복수 동사 (복수 주어) 현재시제	일반동사 → 동사원형 be동사 → are do동사 → do have동사 → have	⑤ The mall workers actively **assist** customers. ~~assists~~ ⑥ These articles **are** easy to read. ~~is~~

주의 be동사의 과거형의 경우, 3인칭 단수 주어에는 was를, 복수 주어에는 were를 쓴다. 일반동사의 과거형이나 미래형의 경우, 동사의 형태는 주어의 단수/복수와는 무관하다.

① 우리 소프트웨어는 소규모 기업가들에게 이상적이다. ② 경제학자들은 부동산 가격이 떨어질 것이라고 추정한다. ③ 그 강은 도시를 두 부분으로 나눈다. ④ 이 모델은 다양한 특징을 갖고 있다. ⑤ 그 쇼핑몰의 직원들은 고객들을 적극적으로 돕는다. ⑥ 이 기사들은 읽기 쉽다.

SELF-TEST

기본 개념이 토익에는 어떻게 출제되는지 알아보자. ⏰ 제한시간 03:00

다음 핵심 포인트를 참고하여
정답이 되는 이유를 적어보자. NOTE

1. Market analysts ------- that stock prices of food corporations will increase during the holiday season.

 (A) predicts (B) is predicting
 (C) predict (D) predictable

2. Either the managers or the art director ------- the graphic designer who will receive the performance bonus.

 (A) select (B) selects
 (C) selecting (D) selective

3. The integration of Starr Pharmaceuticals into Easton Laboratories ------- a thorough review of their operations.

 (A) requires (B) requiring
 (C) requirement (D) require

4. Staff members who ------- heavy equipment must receive regular training to ensure their safety.

 (A) operates (B) operate
 (C) is operating (D) is operated

5. All of the carpet companies ------- eager to participate in the construction fair.

 (A) to be (B) are
 (C) is (D) being

6. To fully restore the museum, a large amount of money ------- to be invested.

 (A) need (B) needing
 (C) needs (D) are needed

NOTE

1. 주어의 단수/복수 구별

2. 상관접속사의 수일치

3. 긴 주어의 수일치

4. 관계사절 내 동사의 수일치

5. <all of the + 가산명사의 복수형>의 수일치

6. <an amount of + 불가산명사>의 수일치

문제별 출제 POINT ▶ 다음 페이지에서 확인하기

주어와 동사의 수일치

선택지에 동사의 단수와 복수 형태가 모두 있다면 수일치 문제일 확률이 높다. 수일치 문제는 수일치의 개념을 확실히 이해해야 하며, 상관접속사로 이어진 주어의 수 또한 주의해서 파악해야 한다.

Market analysts **predict** that stock prices of food corporations will increase during the holiday season.

(A) predicts (B) is predicting
(C) predict (D) predictable

빈칸은 동사 자리로 동사의 알맞은 형태를 묻는 문제이다. 주어 Market analysts가 가산명사의 복수 형태이므로 동사도 복수형이어야 한다. 따라서 정답은 (C) predict.

해석 | 시장 분석가들은 휴가철에 식품 회사들의 주가가 오를 것이라고 예상한다.

1. 주어의 단수/복수 구분

단수 주어 뒤에는 단수 동사가, 복수 주어 뒤에는 복수 동사가 온다는 것이 수일치의 기본 법칙이다. 주어의 단수/복수 구분이 중요하므로 다음을 주의해서 알아두자.

단수 취급 주어	가산명사의 단수	The supervisor **assigns** shifts based on worker availability. ~~assign~~ 그 관리자는 직원의 가능 여부를 바탕으로 근무조를 배정한다.
	불가산명사	Information **spreads** quickly in this age of high technology. ~~spread~~ 지금의 첨단 기술 시대에서 정보는 빠르게 확산된다.
	to부정사(구) 동명사(구)	Cooperating with team members **is** the best way to build trust. ~~are~~ 팀원들과 협력하는 것이 신뢰를 쌓는 가장 좋은 방법이다.
	명사절	That the Internet package options are limited **is** disappointing. 인터넷 가격 선택권이 제한되어 있다는 것이 실망스럽다. ~~are~~
복수 취급 주어	가산명사의 복수	The managers **set** sales goals on a monthly basis. ~~sets~~ 관리자들은 매달 매출 목표를 설정한다.

Either the managers or the art director **selects** the graphic designer who will receive the performance bonus.

(A) select **(B) selects**
(C) selecting (D) selective

상관접속사 either A or B 형태의 주어는 B의 수에 동사를 일치시켜야 한다. the art director가 단수이므로 단수 동사인 (B) selects가 정답이다. the managers에 수일치하는 복수 동사인 (A) select를 고르지 않도록 주의하자.

해석 | 관리자들이나 미술 감독이 성과급을 받을 그래픽 디자이너를 선정한다.

2. 상관접속사의 수일치

주어가 and로 이어지면 복수로 취급하고, but 또는 or로 이어지면 동사와 가까이에 있는 주어의 수에 동사를 일치시킨다.

both A and B	복수 취급	Both the ceiling and the wall **need** to be repainted. 천장과 벽 모두 페인트칠을 다시 해야 한다. ~~needs~~
not only A but (also) B =B as well as A	B에 수일치	Not only the jacket but also the shirts **are** outdated. 재킷뿐만 아니라 셔츠들도 구식이다. ~~is~~
either A or B neither A nor B	B에 수일치	Neither the managers nor the CEO **favors** the idea. ~~favor~~ 관리자들과 대표이사 모두 그 생각을 선호하지 않는다.

긴 주어의 수일치

수일치 문제의 대부분은 주어와 동사 사이에 수식어구가 등장해 주어를 찾기 힘들게 한다. 또한 관계사절 내의 동사 자리를 묻기도 하는데, 핵심은 주어와 동사를 제대로 찾는 데 있음을 명심하자.

SELF-TEST 3

The integration of Starr Pharmaceuticals into Easton Laboratories **requires** a thorough review of their operations.

(A) requires (B) requiring
(C) requirement (D) require

문장의 동사가 없으므로 빈칸은 동사 자리이다. of부터 Laboratories 까지는 수식어구로 문장의 주어는 단수 명사 The integration이다. 따라서 정답은 단수 동사인 (A) requires이다.

해석 | 스타 제약의 이스턴 연구소로의 통합은 그들의 운영에 대한 철저한 검토를 필요로 한다.

출제원리

1. 주어 + [수식어구] + 동사

주어와 동사 사이에 다양한 수식어구가 삽입되어 주어가 길어지는 경우가 흔하다. 따라서 수식어구를 제외하고 주어와 동사를 정확하게 찾아내는 것이 중요하다.

주어 + [부사] + 동사	The new pay increase [only] **applies** to full-time workers. ~~apply~~ 새로운 급여 인상은 정규직 직원들에게만 적용된다.
주어 + [전치사구] + 동사	The stores [in the shopping district] **open** at 10 A.M. ~~opens~~ 그 상점가 매장들은 오전 10시에 문을 연다.
주어 + [분사구] + 동사	The woman [standing by the bookshelves] **seems** to be the owner. ~~seem~~ 책장 옆에 서 있는 여자가 주인처럼 보인다. Any belongings [left on the train] **are** taken to the lost-and-found. ~~is~~ 기차에 남겨진 모든 소지품은 분실물 센터로 보내진다.
주어 + [to부정사구] + 동사	The agreement [to merge the two companies] **was** settled. ~~were~~ 두 회사를 합병하는 합의안이 체결되었다.
주어 + [관계사절] + 동사	The reimbursement [that Mr. Jones requested] **includes** travel costs. ~~include~~ 존스 씨가 요청한 환급에는 출장 비용이 들어있다.

SELF-TEST 4

Staff members who **operate** heavy equipment must receive regular training to ensure their safety.

(A) operates (B) operate
(C) is operating (D) is operated

주격 관계대명사 who가 이끄는 관계사절에 동사가 없으므로 빈칸은 관계사절의 동사 자리이다. 이때 동사는 관계대명사 앞의 선행사의 수와 일치시켜야 하므로 복수 선행사 Staff members에 어울리는 복수 동사인 (B) operate가 정답이다.

해석 | 중장비를 조작하는 직원들은 그들의 안전을 보장하기 위해 정기적인 교육을 받아야 한다.

2. 관계사절 내 동사의 수일치

관계대명사절 내의 동사는 관계대명사 앞 선행사와 수를 일치시켜야 한다.

단수 선행사		단수 동사
복수 선행사	+ 주격 관계대명사 (who, which, that) +	복수 동사

The committee prefers using a contractor [who **has** extensive experience].
　　　　　　　　　　　　　　　　단수 선행사　　　~~have~~　위원회는 풍부한 경험을 가진 계약업체를 쓰는 것을 선호한다.

Candidates [who **wish** to apply for the fellowship] must submit a proposal by December 15.
복수 선행사　　~~wishes~~　　　　　　연구비를 신청하고 싶은 후보자는 12월 15일까지 제안서를 제출하셔야 합니다.

수량 표현의 수일치

수일치의 가장 고난도 문제는 부정대명사를 이용한 다양한 수량 표현이 등장하는 경우이다. 각 수량 표현마다 취할 수 있는 명사의 종류가 정해져 있으므로 종류별로 구분해서 암기해 두자.

All of the carpet companies **are** eager to participate in the construction fair.

(A) to be **(B) are**
(C) is (D) being

문두의 All of the carpet companies를 보자마자 〈All of the 복수 명사+복수 동사〉를 떠올렸다면 쉽게 풀 수 있다. 따라서 정답은 복수 동사 (B) are. 어떤 대상의 전체나 일부분을 나타내는 수량 표현에 대한 수일치 문제가 가끔 출제되므로 정리해서 알아두어야 한다.

해석 | 모든 카펫 업체는 건축 박람회에 참여하고 싶어 한다.

1. 수량 표현의 수일치

〈수량 관련 대명사+of+한정사+명사〉 표현은 of 뒤의 명사를 기준으로 수일치한다.

all, most, some, any, half		+ 가산명사의 복수형 / 불가산명사	+ 복수 동사 / 단수 동사
many, (a) few, both, several	of the	+ 가산명사의 복수형	+ 복수 동사
much, (a) little		+ 불가산명사	+ 단수 동사

Half of the new employees **were** assigned to overseas branches. 신입 사원의 절반이 해외 지사에 배정되었다.
Half of the money **was** raised by investors in Europe. 돈의 절반이 유럽에 있는 투자자들에 의해 모아졌다.

2. 항상 단수 취급하는 표현

한정사로 쓰일 때는 단수 명사만 수식하고, 대명사로 쓰일 때는 항상 단수로 취급하여 단수 동사가 온다.

one 하나(의) each 각각(의) every 모든 either 둘 중 어느 하나 neither 둘 다 모두 아닌

One of my colleagues **wants** to start her own business. 내 동료 중 한 명은 자신의 사업을 시작하고 싶어 한다.

To fully restore the museum, a large amount of money **needs** to be invested.

(A) need (B) needing
(C) needs (D) are needed

수량 표현들은 함께 쓰이는 명사의 종류가 정해져 있고, 그 명사의 수에 동사의 수를 일치시켜야 한다. an amount of 뒤에는 불가산명사 money가 오기 때문에 단수 동사인 (C) needs가 정답.

해석 | 박물관을 완전히 복원하기 위해서, 거액의 돈이 투자되어야 한다.

3. 주의해야 할 수량 표현

〈a[an]+명사+of〉 형태는 형용사처럼 쓰이는 수량 표현으로, 뒤에 오는 명사에 수를 일치시켜야 한다.

a lot of, lots of, plenty of 많은	+	가산명사의 복수형 / 불가산명사	+ 복수 동사 / 단수 동사
a number of, a range of 많은 a couple of 둘의, 몇몇의 a variety of 다양한		+ 가산명사의 복수형	+ 복수 동사
an amount of 많은, 상당한		+ 불가산명사	+ 단수 동사

A lot of coordination **is** needed for that task. 그 업무에는 많은 협조가 필요하다.
A number of publishers **are** interested in her novel. 많은 출판사들이 그녀의 소설에 관심을 갖고 있다.

주의 the number of는 '~의 수'라는 의미로 항상 단수 취급한다.
 The number of publishers **is** decreasing. 출판사들의 수가 줄어들고 있다.

FINAL TEST

1. The new security measure ------- visitors from entering the building without showing an identification card.

(A) restrict
(B) restricts
(C) restrictive
(D) restriction

2. ------- of Berry Field's financial problems were strongly denied by the food company's management.

(A) Reports
(B) Reporting
(C) Reported
(D) Report

3. In the downtown area, each of the establishments ------- to business regulations set by the city government.

(A) conformist
(B) conforming
(C) conform
(D) conforms

4. Even though ------- of the desks are not currently in stock, all types will be available next week.

(A) every
(B) most
(C) either
(D) neither

5. Some nurses at the hospital ------- longer hours nowadays due to the large number of patients.

(A) works
(B) work
(C) workers
(D) working

6. Neither the hotel Web site nor the brochures ------- any complimentary services to regular guests.

(A) mention
(B) to mention
(C) mentions
(D) mentioning

7. There are a number of ------- that respondents must answer in the market survey form.

(A) questions
(B) questioning
(C) questioned
(D) question

8. The shipment requested by local customers ------- to the Marks & Vaughn warehouses in Slough yesterday.

(A) delivery
(B) delivering
(C) was delivered
(D) were delivered

9. Employees arranging conference calls must notify all attendees whenever they ------- a change in their schedules.

(A) expectation
(B) expect
(C) expects
(D) expectedly

10. Tromso Hardware sells wood in a ------- of styles, and it makes the store popular among consumers.

(A) priority
(B) quotation
(C) limit
(D) variety

11. Reading Corner's improved purchasing system immediately ------- problems with recording and processing customer orders.

(A) reducing
(B) reduced
(C) reduce
(D) have reduced

12. The hallway that ------- to the fitness gym on the sixth floor has been closed to make way for the renovation.

(A) leading
(B) leads
(C) lead
(D) leader

13. The ------- to be made on the Web pages strongly suggest that the graphic artists missed some instructions from the client.

(A) changes
(B) change
(C) changeable
(D) changed

14. The use of plastic cutlery and disposable containers ------- by the Environmental Office.

(A) are prohibited
(B) to prohibit
(C) prohibiting
(D) is prohibited

Questions 15-18 refer to the following memo.

To: Marketing department employees
From: Heather Gray, Marketing Director
Date: September 2
Subject: Monthly meeting

A luncheon will be held on Friday, September 10, in the sixth-floor cafeteria for all marketing department employees to learn about our latest analysis. ------. Afterward, we will have time to
15.
talk about our future marketing plans.

The new strategies to be implemented in the upcoming quarter ------ to reflect the team's new
16.
findings. In brief, quite surprisingly, a survey conducted by the team showed that customers prefer the black-and-white advertisements to the bright and colorful ------. To take advantage of
17.
this trend, we look forward to hearing ------ insights and ideas on September 10.
18.

15. (A) We will be discussing which intern to hire
 as a full-time employee.
 (B) Our research team will present the results
 of their most recent study.
 (C) We will invite all of our customers to
 come eat with us.
 (D) First, an art organization will show us the
 recent works of local artists.

16. (A) are expected
 (B) expects
 (C) expecting
 (D) expectation

17. (A) ones
 (B) others
 (C) most
 (D) either

18. (A) you
 (B) yourself
 (C) your
 (D) yours

June 4

Wetzel Enterprises
507 Palmer Road
Westerville, OH 43081

To Whom It May Concern:

I would like to formally complain about a defective 3-in-1 Emblem printer I bought from your store last week. I'm providing a few ------ on the printer's strange performance. Whenever I produce
19.
graphs in color, it prints black in locations that are designated for color ink. Also, I cannot select the "high-resolution" ------ on the LCD screen when saving a scanned document. However,
20.
your manual states that the device's selection panels easily ------ users to control the printer's
21.
settings. I believe that the ink nozzle and touch screen are damaged. ------. I demand your
22.
immediate response to them. Call me at 555-0909.

Sincerely,

Richard Sanghi

19. (A) remark
 (B) remarkable
 (C) remarkably
 (D) remarks

20. (A) option
 (B) favor
 (C) concept
 (D) cause

21. (A) allowing
 (B) allow
 (C) is allowed
 (D) to allow

22. (A) I strongly suggest recalling all your printers.
 (B) Thank you for recommending a solution to my concern.
 (C) Your shop repaired my scanner within a day.
 (D) I have been seriously inconvenienced by these problems.

CHAPTER

3

-

동사편

DAY 05
시제

—

기본 개념 노트

본 학습에 들어가기 전에 기본 문법 개념의 틀을 잡아보자.

❶ 개념 및 형태

시제란 동사의 형태 변화를 통해 시간 관계를 표현하는 것을 말한다. 총 12시제가 있다.

	단순	진행	완료	완료 진행
현재	단순 현재 am[are, is] 동사원형(+(e)s)	현재진행 am[are, is] *doing*	현재완료 have[has] *p.p.*	현재완료 진행 have[has] been *doing*
과거	단순 과거 was[were] 동사원형+(e)d or 불규칙 과거형	과거진행 was[were] *doing*	과거완료 had *p.p.*	과거완료 진행 had been *doing*
미래	단순 미래 will 동사원형	미래진행 will be *doing*	미래완료 will have *p.p.*	미래완료 진행 will have been *doing*

❷ 종류 및 의미

각기 다른 시제는 의미하는 시간의 범위가 다르다.

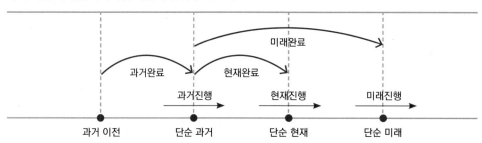

❸ 쓰임

시간의 부사를 확인하고 알맞은 시제를 찾아야 한다.

① Mr. Belzoni <u>usually</u> **commutes** to work by subway.

　　　　　　　　반복, 습관을 나타내는 현재 시제

② He **started** working as the marketing director <u>last week</u>.

　　　　'지난주'라는 과거 특정 시점의 일을 나타내는 과거 시제

③ Many people **will attend** the event <u>tomorrow</u>.

　　　　'내일'이라는 미래 특정 시점의 일을 나타내는 미래 시제

① 벨조니 씨는 보통 지하철로 출근한다. ② 그는 지난주에 마케팅 부장으로 일을 시작했다. ③ 많은 사람들이 내일 행사에 참석할 것이다.

SELF-TEST

기본 개념이 토익에는 어떻게 출제되는지 알아보자. ⏱ 제한시간 03:00

다음 핵심 포인트를 참고하여
정답이 되는 이유를 적어보자. **NOTE**

DAY 05

1. The new marketing campaign ------- significant profits to the company last month.

 (A) brought　　　　　(B) has brought
 (C) brings　　　　　 (D) is bringing

 1. last month

2. The Merchants Association ------- a free business seminar next Saturday, May 10.

 (A) was hosting　　　(B) will be hosting
 (C) hosted　　　　　(D) host

 2. next Saturday

3. Since EL Chorizo created the employee recognition program, employee motivation ------- considerably.

 (A) will increase　　(B) increases
 (C) increased　　　 (D) has increased

 3. Since

4. Before its owner decided to sell it, the old building ------- abandoned for twenty years.

 (A) has been　　　　(B) was
 (C) had been　　　　(D) will be

 4. before 접속사절의 과거 시제

5. Marathon participants will be arriving at the venue thirty minutes before the event -------.

 (A) will begin　　　 (B) begin
 (C) begins　　　　　(D) has begun

 5. 시간·조건 부사절의 시제

6. The sound technician asked that all cell phones ------- off to prevent noise.

 (A) are turned　　　(B) turns
 (C) be turned　　　 (D) turned

 6. 주장·제안·명령·요구 동사 + that절

문제별 출제 **POINT** ▶ 다음 페이지에서 확인하기

51

단순 시제 & 진행 시제

동사의 올바른 형태를 묻는 문제에서는 시제를 반드시 확인해야 한다. 이때 부사와 시간 표현이 시제의 단서가 되므로 문장을 모두 해석하려 하지 말고 단서를 빠르게 찾아 정답을 고르도록 하자.

SELF-TEST 1

The new marketing campaign **brought** significant profits to the company last month.

(A) brought (B) has brought
(C) brings (D) is bringing

선택지를 보니 시제에 맞는 동사의 형태를 묻는 문제로, 시제를 나타내는 단서를 찾아내는 것이 관건이다. 문장 마지막에 last month라는 과거를 나타내는 표현이 있으므로 과거 시제인 (A) brought가 정답.

해석 | 새로운 마케팅 캠페인은 지난달 회사에 상당한 이익을 가져다 주었다.

1. 단순 시제

현재, 과거, 미래 시제를 단순 시제라고 한다. 각각의 단순 시제와 어울려 쓰이는 다양한 시간 표현들이 있는데, 시제를 명확히 보여주는 단서가 되므로 정리하여 알아두자.

현재 시제	▸ 현재의 사실이나 상태, 일반적 사실, 반복적 행위를 나타낸다. 단서: always, currently, each+시간 명사, every, generally, normally, now, often, usually She <u>always</u> **participates** in annual training sessions. 그녀는 연례 연수 과정에 항상 참여한다.
과거 시제	▸ 과거의 동작이나 상태, 과거에 일어난 일을 나타낸다. 단서: ago, last, once, past+시간 명사, previously, then The famous rock band **toured** the country <u>last year</u>. 그 유명한 록 밴드는 작년에 전국을 순회했다.
미래 시제	▸ 미래의 계획, 예상이나 추측을 나타낸다. 단서: later (on), soon, starting[beginning]+시간 명사, this[next]+시간 명사, tomorrow The store **will raise** its prices <u>beginning next month</u>. 다음 달부터 그 상점은 가격을 인상할 것이다.

SELF-TEST 2

The Merchants Association **will be hosting** a free business seminar next Saturday, May 10.

(A) was hosting **(B) will be hosting**
(C) hosted (D) host

미래를 나타내는 시간 부사구 next Saturday가 결정적인 단서이다. 따라서 미래 시제가 와야 하는데, 단순 미래는 선택지에 없고 미래의 일을 나타내는 미래진행형이 있으므로 정답은 (B) will be hosting.

해석 | 상인 조합은 다음 주 토요일인 5월 10일에 무료 사업 세미나를 주최하고 있을 것이다.

2. 진행 시제

진행 시제는 〈be동사+doing〉의 형태로, 특정 시점에 진행 중인 일을 강조할 때 쓴다. 이때, 현재진행형의 경우 가까운 미래의 계획을 나타내기도 하는데, 보통 미래의 시간 표현이 함께 수반된다. 토익에 미래 시제 대신 현재진행형이나 미래진행형이 정답으로 자주 출제된다.

현재진행	He **is interviewing** some applicants <u>now</u>. 그는 지금 몇 명의 지원자들을 면접 보는 중이다. Mr. Miller **is retiring** <u>next month</u> after twenty years as an investment analyst. 밀러 씨는 투자 분석가로 20년 동안 일한 뒤 다음 달에 은퇴할 것이다.
과거진행	Mr. Jones **was working** on his presentation <u>when his boss called</u>. 상사가 전화했을 때 존스 씨는 발표 준비 중이었다.
미래진행	James **will be reviewing** the monthly report <u>at 6 P.M. today</u>. 제임스 씨는 오늘 저녁 6시에 월간 보고서를 검토하고 있을 것이다.

완료 시제

시제를 묻는 문제 중에서도 현재완료 시제를 묻는 문제가 가장 자주 출제된다. '완료'라는 개념을 명확히 이해하고 완료 시제가 정답임을 보여주는 단서를 파악하여 정확하게 정답을 고르도록 하자.

SELF-TEST 3

Since EL Chorizo created the employee recognition program, employee motivation **has increased** considerably.

(A) will increase (B) increases
(C) increased **(D) has increased**

문맥상 '제도를 만든 이후로 직원의 업무 동기가 상당히 증가하였다' 란 뜻이 되어야 하므로 현재완료인 (D) has increased가 정답. 〈Since+주어+과거 시제 ~, 주어+have[has] *p.p.*〉는 '~ 이후로 계속 …해 왔다'란 뜻으로 자주 쓰이므로 하나의 구문처럼 알아두자.

해석 | 엘 초리조 사가 직원 표창 제도를 만든 이후로, 직원의 업무 동기가 상당히 증가하였다.

출제원리

1. 현재완료

현재완료는 〈have[has]+*p.p.*〉의 형태로, 특정한 시점을 나타내는 과거 시제와 달리 과거의 일이 현재까지 지속되는 상태거나[계속], 과거에서 비롯된 일이 현재까지 영향을 미칠 때[완료, 경험, 결과] 쓰인다.

완료	▸ 최근 (막) ~했다 단서: already 이미 just 막 not yet 아직 ~아니다 recently[lately] 최근에 The company **has** already donated to this charity. 그 회사는 이 자선 단체에 이미 기부했다.
계속	▸ (과거부터 현재까지) 계속 ~하고 있다 단서: for ~ 동안 over the past[last]+시간 표현 지난 ~ 동안 since ~ 이후로 until now 지금까지 Mr. Paul **has been** at headquarters for two years. 폴 씨는 2년 동안 계속 본사에 있다.
경험	▸ (과거부터 현재까지) ~ 해본 적이 있다 단서: before 이전에 ever 한 번이라도 never 결코 ~이 아닌 He **has** never negotiated a contract by himself. 그는 혼자서 계약을 성사시켜 본 적이 없다.
결과	▸ (과거에) ~해서 (지금) …인 상태이다 Mr. Pitt **has gone** to Beijing to meet clients. 피트 씨는 고객을 만나러 베이징에 가고 없다.

SELF-TEST 4

Before its owner decided to sell it, the old building **had been** abandoned for twenty years.

(A) has been (B) was
(C) had been (D) will be

문맥상 '주인이 건물을 팔기로 결정하기 전에 20년 동안 버려져 있었다' 라는 뜻이 되어야 한다. 과거의 특정 시점(decided)까지 지속된 동작이나 상태는 과거완료 시제로 나타내므로 정답은 (C) had been.

해석 | 주인이 팔기로 결정하기 전에 그 오래된 건물은 20년 동안 버려져 있었다.

출제원리

2. 과거완료

과거완료는 〈had+*p.p.*〉의 형태로, 과거에 일어난 두 가지 일 중 먼저 일어난 일을 나타내거나, 과거 이전부터 과거 특정 시점까지 동작이나 상태가 지속되었음을 나타낸다.

Mr. Frank repaid the loan that he **had borrowed** three years before.
 과거 과거 이전 프랭크 씨는 3년 전에 빌렸던 융자금을 상환했다.

Because we arrived late to the café, Amanda **had waited** for nearly an hour.
우리가 카페에 늦게 도착했기 때문에, 아만다 씨는 거의 한 시간 동안 기다렸다.

3. 미래완료

미래완료는 〈will+have+*p.p.*〉의 형태로 동작이나 상태가 미래의 어느 때까지 완료 또는 계속될 것임을 나타내며, by, by the time, by the end of+시점 표현과 주로 쓰인다.

Congress **will have approved** the law by Monday. 국회는 월요일까지 그 법안을 승인할 것이다.

시제 일치의 예외

시제 일치란 종속절과 주절의 동사 시제를 일치시키는 것을 말하는데, 그 예외인 경우가 가끔 출제된다.
토익에 출제되는 시제 일치의 예외는 그 종류가 정해져 있으므로 다음의 출제원리를 확실히 알아두자.

Marathon participants will be arriving at the venue thirty minutes before the event **begins**.

(A) will begin (B) begin
(C) begins (D) has begun

시간, 조건의 부사절에서는 미래 시제 대신 현재 시제를 쓴다는 것을 알아야 풀 수 있는 문제이다. 주절의 동사가 미래 시제(will be arriving)로 쓰였지만, before가 이끄는 시간 부사절에서는 미래의 일을 나타낼 때 현재 시제를 써야 하므로 부사절의 단수 주어 the event에 수일치한 (C)가 정답이다.

해석 | 마라톤 참가자들은 행사가 시작되기 30분 전에 행사장에 도착할 것이다.

1. 시간이나 조건의 부사절

시간이나 조건의 부사절에서는 미래의 일을 나타낼 때 현재 시제를 쓴다. 단, 과거의 일은 그대로 과거 시제로 쓴다.

시간 부사절	after ~ 후에 as soon as ~하자마자 before ~ 전에 by the time ~할 때쯤 until ~할 때까지 when[as] ~할 때 while ~ 동안 After we **remove** the hazardous materials, we will resume production. ~~will remove~~ 위험 물질을 제거한 후에, 우리는 생산을 재개할 것이다. The seminar will begin as soon as the guest speaker **arrives**. 연사가 도착하자마자 세미나가 시작될 것이다. ~~will arrive~~
조건 부사절	if ~ 한다면 unless ~이 아니라면 providing[provided] (that) ~라면 The sales team will be pleased if they **meet** their goal. 영업팀은 목표를 달성한다면 기쁠 것이다. ~~will meet~~ Unless we **succeed** in winning this bid, we will not get a bonus. ~~will succeed~~ 이 입찰을 따는데 성공하지 않으면, 우리는 상여금을 받지 못할 것이다.

The sound technician asked that all cell phones **be turned** off to prevent noise.

(A) are turned (B) turns
(C) be turned (D) turned

동사 ask는 요구를 나타내는 동사이므로 이 뒤에 나오는 that절의 동사는 〈should+동사원형〉이 되어야 한다. 이때의 should는 보통 생략되므로 동사원형인 (C) be turned가 정답이다.

해석 | 음향 기사는 소음을 방지하기 위해 모든 휴대폰 전원을 끌 것을 요청했다.

2. that절에 동사원형을 쓰는 경우

주절에 주장, 제안, 명령, 요구를 나타내는 동사나 의무, 필수를 나타내는 형용사가 나오면, 그 필요성과 당위의 의미를 강조하기 위해 that절의 동사는 시제와 관계없이 〈should+동사원형〉을 쓴다. 이때 should는 보통 생략된다.

주장, 제안, 명령, 요구 동사	ask 요구하다 insist 주장하다	demand 요구하다 order 명령하다	recommend 권고하다 request 요청하다	suggest 제안하다 require 요청하다
의무, 필수 형용사	crucial 결정적인 essential 필수적인	imperative 긴요한 important 중요한	mandatory 의무적인 necessary 필요한	vital 필수적인 urgent 급한

Ms. Rose requested that she (should) **be seated** in the front row. 로즈 씨는 앞줄에 앉기를 요청했다.

It is important that employees (should) **cooperate** with each other. 직원들이 서로 협력하는 것은 중요하다.

주의 의미상 필요성과 당위의 의미가 아닌 객관적 사실을 의미할 경우에는 시제 일치를 따른다.

Recent statistics suggest that consumer spending **is** on the rise.
최근 통계 자료는 소비자 지출이 상승하고 있음을 암시한다. ~~be~~

FINAL TEST

1. An increase in oil price normally ------- the costs of basic commodities, such as rice and flour.

(A) affects　　　　　(B) was affected
(C) is affecting　　　(D) affect

2. Stockholders should call the public relations office to ------- their attendance to the general meeting.

(A) remind　　　　　(B) approve
(C) support　　　　　(D) confirm

3. Smitty Fashion ------- a new marketing campaign next quarter for their latest collection.

(A) is launching　　　(B) launch
(C) to launch　　　　(D) has launched

4. Two years ago, Swiss Pharma ------- an exclusive license to manufacture vaccines for newborns.

(A) obtains　　　　　(B) has obtained
(C) obtained　　　　　(D) obtaining

5. Over the past thirty years, Wilcon Crystals ------- a high standard of excellence in jewelry making.

(A) will be setting　　(B) has set
(C) is being set　　　(D) sets

6. Mr. Mullahy's team ------- its proposed Web design by the end of the week.

(A) is completing　　　(B) will have completed
(C) completes　　　　(D) was completed

7. Due to the heavy snow, the tour guide suggested that the fishing trip ------- until tomorrow.

(A) will postpone　　　(B) to postpone
(C) be postponed　　　(D) are postponed

8. The new train station on Libby Street ------- operating next month in time for the holidays.

(A) has begun　　　　(B) had begun
(C) will begin　　　　(D) was beginning

9. If the factory director ------- stricter quality assurance requirements, he will reduce the number of defective products.

(A) develops　　　　　(B) developed
(C) will develop　　　(D) develop

10. Last month's budget cut has ------- influenced several departments in a significant way.

(A) yet　　　　　　　(B) currently
(C) soon　　　　　　(D) already

11. According to the quality inspector, some of the dairy items ------- on display for over two weeks now.

(A) sit　　　　　　　(B) to sit
(C) have been sitting　(D) were sitting

12. It is important that all motorists ------- aware of potential risks and hazards on the road.

(A) be　　　　　　　(B) were
(C) is being　　　　　(D) to be

13. Drivers must continue to use the detour because heavy rains ------- the completion of the highway expansion.

(A) were delaying　　(B) have delayed
(C) delaying　　　　　(D) delays

14. Companies in the region ------- unable to find affordable office supplies before OfficeBlock started to sell inexpensive goods.

(A) have been　　　　(B) would be
(C) had been　　　　　(D) are being

CHAPTER
3

-

동사편

DAY 06
태

—

기본 개념 노트

본 학습에 들어가기 전에 기본 문법 개념의 틀을 잡아보자.

❶ 개념

주어가 동사의 행위를 직접 한 것을 '능동', 행위를 당한 것을 '수동'이라고 한다. 따라서 능동태는 '~가
…한다'로, 수동태는 '~가 …되었다[당한다]'로 해석한다.

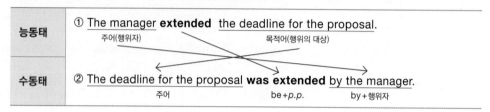

능동태	① The manager **extended** the deadline for the proposal.
	주어(행위자)　　　　　　　　　　　　목적어(행위의 대상)
수동태	② The deadline for the proposal **was extended** by the manager.
	주어　　　　　　　be+p.p.　　　by+행위자

❷ 시제에 따른 수동태의 형태

시제에 따라 수동태의 형태가 달라진다.

	단순	진행	완료
현재	am[are, is]+p.p.	am[are, is] being+p.p.	have[has] been+p.p.
과거	was[were]+p.p.	was[were] being+p.p.	had been+p.p.
미래	will be+p.p.	-	will have been+p.p.

현재	③ Smoking **is permitted** in the designated areas.
현재진행	④ The badly injured passengers **are being treated** at the hospital.
현재완료	⑤ Our hotel **has been featured** in a number of travel magazines.
과거	⑥ An information packet **was sent** to all potential investors.
과거진행	⑦ Several movies **were being released** at the same time.
과거완료	⑧ Mr. Miller found he **had been overcharged** for the utilities for two years.
미래	⑨ The successful candidate **will be contacted** on April 13.
미래완료	⑩ The building **will have been completed** by the end of the month.

① 관리자가 제안서 마감일을 연장했다. ② 제안서 마감일이 관리자에 의해 연장되었다. ③ 흡연은 지정된 장소에서 허용된다. ④ 크게 다친 승객들이 병원에서 치료를 받는 중이다. ⑤ 우리 호텔은 여러 여행 잡지에 특집으로 소개된 바 있다. ⑥ 정보 모음집이 모든 잠재 투자자들에게 보내졌다. ⑦ 여러 편의 영화가 한꺼번에 상영되고 있었다. ⑧ 밀러 씨는 자신이 지난 2년간 공과금에 대해 과다 청구 받아왔다는 사실을 알았다. ⑨ 합격자에게는 4월 13일에 연락이 갈 것이다. ⑩ 그 건물은 이번 달 말까지 완공될 것이다.

SELF-TEST

기본 개념이 토익에는 어떻게 출제되는지 알아보자. ⏱ 제한시간 03:00

다음 핵심 포인트를 참고하여
정답이 되는 이유를 적어보자. **NOTE**

1. Because the CEO had another important matter to handle, the meeting ------- a couple of hours in advance.

 (A) held (B) was holding
 (C) hold (D) was held

 1. 3문형 동사의 태

2. A person who designs houses and buildings with technical skills ------- to as an architect.

 (A) is referring (B) will refer
 (C) has referred (D) is referred

 2. 〈자동사 + 전치사〉의 태

3. The Employee of the Year Award ------- to the company spokesperson, Mr. Andrew Sigh.

 (A) gave (B) was given
 (C) is giving (D) gives

 3. 4문형 동사의 태

4. Mr. Lee is generally ------- one of the top executives in the company.

 (A) considered (B) consideration
 (C) considerably (D) considering

 4. 5문형 동사의 태

5. The marketing team was ------- with the positive feedback on its new advertisement.

 (A) pleasant (B) pleasure
 (C) pleasing (D) pleased

 5. 감정 동사의 태

6. All conference rooms ------- with multimedia systems for presentations and meetings.

 (A) equip (B) have equipped
 (C) are equipped (D) are equipping

 6. 수동태 구문

문제별 출제 **POINT** ▶ 다음 페이지에서 확인하기

3문형 동사의 태

능동태와 수동태를 구분하는 문제는 토익에 매회 출제되고 있다. 그중에서도 특히 3문형에서 비롯된 수동태를 묻는 문제가 자주 출제되므로 3문형 수동태 문장의 특징을 살펴보자.

SELF-TEST 1

Because the CEO had another important matter to handle, the meeting **was held** a couple of hours in advance.

(A) held (B) was holding
(C) hold **(D) was held**

선택지를 보니 알맞은 동사 형태를 고르는 문제로, 주어와 동사의 관계를 살펴본다. 주어 the meeting이 수동적으로 열리는 것이므로 수동태를 써야 한다. 따라서 정답은 (D) was held.

해석 | 대표이사가 처리할 다른 중요한 일이 있어서, 회의가 두어 시간 미리 열렸다.

출제원리

1. 수동태로 쓸 수 없는 자동사

목적어를 취하지 않는 자동사들은 수동태로 쓰이지 않는다. 아래 대표적인 자동사들을 확인해보자.

arrive 도착하다	decline 감소하다	grow 증가하다, 자라다	last 지속되다	rise 증가하다
continue 계속되다	expire 만료되다	happen 발생하다	remain ~인 상태로 남다	sell 팔리다

The voucher for a one-way ticket **expires** on December 31.
~~is expired~~ 편도 티켓 할인권은 12월 31일에 사용 기한이 만료된다.

Weather forecasters do not think the mild weather will **last**. 기상 예보관들은 온화한 날씨가 지속될 것으로 보지 않는다.
~~be lasted~~

2. 3문형 동사의 수동태

〈주어＋타동사＋목적어〉 어순의 3문형에 쓰이는 동사들은 대부분 수동태로도 쓰이며, 이때 목적어가 주어 역할을 하므로 동사 뒤에 목적어가 없다. 따라서 대부분의 태 구별 문제는 빈칸 뒤 목적어의 유무가 큰 단서가 된다.

3문형 동사 guarantee 보장하다 like 좋아하다 plan 계획하다 provide 제공하다 reject 거절하다 repair 수리하다

능동태 The expert **discovered** several product defects.
 목적어 전문가가 다수의 제품 결함을 발견했다.

수동태 Several product defects **were discovered** by the expert.
 주어 전문가에 의해 다수의 제품 결함이 발견되었다.

SELF-TEST 2

A person who designs houses and buildings with technical skills **is referred** to as an architect.

(A) is referring (B) will refer
(C) has referred **(D) is referred**

동사 refer의 알맞은 형태를 고르는 문제이다. 주어 A person은 다른 사람들에 의해 '불리는(refer to)' 대상이므로 수동태 동사인 (D) is referred가 정답. 〈자동사＋전치사〉 구조의 구동사는 하나의 타동사 역할을 하므로 수동태로 쓰일 수 있음을 기억하자.

해석 | 전문적인 기술로 집과 건물을 설계하는 사람은 건축가라고 불린다.

출제원리

3. 〈자동사＋전치사〉의 수동태

자동사가 전치사와 함께 오는 구동사는 타동사처럼 뒤에 목적어가 올 수 있기 때문에 수동태로 쓰일 수 있다. 자주 쓰이는 〈자동사＋전치사〉의 수동태를 정리해 두자.

be accounted for 설명되다	be dealt with 처리되다	be referred to 언급되다
be carried out 실행되다	be objected to 반대되다	be taken care of 돌봐지다

The manager **dealt with** the customers' complaints. 관리자가 고객들의 불만을 처리했다.
→ The customers' complaints **were dealt with** by the manager. 고객들의 불만이 관리자에 의해 처리되었다.

출제 POINT ⑰

4문형, 5문형 동사의 태

빈칸 뒤에 목적어가 있다고 무조건 능동태를 답으로 고르는 함정에 빠져선 안 된다. 4문형이나 5문형의 경우 수동태 뒤에 명사나 형용사 등이 올 수 있으므로, 주어와 동사와의 관계를 명확히 파악해야 한다.

SELF-TEST 3

The Employee of the Year Award **was given** to the company spokesperson, Mr. Andrew Sigh.

(A) gave **(B) was given**
(C) is giving (D) gives

주어 The Employee of the Year Award는 spokesperson에게 주어지는(give) 대상이므로 빈칸에 수동태가 와야 한다. 따라서 정답은 (B) was given. 동사 give는 대표적인 4문형 동사로, 직접목적어가 주어로 쓰여 빈칸 뒤에 전치사 to가 이끄는 전치사구가 나왔다.

해석 | 올해의 직원상은 회사의 대변인인 앤드류 사이 씨에게 주어졌다.

출제원리

1. 4문형 동사의 수동태

〈주어+동사+간접목적어+직접목적어〉 어순의 4문형은 목적어가 두 개이므로 수동태 또한 두 가지 형태가 있다. 간접목적어가 주어로 쓰인 수동태에서는 동사 뒤에 직접목적어가 남는데, 이를 3문형 능동태의 목적어로 착각할 수 있으므로 주의해야 한다. 직접목적어가 주어로 쓰인 수동태에서는 동사 뒤에 전치사구가 남는다.

4문형 동사	buy 사주다 give 주다 make 만들어주다 offer 제안하다 send 보내다 tell 알려주다

능동태	The store **gives** <u>new customers</u> <u>free coupons</u>. 그 매장은 신규 고객들에게 무료 쿠폰을 준다.
	간접목적어 직접목적어

간접목적어 주어 수동태 <u>New customers</u> **are given** <u>free coupons</u>. 신규 고객들은 무료 쿠폰을 받는다.
 주어 직접목적어

직접목적어 주어 수동태 <u>Free coupons</u> **are given** <u>to new customers</u>. 무료 쿠폰이 신규 고객들에게 주어진다.
 주어 전치사구

SELF-TEST 4

Mr. Lee is generally **considered** one of the top executives in the company.

(A) considered (B) consideration
(C) considerably (D) considering

빈칸 앞 is와 함께 수동태를 만드는 (A)와 현재진행형을 만드는 (D)가 정답 후보. 문맥상 '한 사람으로 여겨진다'라는 의미이므로 수동태를 만드는 (A) considered가 정답이다.

해석 | 이 씨는 일반적으로 회사의 고위 간부 중 한 사람으로 여겨진다.

출제원리

2. 5문형 동사의 목적격 보어가 명사/형용사인 경우

〈주어+동사+목적어+목적격 보어〉 어순의 5문형은 수동태가 되면 동사 뒤에 목적격 보어인 명사 또는 형용사가 그대로 남아 능동태로 착각하기 쉬우므로 조심해야 한다.

be considered + 명사[형용사] ~로 여겨지다 be left + 형용사 ~인 상태로 남겨지다
be elected + 명사 ~로 선출되다 be made + 명사[형용사] ~로 뽑히다(~한 상태가 되다)
be kept + 형용사 ~인 상태로 유지되다 be named + 명사 ~로 불리다

Punctuality **is considered** <u>a priority</u>. 시간 엄수는 최우선으로 여겨진다.

3. 5문형 동사의 목적격 보어가 to부정사구인 경우

5문형의 수동태 중, 목적격 보어인 to부정사구가 수동태에 그대로 남아있는 경우는 대표적으로 다음과 같다.

be advised to *do* ~하라고 조언받다 be intended to *do* ~하기로 의도되다
be allowed to *do* ~할 것을 허가받다 be required to *do* ~하라고 요구받다
be expected to *do* ~할 것으로 기대되다 be scheduled to *do* ~할 예정이다

The demolition of the building **is scheduled** <u>to begin</u> next week. 그 건물의 철거가 다음 주에 시작될 예정이다.

감정 동사의 태와 수동태 구문

감정 동사의 태를 묻는 문제는 주어와 감정 동사와의 관계를 정확히 파악하여 감정 유발의 주체를 찾아야 한다. 또한 **by** 이외의 전치사와 함께 쓰인 수동태 구문은 미리 외워두면 답을 빠르게 찾을 수 있다.

SELF-TEST 5

The marketing team was **pleased** with the positive feedback on its new advertisement.

(A) pleasant (B) pleasure
(C) pleasing **(D) pleased**

주어 The marketing team이 긍정적인 피드백으로 인해 기쁜 감정을 느낀 것이므로 빈칸 앞 was와 함께 수동태를 만드는 (D) pleased가 정답이다. 주로 감정을 느끼게 하는 사물이 주어이면 능동태, 감정을 느끼는 사람이 주어이면 수동태를 사용한다.

해석 | 마케팅팀은 새 광고에 대한 긍정적인 피드백에 만족했다.

출제원리

1. 감정 동사의 능동태와 수동태

감정을 나타내는 동사들은 대개 '~에게 …한 감정을 불러일으키다'라는 타동사적 의미를 가지고 있기 때문에 주어가 감정을 느끼게 하는 원인이면 능동태를, 주어가 감정을 느끼는 주체이면 수동태를 써서 표현한다. 이러한 특성에 따라 주로 능동태는 사물 주어와 함께 쓰이고, 수동태는 사람 주어와 어울려 쓰인다.

기쁨, 만족	amuse 즐겁게 하다 encourage 격려하다	entertain 즐겁게 하다 excite 흥분시키다	fascinate 매료시키다 interest 흥미를 일으키다	please 기쁘게 게다 satisfy 만족시키다
실망, 불만족	bore 지루하게 하다	disappoint 실망시키다	dissatisfy 불만을 느끼게하다	frustrate 좌절감을 주다
놀라움, 혼란	amaze 놀라게 하다	overwhelm 압도하다	startle 깜짝 놀라게 하다	surprise 놀라게 하다

The poor performance of the stock **disappointed** investors.
~~was disappointed~~ 저조한 주식 실적이 투자자들을 실망시켰다.

The government project manager **was disappointed** by the news.
~~disappointed~~ 정부 프로젝트 담당자는 그 소식에 실망했다.

SELF-TEST 6

All conference rooms **are equipped** with multimedia systems for presentations and meetings.

(A) equip (B) have equipped
(C) are equipped (D) are equipping

동사 equip은 '(장비 등을) 갖추다'라는 의미의 타동사지만, 빈칸 뒤에 목적어가 없으므로 수동태를 의심해 봐야 한다. 문맥상으로도 주어인 All conference rooms가 '멀티미디어 시스템을 갖추게 되는' 대상이므로 수동태가 와야 맞다. 따라서 정답은 (C) are equipped. equip은 수동태일 때 전치사 with와 함께 쓰인다는 것을 기억해 두자.

해석 | 모든 회의실은 발표와 회의를 위한 멀티미디어 시스템을 갖추고 있다.

출제원리

2. 〈수동태+전치사〉 구문

by가 아닌 특정 전치사와 함께 쓰이는 수동태 구문이 있다. 이들은 대부분 능동태에서 특정 전치사구를 동반하는 동사들로, 수동태에서도 전치사구가 남아 하나의 어구처럼 쓰인다.

〈be p.p. in〉	be included in ~에 포함되다 be interested in ~에 관심이 있다	be involved in ~에 관련되다 be located in[on] ~에 위치하다
〈be p.p. with〉	be concerned with ~에 관계가 있다 be equipped with ~을 갖추다	be pleased with ~에 만족하다 be satisfied with ~에 만족하다
〈be p.p. to〉	be dedicated to ~에 전념하다	be submitted to ~에게 제출되다
〈be p.p. for〉	be exchanged for ~로 교환되다	be used for ~에 사용되다

There will be a planning meeting for everyone who **is involved in** the Larson project.
라슨 프로젝트에 관련된 모든 이들을 대상으로 한 기획 회의가 있을 예정이다.

The empty office on the third floor will **be used for** temporary workers.
3층의 빈 사무실 공간은 임시 직원들을 위해 사용될 것이다.

FINAL TEST

1. Crime rates in the city ------- after several strict measures were taken.

(A) declined (B) declining
(C) was declined (D) has been declined

2. The human resources department formed a committee ------- to the preparations for the Engineering Masters Conference.

(A) dedicated (B) interested
(C) registered (D) concerned

3. All container vans must be ------- by a Customs Division official as soon as they arrive at the port.

(A) inspecting (B) inspect
(C) inspected (D) inspection

4. Managers ------- to make advance reservations to ensure they may attend the leadership training.

(A) advised (B) has been advised
(C) is advising (D) are advised

5. The customer service department was understaffed today, so the volume of work was ------- all the employees.

(A) overwhelming (B) overwhelmed
(C) overwhelm (D) overwhelmingly

6. Next January, artist James Cornice ------- his latest collection of ceramic pots and vases at the art museum.

(A) will exhibit (B) will be exhibited
(C) was exhibiting (D) have been exhibited

7. At the communication meeting, the company president mentioned that he ------- with the company's performance in the third quarter.

(A) satisfies (B) is satisfied
(C) satisfy (D) will have satisfied

8. According to the finance team, part of the operations' budget ------- for the sports festival and software training in August.

(A) were being reserved (B) will reserve
(C) has been reserved (D) is reserving

9. The security guards contacted Mr. Brown because they noticed that his car ------- unlocked in the office parking lot.

(A) leave (B) were left
(C) left (D) was left

10. Upon expiration, one of the magazine's staff members ------- Ms. Wilson that she needed to renew her annual subscription.

(A) was told (B) tell
(C) told (D) will be told

11. The order form was ------- to the supplier last week, so the tools should arrive today.

(A) submission (B) submitting
(C) submits (D) submitted

12. Anyone who was on the guest list ------- an invitation to the furniture auction yesterday.

(A) will be sent (B) sends
(C) was sending (D) was sent

13. Entries to all categories of the costume design competition ------- at the Fashion Society Office until June 30 only.

(A) are being accepted (B) are accepting
(C) is accepted (D) have accepted

14. Any issues raised by our clients regarding our kitchen products ------- with carefully by our experienced consumer support team.

(A) dealt (B) is being dealt
(C) are dealt (D) deal

DAY 06

63

Questions 15 to 18 refer to the following notice.

NOTICE TO ALL EMPLOYEES

Management ------ to announce a new benefit for all Bells Cargo staff members. By presenting
15.

your employee ID cards, you and your families may enjoy exclusive discounts from popular

restaurants in Florida.

On our employee Web site, you will find a link with promotions for ------ restaurants. Particularly
16.

interesting offers ------ every month. This June, you can enjoy a 10 percent discount when you
17.

dine in any branch of Pizza Plaza, Amigo, or Chandler Burgers.

------. For questions and feedback, please e-mail hr@bellscargo.com.
18.

15. (A) pleases
 (B) is pleased
 (C) pleasing
 (D) to please

16. (A) appointed
 (B) designated
 (C) instructed
 (D) determined

17. (A) has been announced
 (B) announce
 (C) are announcing
 (D) will be announced

18. (A) You may claim your ID cards from the human resources office.
 (B) We strongly encourage everyone to take advantage of this benefit.
 (C) This is a great investment opportunity for all employees.
 (D) The discount coupons are available on our Web site.

Questions 19 to 22 refer to the following advertisement.

Experience the coolness of the South Pole with the Antarctica refrigerator!

The latest addition to Evergreen's no-frost refrigerators, Antarctica is stylish and functional, yet affordable. Our new model is equipped with a bottom freezer and icemaker, and it comes in two-door and three-door units. ------.
19.

Antarctica is further proof of Evergreen's capacity for creating excellent technology. ------
20.
its launch in England three months ago, Antarctica has received many positive reviews for its advanced features. In fact, it ----- Innovation of the Year by Europe's Consumer Union.
21.

Right now, we ------ a 15 percent discount and extended warranty to customers who purchase
22.
Antarctica refrigerators. This offer ends on June 30, so hurry to your nearest appliance store today.

DAY 06

19. (A) It is the first refrigerator manufactured by Evergreen.
　　(B) In addition, it is one of the cheapest on the market today.
　　(C) The Antarctica refrigerator is intended for personal use.
　　(D) Our talented designers simplified its features.

20. (A) As
　　(B) While
　　(C) Because of
　　(D) Since

21. (A) was named
　　(B) named
　　(C) is named
　　(D) names

22. (A) to give
　　(B) gave
　　(C) were given
　　(D) are giving

정답 및 해설 21쪽

CHAPTER

4

-

준동사편

DAY 07
부정사

—

기본 개념 노트

본 학습에 들어가기 전에 기본 문법 개념의 틀을 잡아보자.

❶ 개념 및 역할

동사에서 비롯되었지만 동사로 쓰이지 않는 to부정사는 〈to + 동사원형〉 형태로 문장 안에서 명사, 형용사, 부사의 역할을 한다.

명사 역할	① Management has decided **to improve** the benefits packages. [동사의 목적어]
형용사 역할	② The cash incentives **to reward** staff will be paid on May 1. [명사 수식]
부사 역할	③ **To enroll** in this course, send your application to Ms. White. [문장 수식]

주의 to부정사의 행위자가 문장의 주어와 다른 경우 의미상의 주어는 〈for + 목적격〉으로 표시한다.
④ We will rearrange the schedule **for them** to attend the seminar. [attend의 의미상의 주어 them]

❷ 형태

기본 형태는 〈to + 동사원형〉이지만 쓰임에 따라 다양한 형태로 사용된다.

기본형 〈to + 동사원형〉	⑤ Students need **to prepare** thoroughly for their exams.
부정형 〈not to + 동사원형〉	⑥ She promised **not to share** the confidential information.
수동형 〈to be *p.p.*〉	⑦ Most of the employees want **to be paid** higher wages.
완료형 〈to have *p.p.*〉	⑧ The passengers were upset **to have waited** so long.

❸ 특징

to부정사는 동사에서 비롯되어 동사의 성질을 가져 보어, 목적어, 수식어구를 취한다.

보어 동반	⑨ The new technology helped many companies **to become** successful.
목적어 동반	⑩ Mr. Blackburn wants **to purchase** a season ticket for his favorite team.
부사의 수식	⑪ The profits are expected **to increase** steadily.

① 경영진은 복지 혜택을 개선하기로 결정했다. ② 직원들에게 보상해 줄 현금 수당은 5월 1일에 지급될 것이다. ③ 이 강좌에 등록하기 위해서는, 화이트 씨에게 신청서를 보내주시기 바랍니다. ④ 그들이 세미나에 참석할 수 있도록, 저희는 일정을 재조정할 것입니다. ⑤ 학생들은 시험을 위해 철저히 준비해야 한다. ⑥ 그녀는 기밀 정보를 공유하지 않기로 약속했다. ⑦ 대부분의 직원들은 더 높은 임금을 받기를 원한다. ⑧ 승객들은 너무 오래 기다린 것에 화가 났다. ⑨ 새로운 기술은 많은 기업들이 성공하도록 도와주었다. ⑩ 블랙번 씨는 자신이 가장 좋아하는 팀의 시즌권을 구입하고 싶어 한다. ⑪ 이익이 꾸준히 증가할 것으로 기대된다.

SELF-TEST

기본 개념이 토익에는 어떻게 출제되는지 알아보자. ⏱ 제한시간 03:00

1. It is important ------- ticket reservations at least one week before the departure date.

(A) to confirm (B) confirms
(C) confirmation (D) confirmed

1. 가주어 it

2. ANP Channel will hold a party ------ the tenth anniversary of the broadcasting station.

(A) celebrates (B) to celebrate
(C) celebration (D) celebrated

2. to부정사의 역할

3. Mr. Fulton plans ------- the list of activities for this year's company outing tomorrow.

(A) to submit (B) submitted
(C) submits (D) submitting

3. 타동사 plan의 목적어

4. The leadership seminar date needs ------- to June because some speakers are unavailable in May.

(A) is changed (B) to change
(C) will change (D) to be changed

4. to부정사의 태

5. Customers are advised ------- their coffee in air-tight containers to preserve its flavor.

(A) storing (B) store
(C) to store (D) stored

5. to부정사를 목적격 보어로 취하는 동사

6. Pen Mate helps graphic illustrators ------- high-quality images quickly and easily.

(A) produced (B) production
(C) producing (D) produce

6. 원형부정사를 목적격 보어로 취하는 동사

문제별 출제 **POINT** ▶ 다음 페이지에서 확인하기

to부정사 역할

문장에서 명사, 형용사, 부사 역할을 하는 **to부정사**를 고르는 문제가 출제된다. 그 중에서도 목적을 나타내는 부사 역할을 묻는 문제가 가장 자주 출제되므로 이 부분은 확실하게 알아두자.

SELF-TEST 1

It is important **to confirm** ticket reservations at least one week before the departure date.

(A) to confirm (B) confirms
(C) confirmation (D) confirmed

문장 앞의 It is important를 보고 가주어-진주어 구문이 쓰였음을 알 수 있어야 한다. 따라서 빈칸은 진주어 자리로, 선택지 중에서 to부정사인 (A) to confirm이 정답. 〈It is+형용사+to do〉의 형태를 기억해 두자.

해석 | 최소한 출발일 1주일 전에 티켓 예약을 확정하는 것이 중요하다.

출제원리

1. to부정사의 명사 역할

명사처럼 문장의 주어, 목적어, 보어로 쓰이며 '~하는 것, ~하기'로 해석된다.

주어	**To hire** new employees is a difficult task. 새로운 직원들을 고용하는 것은 어려운 일이다
목적어	He wants **to share** his ideas with the audience. 그는 자신의 생각을 청중들과 공유하고 싶어 한다.
보어	Our goal is **to provide** assistance for the homeless. 우리의 목표는 노숙자들에게 도움을 주는 것이다.

주의 주어나 목적어로 쓰인 to부정사가 길면 가주어/가목적어 it을 문두에 놓고, 진주어/진목적어 to부정사를 뒤에 놓는다.

It is difficult **to deliver** orders ahead of schedule. [가주어-진주어]
~~delivering, delivers~~ 주문품을 일정보다 앞서 배송하는 것은 어렵다.

Most people consider **it** polite **to treat** guests well. [가목적어-진목적어]
~~treating, treats~~
대부분의 사람들은 손님을 잘 대접하는 것을 예의 바르다고 여긴다.

SELF-TEST 2

ANP Channel will hold a party **to celebrate** the tenth anniversary of the broadcasting station.

(A) celebrates **(B) to celebrate**
(C) celebration (D) celebrated

문맥상 '축하하기 위해' 파티를 연다는 의미이므로 목적을 나타낼 수 있는 품사를 골라야 한다. to부정사가 부사 역할을 하면서 목적을 나타내므로 정답은 (B) to celebrate.

해석 | 에이엔피 채널은 방송국의 개국 10주년을 축하하기 위해서 파티를 열 것이다.

출제원리

2. to부정사의 형용사 역할

명사 뒤에서 앞의 명사를 수식하며 '~할, ~하는'으로 해석된다. 〈명사+to부정사〉의 형태로 쓰이는 명사들을 기억하자.

an ability to *do* ~할 능력 a chance[an opportunity] to *do* ~할 기회 a plan to *do* ~할 계획
an attempt to *do* ~하려는 시도 an effort to *do* ~하려는 노력 a way to *do* ~하는 방법

The conference is a good opportunity **to develop** business contacts.
그 총회는 사업 관계를 맺기 위한 좋은 기회이다.

3. to부정사의 부사 역할

부사처럼 다른 품사나 절, 문장 전체를 수식해서 목적, 결과, 원인, 이유 등을 의미한다.

| 목적 | **To obtain** a parking permit, you should complete this application form.
=In order to[So as to] obtain 주차권을 받기 위해서는, 이 신청서를 작성해야 한다. |
| 감정의 원인 | I am sorry **to hear** that the repairs did not fix the problem.
　　　감정　　원인　　　　　　수리를 했지만 문제가 해결되지 않은 것에 대해 유감스럽게 생각한다. |

to부정사 관용표현

동사 또는 형용사 뒤 빈칸에 들어갈 to부정사를 찾는 문제가 출제된다. to부정사와 함께 쓰이는 동사, 형용사들을 미리 기억하고 있으면 문장을 모두 해석하지 않고도 쉽게 답을 고를 수 있다.

SELF-TEST 3

Mr. Fulton plans **to submit** the list of activities for this year's company outing tomorrow.

(A) to submit (B) submitted
(C) submits (D) submitting

빈칸 앞 동사 plans는 to부정사를 목적어로 취하는 대표적인 동사이다. 따라서 정답은 (A) to submit. to부정사를 목적어로 취하는 동사들을 정리해두면 문장을 모두 해석하지 않고도 빠르게 답을 고를 수 있다.

해석 | 풀턴 씨는 내일 있을 올해 회사 야유회에서 할 활동 목록을 제출할 계획이다.

출제원리

1. to부정사를 목적어로 취하는 동사

다음은 to부정사를 목적어로 취하는 토익 대표 동사이다.

희망, 기대, 노력	want[wish] to *do* ~하기를 원하다 would like to *do* ~하고 싶다	hope to *do* ~하기를 바라다 decide to *do* ~하기로 결정하다	expect to *do* ~하기를 기대하다 strive to *do* ~하려고 노력하다
계획, 동의	plan to *do* ~할 계획이다	intend to *do* ~하기를 의도하다	agree to *do* ~하는 데 동의하다
기타	ask to *do* ~할 것을 요청하다	offer to *do* ~할 것을 제안하다	hesitate to *do* ~하기를 주저하다

Management <u>decided</u> **to review** the company's policies.
~~reviewing~~ 경영진은 회사의 정책을 검토하기로 결정했다.

2. 〈be동사＋형용사＋to부정사〉 구문

다음은 〈be동사＋형용사＋to부정사〉의 형태로 빈출되는 구문이다.

be able to *do* ~할 수 있다 be likely to *do* ~할 것 같다 be reluctant to *do* ~하기를 꺼리다
be eager to *do* 몹시 ~하고 싶다 be pleased to *do* ~하게 되어 기쁘다 be unable to *do* ~할 수 없다
be eligible to *do* ~할 자격이 있다 be ready to *do* ~할 준비가 되다 be willing to *do* 기꺼이 ~하다

All shareholders <u>are eligible</u> **to vote** in the meeting.
모든 주주들은 회의에서 투표할 자격이 있다.

SELF-TEST 4

The leadership seminar date needs **to be changed** to June because some speakers are unavailable in May.

(A) is changed (B) to change
(C) will change **(D) to be changed**

동사 need는 to부정사를 목적어로 취하므로 (B)와 (D)가 정답 후보. 의미상 주어 The leadership seminar date는 변경되어야 하는 대상이므로 to부정사의 수동형인 (D) to be changed가 정답이다.

해석 | 일부 연사들이 5월에는 시간이 되지 않으므로 리더십 세미나 날짜는 6월로 변경되어야 한다.

출제원리

3. to부정사의 시제와 태

to부정사는 동사의 성질을 가지고 있어 시제와 태를 나타낼 수 있다.

완료형	▸ to부정사의 시점이 주절 동사의 시점보다 이전인 경우에 완료형 〈to have *p.p.*〉를 쓴다. The client <u>expected</u> Mr. Ito **to have completed** the project by now. 과거 과거 이전 그 의뢰인은 이토 씨가 제안서를 지금쯤은 완료했기를 기대했다.
수동형	▸ 의미상의 주어와 to부정사의 관계가 수동인 경우에 수동형 〈to be *p.p.*〉를 쓴다. The suitcases need **to be unpacked** as soon as possible. 여행 가방들을 가능한 한 빨리 풀어야 한다. [to부정사의 의미상 주어 the suitcases와 unpack은 수동 관계]

목적격 보어로 쓰이는 부정사

목적격 보어 자리에 to부정사나 원형부정사를 고르는 문제가 종종 출제된다. 이때 선택지에 원형부정사와 to부정사가 함께 나타나는 경우가 있으므로, 어떠한 부정사를 취하는 동사인지 구별하여 기억해 두자.

Customers are advised **to store** their coffee in air-tight containers to preserve its flavor.

(A) storing (B) store

(C) to store (D) stored

빈칸 앞 are advised를 보자마자 be advised to do 구문을 떠올릴 수 있어야 한다. 따라서 정답은 (C) to store. advise는 to부정사를 목적격 보어로 취하는 대표적인 동사로, 여기에서는 수동태로 쓰여 목적어 없이 to부정사가 동사 바로 뒤에 나왔다.

해석 | 고객들은 그 맛을 유지하기 위해 커피를 밀폐된 용기에 보관하도록 권장된다.

1. to부정사를 목적격 보어로 취하는 동사

〈동사+목적어+to do〉의 형태로 쓰여 to부정사를 목적격 보어로 취하는 동사들은 다음과 같다. 이 동사들은 수동의 형태 〈be+p.p.+to do〉로도 자주 쓰이므로 참고하여 알아두자.

능동태 〈동사+목적어+to do〉	수동태 〈be+p.p.+to do〉
advise A to do ~하도록 권장하다	be advised to do ~하도록 권장되다
allow A to do ~하는 것을 허락하다	be allowed to do ~하도록 허락되다
ask A to do ~해달라고 요청하다	be asked to do ~하도록 요청 받다
convince A to do ~하라고 설득하다	be convinced to do ~하라고 설득되다
encourage A to do ~할 것을 권하다	be encouraged to do ~하라고 권장 받다
expect A to do ~할 것을 기대하다	be expected to do ~하도록 기대되다
force A to do ~하도록 강요하다	be forced to do ~하도록 강요되다
inspire A to do ~할 것을 격려하다	be inspired to do ~하도록 격려되다
intend A to do ~하도록 의도하다	be intended to do ~하도록 의도되다
require A to do ~할 것을 요구하다	be required to do ~하도록 요구되다

능동 Jim **asked** his assistant **to organize** the folders. 짐 씨는 그의 부하 직원에게 서류철을 정리해 달라고 요청했다.

수동 The assistant **was asked to organize** the folders. 그 부하 직원은 서류철을 정리하도록 요청 받았다.

Pen Mate helps graphic illustrators **produce** high-quality images quickly and easily.

(A) produced (B) production

(C) producing **(D) produce**

빈칸은 동사 helps의 목적어 graphic illustrators를 보충 설명해주는 목적격 보어 자리이다. help는 to부정사나 원형부정사를 목적격 보어로 취하므로 원형부정사 (D) produce가 정답.

해석 | 펜 메이트 사는 그래픽 삽화가들이 고품질 이미지를 빠르고 쉽게 만드는 것을 도와준다.

2. 원형부정사를 목적격 보어로 취하는 동사

원형부정사란 to가 없는 부정사로 형태는 동사원형과 같으며, 주로 사역동사, 동사 help, 지각동사와 함께 쓰인다.

사역동사 **make[let, have]+A+do** A가 ~하게 하다	The regulations are expected to **make** taxes **decline**. 그 규정들이 세금을 낮춰줄 것으로 기대된다.
준사역동사 **help+A+(to) do** A가 ~하는 것을 돕다	Mr. Morgan **helped** us **(to) organize** the monthly meeting. 모건 씨는 우리가 월례 회의를 준비하는 것을 도와주었다.
지각동사 **see[watch, hear]+A+do[doing]**	I **heard** the security guard **lock[locking]** the door. 나는 경비원이 문을 잠그는 소리를 들었다.

FINAL TEST

1. Chattler Life employs certified agents ------- clients with their insurance and investment needs.

 (A) are assisted (B) assists
 (C) assistance (D) to assist

2. The Public Works Ministry is expected ------- roads that will connect three cities to the new highway.

 (A) creative (B) create
 (C) creation (D) to create

3. The architect is eager ------- the presentation about the new building project, but he has to wait for some late arrivals.

 (A) began (B) beginning
 (C) to begin (D) begin

4. Kolp Lifeboats have the ability ------- automatically as soon as they are released into the water.

 (A) expanding (B) expansion
 (C) to have expanded (D) to expand

5. According to the delivery policy, it is important ------- purchased items to customers within three working days.

 (A) to be sent (B) sending
 (C) to send (D) will send

6. After meeting with their supervisor, the civil engineers put their requests in a single document ------- him to review.

 (A) to (B) as
 (C) with (D) for

7. The office technician asked Ms. Green ------- her password on the new laptop after switching on the device.

 (A) typed (B) typing
 (C) to type (D) would type

8. Many people are happy ------- a small amount of their own comfort to make a generous donation to the shelter each year.

 (A) to sacrifice (B) sacrificed
 (C) to be sacrificed (D) that sacrifice

9. The chairman received a special invitation ------- the grand opening of Flayton Hotel this week.

 (A) attending (B) is attending
 (C) attends (D) to attend

10. Because of the reservation system, it is easy to make the staff ------- the number of visitors.

 (A) to be noticed (B) notice
 (C) notices (D) to notice

11. For questions about the new branch of our appliance shop, please do not hesitate ------- our hotline.

 (A) call (B) to call
 (C) to have called (D) calling

12. Venetian Drapes is conducting a big sale ------- empty its stockrooms and give space for new products next month.

 (A) prior to (B) as long as
 (C) in order to (D) because

13. The popularity of our latest model has helped us ------- a competitive advantage over the rest of the field.

 (A) securities (B) secure
 (C) for securing (D) be secured

14. Please allow around three days for your bulk orders ------- by our sales team.

 (A) have been processed (B) are processed
 (C) processing (D) to be processed

정답 및 해설 26쪽

CHAPTER
4

-

준동사편

DAY 08
동명사

—

기본 개념 노트

본 학습에 들어가기 전에 기본 문법 개념의 틀을 잡아보자.

❶ 개념 및 역할

동사적 성질을 띤 명사인 동명사는 〈동사원형 + -ing〉의 형태로 문장 안에서 주어, 목적어, 보어의 역할을 한다.

주어		① **Resigning** from the position <u>was</u> not an easy decision.
목적어	타동사의 목적어	② She <u>dislikes</u> **commuting** to work by bus.
	전치사의 목적어	③ Mr. Wilson is interested <u>in</u> **learning** public speaking skills.
보어		④ <u>Amy's hobby</u> is **collecting** rare coins from various countries.

주의 동명사의 행위자가 문장의 주어와 다른 경우 의미상의 주어는 동명사 앞에 소유격으로 표시한다.
⑤ <u>We</u> were worried about **his** <u>traveling</u> in the storm. [traveling의 의미상의 주어=he]

❷ 형태

기본 형태는 〈동사원형 + -ing〉이지만 쓰임에 따라 다양한 형태로 사용된다.

기본형 〈동사원형 + -ing〉	⑥ **Satisfying** its clients is the company's main objective.
부정형 〈not + 동사원형 + -ing〉	⑦ The board considered **not changing** company policies.
수동형 〈being *p.p.*〉	⑧ He is proud of **being promoted** to the new position.
완료형 〈having *p.p.*〉	⑨ Helen was angry about **having missed** the train.

❸ 특징

동명사는 동사처럼 보어, 목적어, 수식어구를 취한다.

보어 동반	⑩ We look forward to **becoming** <u>your business partner</u>.
목적어 동반	⑪ The device is used for **transmitting** <u>messages</u>.
부사의 수식	⑫ This project requires <u>carefully</u> **proofreading** the given text.

① 그 자리에서 물러나는 것은 쉬운 결정은 아니었다. ② 그녀는 버스로 통근하는 것을 싫어한다. ③ 윌슨 씨는 대중 연설 기술을 배우는 것에 관심이 있다. ④ 에이미 씨의 취미는 여러 국가의 희귀한 동전을 수집하는 것이다. ⑤ 우리는 그가 폭풍우에 여행하는 것에 대해 걱정했다. ⑥ 고객들을 만족시키는 것은 그 회사의 주된 목표이다. ⑦ 이사회는 회사 방침을 변경하지 않는 것을 고려했다. ⑧ 그는 새로운 직위로 승진된 것을 자랑스러워한다. ⑨ 헬렌 씨는 기차를 놓친 것에 대해 화가 났다. ⑩ 저희는 귀사의 사업 파트너가 되기를 고대합니다. ⑪ 이 장치는 메시지를 전송하는 데 사용된다. ⑫ 이 프로젝트는 주어진 원고를 주의 깊게 교정하는 것을 필요로 한다.

SELF-TEST

기본 개념이 토익에는 어떻게 출제되는지 알아보자. 🕐 제한시간 03:00

다음 핵심 포인트를 참고하여
정답이 되는 이유를 적어보자. **NOTE**

1. The conference organizers helped foreign attendees by
 ------- headsets with live interpretation.

 (A) provides (B) providing
 (C) to provide (D) provided

 1. 전치사의 목적어

2. Power Mobile is considering ------- one of its smart
 phone manufacturing plants to Beijing.

 (A) relocate (B) relocating
 (C) relocated (D) to relocate

 2. 타동사 consider의 목적어

3. The Foreign Affairs Department is in charge of ------- the
 new visa application process.

 (A) implementing (B) implemented
 (C) implements (D) implementation

 3. 동명사 vs. 명사

4. Mr. Issac apologized for ------- in the middle of last
 weeks' meeting.

 (A) to leave (B) leave
 (C) having left (D) have left

 4. 과거(apologized) 이전의 일

5. Small Steps is ------- to producing high-quality and
 comfortable footwear for children.

 (A) committed (B) compared
 (C) scheduled (D) promoted

 5. 동명사 관용표현

6. ------- returning from his vacation, the CEO will visit the
 company's offices in Europe.

 (A) Since (B) Upon
 (C) Between (D) Apart

 6. 동명사 관용표현

문제별 출제 **POINT** ▶ 다음 페이지에서 확인하기

동명사 역할

동명사 문제는 대부분 전치사 뒤 목적어 자리를 묻는 문제로 출제된다. 또한 동명사만을 목적어로 취하는 동사 뒤 목적어 자리를 묻는 문제도 출제되므로 해당 동사는 반드시 암기해 두자.

The conference organizers helped foreign attendees by **providing** headsets with live interpretation.

(A) provides **(B) providing**
(C) to provide (D) provided

빈칸은 전치사 by의 목적어 자리이다. 전치사 뒤에 목적어로 올 수 있는 것은 선택지 중에서 동명사뿐이므로 정답은 (B) providing. 동사의 현재 시제, to부정사, 과거분사는 전치사 뒤에 목적어로 올 수 없으므로 (A), (C), (D) 모두 오답이다.

해석 | 학회 주최 측은 동시 통역이 나오는 헤드셋을 제공함으로써 외국인 참석자들을 도왔다.

1. 동명사의 명사 역할

동명사는 명사와 마찬가지로 문장에서 주어, 목적어, 보어로 쓰이며, '~하는 것, ~하기'로 해석된다. 특히 동명사는 to부정사와 달리 전치사의 목적어로 쓰일 수 있다는 것을 기억해 두자.

주어		**Getting** this job seems like a ticket to success. 이 일자리를 얻는 것은 성공에 이르는 승차권이 될 것 같다.
목적어	타동사의 목적어	The director suggested **editing** the financial report. 이사는 재무 보고서 수정을 제안했다.
	전치사의 목적어	The factory continues to progress by **upgrading** its facilities. 그 공장은 시설을 개선함으로써 계속 발전하고 있다.
보어		One of her responsibilities is **answering** calls from customers. 그녀의 업무들 중 하나는 고객 전화를 받는 것이다.

Power Mobile is considering **relocating** one of its smart phone manufacturing plants to Beijing.

(A) relocate **(B) relocating**
(C) relocated (D) to relocate

빈칸은 동사 is considering의 목적어 자리이므로 명사 역할을 할 수 있는 동명사 (B)와 to부정사 (D)가 정답 후보이다. 그런데 동사 consider는 동명사만을 목적어로 취하는 대표적인 동사이므로 정답은 (B) relocating.

해석 | 파워 모바일 사는 스마트폰 제조 공장 중 하나를 베이징으로 이전시키는 것을 고려하고 있다.

2. 동명사를 목적어로 취하는 동사

목적어로 to부정사가 오는 동사들이 있는 반면, 동명사만을 목적어로 취하는 동사들도 있다. 다음은 동명사만을 목적어로 취하는 토익 대표 동사이므로 반드시 암기해 두자.

고려, 제안	consider *doing* ~을 고려하다	recommend *doing* ~을 추천하다	suggest *doing* ~을 제안하다
선호	avoid *doing* ~을 피하다 mind *doing* ~을 꺼리다	deny *doing* ~을 부정하다 resist *doing* ~을 반대하다	dislike *doing* ~을 싫어하다 enjoy *doing* ~을 즐기다
연기, 중단	postpone *doing* ~을 미루다	put off *doing* ~을 연기하다	finish *doing* ~을 끝내다
기타	admit *doing* ~을 인정하다	include *doing* ~을 포함하다	imagine *doing* ~을 상상하다

Mr. Hanning is considering **acquiring** new qualifications to advance his career.
해닝 씨는 출세하기 위해 새로운 자격증을 따는 것을 고려하고 있다.

Logan's job includes **inputting** customer information into the database system.
로건 씨의 일은 고객 정보를 데이터베이스 시스템에 입력하는 것을 포함한다.

동명사 vs. 명사

역할이 같다는 점을 이용해서 동명사와 명사를 구별하는 문제가 출제된다. 동명사는 명사와 달리 목적어를 취할 수 있고 부사의 수식을 받을 수 있다. 동명사는 시제와 태를 나타낼 수 있다는 점도 기억해 두자.

SELF-TEST 3

The Foreign Affairs Department is in charge of **implementing** the new visa application process.

(A) implementing (B) implemented
(C) implements (D) implementation

빈칸은 전치사 of의 목적어 자리로 동명사 (A)와 명사 (D)가 정답 후보. 빈칸 뒤의 the new visa application process를 목적어로 취할 수 있는 것은 동명사뿐이므로 (A) implementing이 정답.

해석 | 외무부는 신규 비자 신청 절차를 시행하는 일을 담당하고 있다.

출제원리

1. 동명사와 명사의 구별 ① 목적어 유무

동명사와 명사는 그 쓰임이 비슷하나 동명사는 동사의 성질을 가지고 있어 뒤에 목적어를 취할 수 있고, 명사는 뒤에 목적어가 바로 올 수 없다는 점에서 차이가 있다.

동명사	**Improving** energy efficiency is an important factor for all businesses.
	동명사의 목적어 에너지 효율을 향상시키는 것은 모든 사업에 있어서 중요한 요소이다.
명사	The **improvement** of energy efficiency is an important factor for all businesses.
	전치사구 에너지 효율의 향상은 모든 사업에 있어서 중요한 요소이다.

2. 동명사와 명사의 구별 ② 수식어 품사의 차이

동사의 성질을 유지하는 동명사는 부사의 수식을 받을 수 있으나, 명사는 한정사와 형용사의 수식을 받는다.

동명사	We will save money by thoroughly **reviewing** recent expenditure.
	부사 ~~review~~
	우리는 최근 지출을 철저하게 검토함으로써 돈을 절약할 것이다.
명사	We will conduct a thorough **review** of recent expenditure.
	관사＋형용사 ~~reviewing~~
	우리는 최근 지출의 철저한 검토를 할 것이다.

SELF-TEST 4

Mr. Issac apologized for **having left** in the middle of last weeks' meeting.

(A) to leave (B) leave
(C) having left (D) have left

빈칸은 전치사 for의 목적어 자리이므로 명사 역할을 하는 문장 성분이 올 수 있는데, 선택지 중에는 동명사인 having left뿐이므로 정답은 (C). 아이작 씨가 자리를 떠난 시점이 사과한 시점(apologized) 보다 이전의 일이므로 동명사의 완료형인 having left가 쓰였다.

해석 | 아이작 씨는 지난주 회의 도중 자리를 뜬 것에 대해 사과했다.

출제원리

3. 동명사의 시제와 태

동명사는 동사의 성질을 가지고 있어 시제와 태를 나타낼 수 있다.

완료형	▶ 동명사의 시점이 주절 동사의 시점보다 이전인 경우에 완료형 〈having *p.p.*〉를 쓴다.
	Mary feels relieved about **having finished** the presentation yesterday.
	현재 현재 이전 메리 씨는 어제 발표를 끝냈다는 것에 대해 안도한다.
수동형	▶ 의미상의 주어와 동명사의 관계가 수동인 경우에 수동형 〈being *p.p.*〉를 쓴다.
	Mr. Cooper doesn't like **being disrupted** while working. [의미상의 주어=Mr. Cooper]
	~~disrupting~~ 쿠퍼 씨는 일하는 중에 방해받는 것을 좋아하지 않는다.
	주의 disrupt가 능동형인 disrupting으로 쓰이려면 동명사 뒤에 목적어가 필요하다.

동명사 관용표현

종종 출제되는 동명사와 관련된 관용표현의 경우, 어휘 문제로 출제되기도 하므로 아래 표현들을 평소에 익혀두면 해석할 필요 없이 빠르게 답을 고를 수 있으니 필히 암기하자.

Small Steps is **committed** to producing high-quality and comfortable footwear for children.

(A) committed　　(B) compared

(C) scheduled　　(D) promoted

빈칸 뒤 〈전치사 to+동명사〉 구조를 보자마자 동명사 관용표현은 아닌지 의심해 보아야 한다. be committed to *doing*은 '~에 전념하다'라는 뜻의 관용표현으로 문맥에도 적절하다. 따라서 정답은 (A) committed.

해석 | 스몰 스텝스 사는 고품질의 편안한 유아용 신발 생산에 전념하고 있다.

1. 〈전치사 to+동명사〉 관용표현

전치사 to가 쓰인 동명사 관용표현은 전치사 to를 to부정사로 착각하기 쉽다. 따라서 빈출되는 다음 동명사 관용표현은 반드시 외워두자.

> be accustomed[used] to *doing* ~하는 것에 익숙하다
> be committed to *doing* ~에 전념하다, ~하는 것을 약속하다
> be dedicated[devoted] to *doing* ~하는 것에 전념하다
> be opposed to *doing*, object to *doing* ~하는 것을 반대하다
> contribute to *doing* ~하는 것에 기여하다
> look forward to *doing* ~할 것을 기대하다, 고대하다

The new automobile model **contributes to reducing** pollution.
그 새로운 자동차 모델은 오염 감소에 기여한다.

Mr. Brady is **looking forward to signing** the contract for his new house.
브래디 씨는 자신의 새 주택 계약서에 서명하기를 기대하고 있다.

Upon returning from his vacation, the CEO will visit the company's offices in Europe.

(A) Since　　　**(B) Upon**

(C) Between　　(D) Apart

upon[on] *doing*은 '~하자마자'라는 뜻의 동명사 관용표현으로, 문맥상으로도 '휴가에서 돌아오자마자 회사 사무실을 방문할 것이다'라는 의미가 자연스럽다. 따라서 정답은 (B) Upon.

해석 | 휴가에서 돌아오자마자, 대표이사는 유럽에 있는 회사 사무실을 방문할 것이다.

2. 동명사 관용표현

다음은 관용적으로 쓰이는 대표적인 동명사 구문이다.

> be busy (in) *doing* ~하느라 바쁘다
> be worth *doing* ~할 가치가 있다
> cannot help *doing* ~하지 않을 수 없다
> feel like *doing* ~하고 싶다
> go *doing* ~하러 가다
>
> have difficulty (in) *doing* ~하는 데 어려움을 겪다
> it is no use *doing* ~해봐야 아무 소용이 없다
> keep (on) *doing* 계속해서 ~하다
> spend[waste] 시간[돈] (in) *doing* ~에 시간[돈]을 쓰다
> upon[on] *doing* ~하자마자

Most viewers believed the movie **was not worth seeing**.
대부분의 관람객들은 그 영화는 볼 가치가 없다고 생각했다.

The company **had difficulty (in) finding** a replacement for Ms. Keating.
그 회사는 키팅 씨의 후임자를 찾는 데 어려움을 겪었다.

FINAL TEST

1. The Brazilian sculptor Edwin Pedrosa is best known for ------- patriotic themes into his work.
 - (A) incorporation
 - (B) incorporate
 - (C) incorporating
 - (D) incorporates

2. Low unemployment rate and high consumer spending can greatly contribute ------- boosting the economy of a country.
 - (A) at
 - (B) to
 - (C) for
 - (D) on

3. Everyone on the team is looking forward to ------- with Mr. Wilken on another marketing campaign in the future.
 - (A) worker
 - (B) working
 - (C) works
 - (D) worked

4. Read and follow the instructions carefully when assembling the dresser to avoid ------- the furniture.
 - (A) damages
 - (B) damaged
 - (C) damaging
 - (D) to damage

5. After ------- improving telecommunication networks around the country, the government has focused on transportation infrastructure.
 - (A) substantially
 - (B) substantial
 - (C) substance
 - (D) substantive

6. Every month, *Runway* editors spend time ------- stories that will be published in the next issue of the magazine.
 - (A) discussion
 - (B) discussed
 - (C) discussing
 - (D) discuss

7. The financial advisor did not have time to explain all of the budget details before ------- by the CEO.
 - (A) interrupted
 - (B) being interrupted
 - (C) to interrupt
 - (D) having interrupted

8. During the trade fair, Robin will be busy ------- the features of the company's latest laser printers.
 - (A) demonstrating
 - (B) to demonstrate
 - (C) demonstrate
 - (D) demonstration

9. ------- support for the credit card anti-abuse law has been more challenging than the group had expected.
 - (A) Gather
 - (B) Gathering
 - (C) Gathered
 - (D) Gatherings

10. The book *Talk Wisely*, by Amanda Taylor, teaches readers effective ways of communicating in a formal -------.
 - (A) setting
 - (B) standard
 - (C) condition
 - (D) preparation

11. The new intern, Colin Martel, surprised his colleagues and supervisors by ------- casually for the year-end office party.
 - (A) dressy
 - (B) dressed
 - (C) dress
 - (D) dressing

12. Lancaster Consultants is ------- to maximizing the profits of its clients through expertise and careful planning.
 - (A) dedicating
 - (B) dedication
 - (C) dedicate
 - (D) dedicated

13. In a press release, Golden Harvest said its action plan includes ------- problems that seriously affect its productivity.
 - (A) resolves
 - (B) resolving
 - (C) to resolve
 - (D) resolved

14. For twenty-five years, Anaya Properties has been striving ------- cutting-edge residential spaces for families with children.
 - (A) building
 - (B) builds
 - (C) to build
 - (D) build

Questions 15-18 refer to the following e-mail.

To: Robert Canary <r_canary@heartcakes.com>
From: Alice Walker <a.walker@bakemate.com>
Date: September 15
Subject: Confirmation and delivery update

Dear Mr. Canary,

We appreciate your ------ Bakemate as a regular supplier for your bakery. This is to confirm that
 15.
we received your orders yesterday.

Your delivery was originally scheduled for Wednesday, May 4. However, we regret to inform

you that we are currently having difficulties with our transportation system. ------. We sincerely
 16.
apologize for any trouble this issue may cause you. Expediting our delivery process is the primary

------ of our logistics department now. We will update you with the exact date of delivery as soon
17.
as we find a solution to the problem.

We thank you for ------ us as your supplier for so many years and look forward to continuing to
 18.
serve you.

Yours truly,

Alice Walker
Sales Manager, Bakemate

15. (A) connecting
 (B) informing
 (C) communicating
 (D) considering

16. (A) Most of our baking tools are on sale.
 (B) As a result, delivery of your items will be delayed.
 (C) The local courier has taken responsibility for this issue.
 (D) In addition, we have received your returned items.

17. (A) concern
 (B) concerning
 (C) to concern
 (D) concerned

18. (A) being chosen
 (B) having chosen
 (C) choice
 (D) choose

Questions 19-22 refer to the following letter.

December 5

Melissa Sunders
4522 Clark Street
Patchogue, NY 11772

Dear Ms. Sunders,

We are writing to let you know that we have received your application for the copywriter position. Although our editors have reviewed your ------ for the vacancy and found your credentials rather
19.
impressive, you were not selected for this position.

However, Ework Publishing International is interested in your professional background. ------.
20.
Enclosed is another offering. In addition to ------ news events, this position includes some
21.
reporting work. It might be more suited to your interests. You are encouraged ------ us again if
22.
you wish to apply for this job.

Best regards,

Joan Hopkins
HR Specialist, Ework Publishing International

DAY 08

19. (A) qualifications
 (B) establishments
 (C) facilities
 (D) contributions

20. (A) We are sending a new résumé for your review.
 (B) We are in need of talented individuals to join our growing editorial team.
 (C) Please wait for your second interview schedule.
 (D) Rest assured that we will notify you about future career opportunities.

21. (A) write
 (B) written
 (C) writing
 (D) writer

22. (A) contacting
 (B) contacts
 (C) to contact
 (D) contact

정답 및 해설 29쪽

CHAPTER

4

-

준동사편

DAY 09
분사

기본 개념 노트

본 학습에 들어가기 전에 기본 문법 개념의 틀을 잡아보자.

❶ 개념 및 형태

분사란 동사원형에 -ing나 -ed를 붙여 동사를 형용사처럼 쓸 수 있게 변형한 형태로 기본적으로 동사의 시제(be -ing)나 태(be *p.p.*)를 나타낼 때 활용된다.

현재분사 〈동사원형+-ing〉	① We are **generating** reports on our financial status.
과거분사 〈동사원형+-ed〉	② Every product of Wein & Gaber is individually **customized**.

❷ 의미

현재분사는 능동과 진행의 의미를 가지며 과거분사는 수동과 완료의 의미를 갖는다.

현재분사	③ **Visiting** executives will participate in the open discussion. [능동] ④ The couple saw the baby **sleeping** peacefully in the cradle. [진행]
과거분사	⑤ It is difficult to compete against **established** businesses. [수동] ⑥ Mr. Nelson has **done** his work with the assistance of his colleague. [완료]

❸ 역할

문장 내에서 형용사처럼 쓰여 명사를 수식하거나 명사를 서술하는 보어 역할을 한다.

명사 수식	분사+명사	⑦ The supplier suggested an **extended** contract to our firm.
	명사+분사구	⑧ The woman **leading the conference** is well-known in her field.
명사 서술	주격 보어	⑨ Helen appeared **satisfied** after hearing the good news.
	목적격 보어	⑩ Mr. Lewis had to leave the visitor **waiting** in the lobby.

❹ 분사구문

〈접속사+주어+동사〉 형태의 부사절을 분사를 이용해 부사구로 바꾼 것을 분사구문이라고 한다.

❶When ❷I ❸reviewed the article, I noticed a mistake.

⑪ **Reviewing** the article, I noticed a mistake.

❶ 접속사 생략
❷ 접속사절과 주절의 주어가 같으므로 접속사절 주어 생략
❸ 동사를 〈동사원형+-ing〉로 바꿈

① 우리의 재정 상태에 대한 보고서를 작성하고 있다. ② 바인 앤 개버 사의 모든 제품은 개인별로 맞춤 제작된다. ③ 방문한 임원들은 공개 토론에 참가할 것이다. ④ 그 부부는 아이가 요람에서 평화롭게 자는 것을 지켜봤다. ⑤ 확실히 자리를 잡은 업체들과 경쟁하는 것은 어렵다. ⑥ 넬슨 씨는 동료의 도움으로 그의 일을 끝냈다. ⑦ 공급 업체는 우리 회사에 연장된 계약을 제안했다. ⑧ 회의를 이끌고 있는 저 여성은 자신의 분야에서 잘 알려져 있다. ⑨ 헬렌 씨는 좋은 소식을 들은 후 만족하는 것 같았다. ⑩ 루이스 씨는 방문객을 로비에서 기다리도록 두어야만 했다. ⑪ 기사를 검토했을 때, 나는 오류를 발견했다.

SELF-TEST

기본 개념이 토익에는 어떻게 출제되는지 알아보자. ⏱ 제한시간 03:00

다음 핵심 포인트를 참고하여
정답이 되는 이유를 적어보자. **NOTE**

1. The administrative assistant has booked flights for employees ------- to the head office in Arizona.

(A) traveling (B) traveled
(C) travels (D) travel

2. The directors of the new start-up venture are still searching for a ------- office space to lease.

(A) suit (B) suited
(C) suiting (D) suitable

3. The deputy chairperson's proposal regarding the joint venture with the conglomerate seems -------.

(A) excite (B) exciting
(C) excited (D) excites

4. Free delivery services are offered in all STF Electronics outlets for a ------- period only.

(A) limits (B) limit
(C) limiting (D) limited

5. Mr. Tan accidentally damaged his credit card, ------- it invalid for use.

(A) made (B) making
(C) to make (D) maker

6. ------- in retail for ten years, Mr. Simmons was the best candidate for the sales manager position.

(A) Worked (B) Having worked
(C) Works (D) To work

DAY 09

1. 현재분사 vs. 과거분사

2. 분사 vs. 형용사

3. 감정 관련 분사

4. 분사 형태의 형용사

5. 결과를 나타내는 구문

6. 분사구문의 시제

문제별 출제 **POINT** ▶ 다음 페이지에서 확인하기

87

현재분사 vs. 과거분사 vs. 형용사

분사 문제는 대부분 현재분사와 과거분사의 구별을 묻는다. 선택지에 현재분사와 과거분사, 그리고 형용사까지 함께 나오면 더욱 까다로워지므로 각각의 쓰임 차이를 명확하게 구별하여 알아두자.

The administrative assistant has booked flights for employees **traveling** to the head office in Arizona.

(A) **traveling** (B) traveled
(C) travels (D) travel

빈칸 이하가 employees를 수식하는 구조이므로 형용사 역할을 할 수 있는 현재분사 (A) traveling과 과거분사 (B) traveled가 정답 후보. 이때 동사 travel과 employees는 능동의 관계이므로 정답은 (A).

해석 | 그 행정 비서는 애리조나에 있는 본사로 출장 가는 직원들을 위해 비행기를 예약했다.

1. 현재분사 vs. 과거분사

분사와 수식하거나 보충하는 명사와의 관계가 의미상 능동이면 현재분사, 수동이면 과거분사를 쓴다. 또한 명사를 뒤에서 수식할 때 타동사의 현재분사 뒤에는 목적어가 있으나 과거분사 뒤에는 목적어가 없다.

현재분사	능동 (일반적으로 목적어 있음)	The person **managing** the accounting department is Ms. Oliver. managed 회계부서를 관리하고 있는 그 사람은 올리버 씨이다.
과거분사	수동 (목적어 없음)	Problems **identified** by management will be addressed immediately. identifying 경영진에 의해 확인된 문제가 즉시 처리될 것이다.

주의 자동사의 경우 뒤에 목적어가 올 수 없기 때문에 수동의 의미로 나타낼 수 없고, 과거분사 형태로도 쓸 수 없다.

The employee **remaining** in the office took the message for Ms. Jones.
remained 사무실에 남아 있던 직원이 존스 씨에게 온 메시지를 받았다.

The directors of the new start-up venture are still searching for a **suitable** office space to lease.

(A) suit (B) suited
(C) suiting (D) **suitable**

빈칸은 뒤에 명사구 office space를 수식할 형용사 자리이므로 형용사 역할을 하는 분사 (B), (C)와 순수 형용사인 (D)가 정답 후보. 형용사와 분사가 의미의 차이가 없다면 형용사가 분사보다 우선한다. 따라서 '적당한'이란 뜻의 형용사 (D) suitable이 정답.

해석 | 신생 벤처 기업의 이사들은 여전히 임대할 적당한 사무실 공간을 찾고 있다.

2. 분사 vs. 형용사

의미가 유사할 경우 명사 앞에는 형용사가 분사보다 우선하며, 의미가 다른 경우에는 문맥에 맞는 것을 고른다.

an (**attractive**/~~attracting~~) garden 눈에 띄는 정원 (**impressive**/~~impressing~~) performance 인상적인 공연	a (**suitable**/~~suited~~) candidate 적합한 지원자 (**valuable**/~~valued~~) information 귀중한 정보

The hotel features a swimming pool and an **attractive** garden area.
그 호텔은 수영장과 눈에 띄는 정원 구역이 있는 것이 특색이다. attracting

분사 형용사 / 순수 형용사

distinguished 뛰어난 / **distinguishable** 구별할 수 있는 **extended** 길어진 / **extensive** 광범위한 **informed** 잘 아는 / **informative** 유익한	**introducing** 소개하는 / **introductory** 초보의 **respected** 훌륭한 / **respectful** 존경심을 보이는 **satisfying** 만족을 주는 / **satisfactory** 만족스러운

He is a **distinguished** financial expert. 그는 뛰어난 재무 전문가이다.
Our logo is easily **distinguishable** from those of our competitors.
우리의 로고는 경쟁사들의 로고와 쉽게 구별할 수 있다.

출제 POINT 26 | 형용사로 굳어져 쓰이는 분사

감정 관련 분사 문제는 감정을 유발하는 원인은 현재분사와, 감정을 느끼는 대상은 과거분사와 어울려 쓰인다는 것을 알아야 한다. 분사의 형태로 굳어진 형용사들은 단어의 의미를 그대로 기억해 두자.

SELF-TEST 3

The deputy chairperson's proposal regarding the joint venture with the conglomerate seems **exciting**.

(A) excite **(B) exciting**
(C) excited (D) excites

빈칸은 주격 보어 자리이므로 형용사 역할을 하는 분사 (B)와 (C)가 정답 후보. excite와 같은 감정 동사는 수식하거나 보충하는 명사가 감정의 원인일 때는 현재분사, 감정을 느끼는 대상일 때는 과거분사 형태로 쓴다. 주어 proposal은 흥미로운 감정을 일으키는 원인이므로 정답은 현재분사 (B) exciting.

해석 | 대기업과의 합작 투자에 관한 부의장의 제안은 흥미로워 보인다.

출제원리

1. 감정 관련 분사

감정과 관련된 분사의 경우 감정을 일으키는 원인은 현재분사, 감정을 느끼는 대상은 과거분사와 함께 쓴다.

amazing story 놀라운 이야기 **amazed** audiences 놀란 관객들	**interesting** applicants 흥미로운 지원자들 **interested** interviewers 흥미를 보이는 면접관들
confusing instructions 혼란스러운 지시 사항 **confused** users 혼란스러워 하는 사용자들	**pleasing** atmosphere 즐거운 분위기 **pleased** guests 기쁜 손님들
disappointing sales figures 실망스러운 매출 수치 **disappointed** shareholders 실망한 주주들	**satisfying** performance 만족스러운 성과 **satisfied** clients 만족한 고객들

Though it does not pay much, Laura finds her work **satisfying**.
돈을 많이 주지는 않지만, 로라 씨는 그녀의 일을 만족스럽다고 여긴다. ~~satisfied~~

In the advertising industry, it is not easy to keep your customers **interested**.
광고 업계에서는, 고객들이 계속 흥미를 느끼도록 하는 것이 쉽지 않다. ~~interesting~~

SELF-TEST 4

Free delivery services are offered in all STF Electronics outlets for a **limited** period only.

(A) limits (B) limit
(C) limiting **(D) limited**

〈관사 + 빈칸 + 명사〉의 구조에서 빈칸은 형용사 자리이다. 선택지 중에서 limited는 '한정된'이란 의미의 과거분사 형태로 굳어진 대표적인 형용사이므로 정답은 (D). 분사 형태의 형용사와 자주 어울려 쓰이는 명사를 함께 암기하여 문제 푸는 시간을 단축시키도록 하자.

해석 | 무료 배송 서비스는 한정된 기간 동안만 모든 에스티에프 전자 사의 할인점에서 제공된다.

출제원리

2. 분사 형태의 형용사

형용사로 품사가 굳어진 분사 형태의 단어들은 능동/수동 관계를 따지기 보다는 단어의 의미 그대로 기억해 두자.

현재분사 + 명사	과거분사 + 명사
a **challenging** problem 어려운 문제	**assigned** sessions 할당된 세션들
demanding work 힘든 일	**damaged** goods 손상된 상품
existing facility 기존 시설	**designated** areas 지정된 장소들
growing population 증가하는 인구	**detailed** information 자세한 정보
lasting impression 지속적인 인상	an **enclosed** form 동봉된 서식
leading companies 선두 기업들	an **extended** deadline 연장된 마감 시간
missing luggage 분실된 짐	a **limited** time 한정된 시간
remaining work 남은 일	a **revised** version 수정된 버전
surrounding areas 인근 지역들	an **unexpected** bonus 예상치 못한 상여금

The **remaining** balance is due on August 31. 잔여 금액의 지불 기일은 8월 31일이다.
The restaurant had some **unexpected** expenses. 그 식당에 예상치 못한 비용이 조금 발생했다.

분사구문

부사절 역할을 하는 분사구문의 시제와 태를 파악하여 알맞은 형태의 분사를 채우는 문제가 주로 출제된다. 따라서 분사구문의 기본 형태와 역할을 명확하게 알아두자.

Mr. Tan accidentally damaged his credit card, **making** it invalid for use.

(A) made **(B) making**
(C) to make (D) maker

분사구문 문제로는 접속사와 주어가 생략된 분사구문의 기본 형태를 알고 있으면 쉽게 풀 수 있는 문제들이 출제된다. 신용카드가 훼손되었고 그 결과 사용이 불가능하게 되었으므로 결과를 나타내는 분사구문이 적절하다. 따라서 정답은 (B) making.

해석 | 탄 씨는 실수로 자신의 신용카드를 훼손해서 사용 불가능하게 만들었다.

1. 분사구문의 역할

형용사처럼 쓰이는 분사와 달리 분사구문은 시간, 이유, 결과, 연속 동작 등 다양한 의미를 나타내는 부사 역할을 한다.

시간	**Entering** the building, he ran into his former supervisor. = **While he entered** the building, he ran into his former supervisor. 건물로 들어오면서, 그는 그의 예전 상사와 마주쳤다.
이유	**Having** lower prices than its competitor, the shop gets more customers. = **Since it has** lower prices than its competitor, the shop gets more customers. 경쟁사보다 가격이 낮아서 그 가게는 고객들이 더 많다.
결과	The marketing strategy was a success, **expanding** our customer base. = The marketing strategy was a success, **and it expanded** our customer base. 마케팅 전략은 성공적이었고, 그로 인해 우리의 고객 기반이 확대되었다.
연속 동작	The firm opened a new branch, **adding** over 100 new employees. = The firm opened a new branch, **and it added** over 100 new employees. 그 회사는 새 지점을 열고 100명 이상의 신입 사원을 충원했다.

주의 분사구문의 정확한 의미 전달을 위해 때로는 접속사를 생략하지 않는다.

You should always wear a helmet **when riding** a bike. 오토바이를 탈 때에는 항상 헬멧을 착용해야 한다.

Having worked in retail for ten years, Mr. Simmons was the best candidate for the sales manager position.

(A) Worked **(B) Having worked**
(C) Works (D) To work

콤마 뒤가 완전한 문장이므로 빈칸부터 콤마까지는 이를 수식하는 역할을 한다. 따라서 동사 (C)는 오답. 문맥상 10년간 일한 것이 주절의 과거 시제(was)보다 이전이므로 분사구문의 완료형인 (B) Having worked가 정답이다.

해석 | 소매업에서 10년간 일했기 때문에, 시먼스 씨가 영업부장 직책에 최고의 후보자였다.

2. 분사구문의 시제와 태

분사구문의 시제는 주절의 시제를, 분사구문의 태는 분사의 주어를 파악해서 알맞은 형태를 써야 한다.

완료형	▸ 분사구문의 시제가 주절의 시제보다 앞설 때 〈Having p.p.〉의 완료 형태를 쓴다. **Having finished** lunch, we <u>went</u> out for a walk. 점심 식사를 마치고, 우리는 산책하러 나갔다. <u>과거 이전</u> <u>과거</u>
수동형	▸ 부사절의 동사와 주절의 주어 관계가 수동일 때 기본적으로 〈Being p.p.〉 형태를 쓰며, 완료 수동형은 〈Having been p.p.〉를 쓴다. **Being employed**, <u>she</u> could afford a car. 취직을 해서, 그녀는 차를 살 여유가 되었다. **Having been checked**, <u>the document</u> was now ready for submission. 확인되었기 때문에, 그 서류는 이제 제출 준비가 됐다.

FINAL TEST

1. The cost of our insurance packages depends on the ------- value of the vehicles.

(A) assessed (B) assessing
(C) assess (D) to assess

2. Because of his background in the field of architecture, Dave was able to offer ------- advice for the project.

(A) valued (B) values
(C) valuable (D) value

3. The previous leadership seminar conducted by the CEO had a ------- effect on the junior managers.

(A) lasting (B) lasted
(C) lastly (D) lasts

4. ------- catering services to various events for ten years, Blanc is known for its signature dishes carefully made to perfection.

(A) Provide (B) To provide
(C) Provided (D) Having provided

5. ------- in 1978, Roadside employs experienced mechanics who specialize in restoring old vehicles.

(A) Founding (B) Founded
(C) To found (D) Found

6. Please read the ------- brochure and let us know if you are interested in signing up for the yoga classes.

(A) controlled (B) accepted
(C) extended (D) enclosed

7. Many people hire professional accountants to prepare their taxes because the process is so -------.

(A) complicating (B) complicate
(C) complicatedly (D) complicated

8. Designers at Lily Clothing are always knowledgeable of the strong influences ------- the fashion industry.

(A) shaped (B) are shaped
(C) is shaping (D) shaping

9. ------- over 20,000 workers across the globe, Cooler Corporation is one of the world's largest beverage manufacturers.

(A) Employment (B) Employ
(C) Employing (D) Employed

10. We found it extremely ------- that the Southgate Foundation chose to cancel the technology convention.

(A) disappoint (B) disappointing
(C) disappointment (D) disappointed

11. As ------- in the contract, the completion date for the office renovation project is August 31.

(A) specifies (B) specifying
(C) specified (D) specification

12. Popular among cooks all over the world, Abdullah Old Market is home to stores selling spices ------- from Iran and India.

(A) importing (B) imports
(C) import (D) imported

13. The ------- number of foreign visitors in the country proves that the Tourism Ministry's marketing campaign is a complete success.

(A) growing (B) closed
(C) experienced (D) decreasing

14. After ------- registered as a premium member for five years, you are entitled to a free phone and a plan upgrade.

(A) had been (B) having been
(C) has been (D) will be

DAY 09

CHAPTER
5

-

수식어편

DAY 10
형용사

—

기본 개념 노트

본 학습에 들어가기 전에 기본 문법 개념의 틀을 잡아보자.

❶ 개념 및 역할

명사 또는 대명사를 수식하거나 보어 역할을 하며 명사 또는 대명사의 성질이나 상태를 나타낸다.

명사 수식	명사 앞	① We look forward to a **positive** outcome from the survey.
	명사 뒤	② The director noticed someone **new** in the office.
보어 역할	주격 보어	③ The company is becoming **reliant** on too few products.
	목적격 보어	④ Mr. Bans considered Mr. Yomoshi **suitable** for the position.

❷ 형태

형용사는 대개 -al, -able, -ible, -ful, -tive, -ic, -ous, -y 등의 접미사로 끝나는 형태이다. 그 외에 〈명사 + -ly〉의 형태나 분사가 형용사로 굳어진 형태도 있다.

일반 형용사	successful 성공한	considerable 상당한	economic 경제의	comparative 비교의
명사 + -ly	friendly 친근한	costly 비용이 드는	timely 시기적절한	orderly 정돈된
현재분사형	outstanding 뛰어난	leading 선도하는	remaining 남아있는	existing 기존의
과거분사형	broken 고장 난	limited 제한된	detailed 자세한	complicated 복잡한

⑤ Mr. Tamil's strategy for increasing revenues will be **successful**.
⑥ The utility bills have been paid in a **timely** manner.
⑦ Welake is a **leading** auto parts manufacturer.
⑧ Helen needs a more **detailed** report for the board.

① 우리는 그 설문 조사에서 긍정적인 결과를 기대한다. ② 부장은 사무실에 새로운 누군가가 있음을 알았다. ③ 그 회사는 너무 적은 수의 제품에만 의존해 가고 있다. ④ 반스 씨는 요모시 씨가 그 자리에 적합하다고 생각했다. ⑤ 수익을 늘리기 위한 타밀 씨의 전략은 성공적일 것이다. ⑥ 공과금 청구서는 적절한 때에 지불되었다. ⑦ 위레이크 사는 자동차 부품 제조 선두 업체이다. ⑧ 헬렌 씨는 이사회를 위해 좀 더 자세한 보고서가 필요하다.

SELF-TEST

기본 개념이 토익에는 어떻게 출제되는지 알아보자. ⏱ 제한시간 03:00

다음 핵심 포인트를 참고하여 정답이 되는 이유를 적어보자. **NOTE**

DAY 10

1. The internship program is an ------- opportunity to learn useful skills for the workplace.

 (A) excelled (B) excellence
 (C) excellently (D) excellent

1. 명사 수식

2. Intellectual property laws make it ------- for artists and designers to profit from someone else's work.

 (A) difficulty (B) difficulties
 (C) difficult (D) difficultly

2. 목적격 보어 자리

3. The new convenience store is expected to be operational in the next ------- weeks.

 (A) few (B) any
 (C) little (D) more

3. 수량형용사

4. The research team tested the lotion on ------- age groups before choosing the target audience.

 (A) vary (B) various
 (C) variable (D) variety

4. 문맥에 알맞은 형용사

5. High-performing employees are ------- for an annual salary increase of at least 5 percent.

 (A) famous (B) eligible
 (C) acceptable (D) possible

5. ⟨be동사 + 형용사 + 전치사⟩

6. Concert attendees are ------- to purchase souvenir items at the venue after the show.

 (A) enjoyable (B) early
 (C) likely (D) considerable

6. ⟨be동사 + 형용사 + to부정사⟩

문제별 출제 **POINT** ▶ 다음 페이지에서 확인하기

형용사 자리

형용사 자리 문제는 명사를 수식하는 품사를 고르는 문제로 자주 출제된다. 또한 보어로 쓰인 형용사 자리를 묻는 문제로도 출제되므로 주격 보어와 목적격 보어로 쓰이는 형용사의 역할도 반드시 알아두자.

The internship program is an **excellent** opportunity to learn useful skills for the workplace.

(A) excelled (B) excellence
(C) excellently **(D) excellent**

빈칸은 뒤의 명사 opportunity를 수식하는 형용사 자리이므로 명사 (B) excellence와 부사 (C) excellently는 오답으로 제외. 과거분사가 형용사 역할을 할 수 있으나, (A) excelled는 '뛰어나게 된'이란 의미로 문맥상 어색하다. 따라서 정답은 (D) excellent.

해석 | 그 인턴십 프로그램은 직장에 필요한 유용한 기술을 배울 수 있는 훌륭한 기회이다.

1. 명사 또는 대명사 수식

형용사는 명사 또는 대명사를 수식하여 이들의 성질이나 상태를 나타낸다. 형용사는 대부분 (대)명사를 앞에서 수식하지만 -thing, -body, -one, -where로 끝나는 부정대명사는 뒤에서 수식한다. 일부 -able[-ible]로 끝나는 형용사는 (대)명사를 뒤에서 수식하는 경우도 있으니 함께 알아두자.

(한정사+)형용사+명사	He developed an **effective** strategy for increasing customer satisfaction. 그는 고객 만족도를 높이는데 효과적인 전략을 개발했다.
대명사+형용사	They need to find someone **reliable** to work in the security team. 그들은 보안팀에서 일할 믿을만한 사람을 찾아야 한다.
명사+형용사	The new director is reviewing all the references **available** right now. 새로 온 부장은 당장 이용 가능한 모든 참고 자료들을 검토 중이다.

Intellectual property laws make it **difficult** for artists and designers to profit from someone else's work.

(A) difficulty (B) difficulties
(C) difficult (D) difficultly

⟨make+가목적어 it+목적격 보어+진목적어 to부정사⟩ 구문임을 파악하는 것이 관건이다. 빈칸은 목적격 보어 자리이므로 명사인 (A)와 (B), 형용사인 (C)가 정답 후보이다. 문맥상 진목적어인 to profit from someone else's work가 difficulty와 동격 관계가 될 수 없으므로 명사 (A)와 (B)는 오답이다. 따라서 목적어의 상태를 서술해 주는 형용사가 적절하므로 정답은 (C) difficult.

해석 | 지적 재산법으로 예술가 및 디자이너들이 다른 사람의 작품으로 이익을 얻기가 어려워진다.

2. 보어 역할

형용사는 2문형과 5문형에서 주격 보어와 목적격 보어로 쓰이는데, 이때 문장의 주어나 목적어의 성질, 상태, 신분 등을 보충 설명해 주는 역할을 한다.

주격 보어	The office phone number will remain **unchanged**. 사무실 전화번호는 변경되지 않을 것이다. ~~unchangeably~~
목적격 보어	Bruce tried to make his company's Web site **educational** for people. ~~educationally~~ 브루스 씨는 사람들을 위해 그의 회사 웹사이트를 교육적으로 만들려고 노력했다.

주의해야 할 형용사

꾸준히 출제되고 있는 수량형용사를 고르는 문제는 빈칸이 수식하는 명사의 성질을 파악하는 것이 관건이므로 명사의 수나 양을 잘 살펴보자. 또한 형태가 비슷하지만 뜻이 다른 형용사도 주의하여 살펴보자.

The new convenience store is expected to be operational in the next **few** weeks.

(A) few (B) any
(C) little (D) more

빈칸이 수식하는 weeks가 가산명사 복수형이므로 불가산명사를 수식하는 (C) little은 오답으로 제외. 빈칸 앞 한정사 the는 any나 more와 함께 쓸 수 없으므로 (B)와 (D)도 오답이다. 따라서 정답은 수가 많지 않음을 나타내는 수량형용사 (A) few.

해석 | 그 새로운 편의점은 몇 주 내로 운영할 것으로 예상된다.

1. 수식하는 명사에 따라 달라지는 수량형용사

수나 양의 많고 적음을 나타내는 수량형용사는 수식하는 명사와 수일치가 되어야 한다.

수	many 많은	a few 조금 있는	few 거의 없는	fewer 더 적은	+ 가산명사 복수형
양	much 많은	a little 조금 있는	little 거의 없는	less 더 적은	+ 불가산명사

Few opinions were made about improving the local park. 지역 공원 개선에 대한 의견은 거의 없었다.
We have **little** time to solve this financial crisis. 우리는 이 재정 위기를 해결할 시간이 거의 없다.

2. 수량형용사 대신 쓸 수 있는 수량 표현

수량형용사와 마찬가지로 명사의 수나 양에 따라서 사용할 수 있는 수량 표현들이 달라지므로 구분하여 기억해 두자.

수	several 몇몇의 a number of 많은	a couple of 두서넛의 a variety of 여러 가지의	numerous 많은 a range of 다양한	+ 가산명사 복수형
양	a large amount of, a great deal of 많은			+ 불가산명사
수/양	all 모든 more 더 많은 no 어떤 ~도 없는	most 가장 많은 some, any 약간의 a lot of, lots of, plenty of 많은		+ 가산명사 복수형 / 불가산명사

Ms. Garcia is in charge of **numerous** departments. 가르시아 씨는 많은 부서를 담당하고 있다.

The research team tested the lotion on **various** age groups before choosing the target audience.

(A) vary **(B) various**
(C) variable (D) variety

빈칸은 명사구 age groups를 수식하는 형용사 자리이므로 (B)와 (C)가 정답 후보. 문맥상 '가변적인' 연령대라는 의미는 어색하고 '다양한' 연령대라고 하는 것이 자연스러우므로 정답은 (B) various.

해석 | 연구팀은 광고 대상 선정 전에 그 로션을 다양한 연령대에 시험해 보았다.

3. 혼동하기 쉬운 형용사

형태가 비슷하지만 각각 다른 뜻을 가진 형용사들은 수식하는 명사와 문맥에 어울리게 사용해야 한다.

comprehensible 이해할 수 있는 comprehensive 종합적인	considerable 상당한 considerate 사려 깊은	successful 성공한 successive 연속적인
confident 확신하는 confidential 기밀의	dependable 믿을 수 있는 dependent 의존하는	variable 가변적인 various 다양한

The new products launched last month are highly **successful**. 지난달에 출시된 신제품들은 매우 성공적이다.
The team has won the championships for two **successive** years. 그 팀은 2년 연속 우승을 차지했다.

형용사 관용표현

형용사 관용표현인 〈be동사＋형용사＋전치사[to부정사]〉 구문에서 형용사 어휘 문제나 전치사 또는 to부정사 자리가 빈칸으로 출제된다. 따라서 시험에 자주 나오는 표현들은 한 덩어리로 외워두자.

High-performing employees are **eligible** for an annual salary increase of at least 5 percent.

(A) famous **(B) eligible**
(C) acceptable (D) possible

'~에 대한 자격이 있다'라는 뜻의 be eligible for는 형용사 뒤 전치사 for가 오는 대표적인 관용표현이다. 이 표현을 알았다면 바로 풀 수 있는 문제로, 정답은 (B) eligible이다. 참고로 (D) possible은 주어가 사람일 때 보어로 쓸 수 없다.

해석 | 일을 잘하는 직원들은 최소 5퍼센트의 연봉 인상에 대한 자격이 있다.

1. 〈be동사＋형용사＋전치사〉 구문

특정 전치사를 동반하여 be동사의 보어로 쓰이는 형용사 구문들이 있다. 그 중에서도 토익에 자주 출제되는 형용사 구문을 살펴보자.

for	to	of
be adequate for ~에 적합하다	be accessible to ~에 접근 가능하다	be (un)aware of ~을 알다(모르다)
be available for ~가 가능하다	be close to ~에 가깝다	be capable of ~에 유능하다
be eligible for ~에 대한 자격이 있다	be payable to ~에게 지불 청구하다	be critical of ~을 비난하다
be famous for ~로 유명하다	be responsive to ~에 반응하다	be full of ~로 가득 차다
be ideal for ~에 이상적이다	be similar to ~와 비슷하다	be indicative of ~을 나타내다
be responsible for ~을 담당하다	be subject to ~하기 쉽다	be representative of ~을 대표하다
be suitable for ~에 적합하다	be vital to ~에 필수적이다	be sure of ~에 확신을 가지다

Mr. Gabriel **is responsible for** assigning each team member's workload.
가브리엘 씨는 각 팀원들의 업무를 배정하는 일을 담당하고 있다.

This agreement **is subject to** change without notice.
이 계약서는 통보 없이 변경될 수 있다.

Concert attendees are **likely** to purchase souvenir items at the venue after the show.

(A) enjoyable (B) early
(C) likely (D) considerable

문맥에 알맞은 형용사 어휘를 고르는 문제이다. be likely to do는 '~할 것 같다'라는 뜻의 to부정사를 동반하는 형용사 관용표현으로, '기념품을 구매할 것 같다'라는 의미로 문맥에 가장 알맞다. 따라서 정답은 (C) likely. (A) enjoyable은 사람과 함께 쓰지 않는 형용사이므로 오답이다.

해석 | 콘서트 참석자들은 쇼가 끝난 뒤 그 장소에서 기념품을 구매할 것 같다.

2. 〈be동사＋형용사＋to부정사〉 구문

to부정사를 동반하는 형용사 구문도 있다. 형용사 어휘를 묻는 문제로 자주 출제되므로 아래 표현들을 평소에 한 단어처럼 외워두자.

be (un)able to *do* ~을 할 수 있다(없다)	be likely to *do* ~할 것 같다
be eager[anxious] to *do* 간절히 ~하고 싶어 하다	be ready to *do* ~할 준비가 되다
be eligible[entitled] to *do* ~할 자격이 있다	be reluctant to *do* ~하는 것을 꺼리다
be hesitant to *do* ~하기를 주저하다	be willing to *do* 기꺼이 ~하다

All employees **are entitled to apply** for the leadership program.
모든 직원들은 리더십 프로그램에 지원할 자격이 있다.

Mr. Paige **is willing to work** overtime to meet the deadline.
페이지 씨는 마감을 맞추기 위해 기꺼이 시간외 근무를 한다.

FINAL TEST

1. The cabin crew received recognition for its
------- management of a medical emergency
during a flight.
 - (A) skillfully
 - (B) skill
 - (C) skillful
 - (D) skills

2. Clothing purchased at the Pink Closet is
------- for seven days based on the shop's
return policy.
 - (A) refunding
 - (B) refunds
 - (C) refund
 - (D) refundable

3. Opening a second location on Sixth Street
will be favorable to ------- clients of Super
Laundry.
 - (A) several
 - (B) less
 - (C) each
 - (D) one

4. The advisor has ------- influence on the
mayor's decision, but not enough to make a
difference.
 - (A) various
 - (B) much
 - (C) few
 - (D) a little

5. Researchers at the Animal Institute were able
------- all the probable causes of the disease
affecting livestock in Wales.
 - (A) to be explained
 - (B) to explain
 - (C) have explained
 - (D) being explained

6. Some information about the fire will remain
------- until the investigation is finished.
 - (A) confident
 - (B) confidential
 - (C) confidentially
 - (D) confidence

7. Moseby Office Solutions is looking for
account executives who are ------- of working
on multiple projects at a time.
 - (A) capable
 - (B) capability
 - (C) capably
 - (D) capabilities

8. Ms. Gladwell is a busy sales manager,
but she is always ------- to help her staff
members meet their targets.
 - (A) willing
 - (B) subjective
 - (C) necessary
 - (D) essential

9. Dorothy Mayer makes her software reviews
------- for readers with limited knowledge of
Illustrador's graphic design programs.
 - (A) educated
 - (B) educate
 - (C) educational
 - (D) education

10. For security purposes, high-definition
cameras are strategically installed on -------
floor of the commercial building.
 - (A) every
 - (B) all
 - (C) some
 - (D) many

11. The personnel manager is responsible -------
updating the training curriculum regularly to
include any changes in office rules.
 - (A) of
 - (B) for
 - (C) on
 - (D) at

12. For the annual management lecture series,
the advertising director did his presentation
on ------- marketing methods.
 - (A) success
 - (B) successfully
 - (C) successive
 - (D) successful

13. Qatar is set to become a perfect place
for foreign investment in the ------- future
because of its relaxed business regulations.
 - (A) foreseeable
 - (B) foreseen
 - (C) foreseeably
 - (D) foreseeing

14. The CEO is worried that the company is
becoming increasingly ------- on a few key
markets in Asia and Europe.
 - (A) dependent
 - (B) depending
 - (C) dependable
 - (D) dependence

DAY 10

Questions 15-18 refer to the following article.

AUGUSTA, June 2—Augusta mayor Alfred Bates announced the approval for the construction of the Gilmore Shopping Mall, a project proposed by Gilmore Estates a month ago. ------. "Thanks
15.
to this new shopping mall, our city will earn more than $20 million in taxes and tourism revenue

------ year," Bates explained.
16.

Despite these benefits, the announcement received a mixed response and has become ------.
17.
Local residents, who are used to the quiet area, are concerned that they will now be ------
18.
to noise and pollution from the traffic increase. However, Bates said he was confident that opponents will change their minds once they see the positive effects of the Gilmore Shopping Mall.

15. (A) Environmentalists immediately expressed their disapproval of the decision.
(B) The building is expected to cost the town a lot of money.
(C) However, the project has already posed many unforeseen problems.
(D) The mayor believes the project will help to boost the town's economy.

16. (A) each
(B) other
(C) much
(D) few

17. (A) controversially
(B) controversies
(C) controversial
(D) controversy

18. (A) submissive
(B) subject
(C) confirmed
(D) required

Questions 19-22 refer to the following e-mail.

To: Department Heads <deptheads@venusmobile.com>
From: Jason Franco <j.franco@venusmobile.com>
Date: March 2
Subject: Emergency Meeting Schedule

Hello everyone,

As you all know, we've recently received ------ complaints about our latest smartphone, the
 19.
HB-1011. Customers claim that the colors on the phone's LCD screen change when it is being

charged. To deal with this issue, management called for an ------ meeting this afternoon.
 20.
However, this meeting will be postponed until tomorrow at 9 A.M. so that Mr. Aldrin Lopez, the

sales director of our touch-screen supplier, may join us. ------. We need his explanation on the
 21.
defective LCD screens.

Problems related to ------ products are usually manageable, provided that we immediately
 22.
identify their root cause. Therefore, I request that you prioritize this meeting over any other

engagements.

Sincerely,

Jason Franco
Vice-President for External Affairs, Venus Mobile

19. (A) many
(B) another
(C) no
(D) any

20. (A) urgent
(B) urgently
(C) urgency
(D) urges

21. (A) Mr. Lopez has been with our company for three years.
(B) I believe it is important to include him in the discussion.
(C) He was one of the clients who returned a defective phone.
(D) This calls for an expert in crisis management.

22. (A) damage
(B) damaged
(C) damaging
(D) damages

CHAPTER

5

-

수식어편

DAY 11
부사 ①

기본 개념 노트

본 학습에 들어가기 전에 기본 문법 개념의 틀을 잡아보자.

❶ 개념 및 역할

동사, 형용사, 부사와 구, 절, 문장 전체까지 수식하며 때, 장소, 방법, 빈도 등을 나타낸다.

동사 수식	① You must **exactly** follow all the procedures listed.
형용사 수식	② Workers at EMP Inc. have to do **increasingly** intensive work.
부사 수식	③ That term has been used **very** often in many different contexts.
구 수식	④ The newly acquired business will be operated **entirely** in the same way.
절 수식	⑤ The battery can be inserted into the machine **only** while it is turned off.
문장 수식	⑥ **Usually**, Mr. Grant is the first to arrive at the office.

❷ 형태

일반적으로 〈형용사 + -ly〉의 형태이지만 다른 형태의 부사들도 있다.

형용사 + -ly	casually 우연히 currently 현재, 지금	conveniently 편리하게 directly 곧장, 똑바로	immediately 즉시, 즉각 unfortunately 유감스럽게도
기타 형태	always 항상　　ever 한 번이라도 even 심지어　　just 막, 단지	only 오직 still 여전히	well 잘 yet 아직

⑦ **Unfortunately**, we have to end our agreement with your company.
⑧ The manager is **always** available to provide assistance.

① 열거된 모든 절차를 정확하게 따라야 한다. ② 이엠피 주식회사의 직원들은 점점 강도가 높아지는 업무를 해야 한다. ③ 그 용어는 많은 다른 문맥에서 매우 자주 사용되어 왔다. ④ 새로 인수된 사업은 완전히 같은 방식으로 운영될 것이다. ⑤ 배터리는 전원을 끈 동안에만 기계에 넣을 수 있다. ⑥ 대개 그랜트 씨가 사무실에 제일 먼저 도착하는 사람이다. ⑦ 유감스럽게도, 저희는 귀사와의 협정을 종결해야 합니다. ⑧ 관리자가 항상 도움을 줄 수 있다.

SELF-TEST

기본 개념이 토익에는 어떻게 출제되는지 알아보자. ⏱ 제한시간 03:00

다음 핵심 포인트를 참고하여
정답이 되는 이유를 적어보자. NOTE

1. Because Jade Buses ------- met its revenue target last quarter, all sales employees received bonuses.

 (A) succeed (B) successfully
 (C) succeeded (D) successful

 1. 동사 수식

2. Ms. Keats offers ------- priced packages for her party planning services.

 (A) reasoning (B) reasonable
 (C) reasonably (D) reason

 2. 형용사 수식

DAY 11

3. Since the product launch event is exclusive, ------- clients on the organizer's list are invited.

 (A) only (B) quite
 (C) similarly (D) moreover

 3. 명사구 수식

4. Many employees arrived ------- to work this morning due to heavy traffic.

 (A) later (B) late
 (C) lately (D) lateness

 4. -ly가 붙어서 뜻이 변하는 부사

5. Tomorrow's safety training will not include topics that were ------- discussed today.

 (A) early (B) already
 (C) yet (D) still

 5. 시간 부사

6. Since Speedy Cleaners changed its Web site, placing a job order is faster than -------.

 (A) ever (B) once
 (C) just (D) more

 6. faster than

문제별 출제 **POINT** ▶ 다음 페이지에서 확인하기

부사 자리

부사 자리를 묻는 문제로는 동사를 수식하는 부사의 역할을 묻는 문제가 가장 많이 출제되고 있다. 동사를 수식하는 것뿐만 아니라 형용사나 부사 또는 문장 전체를 수식하는 부사 자리 문제도 출제된다.

Because Jade Buses **successfully** met its revenue target last quarter, all sales employees received bonuses.

(A) succeed **(B) successfully**
(C) succeeded (D) successful

주어 Jade Buses와 동사 met 사이에 위치해 있는 것으로 보아 빈칸은 동사 met을 수식하는 부사 자리임을 알 수 있다. 따라서 정답은 (B) successfully. 동사를 수식하는 부사의 다양한 위치를 기억해 두자.

해석 | 제이드 버스 사가 지난 분기에 목표 수익을 달성했기 때문에, 모든 영업 사원들은 보너스를 받았다.

1. 동사 수식

동사를 수식하는 경우 부사는 동사 앞이나 뒤에 위치하지만 동사와 목적어 사이에는 오지 못한다.

부사+동사(+목적어)	The university **occasionally** holds meetings for the entire faculty. ~~occasional~~ 그 대학은 전체 교수진을 대상으로 가끔 회의를 연다.
동사(+목적어)+부사	The workers examine the machinery **thoroughly** every day. 직원들은 매일 기계를 철저히 검사한다. ~~thorough~~
조동사+부사+동사	The organizers will **definitely** refund the full price of the ticket. 주최측은 틀림없이 티켓을 전액 환불해 줄 것이다.
be동사+부사+p.p.[doing]	The taxi stand is **conveniently** located next to the airport exit. 택시 승강장은 공항 출구 옆에 편리하게 위치해 있다.
have동사+부사+p.p.	Mr. Doherty's computer has **completely** stopped working. 도허티 씨의 컴퓨터는 작동을 완전히 멈췄다.

주의 부사는 동사의 성질을 가지고 있는 to부정사, 동명사, 분사도 수식할 수 있다.

He double-checked the proposal before **finally** submitting it.
그는 최종적으로 제출하기 전에 그 제안서를 다시 한 번 확인했다.

Ms. Keats offers **reasonably** priced packages for her party planning services.

(A) reasoning (B) reasonable
(C) reasonably (D) reason

빈칸은 뒤의 형용사 priced를 수식하는 부사 자리이다. 따라서 정답은 (C) reasonably. 형용사를 수식하는 경우 부사는 주로 형용사의 바로 앞에 위치한다.

해석 | 키츠 씨는 자신의 파티 계획 서비스용 패키지를 합리적으로 매긴 가격으로 제공한다.

2. 형용사/부사/문장 전체 수식

형용사나 부사를 수식하는 경우 주로 수식하는 형용사나 부사의 바로 앞에 온다. 일반적인 형용사뿐만 아니라 형용사 역할을 하는 분사와 숫자 표현 모두 부사의 수식을 받을 수 있다.

부사+형용사	A variety of home appliances is **readily** available at the store. 그 매장에서 다양한 가전제품을 쉽게 구입할 수 있다.
부사+부사	The items should be packed **very** carefully before shipping. 운송 전에 그 물품들은 매우 조심스럽게 포장되어야 한다.
부사+문장 전체	**Unfortunately**, the bank was closed when I got there. 유감스럽게도, 내가 도착했을 때는 은행이 닫혀 있었다.

주의해야 할 부사

동사, 형용사, 부사 외에 구나 절을 수식하는 부사 문제는 가끔 출제되지만 쉬운 편이므로 맞혀야 한다. 또한 형태가 비슷하나 의미가 다른 부사 문제도 종종 출제되므로 반드시 암기해 두자.

Since the product launch event is exclusive, **only** clients on the organizer's list are invited.

(A) only (B) quite
(C) similarly (D) moreover

빈칸 뒤의 명사구 clients on the organizer's list를 수식하며 그 의미를 강조해 줄 수 있는 부사를 찾는 문제. 선택지 중에서 명사구를 수식할 수 있는 부사 (A) only와 (B) quite가 정답 후보. 문맥상 '목록에 있는 고객들만'이라는 뜻이 적절하므로 정답은 (A).

해석 | 그 제품 출시 행사가 특정 회원을 대상으로 하는 것이어서, 행사 주최자의 목록에 있는 고객들만 초대된다.

1. 구나 절을 수식하는 부사

일반적으로 부사는 동사(구)를 수식하지만, 명사구, 전치사구, 절을 수식하는 부사들도 있다.

부사 + 명사구 only, just 오직, 단지 quite 광장히	**Only** <u>experienced candidates</u> will be considered for the editing job. 경력이 있는 후보자만 그 편집 업무에 고려될 것이다. The documentary about African wildlife was **quite** <u>a disappointment</u>. 아프리카 야생 동물에 관한 그 다큐멘터리는 광장히 실망스러웠다.
부사 + 전치사구 even 심지어 ~조차도 well 훨씬	It was difficult for him to communicate, **even** <u>with an interpreter</u>. 그는 심지어 통역사와도 의사소통을 하는 것이 어려웠다. The home was sold for **well** <u>below the market value</u>. 그 집은 시장 가격보다 훨씬 낮게 팔렸다.
부사 + 절 just, right 바로	Ms. Devenney doesn't like to eat **just[right]** <u>before she works out</u>. 데브니 씨는 운동하기 바로 직전에 먹는 것을 좋아하지 않는다.

Many employees arrived **late** to work this morning due to heavy traffic.

(A) later **(B) late**
(C) lately (D) lateness

빈칸은 동사 arrived와 전치사구 to work 사이에서 앞의 동사를 수식하는 부사 자리로, 선택지 중 부사인 (A), (B), (C)가 정답 후보이다. 문맥상 '늦게 출근했다'는 것이 적절하므로 정답은 (B) late. (C) lately는 late 뒤에 -ly가 붙은 형태지만 '최근에'라는 뜻으로 그 의미가 확연히 달라진다는 것을 기억하자.

해석 | 많은 직원들이 교통 체증 때문에 오늘 아침에 늦게 출근했다.

2. -ly가 붙어서 뜻이 변하는 부사

-ly가 붙어서 뜻이 달라지는 부사들이 있다. 이들의 의미 차이를 암기하여 문맥에 맞는 것을 고를 수 있도록 하자.

close 가까이	—	closely 면밀히	late 늦게	—	lately 최근에
great 아주 잘	—	greatly 대단히	most 가장	—	mostly 주로
hard 힘들게	—	hardly 거의 ~않다	near 가까이	—	nearly 거의
high 높이	—	highly 매우	short 짧게	—	shortly 곧

He raised the sign **high** so everyone could see it. 그가 표지판을 높이 들어서 모두가 그것을 볼 수 있었다.
That work requires a **highly** skilled programmer. 그 일은 매우 숙련된 프로그래머가 필요하다.

The staff meeting ran **late**, so Ms. Goldman missed her appointment.
직원 회의가 늦어져서, 골드먼 씨는 약속을 지키지 못했다.
The store has been receiving a lot of positive customer reviews **lately**.
그 매장은 최근에 긍정적인 고객 평가를 많이 받고 있다.

시간 부사

뜻이 비슷한 시간 부사들은 해석만으로는 문제를 풀기 어려울 때가 있으므로 부사의 위치나 문장의 종류에 따라 그 쓰임을 구별하자. 특히 빈출되는 **already**, **yet**, **still**의 쓰임의 차이는 정확히 알아두자.

Tomorrow's safety training will not include topics that were **already** discussed today.

(A) early **(B) already**
(C) yet (D) still

문맥상 '이미 논의됐던 주제는 포함하지 않을 것'이란 의미가 자연스러우므로 정답은 (B) already. (A) early는 early today로 붙여 써야 하고, (C) yet은 '아직'이란 의미로 부정문에서 쓰이며 (D) still은 '아직, 여전히'란 의미로 문맥상 적절하지 않아 모두 오답이다.

해석 | 내일 있을 안전 교육은 오늘 이미 논의됐던 주제는 포함하지 않을 것이다.

1. already, yet, still

의미가 비슷한 시간 부사들은 위치나 문장의 종류에 따라 구별된다. 다음 쓰임의 차이를 확인해 보자.

already (긍정문) 이미, 벌써	The R&D team has **already** finished developing the new engine. 연구 개발팀은 이미 새로운 엔진 개발을 끝냈다.
yet (부정문, 의문문) 아직 (긍정문) **have yet to** *do* 아직 ~하지 않았다	The president has <u>not</u> **yet** issued a statement about the scandal. [**not** 뒤에 위치] 회장은 추문에 대해 아직 성명서를 발표하지 않았다. Even though it's due tomorrow, Thomas **has yet to write** the report. 비록 내일이 마감이지만, 토마스 씨는 아직 보고서를 쓰지 않았다.
still (긍정문, 부정문) 아직, 여전히 although, even though, despite와 자주 쓰인다.	Peter has **still** <u>not</u> received a response to his e-mail. [**not** 앞에 위치] 피터 씨는 그의 이메일에 대한 답변을 아직 받지 못했다. <u>Although</u> Ms. Dunphy speaks German well, she **still** makes small mistakes. 던피 씨는 독일어를 잘 하지만, 여전히 작은 실수를 한다.

Since Speedy Cleaners changed its Web site, placing a job order is faster than **ever**.

(A) ever (B) once
(C) just (D) more

빈칸 앞 faster than이 결정적인 단서이다. 부사 ever는 〈비교급+than ever〉 형태로 비교급을 강조하므로 정답은 (A). (B) once도 막연한 과거의 시점을 나타낼 때 쓰이나 비교급을 강조하지는 않으므로 오답이다.

해석 | 스피디 클리너스 사가 자사의 웹사이트를 변경해서 작업 요청이 어느 때보다 더 빨라졌다.

2. once, ever, ago

시간 부사 once와 ever, ago는 의미가 유사해 보이지만 각각 쓰이는 문장의 종류가 다르다.

once (긍정문) 한때, 언젠가, 한 번	Mr. Jacobson has attended an annual conference **once**. 제이콥슨 씨는 연간 회의에 참석한 적이 한 번 있다.
ever (부정문, 의문문, 조건문) 한때, 언젠가 (비교급/최상급 강조) 어느 때	If Sam **ever** gets a raise, he will buy a new car. 샘 씨의 급여가 언젠가 오르기만 하면, 새로운 차를 구매할 것이다. The new network system is <u>more reliable than</u> **ever**. 그 새로운 네트워크 시스템은 어느 때보다 더 믿을 만하다.
ago 이전에 과거시제와 주로 쓰인다.	That request was approved <u>two days</u> **ago**. 그 요청 사항은 2일 전에 승인되었다.

FINAL TEST

1. Online banking has made it possible to move funds ------- from one account to another.

(A) electronics
(B) electronically
(C) electronic
(D) electronical

2. The Ethel Marine Park's management department ------- monitors the living conditions of all its sea animals.

(A) closing
(B) closed
(C) closely
(D) close

3. Because winter is coming, the demand for warm clothing is expected to increase -------.

(A) already
(B) regularly
(C) conversely
(D) soon

4. Kenneth should have been here an hour ago, but he has ------- not arrived, and he is not answering his phone.

(A) only
(B) yet
(C) enough
(D) still

5. After ------- reducing operating costs, Pharmacare Research Center was able to buy advanced laboratory equipment.

(A) considerably
(B) considerable
(C) consideration
(D) consider

6. Although Ms. Mills passed the exam -------, her boss wanted her to take it again to get a recent score on record.

(A) once
(B) then
(C) ago
(D) ever

7. Thanks to the ------- introduced strategy, profits have gone up by 10 percent.

(A) new
(B) newly
(C) news
(D) newer

8. The CEO had seen the proposed storyboard ------- before his scheduled meeting with the marketing team.

(A) ever
(B) still
(C) even
(D) now

9. The business forum participants asked questions ------- after the speaker presented some profitable investment opportunities.

(A) short
(B) shorter
(C) shortly
(D) shorten

10. The supervisor needs to make sure that all her employees have ------- prepared for their upcoming presentations.

(A) adequate
(B) adequately
(C) adequacy
(D) adequateness

11. Place your Marvelous Meals dish in the microwave, and your delicious dinner will be ready in ------- three minutes.

(A) quite
(B) just
(C) well
(D) below

12. To prolong the life of your digital piano, ------- follow the product care instructions specified on the last page of the user guide.

(A) simple
(B) simplistically
(C) simply
(D) simplify

13. The special selection of wine and spirits at the Brown Cellar is ------- recommended by food critics in New York.

(A) highly
(B) merely
(C) instantly
(D) generously

14. The local government has ------- to decide where to hold the fireworks display for the founding anniversary of the city.

(A) anyway
(B) usually
(C) not
(D) yet

정답 및 해설 42쪽

CHAPTER

5

-

수식어편

DAY 12
부사 ②

—

기본 개념 노트

본 학습에 들어가기 전에 기본 문법 개념의 틀을 잡아보자.

❶ 빈도 부사의 개념과 종류

어떠한 행동이 얼마나 자주 일어나는지를 나타내는 부사로, 조동사나 be동사 뒤에, 일반동사 앞에 위치한다.

sometimes 때때로	often 자주	usually 대개	always 항상
hardly, rarely, barely, scarcely, seldom 거의 ~않다		never 절대 ~않다	

① The number of exports **always** increases in May.
② The directory contains errors because it is **rarely** updated.

❷ 접속 부사의 개념과 종류

두 개의 문장을 의미적으로 연결해 주는 것으로, 품사는 부사이기 때문에 단독으로는 접속사처럼 절과 절을 연결할 수 없다. 따라서 두 절을 연결할 때에는 접속사나 세미콜론(;)과 함께 쓰인다.

however 그러나	nevertheless, nonetheless 그럼에도 불구하고
therefore, hence 그러므로	moreover, besides, in addition, furthermore 게다가
otherwise 그렇지 않으면	likewise 마찬가지로

③ The apartment is furnished. **Therefore**, the rent is higher. [문장. 접속 부사, 문장]
 The apartment is furnished, <u>and</u> **therefore**, the rent is higher. [접속사인 and와 사용]
 The apartment is furnished; **therefore**, the rent is higher. [접속의 기능을 가진 세미콜론(;)과 사용]

① 5월에는 수출품의 수가 항상 증가한다. ② 전화번호부가 좀처럼 갱신되지 않아서 오류가 있다. ③ 그 아파트는 가구가 다 비치되었다. 그러므로 임대료가 더 비싸다.

SELF-TEST

기본 개념이 토익에는 어떻게 출제되는지 알아보자. ⏱ 제한시간 03:00

1. On weekends, Ms. Kang ------- visits the Orchard Spa with her friends and gets a massage.

 (A) great (B) late
 (C) shortly (D) often

 1. 빈도 부사

2. There are many souvenir shops located on Jumeirah Street, but they ------- open before 10 A.M.

 (A) seldom (B) quite
 (C) ever (D) very

 2. 부정 부사

3. The customer wanted to mail a large and heavy item, and -------, the shipper recommended using a crate box.

 (A) both (B) therefore
 (C) neither (D) however

 3. 접속 부사

4. Employees at E&G Inc. should send work reports to their supervisors every Friday unless ------- instructed.

 (A) instead (B) otherwise
 (C) likewise (D) so

 4. 주의해야 할 접속 부사

5. Fans around the world are ------- awaiting the release of the next movie in the action series.

 (A) eagerly (B) greatly
 (C) strongly (D) temporarily

 5. 동사 await와 자주 어울려 쓰이는 부사

6. Finnegan Bedding's sales have been decreasing at a rate of ------- 5 percent each month.

 (A) nearly (B) mostly
 (C) slowly (D) largely

 6. 숫자 수식 부사

DAY 12

문제별 출제 **POINT** ▶ 다음 페이지에서 확인하기

빈도 부사

빈도 부사는 주로 그 의미의 차이를 구별하는 문제로 자주 출제되므로 문맥에 맞는 빈도 부사를 고르는 연습이 필요하다. 출제되면 당연히 맞혀야 하는 쉬운 문제이므로 그 뜻을 명확하게 짚고 넘어가자.

On weekends, Ms. Kang **often** visits the Orchard Spa with her friends and gets a massage.

(A) great (B) late
(C) shortly **(D) often**

문맥에 어울리는 부사 어휘를 고르는 문제로, 빈칸은 동사 visits와 어울리면서 문맥에도 적절해야 한다. 문맥상 '스파에 자주 방문한다'는 내용이 적절하므로 빈도 부사인 (D) often이 정답.

해석 | 주말에, 강 씨는 그녀의 친구들과 오처드 스파를 자주 방문해서 마사지를 받는다.

1. 빈도 부사

빈도 부사는 보통 조동사나 be동사 뒤에, 일반동사 앞에 위치한다. 그러나 always를 제외한 빈도 부사들은 문장 맨 앞이나 맨 뒤에도 올 수 있다.

때때로	자주	대개	항상
sometimes, occasionally	often, frequently	usually, normally	always

Vacancies <u>are</u> **usually** filled by temporary workers. [be동사 뒤]
공석은 대개 비정규직 직원들에 의해 채워진다.

Ms. Allison **always** <u>participates</u> in workshops and training sessions. [일반동사 앞]
앨리슨 씨는 워크숍이나 연수 과정에 항상 참여한다.

Sometimes the instructions given by the supervisor are not clear. [문장 맨 앞]
때때로 그 감독관에게 받은 지시 사항들은 명확하지 않다.

The sales managers meet with their clients **frequently**. [문장 맨 뒤]
영업부장들은 그들의 고객들을 자주 만난다.

There are many souvenir shops located on Jumeirah Street, but they **seldom** open before 10 A.M.

(A) seldom (B) quite
(C) ever (D) very

문맥에 어울리는 부사를 고르는 문제는 의미 파악이 우선되어야 한다. '가게들이 오전 10시 이전에 거의 문을 열지 않는다'는 의미가 가장 적절하므로 '거의 ~않다'라는 의미인 부정 부사 (A) seldom이 정답.

해석 | 주메이라 가에 위치한 기념품 가게가 많은데, 그곳들은 오전 10시 이전에 거의 문을 열지 않는다.

2. 부정 부사

부정 부사는 그 자체에 부정의 의미를 포함하고 있어 not과 같은 다른 부정어와 함께 쓰이지 않는다.

거의 ~않다	절대 ~않다
hardly (ever), rarely, barely, scarcely, seldom	never

The president <u>is</u> **hardly ever** available for interviews. 그 회장은 면접을 할 시간이 거의 없다.
~~hardly never~~

Inworth Bank <u>will</u> **never** contact you via e-mail to request your personal information.
인워스 은행은 귀하의 개인 정보를 요청하기 위해 절대 이메일을 통해 연락하지 않을 것입니다.

주의 barely는 '겨우 ~했다'라는 의미인 barely managed 형태로도 출제된다.

Mr. Kim **barely managed** to get home before the storm started.
김 씨는 폭풍이 시작되기 전에 겨우 집에 올 수 있었다.

접속 부사

접속 부사는 두 문장을 연결하기 때문에 **Part 6**에서 자주 출제되지만 최근 **Part 5**에서도 가끔 출제되고 있다. 두 절의 의미를 연결해 주는 것이므로 두 절의 의미 관계를 파악하는 것이 핵심이다.

The customer wanted to mail a large and heavy item, and **therefore**, the shipper recommended using a crate box.

(A) both **(B) therefore**
(C) neither (D) however

빈칸 앞에 절이 있고 뒤에도 절이 이어지므로 접속사 자리로 오해하기 쉬운 문제이다. 그러나 이미 빈칸 앞에 접속사 and가 있고 문맥상 '그러므로'의 의미가 적절하므로 정답은 접속 부사인 (B) therefore.

해석 | 고객이 크고 무거운 물품을 우편으로 보내기를 원해서, 그 때문에 운송 회사는 대형 나무 상자를 사용하는 것을 추천했다.

1. 접속 부사

접속 부사는 의미적으로 두 절을 연결해 주지만 품사는 부사이므로 혼자서 절과 절을 연결할 수 없으며 전치사처럼 뒤에 바로 명사가 올 수도 없다.

	접속 부사	접속 부사 역할을 하는 구
시간	meanwhile, in the meantime 그 동안 then, afterwards, subsequently 그리고 나서	at the same time 동시에
양보	nevertheless, nonetheless 그럼에도 불구하고	even so 그렇기는 하지만
대조	however 그러나	on the contrary, in contrast 반면에
결과	therefore, hence, thus, consequently 그러므로	as a result 결과적으로
첨가	moreover, additionally, furthermore 게다가	in addition 게다가
기타	otherwise 그렇지 않으면 instead 대신에	in fact 사실 for instance 예를 들면

He applied for a patent last month. **However**, he's still waiting for approval.
그는 지난달에 특허를 신청했다. 그러나 여전히 승인을 기다리는 중이다.

Employees at E&G Inc. should send work reports to their supervisors every Friday unless **otherwise** instructed.

(A) instead **(B) otherwise**
(C) likewise (D) so

문맥상 '달리 지시를 받지 않는다면'이란 내용이 자연스러우므로 '다르게, 달리'라는 의미의 부사 (B) otherwise가 정답. otherwise가 일반 부사로 쓰이는 경우 접속사 unless와 함께 '달리 ~이 없으면'이라는 뜻으로 자주 쓰이니 unless otherwise *p.p.* 형태로 기억해 두자.

해석 | 이앤지 사의 직원들은 달리 지시를 받지 않는다면 매주 금요일에 자신의 상사에게 업무 보고서를 보내야 한다.

2. 주의해야 할 접속 부사

일반 부사나 전치사로 쓰일 때 그 의미가 달라지는 접속 부사 otherwise와 besides의 쓰임을 구별하여 알아두자.

otherwise	접속 부사 (그렇지 않으면)	You must find a good job; **otherwise**, you won't be able to pay rent. 당신은 좋은 직업을 구해야 한다. 그렇지 않으면 집세를 내지 못할 것이다.
	일반 부사 (다르게, 달리)	Unless **otherwise** stated, all items come with complimentary gifts. 달리 언급이 없다면, 모든 품목에 무료 선물이 따라온다.
besides	접속 부사 (게다가)	Tom is not qualified for the job. **Besides**, his application was late. 톰 씨는 그 일을 맡을 자격이 없다. 게다가, 그의 지원도 늦었다.
	전치사 (~ 외에)	Ms. Cho has many skills **besides** editing. 조 씨는 편집 외에 많은 능력을 가지고 있다.

DAY 12

특정 표현과 어울려 쓰이는 부사

특정 표현과 어울리며 문맥에 적절한 부사 어휘를 묻는 문제가 종종 출제된다. 자주 어울리는 표현들을 미리 알아두면 문제를 좀 더 쉽게 풀 수 있으므로 한 단어처럼 암기해 두자.

Fans around the world are **eagerly** awaiting the release of the next movie in the action series.

(A) **eagerly** (B) greatly
(C) strongly (D) temporarily

문맥에 알맞은 부사 어휘를 찾는 문제는 부사가 수식하는 대상을 찾아 의미를 파악해야 한다. 빈칸이 수식하는 동사 await는 부사 eagerly와 자주 어울려 '간절히 기다리다'라는 의미로 사용되므로 정답은 (A).

해석 | 전 세계에 있는 팬들은 그 액션 영화 시리즈의 후속편 개봉을 간절히 기다리고 있다.

1. 특정 동사와 자주 어울려 쓰이는 부사

다음은 토익에 빈출되는 특정 동사와 자주 어울려 쓰이는 부사 표현이다. 부사 어휘를 묻는 문제로 자주 출제되므로 아래 표현들을 평소에 한 단어처럼 외워두자.

answer promptly 즉시 대답하다	adequately reward 적절히 보상하다
check regularly 정기적으로 확인하다	adversely affect 악영향을 주다
close temporarily 일시적으로 문을 닫다	briefly summarize 간단히 정리하다
increase steadily[remarkably] 꾸준히[현저하게] 증가하다	conveniently locate 편리하게 위치시키다
review thoroughly 꼼꼼히 검토하다	eagerly await 간절히 기다리다
speak directly 직접 말하다	generously donate 아낌없이 기부하다
work collaboratively 협력하여 일하다	strongly encourage 적극 권장하다

Ms. Sansa **spoke directly** to the CEO to ask for a promotion.
산사 씨는 승진을 요청하기 위해 대표이사에게 직접 말했다.

A bicycle rental store **is conveniently located** next to the beach.
자전거 대여소는 해변 옆에 편리하게 위치해 있다.

Finnegan Bedding's sales have been decreasing at a rate of **nearly** 5 percent each month.

(A) **nearly** (B) mostly
(C) slowly (D) largely

선택지를 보니 문맥상 알맞은 부사를 고르는 문제이다. 빈칸 뒤의 숫자 표현과 어울리며 문맥상 '거의 5퍼센트씩 줄고 있다'란 의미로 자연스러운 것은 '거의, 약'이란 의미인 nearly. 따라서 정답은 (A).

해석 | 피네건 침구 사의 매출이 매달 거의 5퍼센트씩 줄고 있다.

2. 숫자나 양을 수식하는 부사

숫자나 양을 수식하는 부사는 숫자나 양 앞에 위치하여 그 의미를 더해준다. 토익에 빈출되는 숫자나 양을 수식하는 부사를 기억해 두자.

almost, nearly 거의, 대부분	approximately, roughly 약	around, about 대략

There are **nearly** one million people living in the state of Montana.
~~mostly~~ 몬타나 주에 살고 있는 사람들이 거의 백만명이다.

The train takes **approximately** two hours to reach Naples.
~~approximate~~ 그 기차는 약 두 시간 후에 나폴리에 도착한다.

주의 nearly는 수치나 근접의 정도를 나타낼 때 '거의'란 의미로 쓰이고, mostly는 일반적으로 사실인 경우 '주로, 대부분'이라는 뜻으로 쓰인다.

The center is **mostly** used by retired people. 그 센터는 은퇴한 사람들이 주로 이용한다.
~~nearly~~

FINAL TEST

1. Ms. Mendez was given the Customer Representative of the Year Award for ------- ignoring the needs of her clients.

 (A) sometimes (B) never
 (C) fast (D) well

2. Mapcat Corp. employees are getting used to the new data entry system, and errors are appearing less ------- than before.

 (A) frequently (B) frequency
 (C) frequents (D) frequented

3. It is ------- profitable for travel companies to offer special promotions during the holidays.

 (A) every (B) other
 (C) often (D) either

4. The table's order was taking a long time to prepare, so the waiter offered a ------- side dish to apologize for the wait.

 (A) complimentary (B) punctual
 (C) fulfilled (D) temporary

5. The office cafeteria was so full this afternoon that there was ------- any place to sit.

 (A) usually (B) hardly
 (C) normally (D) occasionally

6. A loan approval process ------- requires a thorough investigation into the credit record of a client.

 (A) typically (B) familiarly
 (C) prominently (D) cautiously

7. This month, Beauty Box Jewelry had a sudden increase in sales, which is ------- due to the holiday season approaching.

 (A) nearly (B) mostly
 (C) quickly (D) slightly

8. The antique clock is broken, but the customer is ------- interested in buying the item.

 (A) thus (B) nevertheless
 (C) then (D) furthermore

9. Now that e-mail and other convenient communication means are available, people ------- send handwritten letters anymore.

 (A) seldom (B) still
 (C) ever (D) not

10. Our plumbers will be at your place ------- 20 minutes after we send you a text notification.

 (A) approximate (B) approximately
 (C) approximation (D) approximates

11. In November, the Tempus Museum will be ------- closed while its main exhibition hall undergoes renovations.

 (A) intensely (B) previously
 (C) instantly (D) temporarily

12. Dr. Steve Emerson has ------- completed his research study on the latest technology used in eye surgeries for old patients.

 (A) likewise (B) consequently
 (C) near (D) almost

13. The chef thought that the seafood pasta was the most liked dish on the menu, but restaurant reviews suggest -------.

 (A) otherwise (B) accordingly
 (C) in contrast (D) therefore

14. Harrisco's sales are higher this month compared to last month; -------, they are still nowhere near the original target.

 (A) namely (B) specifically
 (C) similarly (D) however

DAY 12

Questions 15-18 refer to the following article.

Thai Metal Artist Amazes Netherlands

AMSTERDAM, February 2—Many art enthusiasts gathered at the National Museum last night for the opening of Richard Phraya's Silver Linings metal art exhibit. The twenty-five-year-old Thai artist has impressed the world by turning metal scraps into breathtaking art. ------. In September, **15.** his friends posted a picture of *Sita*, a life-size figure of a Hindu epic character made from soft-drink cans, on a photo-sharing Web site. The ------ quickly spread throughout social media. **16.** Since then, Phraya has gained more followers than any contemporary artist has ever had.

This is Phraya's first exhibit in Amsterdam. However, he ------ displays his work at events in **17.** Southeast Asia. "Richard is a brilliant artist, and we want many people in Europe to see his extraordinary talent. ------, we are extending his exhibit to April 30," National Museum director **18.** James Noir said.

15. (A) He is expected to arrive for the exhibit tomorrow.
 (B) He will attend an art school in Amsterdam.
 (C) His unique works first became popular online.
 (D) His sculptures will be shipped to the Netherlands.

16. (A) exhibit
 (B) description
 (C) image
 (D) brochure

17. (A) occasioned
 (B) occasions
 (C) occasional
 (D) occasionally

18. (A) For example
 (B) Meanwhile
 (C) Therefore
 (D) Moreover

Questions 19-22 refer to the following advertisement.

Enjoy greater rewards by getting a Prime Card now!

Get more out of your shopping experience with Prime Center account. On top of earning points, you will receive exclusive invitations to fun activities every month. ------, we will give you
19.
coupons that entitle you to a 10 percent discount on products at our partner stores.

Clients with expired accounts are also eligible for this offer. ------. Simply present it at our
20.
customer service desk for instant renewal. We guarantee that your visits to Prime Center ------
21.
considerably more exciting than before.

For information on how to create an account, please call 555-0909 to speak ------ to our
22.
customer service representatives.

DAY 12

19. (A) By contrast
 (B) Otherwise
 (C) In addition
 (D) Consequently

21. (A) being
 (B) will be
 (C) have been
 (D) could have been

20. (A) To take advantage of it, bring your old
 card to one of our stores.
 (B) For a limited time only, all renewals are
 30 percent off.
 (C) Get your first Prime Card by completing
 a form on our Web site.
 (D) Please return any lost cards to Prime
 Center's administrative office.

22. (A) directly
 (B) basically
 (C) thoroughly
 (D) formerly

CHAPTER
5

-

수식어편

DAY 13
전치사 ①

—

기본 개념 노트

본 학습에 들어가기 전에 기본 문법 개념의 틀을 잡아보자.

❶ 개념 및 역할

전치사는 (대)명사와 함께 구를 이루어 문장에서 형용사나 부사 역할을 한다.

형용사 역할	① Tourists are able to visit a <u>lighthouse</u> **near the inn**. [명사 수식]
부사 역할	② Please <u>hand in</u> the expense reports **by five**. [동사 수식]

❷ 종류 및 의미

한 전치사가 여러 가지 의미로 쓰이기도 하고 다른 전치사라도 의미가 비슷한 경우도 있다. 다음은 의미별로 정리한 주요 전치사이다.

시점	in (달, 연도, 계절) ~에	at (시점) ~에	on (요일, 특정 날짜) ~에	by (동작의 완료) ~까지
기간	for ~ 동안	during ~ 동안	over ~에 걸쳐	within ~ 이내에
장소	in (장소, 영역) ~에서	at (특정 지점) ~에서	on (접촉) ~ 위에, ~에서	above ~ 위에
방향	toward(s) ~쪽으로	from ~에서	to ~으로 into ~ 안으로 ↔ out of ~ 밖으로	
이유	for (이유, 원인) ~으로	because of ~ 때문에	owing to ~ 때문에	
양보	despite ~에도 불구하고	in spite of ~에도 불구하고		
제외	except (for) ~을 제외하고는	without ~ 없이	aside from ~ 외에는	
추가	in addition to ~에 더하여	plus ~뿐만 아니라		

❸ 특징

전치사는 명사 이외에도 대명사, 동명사, 명사절을 목적어로 취할 수 있다.

전치사 + 명사(구)	③ There was a delay **of** <u>one week</u> in answering his request.
전치사 + 동명사(구)	④ Please complete the customs form **upon** <u>arriving</u> at the airport.
전치사 + 명사절	⑤ Ms. Anderson is interested **in** <u>what the company offered to her</u>.

① 관광객들은 여인숙 근처의 등대에 방문할 수 있다. ② 5시까지 비용 보고서를 제출하십시오. ③ 그의 요청에 응하는 데 일주일의 지연이 있었다. ④ 공항에 도착하자마자 세관 심사 서류를 작성하십시오. ⑤ 앤더슨 씨는 그 회사가 그녀에게 제안한 것에 관심이 있다.

SELF-TEST

기본 개념이 토익에는 어떻게 출제되는지 알아보자. ⏱ 제한시간 03:00

다음 핵심 포인트를 참고하여
정답이 되는 이유를 적어보자. **NOTE**

1. All reimbursement requests for last month's travel
 expenses must be given to Mr. Jones ------- Monday.

 (A) until (B) by
 (C) in (D) for

2. The second branch of the appliance center will open next
 to the town square ------- a week.

 (A) before (B) regarding
 (C) within (D) without

3. A dinner will be held ------- Wingso Chinese Restaurant
 tonight to celebrate the team's success.

 (A) after (B) at
 (C) to (D) on

4. Brutu's CEO wanted to be at the airport to greet the client
 in person when he arrived ------- Berlin.

 (A) with (B) along
 (C) for (D) from

5. Professor Kim is available ------- the magazine interview
 this Tuesday at 3 P.M.

 (A) for (B) as
 (C) of (D) up

6. No one ------- participants wearing their name tags is
 allowed to enter the conference hall.

 (A) out of (B) except for
 (C) outside (D) in addition to

NOTE

1. 시점 전치사

2. 기간 전치사

3. 장소 전치사

DAY 13

4. 방향 전치사

5. 목적 전치사

6. 제외 전치사

문제별 출제 **POINT** ▶ 다음 페이지에서 확인하기

시점, 기간 전치사

전치사 문제는 문법 문제 중에서도 가장 높은 비율로 출제되는데, 그중에서도 시간 전치사 문제가 가장 많이 출제된다. 특정 시점이나 기간과 함께 쓰이는 전치사의 종류와 그 의미에 대해 알아두자.

SELF-TEST 1

All reimbursement requests for last month's travel expenses must be given to Mr. Jones **by** Monday.

(A) until **(B) by**
(C) in (D) for

빈칸 뒤에 특정 요일이 나왔고 문맥상 '월요일까지 제출되어야 한다'란 의미가 자연스러우므로 완료를 의미하는 시점 전치사 (B) by가 정답. (A) until은 특정 시점까지 계속되는 것을 뜻하고, (C) in은 계절이나 연도와 쓰이고 (D) for는 기간 전치사이므로 모두 오답이다.

해석 | 지난달 출장비에 대한 모든 환급 요청은 존스 씨에게 월요일까지 제출되어야 한다.

출제원리

1. 시점 전치사

시간을 나타내는 전치사는 전치사 뒤의 명사가 시점을 나타내는지 기간을 나타내는지에 따라 구분된다. 같은 시점 전치사라도 함께 어울리는 특정 요소가 다르므로 그 차이점을 구별하여 알아두자.

in (계절, 연도, 월, 아침) ~에 at (시각, 시점) ~에 on (날짜, 요일) ~에	**in** summer 여름에 **in** 2009 2009년도에 **in** May 5월에 **at** 2 o'clock 2시에 **at** noon 정오에 **on** May 15 5월 15일에 **on** Saturday 토요일에
by (finish, complete 등 동작의 완료) ~까지 until, till (wait, remain 등 상황의 계속) ~까지	finish the report **by** 3 P.M. 오후 3시까지 보고서를 끝내다 last **until** 3 P.M. 오후 3시까지 계속되다
since ~ 이래로(현재완료 시제와 쓰임) from ~로부터 before, prior to ~ 전에 after, following ~ 후에 as of ~때부터	**since** last week 지난주 이래로 two weeks **from** today 오늘로부터 2주 **before[prior to]** the negotiation 협상 전에 **after[following]** the negotiation 협상 후에 **as of** August 1 8월 1일자로

The recipient of this award will be announced **on** Friday. 이 상의 수상자는 금요일에 발표될 것이다.
The order must arrive **by** the specified date. 그 주문품은 지정된 날짜까지 도착해야만 한다.

SELF-TEST 2

The second branch of the appliance center will open next to the town square **within** a week.

(A) before (B) regarding
(C) within (D) without

빈칸 뒤 a week는 개점에 소요되는 기간을 뜻하므로 '~ 이내에'라는 뜻의 기간 전치사 (C) within이 정답이다. (A) before는 '~ 전에'라는 의미로 뒤에는 특정 시점을 나타내는 명사구가 와야 하며 (B) regarding은 주제 전치사, (D) without은 제외 전치사로 모두 오답.

해석 | 그 가전제품 센터의 두 번째 지점이 일주일 이내에 마을 광장 옆에 개점할 것이다.

출제원리

2. 기간 전치사

기간을 나타내는 명사(구)와 함께 쓰이는 기간 전치사 역시 의미는 비슷하지만 함께 어울리는 요소가 다르다. 숫자 표현의 기간이 나오는지, 기간 명사(구)가 나오는지에 따라 어울려 쓰이는 전치사를 알아보자.

for (숫자) ~ 동안 during (기간 명사) ~ 동안	**for** three hours 3시간 동안 **during** the conference 회의 동안
through, throughout ~ 내내 over ~ 동안 within ~ 이내에	**through[throughout]** the year 1년 내내 **over** five years 5년 동안 **within** ten days of purchase 구입일로부터 10일 이내에

This promotional price will be available **for** two weeks. 이 할인 가격은 2주 동안 가능합니다.

장소, 방향 전치사

꾸준히 출제되는 장소 전치사는 그 쓰임과 의미를 명확히 구별하여 알아둬야 한다. 그중에서도 대표적인 장소 전치사 in, at, on의 다양한 쓰임의 차이를 알아두고 다양한 방향 전치사들을 정리해 두자.

A dinner will be held **at** Wingso Chinese Restaurant tonight to celebrate the team's success.

(A) after **(B) at**
(C) to (D) on

빈칸 뒤에 장소 명사 Wingso Chinese Restaurant이 있고 문맥상 '식당에서'라는 의미가 자연스러우므로 장소 전치사 (B) at이 정답. (A) after는 시점 전치사, (C) to는 방향 전치사이며, (D) on은 표면에 접하고 있는 상태를 나타내는 장소 전치사이므로 모두 오답이다.

해석 | 팀의 성공을 축하하기 위한 저녁 만찬이 윙소 중국 식당에서 열릴 것이다.

1. 장소 전치사

장소와 접해있는 상태에 따라 각기 다른 장소 전치사를 사용해야 한다. 다음은 토익 대표 장소 전치사이다.

in (장소, 영역) ~에서 **at** (특정 지점) ~에서 **on** (접촉) ~ 위에, ~에서	the largest hotel **in** Beijing 베이징에서 가장 큰 호텔 **at** the corner of the building 그 건물 모퉁이에서 **on** the third floor of the building 그 건물의 3층에서
above ~ 위에 ↔ **below** ~ 아래에 **over** ~ 위에 ↔ **under** ~ 아래에	**above[below]** the desk 책상 위에[아래에] pass **over[under]** the bridge 다리 위로[아래로] 지나가다
between (둘) 사이에 **among** (불특정 다수) 사이에, 가운데	sit **between** Tom and Kate 톰과 케이트 사이에 앉다 sit **among** the audience members 관객들 사이에 앉다
next to, beside, by ~ 옆에 **near** ~ 근처에	**next to[beside, by]** the bus station 버스 정류장 옆에 **near** the amusement park 놀이공원 근처에
throughout, across 전역에, 도처에	**throughout[across]** the country 전국 도처에

Mr. Stan is staying at a hotel **near** the airport. 스탠 씨는 공항 근처 호텔에 머물고 있다.

Brutu's CEO wanted to be at the airport to greet the client in person when he arrived **from** Berlin.

(A) with (B) along
(C) for **(D) from**

빈칸 뒤에 나오는 Berlin에서 오는 고객을 맞이하는 것이므로 문맥상 '~에서'라는 의미의 방향 전치사인 (D) from이 정답. (B) along은 '~을 따라'라는 뜻이므로 문맥상 어울리지 않아 오답.

해석 | 브루투 사의 대표이사는 고객이 베를린에서 도착했을 때 그를 직접 환영하기 위해 공항에 있길 원했다.

2. 방향 전치사

장소를 기준으로 주어가 행동하는 방향에 따라 그 의미에 맞는 방향 전치사를 사용해야 한다.

toward(s) ~ 쪽으로 **from** ~에서	head **toward(s)** the river 강 쪽으로 가다 depart **from** Pittsburgh 피츠버그에서 출발하다
to ~으로 **for** ~을 향해	walk **to** the closest bank 가장 가까운 은행으로 걸어가다 the train **for** Boston 보스턴행 열차
into ~ 안으로 ↔ **out of** ~ 밖으로	walk **into[out of]** the room 방 안으로 들어가다[밖으로 나가다]
across ~을 건너, ~을 가로질러 **through** ~을 지나, 통과해 **along** ~을 따라	**across** the street 길을 건너 **through** Washington 워싱턴을 지나 walk **along** the road 도로를 따라 걷다

After getting off the bus, the traveler walked **toward** the museum.
버스에서 내린 후에 그 여행자는 미술관 쪽으로 걸어갔다.

주요 전치사

빈출되는 전치사 문제는 빈칸 뒤에 오는 명사(구)에 따라 이유, 목적, 양보, 제외, 추가, 대체 전치사를 고르는 문제이다. 선택지에 전치사가 있다면 문장을 해석하여 문맥에 알맞은 전치사를 고르자.

Professor Kim is available **for** the magazine interview this Tuesday at 3 P.M.

(A) for | (B) as
(C) of | (D) up

문맥에 알맞은 전치사를 고르는 문제로 '김 교수가 잡지 인터뷰를 할 시간이 있다'는 의미가 되어야 한다. 잡지 인터뷰를 위한 목적을 나타내므로, 정답은 목적을 나타내는 전치사 (A) for.

해석 | 김 교수는 이번 주 화요일 오후 3시에 잡지 인터뷰를 할 시간이 있다.

1. 이유, 목적, 양보의 전치사

다음은 토익에 빈출되는 이유, 목적, 양보를 나타내는 대표 전치사이다. 그 의미와 쓰임을 정확히 알아두자.

이유	for, due to, owing to, thanks to on account of, because of ~ 때문에	thank you **for** your help 도움에 감사하다 **due to** the extra inconvenience 부가적인 불편 때문에 **because of** a heavy snowfall 폭설 때문에
목적	for ~을 위해	gather **for** the meeting 회의를 위해 모이다
양보	despite in spite of notwithstanding ~에도 불구하고	**despite** the fact 그 사실에도 불구하고 **in spite of** the poor credit history 좋지 못한 신용 기록에도 불구하고

Due to the interior renovation, the restaurant has been closed for two weeks.
내부 개조 공사 때문에 그 식당은 2주 동안 문을 닫았다.

Despite the inconvenient location, Vegar Restaurant was full of people.
장소가 좋지 않음에도 불구하고, 베가 식당은 사람들로 가득 차 있었다.

No one **except for** participants wearing their name tags is allowed to enter the conference hall.

(A) out of | (B) except for
(C) outside | (D) in addition to

문맥상 '이름표를 착용한 참가자들을 제외하고 누구도 회의장에 들어가는 것이 허용되지 않는다'는 의미가 적절하므로 빈칸은 제외를 나타내는 전치사가 와야 한다. 따라서 정답은 (B) except for. (A) out of가 부분을 나타낼 때에는 뒤에 숫자 표현이 나와야 하므로 오답이다.

해석 | 자신의 이름표를 착용한 참가자들을 제외하고 누구도 회의장에 들어가는 것이 허용되지 않는다.

2. 제외, 추가, 대체의 전치사

제외와 추가, 그리고 대체의 의미를 지닌 전치사도 있다. 토익에 자주 등장하는 다음 전치사를 알아보자.

제외	except (for) ~을 제외하고 without, barring, but for ~ 없이 apart from, aside from ~ 외에는	**except (for)** Mr. Banner 배너 씨를 제외하고 **without** your help 당신의 도움 없이 **apart from** some problems 몇 가지 문제들 외에는
추가	in addition to, plus ~에 더하여	**in addition to** conducting group discussions 그룹별 토론에 더하여
대체	instead of, on behalf of ~ 대신에	**instead of** this option 이 옵션 대신

You can make a reservation any day **except (for)** Saturday.
토요일을 제외하고 언제라도 예약이 가능하다.

In addition to a set fee, we charge $10 per kilogram.
저희는 정가에 더하여 킬로그램당 10달러를 부과합니다.

FINAL TEST

1. Customers must hand in their receipts at the client service desk ------- the due date for their refunds.
 (A) at
 (B) since
 (C) before
 (D) between

2. A large year-end bonus was distributed ------- staff members after the company exceeded its targets in the fourth quarter.
 (A) unlike
 (B) among
 (C) besides
 (D) above

3. ------- the stormy weather, Old Santorini Port has cancelled all trips that were scheduled to leave today.
 (A) In favor of
 (B) Notwithstanding
 (C) Due to
 (D) Barring

4. The streets throughout the business district are always filled with people ------- rush hour.
 (A) during
 (B) along
 (C) down
 (D) as of

5. Information counters are located ------- the zoo to assist guests with their needs while they are visiting.
 (A) in
 (B) from
 (C) off
 (D) on

6. Please refer to the city map for directions to various attractions ------- to your hotel.
 (A) attentive
 (B) short
 (C) close
 (D) familiar

7. Athlete's Gear will be gradually relocating its largest factory to China ------- the next decade.
 (A) below
 (B) at
 (C) along
 (D) over

8. If you shop at Home Haven this Sunday, you will receive large discounts ------- free delivery service.
 (A) thanks to
 (B) throughout
 (C) in addition
 (D) plus

9. Mr. Ray decided to open his new restaurant ------- walking distance of the stadium to attract customers from the sporting events.
 (A) for
 (B) aside from
 (C) within
 (D) through

10. The training will be delayed ------- next month since there is a conflict in the managers' schedules.
 (A) by
 (B) until
 (C) despite
 (D) about

11. Tech Computers has established over twenty repair centers ------- the country to provide customer support for its growing client base.
 (A) except
 (B) across
 (C) into
 (D) ahead

12. To hire the experts, the company will use several methods ------- proficiency exams to test each job applicant's abilities.
 (A) apart from
 (B) in spite of
 (C) next to
 (D) owing to

13. ------- the ceramic museum's remote location, it is still being visited by many tourists for its rare pottery collections.
 (A) Despite
 (B) Far from
 (C) Even though
 (D) Before

14. Ms. Mansfield would like to reserve a seat that is ------- the stage so she can be in front of the seminar speakers.
 (A) under
 (B) instead of
 (C) outside
 (D) near

정답 및 해설 50쪽

DAY 13

CHAPTER
5

-

수식어편

DAY 14
전치사 ②

—

기본 개념 노트

본 학습에 들어가기 전에 기본 문법 개념의 틀을 잡아보자.

❶ 주의해야 할 전치사 형태

한 단어로 된 전치사 외에 현재분사나 과거분사 형태의 전치사나, 다른 단어와 결합한 구전치사의 형태도 있으므로 주의해야 한다.

분사형 전치사	barring ~이 없다면 concerning ~에 관하여 considering ~을 고려하여	excluding ~을 제외하여 following ~ 후에 given ~을 고려하여	including ~을 포함하여 regarding ~에 관하여 respecting ~에 관하여
구전치사	according to ~에 따르면 contrary to ~와 반대로 depending on ~에 따라	in advance of ~보다 앞에 instead of ~ 대신에 regardless of ~에 상관없이	related to ~와 관련하여 thanks to ~ 덕분에 up to ~까지

❷ 전치사 관용표현

특정 동사 또는 명사와 어울려 쓰이는 전치사 관용표현이 있다.

〈동사＋전치사〉	① Charity organizers **worry about** whether they will get enough funds.
〈명사＋전치사〉	② **Advances in** modern medicine have saved millions of lives.

① 자선 행사 준비위원들은 그들이 충분한 기금을 받을 수 있을지에 대해 걱정한다. ② 현대 의학의 진보는 수백만의 생명을 구해왔다.

SELF-TEST

기본 개념이 토익에는 어떻게 출제되는지 알아보자. ⏱ 제한시간 03:00

1. Issues ------- production delays will be discussed at this week's meeting with the project manager.

 (A) behind (B) concerning
 (C) ahead of (D) under

 1. 주제 전치사

2. Florida Commercial Credit informs its customers of new products ------- sending e-mails and text messages.

 (A) up (B) from
 (C) as (D) by

 2. 수단 전치사

3. ------- his excellent Spanish skills, Mr. Heath should be able to easily find a job in South America.

 (A) Giving (B) Given
 (C) Give (D) To give

 3. 분사형 전치사

 DAY 14

4. ------- the law, all buildings in Trenton must undergo fire inspection annually.

 (A) Such as (B) In accordance with
 (C) In terms of (D) On behalf of

 4. 출처 전치사

5. Dowen Plumbers provides clients ------- fast and efficient services at reasonable rates.

 (A) with (B) over
 (C) for (D) in

 5. <동사 + A + 전치사 + B> 관용표현

6. During the workshop, parenting expert Jenny Miller gave practical answers ------- questions about child discipline.

 (A) with (B) by
 (C) to (D) for

 6. <명사 + 전치사> 관용표현

문제별 출제 POINT ▶ 다음 페이지에서 확인하기

기타 빈출 전치사

최근 출제 경향을 보면 시간, 장소 전치사 이외의 전치사들의 출제 빈도도 높아지고 있다. 따라서 같은 형태의 전치사라도 문맥에 따라 내포하는 의미가 다르므로 문맥을 먼저 파악해야 한다.

Issues **concerning** production delays will be discussed at this week's meeting with the project manager.

(A) behind
(B) concerning
(C) ahead of
(D) under

빈칸부터 delays까지는 주어 Issues를 수식하는 수식어구로, 문맥상 '생산 지연에 관한 문제들은'이란 뜻이 되어야 알맞다. 따라서 '~에 관하여'라는 뜻의 주제를 나타내는 전치사 (B) concerning이 정답.

해석 | 생산 지연에 관한 문제들은 이번 주 회의에서 프로젝트 관리자와 함께 논의할 것이다.

1. 주제 전치사

다음은 토익에서 빈출되는 대표 주제 전치사이다. 그 쓰임을 정확히 알아두자.

about, on, over, as to, as for ~에 관하여 regarding, concerning ~에 관하여 in[with] regard to, with respect to ~에 관하여 pertaining to ~에 관해서	a seminar **on** finance 재무에 관한 세미나 **regarding** the new contract 신규 계약에 관하여 **in regard to** the project 프로젝트에 관하여 **pertaining to** local news 지역 소식에 관해서

The long dispute **over** the high entrance fee to the amusement park has been settled.
놀이공원의 비싼 입장료에 관한 오랜 논란이 해결되었다.

Florida Commercial Credit informs its customers of new products **by** sending e-mails and text messages.

(A) up
(B) from
(C) as
(D) by

빈칸에 적절한 전치사를 찾는 문제로 문맥을 우선 파악해야 한다. 이메일과 문자 메시지를 보내는 것은 신제품을 알리는 수단이다. 따라서 정답은 수단을 나타내는 전치사 (D) by.

해석 | 플로리다 상업 신용은 고객들에게 이메일과 문자 메시지를 보냄으로써 신제품을 알린다.

2. 기타 전치사

출처나 수단, 소유, 동격 등 다양한 의미의 다음 기타 전치사들도 자주 출제되므로 기억해 두자.

출처	from ~에서, 부터 according to ~에 의하면, 따르면 in accordance with ~에 따라	**from** Ms. Jennings 제닝스 씨로부터 **according to** the rules 규칙에 따르면 **in accordance with** the policy 정책에 따라
수단	with ~을 가지고 by ~로, ~함으로써 through ~을 통해	**with** a toolbox 공구상자를 가지고 **by** expanding the facility 시설을 확장함으로써 **through** e-mail 이메일을 통해
소유/동격	of ~의, ~라는	the cause **of** the malfunction 고장의 원인 the idea **of** moving abroad 해외로 이동하자는 생각
가격/속도/비율	at ~로	**at** no cost 무료로
비유	like ~와 같이 unlike ~와 달리	It can be used just **like** a credit card. 그것은 신용카드처럼 사용할 수 있다.
자격	as ~로서	**as** a member of the design team 디자인팀의 팀원으로서

According to the article, BH Motors will merge with Trail Motors soon.
그 기사에 따르면, 비에이치 모터스 사가 트레일 모터스 사와 곧 합병할 것이다.

He took many pictures of his family **with** his new camera. 그는 자신의 새 카메라로 가족 사진을 많이 찍었다.

분사형 전치사 & 구전치사

분사형 전치사 문제들은 일반적인 전치사의 형태가 아니기 때문에 착각하여 오답을 고르기 쉬우므로 주의 해야 한다. 또한 구전치사 문제도 출제되고 있으므로 주요 구전치사는 반드시 외워두자.

SELF-TEST 3

Given his excellent Spanish skills, Mr. Heath should be able to easily find a job in South America.

(A) Giving (B) **Given**
(C) Give (D) To give

빈칸에 알맞은 품사를 고르는 문제. 콤마 뒤에 주어와 동사가 모두 갖추 어져 있으므로 콤마 앞의 수식어구이다. 문맥상 '스페인어 실력을 고려 해볼 때, 남미에서 쉽게 일을 찾을 수 있을 것'이라는 의미가 자연스러우 므로 '~을 고려하여'의 의미를 가진 분사형 전치사 (B) Given이 정답.

해석 | 그의 뛰어난 스페인어 실력을 고려하면, 히스 씨는 남미에서 쉽게 일을 찾 을 수 있을 것이다.

1. 분사형 전치사

-ing나 *p.p.* 형태의 분사형 전치사들은 -ing 형태의 동명사(구)와 함께 쓸 수 없다. 다음은 대표적인 토익 빈출 분사 형 전치사이다.

barring ~이 없다면	excluding ~을 제외하여	including ~을 포함하여
concerning ~에 관하여	following ~ 후에	regarding ~에 관하여
considering ~을 고려하여	given ~을 고려하여	respecting ~에 관하여

Given his lengthy experience, Mr. Stevens is qualified to do this project.
　　　명사구　　　　　　　　그의 오랜 경력을 고려해 볼 때, 스티븐스 씨가 이 프로젝트를 수행할 자격이 됩니다.

We provide a variety of seafood **including** lobster.
저희는 바닷가재를 포함한 다양한 해산물 요리를 제공합니다.

주의 considering (that), given (that)은 접속사로도 사용 가능하다.

Given that the economy is in recession, the company is performing well.
　　　　　주어　　　동사　　　　　　경제가 침체된 것을 고려하면, 그 회사는 잘 운영되고 있다.

SELF-TEST 4

In accordance with the law, all buildings in Trenton must undergo fire inspection annually.

(A) Such as (B) **In accordance with**
(C) In terms of (D) On behalf of

선택지를 보니 문맥에 알맞은 구전치사를 고르는 문제. 문맥상 '법에 따 라서 매년 점검해야 한다'는 의미가 적절하므로 '~에 따라서'라는 의미 의 구전치사 (B) In accordance with가 정답. 토익에 자주 나오는 구전치사는 반드시 알아두자.

해석 | 법에 따라서, 트렌턴 사의 모든 건물들은 반드시 매년 소화시설 점검을 받 아야 한다.

2. 구전치사

두 단어 이상이 모여 전치사를 이루는 형태로 일반 전치사와 동일하게 명사(구) 또는 동명사(구)를 목적어로 취한다.

across from ~의 바로 맞은편에	in addition to ~에 더하여	in response to ~에 응하여
ahead of ~ 앞에	in advance of ~보다 앞에	in terms of ~라는 점에서
along with ~와 마찬가지로	in case of ~의 경우	in the event of ~의 경우에
as a result of ~의 결과로	in charge of ~을 책임지는	regardless of ~에 상관없이
depending on ~에 따라	in compliance with ~을 준수하여	such as 예를 들어
in accordance with ~에 따라서	in favor of ~에 찬성하여	up to (숫자) ~까지

Mr. Warren has been **in charge of** running all of the projects recently.
워런 씨가 최근 모든 프로젝트의 운영을 책임지고 있다.

The hotel has many amenities, **such as** a fitness center.
그 호텔은 헬스 클럽과 같은 편의 시설을 많이 갖췄다.

전치사 관용표현

전치사가 포함된 관용표현은 어휘 문제 또는 전치사 문제로 출제된다. 표현을 미리 외워두지 않으면 정답을 찾기 어려우므로 동사 또는 명사와 어울려 자주 쓰이는 특정 전치사 관용표현을 반드시 숙지해 두자.

Dowen Plumbers provides clients **with** fast and efficient services at reasonable rates.

(A) with (B) over
(C) for (D) in

빈칸 앞의 동사 provides를 발견했다면 이와 함께 쓰이는 전치사 to, for, with를 바로 떠올릴 수 있어야 한다. 문맥상 '고객에게 서비스를 제공한다'는 의미가 되어야 하므로 provide A with B가 쓰였음을 알 수 있다. 따라서 정답은 (A).

해석 | 도웬 배관공업사는 고객들에게 빠르고 효율적인 서비스를 합리적인 가격으로 제공한다.

1. 〈동사+전치사〉 관용표현

특정 전치사와 어울리는 〈동사+전치사〉 관용표현을 알아보자.

to	in	for/from/with
apply to ~에 적용하다 contribute to ~에 공헌하다 reply[respond] to ~에 답하다	enroll in ~에 등록하다 participate in ~에 참석하다 specialize in ~을 전문으로 하다	apply[sign up] for ~에 지원[신청]하다 refrain from ~을 삼가다 work with ~와 함께 일하다

Please **refrain from** using a cell phone during the performance. 공연 중에는 휴대폰 사용을 삼가주십시오.

2. 〈동사+A+전치사+B〉 관용표현

목적어 뒤에 특정 전치사를 취하는 동사들을 정리해 보자.

of/for	from/with
advise[inform, notify] A of B A에게 B에 대해 알리다 blame A for B A를 B에 대해 비난하다 charge A for B A를 B에 대해 청구하다 exchange A for B A와 B를 교환하다	prohibit A from B A를 B로부터 금지하다 remove A from B A를 B에서 제거하다 equip A with B A에게 B를 갖추게 하다 provide A with B A에게 B를 제공하다

This notice **informs** you **of** changes to the office hours. 이 공지는 당신에게 근무시간 변경에 대해 알려준다.

During the workshop, parenting expert Jenny Miller gave practical answers **to** questions about child discipline.

(A) with (B) by
(C) to (D) for

빈칸에 적절한 전치사를 고르는 문제로, 빈칸 앞 명사 answer에 주목한다. 명사 answer는 전치사 to와 함께 answer to의 형태로 '~에 대한 답변'이라는 뜻으로 쓰인다. 따라서 정답은 (C).

해석 | 워크숍 동안에 육아 전문가인 제니 밀러 씨가 자녀 훈육과 관련한 질문에 실질적인 대답을 해 주었다.

3. 〈명사+전치사〉 관용표현

토익에 빈출되는 대표 〈명사+전치사〉 관용표현을 살펴보자.

to	in	for/on
access to ~로의 접근 answer to ~에 대한 답변 attention to ~에 대한 관심 reaction to ~에 대한 반응	advance in ~의 진보 decrease[decline] in ~의 감소 increase[rise] in ~의 증가 interest in ~에 대한 관심	demand for ~에 대한 요구[수요] reason for ~에 대한 이유 influence on ~에 대한 영향 emphasis on ~에 대한 강조

Mr. Jones expressed his **interest in** the new project. 존스 씨는 새로운 프로젝트에 대한 관심을 표현했다.

FINAL TEST

1. ------- the company president, Aspen Forwarders made record-breaking achievements in the third quarter.

(A) According to
(B) In view of
(C) In addition to
(D) On behalf of

2. Mr. Kingston's lecture ------- Western Graphics' company culture was helpful for all the new hires.

(A) at
(B) upon
(C) by
(D) on

3. The manager left her phone number so that the employees could reach her ------- an emergency.

(A) in front of
(B) in spite of
(C) on top of
(D) in case of

4. Students who ------- in scuba diving classes are requested to submit medical clearance from their physicians.

(A) attend
(B) support
(C) enroll
(D) hand

5. Ms. Fenster worked ------- an environmental expert in order to write the grant proposal for the research study.

(A) toward
(B) to
(C) with
(D) from

6. Stallion Mining has issued a press release ------- response to complaints about its latest excavation projects.

(A) within
(B) in
(C) for
(D) of

7. Please contact our manager, Ms. Catherine Tan, for any inquiries ------- the function room reservation for your company banquet.

(A) regard
(B) regarded
(C) regarding
(D) to regard

8. Our car service drivers will take customers to any destination within the city ------- the traffic situation.

(A) regardless of
(B) along with
(C) because of
(D) aside from

9. Chesler Records released additional copies of Amanda Tate's bestselling album, *Freedom*, due to the strong ------- for her compositions.

(A) reaction
(B) demand
(C) struggle
(D) efficiency

10. Some travel company representatives will be invited to a tour ------- the hotel resort's renovated facilities next week.

(A) as
(B) onto
(C) of
(D) to

11. Within the United States, Flawless Cosmetics charges a standard shipping fee of $8 ------- product purchases below $40.

(A) for
(B) to
(C) off
(D) like

12. Successful applicants for senior positions will receive attractive salary and compensation packages, ------- thirty paid vacation days.

(A) concerning
(B) under
(C) including
(D) among

13. Many interior designers expressed ------- in several furniture pieces displayed at this year's Home and Garden Fair.

(A) concept
(B) inspiration
(C) interest
(D) attention

14. ------- his extensive experience in aircraft engineering, Dr. Fritz will most likely be hired by the Aeronautics Institute.

(A) Since
(B) About
(C) For
(D) Given

DAY 14

Questions 15-18 refer to the following advertisement.

Get the most out of life at Breeze Tower!

Almira Corporation, which provides property development services ------ the Middle East, has
 15.
built its signature residential towers in Dubai.

Situated near Marina Plaza, Breeze Tower gives you everything you need without the hassle.
Along with ------ luxurious amenities, Breeze Tower features spacious one- and two-bedroom
 16.
units. Breeze Tower also has studio apartments perfect for a sophisticated yet ------ lifestyle.
 17.

------. If you sign a contract by March 31, you will get a 5 percent discount. Simply present this
18.
advertisement to your agent upon visiting our showroom.

To learn more, call us at 555-0900 or visit www.breezetower.net.

15. (A) between
 (B) throughout
 (C) before
 (D) until

16. (A) it
 (B) its
 (C) they
 (D) their

17. (A) confined
 (B) indifferent
 (C) practical
 (D) usual

18. (A) Experience the finest city living in our
 apartments at a good price.
 (B) Breeze Tower is one of the best resorts in
 Dubai.
 (C) We also offer online reservations and
 special tour packages.
 (D) Our office units are home to Dubai's
 famed companies.

Questions 19-22 refer to the following notice.

PUBLIC NOTICE

The city government has started preparations for this year's Fort Lauderdale Orchid Festival. ------. City officials have also formed a committee dedicated to ------ the activities for the
 19. **20.**
festival. Registration is now open for the following events:

Flower Parade: January 20, 8 A.M. to 11 A.M.
Street Dance: January 21, 2 P.M. to 4 P.M.
Town Games: January 22, 8 A.M. to 12 P.M.
Live Band Contest: January 22, 2 P.M. onwards

Unlike previous years, we are allotting only a half day for town games. This is because many residents wanted a live band competition. Few opposed the idea, so the committee voted ------
 21.
changing the tradition.

Residents interested in ------ in the activities should sign up at the town office. For questions,
 22.
please dial 555-8980.

DAY 14

19. (A) The event will celebrate the arrival of spring.
 (B) The schedule for each day has already been decided.
 (C) Competing towns have signed up for the activities.
 (D) Thank you for your support during the festival.

20. (A) preparation
 (B) preparing
 (C) prepared
 (D) prepare

21. (A) in favor of
 (B) ahead of
 (C) prior to
 (D) against

22. (A) registering
 (B) accommodating
 (C) supporting
 (D) participating

CHAPTER

6

–

연결어편

DAY 15
등위/상관접속사
& 명사절 접속사

기본 개념 노트

본 학습에 들어가기 전에 기본 문법 개념의 틀을 잡아보자.

❶ 등위접속사 개념 및 종류

문법적 성격이 동등한 단어, 구, 절과 같은 문장 요소들을 연결하는 접속사를 말하며 첨가, 선택, 대조, 결과, 원인을 의미한다.

첨가	① The benefits of this job include a pension **and** many vacation days.
선택	② You can keep your bag with you **or** check it.
대조	③ There was a staff picnic planned, **but** it was canceled because of the rain. ④ Competition has increased, **yet** the company's profits have not suffered.
결과	⑤ The printer was defective, **so** we returned it to the manufacturer.
원인	⑥ A deal was never reached, **for** the parties were unwilling to negotiate.

❷ 명사절 접속사 개념 및 역할

문장에서 주어, 목적어, 보어 역할을 하는 절을 이끄는 접속사를 말하며 that, whether, if 그리고 명사절을 이끄는 의문사가 있다.

주어	⑦ **Whether** Douglas is suitable for the job is a subject of debate.
목적어	⑧ The patient wondered **if** the vaccination would have side effects.
전치사의 목적어	⑨ They were surprised by **who** was selected as the chairperson.
보어	⑩ The goal is **that** participants gain confidence in public speaking.

① 이 직업의 복지 혜택에는 연금과 많은 휴가가 포함되어 있다. ② 가방을 직접 소지하시거나, 부치실 수 있습니다. ③ 직원 야유회가 계획되어 있었으나, 우천으로 인해 취소되었다. ④ 경쟁이 심해졌지만, 그 회사의 이익은 나빠지지 않았다. ⑤ 그 프린터는 결함이 있어서, 우리는 그것을 제조업체에 돌려보냈다. ⑥ 거래가 성사되지 않았는데, 당사자들이 협상할 의지가 없었기 때문이다. ⑦ 더글러스 씨가 이 일에 적합한지가 논의 주제이다. ⑧ 그 환자는 예방접종이 부작용이 있는지 궁금해 했다. ⑨ 그들은 의장으로 누가 선출되었는지를 알고 놀랐다. ⑩ 목표는 참가자들이 대중 연설 시 자신감을 얻는 것이다.

SELF-TEST

기본 개념이 토익에는 어떻게 출제되는지 알아보자. ⏱ 제한시간 03:00

다음 핵심 포인트를 참고하여 정답이 되는 이유를 적어보자. **NOTE**

1. Mr. Kim is our manager, ------- he has been in the company for three years.

 (A) and　　　　　　(B) so
 (C) because　　　　(D) while

2. The seminar kits provided to participants consist of ------- handouts and writing materials.

 (A) or　　　　　　(B) neither
 (C) both　　　　　(D) yet

3. ------- the employees' benefits will be suspended was just a rumor.

 (A) With　　　　　(B) That
 (C) For　　　　　　(D) Because

4. Value for money is ------- makes Kingston Detergent better than other brands of laundry soap.

 (A) and　　　　　　(B) but
 (C) that　　　　　(D) what

5. The maintenance team is checking ------- the storm damaged anything in the building.

 (A) either　　　　(B) whether
 (C) whenever　　　(D) about

6. The IT department has not identified ------- server needs immediate replacement.

 (A) when　　　　　(B) which
 (C) how　　　　　　(D) who

NOTE

1. 등위접속사

2. 상관접속사

3. 주어 역할을 하는 명사절

4. 명사절 접속사 vs. 관계대명사

5. 목적어 자리

6. 명사절을 이끄는 의문사

DAY 15

문제별 출제 POINT ▶ 다음 페이지에서 확인하기

등위접속사 & 상관접속사

문맥에 적절한 등위접속사를 고르는 문제 또는 등위접속사 앞이나 뒤에 문법적으로 대등한 품사를 고르는 문제가 자주 출제된다. 특히 상관접속사 문제는 단어 짝을 찾는 문제로 출제되므로 정리해 두자.

Mr. Kim is our manager, **and** he has been in the company for three years.

(A) and　　　　　(B) so
(C) because　　　　(D) while

빈칸 앞뒤의 절을 연결해주는 접속사를 찾는 문제. 문맥상 '김 씨는 관리자이고, 회사에서 3년 동안 일해왔다'란 의미가 자연스러우므로 '첨가'의 의미를 지닌 (A) and가 정답이다. 여기에서 and는 등위접속사로 두 개의 절을 병렬 구조로 연결해 주고 있다.

해석 | 김 씨는 우리의 관리자이고, 그는 회사에서 3년 동안 일해왔다.

1. 등위접속사

등위접속사는 문법적 특성이 동등한 단어, 구, 절을 연결하며 중복된 부분은 생략 가능하다. 이와 같은 병렬 구조가 등위접속사의 가장 큰 특징이며 문두에 올 수 없다는 점에서 부사절 접속사와 구분된다.

and 그리고	or 또는	but 그러나	yet 그러나	so 그래서	for 왜냐하면

단어와 단어　Mr. Bailey is in charge of <u>production</u> **and** <u>operations</u>.
　　　　　　　　　　　　　　　　　명사　　　　　　　명사　　　베일리 씨는 생산과 운영을 담당하고 있다.

구와 구　　The regulation <u>has been changed</u> **but** <u>(has) not been announced</u>.
　　　　　　　　　　　　동사구　　　　　　　　　　　　동사구　　규정이 변경되었으나 발표되지는 않았다.

절과 절　　<u>This quarter's sales are low</u>, **so** <u>we need to take action</u>.
　　　　　　　　절　　　　　　　　　　　　　　절　　이번 분기의 매출이 낮아서, 우리는 조치를 취해야 한다.

주의 등위접속사 so와 for는 절과 절만 연결할 수 있으며 단어나 구는 연결하지 못한다.

　　<u>The presentation was delayed</u>, **for** <u>the speaker arrived late</u>.
　　　　　　절　　　　　　　　　　　　　절　　발표가 지연되었는데, 발표자가 늦게 도착했기 때문이었다.

The seminar kits provided to participants consist of **both** handouts and writing materials.

(A) or　　　　　(B) neither
(C) both　　　(D) yet

빈칸 뒤에 handouts와 writing materials는 모두 전치사 of의 목적어이다. 이 두 명사가 등위접속사 and로 이어지고 있으므로, 빈칸에는 'A와 B 둘 다'의 의미인 상관접속사 both A and B 구문에서 and와 짝을 이루는 both가 들어가야 알맞다. 따라서 정답은 (C).

해석 | 참석자들에게 제공된 세미나 세트는 유인물과 문구류 둘 다로 구성된다.

2. 상관접속사

상관접속사 역시 등위접속사로 구성되어있기 때문에 접속사 앞뒤에 문법적으로 동등한 요소가 와야 한다.

both A and B A와 B 둘 다	either A or B A와 B 둘 중 하나	neither A nor B A도 B도 아닌
not A but B A가 아니라 B	not only A but (also) B[B as well as A] A뿐만 아니라 B도	

This new car will cut down on **both** <u>pollution</u> **and** <u>gas usage</u>.
이 신형 차는 공해와 휘발유 사용 둘 다 줄여줄 것이다.

Neither <u>the vice president</u> **nor** <u>the CEO</u> wants to accept the offer.
부사장도 대표이사도 둘 다 그 제안을 받아들이고 싶어하지 않는다.

Pineville Paper **not only** <u>designs pamphlets</u> **but also** <u>prints customized posters</u>.
= Pineville Paper <u>prints customized posters</u> **as well as** <u>designs pamphlets</u>.
　　파인빌 제지사는 소책자를 디자인할 뿐만 아니라 맞춤형 포스터도 출력한다.

명사절 접속사 that

문장의 목적어 역할을 하는 명사절을 이끄는 접속사 **that**에 대해 묻는 문제가 빈출된다. 또한 명사절 접속사 **that**과 관계대명사 **what**을 구분하는 문제도 출제되므로 이 둘의 차이를 명확히 기억해 두자.

That the employees' benefits will be suspended was just a rumor.

(A) With **(B) That**
(C) For (D) Because

be동사 was가 문장 전체의 본동사임을 파악하는 것이 관건이다. 따라서 빈칸은 was의 주어가 되는 명사절을 이끄는 접속사가 들어가야 할 자리이므로 정답은 명사절 접속사 (B) That.

해석 | 직원들의 혜택이 중단된다는 것은 소문일 뿐이었다.

1. 명사절 접속사 that

명사절 접속사 that이 이끄는 절은 문장에서 주어, 목적어, 보어 역할을 하고 that 뒤에는 완전한 절이 온다. 목적어절을 이끄는 경우에는 that을 생략할 수 있으며 전치사 뒤에는 that절이 올 수 없다.

주어	**That** personal information needs protection is true. 개인 정보 보호가 필요한 것은 사실이다.
목적어	Studies indicate (**that**) smoking harms one's health. 연구에 따르면 흡연은 건강에 해롭다.
보어	The problem is **that** the competition is too high. 문제는 경쟁이 너무 심하다는 것이다.

2. 동격의 that절

명사절 접속사 that은 사실, 의견, 소식을 의미하는 명사 뒤에서 명사의 내용을 서술하는 동격절을 이끌기도 한다.

the fact[truth] that ~라는 사실 the idea[thought] that ~라는 생각 the opinion that ~라는 의견
the hope that ~라는 바람 the news that ~라는 소식 the report that ~라는 보도

Bankers admit **the fact that** homebuyers have difficulty getting loans.
은행원들은 주택 구매자들이 대출을 받는 데 어려움이 있다는 사실을 인정한다.

Value for money is **what** makes Kingston Detergent better than other brands of laundry soap.

(A) and (B) but
(C) that **(D) what**

빈칸부터 문장 끝까지는 주격 보어로, 빈칸은 보어 역할을 하는 명사절을 이끄는 접속사 자리이다. 빈칸 뒤의 절이 동사 makes로 시작하므로 주어가 빠진 불완전한 절이다. 따라서 불완전한 절을 이끌며 명사절 역할을 하는 관계대명사 (D) what이 정답이다.

해석 | 가격에 합당한 가치는 킹스턴 세제를 다른 세탁 세제 브랜드보다 더 좋게 만드는 것이다.

3. 명사절 접속사 that vs. 관계대명사 what

명사절을 이끄는 역할을 한다는 공통점이 있지만 다음과 같은 차이가 있다.

	명사절 접속사 **that**	관계대명사 **what**
뒤의 절	완전한 절	불완전한 절
생략	목적어 절을 이끌 때 생략 가능	생략 불가
전치사의 목적어	불가능	가능

Sylvia assumed (**that**) her expenses would be reimbursed.
 완전한 절 실비아 씨는 그녀가 사용한 비용을 배상 받을 수 있을 것이라고 생각했다.

Ms. Dale was shocked by **what** she heard from Mr. Davison.
 불완전한 절(목적어 없음) 데일 씨는 데이비슨 씨에게 들은 것에 의해 충격을 받았다.

명사절 접속사 whether/if & 의문사

whether와 if는 둘 다 부사절 접속사로도 쓰이기 때문에 문장에서의 역할을 파악하는 것이 중요하다.
명사절을 이끄는 의문사는 형태상 다른 문법 요소와 혼동할 수 있으니 각각의 쓰임을 정확히 알아두자.

SELF-TEST 5

The maintenance team is checking **whether** the storm damaged anything in the building.

(A) either **(B) whether**
(C) whenever (D) about

빈칸은 동사 is checking의 목적어가 되는 명사절을 이끄는 접속사가 들어가야 할 자리로, 문맥상 '손상시켰는지 아닌지'란 뜻이 되어야 한다. 따라서 명사절 접속사 (B) whether가 정답.

해석 | 관리팀은 그 폭풍이 건물 안의 어떤 것이라도 손상시켰는지 아닌지를 확인하고 있다.

출제원리

1. 명사절 접속사 whether/if

명사절 접속사 whether와 if는 '~인지 아닌지'로 해석되며 뒤에 완전한 문장이 오는 것은 같지만 그 쓰임이 다르다. 특히 if는 whether에 비해 사용에 제한이 많으므로 주의해야 한다. 다음 두 접속사의 차이를 확인해 보자.

주어	**Whether** you work in the office or from home is your choice. if 사무실에서 근무할지 아니면 재택 근무할지는 당신의 선택입니다.
타동사의 목적어	It is difficult to determine **whether[if]** Randall will make a good accountant. 랜들 씨가 좋은 회계사가 될지 아닐지는 알아내기 어렵다.
전치사의 목적어	The boss thought about **whether** Ms. Glanzer's raise was deserved. about if 그 상사는 글랜저 씨의 임금 인상이 타당한 것인지에 대해 생각했다.
whether+to do	The firm is deciding **whether to import** or buy the goods domestically. if to import 그 회사는 제품을 수입할지 국내에서 구입할지 결정 중이다.

SELF-TEST 6

The IT department has not identified **which** server needs immediate replacement.

(A) when **(B) which**
(C) how (D) who

빈칸은 동사 has not identified의 목적어가 되는 명사절을 이끌며 동시에 빈칸 뒤의 명사 server를 수식하는 자리이다. 선택지 중에서 명사를 한정해 주는 한정사 역할을 할 수 있는 것은 의문형용사 which뿐이다. 따라서 정답은 (B).

해석 | IT 부서는 어느 서버가 즉시 교체가 필요한지 알아보지 않았다.

출제원리

2. 명사절을 이끄는 의문사

명사절을 이끄는 의문사는 〈의문사+주어+동사〉의 간접의문문 형태로 명사 역할을 하며, 그 쓰임에 따라 의문대명사, 의문형용사, 의문부사 세 가지로 나뉜다. 〈의문사+to do〉의 쓰임 또한 함께 알아두자.

의문대명사	who(m), what, which+불완전한 절	명사절에서 대명사 역할
의문형용사	whose, what, which+명사	명사를 한정하는 한정사 역할
의문부사	when, where, how, why+완전한 절	명사절에서 부사 역할

The audience was amazed by **who** came on stage next.
불완전한 절 관중들은 다음 무대에 누가 올라왔는지를 알고 놀랐다.

Nicole is choosing **which** fabric she wants for the curtains.
명사 니콜 씨는 커튼용으로 어떤 천이 좋을지 고르고 있는 중이다.

The question is **where** the conference will be held this year.
완전한 절 문제는 올해 어디에서 회의가 열리냐는 것이다.

The representative did not know **what to say** about that matter. [의문사+to do]
대표자는 그 사안에 대해 뭐라고 말해야 할지 몰랐다.

FINAL TEST

1. Neither the laptop's microphone ------- the speakers are working, so this computer cannot be used in the conference call.

(A) nor (B) and
(C) or (D) both

2. The product labels on the canned food indicate ------- the products were manufactured a few months ago.

(A) that (B) while
(C) why (D) then

3. The tenant wants to know ------- the lease can be extended for another month at the end of the year.

(A) yet (B) so
(C) if (D) what

4. The company is cutting back on operation costs, ------- it will not cancel the year-end party.

(A) so (B) or
(C) for (D) but

5. Speakers must ------- call the event organizer or send an e-mail to reschedule their presentations.

(A) neither (B) both
(C) either (D) not only

6. The reason for the overnight flight's cancelation is ------- a severe snowstorm is expected to start this evening.

(A) while (B) that
(C) for (D) what

7. After hearing from all participants, the client will determine ------- presentation was the most convincing.

(A) who (B) where
(C) when (D) whose

8. Soundmatic is not only the most advanced ------- the largest recording studio in Brooklyn.

(A) in addition to (B) as a result
(C) after all (D) but also

9. For a limited time only, Street Motors customers may receive a special discount ------- a free car accessory of their choice.

(A) if (B) or
(C) so (D) yet

10. If products are defective, they must be ------- to Oliver Online within thirty days after the date of purchase.

(A) reviewed (B) returned
(C) remade (D) realized

11. The layout design of the quarterly publication will depend on ------- long the articles are.

(A) how (B) so
(C) if (D) for

12. Lobbyists have hopes ------- these measures will be implemented nationally within the next few months.

(A) how (B) that
(C) which (D) then

13. Management has yet to decide ------- to acquire new vehicles or hire the services of a car rental company.

(A) meanwhile (B) whether
(C) neither (D) if

14. A detailed shopping list will allow hardware salespeople to quickly provide ------- customers need for their renovation projects.

(A) also (B) that
(C) what (D) if

DAY 15

CHAPTER
6

연결어편

DAY 16
부사절 접속사

기본 개념 노트

본 학습에 들어가기 전에 기본 문법 개념의 틀을 잡아보자.

❶ 개념 및 역할

부사절 접속사는 주절을 수식하는 종속절을 이끄는 접속사를 말하며, 문장에서 부사 역할을 한다.
부사절은 <접속사+주어+동사>의 형태이며 주절 앞이나 뒤에 모두 올 수 있다.

① **When** <u>she</u> <u>designs</u> an advertisement, Jenny uses a special software program.
　　접속사　주어　　동사

= Jenny uses a special software program **when** <u>she</u> <u>designs</u> an advertisement.
　　　　　　　　　　　　　　　　　　　　　접속사　주어　　　동사

❷ 종류 및 의미

부사절은 문장에서 시간, 조건, 이유, 양보 등 다양한 의미로 쓰인다.

시간	when ~할 때　　while ~ 동안에　　　　as ~하면서　　before ~ 전에　　after ~ 후에
조건	if ~하면　　　　unless ~하지 않으면　　in case (that), in the event (that) ~할 경우에 대비해서
이유	because, since, as, now that ~ 때문에, ~이므로　　in that ~이므로, ~라는 점에서
양보	although, even though, even if (비록) ~이지만　　while ~하는 반면에
목적	so that ~ can[may] ~할 수 있도록　　in order that ~ can[may] ~하기 위해서
결과	so+형용사[부사]+that, such+(한정사)+(형용사)+명사+that 너무 ~해서 …하다
제외	except (that) ~을 제외하고

① 광고를 디자인 할 때, 제니 씨는 특별한 소프트웨어 프로그램을 사용한다.

SELF-TEST

기본 개념이 토익에는 어떻게 출제되는지 알아보자. ⏱ 제한시간 03:00

1. Please do not forget to turn off the lights ------- the coffee shop has been closed for the night.

 (A) though (B) once
 (C) so (D) yet

2. Bella Salon is moving to Taipei ------- it can be closer to more clients.

 (A) instead of (B) not only
 (C) so that (D) even though

3. Mail your proposal by March 10 ------- you wish to present at the upcoming international affairs convention.

 (A) how (B) if
 (C) while (D) that

4. Many people went to James Lind's concert last night ------- it was raining hard.

 (A) although (B) besides
 (C) as if (D) unless

5. The company picnic has been rescheduled for next week ------- the typhoon is coming.

 (A) between (B) due to
 (C) because (D) where

6. ------- putting something in the microwave, make sure that the item has no metal component.

 (A) When (B) In case
 (C) During (D) Meanwhile

1. 시간 접속사

2. 목적 접속사

3. 조건 접속사

4. 양보 접속사

5. 접속사 vs. 전치사

6. 부사절의 생략

DAY 16

문제별 출제 **POINT** ▶ 다음 페이지에서 확인하기

시간, 이유, 목적, 결과의 접속사

부사절 접속사 문제는 먼저 절과 절을 연결하는 역할을 하는 자리인지를 확인한 후 시간, 이유, 목적 등 문맥에 맞는 접속사를 찾는 것이 핵심이다. 두 절 사이의 의미 관계를 확실히 파악하자.

SELF-TEST 1

Please do not forget to turn off the lights **once** the coffee shop has been closed for the night.

(A) though **(B) once**

(C) so (D) yet

빈칸은 절과 절을 연결해 주는 접속사 자리. 문맥상 '커피숍 문을 닫고 나서 불을 끄라'는 의미이므로 시간을 나타내는 부사절 접속사가 적절하다. 따라서 정답은 (B) once. (A)는 '~이지만'의 의미인 양보의 접속사, (C)는 '그래서', (D)는 '그러나'의 의미인 등위접속사로 오답이다.

해석 | 일단 밤에 커피숍 문을 닫고 나서 불을 끄는 것을 잊지 마십시오.

출제원리

1. 시간을 나타내는 접속사

시간을 나타내는 부사절 접속사는 부사나 전치사의 형태로 익숙한 것이 많으므로 구분하여 알아둬야 한다.

when, as ~할 때	while ~ 동안에	once 일단 ~하고 나서	as soon as ~하자마자
before ~ 전에	after ~ 후에	(ever) since ~ 이래로 (줄곧)	until ~까지

Mr. Harry left **as soon as** the meeting was over. 해리 씨는 회의가 끝나자마자 떠났다.

Since she was promoted, Sheila's confidence has increased. 승진이 된 이래로 실라 씨의 자신감이 상승했다.

2. 이유를 나타내는 접속사

because, since, as 외에도 now that과 in that 또한 이유를 나타내므로 그 형태와 의미에 주의하여 알아두자.

because, since, as, now that ~ 때문에, ~이므로	in that ~이므로, ~라는 점에서

As the author refused to meet with us, we called the editor. 작가가 우리와 만나길 거절해서, 편집자에게 연락했다.

Now that Mr. Els has an assistant, he does not have to do administrative tasks.
엘스 씨에게 비서가 있으므로, 그는 행정 업무를 할 필요가 없다.

SELF-TEST 2

Bella Salon is moving to Taipei **so that** it can be closer to more clients.

(A) instead of (B) not only

(C) so that (D) even though

문맥에 어울리는 접속사를 찾는 문제로, 벨라 살롱 사가 '더 많은 고객들에게 가까워지기 위해서' 타이베이로 이사가는 것이므로 목적을 나타내는 접속사 (C) so that이 정답.

해석 | 벨라 살롱 사는 더 많은 고객들에게 가까워지기 위해서 타이베이로 이사갈 것이다.

출제원리

3. 목적을 나타내는 접속사

목적을 나타내는 부사절 접속사로는 so that과 in order that이 주로 쓰인다.

so that ~ can[may] ~할 수 있도록	in order that ~ can[may] ~하기 위해서

If you are interested, let us know **so that[in order that]** we **can[may]** add you to our list.
관심이 있으시면, 귀하를 저희 목록에 추가할 수 있도록[추가하기 위해서] 저희에게 알려주십시오.

4. 결과를 나타내는 접속사

결과를 나타내는 접속사 so ~ that과 such ~ that은 의미는 같으나 so와 such가 수식하는 품사의 차이가 있다.

so+형용사[부사]+that, such+(한정사)+(형용사)+명사+that 너무 ~해서 …하다

The material is **so** light **that** it can be easily transported. 그 자재는 너무 가벼워서 쉽게 운반할 수 있다.
~~such, very, too~~

조건, 양보, 유사/비교, 제외의 접속사

조건이나 양보, 유사/비교와 제외를 나타내는 부사절 접속사를 고르는 문제는 문맥 파악이 최우선이다.
더불어 시간과 조건 부사절에서는 미래를 나타낼 때 현재 시제를 쓴다는 것도 함께 기억해 두자.

SELF-TEST 3

Mail your proposal by March 10 **if** you wish to present at the upcoming international affairs convention.

(A) how (B) if
(C) while (D) that

빈칸은 두 개의 절을 연결하는 접속사 자리이므로 두 절의 의미 관계를 파악해야 한다. 문맥상 '발표하고 싶으면 제안서를 보내라'는 조건의 의미가 적절하므로 조건을 나타내는 접속사 (B) if가 정답이다.

해석 | 곧 있을 국제 관계 학회에서 발표하고 싶으시면 3월 10일까지 귀하의 제안서를 우편으로 보내십시오.

출제원리

1. 조건을 나타내는 접속사

조건을 나타내는 부사절 접속사는 주절의 전제 조건이 되는 절을 이끌 때 사용되는데, 구전치사 혹은 분사 형태의 접속사도 있으므로 그 형태에 주의하여 기억하자.

(only) if 만약 ~하면 unless ~하지 않으면(=if ~ not) once 일단 ~하면 as long as ~하기만 하면
in case (that), in the event (that) ~할 경우에 대비해서 considering (that), given (that) ~을 고려하면
providing[provided] (that), supposing[supposed] (that), assuming (that) ~라고 가정하면

If it is released, the sensitive information could pose a security threat.
만약 공개되면, 그 민감한 정보는 보안을 위협할 수 있다.

주의 시간 부사절과 조건 부사절에서는 미래를 나타낼 때 현재 시제를 쓴다.

If we **succeed** in winning this bid, Mr. Watson will give us all bonuses.
~~will succeed~~ 이 입찰을 따는 데 성공하면, 왓슨 씨가 우리 모두에게 보너스를 줄 것이다.

DAY 16

SELF-TEST 4

Many people went to James Lind's concert last night **although** it was raining hard.

(A) although (B) besides
(C) as if (D) unless

빈칸은 두 개의 절을 이어주는 접속사 자리이므로, 전치사나 접속 부사로 쓰이는 (B) besides는 오답으로 제외. 문맥상 '많은 사람들이 콘서트에 갔다'는 것과 '비가 심하게 내렸다'는 것은 대조되는 내용이므로 '~에도 불구하고'란 뜻의 양보를 나타내는 접속사 (A) although가 정답.

해석 | 비가 심하게 내렸음에도 불구하고 지난밤 많은 사람들이 제임스 린드의 콘서트에 갔다.

출제원리

2. 양보를 나타내는 접속사

양보를 나타내는 부사절 접속사는 예상하지 못한 결과나 기대와 반대되는 내용을 표현할 때 사용한다.

although, (even) though, even if (비록) ~이지만 while ~하는 반면에
whereas ~한 반면에 whether (or not) ~에 상관없이

No one has submitted a proposal for the new project **even though** the deadline is tomorrow.
마감일이 내일이지만 누구도 새로운 프로젝트의 제안서를 제출하지 않았다.

3. 유사/비교와 제외를 나타내는 접속사

유사/비교의 접속사와 제외를 나타내는 접속사도 그 의미를 정확히 알아두자.

as ~한 대로 as if, as though 마치 ~인 것처럼 except that[when] ~을 제외하고

Jerry sometimes talks **as if[as though]** he ran the company. 제리 씨는 가끔 그가 회사를 경영하는 것처럼 말한다.
It would be a good job **except that[when]** the schedule is quite rigorous.
일정이 꽤 엄격하다는 것을 제외하고는 그것은 괜찮은 일일 것이다.

접속사 vs. 전치사

자주 출제되는 접속사와 전치사를 구별하는 문제에서는 빈칸 뒤에 절이 나오면 접속사를 답으로 고르면 된다. 그러나 접속사 자리 뒤에 분사, 형용사 등이 오는 경우도 있으므로 구조에 주의하여 살펴보자.

SELF-TEST 5

The company picnic has been rescheduled for next week **because** the typhoon is coming.

(A) between (B) due to
(C) because (D) where

'회사 야유회 일정이 다음 주로 변경되었다'는 결과가 빈칸 앞에 나오고 빈칸 뒤에는 '태풍이 오고 있다'는 일정 변경 이유가 나오므로 정답은 이유를 나타내는 접속사 (C) because. (B) due to도 이유를 나타내지만 구전치사이므로 뒤에 (대)명사나 동명사만 취할 수 있으므로 오답이다.

해석 | 태풍이 오고 있기 때문에 회사 야유회 일정이 다음 주로 변경되었다.

출제원리

1. 접속사 vs. 전치사

일반적으로 부사절 접속사 뒤에는 〈주어+동사〉가 있는 완전한 절이, 전치사 뒤에는 명사류가 나온다.

종류	접속사+주어+동사	의미	전치사+명사류
시간	while as soon as before after	~하는 동안 ~하자마자 ~ 전에 ~ 후에	during upon[on] *doing* before, prior to after, following
조건	in case (that), in the event (that) unless	~인 경우에 ~가 아니라면	in case of, in the event of barring, without
이유	because, since, as, now that	~ 때문에	because of, due to, owing to
양보	although, (even) though, even if	(비록) ~이지만	despite, in spite of, notwithstanding
목적	so that ~ can[may] in order that ~ can[may]	~을 위해서	for
제외	except (that)	~을 제외하고	except (for), aside from, apart from

~~Despite~~ **Although** <u>Donna lost her passport</u>, she was able to get a new one before her vacation.
 절(주어+동사) 비록 도나 씨는 여권을 잃어버렸지만, 휴가 전에 새 여권을 발급받을 수 있었다.

SELF-TEST 6

When putting something in the microwave, make sure that the item has no metal component.

(A) When (B) In case
(C) During (D) Meanwhile

문맥상 '전자레인지에 무엇인가를 넣을 때'라는 의미가 자연스러우므로 정답은 (A) When. 접속사 when 뒤에 〈주어+be동사〉가 생략되어 현재분사 putting이 나온 구조이다. 빈칸 뒤 putting을 동명사로 오인하여 전치사 (D) During을 고르지 않도록 하자.

해석 | 전자레인지에 무엇인가를 넣을 때에는 반드시 물품에 금속 성분이 없도록 하십시오.

출제원리

2. 부사절의 생략

as, when, while, unless, once, before, after 등의 접속사가 쓰인 부사절에서 〈주어+be동사〉는 생략이 가능하여 접속사 뒤에 절이 아닌 분사나 형용사 등이 올 수 있다.

과거분사	**As** (it is) <u>stated</u> in the job posting, the salary is negotiable. 구인 광고에 쓰인 대로, 급여는 협의가 가능합니다.
현재분사	**While** (she was) <u>reviewing</u> the article, Ms. Sollis noticed several typos. 기사를 검토하는 중에 솔리스 씨는 몇 개의 오타를 발견했다.
형용사	**When** (you are) <u>ready</u>, press 'Start' to proceed. 준비가 되면, 진행을 위해 '시작' 버튼을 눌러주십시오.

FINAL TEST

1. Mr. Amal took the printer to the service center ------- it was malfunctioning this morning.

 (A) since (B) so that

 (C) whether (D) except

2. ------- the glass dealer provided a large discount, the price of the tempered windows is still high.

 (A) Rather (B) Except that

 (C) Even though (D) Wherever

3. The price of seasoned turkey is expected to increase ------- the thanksgiving season due to high demand.

 (A) while (B) until

 (C) when (D) during

4. ------- the cooking demonstration started, attendees were advised to turn off their mobile devices to avoid any distractions.

 (A) So (B) Before

 (C) Unless (D) If

5. Driving to the art museum would take 45 minutes ------- taking the subway would only take 20 minutes.

 (A) aside from (B) whereas

 (C) which (D) unless

6. When ------- your visit to the embassy, you should keep in mind that the average appointment lasts about one hour.

 (A) scheduling (B) scheduled

 (C) schedule (D) to schedule

7. Piota Entertainment will launch its new mobile game on October 20 ------- the designers meet all the deadlines.

 (A) as (B) whether

 (C) provided that (D) in the event

8. ------- Ms. Summers immediately met her sales target last month, the other managers had difficulty finding clients.

 (A) Except for (B) In spite of

 (C) In order that (D) While

9. ------- you subscribe to the Omni newsletter, you will receive regular updates on our products.

 (A) In case (B) As long as

 (C) Even if (D) Rather than

10. Mr. Parson's plan was ------- well designed that the construction project was completed ahead of schedule.

 (A) very (B) so

 (C) too (D) such

11. ------- technical difficulties, the Ministry of Education successfully built multimedia classrooms and computer laboratories.

 (A) Through (B) Although

 (C) Despite (D) Nevertheless

12. The company closed some of its departments last month, yet it continues to operate ------- nothing had changed.

 (A) how (B) as if

 (C) if only (D) considering that

13. The car show can be held this Friday ------- the vehicles have arrived from Japan.

 (A) otherwise (B) due to

 (C) therefore (D) now that

14. ------- several major streets are blocked because of the blizzard, employees probably will not get in trouble for arriving late.

 (A) Given that (B) Except that

 (C) Unless (D) Notwithstanding

DAY 16

153

Questions 15-18 refer to the following article.

Sky Asia Adds Flights to France

SINGAPORE, JANUARY 5—Sky Asia, Singapore's top budget airline, will launch its first direct flight to Paris, France, from Changi Airport at 8 A.M. tomorrow. ------. Sky Asia chairman
15.
Emerson Kong expressed pride in the airline's latest destination. "Becoming the world's best budget carrier is our goal. We have been opening new routes at least every two years ------ our
16.
airline was established," Kong said. "Through this and other Sky Asia routes, our passengers can ------ many parts of the world."
17.

To celebrate its first European route, Sky Asia is offering 20 percent off fares until January 31. Please note ------ to get this promotion, ticket purchases must be made on the Sky Asia Web site
18.
only.

15. (A) This means passengers to Europe will no longer have layovers.
 (B) The passenger carrier will return to Paris within the day.
 (C) Sky Asia will start selling tickets for its first flight to Europe.
 (D) The flight left London an hour after its passengers checked in.

16. (A) when
 (B) now
 (C) before
 (D) since

17. (A) access
 (B) aspire
 (C) support
 (D) arrive

18. (A) about
 (B) except
 (C) during
 (D) that

Questions 19-22 refer to the following letter.

Robert Cosby
35 Chestnut Drive
Silvertown, PA 19320

January 15

Dear Mr. Cosby,

Congratulations! Your entry to the Armcore Photo Contest, titled *Even Lights*, has been chosen as the best picture. As the first-prize winner, you will receive $1,000 in cash and a two-year scholarship at the American School of the Arts. The scholarship covers for a maximum of 20 credits every semester ------- it expires.
 19.

Enclosed is a certificate from our company. It specifies all the prizes and ------- that you are
 20.
entitled to. We are holding an awards ceremony on February 25 and hope that you can attend.
-------, we will send your prizes to your address.
21.

-------. You may call us at 555-0900 or send an e-mail to publicrelations@armcore.com. Thank
22.
you.

Sincerely,

Geneva Owens
Armcore Photo Contest Chairman

DAY 16

19. (A) yet
 (B) before
 (C) until
 (D) for

20. (A) beneficiary
 (B) benefits
 (C) benefitting
 (D) beneficial

21. (A) Nevertheless
 (B) Accordingly
 (C) However
 (D) Otherwise

22. (A) Please let us know what you plan to name your entry.
 (B) We would appreciate receiving your photograph soon.
 (C) We request that you confirm receipt of this notification.
 (D) You may get your registration form at our office.

정답 및 해설 62쪽

CHAPTER
6

-

연결어편

DAY 17
관계사

기본 개념 노트

본 학습에 들어가기 전에 기본 문법 개념의 틀을 잡아보자.

❶ 관계사의 역할

관계대명사는 <접속사＋대명사>의 역할, 관계부사는 <접속사＋부사>의 역할을 하며 관계사절 앞의 명사(선행사)를 수식하는 형용사절을 이끈다.

관계대명사	① You have to take the documents **and they** are on the cabinet. → You have to take <u>the documents</u> [**which** are on the cabinet].
관계부사	② Please visit our bank **and** you can deposit your money **here** safely. → Please visit <u>our bank</u> [**where** you can deposit your money safely].

❷ 관계대명사 종류

관계대명사는 선행사의 종류와 격에 따라 구분된다. 관계대명사 뒤에는 불완전한 절이 나온다.

선행사　　격	주격	소유격	목적격
사람	who	whose	who(m)
사물	which	whose, of which	which
사람, 사물	that	-	that

③ <u>The building</u> [**that** the company owns] is currently unoccupied.

주의 관계대명사 what은 선행사를 포함하여 '~하는 것(the thing which)'으로 해석되며 명사절을 이끈다.

④ Since retirement, Mr. Collins has been doing **what** <u>he loves</u>.

❸ 관계부사 종류

관계부사는 선행사의 종류에 따라 구분되며, 격에 따른 구분은 없다. 관계부사는 <전치사＋관계대명사>로 바꿔 쓸 수 있으며 뒤에는 완전한 절이 나온다.

선행사	관계부사	전치사＋관계대명사
시간(the time)	when ~하는 때	at[on, in] which
장소(the place)	where ~하는 장소	at[on, in] which
이유(the reason)	why ~하는 이유	for which
방법(the way)	how ~하는 방법 [the way나 how 둘 중 하나만 쓴다.]	in which

⑤ She is waiting for <u>autumn</u>, **when** the weather cools off.

① 캐비닛 위에 있는 문서를 가지고 가셔야 합니다. ② 귀하의 돈을 안전하게 예금할 수 있는 저희 은행에 방문하십시오. ③ 그 기업이 소유한 건물은 현재 비어있다. ④ 은퇴 이후에 콜린스 씨는 자신이 좋아하는 것을 해오고 있다. ⑤ 그녀는 날씨가 선선해지는 가을을 기다리고 있다.

SELF-TEST

기본 개념이 토익에는 어떻게 출제되는지 알아보자. ⏱ 제한시간 03:00

다음 핵심 포인트를 참고하여
정답이 되는 이유를 적어보자. **NOTE**

1. Free seat upgrades are given to passengers ------- book flights before June 30.

 (A) who (B) whom
 (C) whose (D) which

 1. 사람 선행사

2. The research team interviewed people ------- to the consumer market study.

 (A) relevancy (B) relevant
 (C) relevantly (D) relevance

 2. <주격 관계대명사 + be동사> 생략

3. Professor Yang delivered a talk in ------- he explained the important contributions of technology to agriculture.

 (A) that (B) where
 (C) there (D) which

 3. <전치사 + 관계대명사>

4. King Crab Restaurant is in the lobby of the building ------- Aymen Pharmacy was formerly located.

 (A) where (B) that
 (C) when (D) which

 4. 장소 선행사

 DAY 17

5. Please send this letter to ------- is in charge of handling mutual funds at your company.

 (A) whichever (B) wherever
 (C) whenever (D) whoever

 5. 주어 역할을 하는 복합관계대명사

6. Our servers make good recommendations ------- diners cannot decide what to order.

 (A) whatever (B) whenever
 (C) that (D) with regard to

 6. 복합관계부사

문제별 출제 **POINT** ▶ 다음 페이지에서 확인하기

관계대명사

관계사 문제는 선행사의 종류와 관계사절 내의 역할에 따라 알맞은 관계대명사를 고르는 문제가 빈출된다. 또한 관계대명사가 생략된 관계대명사절의 주어나 동사 자리 또는 선행사 바로 뒤 품사를 묻는다.

Free seat upgrades are given to passengers **who** book flights before June 30.

(A) who　　　　(B) whom
(C) whose　　　　(D) which

선행사 passengers가 사람이고 빈칸 뒤에 동사 book이 있으므로 빈칸에는 주격 관계대명사가 필요하다. 따라서 사람 선행사를 수식하며 관계대명사절에서 주어 역할을 하는 주격 관계대명사 (A) who가 정답이다. (D) which는 주격이지만 사물 선행사를 수식하므로 오답.

해석 | 6월 30일 이전에 항공편을 예약한 승객들에게는 무료 좌석 업그레이드가 주어진다.

1. 관계대명사의 격

관계대명사의 격은 선행사가 관계대명사절에서 어떤 역할을 하는지에 따라 달라진다.

주격	▶ 〈선행사＋**주격**＋동사〉 선행사가 관계대명사절에서 주어 역할을 하는 경우 주격 관계대명사를 쓴다. 이때 관계대명사절의 동사는 선행사에 수와 태를 일치시킨다. Teresa needs help from someone **who[that]** knows computer operating systems. 선행사(사람)　테레사 씨는 컴퓨터의 운영 체제를 아는 사람의 도움이 필요하다. They are looking for a niche market **which[that]** is full of opportunities. 선행사(사물)　그들은 기회로 가득한 틈새 시장을 찾고 있다.
목적격	▶ 〈선행사＋**목적격**＋주어＋타동사〉 선행사가 관계대명사절에서 목적어 역할을 하는 경우 목적격 관계대명사를 쓴다. The manager greeted the woman **whom[that]** he hired as his assistant. 그 관리자는 자신의 조수로 고용한 여자를 반겼다.
소유격	▶ 〈선행사＋**소유격**＋명사〉 선행사가 관계대명사절에서 소유격 역할을 할 때 소유격 관계대명사를 쓴다. 소유격은 한정사이기 때문에 뒤에 명사가 바로 온다. She is a famous designer **whose** work is regularly featured in art shows. 그녀는 작품이 미술 전시회에 정기적으로 다뤄지는 유명한 디자이너이다.

The research team interviewed people **relevant** to the consumer market study.

(A) relevancy　　　**(B) relevant**
(C) relevantly　　　(D) relevance

빈칸 이하가 앞의 명사 people을 수식하는 구조로 명사를 수식할 수 있는 것은 선택지 중 형용사 relevant밖에 없으므로 정답은 (B). be relevant to는 '~와 관련 있다'는 의미로 쓰이며 여기서는 빈칸 앞에 〈주격 관계대명사＋be동사〉인 who are가 생략되었다.

해석 | 연구팀은 소비자 시장 연구와 관련된 사람들을 인터뷰했다.

2. 관계대명사의 생략

〈주격 관계대명사＋be동사〉와 목적격 관계대명사는 생략이 가능하니 주의해서 알아두자.

〈주격 관계대명사＋be동사〉의 생략	▶ 주격 관계대명사 뒤에 be동사가 오는 경우 〈주격 관계대명사＋be동사〉를 생략할 수 있다. 이 경우에는 선행사 바로 뒤에 분사나 형용사가 온다. The manager (**who[that] was**) handling the M&A expressed confidence in the outcome.　~~handle, handled~~ 인수 합병을 담당하는 관리자는 결과에 대한 자신감을 드러냈다.
목적격 관계대명사의 생략	▶ 목적격 관계대명사도 생략이 가능하며 이때 선행사 뒤에는 주어와 동사가 온다. The sales position (**which[that]**) Mr. Miller is seeking requires strong communication skills.　주어　동사 밀러 씨가 구하고 있는 영업직은 강력한 의사소통 능력이 필요하다.

〈전치사+관계대명사〉 & 관계부사

관계대명사가 전치사의 목적어로 쓰이는 경우 전치사 또는 전치사 뒤 관계대명사를 묻는 문제가 출제된다. 또한 〈전치사+관계대명사〉로 바꿔 쓸 수 있는 관계부사를 고르는 문제도 출제된다.

Professor Yang delivered a talk in **which** he explained the important contributions of technology to agriculture.

(A) that (B) where
(C) there **(D) which**

빈칸은 전치사 in의 목적어 역할을 하며 빈칸 뒤의 절을 이끄는 관계대명사 자리. 따라서 (A) that과 (D) which가 정답 후보인데, 관계대명사 that은 전치사 뒤에 올 수 없으므로 정답은 (D). (B) where는 관계부사로 〈전치사+관계대명사〉 역할을 하는데 빈칸 앞에 전치사 in이 이미 있기 때문에 오답이다.

해석 | 양 교수는 농업에 대한 기술의 중대한 기여를 설명하는 강연을 했다.

출제원리

1. 〈전치사+목적격 관계대명사〉

관계대명사가 관계대명사절에서 전치사의 목적어로 쓰인 경우 〈전치사+관계대명사〉 형태가 된다. 이 경우 전치사 뒤에 관계대명사 that은 쓸 수 없으며, 전치사 뒤 관계대명사는 생략할 수 없다.

She can't find the cabinet **[which[that]** the files should be put **in]**.
= She can't find the cabinet **[in which** the files should be put].
~~in that~~ 그녀는 파일을 넣어 놓을 캐비닛을 찾을 수가 없다.

2. 〈부정대명사+of+목적격 관계대명사〉

〈부정대명사+of〉의 뒤에도 목적격 관계대명사가 쓰이며 앞의 선행사가 사람이면 whom을, 사물이면 which를 쓴다.

one[many, both, some, none, all, most] + of + whom[which]
그 중에 하나[다수, 둘 다, 몇몇, 아무(것)도 없음, 모두, 대부분]

MCT Inc. hired 40 performers, **most of whom** are experienced actors.
선행사(사람) ~~who~~ 엠씨티 사가 배우 40명을 고용했는데, 대부분이 경험이 많은 배우이다.

They produced 500 storage devices, **one of which** is defective.
선행사(사물) ~~whom, that~~ 그들은 저장 장치 500대를 생산했는데, 그 중 하나에 결함이 있다.

King Crab Restaurant is in the lobby of the building **where** Aymen Pharmacy was formerly located.

(A) where (B) that
(C) when (D) which

선택지를 보니 선행사에 따른 알맞은 관계사를 고르는 문제이다. 선행사 the building이 장소를 나타내며, 빈칸 이하에 완전한 절이 오고 있으므로 관계부사 (A) where가 정답이다. 관계대명사인 (B)와 (D)도 사물 선행사와 쓰일 수 있으나 뒤에 불완전한 절이 나와야 하므로 오답이다.

해석 | 킹 크랩 식당은 에이멘 약국이 이전에 위치했던 건물 로비에 있다.

출제원리

3. 관계부사

관계부사는 선행사의 종류에 따라 구분되고 뒤에는 완전한 절이 온다.

시간	The payment date **when[on which]** you should repay your loans is coming. 귀하께서 대출 금액을 갚아야 하실 날짜가 다가오고 있습니다.
장소	He withdrew money from the bank **where[at which]** he had deposited $500. 그는 500달러를 예금해 두었던 은행에서 돈을 인출했다.
이유	The reason **why[for which]** Jenny got promoted was that she won the bid. 제니 씨가 승진한 이유는 입찰을 따냈기 때문이다.
방법	Reducing electricity use is **how[in which]** we can cut overhead costs. ~~the way how~~ 전기 사용을 줄이는 것이 우리가 간접비를 줄일 수 있는 방법이다.

복합관계사

해석을 통해 문맥에 알맞은 복합관계사를 찾는 문제가 자주 등장한다. 특히 양보의 부사절로 쓰인 복합관계부사 문제가 자주 출제되므로 그 쓰임과 의미에 대해서 확실히 이해하도록 하자.

Please send this letter to **whoever** is in charge of handling mutual funds at your company.

(A) whichever　　(B) wherever
(C) whenever　　**(D) whoever**

빈칸은 전치사 to의 목적어 자리로 명사절을 이끄는 동시에 명사절 내의 동사 is의 주어 역할을 해야 하므로 복합관계대명사 (A)와 (D)가 정답 후보. 문맥상 '누구든 담당하고 있는 사람에게'란 뜻이 되어야 하므로 정답은 (D) whoever.

해석 | 이 서신을 누구든 귀사에서 뮤추얼 펀드를 담당하고 있는 사람에게 보내주십시오.

1. 복합관계대명사

복합관계대명사는 〈관계대명사+-ever〉의 형태로 선행사를 포함하고 있으므로 선행사가 없다. 또한 형용사절을 이끄는 관계대명사와는 달리 명사절이나 부사절을 이끈다.

종류	명사절(주어, 목적어 역할)	부사절(양보의 의미)
who(m)ever	~하는 사람은 누구나	누가[누구를] ~하든지
whatever	~하는 것은 무엇이나	무엇을 ~하든지
whichever	~하는 것은 어느 것이나	어떤 것을 ~하든지

명사절 **Whoever** has a bank account receives a monthly bank statement. [주어 역할]
은행 계좌가 있는 사람은 누구나 월별 은행 거래 내역서를 받는다.

부사절 **Whichever** you choose, you need to take responsibility for the result. [부사 역할]
당신이 어떤 것을 선택하든지, 그 결과에 대해 책임을 져야 한다.

Our servers make good recommendations **whenever** diners cannot decide what to order.

(A) whatever　　**(B) whenever**
(C) that　　(D) with regard to

빈칸 뒤에 절이 나오므로 접속사 역할을 하는 (A), (B), (C)가 정답 후보. 문맥상 '결정하지 못하실 때는 언제든지'란 의미가 적절하므로 정답은 복합관계부사 (B) whenever. 주어 또는 목적어 역할을 하는 명사절을 이끄는 (A)와 (C)는 오답.

해석 | 저희 서빙 직원들은 식사 손님들이 어떤 것을 주문할지 결정하지 못하실 때는 언제든지 좋은 추천을 해드립니다.

2. 복합관계부사

복합관계부사는 〈관계부사+-ever〉의 형태로 선행사를 포함하고 있으며, 부사절로 쓰여 두 가지 의미로 해석된다.

종류	양보의 의미	시간, 장소, 방법의 의미
whenever	언제든지(=no matter when)	~할 때는 언제나(=every time that)
wherever	어디든지(=no matter where)	~하는 곳은 어디서나(=in all places that)
however	아무리 ~한다 해도(=no matter how)	어떻게 ~할지라도(=in whatever way)

Whenever you need financial aid, just contact us for a free consultation.
=No matter when　금전적인 도움이 필요하실 때 언제든지 저희에게 연락 주시면 무료 상담이 가능합니다.

주의 복합관계부사 however는 다른 복합관계부사들과 달리 뒤에 형용사나 부사가 바로 나온다.

However carefully the inspector examines the facility, the problem could arise.
=No matter how　검사관이 아무리 조심스럽게 시설을 검사한다 해도, 문제는 발생할 수 있다.

FINAL TEST

1. A team of experts is reviewing the resolutions ------- contain laws against creating corporate monopolies.

(A) that (B) whom
(C) what (D) where

2. Tidal Productions' film directors, ------- action movies have received numerous recognitions, are working on a new project.

(A) which (B) that
(C) whose (D) when

3. The hospital is hiring first aiders ------- in responding to emergencies.

(A) experienced (B) instructed
(C) compromised (D) completed

4. The art museum ------- which Mr. Stephen's painting exhibit was held is visited by hundreds of tourists every day.

(A) to (B) for
(C) in (D) from

5. Workers at Protex Construction are required to take heavy-equipment training courses, which ------- the proper procedures to follow.

(A) explanation (B) explain
(C) explaining (D) explains

6. Lawyers who ------- attend seminars on new government policies gain valuable knowledge about their profession.

(A) instantly (B) regularly
(C) reasonably (D) comparatively

7. During difficult economic times, lenders conduct more extensive background checks on the people to ------- they make loans.

(A) whoever (B) what
(C) where (D) whom

8. My assistant sent the client a map of the building ------- we will discuss the terms of the negotiated contract.

(A) where (B) which
(C) who (D) what

9. Each section of a contract should be read carefully in order to know exactly ------- the document states.

(A) what (B) how
(C) some (D) many

10. Arguel Telecom took many measures to address its financial problems, none of ------- saved the firm from bankruptcy.

(A) whom (B) which
(C) that (D) who

11. Eagle Cargo can deliver your packages anywhere, ------- remote the location is.

(A) however (B) whenever
(C) whatever (D) whichever

12. The sales report for Dreda Tech, ------- profits have been increasing every month, showed a slowdown of the growth.

(A) whose (B) what
(C) which (D) that

13. ------- leaves the laboratory last has the responsibility of ensuring that the heating equipment has been shut down.

(A) Whatever (B) Whomever
(C) Whoever (D) Whenever

14. Security officers will block access to the main roads this Saturday, ------- Mayor Gustavo will be giving a speech.

(A) then (B) where
(C) which (D) when

DAY 17

정답 및 해설 68쪽

CHAPTER
7

-

구문편

DAY 18
비교 구문

—

기본 개념 노트

본 학습에 들어가기 전에 기본 문법 개념의 틀을 잡아보자.

❶ 비교급과 최상급의 형태와 의미

원급에 해당하는 형용사, 부사의 형태에 비교의 의미를 가진 -er/more를 붙인 형태를 비교급, 최상의 의미를 가진 -est/most를 붙인 형태를 최상급이라고 한다.

	원급(~만큼 ⋯한)	비교급(~보다 ⋯한)	최상급(가장 ⋯한)
1, 2음절 단어	strong 강한	strong**er** 더 강한	strong**est** 가장 강한
3음절 이상 단어	efficiently 효율적으로	**more** efficiently 더 효율적으로	**most** efficiently 가장 효율적으로
불규칙 변화	good, well 좋은, 잘	better 더 좋은, 더 잘	best 최고의, 가장 잘
	bad, ill 나쁜, 아픈	worse 더 나쁜, 더 아픈	worst 최악의, 최악으로
	many, much 많은, 많이	more 더 많은, 더 많이	most 가장 많은, 가장 많이
	little 적은, 적게	less 더 적은, 더 적게	least 가장 적은, 가장 적게

❷ 비교 구문

원급, 비교급, 최상급을 이용해 만든 구문으로 원급 비교, 비교급 비교, 최상급 비교가 있다.

원급 비교	① Few violinists are **as** talented **as** Leona Baca.
비교급 비교	② His car was **wider than** the parking spot, so he couldn't park there.
최상급 비교	③ This is **the most** sophisticated navigation system.

① 레오나 바카 씨만큼 재능 있는 바이올리니스트는 거의 없다. ② 그의 차는 주차 공간보다 폭이 더 넓어서 그는 그곳에 주차할 수 없었다. ③ 이것은 가장 정교한 내비게이션 시스템이다.

SELF-TEST

기본 개념이 토익에는 어떻게 출제되는지 알아보자. ⏱ 제한시간 03:00

다음 핵심 포인트를 참고하여
정답이 되는 이유를 적어보자. **NOTE**

1. The movie pass lets viewers watch ------- films as they want during the festival.

 (A) so much (B) as many
 (C) as long as (D) at most

2. The new city guidebook for Chester's tourist sites sold out ------- than its previous edition.

 (A) rapid (B) rapidly
 (C) most rapidly (D) more rapidly

3. Knockset is the ------- brand of electronic gate and door locks in Lancaster Hardware.

 (A) cheaper (B) cheap
 (C) cheapest (D) cheaply

4. Managers review project reports ------- than before to accurately measure their teams' productivity.

 (A) most careful (B) most carefully
 (C) more careful (D) more carefully

5. Some of the ------- soccer teams in the World Cup came from Latin American countries.

 (A) strongest (B) stronger
 (C) strength (D) strengthen

6. Boxmate is ------- the top supplier of carton containers to toy manufacturers.

 (A) no longer (B) in return
 (C) no more (D) now that

1. 원급 비교

2. than

3. the, in Lancaster Hardware

4. 형용사 vs. 부사

5. 다양한 비교 구문

6. 비교 구문 관용표현

DAY 18

문제별 출제 **POINT** ▶ 다음 페이지에서 확인하기

원급 & 비교급

빈칸 뒤의 **as**를 보고 원급을 고르는 문제와 **than**을 보고 비교급을 고르는 문제가 주로 출제된다. 비교급을 강조하는 부사를 묻는 문제도 출제되고 있으니 이 부사들은 반드시 외워두자.

SELF-TEST 1

The movie pass lets viewers watch **as many** films as they want during the festival.

(A) so much **(B) as many**
(C) as long as (D) at most

빈칸 뒤의 as를 보고 원급 비교구문인 〈as+many[much]+명사+as〉를 떠올릴 수 있으면 문제를 쉽게 풀 수 있다. 빈칸 뒤 films가 가산명사 복수형이므로 as many가 쓰여야 한다. 따라서 정답은 (B).

해석 | 그 영화 입장권은 관람객이 축제 기간 동안에 원하는 만큼 많은 영화를 볼 수 있게 해준다.

1. 원급 비교 구문

원급 비교란 원급을 이용해 두 대상을 동등하게 비교하는 것으로 〈as+형용사/부사의 원급+as〉의 형태이다.

〈as+형용사+as〉 ~만큼 …한	The second candidate was not **as** <u>confident</u> **as** the first one. 두 번째 후보자는 첫 번째 후보자만큼 자신감이 넘치지 않았다.
〈as+부사+as〉 ~만큼 …하게	Ben operates the branch **as** <u>smoothly</u> **as** the former manager. 벤 씨는 이전 관리자만큼 순조롭게 그 지사를 운영한다.
〈as+many+복수 명사+as〉 ~만큼 많은	Aron does not supervise **as many** <u>people</u> **as** Sheila does. 아론 씨는 실라 씨가 하는 것만큼 많은 사람들을 감독하지는 않는다.
〈as+much+불가산명사+as〉 ~만큼 많은	The new laptop has **as much** <u>memory</u> **as** our current one. 새로운 노트북은 우리의 현재 노트북만큼 많은 메모리를 가지고 있다.

SELF-TEST 2

The new city guidebook for Chester's tourist sites sold out **more rapidly** than its previous edition.

(A) rapid (B) rapidly
(C) most rapidly **(D) more rapidly**

빈칸 뒤에 than이 있으므로 빈칸에는 비교급이 와야 한다. 따라서 정답은 (D) more rapidly. rapidly가 3음절 이상의 단어이므로 more을 붙여 비교급을 만들었다.

해석 | 체스터 시의 관광지에 관한 새로운 도시 여행 안내서는 이전 판보다 더 빨리 팔렸다.

2. 비교급 비교 구문

비교급 비교란 비교급을 이용해 두 대상의 우열을 비교하는 것으로 〈비교급+than〉이 기본 형태이다.

형용사 비교급	▸ 〈비교급+than〉 Tim hired Sam because he was **more outgoing than** the other applicants. 팀 씨는 샘 씨가 다른 지원자들보다 더 외향적이었기 때문에 그를 고용했다.
	▸ 〈비교급+명사+than〉 Cosbro reported **higher** <u>returns</u> **than** its competitors during the first quarter. 코스브로 사는 1분기 동안에 경쟁사들보다 높은 수익을 기록했다고 보고했다.
부사 비교급	▸ 〈비교급+than〉 This year, tax revenues declined **more severely than** last year. 올해 조세 수입이 작년보다 더 심하게 감소했다.

3. 비교급을 강조하는 부사

even, much, far, a lot, still 훨씬	considerably, significantly, substantially 상당히

Mr. Orland's desk is **a lot** <u>tidier</u> than Mr. Garcia's. 올랜드 씨의 책상은 가르시아 씨의 것보다 훨씬 더 깔끔하다.

최상급 & 품사 구별

빈출되는 형용사 최상급 문제의 단서는 빈칸 앞의 **the**와 빈칸 뒤의 범위를 정해주는 전치사구이다. 비교 구문에서 형용사와 부사의 품사를 구별하는 문제도 출제되므로 각 품사의 쓰임을 확실히 알아두자.

Knockset is the **cheapest** brand of electronic gate and door locks in Lancaster Hardware.

(A) cheaper (B) cheap
(C) cheapest (D) cheaply

빈칸 앞의 the와 문장 맨 끝의 in Lancaster Hardware라는 범위를 정해주는 전치사구를 통해 빈칸은 형용사 최상급 자리임을 알 수 있다. 따라서 정답은 (C) cheapest.

해석 | 녹셋은 랭캐스터 철물점에서 파는 전자 현관과 출입문 자물쇠 중 가장 저렴한 브랜드다.

1. 최상급 비교 구문

최상급 비교란 최상급을 이용해 셋 이상의 것 중 그 정도가 가장 큰 것을 나타내는 것이다. 형용사 최상급은 앞에 반드시 the나 소유격이 오고, 보통 뒤에 범위를 나타내는 전치사구나 절이 온다. 부사 최상급에는 the를 붙이지 않는다.

형용사 최상급	▸ 〈the[소유격]+최상급+명사+of[in, among, on]〉 ~ 중에 가장 …한 For safety, the vehicle received **the highest** rating **in** its class. 안전성에서, 그 차는 동급 중 최고의 평가를 받았다. ▸ 〈the[소유격]+최상급+명사+(that)+주어+have ever *p.p.*〉 이제까지 ~한 것 중에 가장 …한 It is **the best** movie I have ever seen. 그것이 내가 이제까지 본 것 중에 최고의 영화다.
부사 최상급	▸ 〈most+부사〉 가장 …하게 Everyone agrees that Emily plays the flute **most beautifully**. 모두들 에밀리 씨가 플루트를 가장 아름답게 연주한다는 데 동의한다.

2. 최상급을 강조하는 부사

much, quite, far, by far, the very 훨씬, 단연코

Jenny is **by far** the most energetic person in the office. 제니 씨는 회사에서 단연 최고로 활동적인 사람이다.

Managers review project reports **more carefully** than before to accurately measure their teams' productivity.

(A) most careful (B) most carefully
(C) more careful **(D) more carefully**

빈칸 뒤에 than이 있으므로 빈칸에는 비교급이 들어가야 한다. 따라서 (C)와 (D)가 정답 후보. 문장을 살펴보니 보어가 필요 없는 완전한 문장이므로 보어 역할을 하는 형용사 비교급인 (C)는 오답이고 동사 review를 수식하는 부사 비교급인 (D) more carefully가 정답이다.

해석 | 관리자들은 팀의 생산성을 정확하게 측정하기 위해 프로젝트 보고서를 이전보다 더 신중하게 검토한다.

3. 비교 구문의 품사 구별_형용사 vs. 부사

문장이 보어가 필요한 불완전한 문장이라면 형용사 비교 구문을, 완전한 문장이라면 부사 비교 구문을 넣어야 한다.

형용사	▸ **불완전한 문장** The limited-edition phone is **more popular than** its regular model. [보어 자리] ~~popularly~~ 그 한정판 전화기는 정규 모델보다 더 인기가 있다.
부사	▸ **완전한 문장** Speedies Inc. ships packages **more reliably than** Quickers. [동사 수식] ~~reliable~~ 스피디스 사는 퀴커스 사보다 더 신뢰감 있게 배송물을 운송한다.

다양한 비교 구문

원급, 비교급, 최상급을 이용한 다양한 구문들과 하나의 어구처럼 굳어져 사용되는 관용표현을 묻는 문제도 출제된다. 따라서 함정에 빠지지 않도록 각 구문을 형태에 주의하여 기억해 두자.

Some of the **strongest** soccer teams in the World Cup came from Latin American countries.

(A) strongest　　(B) stronger
(C) strength　　(D) strengthen

빈칸 앞의 Some of the를 보자마자 '가장 ~한 것 중 일부'란 의미의 〈some of the+최상급+복수 명사〉를 떠올릴 수 있어야 한다. 따라서 정답은 형용사 strong의 최상급인 (A) strongest.

해석 | 월드컵에서 가장 강한 축구팀 중 일부는 라틴 아메리카 국가 중에서 나왔다.

1. 원급을 이용한 구문

〈as+원급+as possible〉 가능한 한 ~한[하게]	He tried to explain the problem **as politely as possible**. 그는 가능한 한 공손하게 그 문제를 설명하려고 노력했다.
〈배수사+as+원급+as〉 …보다 몇 배 ~한[하게]	The new material being developed is **twice as strong as** steel. 개발 중인 그 신소재는 강철보다 두 배 더 튼튼하다.

2. 비교급을 이용한 구문

〈the 비교급, the 비교급〉 ~하면 할수록, 더 …하다	**The more often** you stretch, **the more flexible** you become. 스트레칭을 더 자주 할수록, 더 유연해진다.
〈the+비교급+of the two〉 둘 중에 더 ~한[하게]	Mr. York is **the more demanding of the two** supervisors at our firm. 요크 씨는 우리 회사의 두 감독관 중에서 요구가 더 많은 사람이다.

3. 최상급을 이용한 구문

〈one[some] of the+최상급+복수 명사〉 가장 ~한 것 중의 하나[일부]	This is **one of the most critical moments**. 이번은 가장 중요한 순간 중 하나이다.

Boxmate is **no longer** the top supplier of carton containers to toy manufacturers.

(A) no longer　　(B) in return
(C) no more　　(D) now that

문맥상 '더 이상 최고의 공급사가 아니다'라는 의미이므로 정답은 (A). no longer가 '더 이상 ~이 아닌'의 의미로 쓰인다는 것을 알면 쉽게 풀 수 있는 문제로, 자주 출제되는 비교 구문 관용표현은 외워두자.

해석 | 박스메이트 사는 더 이상 장난감 제조 업체에 종이 상자를 공급하는 최고의 공급사가 아니다.

4. 비교 구문 관용표현

하나의 어구처럼 굳어져 사용되는 원급, 비교급, 최상급을 이용한 관용표현은 표현 그대로 기억해 두자.

as much[many] as ~만큼이나	more or less 거의	no longer 더 이상 ~이 아닌
at least 적어도, 최소한	more than ~ 이상	no more than 단지 ~만큼
at most 기껏해야	no later than 늦어도 ~까지	rather than ~보다는, ~ 대신에
less than ~ 이하	no less than ~만큼씩이나	비교급+than ever 어느 때보다 더

Requests should be submitted **no later than** July 31. 요청 사항은 늦어도 7월 31일까지는 제출되어야 한다.

There is **no longer** a need for substantial cuts in dividend payments.
배당금 지급액의 상당 부분을 더 이상 삭감할 필요가 없다.

FINAL TEST

1. Customers whose pizza deliveries are delayed for more ------- 30 minutes are entitled to a $10 gift certificate.

 (A) than (B) as
 (C) for (D) over

2. Finding a job has become ------- more difficult in New York where many companies are affected by the economic crisis.

 (A) around (B) even
 (C) very (D) about

3. All advanced measures were taken for the maintenance work on the bridge to be as ------- as possible.

 (A) smoothly (B) smoothest
 (C) smooth (D) smoother

4. The number of foreign tourist arrivals in Bali is typically the ------- in July and August.

 (A) greatest (B) greatly
 (C) greater (D) great

5. With the rearranged shelves at Anton Supermarket, the dairy products may now be found ------- easily than other items.

 (A) more (B) very
 (C) most (D) least

6. ------- than closing some offices, the advertising company offered an early retirement package to senior staff members.

 (A) Less (B) Rather
 (C) More (D) Instead

7. The Wonder induction stove comes with energy-saving features, so it uses ------- electricity than other brands.

 (A) few (B) less
 (C) most (D) least

8. The director provided ------- support to the sales team as to the marketing communications group.

 (A) as long as (B) so that
 (C) as much (D) so many

9. The city's ------- parking policies have cleared the busy streets in the downtown area.

 (A) strictness (B) strictly
 (C) more strictly (D) strictest

10. Mr. Elliot reacted ------- to our latest window design suggestion than to the previous ones.

 (A) most positively (B) more positively
 (C) more positive (D) most positive

11. In a recent study, automatic trains were found to be safer than those ------- by human.

 (A) operated (B) switched
 (C) debated (D) canceled

12. This month's anniversary issue of *Business Magazine* features some of the ------- billionaires in Washington.

 (A) young (B) younger
 (C) youngest (D) youth

13. Employees who wish to sign up for the badminton league need to notify the HR department no ------- than June 15.

 (A) later (B) latest
 (C) lately (D) late

14. The ------- the company invests in the new construction project, the greater its legal liability becomes.

 (A) most (B) more
 (C) mostly (D) moreover

DAY 18

Questions 15-18 refer to the following advertisement.

GreatJobs1.com has come to Malaysia!

We are pleased to inform you that Greatjobs1.com, one of Europe's largest employment firms, is now serving Malaysia. We are in the process of building the new network, through ------ **15.** companies across the country will be able to find the best candidates.

We specialize in banking and finance placements, and we maintain the ------ service packages in **16.** our field. We provide online recruitment, classified advertisement, and outsourced headhunting services. Through these services, we link ------ 50,000 job seekers to vacancies that best suit **17.** their credentials every day.

Register for a free trial of our services and strengthen your workforce now by calling 555-9097. ------. **18.**

15. (A) whom
 (B) which
 (C) whose
 (D) that

16. (A) more comprehensively
 (B) comprehension
 (C) comprehensively
 (D) most comprehensive

17. (A) more
 (B) at least
 (C) equal to
 (D) less

18. (A) Our recruitment experts are waiting to assist you.
 (B) You may extend your subscription anytime this month.
 (C) Our staff will provide you with useful financial advice.
 (D) We can find you a job you love quickly.

Questions 19-22 refer to the following memo.

To: All Employees
From: Administrative Office
Date: June 5, Friday
Subject: Repair work

------. During the last inspection, the maintenance team noticed that many heater pipes in the
 19.
floor's ceiling were ------ damaged. We have ordered new pipes, but they will not arrive until next
 20.
week. Because of this, it might take ------ than one week for our heating system to be restored.
 21.

We understand that the staff members of the finance department are currently affected by the

problem. Therefore, they will be temporarily relocated to the fifth floor, ------ the sales team used
 22.
to operate.

Thank you for your patience and understanding. If you have questions, please let us know.

19. (A) As you know, our office building will
 undergo an inspection.
 (B) We are pleased to inform you that the air
 conditioning units have been replaced.
 (C) We would like to announce that we are
 moving to a new building.
 (D) Please be advised that the heating
 system on the third floor is under repair.

20. (A) usually
 (B) severely
 (C) exactly
 (D) toughly

21. (A) length
 (B) longest
 (C) longer
 (D) long

22. (A) where
 (B) since
 (C) whereas
 (D) then

DAY 18

정답 및 해설 71쪽

CHAPTER

7

-

구문편

DAY 19
가정법과 도치

—

기본 개념 노트

본 학습에 들어가기 전에 기본 문법 개념의 틀을 잡아보자.

❶ 가정법 개념

실제로 일어나지 않았거나 사실과 반대인 일을 가정할 때 사용하는 표현을 가정법이라 한다.

직설법	① **If** she **has** the warranty, she **can receive** a full refund. 그녀가 보증서를 가지고 있으면, 전액 보상을 받을 수 있다. [실현 가능성 높음]
가정법	② **If** she **had** the warranty, she **could receive** a full refund. 그녀가 보증서를 가지고 있다면, 전액 보상을 받을 수 있을 텐데. [실현 가능성 낮음]

❷ 가정법 종류

가정법에는 가정법 과거, 가정법 과거완료, 가정법 미래가 있다.

가정법 과거 만약 ~한다면, …할 텐데 (현재 사실 반대)	If+주어+ [동사 과거형 / were], 주어+would[could, might, should]+동사원형 ③ **If** he **had** enough time, he **would help** you.
가정법 과거완료 만약 ~했다면, …했을 텐데 (과거 사실 반대)	If+주어+had p.p., 주어+would[could, might, should]+have p.p. ④ **If** Tan **had called**, he **would have left** a message.
가정법 미래 만약 ~한다면, …해라 […할 것이다] (실현 가능성 낮은 미래의 일)	If+주어+should+동사원형, [명령문 / 주어+will[can, may, shall]+동사원형] ⑤ **If** there **should be** any change, **please call** me.

❸ 도치 개념

<주어+(조)동사>의 기본 어순과 달리 <(조)동사+주어>로 자리가 바뀌는 현상을 도치라고 한다.

가정법 도치	⑥ **Should** you have any problems, please contact our staff.
부정어구 도치	⑦ **Hardly** had the rain started when the roof began leaking.
보어 도치	⑧ **Enclosed** are the materials needed for the workshop.

① 그녀가 보증서를 가지고 있으면, 전액 보상을 받을 수 있다. ② 그녀가 보증서를 가지고 있다면, 전액 보상을 받을 수 있을 텐데. ③ 그가 시간이 충분하다면, 당신을 도와줄 텐데. ④ 탄 씨가 전화했다면, 메시지를 남겼을 텐데. ⑤ 변경 사항이 있다면, 저에게 연락해 주십시오. ⑥ 문제가 생긴다면, 저희 직원에게 연락해 주십시오. ⑦ 비가 오기 시작하자마자 지붕에서 물이 새기 시작했다. ⑧ 동봉된 것은 워크숍에 필요한 자료들이다.

SELF-TEST

기본 개념이 토익에는 어떻게 출제되는지 알아보자. ⏱ 제한시간 03:00

다음 핵심 포인트를 참고하여
정답이 되는 이유를 적어보자. NOTE

1. If Ms. Bullock had not arrived today, I ------- the speech training myself.

 (A) conduct
 (B) will conduct
 (C) conducted
 (D) would have conducted

 1. If + 주어 + had + P.P

2. If your computer should experience any problem within the warranty period, you ------- free repair service.

 (A) received
 (B) would have received
 (C) receives
 (D) will receive

 2. If + 주어 + should + 동사원형

3. ------- you lose your luggage, please call our hotline at 555-2343 to request a lost item form.

 (A) Should
 (B) In fact
 (C) Where
 (D) Through

 3. 가정법 도치

4. ------- had Darren seen such a long line for a movie on its opening night.

 (A) Never
 (B) None
 (C) Even
 (D) Ever

 4. 부정어구 도치

5. Only recently has the CEO ------- that providing regular salary raises inspires employees to work harder.

 (A) recognizing
 (B) recognize
 (C) recognized
 (D) recognition

 5. 문두의 Only recently

6. ------- is the updated itinerary for Mr. Johnson's business trip to Chennai and Mumbai next week.

 (A) Attaching
 (B) Attached
 (C) Attachable
 (D) Attachment

 6. 보어 도치

DAY 19

문제별 출제 **POINT** ▶ 다음 페이지에서 확인하기

177

가정법

가정법의 알맞은 동사를 묻는 문제가 종종 출제되는데, 이때 주절이나 if절의 동사 형태가 핵심 단서가 된다. 문장의 내용과 시점에 따라 가정법의 동사가 각각 어떤 형태로 쓰이는지 정리해 두자.

SELF-TEST 1

If Ms. Bullock had not arrived today, I **would have conducted** the speech training myself.

(A) conduct (B) will conduct
(C) conducted **(D) would have conducted**

주절에 빈칸이 있으므로 if절의 동사를 잘 살펴봐야 한다. if절의 동사 had not arrived가 과거완료 형태이고 문맥상으로도 과거 사실과 반대되는 일을 가정하고 있으므로, 가정법 과거완료를 써서 would have *p.p.* 형태인 (D) would have conducted가 정답이다.

해석 | 불럭 씨가 오늘 도착하지 않았더라면, 내가 화술 교육을 혼자 진행했을 텐데.

출제원리

1. 가정법 과거

현재 사실을 반대로 가정할 때 아래와 같은 형태로 쓰인다.

> If + 주어 + 동사 과거형(be동사는 were), 주어 + would[could, might, should] + 동사원형 만약 ~한다면, …할 텐데

If he **applied** for the position, he **would get** it. 그가 그 자리에 지원한다면, 붙을 텐데.
If she **were** available, she **would take** the job. 그녀가 여유가 있다면, 그 일을 할 텐데.

2. 가정법 과거완료

과거 사실을 반대로 가정할 때 쓰며 if절에는 과거완료(had *p.p.*), 주절에는 〈조동사의 과거형 + have *p.p.*〉를 쓴다.

> If + 주어 + had *p.p.*, 주어 + would[could, might, should] + have *p.p.* 만약 ~했다면, …했을 텐데

If he **had sent** the proposal on time, the client **would have accepted** our offer.
그가 제안서를 제시간에 보냈다면, 고객이 우리의 제안을 받아들였을 텐데.

SELF-TEST 2

If your computer should experience any problem within the warranty period, you **will receive** free repair service.

(A) received (B) would have received
(C) receives **(D) will receive**

if절의 〈If + 주어 + should + 동사원형〉 구조를 보고 가정법 미래가 쓰였음을 알 수 있고, 문맥상으로도 정중한 제안을 하고 있다. 가정법 미래의 주절에는 명령문이나 〈주어 + will[can, may, shall] + 동사원형〉을 쓰므로 정답은 (D) will receive.

해석 | 보증 기간 내에 귀하의 컴퓨터에 문제가 발생하면, 수리 서비스를 무료로 받으실 것입니다.

출제원리

3. 가정법 미래

미래에 실현될 가능성이 낮은 일을 가정할 때 쓰며, 토익에서는 정중한 요청이나 제안을 하는 경우에 많이 쓰인다.

> If + 주어 + should + 동사원형, ┌ 명령문 만약 ~한다면, …해라
> └ 주어 + will[can, may, shall] + 동사원형 만약 ~한다면, …할 것이다

If you **should lose** your passport, you **can replace** it. 여권을 잃어버리시면, 재발급 받을 수 있습니다.

4. 혼합가정법

과거의 일이 현재에도 영향을 주는 경우 사용하며, 가정법 과거와 가정법 과거완료가 혼합된 형태이다. 보통 주절에 now, today 등의 현재를 나타내는 표현이 쓰인다.

> If + 주어 + had *p.p.*, 주어 + would[could, might, should] + 동사원형 (과거에) 만약 ~했다면 (지금) …할 텐데

If the computer **had worked** well, we **would have** less work <u>now</u>.
컴퓨터가 제대로 작동했다면, 우리는 지금 일이 더 적을 텐데.

가정법 도치 & 부정어구 도치

가정법 문장에서 if가 생략되면, 기본 어순이 《(조)동사+주어》로 도치되며 이를 이용하여 동사 자리를 묻는 문제가 출제된다. 부정어구가 문두에 올 때에도 도치가 일어나므로 형태에 주의하자.

Should you lose your luggage, please call our hotline at 555-2343 to request a lost item form.

(A) Should (B) In fact
(C) Where (D) Through

빈칸이 포함된 절은 문맥상 '만일 ~하면'이라는 뜻인데, 선택지 중에 if가 없으므로 if가 생략된 도치 구문인지 확인해봐야 한다. 주절에 명령문이 쓰인 가정법 미래 구문으로 if가 생략되면서 주어와 조동사가 도치되어 should가 문두로 나간 형태이다. 따라서 정답은 (A).

해석 | 귀하의 짐을 잃어버리셨으면, 저희 상담 전화 555-2343으로 전화하셔서 분실물 신고 양식을 요청하십시오.

1. 가정법 if의 생략과 도치

if절에 be동사 were나 조동사 had, should가 쓰일 경우 if가 생략되고 were나 조동사가 문두에 위치할 수 있다. 이때는 남아 있는 주절의 형태를 보고 가정법 문장임을 짐작할 수 있으므로 if가 생략된 절의 어순에 주의하자.

If+주어+were	→ Were+주어
If+주어+had+*p.p.*	→ Had+주어+*p.p.*
If+주어+should+동사원형	→ Should+주어+동사원형

Were you to buy the items individually, they **would be** very expensive.
= **If** you **were** to buy the items individually, they **would be** very expensive.
그 물품들을 개별적으로 구입하면, 매우 비쌀 텐데.

Had he **heard** the news earlier, he **wouldn't have signed** the contract.
= **If** he **had heard** the news earlier, he **wouldn't have signed** the contract.
그가 그 소식을 더 빨리 들었더라면, 계약서에 서명하지 않았을 텐데.

Should you **need** anything else, simply **contact** the front desk.
= **If** you **should need** anything else, simply **contact** the front desk.
다른 것이 필요하시면, 안내 데스크로 연락해 주십시오.

Never had Darren seen such a long line for a movie on its opening night.

(A) Never (B) None
(C) Even (D) Ever

빈칸 바로 뒤에 《had+주어+*p.p.*》 형태로 도치된 구조를 보고 빈칸이 부정어구 자리인지를 의심해봐야 한다. 문맥상 '본 적이 없다'라는 부정의 의미가 적절하므로 부정어 (A) Never가 정답. (B) None은 부정의 의미이지만 도치 구문을 이끌지 않으므로 오답이다.

해석 | 대런 씨는 개봉 첫날밤에 영화를 보기 위해 그렇게 길게 늘어선 줄을 본 적이 없었다.

2. 부정어구 도치

준부정어나, 부정어구가 포함된 표현이 문두에 올 때 주어와 (조)동사의 도치가 일어난다. 보통 주어와 (조)동사의 위치만 바뀌지만, 일반동사의 경우 《do[does, did]+주어+동사원형》의 형태로 바뀌므로 어순에 주의하자.

hardly, seldom, rarely, scarcely, little 거의 ~ 않다	not until ~할 때까지 … 않다[~하고 나서야 …하다]
never 결코 ~ 않다	no + 명사 어떤 ~도 … 않다

Never should you purchase a used car without a mechanical inspection.
부정어 조동사 주어 기계 점검 없이는 절대 중고차를 구입하지 말아야 한다.

Not until he had heard the full report did he realize the severity of the situation.
do동사 주어 동사원형 상세한 보고를 듣고 나서야 그는 상황의 심각성을 깨달았다.

부사구 및 보어의 도치

〈only+시간을 나타내는 부사(구)/절〉이 문두에 오는 도치 구문에서 동사의 형태를 묻는 문제가 종종 출제된다. 보어가 문두에 오는 도치 구문에서 보어의 형태를 묻는 문제도 출제되므로 어순에 주의하자.

Only recently has the CEO **recognized** that providing regular salary raises inspires employees to work harder.

(A) recognizing (B) recognize

(C) recognized (D) recognition

알맞은 동사의 형태를 묻는 문제로 문두에 나온 Only recently를 보고 〈only+시간을 나타내는 부사〉로 인해 주어와 동사가 도치된 문장임을 파악해야 한다. 〈주어+has p.p.〉가 도치되면 〈has+주어+p.p.〉 형태가 되므로 정답은 (C) recognized.

해석 | 최근에서야 그 대표이사는 정기적으로 임금을 인상하는 것이 직원들로 하여금 더 열심히 근무하도록 고무시킨다는 것을 깨달았다.

1. 〈only+시간을 나타내는 부사(구)/절〉의 도치

only가 시간을 나타내는 부사(구)나 절과 함께 문두에 쓰일 경우 도치 현상이 일어난다.

Only during intermission can audience members use a cell phone.
조동사 주어 휴식 시간 중에만 청중들은 휴대 전화를 사용할 수 있다.

Only after the plane had landed safely was Erica able to relax.
동사 주어 비행기가 안전하게 착륙한 후에야 에리카 씨는 마음을 놓을 수 있었다.

2. 부사구 도치

의미의 강조를 위해 장소, 방향을 나타내는 부사구가 문두에 올 경우 주어와 동사가 도치된다.

From the back of the auditorium came a small voice. 강당 뒤편에서 작은 목소리가 들려왔다.
동사 주어

Attached is the updated itinerary for Mr. Johnson's business trip to Chennai and Mumbai next week.

(A) Attaching **(B) Attached**

(C) Attachable (D) Attachment

빈칸이 be동사 앞에 있어 주어 자리로 착각하기 쉽지만 이 문장은 〈보어+동사+주어〉로 도치된 구문이다. 보어에 해당하는 attached가 문두에 위치할 경우 주어와 동사의 어순이 바뀌므로 정답은 (B). (D) Attachment도 명사로 주어 자리에 올 수 있지만 가산명사의 단수형으로 한정사와 함께 쓰이거나 복수 형태로 쓰여야 하므로 오답이다.

해석 | 첨부된 것은 존슨 씨의 다음 주 첸나이와 뭄바이행 출장의 최신 일정표이다.

3. 보어 도치

문장에서 주어가 긴 경우나 의미의 강조를 위해 보어가 문두에 위치하는 경우 도치가 일어난다. 토익에 자주 등장하는 attached(첨부된)와 enclosed(동봉된)를 반드시 기억하자. 이때는 attached, enclosed를 주어처럼 해석하면 문장 구조가 쉽게 파악된다.

Attached is a copy of the updated service agreement. 첨부된 것은 서비스 동의서의 최신 사본입니다.
보어 동사 주어

4. so와 neither가 이끄는 도치

〈so+(조)동사+주어〉 형태의 도치 구문은 앞의 내용을 간단히 so로 대신해 '~도 역시 …하다'를 뜻한다. 반대로 '~도 역시 …하지 않다'라는 부정의 의미로는 〈neither+(조)동사+주어〉를 쓴다.

The rent should be paid by Monday, and **so** should the deposit.
조동사 주어
집세는 월요일까지 납부되어야 하고 보증금 역시 그렇게 되어야 한다. (보증금도 월요일까지 납부되어야 한다.)

The delivery fee is not included, and **neither** is tax.
동사 주어
배송료는 포함되지 않고 세금 역시 그렇지 않다. (세금도 포함되지 않는다.)

FINAL TEST

1. Mr. Tate could submit a suggestion for the new marketing campaign if the manager ------- the deadline by one week.

(A) extended
(B) extension
(C) extending
(D) extends

2. If Tucker's Works had informed us of the malfunction earlier, we ------- the ordered item much sooner.

(A) had replaced
(B) would replace
(C) replaced
(D) would have replaced

3. ------- could Professor Wiseley have known that his book on personal finance was going to be published in many countries.

(A) A few
(B) Little
(C) Less
(D) Always

4. If Omsen Freight Services ------- on increasing its corporate rates, we would have signed a contract with another supplier.

(A) have insisted
(B) insists
(C) had insisted
(D) insist

5. ------- is a detailed plan of the expansion of the Melville Library on Seventh Street.

(A) Enclosed
(B) Enclosure
(C) Enclosing
(D) Encloses

6. If vacuum cleaner importers supplied clearer instructions, they ------- so many inquiries from retail clients.

(A) did not received
(B) had not received
(C) are not received
(D) would not receive

7. If you should ------- this offer, we will send a representative to your office next week with the contract to be signed.

(A) receive
(B) accept
(C) reduce
(D) expect

8. Rarely does Mr. Gunther ------- past eight o'clock, so Ms. Merica was surprised to see him still in his office at nine.

(A) stay
(B) stays
(C) stayed
(D) will stay

9. If Charles should be promoted to manager, the staff ------- happily under his leadership.

(A) works
(B) will work
(C) will have worked
(D) worked

10. If the renovations for the function room had not finished last week, Ms. Cosswind ------- today's office party.

(A) would cancel
(B) was cancelled
(C) has cancelled
(D) are cancelling

11. During the power failure, the system in the office was not working, and ------- were the outside surveillance cameras.

(A) which
(B) not
(C) whether
(D) neither

12. ------- after tonight's client meeting was Mr. Beacon able to answer all the e-mails he received yesterday.

(A) Only
(B) Often
(C) None
(D) Almost

13. Had Thompson Corporation not acquired Elsave Plans last year, a strong competitor ------- ownership of the insurance company.

(A) should obtain
(B) will be obtaining
(C) would have obtained
(D) has obtained

14. ------- your dental checkup be postponed by Dr. Lucas, we will give you a call the day before your appointment.

(A) So
(B) Should
(C) If
(D) Due to

DAY 19

CHAPTER

8

-

질문 유형편_PART 6

DAY 20
알맞은 문장 고르기

—

기본 개념 노트

본 학습에 들어가기 전에 Part 6의 신유형과 정답 단서를 알아보자.

문맥에 맞는 알맞은 문장을 고르는 문제는 신토익에서 **Part 6**에 새롭게 추가된 문제 유형이다. 빈칸 앞뒤 문장의 흐름에 자연스럽게 이어지는 문장을 고르는 문제로 고난도 유형에 속한다. 전체 지문을 읽어야 풀 수 있는 문제도 출제되어 문제 풀이 시간이 기존보다 오래 걸리지만, 단서 유형을 알고 단서를 찾아가며 문제를 풀다 보면 문제 풀이 시간을 줄일 수 있으므로 단서 찾는 연습을 꾸준히 하자.

❶ Part 6

문제 유형	• 4개의 선택지 중 빈칸에 알맞은 단어/구/문장을 고르는 문제 • Part 5와 같이 구조, 문법, 어휘 지식을 묻는 문제 지문당 3문항 • 빈칸에 문맥상 알맞은 문장을 고르는 문제 지문당 1문항
지문 유형	• 이메일/편지, 메모, 광고, 공지, 기사 등
특징	• 지문 하나당 4개의 문항 출제 • 지문 속에서 전체 맥락을 통해 정답을 골라야 하는 문제도 출제

❷ 신유형

유형	• 문맥에 맞는 알맞은 문장 고르기 문제로 지문당 1문항 출제
문제 위치	• 지문 어디에서나 출제 가능
특징	• 선택지가 모두 완전한 문장 • 단락의 구조와 논리적 흐름 파악이 중요

❸ 정답 단서

지시어 및 대명사	지시어 및 대명사는 반복을 피하기 위해 앞에 언급된 명사 또는 문장 전체를 대신해서 쓰므로 빈칸 앞뒤 내용에 들어갈 알맞은 문장을 고르는 데 중요한 단서가 된다. 예시: he, she, it, this, that, these, those, them
연결어	연결어는 지문의 논리적 흐름을 보여주므로 문맥 파악의 가장 큰 단서가 된다. 예시: however 그러나 therefore 그러므로 otherwise 그렇지 않으면 also 또한 in addition 게다가 that is 즉
지문 구조	지문 구조에 따른 내용을 알아두면 빈칸의 위치에 따라 들어갈 내용을 예측할 수 있다. 서론: 주제나 목적 본론: 구체적인 예시나 문제점, 제품의 특징 등 결론: 요청 사항이나 첨부 내용, 인사말

단서 ① 지시어 및 대명사

지시어 및 대명사는 앞에 언급한 명사 또는 문장 전체를 대신 일컫는 말이다. 지시어나 대명사가 선택지에 나오면 이것이 가리키는 대상을 찾아 선택지를 빈칸에 넣어보고 문맥이 자연스러운지 확인한다.

예제 1

The end of the summer is approaching, but there's still time to book an unforgettable vacation! To help make your dreams come true, Sansha Travels is having an unbelievable sale!

For bookings made in the month of August, we are giving 10 percent off all of our South American packages. ------. Check our Web site at www.sanshatravels.com for a detailed description of each option, and find the perfect destination for you.

1.

Don't miss out on this great opportunity! Take advantage of this limited-time promotion by calling our agency today.

1. (A) Many travel agencies organize trips to that area.
 (B) Hotels are already fully booked for the rest of the summer.
 (C) These include cruises, hiking trips, historical tours, and more.
 (D) We will be closed for that month but will reopen in September.

STEP 1 빈칸 주변 문맥 파악하기

빈칸의 바로 앞뒤 문장을 읽고 문맥을 파악해본다.

▶ 남미 여행 패키지에 할인을 제공한다.
▶ 각각의 옵션과 목적지에 대한 상세한 설명은 웹사이트에 있다.

STEP 2 오답 소거하기

빈칸 앞뒤 문장과 흐름이 자연스럽지 않거나 지문에 사용된 어휘를 이용한 무관한 내용의 선택지는 오답으로 소거한다.

▶ (A) 웹사이트를 통해 여행 정보를 얻으라는 빈칸 다음 문장과 어울리지 않으므로 오답이다.
▶ (B) 첫 문장에서 아직 예약할 수 있다고 했으므로 오답이다.
▶ (D) 빈칸 앞에서 8월에 예약시 할인을 제공한다고 했으므로 오답이다.

STEP 3 정답 선택 및 문맥 확인하기

빈칸의 앞뒤 문장과 자연스럽게 어울리는 선택지를 고르고 선택한 문장을 빈칸에 넣어 문장 연결이 자연스러운지 확인한다.

▶ 선택지의 지시어 these가 빈칸 앞 문장의 our South American packages를 가리키며 해당되는 구체적인 여행의 예를 들고 있다. 또한 뒤 문장에서 각 옵션과 목적지에 대한 구체적인 설명은 웹사이트에서 찾아보라고 했으므로 뒤 문장과도 자연스럽게 연결된다. 따라서 정답은 (C)이다.

DAY 20

풀이전략

1. 지시어 및 대명사
• 지시어 및 대명사는 앞에서 언급한 명사 또는 문장 전체를 가리키며, 남성/여성, 사람/사물, 단수/복수 등에 대한 정보를 담고 있으므로 이를 통해 지시하는 대상을 파악할 수 있다.
• 선택지에 지시어나 대명사가 있다면 빈칸 앞에 그것이 가리키는 대상이 있는지 확인한다.
• 빈칸 앞에 사람 이름이나 특정 사물이 있는 경우 선택지에 이를 가리키는 지시어 또는 대명사가 있는지 읽어본다.
• 빈칸 뒤에 지시어나 대명사가 있다면 그 대명사가 가리키는 사람이나 사물이 언급된 선택지가 있는지 확인한다.

단서 ② 연결어

연결어는 접속 부사, 접속사와 같이 문맥을 연결하는 것들을 통틀어 일컫는 말이다. 문단의 논리 구조에 따른 여러 가지 연결어에 주의하며 빈칸 앞뒤 문맥을 파악해 알맞은 문장을 고르는 훈련을 해 두자.

예제 2

Selmatown, November 11—Propex Mechanics is moving to the outskirts of Selmatown, where it purchased a large area of land. With this space, the car manufacturer plans on expanding its business by producing farming equipment.

According to spokesperson Marie Lucas, Propex Mechanics already started producing a tractor prototype. ------. "Thanks to our rapid growth," Ms. Lucas explained, "we are now confident enough to launch a line of high-quality farming equipment." Locals are excited about the manufacturer's expansion, as it is expected to create more than eight hundred new jobs.

2. (A) However, only Propex cars are currently on the market.
(B) The manufacturer's original product was not selling.
(C) This is why the organization's facilities are being renovated.
(D) This decision was made after a bid had already been placed.

STEP 1 빈칸 주변 문맥 파악하기

빈칸의 바로 앞뒤 문장을 읽고 문맥을 파악해본다.
▶ 트랙터 시제품을 생산하기 시작했다.
▶ 빠른 성장으로 농기구를 출시할 자신이 있다.

STEP 2 오답 소거하기

빈칸 앞뒤 문장과 흐름이 자연스럽지 않거나 지문에 사용된 어휘를 이용한 무관한 내용의 선택지는 오답으로 소거한다.
▶ (B) 빈칸 뒤 '급속한 성장'과 반대되는 내용으로 오답이다.
▶ (C) 시설 보수의 이유가 빈칸 앞에 없으므로 오답이다.
▶ (D) 빈칸 바로 앞에 This decision이 가리키는 내용이 없어 오답이다.

STEP 3 정답 선택 및 문맥 확인하기

빈칸의 앞뒤 문장과 자연스럽게 어울리는 선택지를 고르고 선택한 문장을 빈칸에 넣어 문장 연결이 자연스러운지 확인한다.
▶ 빈칸 앞에 트랙터 시제품을 생산했다고 했고, 빈칸 뒤에는 농기구 출시에 자신이 있다고 했으므로 농기구는 아직 출시 전임을 알 수 있다. 따라서 연결어 However를 사용해 앞의 내용과 대조되는 내용이 나오면서 뒤 문장과도 자연스럽게 연결되는 (A)가 정답.

풀이전략

1. 연결어
• 연결어는 지문의 논리적 흐름을 보여주는 것으로 알맞은 문장을 고르는 문제의 가장 중요한 단서이다.
• 빈칸 앞뒤 문장에 연결어가 있다면, 그 연결어의 내용과 가장 자연스럽게 이어지는 문장을 고르면 된다.
• 선택지에 연결어가 있다면, 그 연결어를 이용하여 빈칸 앞 문장의 내용을 유추할 수 있다.

2. 빈출 연결어

대조	but, however 그러나　nevertheless 그럼에도 불구하고　on the other hand 반면에
추가	also, in addition, additionally 또한　furthermore, moreover, besides 게다가
인과 관계	thus, therefore 그러므로　as a result 결과적으로
결론, 요약	in brief, in short, in summary 요약하면
순서	afterwards 나중에　then 그 다음에　in the meantime, meanwhile 그 동안에
기타	unfortunately 유감스럽게도　instead 대신에

단서 ③ 지문 구조

토익 지문은 대부분 서론에서 목적을 밝히고, 본론에서 구체적인 내용을 언급한 후에, 결론에서 내용을 마무리 짓는다. 따라서 지문 구조에 따라 들어갈 내용이 예측 가능하므로 지문 구조별 내용을 익혀두자.

예제 3

To: Parks, I. <isaparks@flowernet.com>
From: Marvin, S. <smarvin@tinastalib.edu>
Subject: Librarian Position

Dear Ms. Isabelle Parks,

We are pleased to inform you that you have passed the final stage of the Tinasta University Library interview process. We would thus like to offer you the position of reference librarian.

This position consists in assisting faculty with their research and attending monthly conferences. You would also be expected to organize seminars for fellow librarians.

I've attached a contract with details of the benefits you would be entitled to. ------.
 3.

Sincerely,

Stephen Marvin
Assistant Director, Library Services

3. (A) The library employs fifteen librarians and twenty library assistants.
(B) The job may entail updating item records in the database.
(C) Conferences are usually organized by national library associations.
(D) To accept this offer, please send the signed contract back to me by Friday, August 8.

STEP 1 빈칸 주변 문맥 파악하기

빈칸의 바로 앞뒤 문장을 읽고 문맥을 파악해본다.

▶ 계약서를 첨부했다.
▶ 이메일의 마지막 부분이므로 추가 요청이 있을 것으로 예측할 수 있다.

STEP 2 오답 소거하기

빈칸 앞뒤 문장과 흐름이 자연스럽지 않거나 지문에 사용된 어휘를 이용한 무관한 내용의 선택지는 오답으로 소거한다.

▶ (A) 도서관의 현재 고용 인원을 알려주는 내용은 이메일의 결론에 오는 내용이 아니므로 오답이다.
▶ (B) 업무에 대한 구체적인 예시이므로 결론이 아닌 본론에 적합한 내용이다.
▶ (C) 일자리를 제안하는 편지의 결론으로 적합한 내용이 아니므로 오답이다.

STEP 3 정답 선택 및 문맥 확인하기

빈칸의 앞뒤 문장과 자연스럽게 어울리는 선택지를 고르고 선택한 문장을 빈칸에 넣어 문장 연결이 자연스러운지 확인한다.

▶ 빈칸 앞에 첨부된 계약서에 대한 내용이 나오고 있으므로 빈칸에는 서명한 계약서를 보내달라는 추가 요청으로 마무리하는 것이 문맥상 자연스럽다. 따라서 정답은 (D).

풀이전략

1. 서론
• 이메일이나 편지의 경우 대부분 글의 주제나 목적이 나온다.
• 광고의 경우 제품 소개, 할인이나 특별히 제공되는 제품 및 서비스에 대한 내용이 언급된다.

2. 본론
• 서론에서 밝힌 주제나 목적과 관련한 구체적인 내용이 나온다.
• 구체적인 예시나 발전 방향, 문제점들, 제품의 특징들이 나열된다.

3. 결론
• 이메일이나 편지의 경우 첨부하는 내용이나 추가 요청, 글의 요점을 요약하는 내용이 나온다.
• 광고나 정보문에서는 연락 방법이나 혜택을 받는 방법 또는 독자의 행동을 격려하는 내용이 언급된다.

FINAL TEST

Questions 1-4 refer to the following letter.

⏱ 제한시간 15:00

Marisa Jacob
3683 Cherry Tree Drive
Holtsville, NY 00501

March 3

Dear Ms. Jacob,

We are writing to remind you to schedule an appointment with Pearly White Dental Clinic. Your last visit was on August 13, and doctors ------ that patients see a dentist every six months. ------.
 1. **2.**

We understand that you may not feel any pain at this time. ------, it is still advisable to visit your
 3.
dentist. Oral hygiene should be a ------ for patients your age as treatment becomes increasingly
 4.
risky.

To make an appointment, please call us at 824-7952. We look forward to helping you keep your beautiful smile!

Regards,

Stanley Jabbards
Pearly White Dental Clinic Receptionist

1. (A) recommended
 (B) recommending
 (C) is recommended
 (D) recommend

2. (A) Therefore, you are overdue for your checkup.
 (B) For this, we require payment in advance.
 (C) We are grateful for your patronage.
 (D) However, this time slot is no longer available.

3. (A) Thus
 (B) As a result
 (C) Nevertheless
 (D) On the other hand

4. (A) priority
 (B) responsibility
 (C) demand
 (D) damage

Questions 5-8 refer to the following notice.

We regret to have to report an error in ------ of the printed issues of last month's *Hourglass*
 5.

magazine. An article ------ September 12 includes an incorrect job title. The article is a review
 6.

of the restaurant Tocata. ------. In fact, Mr. Dimaggio is Tocata's chef, and Mr. Julian Rose is the
 7.

manager. Our reporter originally had an appointment to interview Mr. Rose. However, the manager

could not make it, so our reporter met with Mr. Dimaggio instead. We apologize for the confusion.

Please note that online versions of our updated articles ------ on our Web site.
 8.

5. (A) every
 (B) less
 (C) much
 (D) some

6. (A) to date
 (B) will be dated
 (C) dated
 (D) is dating

7. (A) Tocata is a renowned restaurant that
 specializes in Italian cuisine.
 (B) In it, Mr. Nicolas Dimaggio is introduced
 as the restaurant's manager.
 (C) This caused the typo to be printed in our
 magazine.
 (D) These include several mistakes concerning
 the Italian eatery.

8. (A) can be accessed
 (B) have accessed
 (C) are accessing
 (D) would be accessing

DAY 20

189

Questions 9-12 refer to the following e-mail.

To: Heather Garrison <hgarrison@extoppharm.com>
From: Mounir Benidris <mbenidris@extoppharm.com>
Date: April 11
Subject: Promotion

Dear Heather Garrison,

------. I'm so glad you were ------ to be the new team manager for the research and development
 9. **10.**
department.

Working as a manager can be ------, but I know you will do a great job. You have a lot of
 11.
experience with Extop Pharmaceuticals, and I believe you are the best person for this position.
I hope you will enjoy your new responsibilities.

We will be seeing each other more often ------ you will be in the office next to mine. It will be a
 12.
pleasure to work more closely with you.

Regards,

Mounir Benidris
Assistant Director

9. (A) You will be designing new research projects.
 (B) I want to congratulate you on your promotion.
 (C) Many candidates have applied for the position.
 (D) I look forward to hearing back from you soon.

10. (A) totaled
 (B) selected
 (C) defined
 (D) limited

11. (A) challenged
 (B) challenger
 (C) challenges
 (D) challenging

12. (A) from
 (B) but
 (C) since
 (D) between

Questions 13-16 refer to the following article.

Wilmington, January 29—Drivers going through Wilmington are still unable to use Southampton Bridge. The bridge suffered damages last month after a truck driver rode his oversized vehicle over ------ without checking the weight requirements. The bridge's supporting columns cracked
 13.
and now require repairs. These will be conducted using a new ------ material that allows for a
 14.
higher weight limit. Wilmington mayor Jennifer Harvest had originally announced that work would
be done before January 30. ------. The renovation project has therefore been delayed. Repairs
 15.
should begin on February 1 and are estimated to be finished on February 15. The bridge ------ on
 16.
the very next day.

13. (A) him
 (B) himself
 (C) it
 (D) itself

14. (A) typical
 (B) innovative
 (C) optional
 (D) irrelevant

15. (A) The mayor is still hesitant about investing in repairs despite the citizens' demands.
 (B) Since then, no accidents have been reported on Southampton Bridge.
 (C) The driver is expected to pay for part of the project out of his pocket.
 (D) Unfortunately, shipment of materials is taking longer than expected.

16. (A) will reopen
 (B) has reopened
 (C) to reopen
 (D) has been reopening

정답 및 해설 81쪽

CHAPTER
8

-

질문 유형편

DAY 21
일반적 문제

—

기본 개념 노트

본 학습에 들어가기 전에 기본적인 독해 문제 유형의 개념을 잡아보자.

일반적인 내용을 묻는 문제에는 지문의 주제나 목적을 묻는 문제와 지문의 대상과 출처를 묻는 문제 유형이 있다. 지문의 주제, 목적을 묻는 문제는 편지나 이메일에서 자주 등장하고, 지문의 대상, 출처를 묻는 문제는 광고, 정보문, 양식 등에서 주로 출제된다는 것도 알아두자.

❶ 빈출 문제 유형

주제	**What** is being **advertised**? 광고되고 있는 것은?
	What is this memo **mainly about**? 이 메모의 주제는?
	What is this article **mainly discussing**? 이 기사가 주로 논의하는 바는?
목적	**What** is the **purpose** of this letter? 이 편지의 목적은?
	Why was the e-mail **written**? 이메일이 쓰여진 이유는?
	Why did Mr. Kim **send** the e-mail? 김 씨가 이메일을 보낸 이유는?
대상	**Who** is this memo **intended for**? 이 메모가 의도하고 있는 대상은?
	To whom is this advertisement **addressed**? 이 광고의 대상은?
출처	**Where** would this information most likely **appear**? 이 정보문을 볼 수 있는 곳은?
	Where can this announcement most likely **be found**? 이 공지를 찾을 수 있는 곳은?
	Who most likely **sent** the notice? 공지를 보냈을 것 같은 사람은?

❷ 정답 단서 표현

주제 및 목적 언급	I'm writing to *do* ~하기 위해 이 글을 씁니다. We plan[would like] to *do* 우리는 ~할 예정입니다.[~하길 원합니다.] Let me know if ~인지 아닌지 알려주십시오. This is for 이것은 ~을 위한 것입니다. The purpose of this e-mail is to *do* 이 이메일의 목적은 ~하기 위함입니다.
대상 관련 사람 명사	current subscribers[customers] of ~의 현재 구독자들[고객들] purchasers[owners, residents] of ~의 구매자들[소유자들, 거주자들] training participants[attendees] 교육 참석자들
글의 출처 관련 표현	manual 설명서 business journal 비즈니스 잡지 directory (이름, 주소 등의 정보를 나열한) 안내 책자 brochure (안내, 광고용) 책자 company newsletter 사보

주제, 목적 문제

지문의 주제 또는 목적을 묻는 문제는 주로 지문의 첫 번째 문제로 출제되며, 단서는 대개 지문의 앞부분에 등장한다. 이메일이나 기사의 경우 제목이 단서가 되기도 하니 그냥 지나치지 말고 반드시 살펴보자.

예제 1

Q. Why was the e-mail written?

STEP 1 문제 유형 파악하기

문제를 먼저 읽고 문제 유형을 파악한다.

▶ 이메일을 쓴 목적을 묻고 있다.

TO: Wendy Anderson <wanderson@speedmail.com>
FROM: Lee Conner <leec@jensonlawfirm.com>
DATE: May 29
단서1 SUBJECT: Tuesday's appointment

Dear Ms. Anderson,

단서2 I just wanted to confirm our appointment for Tuesday to go through the details of the contract with Regency Department Store. I looked through it this morning, and **단서3** there are some things you may wish to negotiate. I will discuss them in more detail at our meeting.

When you come, could you also bring your current bank account information with you? Regency will need to know where to send payment for your products once an agreement has been reached.

Thanks, and I will see you on Tuesday.

Sincerely,

Lee Conner

STEP 2 주제, 목적 문제 단서 찾기

주제나 목적 문제 관련 단서는 보통 지문 앞부분에서 찾을 수 있다. 직접적으로 주제나 목적을 언급하고 있는 부분을 찾는다.

단서1 제목: 화요일의 약속

단서2 화요일 약속을 확인하고자 함

단서3 받는 사람(앤더슨 씨)이 협상하고 싶어 할만한 사항들이 있으며 회의에서 그것들을 더 자세히 의논할 예정임

▶ 단서들을 종합해보면, 화요일에 있을 회의에서 논의할 사항들을 언급하고 있음을 알 수 있다.

Q. Why was the e-mail written?

(A) To provide information about an upcoming appointment
(B) To inform Ms. Anderson of a change in schedule
(C) To confirm the acceptance of a contract
(D) To notify Ms. Anderson of an outstanding payment

STEP 3 정답 선택하기

단서 부분을 선택지와 비교하여 적절히 패러프레이징된 것을 정답으로 고른다.

▶ confirm our appointment, discuss them in more detail → (A) To provide information about an upcoming appointment

따라서 정답은 (A)이다.

풀이전략

1. 주제, 목적 문제

• 출제되는 문제의 순서와 지문 내 단서의 순서는 대부분 일치하기 때문에 주제, 목적 문제의 단서는 지문의 첫 단락에 등장하는 경우가 많다. 따라서 주제, 목적 문제는 지문의 첫 부분에 특히 집중하여 읽어야 한다.
• 간혹 지문의 중간 부분에 however, although, but 등의 연결어가 쓰여 앞의 내용과 반대되는 내용이 등장하기도 하므로 이에 주의한다.
• 정답을 고르기가 애매할 경우 다른 문제를 먼저 풀고 지문 전체에 대한 독해가 완료된 후 다시 풀어본다.

대상, 출처 문제

지문의 대상이나 출처를 묻는 문제 유형은 단서가 직접적으로 등장하기 보다는 지문을 전반적으로 파악하여 어휘를 통해 유추하는 경우가 많다.

Q. To whom is this memo intended?

STEP 1 문제 유형 파악하기

문제를 먼저 읽고 문제 유형을 파악한다.

▶ 메모의 대상을 묻고 있다.

MEMO

Date: January 4

Due to a team leaders meeting at 10 A.M. tomorrow, Arnold Wetherell will not be able to lead the safety training for the new equipment on the production floor. 단서1 The session will be rescheduled for Friday, January 7 at 10 A.M. in the conference room. Please bring a notebook and pen. 단서2 Anyone who signed up for the training but is not available at that time should speak to Mr. Wetherell or a manager today in order to make alternative arrangements. We apologize for the inconvenience.

STEP 2 대상, 출처 문제 단서 찾기

지문의 대상이나 출처를 묻는 문제는 지문의 성격 및 내용과 관련이 깊다. 메모는 보통 'Attention[Attn]: 대상'의 표현으로 첫 부분에 대상을 밝혀주기도 하나 예제처럼 생략되는 경우도 많다. 주제나 목적 문제같이 단서가 직접적으로 제시되지는 않으나 지문의 목적, 상황, 반복되는 어휘를 통해 대상을 유추할 수 있다.

단서1 교육 일정이 변경될 예정임

단서2 교육을 신청했지만 변경된 일정에 시간이 안 되는 사람은 웨더럴 씨나 관리자에게 알려야 함

▶ 단서들을 종합해보면, 교육 참가를 신청한 사람들에게 변경된 일정을 알리고 있음을 알 수 있다.

Q. To whom is this memo intended?

(A) Team leaders
(B) New employees
(C) Management staff
(D) Training attendees

STEP 3 정답 선택하기

단서 부분을 선택지와 비교하여 적절히 패러프레이징된 것을 정답으로 고른다.

▶ Anyone who signed up for the training → (D) Training attendees

따라서 정답은 (D)이다.

1. 대상 문제

- 지문의 대상을 묻는 문제는 지문의 목적이나 상황을 파악하면 해결되는 경우가 많다.
- 공지나 메모의 경우 지문이 쓰인 목적과 관련이 있는 사람들이 의도된 대상이 된다.
- 광고에서는 상품이나 서비스의 대상을 묻는 문제가 출제되므로, 상품의 특장점을 살펴보는 것이 중요하다.

2. 출처 문제

- 지문의 출처를 묻는 문제는 지문에서 주로 다루는 내용을 통해서 지문과 관련이 있는 장소나 매체를 유추할 수 있기 때문에 지문의 주제와 요지를 파악하는 것이 중요하다.
- 출처 문제는 주로 정보문이나 각종 양식, 기사, 광고에서 출제된다.

패러프레이징

패러프레이징은 다른 품사를 활용하거나, 동의어 또는 유의어 활용, 상위 개념 또는 함축 표현을 활용하여 이루어진다. 어떤 방식의 패러프레이징이든지 결국 유사한 의미의 표현을 찾는 것이 관건이다.

	문제	지문	패러프레이징
예제 3	Q. What event is being announced?	In honor of the city's 150th anniversary, Melville is holding an essay contest for community members. The winner will be awarded a cash prize at the Melville Festival on June 13.	**(A) A writing contest** (B) An award ceremony

다음 문제를 풀고 지문에서 패러프레이징의 단서가 된 문장을 찾아 표시해 보세요.

1.

We are writing to inform you that you have successfully registered for this year's leadership workshop. Payment has been received, so no further action is needed. Please bring identification to enter the venue. We look forward to seeing you on August 15.

What is the purpose of the letter?
(A) To confirm registration to an event
(B) To explain an application process

2.

This weekend is members' weekend at Bird's View Camping! To thank our loyal patrons, we are offering fifty percent off all of our tents and apparel to members only. Come to our store Saturday or Sunday and take advantage of this exceptional event!

To whom is this advertisement addressed?
(A) Store cashiers
(B) Regular customers

3.

Mayor Brian Pockter has announced that construction of a new city park will begin at the end of next month. The park will be located between Brandenburg Avenue and Golden Boulevard. Residents will be welcome to enjoy this new green area.

Where can this article most likely be found?
(A) In a local newspaper
(B) In a campaign pamphlet

4.

My name is Trevor Braton. I am applying for the position of sales representative at your firm. Attached, please find my résumé and a letter of recommendation. I've also included a cover letter explaining my career so far and plans for the future. Thank you for your time.

Why was this e-mail written?
(A) To submit a job application
(B) To recommend a candidate

5.

A new air conditioner will be installed over the weekend. To protect belongings from dust and debris, employees on the upper floors are asked to put plastic over their possessions and computers on Friday afternoon.

To whom is this memo intended?
(A) Staff members
(B) Cleaning workers

DAY 21

FINAL TEST

Questions 1-2 refer to the following invitation.

Staff members of Levingstone Museum are invited
to a reception in honor of Casey Williams.
Ms. Williams will be retiring after serving as curator at the museum for ten years.
This is an opportunity for all those who worked alongside her to acknowledge her
outstanding contribution to this fine institution.

Friday, April 10
6:00–9:00 P.M.
Levingstone Museum Atrium

Wine, beer, and finger food will be served free of charge.
Musical entertainment provided by Foster Folk.
Casual attire.

Please reply to Chief Administrator Jacquelyn Corris at 555-8080
at least 24 hours before the event.

1. To whom is this invitation intended?

(A) Financial contributors
(B) Current employees
(C) Retired workers
(D) Regular visitors

2. What will guests be provided with?

(A) Museum memberships
(B) Souvenirs
(C) Light refreshments
(D) Free CDs

Questions 3-5 refer to the following memo.

To: All staff
From: Alicia Wright
Date: July 17

I would like to apologize to employees on the upper floors for the uncomfortable working conditions for the last week or so. The air conditioning unit has been malfunctioning, and because the windows do not fully open on the third, fourth, or fifth floors, it has been very hot and humid.

Please let me reassure you that the management has taken steps to solve the problem. A new air conditioner will be installed over the weekend. To protect belongings from dust and debris, employees on the upper floors are asked to put plastic over their possessions and computers on Friday afternoon. I hope that this will not cause too much inconvenience. Thank you for your patience.

Kind regards,

Alicia Wright
Maintenance Manager

3. What is the purpose of the memo?

(A) To request employee feedback on a matter
(B) To announce a maintenance upgrade
(C) To inform employees of safety guidelines
(D) To report the results of a recent test

4. Why are upstairs workers experiencing difficulties?

(A) Their windows are broken.
(B) The temperature is uncomfortably warm.
(C) The workspace is too crowded.
(D) Their belongings are covered with dust.

5. What are upstairs workers requested to do on Friday?

(A) Cover their equipment
(B) Stay out of the office
(C) Keep the windows closed
(D) Work on a lower floor

DAY 21

CHAPTER
8

-

질문 유형편

DAY 22
세부 정보 문제 ①

기본 개념 노트

본 학습에 들어가기 전에 기본적인 독해 문제 유형의 개념을 잡아보자.

특정 정보 확인 문제와 Not/True 문제는 문제에서 키워드를 파악하여 지문에서 단서를 찾아야 한다는 공통점이 있으며, 모든 지문 유형에서 출제될 수 있다.

❶ 빈출 문제 유형

특정 정보 확인 문제	사람	**Who** is in charge of **acquiring prizes**? 경품 모집을 담당하는 사람은?
	시간	**When** will **the next inspection** be conducted? 다음 점검이 시행될 때는?
	장소	**Where** will **the performance** be held? 공연이 열릴 장소는?
	대상	**What** is **attached** in the e-mail? 이메일에 첨부된 것은?
	방법	**How** should candidates **apply**? 지원자들이 지원하는 방법은?
	이유	**Why** was **the date** of the conference **changed**? 학회 날짜가 변경된 이유는?
True		**Which** of the following is **true about** ~? ~에 대해 사실인 것은?
		What is **mentioned[indicated, stated] about** ~? ~에 대해 언급된 것은?
Not True		**What** is **NOT true about** ~? ~에 대해 사실이 아닌 것은?
		What is **NOT mentioned[indicated, stated] about** ~? ~에 대해 언급되지 않은 것은?
		What is **NOT included** in ~? ~에 포함되지 않은 것은?

특정 정보 확인 문제

지문에 등장한 특정 인물이나 대상에 대한 세부적인 정보를 묻는 유형이다. 여러 의문사를 이용하여 문제를 만들 수 있기 때문에 가장 다양한 형태로 출제되며 **Part 7**에서 가장 빈출되는 문제 유형이다.

예제 1

Q. What is a required qualification for all applicants?

STEP 1 문제 유형 파악하기

문제를 먼저 읽고 문제 유형을 파악한다.

▶ 지원자들의 자격 요건을 묻고 있다.

Flight Attendant Positions Available:

Emerald Isles Air is seeking qualified applicants for flight attendant positions. Due to its upcoming expansion into Spain, Greece, and Italy, the airline is looking to hire 28 additional flight-crew staff members.

DUTIES:
* Ensure safety standards are met throughout the duration of flights
* Serve food and beverages
* Sell duty-free items

REQUIREMENTS:
* 단서1 One year minimum of experience in the customer service industry
* 단서2 Fluency in written and verbal English
* 단서3 Availability to work at any time of the day

Please forward a résumé and cover letter to recruitment@emeraldislesair.com. Only those selected for interviews will be contacted.

STEP 2 특정 정보 문제 단서 찾기

질문에서 묻고 있는 핵심 단어인 자격 요건을 염두에 두고 지문을 읽는다. 구인 공고의 경우 지원자들의 자격 요건을 나열하는 경우가 많으므로 그 부분에 집중하도록 한다.

단서1 최소 1년의 고객 서비스업 경험이 있어야 함

단서2 유창한 문어체, 구어체 영어를 구사해야 함

단서3 하루 중 아무 때나 근무할 수 있어야 함

Q. What is a required qualification for all applicants?

(A) Experience in the food service industry
(B) Fluency in at least two languages
(C) Previous work as a flight attendant
(D) Twenty-four-hour availability

STEP 3 정답 선택하기

단서 부분을 선택지와 비교하여 적절히 패러프레이징된 것을 정답으로 고른다.

▶ Availability to work at any time of the day → (D) Twenty-four-hour availability

따라서 정답은 (D)이다.

DAY 22

풀이전략

1. 특정 정보 확인 문제

- 특정 인물과 관련된 문제는 그 인물의 이름이나 지칭하는 대명사가 포함된 문장에서 단서를 찾는다.
- 시간이나 장소와 관련된 문제는 시간 표현과 장소명이 언급된 문장에 주목하여 해당 정보를 찾는다.
- 방법을 묻는 문제는 연락 방법, 서류 제출 방법 등을 묻기 쉬우므로 〈by + 수단〉 표현이 포함된 문장에 주목한다.
- 이유를 묻는 문제는 in order to(~하기 위해서), for(~을 위해), so that ~ can[may](~할 수 있도록) 등의 표현을 찾는다.
- 요청하는 것을 묻는 문제의 경우 단서가 보통 지문의 뒷부분에 있으므로, 지문 후반부에 쓰인 표현에 집중한다.

Not/True 문제

특정 대상에 대한 사실 여부를 확인하는 문제로, 특히 **NOT**이 포함된 문제는 지문 속의 정보와 선택지를 대조하여 오답을 소거하며 풀어야 한다.

Q. What is NOT included in the membership?

STEP 1 문제 유형 파악하기

문제를 먼저 읽고 문제 유형을 파악한다.

▶ 회원권에 포함되지 않은 것을 묻고 있다.

Wellness Health Club
Helping you reach past your limits!

Wellness Health Club is offering a special promotion to new members for the month of May only. First-time members can purchase an annual membership at half of the original price of $800. The membership includes:
* 단서1 Use of weight room, aerobic machines, and swimming pools
* 단서2 Weekly personal training sessions of 60 minutes
* 단서3 Individual locker in changing room
단서4 As an additional service free of charge, new members will have access to the tennis courts for the first three months of their membership.
To register for your Wellness Health Club membership, contact one of our knowledgeable staff members at 515-3334.

STEP 2 Not/True 문제 단서 찾기

지문 전체에서 회원권과 관련하여 언급된 내용을 찾는다.

단서1 체력 단련실, 에어로빅 기구와 수영장 사용이 가능함

단서2 매주 60분 개인 트레이닝을 받을 수 있음

단서3 탈의실에 있는 개인 사물함을 이용할 수 있음

단서4 회원권 구입 후 첫 3개월간 테니스 코트를 무료로 이용할 수 있음

Q. What is NOT included in the membership?

(A) Access to fitness equipment
(B) Time with personal trainers
(C) Use of a personal locker
(D) A private changing room

STEP 3 정답 선택하기

단서 부분을 선택지와 비교하여 지문에서 언급된 내용은 오답으로 소거하고, 언급되지 않은 것 또는 다르게 언급된 것을 정답으로 선택한다.

▶ aerobic machines → (A) fitness equipment
▶ personal training sessions of 60 minutes → (B) Time with personal trainers
▶ Individual locker → (C) personal locker

A private changing room은 언급되지 않았으므로 정답은 (D).

1. Not/True 문제

- True 문제는 정답에 대한 확실한 단서를 찾았을 경우 나머지 3개의 선택지를 모두 확인할 필요는 없다.
- Not True 문제의 경우 모든 선택지를 지문과 대조하여 언급된 선택지를 하나씩 소거해가며 정답을 찾는다.
- 단서들이 순서대로 나열되어 있으면 쉽게 정답을 고를 수 있지만, 지문 곳곳에 흩어져 있기도 하므로 주의한다.
- 단서는 대부분 선택지에서 패러프레이징되어 나타나므로 지문과 똑같은 표현이 쓰인 선택지는 주의한다.

패러프레이징

패러프레이징은 다른 품사를 활용하거나, 동의어 또는 유의어 활용, 상위 개념 또는 함축 표현을 활용하여 이루어진다. 어떤 방식의 패러프레이징이든지 결국 유사한 의미의 표현을 찾는 것이 관건이다.

지문	패러프레이징
Q. In addition to our spacious rooms and quality customer service, guests at our hotel can enjoy a variety of amenities. We offer complimentary Internet access in all rooms and a free shuttle bus to and from the airport.	**(A) Hotel guests are able to use a free transportation service.** (B) Customers have to pay an additional fee to use the Internet.

다음 짧은 지문을 읽고 지문과 일치하게 패러프레이징된 문장을 고르세요.

1.
> With Clear Blue, let your message be heard! No matter what industry you work in, we will make your company look great! We use state-of-the-art technology to create today's most appealing advertisements and commercials, which are then strategically placed by our team of experts.

(A) Clear Blue plans to hire experts to analyze commercials.
(B) An agency uses the latest trends in marketing services.

2.
> I am writing to report a missing suitcase. I flew from Berlin to Oslo on flight 605 with your airline today, March 17. The flight landed an hour later than scheduled, and when I arrived, my baggage was nowhere to be found. It is a navy-blue Coralia brand suitcase.

(A) A passenger is reporting that a piece of luggage was lost.
(B) A flight attendant is announcing that a bag was left behind.

3.
> We invite employees from all departments to take part in our annual company banquet on April 15 from 6 P.M. until 8 P.M. Attendees will be entered into a prize lottery, and winners will be announced at the end of the meal.

(A) Staff members may attend a yearly event and win gifts.
(B) A catering service is being contacted for a company banquet.

4.
> The Spring music festival will take place at Wood Gardens Park on April 2. The local high school's symphonic orchestra will open at 1 P.M., followed by the Golden Heart Chorus. Finally, special guest Gloria Strandel will perform "Singing Strings" on the harp.

(A) A number of music performances are scheduled for an afternoon.
(B) A special guest will host a seminar on a musical instrument.

5.
> I am contacting you about the possibility of working as a consultant for our company during our transition into Asia through the Taiwanese market. My colleague, Sam Batter, recommended you and spoke highly of your knowledge of East Asian business practices.

(A) Colleagues recommended working with a Taiwanese company.
(B) The company requires consulting for opening business in Asia.

DAY 22

정답 및 해설 93쪽

FINAL TEST

Join the Landis Sailing Association!

Enjoy these amazing benefits by becoming a member of the association.

* A free subscription to the *Sail the World* monthly magazine
* A 15% discount on all sailing clothing and equipment at Landis Heads retail store
* Free use of the Landis Sailing Club facilities throughout the year

Moreover, sign up to become a member before January 31 and you will receive two complimentary tickets to the Annual Florida Boat Show (valued at $150 each).

Call 555-0982 or visit us at www.landissailing.org.

1. What is the purpose of the information?

(A) To advertise a local sailing apparel store
(B) To announce a change in subscription fees
(C) To promote a newly renovated yacht club
(D) To recruit new members to an association

2. What is NOT offered to members?

(A) A sailing magazine subscription
(B) A discount on sailing gear
(C) Access to free sailing classes
(D) Use of local sailing amenities

3. How can people get free tickets to a boat show?

(A) By joining a club by a certain date
(B) By subscribing to a journal
(C) By attending a yearly event
(D) By inviting a friend to become a member

Questions 4-7 refer to the following e-mail.

TO: Alex Hampton <hampton@xmail.com>
FROM: Samantha Grove <grove@lifebeauty.com>
DATE: May 4
SUBJECT: Consultancy Offer

Dear Mr. Hampton,

My name is Samantha Grove. I am a market analyst at Life Beauty, a natural cosmetics company. We produce luxury cosmetics for consumers who care about their health. Our products are available in North America and Europe, and we are now ready to branch out into the Asian market.

I am contacting you about the possibility of working as a consultant for our company during our transition into Asia through the Taiwanese market. My colleague, Sam Batter, recommended you and spoke highly of your knowledge of East Asian business practices. He told me about your success in introducing health food products to Taiwan's mainstream grocery stores. I was impressed by your reputation.

If you are interested in taking on a freelance consultancy role as we expand our business, please contact us. We hope to begin talking with retailers in Taipei early next month.

We look forward to hearing from you.

Sincerely,

Samantha Grove
Market Analyst and Product Specialist, Life Beauty

4. Why was the e-mail written?

 (A) To schedule a business meeting
 (B) To inform Mr. Hampton of plans to expand
 (C) To request consultation on a project
 (D) To offer Mr. Hampton a full-time job

6. Who is Mr. Batter?

 (A) A Taiwanese language expert
 (B) A freelance consultant
 (C) A grocery store owner
 (D) Mr. Grove's coworker

DAY 22

5. What is NOT stated about Life Beauty?

 (A) It plans to meet with distributors next month.
 (B) It produces expensive beauty items.
 (C) It has branches across Asia.
 (D) It sells products in Europe.

7. What is true about Mr. Hampton?

 (A) He helped distribute products in East Asia.
 (B) He manages the most successful store in Taiwan.
 (C) He has done research in healthful ingredients.
 (D) He is planning to expand his business overseas.

Questions 8-12 refer to the following schedule and e-mail.

Veritas Tour Groups
233 Via Della Spiga, Rome, Italy

The following is the Rome tour schedule for the group from Middleton Incorporated for July 9 to 11. Breakfast and lunch are included for each day, but guests are responsible for their own dinners. All entrance fees are included.

Day 1:

8:00 A.M.	Buffet breakfast at Cesare Hotel
9:00 A.M.–10:30 A.M.	Visit the Coliseum
10:30 A.M.–12:30 P.M.	Visit the Forum Romana
12:30 P.M.	Lunch at Antonio's Ristorante
2:00 P.M.–4:30 P.M.	Visit Trevi Fountain

Day 2:

8:00 A.M.	Buffet breakfast at Cesare Hotel
9:30 A.M.–12:30 P.M.	Visit the Pantheon
12:30 P.M.	Lunch at Delizio Pizzeria
2:00 P.M.–4:30 P.M.	Visit the National Roman Museum
6:30 P.M.	Visit the shopping district

Day 3:

8:00 A.M.	Buffet breakfast at Cesare Hotel
9:30 A.M.–10:30 A.M.	Visit Piazza di Spagna (Spanish Steps)
11:00 A.M.–12:30 P.M.	Visit Castello Sant'Angelo (Saint Angelo Castle)
12:30 P.M.	Lunch at Il Lupo
2:00 P.M.–4:00 P.M.	Souvenir shopping at Porta Portese Market
6:00 P.M.–8:00 P.M.	Attend *La Traviata* opera

To:	Sonia Lorenzo <sonlo@veritastours.com>
From:	Gary Martin <gmartin@middletoninc.com>
Date:	June 3
Subject:	Tour Schedule for Rome

Dear Ms. Lorenzo,

Thank you for sending me the copy of the plans for our group's visit to Rome. Everything looks fine, but there were just a few questions I had for you.

First, would it be possible to cancel the last event on Day 2? We are actually planning to do a small awards ceremony for the staff, and I think that would be the best time to do it.

Also, I noticed that not all meals are included in the cost of the tour. How much extra would it cost to have all meals covered?

Finally, as we are quite a large group, I was wondering if you could arrange transport for us from the airport to the Cesare Hotel. We will arrive at 7:20 P.M. at Rome Fiumicino Airport on July 8 on Northstar Airlines flight NA688. Please let me know as soon as possible.

Sincerely,
Gary Martin

8. What is indicated about the scheduled tour?

(A) It provides visits to historic sites.
(B) Its cost includes all food and drinks.
(C) It takes visitors to several cities.
(D) Its price does not cover entrance fees.

9. When is Mr. Martin's group scheduled to see a performance?

(A) July 8
(B) July 9
(C) July 10
(D) July 11

10. To whom was the e-mail sent?

(A) An airline staff member
(B) A tour agency representative
(C) A car service driver
(D) A hotel manager

11. Which event does Mr. Martin want to cancel?

(A) The tour of the Pantheon
(B) The visit to a museum
(C) The outing to a retail area
(D) The lunch at a pizza restaurant

12. What is one of Mr. Martin's requests?

(A) A pickup service
(B) A hotel reservation
(C) A flight upgrade
(D) A group discount

DAY 22

CHAPTER
8

-

질문 유형편

DAY 23
세부 정보 문제 ②

기본 개념 노트

본 학습에 들어가기 전에 기본적인 독해 문제 유형의 개념을 잡아보자.

다음에 할 일을 묻는 문제와 추론 문제는 세부 정보를 묻는 문제 유형에 속한다. Part 7에 등장하는 전체 문제 유형 중에서 출제 비율이 높은 편은 아니지만, 문제 풀이에 시간이 다소 걸릴 수 있으므로 빈출 문제 유형과 풀이전략을 잘 살펴보도록 하자.

❶ 빈출 문제 유형

다음에 할 일	**What most likely** will **happen** on Tuesday? 화요일에 일어날 것 같은 일은?
	What will happen in front of the Waters Hotel? 워터스 호텔 앞에서 일어날 일은?
	What will Ms. Hanlon **probably do** in the future? 핸런 씨가 앞으로 할 것 같은 일은?
	What does Ms. Dorn say she **will do**? 돈 씨가 앞으로 하겠다고 한 일은?
추론	**What** can be **inferred about** Mr. Wilson? 윌슨 씨에 대해 추론할 수 있는 것은?
	What is **suggested[implied] about** the insurance company? 그 보험 회사에 관해 암시된 것은?

다음에 할 일을 묻는 문제

특정한 시점이나 미래에 일어날 일 또는 특정 인물이 앞으로 할 일을 묻는 문제 유형이다. 보통 지문 후반부에 단서가 등장하는 경우가 많으므로 지문의 뒷부분에 특히 집중해서 읽도록 하자.

예제 1

Q. What will happen next year?

STEP 1 문제 유형 파악하기

문제를 먼저 읽고 문제 유형을 파악한다.

▶ 내년에 일어날 일을 묻고 있다.

Kim's Dry-Cleaning Expands to Serve Clientele

Boston's leading dry-cleaning company announced this week that it is going to expand its business. Kim's Dry-Cleaning has proudly served the Boston area for over ten years and is known for its quality service and affordable prices. The owner, John Kim, explained that an expansion is necessary to serve the company's ever growing customer base.

A second dry-cleaning shop will open on the city's east side in August and will be twice the size of the original downtown location. In addition, service hours will be extended into the late evening.

단서1 Next year, Kim's Dry-Cleaning will further enhance its services. 단서2 "Eventually we will offer next-day express service and home pick-up as well," said Kim, giving Boston residents a lot to look forward to.

STEP 2 다음에 할 일 문제 단서 찾기

다음에 할 일을 묻는 문제의 단서는 대개 지문 뒷부분에서 찾을 수 있다. 회사의 내년 계획을 언급하고 있는 부분을 찾는다.

단서1 내년에 킴스 드라이클리닝 사는 서비스를 더 향상시킬 예정임

단서2 익일 특급 서비스와 가정 방문 수거 서비스를 제공하려고 함

▶ 단서들을 종합해보면, 킴스 드라이클리닝 사는 내년에 기존 서비스 외에 다양한 서비스를 추가할 것임을 알 수 있다.

Q. What will happen next year?

(A) A new store will open.
(B) Service fees will increase.
(C) A store's location will be moved.
(D) Additional services will be offered.

STEP 3 정답 선택하기

단서 부분을 선택지와 비교하여 적절히 패러프레이징된 것을 정답으로 고른다.

▶ we will offer next-day express service and home pick-up → (D) Additional services will be offered.

따라서 정답은 (D)이다.

DAY 23

풀이전략

1. 다음에 할 일을 묻는 문제

• 다음에 할 일을 묻는 문제는 한 지문에 딸린 여러 문제들 중 마지막 순서로 등장하는 경우가 많다.
• 앞으로 일어날 일이나 상대방에게 부탁하는 말 등은 글을 마무리하면서 언급하는 것이 자연스럽기 때문에 대부분 지문 마지막 부분에서 단서를 찾을 수 있다.
• 지문에 향후 계획이나 일정의 변경 사항, 특정 인물이 할 일이 언급되었다면 그 부분을 특히 주의해서 읽어야 한다.
• 문제에 구체적인 시점이나 특정 인물의 이름이 나타나는 경우가 많은데, 이는 일반적으로 패러프레이징이 어렵기 때문에 지문에 같은 표현이 나올 확률이 높으므로 그 표현들에 유의하자.

추론 문제

지문을 읽고 추측, 예상하여 정답을 찾아야 하는 고난도 문제 유형이며 문제의 동사로는 **suggest**, **imply**, **infer**를 사용한다. 정답이 직접적으로 제시되지 않으므로 단서의 함축적인 내용을 이해하자.

예제 2

Q. What is suggested about the steel pipes?

TO: Derek Houston <dhouston@houstonsteel.com>
FROM: Heather Carlson <heather@sterling.com>
DATE: May 28
SUBJECT: Re: Problem with Delivery Delays

Dear Mr. Houston,

단서1 I'm contacting you today regarding your factory's recent shipments of steel pipes to our warehouse. I received each of the last three shipments between two and three days late. 단서2 The delays in delivery have caused setbacks to our construction schedule. Our clients depend on Sterling Construction to finish the projects on time. Therefore, timely delivery of materials from our suppliers is essential to the success of our business.

I am scheduled to visit your factory on June 3. I would like to discuss with you directly how we can ensure that future deliveries will arrive on time. I appreciate your attention to this matter.

Heather Carlson
Warehouse Manager, Sterling Construction

Q. What is suggested about the steel pipes?

(A) They take several days to ship.
(B) They are used in construction projects.
(C) They are sold by Sterling Construction.
(D) They are delivered daily.

STEP 1 문제 유형 파악하기

문제를 먼저 읽고 문제 유형을 파악한다.

▶ 강철 파이프에 대해 암시된 것을 묻고 있다.

STEP 2 추론 문제 단서 찾기

문제의 추론 대상인 강철 파이프가 언급된 문장의 함축적 내용을 이해하도록 한다.

단서1 이메일을 보낸 사람이 최근에 강철 파이프를 2~3일 정도 늦게 배송받음

단서2 배송 지연이 건설 일정에 차질을 빚게 함

▶ 단서들을 종합해보면, 강철 파이프를 늦게 배송받아 건설 공사의 일정에 영향을 주었다는 것을 알 수 있다.

STEP 3 정답 선택하기

단서들의 함축적 내용을 종합하여 정답을 고른다.

▶ 강철 파이프의 배송 지연으로 건설 일정에 차질을 빚었다고 하였으므로, 강철 파이프가 건설 공사에 사용된다는 것을 추론할 수 있다. 따라서 정답은 (B).

풀이전략

1. 추론 문제

- 추론 문제는 지문 전체를 읽어야 답을 고를 수 있는 경우가 많으므로, 지문 전체에 흩어져 있는 단서들의 함축적 내용을 종합하여 가장 알맞은 답을 골라야 한다.
- What can be inferred about ~?이나 What is suggested[implied] about ~? 형태의 질문에서 about 뒤에 추론의 대상이 명시되므로 반드시 문제를 먼저 읽고 그 부분에 주의하며 지문에서 단서를 찾는다.
- 추론 문제이지만 지문에 없는 내용을 추측, 예상해선 안 되며 반드시 지문에 언급된 내용을 바탕으로 정답을 골라야 한다.

패러프레이징

패러프레이징은 다른 품사를 활용하거나, 동의어 또는 유의어 활용, 상위 개념 또는 함축 표현을 활용하여 이루어진다. 어떤 방식의 패러프레이징이든지 결국 유사한 의미의 표현을 찾는 것이 관건이다.

	문제	지문	패러프레이징
예제 3	Q. What will the Fischer Center do this spring?	The Fischer Center announced today that the organization has finally raised enough money for its community project to build a park and soccer field. The project will begin in the spring.	(A) Hold a charity fundraiser → **(B) Build a recreational area**

패러프레이징 연습

다음 문제를 풀고 지문에서 패러프레이징의 단서가 된 문장을 찾아 표시해 보세요.

1.
> Whether you need a quick breakfast early in the morning or a fun snack late at night, Sweet Dreams is there for you! Come check out the newest bakery in Allentown. We specialize in beautiful pastries, but we've got everything from fresh bread to luxury cakes.

What can be inferred about Sweet Dreams?
(A) It has been in business for many years.　　(B) It stays open for long hours.

2.
> Installation of new software will begin on Monday, June 1 at 10 A.M. We expect the process to take about twenty minutes. During this time, your computer may restart itself several times. To avoid losing data, please save all work onto a separate device before 10 A.M.

What is implied about the new software?
(A) Its installation might cause shutdowns.　　(B) It allows easy file storage.

3.
> I booked a room through your Web site for September 3 to September 5. I am a Swan Hotel loyalty cardholder, so I should get 10 percent off; however, my credit card was charged the full amount. Please check my account and call me back as soon as possible.

What is suggested about the hotel?
(A) It offers discounts to loyal customers.　　(B) It is fully booked for September.

4.
> To make sure your integration into our company goes smoothly, we have prepared an orientation program for new employees, which will begin on February 23. Your department heads will contact you shortly with the location of your specific session.

What will the department heads probably do next?
(A) Provide new hires with further information　(B) Announce the successful candidates

DAY 23

5.
> The city council is looking for a company to lead the construction. It will accept proposals from firms in the state starting on April 12. The project is scheduled to start on May 1 and is estimated to last until the end of September.

What will most likely happen on May 1?
(A) A project leader will create a contract.　　(B) Construction work will begin.

정답 및 해설 102쪽

FINAL TEST

Questions 1-2 refer to the following advertisement. ⏱ 제한시간 06:00

Make an ordinary day special!

For over twenty-five years, Fourth Street Flowers has been providing exceptional service to the area. From elegant flower bouquets to plants and gift baskets, you'll be sure to find something that's just right. And if you don't, you can select flowers and make your own unique design! Visit our Web site at www.4thstreetflowers.com and sign up for our monthly newsletter, which tells you about the latest trends and has special discount coupons. You can place orders online for same-day delivery if requested before noon, or stop by the store and see our arrangements for yourself. Right now, we have special Valentine bouquets available for a limited time only. Try us today and turn your special moment into a special memory.

1. According to the advertisement, how can customers get a reduced price?

 (A) By coming on certain dates
 (B) By ordering online
 (C) By making multiple orders
 (D) By subscribing to a newsletter

2. What can be inferred about Fourth Street Flowers?

 (A) It is a new business that opened recently.
 (B) It offers holiday-themed products temporarily.
 (C) Its most popular item is sold only in the morning.
 (D) It charges an additional fee for expedited delivery.

Questions 3-6 refer to the following article.

City Announces Construction of Community Center

During a press conference on Tuesday, city council chairperson Samantha Davies announced plans for the construction of a community center on Chesterton Avenue. The new facility will feature a large event hall, three classrooms, and a conference room. It will also include an art studio and gallery area. "The council felt that such facilities would really improve the quality of life in the city," Davies said. "We will now have a place to hold community events and conduct special courses, such as art classes."

The city council is looking for a company to lead the construction. It will accept proposals from firms in the state starting on April 12. The project is scheduled to start on May 1 and is estimated to last until the end of September. Those interested in bidding on the construction project may contact the project manager, Daniel Lewis, at danlew@summerlandcity.org for information on submitting a proposal and application.

For additional information on the plans and features for the new facility, please visit www.summerlandcitycouncil.org/communitycenter.

3. What is the purpose of the article?

(A) To request a town meeting
(B) To raise money for a building
(C) To argue against a proposal
(D) To explain plans for a project

4. What does the article suggest about the construction project?

(A) The building contractors have not been chosen yet.
(B) A private company will pay for the expenses.
(C) It was designed by art specialists.
(D) The city council was originally opposed to it.

5. What will most likely happen on April 12?

(A) The facility construction will begin.
(B) Council members will select a winning bid.
(C) Proposals will be submitted to the city council.
(D) The community center will open to the public.

6. How can interested firms get information on submitting a bid for the project?

(A) By calling Samantha Davies
(B) By visiting a Web site
(C) By sending an e-mail
(D) By submitting a form at City Hall

DAY 23

정답 및 해설 104쪽

217

CHAPTER
8

-

질문 유형편

DAY 24
동의어 문제 &
의도 파악 문제

—

기본 개념 노트

본 학습에 들어가기 전에 기본적인 독해 문제 유형의 개념을 잡아보자.

동의어를 찾는 문제와 신토익에서 새롭게 추가된 화자의 의도를 파악하는 문제는 주어진 단어나 문장의 문맥 속 의미를 찾는 유형이므로 지문 맥락 파악이 관건이다. 특히 의도 파악 문제는 문자 메시지와 온라인 채팅 지문에서 출제되는데, 대화를 소재로 한 지문 성격상 구어체 표현이 출제될 수 있다.

❶ 빈출 문제 유형

동의어	**The word** "interest" **in paragraph** 1, **line** 3, **is closest in meaning to** 첫째 단락 세 번째 줄의 "interest"와 의미상 가장 가까운 단어는?
의도 파악	**At** 10:11, **what does** Mr. Stark **mean when he writes,** "Sure thing"? 10시 11분에, 스타크 씨가 "물론이죠"라고 한 것에서 그가 의도한 것은? **At** 4:15 P.M., **what does** Ms. Lee most likely **mean when she writes,** "Of course"? 오후 4시 15분에, 이 씨가 "물론이죠"라고 한 것에서 그녀가 의도한 것은?

동의어를 찾는 문제는 시험마다 **2~3문제**씩 출제된다. 단어의 사전적 의미가 아니라 문맥을 알아야만 정확한 의미 파악이 가능한 경우가 대부분이므로 제시된 단어 주변의 문맥을 정확하게 파악하도록 하자.

예제 1

Q. The word "figure" in paragraph 1, line 7 is closest in meaning to

STEP 1 제시어 위치 확인하기

문제에서 묻는 단어와 그 위치를 확인한다.

▶ 첫째 단락 일곱 번째 줄에 있는 "figure"의 동의어에 대해 묻고 있다.

Eden Lake Public Library Celebrates 100 Years

The Eden Lake Public Library will hold a social on March 13 in honor of its 100 years of service. Valarie Lee, a city council member, is organizing the event. She said the purpose of the event is to celebrate the history of the city as well as bring together members of the community. The library was founded in 1910 with a private donation of $8,000 from 단서1 Robert Milford, an important figure in Eden Lake's history. The library has since stood as a center for community activity and has expanded its services over the years to include tutoring for students, educational lectures, and Internet access.

STEP 2 문맥상 의미 파악하기

동의어 문제는 단어가 포함된 문장과 그 앞뒤의 문장을 잘 살펴보며 그 뜻을 파악한다.

단서1 로버트 밀퍼드 씨가 에덴 레이크의 역사에 있어 중요한 figure임

▶ 로버트 밀퍼드 씨는 사람이므로 figure가 '인물'을 의미하는 것을 알 수 있다.

Q. The word "figure" in paragraph 1, line 7 is closest in meaning to

(A) shape
(B) number
(C) amount
(D) person

STEP 3 정답 선택하기

제시된 단어의 문맥상 의미와 가장 가까운 것을 고른다.

▶ '로버트 밀퍼드 씨가 역사에 있어 중요한 인물' 이라는 문맥이므로 여기서 figure는 '인물'이란 뜻으로 쓰였음을 알 수 있다. 따라서 정답은 (D)이다.

DAY 24

풀이전략

1. 동의어 문제

- 단어가 포함된 문장과 앞뒤의 문맥을 파악하는 것이 문맥 속 의미의 동의어를 고르는데 도움이 된다.
- 제시어와 동의어지만 문맥 속 의미와는 다른 의미를 뜻하는 단어들이 오답으로 나오는 경우도 있으므로, 사전적 의미가 아니라 문맥 속 의미를 파악해야 한다.
- 다의어는 그 뜻에 유의하여 평소에 비슷한 어휘를 함께 암기해 두면 문제 푸는 시간을 줄일 수 있다.

동의어

동의어 문제로 출제되기 쉬운 동의어 짝을 알아보자.

어휘	의미	동의어
action	행동, 조치	measure, step
adjust	조정하다	adapt
as	~ 때문에	because
association	연계, 유대	connection
assume	(권력, 책임을) 맡다	undertake
assure	장담하다, 확언하다	promise
boost	신장시키다	increase
carry	취급하다	keep in stock
carry out	~을 수행하다 완료하다	perform accomplish
command	지휘, 통솔	mastery
compensation	보상(금)	payment
complimentary	무료의	free
concern	(무엇에) 관한 것이다	involve
cover	다루다 보도하다	deal with report
credit	인정, 칭찬	recognition
critical	대단히 중요한	essential
degree	정도	level
distinction	뛰어남, 탁월함	reputation
draw	끌어당기다	attract
establish	설립하다 개설하다	set up introduce
extend	주다, 베풀다	offer
fairly	공정하게, 타당하게	reasonably
field	분야	profession, area
figure	수치 인물	amount, balance person
fine	잘, 괜찮게	acceptable
follow	유심히 지켜보다	pay attention to
given	~을 고려해 볼 때	considering

어휘	의미	동의어
help	돕다	assist
honor	지키다, 이행하다	fulfill
just	단지	only
last	바로 앞의, 지난	previous
mark	기념하다	celebrate
matter	상황	situation
model	(상품의) 모델	version
note	~에 주목하다	be aware
outstanding	뛰어난	superior
over	~ 하는 동안에	during
place	장소 놓다, 두다	seat put
property	재산, 소유물 부동산, 건물	belongings location
raise	제기하다, 언급하다	voice
rate	요금	price
recognize	알아보다 인정하다	realize acknowledge
reflect	나타내다	indicate, show
sensitive	(정보 등이) 민감한	confidential
set	계획된, 정해진	prepared, ready
so far	지금까지	to this point
speculate	추측하다	guess
stretch	펼쳐져 있는 지역, 구간	section
suit	맞다, 어울리다	fit
taste	기호, 취향	preference
tentative	잠정적인, 머뭇거리는	not finalized
trace	추적하다, 밝혀내다	find
treat	처리하다	handle
volume	양	numbers

의도 파악 문제

의도 파악 문제는 신유형 지문인 문자 메시지와 온라인 채팅 지문에서 각각 1문제씩 출제된다. 특정 시간에 화자가 말한 표현을 찾아 그 의도를 파악하는 문제로, 인용구 앞뒤의 문맥 파악이 중요하다.

예제 2

Q. At 11:05, what does Ms. Harper mean when she writes, "He's on it"?

STEP 1 화자와 인용구 확인하기

문제를 먼저 읽고 화자의 이름과 인용구가 제시된 시간을 확인한다.

▶ 11시 5분에 하퍼 씨가 "그분이 하고 있어요"라고 말한 의도를 묻고 있다.

CARL SIMMONS 11:01
Brendon said he submitted a request to have off this Friday but hasn't gotten approval yet. He is wondering if you need him that day.

LINDA HARPER 11:03
Oh, there is a problem with my account. I wasn't able to log into the system this morning, so I didn't see his request.

CARL SIMMONS 11:04
I see. 단서1 Do you need me to contact Gustavo Quiroz from IT to figure it out?

LINDA HARPER 11:05
단서2 No. I've actually already contacted him. He's on it. Just let Brendon know he can take Friday off.

STEP 2 인용구 주변 문맥 파악하기

인용구 앞의 메시지에 응답하는 표현의 의도를 묻는 경우가 많으므로 앞의 메시지 내용을 주의해서 파악한다.

단서1 시먼스 씨가 문제 확인을 위해 IT 부서의 구스타보 퀴로즈 씨에게 연락해야 하는지 물어봄

단서2 하퍼 씨가 이미 자신이 연락했으므로 그렇게 할 필요 없다고 함

▶ 단서들을 종합해보면, 하퍼 씨가 이미 퀴로즈 씨에게 연락해 문제를 해결할 방안을 찾고 있음을 알 수 있다.

Q. At 11:05, what does Ms. Harper mean when she writes, "He's on it"?

(A) Mr. Quiroz told her he will not be in the office Friday.
(B) Mr. Quiroz is looking for a solution to her problem.
(C) She is using Mr. Quiroz's account to log on.
(D) She told Mr. Quiroz to approve Brendon's day off.

STEP 3 정답 선택하기

단서 부분을 선택지와 비교하여 적절히 패러프레이징된 것을 정답으로 고른다.

▶ figure it out → is looking for a solution

따라서 정답은 (B)이다.

풀이전략

1. 의도 파악 문제

- 의도 파악 문제가 출제되는 지문에는 직장 동료 간에 업무를 요청하거나 정보를 공유하는 내용이 주로 나온다.
- 인용구 앞뒤의 문맥을 파악하는 것이 정답을 고르는데 직접적인 단서가 된다.
- 부탁이나 요청에 대한 응답일 경우가 많으므로 인용구 의미가 긍정인지 부정인지를 확인하고 의도를 파악한다.
- 인용구에 대명사가 있다면, 인용구 앞에서 대명사가 지칭하는 명사를 확인하자.
- 문자 메시지나 온라인 채팅은 대화를 소재로 한 지문이므로 구어체 표현이 나온다.
- 3인 이상이 참여하는 온라인 채팅 지문에서는 대화 도중에 참여하는 인물도 등장하기 때문에 유의한다.

구어체 표현

의도 파악 문제로 출제되기 쉬운 구어체 표현을 알아보자.

표현	의미	표현	의미
Anything that interests you.	좋아하시는 것 아무거나요.	I would appreciate it.	그렇게 해주면 고맙겠어요.
Be my guest.	좋을 대로 하세요.	It's a shame ~ = What a shame ~	~해서 안타깝네요
Call off the meeting.	회의 취소하세요.	It's your call. = It's up to you.	당신에게 달렸어요.
Don't fret about it.	걱정하지 마세요.	Let me figure it out.	제가 알아볼게요.
Don't get me wrong.	오해하지 마세요.	Let me treat you. = It's on me.	제가 대접할게요.
Don't get your hopes up.	너무 기대하지 마세요.	Never mind.	신경 쓰지 마세요.
Go for it!	그냥 한번 해보세요!	Same here.	나도 똑같이 생각해요.
Help yourself.	마음껏 드세요.	Sure thing.	물론이지요.
I can handle[manage] it.	나 혼자 할 수 있어요.	That's all that matters.	바로 그게 중요한거죠.
I can't stand it.	난 견딜[참을] 수가 없어요.	That's better than nothing.	아무것도 아닌 것보다 낫죠.
I couldn't agree with you more.	당신 말에 전적으로 동의해요.	The blame is all mine.	모두 제 잘못이에요.
I didn't mean to. = It wasn't intentional.	고의가 아니었어요.	Way to go!	정말 잘했어요!
I doubt it.	그렇지 않을 걸요.	What a pity. = That's too bad.	안타깝네요.
I got your back.	나만 믿으세요.	You bet!	물론이지요!
I have a long way to go.	아직 멀었어요.	You can say that again. = You're telling me.	내 말이 그 말이에요.
I'm almost done with it.	거의 다 했어요.	You can't miss it.	쉽게 찾을 거예요.
I'm for it.	그 말에 찬성이에요.	You deserve it.	당신은 그럴 자격이 있어요.
I'm not following you.	당신 말을 이해 못하겠어요.	You have my word. = I'll give you my word.	약속할게요.
I'm not in the mood.	그럴 기분이 아니에요.	You name it.	뭐든지 말만 하세요.

패러프레이징

패러프레이징은 다른 품사를 활용하거나, 동의어 또는 유의어 활용, 상위 개념 또는 함축 표현을 활용하여 이루어진다. 어떤 방식의 패러프레이징이든지 결국 유사한 의미의 표현을 찾는 것이 관건이다.

지문	패러프레이징
Q. While similar companies are dropping prices to stay competitive, Underwood Electronics continues to thrive. Their loyal customer base is willing to pay more for the quality of Underwood's products, keeping the company's profits steadily on the rise.	(A) Some of the customers do not want to pay more for Underwood Electronics products. **(B) Underwood Electronics is able to maintain sales without cutting prices.**

다음 짧은 지문을 읽고 지문과 일치하게 패러프레이징된 문장을 고르세요.

1.

> Yealy Bakery is opening its doors on July 5! To celebrate, we will have various special deals for our grand opening! Come and check out our various breads, cakes, pastries, and more. For our first day, we will be giving out free samples of our delicious chocolate cake.

(A) A new business is having an event.
(B) Chocolate cakes are on sale.

2.

> In 2003, Amelia Harrison met chef Paige Jarvis at a food festival in Tucson, Arizona. This fortunate encounter would eventually result in the creation of the largest barbecue sauce producers in Brazos County.

(A) After meeting, they started a company together.
(B) They won first place at a contest.

3.

> Your interview is scheduled for Thursday, December 8 at 1 P.M. at the Hamelin headquarters. You should arrive at the office at least fifteen minutes early. Please bring four hard copies of your résumé. The interview should last approximately thirty minutes.

(A) An interview needs to be rescheduled.
(B) A candidate should print out a document.

4.

> Abstract painter Douglas Flavio is grabbing the attention of art critics all around the city. Flavio, who was unknown just a year ago, has now been featured in several art magazines. Most impressive of all, one of his works will be exhibited at Millwood City's art museum.

(A) A famous critic is opening a new art gallery.
(B) A contemporary artist is rising to fame.

5.

> This is to confirm your reservation at Cloud Hotel from March 3 to March 6. You will be staying in a non-smoking twin room. A maximum of two guests are allowed in the room. And breakfast is included for all three mornings for two people.

(A) A booking has successfully been completed.
(B) A reservation was changed to add another person.

정답 및 해설 108쪽

FINAL TEST

Questions 1-2 refer to the following text message chain.

제한시간 10:00

EDWARD CORSICA ·· 10:30

Dennis, how is everything going? Do you have a lot left to do for the conference?

DENNIS CALDWELL ·· 10:32

Not that much. The tables are all ready, and I'm just about finished putting out the cold sandwiches. Then I'll just need to set up the beverage machines, and I'll be done.

EDWARD CORSICA ·· 10:33

That's all you have left? Good. The presenters will be here soon.

DENNIS CALDWELL ·· 10:34

Well, it might take a little longer than planned. There is a problem with the coffee machine. The faucet is missing.

EDWARD CORSICA ·· 10:35

Oh? I thought it was a brand-new machine. How did that happen?

DENNIS CALDWELL ·· 10:36

Not sure. I think it might have broken off when I took it out of the van. So I'm going to have to go get another one.

1. What type of business does Mr. Caldwell work for?

 (A) A coffee shop
 (B) A catering service
 (C) A restaurant
 (D) A moving company

2. At 10:36, what does Mr. Caldwell mean when he writes, "Not sure"?

 (A) He can not predict when he will be finished.
 (B) He does not have enough food for the event.
 (C) He has not thought of a way to fix the problem.
 (D) He does not know exactly why the device is damaged.

Questions 3-6 refer to the following online chat discussion.

Jeremy Finning 15:03	Bella, can you check the employee description page? It used to have the biographies of all of our personal trainers, and it had pictures of each. Now, everything is gone.	
Bella Stanley 15:05	Oh, they're all blank! Only the list of names is left. When did you notice this?	
Jeremy Finning 15:06	Just now. I got an e-mail from a customer saying she couldn't find any information about our trainers.	
Bella Stanley 15:07	Eric, the employee profiles page seems to have a problem. Can you take a look? We updated the Web site earlier today, so there must have been an error in the change.	
Eric Gafaga 15:09	I'm checking now. That's weird. I don't think we've ever had this happen before. I know how to fix it, though.	
Bella Stanley 15:10	Are we going to have to rewrite the biographies and upload all of the pictures again?	
Eric Gafaga 15:11	That won't be necessary. I have the older version of the Web site saved. In the meantime, Jeremy, please e-mail the customer with a picture of our brochure. It has an introduction of all of our personal trainers.	

[|] SEND

3. What is mainly being discussed?

(A) Missing information on a Web site
(B) Malfunctioning computers
(C) Failed picture uploads
(D) Incorrect names on profiles

4. What is indicated about the Web site?

(A) It was recently changed.
(B) It received positive reviews.
(C) It includes several typos.
(D) It has an outdated design.

5. At 15:11, what does Mr. Gafaga mean when he writes, "That won't be necessary"?

(A) The biographies do not have to be included on the page.
(B) The Web site does not require an update.
(C) The profiles do not need to be recreated.
(D) The employee description page is not accessible by customers.

DAY 24

6. What will Mr. Finning most likely do next?

(A) Update the Web site
(B) Write new biographies
(C) Upload a previous page
(D) Send a file to a customer

Smoker's Expands Operations

By Sean Parsons

In 2003, Amelia Harrison met chef Paige Jarvis at a food festival in Tucson, Arizona. This fortunate encounter would eventually result in the creation of the largest barbecue sauce producer in Brazos County.

Originally, Harrison was not involved in the recipe-making business at all. She was operating a small grill shop in New Orleans. However, she has always been a fan of quality barbecue, so she joined forces with Jarvis to create one of the country's favorite bottled sauces: Smoker's.

In 2007, Harrison and Jarvis began hosting cooking contests, which have become the most popular attraction of barbecue festivals across the country. This boosted Smoker's success dramatically. They will be the hosts of the contest for the 25th Annual Mid-American Barbecue Convention, too.

Today, Smoker's is moving to a bigger 3,600-square-foot location at 5831 San Felipe St. "We are absolutely thrilled about the move," Amelia Harrison said. "We hoped that this would happen eventually, but never dreamed it would come about so quickly."

25TH ANNUAL MID-AMERICAN BARBECUE CONVENTION
Owensboro, Kentucky
Saturday, July 10–Sunday, July 11

The Annual Mid-American Barbecue Convention has returned! For two days, barbecue lovers can wander around our fair grounds, trying free samples of various foods and drinks served at each booth. On Saturday, a private convention will be held indoors for business owners and professionals to learn about various aspects of the barbecue industry while patrons enjoy the fair outside. On Sunday, everyone will be entertained by various events and performances on the main stage outside, including the highly anticipated cook-off competition.

TIME	SATURDAY	SUNDAY
10:00 A.M.–11:00 A.M.	*From Chef to Sauce Maker*, Paige Jarvis	Pie-Eating Contest
11:00 A.M.–12:00 P.M.	*Branding your Product*, Jake Dyer	Blue Steel Band
12:00 P.M.–2:00 P.M.	Free time for lunch and exploring the festival	Various Children's Games
2:00 P.M.–3:00 P.M.	*The Business of barbecue*, Michael Flemming	Backyard Cook-Off Competition
3:00 P.M.–4:00 P.M.	*It's All in the Equipment*, Ashley James	Blindfolded Sauce Taste Test

From: Joel Price

Wednesday, July 14 10:11 A.M.

Hello, Ms. Paige. I really enjoyed your presentation at the convention last weekend. Your innovative ideas are truly inspiring. In fact, you have motivated me to design completely new modern menus for my customers. I look forward to seeing you again.

7. Why was the article written?

(A) To report a merger between two companies

(B) To announce the opening of a restaurant

(C) To promote a new line of barbecue products

(D) To describe the growth of a business

8. In the article, the word "boosted" in paragraph 2, line 5, is closest in meaning to

(A) increased

(B) supported

(C) sustained

(D) promoted

9. Which event is Smoker's most likely to host?

(A) Pie-Eating Contest

(B) Children's Games

(C) Backyard Cook-Off Competition

(D) Blindfolded Sauce Taste Test

10. What is indicated about the convention?

(A) Lectures are open to the general public.

(B) Smoker's will set up a taste-testing booth.

(C) Speakers will give presentations outside.

(D) Food will be available for free.

11. What can be inferred about Mr. Price?

(A) He applied for a job with Smoker's.

(B) He is a business owner.

(C) He organized a competition at the event.

(D) He helped Ms. Jarvis to grow her company.

DAY 24

CHAPTER

8

-

질문 유형편

DAY 25
문장 위치 찾기 문제

—

기본 개념 노트

본 학습에 들어가기 전에 기본적인 독해 문제 유형의 개념을 잡아보자.

문장 위치 찾기 문제는 신토익에 새롭게 추가된 유형으로, 지문의 논리적인 흐름을 파악해야 풀 수 있다. 시험마다 2문제씩 출제되며 주로 기사와 이메일, 편지의 마지막 문제로 출제된다. 제시된 문장의 대명사 및 지시어의 사용, 연결어, 시간 순서나 수량 표현을 단서로 문장의 위치를 찾을 수 있다.

❶ 빈출 문제 유형

In which of the positions marked [1], [2], [3], and [4] does the following sentence best belong?

"He says this is due to the high cost of fuel and housing."

[1], [2], [3], [4]번으로 표시된 위치들 중 다음 문장이 들어가기에 가장 적절한 곳은?

"그는 이것이 높은 연료비와 주거비 때문이라고 말한다."

❷ 정답 단서

대명사	인칭대명사	I, you, he, she, it, we, they, myself, themselves, ...
	지시대명사	this, that, these, those
	부정대명사	one, another, others, the others, some, any, ...
연결어	결과	therefore, hence, thus, consequently 그러므로, 따라서
	첨가	in addition, as well as, what is more 게다가
	대조	however, yet, but 그러나
	예시	for instance, for example 예를 들어
	시간 순서	after 후에 before 전에 and then 그런 다음 first 첫 번째로

문장 위치 찾기 문제 ①

문장 위치 찾기 문제는 시험마다 2문제씩 출제되며 지문의 전체적인 흐름을 파악해야 한다. 제시된 문장을 먼저 읽고 단서가 되는 대명사와 지시어를 바탕으로 문맥을 파악하여 적절한 위치를 찾는다.

예제 1

Q. In which of the positions marked [1], [2], [3], and [4] does the following sentence best belong?

"He says this is due to the high cost of fuel and housing."

STEP 1 제시된 문장 내용 파악하기

제시된 문장을 먼저 읽고 앞에 올 내용을 예상한다.

▶ 인칭대명사 He와 지시대명사 this가 단서. 제시된 문장 앞에 He가 가리키는 대상과 '높은 연료비와 주거비'로 인해 발생한 일(this)이 언급될 것이다.

Economic Recession Predicted

Despite attempts by the Reserve Bank to battle persistent inflationary pressure, market conditions continue to worsen. — [1] — With unemployment and inflation rates continuously increasing, leading economists predict the country will fall into a recession before the end of the year. — [2] —

단서1 Mark Whimsey, a senior economist with the Institute for Economic Stability, says there has been a steady decline in the domestic economy. — [3] — He points to the price of oil, which surged last week to a record high of $1.50 a gallon, and the continuing slump in the real estate market, as major contributors to the downturn. — [4] —

STEP 2 선택지 위치별 맥락 파악하기

각 번호 앞의 내용을 확인하여 제시된 문장을 삽입할 수 있는 위치를 찾는다.

▶ [1] 악화되는 시장 상황에 대한 내용으로 대명사 He가 들어갈 수 없다.

▶ [2] 경제학자들(economists)의 경제 관련 예측으로 He로 지칭할 수 있는 인물이 등장하지 않는다.

▶ [3] 마크 윔지가 소개되고 국내 경제 불황에 대한 그의 말이 언급되고 있어 제시된 문장이 들어갈 수 있다.

▶ [4] 연료비의 인상과 부동산 시장의 침체라는 내용이 언급되고 있는데, 이것은 높은 연료비와 주거비에 관해 뒷받침하는 부연 설명이므로 제시된 문장이 이 뒤에 이어지는 것은 적절하지 않다.

Q. In which of the positions marked [1], [2], [3], and [4] does the following sentence best belong?

"He says this is due to the high cost of fuel and housing."

(A) [1]
(B) [2]
(C) [3]
(D) [4]

STEP 3 정답 선택하기

제시된 문장의 단서를 바탕으로 문맥에 알맞은 답을 선택한다.

▶ 앞에 언급된 마크 윔지라는 경제학자를 He로 가리키고 그가 말한 국내 경제의 쇠퇴를 this로 언급하며 그 원인을 높은 연료비와 주거비 때문이라고 하는 것이 문맥상으로도 가장 자연스럽다. 따라서 정답은 (C) [3].

1. 문장 위치 찾기 문제 ①

• 제시된 문장에 he, she, they 등의 인칭대명사가 있으면 지문에서 대명사가 지칭하는 인물을 찾는다.
• 제시된 문장에 this, that 등의 지시대명사가 있으면 이것이 가리키는 사물, 사건, 또는 상황을 찾는다.
• 제시된 문장에 one, another, others 등의 부정대명사가 있으면 앞이나 뒤에 언급된 다른 부정대명사를 찾은 뒤 문맥에 맞는 위치를 고른다.
• 대명사가 가리키는 대상이 있는 문장의 바로 다음 위치가 정답일 가능성이 높다.

문장 위치 찾기 문제 ②

대명사와 지시어 외에 연결어를 단서로 정답을 찾을 수도 있다. 연결어는 지문의 논리적 흐름을 보여주므로 지문에서 흐름이 어색한 부분을 찾아 제시된 문장이 자연스럽게 이어지는지 확인한다.

Q. In which of the positions marked [1], [2], [3], and [4] does the following sentence best belong?

"After the decision was made, I met with one of my colleagues in our accounting department."

STEP 1 제시된 문장 내용 파악하기

제시된 문장을 먼저 읽고 앞에 올 내용을 예상한다.

▶ 제시된 문장에 연결어 After가 있고 그 결정이 내려진 후에 동료를 만났다고 했으므로 앞에 어떤 결정이 내려졌다는 내용이 나올 것이다.

To: Bill Underwood <underwoodbill@lkc.com>
From: Linda Chase <chaselinda@nseducore.com>
Subject: Request for data

Good morning, Bill. **단서1** I want you to know that we're all excited that your company will be building our new corporate headquarters.

— [1] — He had several questions about the distribution of the budget designated for architectural design. — [2] — I trust you can supply us with this data, since you have already planned out most of your expenditures. — [3] — I'd like this information, as well as an outline of your budget, as soon as possible.

— [4] — Please e-mail this to me and my supervisor, Chris Morrell, at your earliest convenience.

Thank you for your time.
Linda

STEP 2 선택지 위치별 맥락 파악하기

각 번호 앞의 내용을 확인하여 제시된 문장을 삽입할 수 있는 위치를 찾는다.

▶ [1] 신사옥 건설을 진행하게 되었다는 앞의 내용으로 보아 이 결정 뒤에 제시된 문장이 들어갈 수 있다.

▶ [2] 결정과 관련된 동료의 질문에 대한 내용으로, 이 뒤에 동료를 만났다는 내용이 이어지는 것은 적절하지 않다.

▶ [3], [4] 필요한 정보를 요청하는 내용이 앞에 나오는데, 결정이 내려졌다고 판단할 수 있는 내용이 없으므로 제시된 문장이 들어갈 수 없다.

Q. In which of the positions marked [1], [2], [3], and [4] does the following sentence best belong?

"After the decision was made, I met with one of my colleagues in our accounting department."

(A) [1]
(B) [2]
(C) [3]
(D) [4]

STEP 3 정답 선택하기

제시된 문장의 단서를 바탕으로 문맥에 알맞은 답을 선택한다.

▶ 신사옥 건설을 진행하기로 결정되어서 기쁘다는 내용이 나오고 그 결정 이후에 동료를 만나 대화를 나눴다는 내용이 이어지는 것이 문맥상 자연스럽다. 따라서 정답은 (A) [1].

풀이전략

1. 문장 위치 찾기 문제 ②

- 제시된 문장에 therefore, in addition, however와 같은 결과, 첨가, 대조 등을 나타내는 연결어가 있으면 앞 문장과의 의미 관계를 따져보고 정답을 찾는다.
- 제시된 문장에 after, before, and then, first 등의 시간 순서를 나타내는 표현이 있으면 전후 관계를 따져본다. 사건의 전후 내용을 파악하여 단서가 되는 문장 앞뒤에 제시된 문장을 삽입해 보고 흐름이 자연스러운지 확인한다.
- 제시된 문장에 one, two, both 등의 수량 표현이 있으면 지문에서 해당 숫자가 언급되었는지 살펴본다. 단서가 되는 문장의 수량 표현과 수의 일치가 되는지 확인하며 정답을 고른다.

패러프레이징

패러프레이징은 다른 품사를 활용하거나, 동의어 또는 유의어 활용, 상위 개념 또는 함축 표현을 활용하여 이루어진다. 어떤 방식의 패러프레이징이든지 결국 유사한 의미의 표현을 찾는 것이 관건이다.

문제	지문	패러프레이징
Q. How will employees get to the picnic site?	For those of you who are attending the company picnic this Friday, please meet in front of the building at 4 P.M. We have decided to rent a shuttle bus so that we can all go together.	**(A) By riding a bus** (B) By using a car

다음 문제를 풀고 지문에서 패러프레이징의 단서가 된 문장을 찾아 표시해 보세요.

1.

Starting on September 16, employees will no longer need prior approval from a manager to rent out video equipment from the storage room. Employees who require cameras or other devices may thus go directly to the storage keeper to make their requests.

What is the purpose of the notice?
(A) To inform of a change in policy
(B) To report a missing item

2.

Train 256 has experienced some mechanical difficulties. As a result, it left Clearsprings ten minutes late, at 5:35 P.M. It is thus now scheduled to arrive at Graston ten minutes late, at 7:21 P.M. instead of 7:11 P.M. Thank you for your patience.

What caused the delay in Train 256?
(A) Mechanics strikes
(B) Technical problems

3.

Neurologist Meredith Bowser has dedicated her career to studying the effects of Alzheimer's on memory. Yesterday, Dr. Bowser announced the creation of a foundation to support Alzheimer research. On August 13, the foundation will hold its first fundraiser.

What will happen on August 13?
(A) A new organization will be launched.
(B) An event will take place.

4.

A new restaurant will be located in the city's West End, miles away from Canneli's original downtown hotspot. The opening date has not been officially set, but Canneli estimates it will be in service before October 1. You can visit the Web site www.agorarestaurant.com for up-to-date information.

What is expected to happen by October 1?
(A) A new restaurant will open for business.
(B) Canneli will relocate his first eatery.

5.

We have received your complaint about the defective flashlight you purchased yesterday. We are very sorry about the inconvenience. To get a full refund, please mail the product back along with its receipt to any Night Light retailer.

How can the customer get a refund?
(A) By sending the item to any store branch
(B) By attaching the receipt to an e-mail

정답 및 해설 117쪽

DAY 25

FINAL TEST

제한시간 06:00

Anita Brancato
823 Remarque
Quebec City, Quebec

Dear Ms. Brancato,

I work with New England Express Bus Carriers, a full-service express transportation provider operating in the northeastern United States and southeastern Canada. I am contacting you because you are a frequent traveler in the region, and I believe you will enjoy our services. — [1] —

For instance, you can spend your next journey from Montreal to Boston in one of our ultra-comfortable buses. — [2] — Round-trips start at $34.50, which is less than a third of the cost of the average plane ticket, without all the check-in hassles and flight delays. — [3] — And with today's high gas prices, why take your car? Leave the driving to us! — [4] —

So for your next trip, contact New England Express Bus Carriers and let us show you what we can do!

Fred Eldridge, District Manager
New England Express Bus Carriers

1. What is the purpose of this letter?

 (A) To introduce a new driver
 (B) To describe a vacation
 (C) To advertise a company's services
 (D) To announce an ongoing sale

2. According to the letter, why is bus travel better than air travel?

 (A) Airline schedules are not reliable.
 (B) Bus travel is less dangerous.
 (C) Airplane seats are not comfortable.
 (D) Buses run more frequently.

3. In which of the positions marked [1], [2], [3], and [4] does the following sentence best belong?

 "These are specially designed to provide a relaxing ride."

 (A) [1]
 (B) [2]
 (C) [3]
 (D) [4]

George Canneli Goes for Second Success

Kate Warner

Renowned chef and restaurant owner George Canneli has announced the upcoming opening of his second restaurant, Agora. Canneli, already well-known for his Italian eatery Il Conto, will try his luck with a Mediterranean fusion restaurant at the end of September. — [1] —

Canneli was trained in traditional Italian cooking. However, the chef wishes to move away from the limitations of a single culture's cuisine. — [2] — "Our hope is to combine flavors from across the region and create new tastes," says Andrea Ricardo, who will serve as the new establishment's head chef.

The restaurant will be located in the city's West End, miles away from Canneli's original downtown hotspot. — [3] — The opening date has not been officially set, but Canneli estimates it will be in service before October 1. You can visit the Web site www.agorarestaurant.com for up-to-date information. — [4] —

4. Why was the article written?

(A) To review a local Italian restaurant
(B) To report the opening of a new restaurant
(C) To introduce a restaurant's new head chef
(D) To give instructions on making reservations

5. What is NOT indicated about George Canneli?

(A) He got trained in Italian cuisine.
(B) He has a good reputation.
(C) He wants to diversify his menus.
(D) He is from the Mediterranean region.

6. What can be inferred about Agora?

(A) Its location is far from Il Conto.
(B) Its reservation system is not ready.
(C) Its opening event will be held in October.
(D) Its Web site has not launched yet.

7. In which of the positions marked [1], [2], [3], and [4] does the following sentence best belong?

"Therefore, Agora will serve dishes that come from a variety of Mediterranean countries."

(A) [1]
(B) [2]
(C) [3]
(D) [4]

DAY 25

CHAPTER
9

-

지문 유형편

DAY 26
이메일/편지 &
메모/공지

—

기본 개념 노트

본 학습에 들어가기 전에 기본적인 독해 지문 유형의 개념을 잡아보자.

이메일/편지와 메모/공지는 수신자와 발신자가 있고, 글의 목적이 명확하게 명시된다는 점에서 유사하다.
빈출 상황별 대표 어휘와 연계 지문을 정리해 보자.

❶ 빈출 상황별 대표 어휘

제품 불만 제기	complimentary 무료의 defect 결함 exchange[replacement] 교환 guarantee 보장하다 malfunction 기능 불량	out of stock (재고) 품절 policy 방침, 정책 receipt 영수증 refund 환불(하다) voucher 상품권
회의 및 공식 모임	agenda 안건 announce A to B A를 B에게 발표하다 board of directors 이사회 conference 학회	participation 참가 presentation 발표 representative 대표 venue 장소
변경된 일정 공지	be scheduled for ~로 예정되어 있다 inform A of B A에게 B를 알리다 be pushed back[be put off, be postponed] 미뤄지다 reschedule[cancel] the meeting 회의를 다시 잡다[취소하다]	please note that ~라는 것에 유의하십시오 scheduling conflict 일정 충돌
회사 내 변경 사항	benefits package 복지 혜택 implement 시행하다 incentive 추가 수당	introduce 도입하다 motivate 동기를 부여하다 take effect 효력이 발생하다

❷ 빈출 연계 지문

이메일 & 이메일	예약 확인, 변경 요청 이메일 & 오류 정정 이메일 회사 내 문제 사항 보고 이메일 & 해결 방법 안내 이메일
메모 & 이메일	기업 내 변경 사항을 알리는 메모 & 문의, 요청 이메일
공지 & 이메일	행사 일정 안내, 변경 사항 공지 & 문의 이메일
표[양식, 웹사이트] & 이메일	일정표, 기업이나 상품 등을 소개하는 웹사이트 & 문의 이메일
이메일 & 양식 & 이메일	분실물 신고 이메일 & 관련 양식 & 결과 안내 이메일
편지 & 광고 & 이메일	행사 관련 요청 편지 & 행사 광고 & 답장, 문의 이메일

이메일/편지

이메일과 편지는 **Part 7** 전체 지문 중 **40퍼센트 이상**의 출제 비율을 차지한다. 이메일과 편지 모두 비슷한 흐름으로 지문이 구성되므로 지문의 구조를 파악하여 정답을 빠르게 찾자.

예제 1

TO: Sara Carlson <orders@oakland.com>
FROM: Gary Folsom <gfolsom@speedmail.com>
DATE: September 22
❶ SUBJECT: Order Refund

Dear Ms. Carlson,

I recently talked with you on the phone. As discussed, ❷ I am sending you my bank account details for the refund.

This is in regards to an order I had placed for a dining room table. After paying, I had received notice that the item was out of stock. ❸ You explained that your company's policy in this case is to refund the full amount and that the process takes no longer than two days.

❹ If you need any more information from me, you can reach me at 555-3299.

Thank you for your help in this matter.

Regards,

Gary Folsom

❶ 수신자, 발신자, 날짜, 제목

제목을 통해 내용을 미리 유추해볼 수 있다.

▶ 주문품 환불에 대한 내용

❷ 글의 목적

이메일의 목적은 대부분 지문 앞부분에서 제시된다.

▶ 은행 계좌 세부 사항을 보냄

+ 출제되는 문제 유형

Q. What is the purpose of the e-mail?
이메일의 목적은?

A. To provide information
정보를 제공하기 위해

❸ 세부 내용 및 요청 사항

주제 및 요청 사항과 관련하여 구체적인 내용이 언급된다.

▶ 정보 제공의 이유를 알리고 환불 기간을 확인함

+ 출제되는 문제 유형

Q. What will happen within two days?
이틀 내에 일어날 일은?

A. Mr. Folsom will get his money back for his order.
폴섬 씨가 주문 금액을 돌려받을 것이다.

❹ 추가 정보 및 첨부

이메일의 후반부에는 보통 추가 정보나 연락 방법, 첨부한 것을 언급한다.

▶ 추가 정보가 필요하면 전화로 연락하라고 함

+ 출제되는 문제 유형

Q. What information does Mr. Folsom provide? 폴섬 씨가 제공하는 정보는?

A. Contact details 연락처

DAY 26

풀이전략

1. 이메일/편지

- 대부분 비즈니스 상황에서 회사 간 또는 회사와 개인 간에 주고받는 이메일/편지가 다양한 주제로 등장한다.
- 이메일은 업무 전달 사항, 여행 일정이나 숙소 예약 확인, 제품이나 서비스에 대한 감사나 불만, 고객 문의에 대한 답변 내용을 주로 다룬다.
- 편지는 행사 안내와 초대, 인력 추천, 합격 통보, 잡지 구독 기간 만료 공지, 기부금 요청 등에 관한 내용이 빈출된다.
- 이메일/편지는 그 흐름이 비슷하므로, 흐름을 미리 알아두면 문제 유형별 단서가 등장할 부분을 예상할 수 있다.
- 수/발신자 관련 문제는 인물 이름을 우선 파악한 후, 지문에 등장하는 이름과 인칭대명사에 주의하며 풀어야 한다.

메모/공지

메모와 공지는 한 사람이 다수의 사람들을 대상으로 정보를 알리기 위해 작성한 글이다. 지문의 구조를 파악하여 어떤 정보를 전달하고 있는지 파악하는 것이 핵심이라는 점을 염두에 두자.

예제 2

MEMORANDUM

❶ TO: Design Staff
FROM: Derek White, Director of Marketing
SUBJECT: Practice Meeting

❷ Please be on time for tomorrow's 1 P.M. meeting to review the presentation for the Mullane account. We will practice the presentation for about an hour, so you will be free from 2 P.M. until clients arrive.

❸ They were originally planning to come to the office at 3 P.M., but due to a scheduling conflict, the presentation will be pushed back one hour.

Both the presentation and the meeting will take place in Conference Room A. Mr. Hayes will be responsible for setting up all of the equipment.

Thank you.

❶ 수신자, 발신자, 제목

주로 조직의 관리자나 행사 등의 책임자가 조직 구성원들에게 전달 사항을 알린다.

▶ 마케팅 팀장이 디자인 부서 직원들에게 연습 회의에 대해 알리고 있음

❷ 글의 목적

메모의 목적은 주로 첫 부분에 언급되며, 앞에서 목적을 파악하고 나면 뒤에 나오는 세부 사항들을 보다 쉽게 이해할 수 있다.

▶ 발표 연습 회의 일정을 알림

＋ 출제되는 문제 유형

Q. What is the purpose of the memo?
메모의 목적은?

A. To remind of a practice session
연습 시간을 상기시키기 위해

❸ 세부 내용

구체적인 전달 사항이 나타나는 부분으로, 회의 및 공식 모임의 목적, 주제, 참가자 또는 일정 변경의 이유 등을 알린다.

▶ 발표 시간 변경 이유와 발표 장소, 업무 담당자를 알리고 있음

＋ 출제되는 문제 유형

Q. What time will the presentation occur? 발표가 시작될 시간은?

A. 4 P.M. 오후 4시

풀이전략

1. 메모/공지

• 메모는 회사에 새로운 규정이나 시스템을 도입하는 것, 조직 구조를 변경하는 것, 계획된 일정이나 일정 변경을 알리는 내용을 주로 다룬다.
• 공지는 공공 시설이나 서비스와 관련된 안내 사항이나 교육, 세미나, 회의 개최를 알리는 내용 등 다양한 사람들을 대상으로 하는 내용을 다룬다.
• 메모/공지는 이메일/편지와 내용 구성이 비슷하지만 더 간결하고 핵심적인 정보만 담고 있다.
• 메모와 공지는 그 목적과 대상이 다소 다르다. 메모는 주요 공지 사항을 같은 조직내의 구성원들에게 알리기 위한 문서 형식이며, 공지는 공개적인 장소에 게시되어 특정한 정보를 전달하는 것이 목적인 글이다.

패러프레이징

패러프레이징은 다른 품사를 활용하거나, 동의어 또는 유의어 활용, 상위 개념 또는 함축 표현을 활용하여 이루어진다. 어떤 방식의 패러프레이징이든지 결국 유사한 의미의 표현을 찾는 것이 관건이다.

지문	패러프레이징
Q. Although I am registered for the basic phone package, I was charged extra for the premium package on my July statement. I am paying the regular amount and expect this correction to be reflected on my next bill.	**(A) The customer was overcharged in July for a monthly utility service.** (B) Payment must be made to maintain premium status.

다음 짧은 지문을 읽고 지문과 일치하게 패러프레이징된 문장을 고르세요.

1.
> I ordered a t-shirt on October 30. I chose the blue option in size small. The t-shirt I got had the correct color, but it came in medium. I will send it back. In the meantime, please ship me the correct size.

(A) A customer wishes to order a different-color shirt.
(B) A customer received a clothing item in the wrong size.

2.
> Business expense refunds no longer require hard copies to be submitted by each department. Claims can now be processed entirely through the company Web site. Please fill out the new online form found at the "Expenses" link to make your requests.

(A) The budget was expanded to update the company Web site.
(B) The reimbursement procedure is now done online.

3.
> On January 10, a computer and design job fair will be held at the Deniver Convention Center from 2 P.M. until 5 P.M. This event is open to anyone interested in a career in technology. However, registration is required. Apply early at www.deniverjobfair.com.

(A) Job searchers can register for an event online.
(B) Employers are affected by advances in technology.

4.
> I would like to thank your agency for the wonderful vacation you put together for me and my family. You provided a customized package at a price that was lower than we expected. The trip was wonderful, and we were highly impressed by your service.

(A) A customer paid less than planned for a vacation.
(B) A writer is recommending a travel agency to a colleague.

5.
> I have received your voicemail about the late delivery of a Maxwell 24-inch monitor ordered on April 15. The order summary states that you paid an additional fee for express shipping to receive the package on April 18. I am sorry to hear that the item was delivered late.

(A) A customer requested expedited delivery.
(B) An electronic item was delivered damaged.

FINAL TEST

Questions 1-2 refer to the following memo.

To: All Employees

Dupré Manufacturing is currently in the process of updating its employee directory. We just filled several new positions, so we think it's important to double-check that our directory is current at this time. Please take a moment to find your listing in the directory and make sure it is up-to-date. You can upload a new picture or add extra information about yourself. If any of the information is wrong, please correct it.

To access your page in the directory, click on "Directory" from the main page of the company Web site and type your name into the search box. Each page contains an "Update" button and can be accessed by using your ID number and password.

We look forward to seeing everyone's updates!

Iris Turner, Human Resources Director
Dupré Manufacturing Company

1. What has Dupré Manufacturing recently done?

(A) Upgraded its directory
(B) Issued updated passwords
(C) Hired new employees
(D) Launched a Web site

2. What is indicated about updating the directory?

(A) It happens automatically.
(B) It can be done only by the director.
(C) It requires entering log-in information.
(D) It affects the design of the main page.

Questions 3-5 refer to the following letter.

Joe Scott
4547 Kennedy Court
West Roxbury, MA 02132

April 29

Dear Mr. Scott,

I have received your voicemail about the late delivery of a Maxwell 24-inch monitor ordered on April 15. The order summary states that you paid an additional fee for express shipping to receive the package on April 18. I am sorry to hear that the item was delivered late. The delay was caused by a virus in one of our database programs. We regret that we were not able to solve the problem quickly enough for your package to be delivered on time.

As an apology for your inconvenience, I am including a free USB drive with this letter and a voucher for 15% off your next order. We will also be refunding the extra fee you paid for expedited service. I hope you will remain a loyal customer.

Thank you for your understanding,

Alton Phelan
Maxwell Electronics

3. What is the purpose of the letter?

(A) To confirm receipt of a package
(B) To modify a shipping option
(C) To advertise a sales event
(D) To apologize for a late delivery

4. What was the reason for the problem?

(A) An employee error
(B) An out-of-stock item
(C) A damaged delivery vehicle
(D) A software malfunction

5. What is NOT offered by Mr. Phelan?

(A) An additional product
(B) Free shipping on a future order
(C) A discount coupon
(D) A partial refund

DAY 26

Bernard Dean
876 Jewell Road
Minneapolis, MN 55415

NOTICE: March 15

We would like to inform you that we are still awaiting payment on services provided by our clinic. Your account is outstanding in the amount of $345. Please send a check or make a transfer to our finance offices. A description of the charges for your treatments is provided for your records. Prices indicated include taxes and any related fees. If you have any questions about the charges, please contact our billing department at billing@fountaindentalclinic.com.

Date of Treatment	February 22
Checkup and Cleaning	$90
Dental X-rays	$75
Teeth Whitening	$180
Total Amount Due	$345

Payment should be received by March 31 in order to prevent late fees. We thank you for taking care of this matter promptly.

Paul Mercer
Accountant Fountain Dental Clinic

Please send payment to:
Fountain Dental Clinic
693 Stratford Park
Minneapolis, MN 55415

Bank: TY Bank
Account Holder: Carlos Correa
Account Number: 346555

To:	<billing@fountaindentalclinic.com>
From:	Bernard Dean <bernarddean@emailbox.net>
Date:	March 18
Subject:	Account payment

To whom it may concern:

I am writing to you about a notice from your billing department regarding a series of treatments I received at your clinic on February 22. The day after I visited your clinic, I immediately submitted my bills to my insurance company and was awaiting a response from them. I just talked to one of their representatives, who said they will be transferring a payment to your account on March 19 for all procedures except for the teeth whitening, which is cosmetic. I mailed a check this morning to cover the cost of that procedure. Please send me an e-mail when you receive this payment so that I can be sure that it arrived and was applied to the charges on my account. I hope that this will take care of the matter in full.

Thank you,

Bernard Dean

6. What is the purpose of the notice?

 (A) To give an estimate of service costs
 (B) To announce an increase in rates
 (C) To confirm a medical appointment
 (D) To remind of a due payment

7. The word "outstanding" in paragraph 1, line 2, of the notice is closest in meaning to

 (A) unpaid
 (B) noticeable
 (C) excellent
 (D) essential

8. What is suggested about the insurance company?

 (A) It sent a bill to Fountain Dental Clinic.
 (B) It had to pay a late fee.
 (C) It does not cover cleaning expenses.
 (D) It will make a payment to Carlos Correa.

9. How much did Mr. Dean send on March 18?

 (A) $75
 (B) $90
 (C) $180
 (D) $345

10. What is requested by Mr. Dean?

 (A) Confirmation of payment
 (B) An e-mail with policy information
 (C) An extension to a due date
 (D) Additional insurance coverage

DAY 26

CHAPTER
9

-

지문 유형편

DAY 27
SNS 대화문

—

기본 개념 노트

본 학습에 들어가기 전에 기본적인 독해 지문 유형의 개념을 잡아보자.

문자 메시지와 온라인 채팅은 신토익에서 처음 등장한 지문 유형이다. 두 사람 이상이 참여하는 대화 형식이며 대화문 특성상 주어가 생략된 구어체 표현도 등장한다. 대화에 사용된 표현을 인용하여 그 의도를 파악하는 문제가 한 문제씩 반드시 출제되므로 전후 맥락을 파악하여 문맥상 의미를 찾는 훈련이 필요하다.

❶ 빈출 상황별 대표 어휘

회사 전반	administrative 관리상의, 행정상의 arrange a meeting 회의를 준비하다 attend ~에 참석하다 be concerned about ~에 대해 염려하다 branch 지점, 지사 colleague 동료 department 부서	facilities in the company 회사 내 시설 maintenance of office 사무실의 유지 보수 renovate 개조하다 reorganize 조직을 개편하다 requirement 필요조건 sign a contract 계약에 서명하다 supervisor 감독관, 상사
업무 요청	approval 승인 assume responsibility 책임을 맡다 be aware of ~을 알다 budget 예산 business trip 출장 collaborate with ~와 공동으로 일하다 complete 마치다	fix 고치다 handle 처리하다 on site 현장에서 reply 회신하다 set up 설치하다 submit a proposal 제안서를 제출하다 take care of ~을 처리하다
상품 구매	advertise a new product 신제품을 광고하다 affordable price 알맞은 가격 available 이용 가능한 complaint 불만 demonstrate 시연하다	have trouble *doing* ~하는 데 어려움이 있다 inventory 재고 launch 출시하다 regular customers 단골 고객 take a look at ~을 살펴보다
교통 상황	arrive 도착하다 be stuck in ~에 갇히다 congested road 혼잡한 도로 delay 연기하다, 지연시키다	highway 고속도로 in time for ~에 맞춰서 make it 시간 맞춰 가다 traffic jam 교통체증

문자 메시지

문자 메시지는 지문 특성상 짧고 간결한 표현들이 사용되며 구어체 표현이 등장하기도 한다. 문자 메시지가 오간 순서나 시간 등을 통해 대화 흐름 및 행간의 의미를 파악하자.

예제 1

HEATHER OLLIS 10:04 A.M.
Hey, Trevor. ❶I got your e-mail with the market analysis report.

TREVOR BAXTER 10:05 A.M.
Oh, good. Was it clear?

HEATHER OLLIS 10:06 A.M.
❷Actually, I was not able to read it. My computer couldn't open the attachment.

TREVOR BAXTER 10:08 A.M.
That's strange. Don't you have the analysis software installed on your computer?

HEATHER OLLIS 10:10 A.M.
I do have it, but I think I've got an older version. I'll talk to the IT department about it. ❸In the meantime, can we meet in person to discuss the report?

TREVOR BAXTER 10:11 A.M.
Sure. The best for me would be to meet this afternoon. ❸Can you stop by my office around 2?

HEATHER OLLIS 10:12 A.M.
❸That works. I'll see you then.

❶ **주제, 목적**

문자 메시지의 앞부분에는 대부분 대화의 주제나 메시지를 보낸 목적을 언급한다.

▶ 시장 분석 보고서에 대해 이야기 함

❷ **세부 내용**

메시지의 주제에 대해 구체적인 내용을 다루는 부분으로, 각 화자의 생각이나 의견이 제시되기도 한다.

▶ 올리스 씨가 첨부 파일을 열 수 없어서 보고서를 읽지 못함

+ 출제되는 문제 유형

Q. What problem does Ms. Ollis mention?
올리스 씨가 언급한 문제점은?

A. She cannot view a document.
문서를 볼 수 없다.

❸ **향후 계획, 추가 정보**

메시지의 끝부분에는 향후 계획이나 추가 정보를 전달하며 대화를 마무리한다.

▶ 보고서 논의를 위해 직접 만날 일정을 정함

+ 출제되는 문제 유형

Q. At 10:12 A.M., what does Ms. Ollis mean when she writes, "That works"?
오전 10시 12분에, 올리스 씨가 "좋아요"라고 한 것에서 그녀가 의도한 것은?

A. She will visit Mr. Baxter in the afternoon.
오후에 박스터 씨를 방문할 것이다.

풀이전략

1. 문자 메시지

- 다양한 상황에서 출제될 수 있지만, 주로 동료 간 업무 요청과 관련된 내용이 빈출된다.
- 문자 메시지에는 보낸 사람과 보낸 시간이 나타나므로 이를 항상 확인해가며 지문을 읽어야 한다.
- 대부분 두 사람 이상이 한 마디씩 대화를 주고받는 형식이지만, 한 사람이 두 개의 메시지를 연이어 보내기도 한다.
- 인사말은 주로 생략하고 바로 주제나 목적을 언급하는 경우가 대부분이므로 주제, 목적 문제가 출제된 경우 앞부분을 주의 깊게 읽어야 한다.
- 의도 파악 문제가 한 문제씩 반드시 출제되므로 앞뒤 문맥을 파악하고 제시된 표현의 적절한 의미를 찾는다.

온라인 채팅

온라인 채팅은 문자 메시지와 거의 비슷하지만, 대화에 두 사람 이상이 참여하고 한 사람당 보내는 메시지가 더 긴 편이다. 여러 화자가 번갈아가며 이야기하므로 핵심 주제를 놓치지 않도록 주의하자.

예제 2

Naomi O'Neill 11:12 A.M.
❶ I invited you to discuss our upcoming Web site launch. The project is coming to an end, so we should talk about the aspects that we have not yet completed.

Alexander Clark 11:14 A.M.
The site is scheduled to open on July 1. So we need to finish everything a few days earlier to leave us time to check that it all works.

Joseph Haynes 11:18 A.M.
So, here's what we're missing: photos for the About Our Staff page and the entries for the Customer Reviews section. Is that it?

Alexander Clark 11:20 A.M.
No. I was testing the site earlier this week, and I noticed that every time I click on the Contact Us link, I get a blank page. So that needs to be corrected.

Naomi O'Neill 11:22 A.M.
❷ So to summarize, we have three pages to take care of: About Our Staff, Customer Reviews, and Contact Us.

Joseph Haynes 11:23 A.M.
That's correct. Today, let's focus on the Contact Us page since that seems to be the most urgent. ❸ Naomi, can you take care of the issue?

Naomi O'Neill 11:24 A.M.
❸ Okay, I'll get to that this afternoon. I'll send you a message as soon as it is finished.

❶ 주제, 인물 간 관계

온라인 채팅의 도입부에서는 대화의 주제와 대화에 참여한 사람들의 관계를 파악할 수 있다.

▶ 회사의 웹사이트 출시에 대한 동료 간 대화

+ 출제되는 문제 유형

Q. What is the topic of the online chat?
온라인 채팅의 주제는?

A. The development of a Web site
웹사이트 개발

❷ 세부 내용

대화의 주제에 대해 각 화자가 번갈아 가며 문제 상황을 설명하거나 구체적인 내용을 전달한다.

▶ 웹사이트에서 문제가 있는 페이지에 대해 언급함

❸ 요청 및 추가 사항 전달

마무리 부분에는 문제 상황에 대한 요청 사항을 전달하거나 향후 계획을 공유하며 대화를 마무리한다.

▶ 오닐 씨에게 문의 페이지의 문제를 처리해 달라고 요청함

+ 출제되는 문제 유형

Q. At 11:24 A.M., what does Ms. O'Neill mean when she writes, "I'll get to that this afternoon"?
오전 11시 24분에, 오닐 씨가 "오늘 오후에 그것을 처리할게요"라고 말한 것에서 그녀가 의도한 것은?

A. She will repair an incomplete page.
미완성된 페이지를 수정할 것이다.

풀이전략

1. 온라인 채팅
- 온라인 채팅은 두 사람 이상이 등장하므로 인물 간 관계를 파악하는 것이 중요한데, 이는 보통 앞부분에 드러난다.
- 지문을 읽으며 누가 어떤 말을 하는 것인지 정확히 구분해야 하며 특히 대화의 주제에 대해 의견이 서로 다를 경우 화자들의 의견을 잘 정리해가며 읽어야 한다.
- 앞에서 제시된 요청이나 전달 사항에 대한 대답으로 사용된 표현의 의도를 파악하는 문제가 빈출되므로 그 표현이 요청에 대한 긍정의 답변인지 부정의 답변인지를 파악하면 정답 고르기가 쉽다.

패러프레이징

패러프레이징은 다른 품사를 활용하거나, 동의어 또는 유의어 활용, 상위 개념 또는 함축 표현을 활용하여
이루어진다. 어떤 방식의 패러프레이징이든지 결국 유사한 의미의 표현을 찾는 것이 관건이다.

문제	지문	패러프레이징
Q. What is indicated about the writer?	The sales figures for May are not ready yet, so I won't be able to present them in Friday's meeting. Would it be possible for me to do it next week?	**(A) He wants to change a presentation date.** (B) He will not attend the staff meeting.

다음 문제를 풀고 지문에서 패러프레이징의 단서가 된 문장을 찾아 표시해 보세요.

1.
> Snippit Hair Salon is adding a new section to its shop! Our redesigned salon will make your hairstyling experience even more special! However, we are closed for one week during construction. Please come back on November 2 to experience the new Snippit!

Why is Snippit Hair Salon closed?
(A) It is preparing for a special holiday event. (B) It is going through some renovations.

2.
> We are writing to inform you that your subscription to *Stardom* magazine will expire on June 30. Unless you renew your subscription, our June issue will be the last that we send you. To ensure that you receive our July edition, please renew by June 15.

What is true about the reader's subscription?
(A) It will end unless it is extended. (B) It includes the July issue.

3.
> Mayor Bryan Constance has announced that construction of a new highway will begin at the end of March. The new road is meant to reduce traffic congestion in the Caston City's surrounding streets by allowing commuters to enter and exit the city more easily.

What can be inferred about Caston City?
(A) There are traffic jams during rush hours. (B) Residents have decided to move out of the city.

4.
> Thank you for being a member of the Healthy Habits Association. We are conducting a study on the effects of a new treatment for cancer. Please support us by making a donation. Enclosed, please find a pre-addressed envelope for this purpose.

What is the purpose of this letter?
(A) To survey experts about a new medicine (B) To ask for contributions for research

5.
> Autumn School offers classes for all ages! Come learn how to draw a portrait, paint a landscape, or create abstract art! Right now, we have a special deal going on. Sign up for a ten-class package and receive an eleventh class at no cost!

What is being advertised?
(A) Art lessons (B) A gallery exhibition

DAY 27

FINAL TEST

Questions 1-2 refer to the following text message chain.

MARIE RAMOS 16:43

Yessenia, I know you reviewed our monthly order schedule, but there have been some changes that you need to know about.

YESSENIA DUGGAR 16:45

Really? I just submitted that a few days ago. I'm surprised things have changed already.

MARIE RAMOS 16:49

The Des Moines branch just discovered that they still have two boxes of merchandise, so we can ignore its request for more supplies.

MARIE RAMOS 16:51

And because the weather started to get warmer much earlier this year, the Minneapolis branch needs to double its order of bathing suits and sunglasses.

YESSENIA DUGGAR 16:53

Okay, got it. Anything else?

MARIE RAMOS 16:55

Yeah, just one more thing. Richard Kendall from the accounting department asked if he could get the schedule too. So please e-mail him a copy once you update it.

1. Why did Ms. Ramos send the text message?

(A) To correct a mistake in a shipment
(B) To order new products
(C) To discuss employee performance
(D) To update a work plan

2. At 16:55, what does Ms. Ramos mean when she writes, "Yeah, just one more thing"?

(A) A budget needs to be revised.
(B) An order was placed incorrectly.
(C) Another detail needs to be shared.
(D) A delivery is still in the warehouse.

Questions 3-5 refer to the following online chat discussion.

Rosa Hoyt 10:09 A.M.	Hi. I wanted to talk about the new accountant we are trying to hire. Syd, thank you for e-mailing us those résumés.	
Syd Morris 10:11 A.M.	Sure. Only three candidates have applied so far. It seems that people are reluctant to work for small law offices these days.	
Nadine Son 10:13 A.M.	Well, let's look at what we have. I noticed that Erica Ocello's résumé states that she was an intern here, but I don't remember her. Do either of you?	
Syd Morris 10:15 A.M.	She worked in the finance team, so James Cornish was her supervisor. He said she was diligent, very intelligent, and quite friendly.	
Rosa Hoyt 10:17 A.M.	Unfortunately, she's only just graduated from university. We need someone who is more experienced. What about the others?	
Nadine Son 10:19 A.M.	Johan Gibbs had non-negotiable salary expectations that were too high. The third candidate, Norma Scorpio, sounds impressive, but she is currently working for another company and is busy with a project that doesn't end until next month.	
Syd Morris 10:21 A.M.	I see. We need someone who can start right away. Personally, I think we should leave the posting up for a few more days.	
Rosa Hoyt 10:23 A.M.	You're right. There are other potential candidates out there.	
Nadine Son 10:25 A.M.	I feel the same way. So that's settled. Let's continue to advertise the position.	

| | **SEND** |

3. At what type of business do the people most likely work?

(A) A legal firm
(B) An education institute
(C) An accounting company
(D) An advertising company

4. What is indicated about Ms. Ocello?

(A) She has a lot of experience in the field.
(B) She recently completed a degree.
(C) She cannot start working immediately.
(D) She is demanding a high salary.

5. At 10:25 A.M., what does Ms. Son mean when she writes, "So that's settled"?

(A) They have chosen a successful candidate.
(B) They have selected a date for interviews.
(C) They have decided to review more applications.
(D) They have agreed to change the requirements.

DAY 27

정답 및 해설 133쪽

CHAPTER

9

-

지문 유형편

DAY 28
광고 & 기사

—

기본 개념 노트

본 학습에 들어가기 전에 기본적인 독해 지문 유형의 개념을 잡아보자.

광고와 기사는 제목을 통해 그 내용을 유추할 수 있다는 점에서 유사하다. 빈출 상황별 대표 어휘와 빈출되는 연계 지문의 유형을 통해 각 지문의 특성을 알아보자.

❶ 빈출 상황별 대표 어휘

제품 및 서비스 광고	comparable 비교할만한 customized 개개인의 요구에 맞춘 earn recognition 인정받다 extensive services 광범위한 서비스	latest trend 최신 유행 outstanding quality 뛰어난 품질 reasonable price 합리적인 가격 release[launch] 출시하다
구인 광고	be preferred 우대되다 be responsible for ~에 책임이 있다 duties[responsibilities] 직무[책무] experienced 경력이 있는 job openings (직장의) 빈자리	qualification 자격 recommendation 추천서 requirements 자격 조건 review a résumé 이력서를 검토하다 select candidates 후보자를 선택하다
기업[사업] 관련 보도	business strategy 사업 전략 entrepreneur 기업가 expand a business 사업을 확대하다 growing business 성장하는 기업	merge with ~와 합병하다 renew a contract 계약을 갱신하다 sales figures 판매 수치 spokesperson 대변인
경제 상황	domestic market 국내 시장 exchange rate 환율 go bankrupt 파산하다 economic boom[recession, slump, depression] 경제 호황[불황]	overseas investment 해외 투자 positive impacts on ~에 대한 긍정적 영향 unemployment rate 실업률

❷ 빈출 연계 지문

광고 & 이메일	상품, 서비스 광고 & 주문, 배송 관련 문의 이메일
기사 & 이메일	기업 관련 기사 & 관련 문의/오류 정정 요청 이메일
기사 & 광고	신제품, 서비스 도입 기사 & 관련 광고
광고 & 양식 & 이메일	상품, 서비스 광고 & 구매 영수증/송장 & 오류 정정 요청 이메일
기사 & 정보문 & 양식	기업 관련 기사 & 서비스 안내 & 서비스 신청서

광고

광고는 크게 제품 및 서비스 광고와 구인 광고로 나뉘는데 지문에 포함되는 내용이 대부분 비슷하여 그 구조가 예측 가능하다. 광고의 구조를 잘 익혀서 빈출 문제 유형에 대한 단서를 빠르게 찾자.

예제 1

Valerio's Lunchtime

❶ If you like Italian food, you'll love the new lunch buffet at Valerio's. Now, the fine dining and quality cuisine you've enjoyed for dinner is available at lunchtime.

Our reasonably priced buffet offers a wide range of pastas with various sauces, pizzas topped with authentic Italian ingredients, and homemade soups and sides. ❷ Our new opening time is 11 A.M. instead of 2 P.M., and the buffet is served Monday through Friday from 11 A.M. to 1:30 P.M. Note that ordering from the menu will not be available during the buffet hours. However, you will still be welcomed with our outstanding service that has earned recognition throughout the area.

❸ To celebrate our new service, we are offering $5 off to everyone who comes until April 20. So stop in to Valerio's today for a great meal.

❶ 제품 및 서비스 소개

광고의 제목과 앞부분에서 광고하는 제품이나 서비스를 간략히 소개한다.

▶ 식당에서 점심에도 뷔페를 이용 가능함

+ 출제되는 문제 유형

Q. What is being advertised?
광고하는 것은?

A. A new buffet option 새로운 뷔페 선택권

❷ 제품 및 서비스 특징, 정보

본론에서는 제품 및 서비스의 특장점을 묘사하고 고객에게 제공하는 할인 혜택 등을 알리기도 한다.

▶ 뷔페 메뉴, 운영 시간, 특장점

+ 출제되는 문제 유형

Q. What is true about Valerio's?
발레리오즈에 대해 사실인 것은?

A. It is open earlier than before.
이전보다 일찍 문을 연다.

❸ 마무리

마지막 부분에서는 제품 구매 및 할인 정보를 알리거나 제품 및 서비스를 이용해볼 것을 권유하면서 마무리한다.

▶ 할인 정보, 식당 방문 권유

+ 출제되는 문제 유형

Q. How can customers get a discount?
고객들이 할인받을 수 있는 방법은?

A. By visiting before a certain date
특정일 전에 방문함으로써

풀이전략

1. 광고

- 제품 및 서비스 광고는 〈제품 및 서비스 소개 → 제품 및 서비스 특징 → 제품 구매 및 할인 혜택 정보〉로 구성된다.
- 구인 광고는 〈간단한 회사 소개 → 직책 및 담당 업무 → 자격 요건 및 지원 방법〉으로 구성된다.
- 광고의 제목에는 알리고자 하는 제품이나 서비스의 내용과 특징이 잘 나타나 있으므로 반드시 읽어야 한다.
- 제품의 특징이나 담당 업무를 리스트로 제공하는 경우가 있는데, 세부 사항을 묻는 문제의 경우 이 리스트를 단서로 하여 정답을 빠르게 고를 수 있다.

기사

기사는 비즈니스뿐만 아니라 다양한 주제를 다루며, 전문적인 정보나 어려운 단어가 포함되어 다른 지문 유형에 비해 길고 복잡하다. 따라서 많은 정보 중에서 필요한 정보를 빠르게 찾아내는 훈련을 하자.

예제 2

① Rine Industries to Merge with Long-Time Competitor, Lindley Manufacturing

Rine Industries, known for its hair and dental care products, informed the public yesterday of its plans to expand its business. ①It will be merging with Lindley Manufacturing in an attempt to create one of the largest consumer products companies in the nation.

②Rine stopped manufacturing products for the skin several years ago because it could not compete with Lindley's loyal customer base. The merger will help fill this gap in Rine's product line.

The merger is scheduled to take place sometime next month. The CEO of Rine will manage this new corporation, and ③Lindley's CEO has accepted a position as a professor in an MBA program.

① 주제

일반적으로 기사의 제목과 첫 문단에는 기사 전체의 주제가 드러난다.
▶ 라인 산업이 린들리 제조사와 합병할 계획임

+ 출제되는 문제 유형

Q. What is the article mainly about?
기사의 주제는?

A. The merger of two companies
두 회사의 합병

② 세부 정보

본론에서 주제와 관련된 구체적인 정보가 나열된다.
▶ 라인 사의 특징, 합병의 이점

+ 출제되는 문제 유형

Q. Which category of product is NOT currently produced by Rine Industries?
라인 산업에 의해 현재 생산되지 않는 제품군은?

A. Skin care 피부 관리 제품

③ 부가 설명

후반부에는 향후 계획이나 전망을 언급한다.
▶ 합병 이후의 계획

+ 출제되는 문제 유형

Q. What will Lindley's CEO likely do in the future?
린들리 사의 대표이사가 향후에 할 일은?

A. Teach business classes
경영 수업 가르치기

풀이전략

1. 기사

- 기업의 신제품 출시, 경영 환경의 변화, 경영인에 대한 이야기, 경제 전망, 행사 홍보 등의 내용을 주로 다룬다.
- 지역 사회 소식으로 쇼핑몰, 지역 센터, 도로 등의 건설 공사 소식이나 지역 내 변화 관련 소식을 전한다.
- 기사는 광고와 마찬가지로 간략하면서 의미가 함축된 제목을 통해 주제와 그 내용을 유추할 수 있다.
- 기사 제목은 광고보다는 더 객관적이고 정확한 사실을 바탕으로 한다.
- 기사에는 권위자, 담당자 등의 이름이 등장하고 그들의 말이 종종 인용되는데, 인물에 대한 특정 정보 확인 문제나 추론 문제가 출제될 수 있으므로 고유명사가 등장하는 부분에 주의해서 지문을 읽어야 한다.

패러프레이징

패러프레이징은 다른 품사를 활용하거나, 동의어 또는 유의어 활용, 상위 개념 또는 함축 표현을 활용하여 이루어진다. 어떤 방식의 패러프레이징이든지 결국 유사한 의미의 표현을 찾는 것이 관건이다.

지문	패러프레이징
Q. All employees are expected to attend a safety training workshop on Thursday at 2 P.M. The training will cover basic first aid and the handling of office emergencies.	**(A) A safety program will be held for all employees.** (B) Certified workers are invited to a workshop.

다음 짧은 지문을 읽고 지문과 일치하게 패러프레이징된 문장을 고르세요.

1.
Mr. Molinka was supposed to lead the meeting about last quarter's performance on Monday, May 7. However, due to an unforeseen situation with a client, he must go on an urgent business trip to Florida. The meeting is therefore postponed to Thursday, May 10.

(A) A meeting will take place later than planned.
(B) An employee has to cancel his travel plans.

2.
In December, we will offer free present wrapping to our customers. Employees who volunteer to wrap presents will be paid ten dollars an hour. If you wish to work overtime at the wrapping station, please e-mail Harry Milter at hmilter@corastore.com.

(A) Overtime work is needed after December.
(B) Volunteers should contact Harry Milter.

3.
You have been selected to receive the Berenice Meyers Scholarship for Women in the Arts. As a winner of this scholarship, you will receive one thousand dollars a semester for your tuition. You must sustain an average grade of at least B+ to maintain your status.

(A) The student should keep a minimum grade for her scholarship.
(B) An organization is donating one thousand dollars to a university.

4.
The Sanderson Conference Hall has a capacity of two hundred people. The stage features state-of-the-art equipment for showing slideshows and videos in high definition with a surround sound system. Call Mr. Macy at 258-6607 to reserve Sanderson Conference Hall!

(A) Mr. Macy has reserved the room for a conference.
(B) The room has enough seating for up to two hundred people.

5.
Organics Market has initiated a new service that will change the landscape of personal grocery shopping. The program, called Home Harvest, provides customers with weekly deliveries of fresh organic produce at a lower cost than in a store.

(A) Home Harvest produces natural food for restaurant.
(B) A store provides a new approach to buying groceries.

정답 및 해설 137쪽

DAY 28

FINAL TEST

⏱ 제한시간 10:00

Job Opportunity!

Sunset Resort, which provides four-star luxury accommodations on Davey Beach, is accepting applications for the position of Housekeeping Manager. This individual will be responsible for overseeing the day-to-day operations of the housekeeping staff, hiring and training staff, and ensuring the overall cleanliness of all guest facilities. Knowledge of the hospitality industry and previous management experience are required. The individual must also possess excellent communication and customer service skills. Preference will be given to candidates with proficiency in at least one foreign language. The work schedule includes some evenings and weekends.

Submit your résumé, cover letter, and salary expectations to:
Sunset Resort, Personnel Office
Attn: Burt Kleffner
11 Palmridge Rd.
Davey Beach, CA

1. What is NOT mentioned as a duty of this position?

 (A) Recruiting housekeeping employees
 (B) Supervising cleaning work
 (C) Managing hotel room supplies
 (D) Maintaining the hotel's appearance

2. What does this job require?

 (A) Knowledge of the Davey Beach area
 (B) Availability at flexible times
 (C) Fluency in several languages
 (D) Experience as a hotel manager

Questions 3-6 refer to the following article.

Organics Market Transforms Grocery Shopping
By Andrew Garner

Health foods retailer Organics Market has initiated a new service that will change the landscape of personal grocery shopping. The program, called Home Harvest, provides customers with weekly deliveries of fresh organic produce at a lower cost than in a store. – [1] –

Spokesperson Jane Ryder claims that the program will benefit both the local community and the customers. The company will use only produce from local farmers, increasing revenue for small businesses. – [2] –

The region's director of health, Mark Swenson, is giving his support for Organics Market's program. He plans to encourage hospitals to advertise the service, and to educate the public about the importance of choosing healthy local foods. – [3] – People interested in the program can attend one of Organics Market's information sessions, which are held weekly on Wednesdays at 7 P.M. – [4] – Details of the program can be found at www.organicsmarket.net. Registration forms are available at the customer service desk of any Organics Market retailer.

3. What is the article mainly about?

(A) The organic food market
(B) The local farming industry
(C) A public health campaign
(D) A home delivery service

4. What is NOT true about the Home Harvest program?

(A) It reduces grocery costs.
(B) It supports farmers in the region.
(C) It delivers produce daily.
(D) It sells fresh produce.

5. What is suggested about Mark Swenson?

(A) He believes healthy eating is important.
(B) He developed the Home Harvest program.
(C) He works at a regional hospital.
(D) He designed health awareness advertisements.

6. In which of the positions marked [1], [2], [3], and [4] does the following sentence best belong?

"As for customers, they get high-quality organic produce."

(A) [1]
(B) [2]
(C) [3]
(D) [4]

Travel in Comfort!

Rondeau Rides has been providing excellent transportation services to individuals and businesses throughout Ohio since 1977. We offer everything from private limousines for individuals to large buses for groups. We take excellent care of our vehicles by checking them regularly and cleaning them thoroughly after every ride.

Each Rondeau driver receives sixty hours of training and is required to complete courses in defensive driving. They know the city very well and are able to navigate the best routes—even with heavy traffic—in order to save time.

When you travel with us, you will always feel safe and comfortable. Call Rondeau Rides at 276-2349 today to book a pickup!

Mayra Santiago
Rondeau Rides, Cheapside
2641 Viking Drive
Worthington, OH 43085

Dear Ms. Santiago,

I wanted to commend your employees for their professionalism. I am the general manager of Impala Hotels, and for the last five years, our two companies have worked together. I can always rely on the quality of your service to provide transportation to my guests.

Recently, I've received a number of positive reviews from customers mentioning your drivers, so I wanted to send a small token of my gratitude. Enclosed with this letter are coupons to be given to each of your drivers. Since we have a branch near your headquarters, I thought they might like to try that hotel's restaurant. Please accept these coupons with my compliments.

Kind thanks,

Esteban Odell
General Manager, Impala Hotels

* IMPALA HOTELS COUPON *

Issued by: Esteban Odell

Holder: _Jeanie Battochi, Rondeau Rides_

The holder of this coupon is entitled to one free sandwich set, which includes the soup of the day and a drink. This voucher is valid at the following locations: Amore in Downtown, Juliano's in Southend, Bella in Cheapside, Napoli in Doonesbury.

Please present this voucher to the service staff when placing your order.

Coupon valid until: September 4

7. What is mentioned about the Rondeau Rides?

(A) It maintains its vehicles in good condition.
(B) It recently opened its business.
(C) It has never gotten into an accident.
(D) It just repainted its vehicles.

8. Why did Mr. Odell write to Ms. Santiago?

(A) To ask about pricing options
(B) To express gratitude for a service
(C) To form a new partnership
(D) To arrange a pick-up location

9. What is NOT indicated on the voucher?

(A) When it was issued
(B) How to use it
(C) Where it can be used
(D) Who it belongs to

10. What can be inferred about Ms. Battochi?

(A) She is planning to reserve a private car.
(B) She wrote a positive review about Rondeau Rides.
(C) She often stays at Impala Hotel.
(D) She has taken a driving class.

11. At which restaurant will Ms. Battochi most likely use her voucher?

(A) Amore
(B) Juliano's
(C) Bella
(D) Napoli

DAY 28

CHAPTER
9

-

지문 유형편

DAY 29
설명서/지시문 &
웹페이지

—

기본 개념 노트

본 학습에 들어가기 전에 기본적인 독해 지문 유형의 개념을 잡아보자.

제품이나 서비스에 관한 설명서 및 지시문은 이용 절차를 단계별이나 항목별로 서술한다는 점이 특징이다. 또한 웹페이지에는 회사의 웹페이지가 자주 출제되며 회사 소개, 제품 설명 및 사용 후기 등을 다룬다는 점이 특징이다.

❶ 빈출 상황별 대표 어휘

설명 및 절차	complete guidelines for ~에 대한 완벽한 지침 easy-to-follow instructions 간단한 사용설명서 first[firstly, first of all] 우선, 첫째로 finally[lastly] 마지막으로 follow instructions 설명서를 따르다 note[notice] that, beware of, be careful[cautious] about ~에 주의하다	install 설치하다 manual 설명서 procedures for ~에 대한 절차 user-friendly 사용하기 쉬운 warranty 품질 보증서
온라인 구매 및 후기	be satisfied with ~에 만족하다 bulletin board 게시판 customer review 고객 후기 free estimate service 무료 견적 서비스 get free samples 무료 샘플을 얻다 highly recommend 매우 추천하다 under special circumstances[conditions] 특정한 상황[조건] 하에서	keep confidential 기밀로 해두다 online payment 온라인 지불 post 게시하다 product specification 제품 사양 shopping cart 장바구니 special offer 특가 제공, 특가 판매
온라인 예약	application 신청서 complete 작성하다 fill out a form 신청서를 작성하다	itinerary 여행 일정 make a reservation 예약하다 register for, sign up for ~을 신청하다

❷ 빈출 연계 지문

설명서/지시문 & 이메일	제품 사용 설명서 & 제품 사용 불만 이메일
웹페이지 & 이메일	신제품 안내 웹페이지 & 고객 불만 이메일
웹페이지 & 양식	분실물 신고 안내 웹페이지 & 분실물 신고서 양식
공지 & 웹페이지	치과 예약 확인 공지 & 예약 확인 웹페이지
정보문 & 설명서 & 웹페이지	제품 상세 정보문 & 제품 조립 방법 안내 설명서 & 제품 사용 후기 웹페이지
구인 광고 & 이메일 & 설명서	구인 광고 & 합격 안내 이메일 & 직원 근무 안내 설명서
웹페이지 & 영수증 & 이메일	여행지 안내 웹페이지 & 패키지 구매 영수증 & 고객 후기 이메일

설명서/지시문

설명서 및 지시문은 빈출 지문 유형은 아니지만 연계 지문으로 종종 출제되므로 그 형식을 익혀두는 것이 좋다. 주로 단계별이나 항목별로 이용 절차를 나열하기 때문에 설명 순서를 파악하는 것이 중요하다.

❶ **K-MAX90 Blender User's Manual**

Package Contents: K-MAX90 motor base, regular blade set, 64 oz. blender jar with lid, interior juice strainer, recipe booklet

Set-up Instructions:
1) ❷ Assemble the blender by screwing the blade set into the base of the blender jar.
2) Place the jar on the motor base and turn clockwise until it clicks into place.
3) Plug in the device. Your blender is now ready for use.

Safety Warnings:
– Do not operate the device if it appears to be damaged.
– ❸ Only food and beverage items should be placed in the device.
– Unplug the motor when not in use.

For questions or concerns about this product, please contact us at service@kmaxelectronics.com.

❶ 제목 및 도입부
설명서 제목이나 본문 도입부에 명시된 제품 이름을 통해 어떤 제품에 대한 설명서인지 유추해 볼 수 있다.
▶ 믹서기 사용 설명서

❷ 제품 조립 및 사용 안내
제품의 조립법이나 사용법 안내는 대부분 first, next, finally와 같은 부사 표현과 함께 단계별, 항목별로 제시된다.
▶ 믹서기 조립 방법 안내

+ 출제되는 문제 유형
Q. What should be done before placing the jar on the motor base?
전동기 받침 위에 단지를 올리기 전 해야 할 일은?
A. Assembling the blender by screwing the blade set
칼날을 돌려 믹서기 조립하기

❸ 주의 사항 및 추가 정보
제품 사용시 주의 사항을 안내하는 부분으로, *(별표)나 Note(유의 사항)로 표기하기도 한다. 또한 제품 사용에 대한 추가 문의 응대 연락처를 제공하기도 한다.
▶ 안전 유의 사항, 추가 문의 응대 연락처 안내

+ 출제되는 문제 유형
Q. What does the user's manual warn against?
사용 설명서가 경고하는 것은?
A. Putting inedible items in the device
기기 안에 먹을 수 없는 제품을 넣기

1. 설명서/지시문

• 제품 설명서, 서비스 이용[등록] 절차, 제품 반품[교환] 절차 혹은 건물 안전 지침 등에 대한 내용을 다룬다.
• 설명서나 지시문은 단일 지문뿐만 아니라 연계 지문으로도 자주 출제되므로 필요한 정보를 빠르게 찾아 종합하는 훈련을 해야 한다.
• 단계별로 서술한 설명서의 경우 first, next, finally와 같은 부사 표현에 유의하며 절차를 파악해야 한다.
• *(별표)나 Note(유의 사항) 등으로 표기된 주의 사항에서 문제가 자주 출제되는 편이니 이 부분을 놓치지 말아야 한다.

웹페이지

웹페이지는 단어 수가 많지 않아 비교적 단시간에 읽을 수 있는 지문 유형이다. 설명서나 지시문과 마찬가지로 연계 지문으로 자주 출제되므로 필요한 정보를 빠르게 찾는 연습을 해야 한다.

Mansion Homes
Live a life of luxury!

| HOME | INFORMATION | **VISITATIONS** | ❶PICTURES |

If you are interested in viewing some of the units available at the Mansion Homes residential area, we would be more than happy to arrange that for you!

Tours of homes are available from Monday through Saturday anytime between 10 A.M. and 1 P.M. Just let us know which time is the most convenient for you. You can choose to see three different units, or simply choose the ones you are most interested in viewing:

- Palace Unit: A two-bedroom home with a living room, kitchen, dining room, and bathroom
- Mansion Unit: A two-bedroom home with a living room, kitchen, dining room, and two bathrooms
- ❷Castle Unit: A three-bedroom home with a living room, kitchen, dining room, two bathrooms, and garage

❸Simply send an e-mail to office@mhomes.com, and we can make an appointment for you.

❶ 웹페이지 주소, 회사명, 메뉴

웹페이지의 주소, 회사명과 메뉴를 통해 업종과 웹페이지가 제공하는 정보를 예측할 수 있다.

▶ '사진' 메뉴를 통해 사진들을 제공할 것임

+ 출제되는 문제 유형

Q. What can visitors see on the Web site?
방문자들이 웹사이트에서 볼 수 있는 것은?

A. Photographs of the properties
건물들의 사진

❷ 세부 내용

웹페이지에서 제공하는 세부 정보들은 비교적 간략하게 명시하므로 문제에서 묻는 정보를 쉽게 찾을 수 있다.

▶ 살펴볼 수 있는 주택 정보 제공

+ 출제되는 문제 유형

Q. What is unique about the Castle unit?
캐슬 주택의 특이한 점은?

A. A parking space
주차 공간

❸ 추가 정보 및 의견

마지막에 추가 정보나 의견이 제시되며 이와 관련한 문제들이 출제되기도 한다.

▶ 이메일을 보내 주택을 볼 일정을 잡을 수 있음

+ 출제되는 문제 유형

Q. How can potential customers arrange to see a unit?
잠재 고객들이 주택을 볼 일정을 잡는 방법은?

A. By sending an e-mail
이메일을 보내서

1. 웹페이지

- 주로 회사의 웹페이지가 출제되며 회사 소개, 제품 설명, 고객 후기, 예약 등의 내용을 다룬다.
- 단일 지문뿐만 아니라 웹페이지와 관련한 예약이나 주문, 신청 등 각종 양식과 함께 연계 지문으로도 자주 출제되므로 필요한 정보를 빠르게 찾아 종합하는 훈련을 해야 한다.
- 웹페이지의 메뉴도 중요한 단서가 될 수 있으므로 놓치지 말아야 한다.
- 웹페이지 하단에 다른 페이지로 연결되는 링크나 버튼 등으로 표기된 추가 정보에서도 문제가 종종 출제되므로 주의 깊게 살펴본다.

패러프레이징

패러프레이징은 다른 품사를 활용하거나, 동의어 또는 유의어 활용, 상위 개념 또는 함축 표현을 활용하여 이루어진다. 어떤 방식의 패러프레이징이든지 결국 유사한 의미의 표현을 찾는 것이 관건이다.

문제	지문	패러프레이징
Q. Why was the e-mail sent?	On behalf of the Social Research Association, I'd like to express my appreciation for your participation in our research project.	**(A) To thank the reader for participating in a study** (B) To invite the reader to an upcoming conference

다음 문제를 풀고 지문에서 패러프레이징의 단서가 된 문장을 찾아 표시해 보세요.

1.
> We are writing to inform you that your February electricity bill was due on March 10. Two weeks have passed since that date, so $5 were added to your balance. You now have a balance of $32. Please make a payment before April 8 to avoid further fees.

Why was the notice written?
(A) To warn that a bill is overdue
(B) To confirm receipt of a payment

2.
> Tomorrow's conference was originally scheduled to start at 8:30 A.M. However, some attendees are coming from far away and asked for a later start. The presentations will therefore be pushed back thirty minutes. Thus, we will begin at 9 A.M. and end at 5:30 P.M.

To whom was this e-mail most likely sent?
(A) Drivers for a transportation service
(B) Guests for an event

3.
> Next Sunday, the Betista band will give a performance at the outdoor theater of Singsong Gardens. There is no entrance fee, but advanced registration is required. Tickets may be reserved from the Singsong Gardens Web site or by phone at 444-0294.

What is true about the performance?
(A) Spectators must pay for a ticket.
(B) Reservations can be done online.

4.
> On October 22, renovations will begin in our office lobby. Workers will be installing a new reception desk. As a result, the main entrance will be blocked for about three weeks. For the duration of the renovations, please use the back door to enter the building.

What are employees asked to do?
(A) Use a back entrance
(B) Replace some equipment

5.
> Business class ticket. Two pieces of check-in luggage under 30 kg permitted. One carry-on bag under 8 kg. Ticket is nonrefundable. Changes permitted for a fee of $85. Please confirm flight 24 hours prior to departure. Online check-in available.

What is indicated about the ticket?
(A) It cannot be reimbursed.
(B) It allows only one suitcase.

정답 및 해설 145쪽

DAY 29

FINAL TEST

Questions 1-2 refer to the following information.

🕐 제한시간 05:00

Thank you for purchasing the Soldo electric piano. To ensure that your new keyboard lasts as long as possible, please follow the directions below.

• Do not stand the Soldo on its side. Always keep it parallel to the ground.
• Do not install the Soldo near any heat source, such as a stove, fireplace, or radiator.
• After plugging in the Soldo, ensure that all of the cables are safely placed away from any walking path to avoid tripping on a cord.
• For cleaning, use a dry cloth to wipe each part. Do not use water as this will damage the circuits.
• Unplug the Soldo during lightning storms.

Your Soldo electric piano comes with a one year warranty. With proper care, it has a life expectancy of approximately ten years.

1. Where can this information be found?

 (A) On a concert program
 (B) In a recipe book
 (C) In a user manual
 (D) In a company policy statement

2. According to the information, what is NOT recommended?

 (A) Using water to clean
 (B) Keeping the device away from heat
 (C) Placing the cables out of reach
 (D) Holding the keyboard flat

Questions 3-5 refer to the following Web page.

FALCON AIR INTERNATIONAL
Gets you where you want to be!

| Home | Flight Schedules | Policies | Frequent Fliers | **Bookings** | Contact |

Please confirm the following information and itinerary for your planned flight. If everything is accurate, click the PAYMENT button below. If any change is required, click BACK and edit where necessary.

RESERVATION NUMBER: 85590-23782

Passenger(s)	Erica Cavendish	Address	1267-B Queens St. Toronto, Ontario
Frequent flier number	EC-74836758	Phone number	(647)555-5823
Passport number	LF548697	E-mail	ercave@zmail.com
Departure	Flight: FA445, March 11, 7:45 A.M. Toronto Pearson International Airport Arrival: Chicago O'Hare International Airport 9:15 A.M.		
Return	Flight: FA443, March 14, 9:30 A.M. Chicago O'Hare International Airport Arrival: Toronto Pearson International Airport 11:00 A.M.		
Details	Business class ticket. Two pieces of check-in luggage under 30 kg permitted. One carry-on bag under 8 kg. Ticket is nonrefundable. Changes permitted for a fee of $85. Please confirm flight 24 hours prior to departure. Online check-in available. ***Request for vegetarian meal received.		

| BACK | PAYMENT |

3. What is indicated about Falcon Air?

(A) It has flights to Chicago every day.
(B) It has a membership program for frequent users.
(C) It refunds tickets under certain conditions.
(D) It accepts payment only online.

4. At what time will Ms. Cavendish's flight land in Chicago?

(A) 7:45 A.M.
(B) 9:15 A.M.
(C) 9:30 A.M.
(D) 11:00 A.M.

5. What is suggested about Ms. Cavendish?

(A) She chose a meal with meat for her flight.
(B) She can get a full refund for her ticket.
(C) She is allowed to bring more than one baggage.
(D) She should arrive at the airport one day prior to departure.

DAY 29

CHAPTER
9

-

지문 유형편

DAY 30
송장/청구서 &
일정표

—

기본 개념 노트

본 학습에 들어가기 전에 기본적인 독해 지문 유형의 개념을 잡아보자.

구입한 물건이나 이용한 서비스에 대한 송장이나 청구서는 제시된 숫자 정보를 빠르게 해석하는 능력이 필요하다. 또한 특별한 행사의 일정이 시간 순으로 나열된 일정표는 시간별 행사 내용과 강연자를 파악하는 것이 중요하다.

❶ 빈출 상황별 대표 어휘

구입/환불	give compensation to ~에게 보상을 주다 keep a receipt 영수증을 보관하다 proof of purchase 구매 증빙 (서류)	reliable supplier 신뢰할 만한 공급업체 return an item 물건을 반품하다 send a shipment 화물을 보내다
지불	amount due 지불해야 할 금액 charge (상품, 서비스에 대한) 요금 claim 청구하다 deposit 예치금 expedited[express] delivery fee 신속 배달 요금 request a revised[corrected] bill 수정된[맞게 고쳐진] 청구서를 요청하다	due date 납부 기한 service initiation fee 서비스 개통비 statement 내역서 outstanding balance 미결제 잔액
일정/계획	opening[closing] speech 개회사[폐회사] question and answer session 질의응답 시간 changes to an itinerary[agenda] 일정표[안건]의 변경 사항	registration procedure 등록 절차 welcome speech 환영사

❷ 빈출 연계 지문

양식 & 이메일	주문한 물품의 송장/청구서 & 오류 정정 요청 이메일 강의 일정표 & 일정 변경 안내 이메일
일정표 & 기사	공연 일정표 & 공연 관련 기사
일정표 & 공지	행사 일정표 & 행사 일정 변경 공지
광고 & 양식 & 이메일/편지	제품 광고 & 제품 주문 송장 & 주문 관련 문의 이메일/편지 교육 프로그램 광고 & 교육 프로그램 일정표 & 프로그램 관련 문의 이메일/편지
초대장 & 웹사이트 & 일정표	행사 초대장 & 행사 정보 안내 웹사이트 & 행사 프로그램 일정표
공지 & 편지 & 일정표	행사 관련 공지 & 행사 참여 독려 편지 & 행사 프로그램 일정표

송장/청구서

구입한 물건이나 이용한 서비스에 대한 송장 및 청구서는 토익에 자주 출제되는 양식 중 하나이다. 다양한 금액이 표기되어 헷갈릴 수 있으므로 문제를 먼저 읽어 어떤 항목에 대해 묻고 있는지 확인해야 한다.

예제 1

❶ Colonial Pottery
Distribution Center
201 Atlantic Drive
Salem, MA 01970

Customer:
Four Seasons Greenhouse
161 North Highway
Lewiston, ME 04240

Statement:

Date	Description	Amount
5/11	Six-inch clay pots, plain (4 dozen)	$36.00
	❷ Sixteen-inch clay pots, ornamental (2 dozen)	$240.00
	Shipping and handling (see below for details)	$59.99
	Discount (see below for details)	$27.60
	Amount due	$308.39

Message:
This shipment was sent by special delivery at the buyer's request. Please return any damaged items, along with the original receipt, within seven working days.
❸ A ten-percent discount applies to all first-time orders placed by retailers. This discount does not apply to shipping and handling charges.

❶ 송장의 발신자, 수신자
물품을 구매한 곳의 주소 및 회사명을 통해 어떤 품목을 구매했는지 예상할 수 있다.
▶ 도자기류(Pottery) 판매 업체

❷ 송장 내역
구매 품목과 수량, 가격이 명시된 송장 내역을 통해 세부 정보를 확인할 수 있다.
▶ 구체적인 주문 내역

+ 출제되는 문제 유형
Q. Which will cost Four Seasons Greenhouse the most?
포 시즌스 그린하우스가 가장 많은 비용을 지불하는 것은?
A. The sixteen-inch clay pots
16인치 점토 화분

❸ 전달 내용
물품 구매시 적용된 혜택이나 배송 정보 및 정책 등을 포함한 내용을 하단에 기재하는 경우가 많다.
▶ 특별 배송, 반송 정책 및 최초 주문 할인 정책 안내

+ 출제되는 문제 유형
Q. Why did Four Seasons Greenhouse receive a discount?
포 시즌스 그린하우스가 할인 받은 이유는?
A. It was the shop's first order.
업체의 첫 주문이었다.

풀이전략

1. 송장/청구서

• 송장이나 청구서는 제품 구매 내역이나 집 또는 자동차 수리 비용, 각종 서비스 이용 요금 등에 대한 내용을 다룬다.
• 송장과 청구서는 다른 지문과 연계해서 금액, 기한 등을 묻는 두 지문 연계 문제로 자주 출제된다.
• 숫자 표현이 등장하기 때문에 숫자가 포함된 표를 빠르게 해석하는 능력이 필요하다.
• 표에 제시된 단편적인 금액뿐만 아니라 할인 또는 추가 금액을 적용하여 실제 납부 금액을 계산해야 하는 문제도 출제되므로, 송장 및 청구서에서 단서에 해당하는 항목을 꼼꼼히 확인해야 한다.

일정표

회의나 강의가 시간 순으로 나열된 일정표는 빈출되는 양식으로, 단일 지문뿐만 아니라 연계 지문에서도 활용된다. 사람 이름과 직책명 등의 고유명사가 등장하므로 이에 주의해서 정보를 파악해야 한다.

❶Tampa Annual Realtors Conference
Saturday, November 3
Mesa Convention Center

9:30 A.M.	Welcome speech Selma Armstrong; President, National Realtor's Association
10 A.M.	Speech: "Using Technology to Maximize Efficiency" Curtis Nolte; Owner, Small-Tech Solutions
11 A.M.	❷Presentation: "Marketing for your Business and your Properties" Kenneth Wright; Director, Southside Real Estate
12 noon	Lunch
1 P.M.	Speech: "The Key to Customer Service" Naomi Lopez; Realtor, Good Neighbors Realty
2 P.M.	Question and answer session with presenters
3 P.M.	Closing speech Selma Armstrong; President, National Realtor's Association

❸All events will take place in Meeting Room 103 with the exception of the catered lunch, which will be provided in the ballroom.

❶ 제목, 날짜, 장소

일정표의 제목과 함께 행사의 날짜 및 장소 등의 정보를 통해 어떤 행사의 일정표인지 예측해볼 수 있다.

▶ 연례 부동산 중개인 총회

❷ 세부 내용

일정표의 시간과 사람 이름, 직책명 등의 고유명사를 통해 행사의 내용을 파악할 수 있다.

▶ 시간별 다른 연설자의 연설 정보 제공

+ 출제되는 문제 유형

Q. Who will most likely speak about advertising?
광고에 관해 연설할 것 같은 사람은?

A. Kenneth Wright
케네스 라이트 씨

❸ 추가 정보

마지막에 추가 정보가 제시되기도 하며 이와 관련한 문제가 출제되기도 한다.

▶ 행사 진행 장소 공지

+ 출제되는 문제 유형

Q. What is indicated about the event?
행사에 대해 시사된 것은?

A. All speeches will be delivered in the same room.
모든 연설은 같은 방에서 진행될 것이다.

1. 일정표

- 일정표는 회의나 모임, 출장이나 여행 일정, 강의 시간표와 같이 시간 순으로 나열되는 일정을 주로 다룬다.
- 시간 순으로 나열된 일정표는 해당 시간에 어떤 행사가 열리는지 파악하는 것이 중요하다.
- 사람 이름, 직책, 회의실 등 고유명사가 많이 등장하지만 어떤 항목을 묻고 있는지 확인한다면 쉽게 해결할 수 있다.
- 교육 일정표는 일정과 시간, 강연자와 강연 내용을 종합하여 정보를 파악할 수 있어야 한다.
- 출장이나 여행 일정표는 날짜나 시간대별로 서술되고 특정 시간에 무엇을 하고 있을지 묻는 문제가 빈출된다.
- 기사나 이메일과 연계해서 일정이나 인물, 강의 등을 묻는 두 지문 연계 문제가 빈출된다.

패러프레이징

패러프레이징은 다른 품사를 활용하거나, 동의어 또는 유의어 활용, 상위 개념 또는 함축 표현을 활용하여 이루어진다. 어떤 방식의 패러프레이징이든지 결국 유사한 의미의 표현을 찾는 것이 관건이다.

지문	패러프레이징
Q. The IT team will install new software on Friday after 5 P.M. There is a small possibility of data loss during this procedure, so employees should back up all important files before leaving for the day.	(A) The new program can back up all data automatically. **(B) An IT procedure could cause a loss of information.**

다음 짧은 지문을 읽고 지문과 일치하게 패러프레이징된 문장을 고르세요.

1. Need a new couch? Come to Snooze Furniture to see our new collection of sofas and chairs. Our entire selection of high-quality merchandise is offered at the best prices around. And with nearly endless choices for every size, color, and feature, you're sure to find what you're looking for.

(A) A wide variety of products is available.
(B) The store specializes in a certain style.

2. Adam Hank's retirement party will be held on May 16 at Faustina's, the Italian restaurant by the office. The private party room is reserved for us from 5 P.M. until 8 P.M. Please arrive at 5 P.M. precisely so that we may give Adam his gift with everyone present.

(A) A gathering is being organized for a retiring employee.
(B) A restaurant manager is promoting a worker.

3. Our sales figures for the second quarter of this year are up. Not only are they higher than last quarter's, but this quarter also saw the highest number of sales we've had so far. We hope to continue this upwards movement in the third quarter.

(A) A big sale's event is taking place.
(B) A company had a successful second quarter.

4. Moon Manors Apartments on High Street feature the latest in comfort and style for modern living. We have two-, three-, and four-bedroom apartments. All of these are equipped with state-of-the-art amenities. Call our agents today!

(A) A real estate agent is looking for new landlords.
(B) The residences have advanced facilities.

5. The demonstration for our new line of window cleaning products was originally scheduled for Thursday, December 5. However, because a marketing conference is on that day, we've decided to postpone our demonstration gathering until December 12.

(A) A demonstration date has been changed.
(B) A product will be launched at a conference.

정답 및 해설 151쪽

FINAL TEST

Questions 1-2 refer to the following invoice.

Invoice

Ben's Electrical Repairs
Tel: (405) 555-8395 Fax: (405) 555-8396
1681 Blue Spruce Lane; Dundalk, MD 21222

Date: February 12

Invoice Number	INF10-23
Customer	Tara Rivers
Address	781 Turnpike Drive; Dundalk, MD 21222
Date of Service	February 10
Billing Period (in days)	30
Due Date	March 12
Description	Installation of external power outlet near garage door

Description	Quantity	Price per Unit	Subtotal
Tilmann XR power switch	1.0	$4.99	$4.99
Tilmann XR switch cover	1.0	$4.25	$4.25
GFCI protected circuit	1.0	$57.50	$57.50
Standard labor	1.75 hrs	$60.00	$105.00

Pre-tax Total: $171.74
Tax: $10.31
Amount Paid: -$0.00
Amount Due: **$182.05**

If you will be claiming the above expenses on your taxes, please notify us by March 1 and we will send you additional documentation.

1. When must the bill be settled?

 (A) February 10
 (B) February 12
 (C) March 1
 (D) March 12

2. What is the total charge for labor costs?

 (A) $60.00
 (B) $105.00
 (C) $171.74
 (D) $182.05

Questions 3-4 refer to the following schedule.

New You Fitness Center: Fall Classes

Keep fit at New You Fitness Center! We are happy to introduce the following fall classes:

· **Rockin' Aerobics:** Monday, Tuesday, Friday/8 A.M., 5 P.M.

Enjoy the benefits of aerobics while having fun dancing to pop and rock music and learning genre-specific moves. This one-hour class includes a new routine every week.

· **Water Workout:** Monday, Thursday, Sunday/7 A.M.

Start your day with a refreshing workout in the pool. This unique class allows participants an intense workout with minimal stress on the ankles and knees. Great for those recovering from an injury.

· **Advanced Yoga:** Monday, Thursday/8 P.M.

This advanced class is limited to 6 people per session. The small group allows you to take advantage of the personal attention of a qualified yoga instructor. The workout includes medium to difficult poses. Please sign up in advance.

All classes are free with membership except Advanced Yoga, which has a $5 fee. Non-gym members can attend classes for $15 per session. All classes are taught by experienced certified instructors.

3. How many Rockin' Aerobics classes are offered each week?

(A) Two
(B) Three
(C) Five
(D) Six

4. What is NOT mentioned about the Advanced Yoga class?

(A) Its class size is restricted.
(B) It is the most popular class.
(C) It has an extra charge.
(D) It is taught in the evening.

Furniture Land's new four-floor showroom has all the furniture you need to make your home comfortable and inviting. Our entire selection of high-quality merchandise is offered at the best prices around. And with nearly endless choices for every size, color, and feature, you're sure to find what you're looking for.

If you buy from Furniture Land, you can take your furniture home with you right away, or pay for delivery. All local orders are guaranteed to arrive the following day, and out-of-town orders may take up to three days. Furniture Land also offers installation and assembly services for a nominal fee. We can send a specially trained employee to assemble your tables, bookcases, dressers, etc. so that you don't have to worry about following written instructions. With our team, you can be sure that the end result will fulfill all your expectations.

Come to Furniture Land today! We look forward to serving you.

WELCOME TO FURNITURE LAND!

Getting your purchases home has never been easier! Our flat-pack boxes are easy to carry and trolleys are available to help you transport your larger purchases to your car. Take things with you today and save!

Need help? Just ask.
If you prefer, we will arrange delivery for you at reasonable rates.

Don't know where to go? Look here.
1st Floor: recliners, love seats, sofa sectionals
2nd Floor: carpets, home office, bookcases
3rd Floor: bedroom sets, mattresses, daybeds
4th Floor: kitchen cabinetry, dining room furniture

FURNITURE LAND				
INVOICE				
417 South 6th Street, Boise, ID 83616				

Order Date: April 2 Shipping Type: [X] Local [] Out of Town		Bill to: Julio Burns 3991 Seltice Way Boise, ID 83702		
Description	**Units**	**Unit Price**		**Line Total**
Springwell Mattress, King Size	1	$2,449.94		$2,449.94
Willowdoll Headboard, King Size	1	$779.94		$779.94
		Subtotal		$3,229.88
		Tax at 8.6%		$277.77
Call Furniture Land at 555-2876 within 30 days if you wish to have an item returned or replaced. Delivery charges may apply.		**Delivery**		$175.00
		Total		$3,682.65
		Paid		$3,682.65
		Total Due		$0.00

5. To whom is the advertisement likely intended?

(A) Homeowners
(B) Crafts people
(C) Interior designers
(D) Delivery workers

6. In the advertisement, the word "assemble" in paragraph 2, line 4, is closest in meaning to

(A) build
(B) customize
(C) deliver
(D) refund

7. What is indicated about Furniture Land?

(A) It does not sell office desks.
(B) Carts are available to move boxes.
(C) Cabinets can be custom-made.
(D) All purchases come with free installation.

8. When will Mr. Burns' order most likely arrive?

(A) On April 2
(B) On April 3
(C) On April 4
(D) On April 5

9. What floor did Mr. Burns visit to make his purchase?

(A) First
(B) Second
(C) Third
(D) Fourth

ACTUAL
TEST

—

Reading Comprehension

실전 모의고사

—

Reading Comprehension

ACTUAL TEST

READING TEST

In the Reading test, you will read a variety of texts and answer several different types of reading comprehension questions. The entire Reading test will last 75 minutes. There are three parts, and directions are given for each part. You are encouraged to answer as many questions as possible within the time allowed.

You must mark your answers on the separate answer sheet. Do not write your answers in your test book.

PART 5

Directions: A word or phrase is missing in each of the sentences below. Four answer choices are given below each sentence. Select the best answer to complete the sentence. Then mark the letter (A), (B), (C), or (D) on your answer sheet.

101. If the team director isn't available, you will interview the final two candidates by -------.

(A) you
(B) your
(C) yourself
(D) yours

102. Workers at Winny's Burger cannot accept any meal coupons ------- drive-through windows.

(A) in
(B) on
(C) by
(D) at

103. Mr. Hudson is the most ------- accountant involved in the project.

(A) knowledgeable
(B) approved
(C) enhanced
(D) accustomed

104. ------- should file all the medical reports and order all the supplies in Dr. Morenci's clinic.

(A) Any
(B) Whoever
(C) The
(D) Someone

105. Ranath Industries ------- hard work from its staff members by giving out generous monthly bonuses.

(A) establishes
(B) rejects
(C) endures
(D) recognizes

106. Please board through the closest ------- to your seat when you get on the train.

(A) entry
(B) entrance
(C) enter
(D) entering

107. It is Mr. Marino's job to create a safe working ------- for all laboratory workers.

(A) environment
(B) foundation
(C) equipment
(D) capacity

108. The construction project was delayed, so please check the ------- work schedule on the city's Web site.

(A) previous
(B) certain
(C) updated
(D) potential

109. Some advertisements are ------- placed near the middle of the magazine so they are not skipped over easily.

(A) strategically
(B) strategy
(C) strategic
(D) strategies

110. F&A Tours ------- its various tour packages on its Web site for the peak season.

(A) outline
(B) to outline
(C) outlining
(D) outlines

111. The contents of the article are not guaranteed to illustrate the ------- of the newspaper editor.

(A) history
(B) views
(C) conclusions
(D) differences

112. When employees ------- come to work late, they receive a written warning from their department head.

(A) routinely
(B) unfortunately
(C) accidentally
(D) temporarily

113. The clothing store manager purchased new mannequins ------- its window displays.

(A) during
(B) for
(C) to
(D) beside

114. When applying for a passport, applicants must ------- a form of identification, such as a driver's license.

(A) protect
(B) record
(C) match
(D) provide

115. Ms. Mendez engaged in an intense ------- with the personnel manager over the specifics of her contract.

(A) negotiated
(B) negotiation
(C) negotiating
(D) negotiator

116. No one ------- the payroll administrators will have access to confidential documents.

(A) except
(B) after
(C) between
(D) over

117. Along with its other skincare products, Ageless Cosmetics sells a ------- priced anti-aging cream.

(A) reasonably
(B) reasonable
(C) reason
(D) reasoned

118. The government reviewed the ------- created to reduce speeding on highways.

(A) decisions
(B) permissions
(C) findings
(D) regulations

119. Snowball Foundation fundraisers are regularly held to raise money to support ------- in the field of cancer study.

(A) researching
(B) researched
(C) research
(D) researches

120. Using new technology, Howard Inc. developed ------- different products from its competitors.

(A) affordably
(B) chiefly
(C) markedly
(D) rapidly

GO ON TO THE NEXT PAGE

ACTUAL TEST

121. Driving through the British countryside is quite enjoyable ------- the unpaved roads and slower speeds.

(A) notwithstanding
(B) otherwise
(C) whether
(D) whereas

122. On March 30, professional chef Timothy Bass is opening his fourth restaurant ------- the direction of his son.

(A) either
(B) across
(C) within
(D) under

123. Some companies assign security passes ------- to make sure that only employees can enter the building.

(A) precisely
(B) relatively
(C) justly
(D) quickly

124. During today's workshop, two software security presentations ------- in Conference Room A.

(A) will offer
(B) offering
(C) offer
(D) will be offered

125. After meeting with several international clients, Ms. Meyers has developed a global ------- on her business affairs.

(A) issue
(B) perspective
(C) concern
(D) selection

126. The Springtime Café introduced a stamp-card program last year ------- reward loyal customers who come in regularly.

(A) in order to
(B) even if
(C) after all
(D) as a result of

127. The CEO ------- the complaints raised by employees regarding the company's overtime payment policy.

(A) will be addressed
(B) has been addressed
(C) is addressing
(D) to address

128. ------- the fact that her package was ordered several weeks ago, Ms. Dawson expected it to have arrived by now.

(A) Because
(B) Since
(C) Except
(D) Given

129. Young adults should put money into a pension fund, ------- ensures them financial security after they retire.

(A) whose
(B) which
(C) that
(D) whatever

130. Flying to Rome seems faster than taking the train, but it takes the ------- amount of time because of the security check.

(A) profitable
(B) equivalent
(C) massive
(D) reliable

PART 6

Directions: Read the texts that follow. A word, phrase, or sentence is missing in parts of each text. Four answer choices for each question are given below the text. Select the best answer to complete the text. Then mark the letter (A), (B), (C), or (D) on your answer sheet.

Questions 131-134 refer to the following information.

Residents of any unit in the Carson Corp. apartment complex are required to purchase parking permits, which are issued by the main offices in the lobby of each building. ------, residents **131.** must renew these every year. Expired passes are not acceptable. ------. Building managers are **132.** responsible for ------ these policies and ticket any vehicle that does not have a visible valid **133.** permit. Owners of unauthorized vehicles ------ large fines. **134.**

131. (A) Similarly
 (B) In fact
 (C) In addition
 (D) However

132. (A) There are no underground parking spots available.
 (B) Therefore, residents are not able to choose their spot numbers.
 (C) Moreover, permits must be displayed visibly to avoid tickets.
 (D) Guest parking spots are limited to four hours at a time.

133. (A) inserting
 (B) enforcing
 (C) eliminating
 (D) verifying

134. (A) have charged
 (B) are charging
 (C) are charged
 (D) to charge

GO ON TO THE NEXT PAGE

ACTUAL TEST

Christmas Holiday Return Policy

Please ----- that items purchased while on sale are not eligible for returns or exchanges. All
135.
other items can be returned as long as they are brought back in an unworn condition and with a
receipt.

-----. However, this period is extended during busy seasons. For instance, the acceptable
136.
return period for this Christmas season will last ----- than at any other time of the year. Thus
137.
we ----- returns for up to two months after the date of purchase. To qualify for this extension,
138.
an item must be purchased between December 1 and January 1.

135. (A) prepare
 (B) note
 (C) determine
 (D) address

137. (A) length
 (B) long
 (C) longest
 (D) longer

136. (A) Clothing may be put on hold for forty-
 eight hours only.
 (B) All tags must still be attached to the
 articles of clothing.
 (C) Without a receipt, an exchange cannot
 be processed.
 (D) All items can be returned within thirty
 days of purchase.

138. (A) are accepted
 (B) accepting
 (C) will accept
 (D) have accepted

To: Engineering Department <engineering@cobasta.com>
From: David Park <dpark@cobasta.com>
Date: August 30
Subject: International Training Fellowship for Engineering Professionals

Good afternoon,

I would like to tell you about the International Training Fellowship for Engineering Professionals. This fellowship brings international engineering knowledge into Brazil and South America. It is intended for civil engineers working for Brazilian firms. Applicants with more than five years' experience are ------ to receive company sponsorship to work overseas for half a year.
139.

In addition to a six-month internship at one of several partner organizations, the program for successful ------ will include a variety of training courses. ------. However, the application review
140. 141.
committee gives ------ to individuals who speak multiple languages. All applications must be
142.
submitted to Mr. Flavio Fela, ffela@itfep.com, by October 1 to be considered.

I hope you will consider applying.

Regards,

David Park
International Team Manager, Cobsta Inc.

139. (A) eligible
(B) reliable
(C) sustainable
(D) cooperative

140. (A) positions
(B) employers
(C) candidates
(D) occupations

141. (A) Only people fluent in Portuguese will be considered.
(B) All qualified engineers working in Brazil are able to apply.
(C) Please bring two reference letters to the interview.
(D) No additional language training will be provided in the program.

142. (A) preferring
(B) preference
(C) preferential
(D) preferred

GO ON TO THE NEXT PAGE

ACTUAL
TEST

Questions 143-146 refer to the following meeting summary.

Tuesday, March 29 Marketing Meeting Notes

The meeting discussed moving Mojo Enterprises business operations from South Carolina to Tennessee. Unfortunately, no decision was reached. _____. According to the opposition, **143.** despite being an extremely prominent _____ of fine china in South Carolina, Mojo will lose **144.** existing customers by moving to Tennessee. Conversely, those supporting the move argued that property taxes are too high in South Carolina and pointed out the benefit of _____ to a state **145.** with lower costs. In response, a manager claimed that one of Mojo's competitors tried to take advantage of a state with lower taxes and failed. _____ it moved its headquarters, it has been **146.** losing customer interest.

143. (A) Correspondingly, a decision must be reached unanimously.
 (B) Currently, management remains divided on the best course of action.
 (C) Therefore, the meeting was determined to be productive.
 (D) This is why Tennessee has fewer government regulations to follow.

144. (A) distribute
 (B) distributing
 (C) distribution
 (D) distributor

145. (A) connecting
 (B) adjusting
 (C) relocating
 (D) joining

146. (A) Since
 (B) Unless
 (C) Not only
 (D) No sooner

PART 7

Directions: In this part, you will read a selection of texts, such as magazine and newspaper articles, e-mails, and instant messages. Each text or set of texts is followed by several questions. Select the best answer for each question and mark the letter (A), (B), (C), or (D) on your answer sheet.

Questions 147-148 refer to the following Web page.

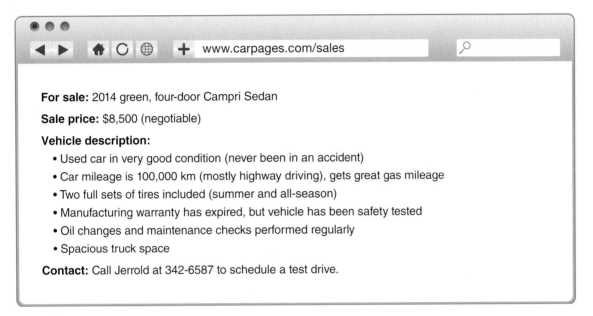

For sale: 2014 green, four-door Campri Sedan

Sale price: $8,500 (negotiable)

Vehicle description:
- Used car in very good condition (never been in an accident)
- Car mileage is 100,000 km (mostly highway driving), gets great gas mileage
- Two full sets of tires included (summer and all-season)
- Manufacturing warranty has expired, but vehicle has been safety tested
- Oil changes and maintenance checks performed regularly
- Spacious truck space

Contact: Call Jerrold at 342-6587 to schedule a test drive.

147. What is suggested about the seller?

(A) He has only owned one vehicle.
(B) He performs his own oil changes.
(C) He is willing to lower the posted price.
(D) He pays a lot for fuel.

148. What is NOT true about the vehicle?

(A) It has time remaining on the warranty.
(B) It has passed official safety checks.
(C) It was driven on the highway regularly.
(D) It comes with an additional set of tires.

GO ON TO THE NEXT PAGE

ACTUAL
TEST

BGI Welcomes New CEO!

BGI Enterprises welcomes Ada Strickland as its new Chief Executive Officer. Ada is an experienced executive with thirty years in executive management and business leadership.

Ada was born right here in Boston, Massachusetts, in 1943. She later moved to New York to complete her undergraduate degree in business. She then relocated a second time to London to get a master's in administration at Cambridge University. Ada started her career as a mortgage broker before becoming a financial analyst and moving back to her hometown.

Ada has been an officer and senior leader for many consulting firms. She has a solid track record of strong corporate leadership and is known for her understanding of tactical business strategies. She has demonstrated an ability to discover, mentor, and lead action-oriented teams of talented individuals. These skills will help her at BGI Enterprises, which is still recovering from a series of aggressive layoffs that took place last year.

149. What is the purpose of the article?

(A) To outline the qualifications needed for a role
(B) To provide the profile of a new executive
(C) To describe a business program
(D) To publicize a job opening

150. What is NOT stated about Ada Strickland?

(A) She earned two university degrees.
(B) She lived in London temporarily.
(C) She grew up in New York City.
(D) She has worked for multiple companies.

151. What is implied about BGI Enterprises?

(A) It recently reduced its work force.
(B) It completed a merger with another firm.
(C) It plans to lay off staff members soon.
(D) It has not had a CEO for several months.

Questions 152-154 refer to the following article.

Hammett Builders Appointed as New Community Builder

By Jennifer Brashears

Mitchell Construction will no longer be responsible for designing and installing the city's new water pipe in Charlton Square. — [1] — Prior to the move-in dates for new residents, a water pipe needs to be installed to provide them all with water service.

Earlier last year, the city council accepted a proposal to install a new water pipe in this location. — [2] — Afterwards, it hired Mitchell Construction to head up the project. Unfortunately, Mitchell Construction had to cancel the agreement, as another project has gone on much longer than expected. — [3] —

Hammett Builders submitted a very cost-effective proposal, and has been selected to replace Mitchell Construction. Its appointment was a decision that Mayor Tara Buzbee is quite pleased with. She stated, "Hammett Builders was the perfect candidate for the job. — [4] — The best part is that, through Hammett, the work is expected to be completed within six weeks, which is much faster than we originally anticipated."

152. What is suggested about Mitchell Construction?

(A) It proposed a project to the city.
(B) It is currently engaged in a project.
(C) It can complete the work within six weeks.
(D) It nominated Hammett Builders to be its replacement.

153. What aspect of Hammett Builders is Ms. Buzbee most satisfied with?

(A) Its safety practices
(B) Its unique design ideas
(C) Its experienced workers
(D) Its time-saving plan

154. In which of the positions marked [1], [2], [3], and [4] does the following sentence best belong?

"This brand-new residential neighborhood was only recently constructed."

(A) [1]
(B) [2]
(C) [3]
(D) [4]

GO ON TO THE NEXT PAGE

ACTUAL TEST

Questions 155-156 refer to the following notice.

Richardson Electronics Shipping and Delivery Policies

- Items will be shipped immediately after credit card payments are processed in full.
- Shipping is free on all domestic orders.
- The cost for international shipping is calculated based on location. The price will be displayed on the check-out page before you complete your order.
- Deliveries are made between 9 A.M. and 4 P.M. on weekdays.
- If our drivers are unable to deliver your purchase, your package will be taken to the nearest postal center, where you may retrieve it in person.

155. For whom is the notice most likely intended?

(A) Delivery drivers
(B) Online shoppers
(C) Customer service agents
(D) Retail clerks

156. What is mentioned about the delivery process?

(A) Shoppers can track deliveries.
(B) Failed deliveries must be picked up.
(C) The fees are the same regardless of the destination.
(D) Drivers can drop off packages on the weekend.

Eudora Vineyards Starts Annual Summer Photo Contest

CALIFORNIA, June 30— Every summer for the last five years, local winery Eudora Vineyards has asked California residents to show their Californian pride by taking pictures of themselves at, or adjacent to, prominent state landmarks like the Golden Gate Bridge. Regardless of what piece of state scenery is in the backdrop, a bottle or glass of wine from Eudora Vineyards must be situated somewhere in the photo.

All photos are posted to the company's social media page, where fans will get to vote for their favorite pictures from July 1 to July 31. Votes are limited to one per person, but each photo typically receives thousands of votes each year.

The first-place winner is invited to take a free tour of the winery. Second- and third-place winners are given smaller prizes that vary from souvenirs to vouchers. The competition has successfully raised the profile of Eudora Vineyards in the community, and helped to increase its annual sales by nearly 15 percent.

157. What is suggested about Eudora Vineyards?

(A) It is located near the Golden Gate Bridge.
(B) It opened five years ago.
(C) It holds regular wine-tasting events.
(D) It gives tours of its winery.

158. What is NOT true about the photo contest?

(A) Fans get to select the winner.
(B) The voting period is a month long.
(C) Winners receive free bottles of wine.
(D) Photos must be related to the winery.

GO ON TO THE NEXT PAGE

Tony's Catering Service

Tony's Catering provides upscale catering services to clients. We cook meals in our facility and deliver prepared food to clients, or we can make meals at external locations.

Server Responsibilities
- Offer menus to guests, explain entrée and drink specials, fill water glasses
- Provide perfect service to every table by paying close attention to the needs of patrons
- Process payments

Food Purchaser Responsibilities
- Build relationships with nearby farmers and producers
- Order meat, produce, and dairy products according to client needs
- Conduct regular on-site visits to local partner vendors

Kitchen Staff Responsibilities
- Confirm menu specials and prepare ingredients every day
- Assure the cleanliness and sanitization of all work areas
- Thoroughly clean all fridges, freezers, and other food storage areas monthly

If you would like additional information about your expected duties, please contact your area manager.

159. Who is the notice intended for?

(A) Dairy producers
(B) Food-service workers
(C) Catering clients
(D) Produce farmers

160. What is suggested about the ingredients used by Tony's Catering?

(A) They are purchased directly by the client.
(B) They are locally sourced.
(C) They are organically farmed.
(D) They are heavily discounted.

161. How often are food storage areas cleaned?

(A) Once a day
(B) Once a week
(C) Once a month
(D) Once a year

JOHN REINHARDT	09:20
I've sent you an e-mail. Have you looked at it yet?	

HAZEL WISEMAN	09:23
Oh, no. I've been traveling the last few days, and I haven't been able to read any e-mails.	

HAZEL WISEMAN	09:24
What did the message say?	

JOHN REINHARDT	09:25
I've completed several design proposals for your living-room remodel, and I sent some possible dates for us to meet and discuss them.	

HAZEL WISEMAN	09:26
I'll be back on Friday morning.	

JOHN REINHARDT	09:27
That's perfect. Let's meet at La Cantina at 1 P.M. on Friday.	

JOHN REINHARDT	09:28
I also have a question. Do you want me to purchase the building materials, or do you want confirmation before I buy anything?	

HAZEL WISEMAN	09:29
I prefer the former. As long as you stay within budget, you can have complete control.	

162. Where most likely does Mr. Reinhardt work?

(A) At a furniture store
(B) At a design firm
(C) At a construction company
(D) At a travel agency

163. At 09:29, what does Ms. Wiseman mean when she writes, "I prefer the former"?

(A) She needs an itemized list of expenses.
(B) She does not need to buy new furniture.
(C) She does not want to make purchasing decisions.
(D) She would like to have an e-mail sent.

GO ON TO THE NEXT PAGE

ACTUAL TEST

Questions 164-167 refer to the following e-mail.

To:	Lonnie Payne <payne@magmail.net>
From:	Meredith McGuire <meredith@meredithmccguire.com>
Date:	April 2
Subject:	Your review
Attachment:	Taste Testing Event

Dear Ms. Payne,

I just wanted to express my sincere gratitude that you wrote a favorable review of my book in your cooking magazine. As a thank you for your kind words, I'd like to invite you to one of my book promotional tour events. —[1]— I will be visiting a local bakery to sign copies of the book and conduct a taste test with some of the recipes I published.

I've attached the schedule details for you. —[2]— The event is at 2 P.M. on April 14. It is free of charge, but there is limited space, so I have reserved a spot for you in case you wish to drop by. —[3]— Also, you are more than welcome to film the event and upload the video link to your magazine's social media site. —[4]—

Let me know if you are interested in attending.

Meredith McGuire

164. Who is Ms. McGuire?

(A) A publicist
(B) A magazine publisher
(C) A book reviewer
(D) A recipe writer

165. Where will the event take place?

(A) At a book store
(B) At a bakery
(C) At a magazine publisher
(D) At a cooking school

166. What did Ms. McGuire send to Ms. Payne?

(A) A link to a video
(B) A copy of a recipe
(C) A program for an event
(D) A magazine article

167. In which of the positions marked [1], [2], [3], and [4] does the following sentence best belong?

"Perhaps it will help expand your online audience."

(A) [1]
(B) [2]
(C) [3]
(D) [4]

Questions 168-171 refer to the following online chat discussion.

Carolyn Lamantia 1:09 P.M.	I wanted to talk to both of you about ordering some more office supplies for the supply cabinet. I noticed that it's getting fairly empty.
Yvonne Castile 1:11 P.M.	It's about that time. Orders are due at the end of the month, which is only a couple of days away.
Wendell Haag 1:13 P.M.	You'll have to check with Martin. He's responsible for placing those orders each month. Unfortunately, he's on vacation, and he won't be back before the due date.
Carolyn Lamantia 1:17 P.M.	What happens if the order isn't submitted by the deadline?
Wendell Haag 1:19 P.M.	It's set up on an automatic system. We have a default order that is placed every month. If we want to modify the amounts, then Martin submits an order manually. Otherwise, the default order is processed.
Yvonne Castile 1:21 P.M.	Martin is really good at caring for these things. If we are lacking supplies, I'm sure he noticed and updated the order.
Wendell Haag 1:23 P.M.	There's an easy way to find out. On the intranet, you can check to see the invoice history. It'll list all the orders that have been placed.

SEND

168. At 1:11 P.M., what does Ms. Castile mean when she writes, "It's about that time"?

(A) Supplies have started to get quite low.
(B) She is prepared for a discussion.
(C) Supplies will be delivered tomorrow.
(D) She is due to take a vacation.

169. What is Ms. Lamantia concerned about?

(A) Contacting Martin
(B) Coordinating vacations
(C) Missing a deadline
(D) Moving the supply cabinet

170. What does Ms. Castile imply about Martin?

(A) He has likely already arranged an order.
(B) He is the only person who can access invoices.
(C) He returned from his vacation early.
(D) He should be given the due date.

171. According to Mr. Haag, what is stored on the intranet?

(A) Order histories
(B) Employee phone numbers
(C) Pricing charts
(D) Supplier contact information

GO ON TO THE NEXT PAGE

ACTUAL TEST

SALEM CORP. COMPANY MONTHLY NEWSLETTER

From January 1 to March 30, we experimented with the use of video conferences to enable all staff members from remote offices to be visibly present at all meetings, both small and large. These video conferences were highly informative.

What was the purpose of these video conferences?

The goal was to determine whether there are better ways to facilitate interaction between project members in different offices.

What are the advantages of video conferences?

First of all, purchasing video conference software is cheaper than continuing to send employees overseas for meetings.

Second, it avoids the misunderstandings that occur through phone calls, e-mails, or instant messages. The lack of face-to-face interaction in these types of meetings prevents people from using facial expressions, gestures, and other forms of communication. Being able to see the people we interact with is critical to ensuring clarity in meetings.

When are video conferences inappropriate?

It is NOT recommended that we use video conferences as a replacement for all in-person meetings, such as our yearly meeting with the board of directors. We believe it is beneficial to have all board members physically present at this time.

172. What is this information mainly about?

(A) The results of a staff meeting
(B) The cost of business travel
(C) A new method of interaction
(D) A problem with e-mail communication

173. What is NOT mentioned as an advantage of video conferences?

(A) They allow for visual communication.
(B) They save on travel expenses.
(C) They prevent misunderstandings.
(D) They shorten meeting lengths.

174. The word "critical" in paragraph 4, line 4, is closest in meaning to

(A) hazardous
(B) analytical
(C) essential
(D) negative

175. What is indicated about the annual board meeting?

(A) It would be easier to do as a video conference.
(B) It is usually held in the first quarter.
(C) It should deal with the topic of communication.
(D) The entire board should attend it.

GO ON TO THE NEXT PAGE

ACTUAL TEST

Questions 176-180 refer to the following e-mails.

To: Sheryl Payan <sheryl@umail.org>
From: David Wolfe <wolfe@coteta.net>
Date: January 21
Subject: Your upcoming trip

Hello Ms. Payan,

I'm pleased to say that I've been able to make your travel arrangements to Costa Rica at a special rate. The total travel package will cost you $3,050.

I found you some plane tickets with Air Americana for a cheaper rate than the standard ticket fares. Your arrival date in Costa Rica will be March 2, at 5 P.M., and your departure date from the Juan Santamaria Airport in Alajuela will be March 15, on a 6 A.M. flight.

I've booked the Traveler's Hotel in Tibás and arranged for a car to take you from the airport to the hotel. I've also reserved the activities you requested, including a walk up a volcano and a boat ride to Quepos. You will also get a tour of the capital, Heredia.

If any changes are needed, just e-mail me.

Sincerely,

David Wolfe,
Corners of the Earth Travel Agency

To: David Wolfe <wolfe@coteta.net>
From: Sheryl Payan <sheryl@umail.org>
Date: January 22
Subject: RE: Your upcoming trip

Dear Mr. Wolfe,

Thank you for your e-mail. I appreciate all the work that you've put into my trip, but there are a few things I would like to clarify. First of all, my arrival date is a bit earlier than I desired. I would like to arrive two days later than you've proposed. There is no need to modify the return date. Is this possible to adjust?

Secondly, could I stay in a hotel in the capital city instead of Tibás? I'll travel from there to the other surrounding cities.

Please let me know once these matters have been dealt with and my trip plans have been finalized.

Thank you,
Sheryl Payan

176. Why did Mr. Wolfe write the first e-mail?

(A) To outline travel warnings to Costa Rica
(B) To send electronic copies of plane tickets
(C) To provide updates on travel arrangements
(D) To request a payment to be processed

177. According to Mr. Wolfe, what activity will Ms. Payan do?

(A) Hiking a mountain
(B) Observing animals
(C) Fishing in the sea
(D) Camping in a park

178. What is true about Ms. Payan?

(A) She has visited Costa Rica before.
(B) She is a loyalty member with Air Americana.
(C) She wants to arrive on March 4.
(D) She plans to rent a car from the airport.

179. In what city does Ms. Payan want to stay?

(A) Alajuela
(B) Heredia
(C) Quepos
(D) Tibás

180. In the second e-mail, the word "matters" in paragraph 3, line 1, is closest in meaning to

(A) substances
(B) meanings
(C) amounts
(D) situations

GO ON TO THE NEXT PAGE

ACTUAL TEST

Attention Drake Corp. Employees

Starting February 1, we will be introducing a new inventory software program here at Drake Corp. With this system, you should be able to log in to our company inventory records remotely. This means that regardless of where you work, you will have access to the inventory records. While all records are viewable for any employee, only relevant personnel have authorization to edit the inventory database. This is both to ensure accuracy, and to protect sensitive information.

To sign in as an editor, you must enter one of these assigned codes followed by your four-digit individual employee number. The department codes are:

Warehouse: 03
Shipment: 05
Production: 07
Returns: 09

To: Clive Redding <redding_c@drakecorp.net>
From: Ebonie Bishop <bishop_e@drakecorp.net>
Date: February 4
Subject: The new system

Dear Clive,

I received a returned box today that has ten headphones inside. I'm trying to reflect that in the database, but I can't log on as an editor. However, my understanding was that the returns department was one of the departments granted inventory database access. When items are brought back to us because of damage or various other reasons, those numbers need to be corrected in the system.

Can you give me authorization to make this change? I'm also curious whether I'm the only person in my department who has had this problem, or if everyone is experiencing the same frustration.

Thanks in advance,

Ebonie

181. What is the purpose of the memo?

 (A) To assign employee identification numbers
 (B) To verify the amount of inventory in the warehouse
 (C) To announce the use of a new computer program
 (D) To outline the record-keeping process

182. According to the memo, what is one of the main features of the new system?

 (A) It reduces expenses over time.
 (B) It eliminates paper records.
 (C) It can be accessed from anywhere.
 (D) It increases department efficiency.

183. What type of company most likely is Drake Corp.?

 (A) An electronics manufacturer
 (B) A software company
 (C) A delivery service
 (D) A publication firm

184. What department code did Ms. Bishop enter into the system?

 (A) 03
 (B) 05
 (C) 07
 (D) 09

185. What does Ms. Bishop ask Mr. Redding to do?

 (A) Go into her office
 (B) Grant her access
 (C) Turn on her computer
 (D) Check her e-mail

GO ON TO THE NEXT PAGE

To: Drew Coleman <coleman@newtonlaw.ca>
From: Shannon Gales <gales@newtonlaw.ca>
Date: June 14
Subject: Lost briefcase

Drew,

As you know, I'm out of town to meet with one of our most important clients this week. Unfortunately, I think I left my briefcase on the train coming here. I am sure I had my briefcase with me both times I transferred. However, shortly after I arrived in Aldersbrook, I realized it was gone. Fortunately, I had my tablet in my purse, or it would be gone too. It's not a nice briefcase or anything, but the thing is, it has the flash drive with the files from the Peterson case. I'm really behind, and I have to prepare for the meeting tomorrow morning. Would you mind going to the station to file out a lost item report to trace the location of my item for me?

Thanks so much,

Shannon

Lost Item Report

Traveler Name: Shannon Gales

Contact Information: gales@newtonlaw.ca

Departure Station: Milford

Travel Date: June 14

Train Number(s): H3AQ, I3WE, N7JD

Arrival Station: Aldersbrook

Connecting Stations: First: Ridgeview; Second: Paddington

Item: briefcase **Brand:** Emos **Color:** navy blue **Size:** thin and narrow

Distinguishing features and/or contents:

Inside the briefcase is a flash drive containing a number of confidential files. Therefore, it is particularly important that this specific item be recovered.

Thank you for submitting a lost item report. We will do our best to get your item back to you.

To: Shannon Gales <gales@newtonlaw.ca>
From: Transit Authority <transport@yaletown.net>
Date: June 16
Subject: Lost Item Report

Dear Ms. Gales,

I am writing in response to the lost item report that you filled. I am pleased to inform you that we have located your briefcase. It was on the third train you took, between your seat and the wall. Unfortunately, as one of our employees was trying to pull it out from beside the seat, part of the side tore. I apologize for the damage. However, you'll be pleased to know that we were able to find the item inside that you were concerned about. We will keep your briefcase at the lost and found desk of your final destination and you may pick it up anytime.

Kind regards,

Yaletown Transit Authority

186. What is indicated about Ms. Gales?

(A) She could not attend the meeting.
(B) She is traveling for business.
(C) She forgot to bring her train ticket.
(D) She left yesterday morning.

187. What information is NOT required in the report?

(A) What the item looks like
(B) How the ticket was purchased
(C) How the owner can be contacted
(D) Where the passenger transferred

188. According to the second e-mail, what is the problem?

(A) The missing property has been claimed.
(B) Ms. Gales's bag could not be located.
(C) The briefcase was damaged.
(D) A fee is charged for lost belongings.

189. What did authorities find in Ms. Gales's bag?

(A) An electronic tablet
(B) A copy of a report
(C) A storage device
(D) An ID card

190. Where will Ms. Gales most likely go to recover her item?

(A) Milford Station
(B) Ridgeview Station
(C) Paddington Station
(D) Aldersbrook Station

GO ON TO THE NEXT PAGE

ACTUAL
TEST

Questions 191-195 refer to the following Web site, receipt, and review.

The Danville Museum has added new rooms for you to enjoy! General admission to the museum is still $10.00 per adult and $5 per child, but all special features are only accessible by purchasing additional tickets. The featured films change seasonally and will be replaced with new ones in the fall.

Butterfly Conservatory

This magical attraction features over 1,000 colorful butterflies living in a green and exotic rainforest-like setting. Be prepared for a butterfly to land on you as you walk through the area.

Emerick Theater (two films)

1) 2D Film: *Learning to Fly*

This 20-minute documentary covers the history of aviation.

2) 3D Film: *Parks and People*

The film will take you on a journey through the country's beautiful national parks.

Desai Planetarium, *Black Universe Show*

This fantastic show will give you a chance to look through the telescope at a replica of the solar system.

Danville Museum Entrance Receipt

Recipient number: 54A632 **Name:** Philip Scots

Date of purchase: July 15 **Credit card number:** 4556 XXXX XXXX 3734

Arrival time: 10:04 A.M.

Exhibition	Quantity	Total Cost
Museum General Entrance	3	$30.00
Butterfly Conservatory	3	$15.00
Emerick Theater, 3D Film	3	$13.50
Desai Planetarium	3	$9.00
	TOTAL	**$67.50**

Tickets are non-refundable.

This receipt is necessary to access the special exhibits specified above. It must be presented along with your general admission tickets.

Customer Feedback Form

Name: Philip Scots **Number of visitors:** 3 **Number of special exhibits seen:** 3

What did you like most about the exhibits?

My favorite part was the planetarium. Looking through the telescope was the highlight of my visit.

What didn't you like about the exhibits?

The cost is quite high to pay for each special exhibit separately. Is it possible to bundle all four together for a cheaper price?

How would you rate your experience?

□ Definitely Disappointed	□ Disappointed	□ Satisfied	■ Definitely Satisfied

Further comments:

I was upset that my group didn't have enough time to see both films showing in the theater, but I plan to come back and watch the other one next time.

191. What is suggested about the Danville Museum?

(A) It offers membership plans.
(B) It has altered its admission pricing.
(C) It recently set up new facilities.
(D) It will play the same movies until the spring.

192. According to the Web site, what can visitors do in the conservatory?

(A) Buy butterfly coloring books
(B) See a magic show
(C) Meet a natural scientist
(D) Observe some insects

193. What is indicated about Mr. Scots?

(A) He went to the museum with two other adults.
(B) He visits the museum frequently.
(C) He paid for his admission in cash.
(D) He chose to watch a documentary about flight.

194. What criticism did Mr. Scots provide?

(A) There are too many exhibits to see in one day.
(B) The prices should be reduced for special elements.
(C) It is excessive to have two movies shown in the theater.
(D) Museum viewing hours should be extended.

195. What will Mr. Scots probably see on his next visit?

(A) The Butterfly Conservatory
(B) *Learning to Fly*
(C) *Parks and People*
(D) *Black Universe Show*

GO ON TO THE NEXT PAGE

ACTUAL TEST

Questions 196-200 refer to the following Web site, online form, and e-mail.

Twinkle Cleaners

| Home | Services | Rates | Request | Contact |

Twinkle Cleaners provides the most reliable and reputable cleaning services in the Stratford area. We've been in business for nearly two years with a growing client base and a reputation for high standards. We take good care of your home and treat it as if it were our own.

We have several ongoing promotions, which include a 10% discount for seniors, a 15% discount for first-time customers, 20% for existing customers who refer friends, and 25% when you upgrade the frequency of your cleaning schedule.

Request Form

Name: Tony Lee
E-mail: tlee@newmail.com
Location of Service: 2359 Clavier Rd.
Phone: 555-239-3495

Type of service (prices are per shift):

	Standard Cleaning	Super Cleaning
One-time service	▫ $200	▫ $230
Once a month	▫ $190	▫ $220
Once a week	▫ $180	▪ ` $210
Twice a week	▫ $170	▫ $200

Preferred Day(s):
☐ Monday ☐ Tuesday ▪ Wednesday ☐ Thursday ▫ Friday

Additional comments:
Your company was referred to me by my friend Phoebe Lentz. She highly recommends your service.

To: Tony Lee <tlee@newmail.com>
From: Leslie Mahlon <leslie@twinkleclean.org>
Date: November 9
Subject: Your request

Dear Mr. Lee,

Thank you so much for your request for Twinkle Cleaners! We would like to do a visit of your home to see the layout and discuss your specific needs. Please confirm that you will be available on November 14 at 9:00 A.M.

Secondly, I regret to inform you that the service you selected is not available on Wednesdays. It is our busiest day of the week and we are currently fully booked. However, if you let us come on Fridays instead, we will do a super cleaning for the standard rate.

Kind regards,

Leslie Mahlon

196. What type of service is being advertised?

(A) Dry cleaning
(B) Carpet repair
(C) House cleaning
(D) Window washing

197. In the Web site, the word "treat" in paragraph 1, line 3, is closest in meaning to

(A) handle
(B) repair
(C) serve
(D) enter

198. What discount will Ms. Lentz be given?

(A) 10%
(B) 15%
(C) 20%
(D) 25%

199. What is indicated about Twinkle Cleaners?

(A) It does not have a weekly service.
(B) It serves many clients on Wednesdays.
(C) It does not currently offer standard cleaning.
(D) It works mornings only.

200. How much will Mr. Mahlon most likely charge Mr. Lee for each shift?

(A) $170
(B) $180
(C) $200
(D) $210

Stop! This is the end of the test. If you finish before time is called, you may go back to Parts 5, 6, and 7 and check your work.

ANSWER SHEET-RC
ACTUAL TEST

READING(Part V ~ VII)

NO.	ANSWER	NO.	ANSWER	NO.	ANSWER	NO.	ANSWER	NO.	ANSWER
	A B C D		A B C D		A B C D		A B C D		A B C D
101	ⓐ ⓑ ⓒ ⓓ	121	ⓐ ⓑ ⓒ ⓓ	141	ⓐ ⓑ ⓒ ⓓ	161	ⓐ ⓑ ⓒ ⓓ	181	ⓐ ⓑ ⓒ ⓓ
102	ⓐ ⓑ ⓒ ⓓ	122	ⓐ ⓑ ⓒ ⓓ	142	ⓐ ⓑ ⓒ ⓓ	162	ⓐ ⓑ ⓒ ⓓ	182	ⓐ ⓑ ⓒ ⓓ
103	ⓐ ⓑ ⓒ ⓓ	123	ⓐ ⓑ ⓒ ⓓ	143	ⓐ ⓑ ⓒ ⓓ	163	ⓐ ⓑ ⓒ ⓓ	183	ⓐ ⓑ ⓒ ⓓ
104	ⓐ ⓑ ⓒ ⓓ	124	ⓐ ⓑ ⓒ ⓓ	144	ⓐ ⓑ ⓒ ⓓ	164	ⓐ ⓑ ⓒ ⓓ	184	ⓐ ⓑ ⓒ ⓓ
105	ⓐ ⓑ ⓒ ⓓ	125	ⓐ ⓑ ⓒ ⓓ	145	ⓐ ⓑ ⓒ ⓓ	165	ⓐ ⓑ ⓒ ⓓ	185	ⓐ ⓑ ⓒ ⓓ
106	ⓐ ⓑ ⓒ ⓓ	126	ⓐ ⓑ ⓒ ⓓ	146	ⓐ ⓑ ⓒ ⓓ	166	ⓐ ⓑ ⓒ ⓓ	186	ⓐ ⓑ ⓒ ⓓ
107	ⓐ ⓑ ⓒ ⓓ	127	ⓐ ⓑ ⓒ ⓓ	147	ⓐ ⓑ ⓒ ⓓ	167	ⓐ ⓑ ⓒ ⓓ	187	ⓐ ⓑ ⓒ ⓓ
108	ⓐ ⓑ ⓒ ⓓ	128	ⓐ ⓑ ⓒ ⓓ	148	ⓐ ⓑ ⓒ ⓓ	168	ⓐ ⓑ ⓒ ⓓ	188	ⓐ ⓑ ⓒ ⓓ
109	ⓐ ⓑ ⓒ ⓓ	129	ⓐ ⓑ ⓒ ⓓ	149	ⓐ ⓑ ⓒ ⓓ	169	ⓐ ⓑ ⓒ ⓓ	189	ⓐ ⓑ ⓒ ⓓ
110	ⓐ ⓑ ⓒ ⓓ	130	ⓐ ⓑ ⓒ ⓓ	150	ⓐ ⓑ ⓒ ⓓ	170	ⓐ ⓑ ⓒ ⓓ	190	ⓐ ⓑ ⓒ ⓓ
111	ⓐ ⓑ ⓒ ⓓ	131	ⓐ ⓑ ⓒ ⓓ	151	ⓐ ⓑ ⓒ ⓓ	171	ⓐ ⓑ ⓒ ⓓ	191	ⓐ ⓑ ⓒ ⓓ
112	ⓐ ⓑ ⓒ ⓓ	132	ⓐ ⓑ ⓒ ⓓ	152	ⓐ ⓑ ⓒ ⓓ	172	ⓐ ⓑ ⓒ ⓓ	192	ⓐ ⓑ ⓒ ⓓ
113	ⓐ ⓑ ⓒ ⓓ	133	ⓐ ⓑ ⓒ ⓓ	153	ⓐ ⓑ ⓒ ⓓ	173	ⓐ ⓑ ⓒ ⓓ	193	ⓐ ⓑ ⓒ ⓓ
114	ⓐ ⓑ ⓒ ⓓ	134	ⓐ ⓑ ⓒ ⓓ	154	ⓐ ⓑ ⓒ ⓓ	174	ⓐ ⓑ ⓒ ⓓ	194	ⓐ ⓑ ⓒ ⓓ
115	ⓐ ⓑ ⓒ ⓓ	135	ⓐ ⓑ ⓒ ⓓ	155	ⓐ ⓑ ⓒ ⓓ	175	ⓐ ⓑ ⓒ ⓓ	195	ⓐ ⓑ ⓒ ⓓ
116	ⓐ ⓑ ⓒ ⓓ	136	ⓐ ⓑ ⓒ ⓓ	156	ⓐ ⓑ ⓒ ⓓ	176	ⓐ ⓑ ⓒ ⓓ	196	ⓐ ⓑ ⓒ ⓓ
117	ⓐ ⓑ ⓒ ⓓ	137	ⓐ ⓑ ⓒ ⓓ	157	ⓐ ⓑ ⓒ ⓓ	177	ⓐ ⓑ ⓒ ⓓ	197	ⓐ ⓑ ⓒ ⓓ
118	ⓐ ⓑ ⓒ ⓓ	138	ⓐ ⓑ ⓒ ⓓ	158	ⓐ ⓑ ⓒ ⓓ	178	ⓐ ⓑ ⓒ ⓓ	198	ⓐ ⓑ ⓒ ⓓ
119	ⓐ ⓑ ⓒ ⓓ	139	ⓐ ⓑ ⓒ ⓓ	159	ⓐ ⓑ ⓒ ⓓ	179	ⓐ ⓑ ⓒ ⓓ	199	ⓐ ⓑ ⓒ ⓓ
120	ⓐ ⓑ ⓒ ⓓ	140	ⓐ ⓑ ⓒ ⓓ	160	ⓐ ⓑ ⓒ ⓓ	180	ⓐ ⓑ ⓒ ⓓ	200	ⓐ ⓑ ⓒ ⓓ

자르는 선 ✂

ANSWER SHEET-RC
ACTUAL TEST

READING(Part V ~ VII)

NO.	ANSWER	NO.	ANSWER	NO.	ANSWER	NO.	ANSWER	NO.	ANSWER
	A B C D		A B C D		A B C D		A B C D		A B C D
101	ⓐ ⓑ ⓒ ⓓ	121	ⓐ ⓑ ⓒ ⓓ	141	ⓐ ⓑ ⓒ ⓓ	161	ⓐ ⓑ ⓒ ⓓ	181	ⓐ ⓑ ⓒ ⓓ
102	ⓐ ⓑ ⓒ ⓓ	122	ⓐ ⓑ ⓒ ⓓ	142	ⓐ ⓑ ⓒ ⓓ	162	ⓐ ⓑ ⓒ ⓓ	182	ⓐ ⓑ ⓒ ⓓ
103	ⓐ ⓑ ⓒ ⓓ	123	ⓐ ⓑ ⓒ ⓓ	143	ⓐ ⓑ ⓒ ⓓ	163	ⓐ ⓑ ⓒ ⓓ	183	ⓐ ⓑ ⓒ ⓓ
104	ⓐ ⓑ ⓒ ⓓ	124	ⓐ ⓑ ⓒ ⓓ	144	ⓐ ⓑ ⓒ ⓓ	164	ⓐ ⓑ ⓒ ⓓ	184	ⓐ ⓑ ⓒ ⓓ
105	ⓐ ⓑ ⓒ ⓓ	125	ⓐ ⓑ ⓒ ⓓ	145	ⓐ ⓑ ⓒ ⓓ	165	ⓐ ⓑ ⓒ ⓓ	185	ⓐ ⓑ ⓒ ⓓ
106	ⓐ ⓑ ⓒ ⓓ	126	ⓐ ⓑ ⓒ ⓓ	146	ⓐ ⓑ ⓒ ⓓ	166	ⓐ ⓑ ⓒ ⓓ	186	ⓐ ⓑ ⓒ ⓓ
107	ⓐ ⓑ ⓒ ⓓ	127	ⓐ ⓑ ⓒ ⓓ	147	ⓐ ⓑ ⓒ ⓓ	167	ⓐ ⓑ ⓒ ⓓ	187	ⓐ ⓑ ⓒ ⓓ
108	ⓐ ⓑ ⓒ ⓓ	128	ⓐ ⓑ ⓒ ⓓ	148	ⓐ ⓑ ⓒ ⓓ	168	ⓐ ⓑ ⓒ ⓓ	188	ⓐ ⓑ ⓒ ⓓ
109	ⓐ ⓑ ⓒ ⓓ	129	ⓐ ⓑ ⓒ ⓓ	149	ⓐ ⓑ ⓒ ⓓ	169	ⓐ ⓑ ⓒ ⓓ	189	ⓐ ⓑ ⓒ ⓓ
110	ⓐ ⓑ ⓒ ⓓ	130	ⓐ ⓑ ⓒ ⓓ	150	ⓐ ⓑ ⓒ ⓓ	170	ⓐ ⓑ ⓒ ⓓ	190	ⓐ ⓑ ⓒ ⓓ
111	ⓐ ⓑ ⓒ ⓓ	131	ⓐ ⓑ ⓒ ⓓ	151	ⓐ ⓑ ⓒ ⓓ	171	ⓐ ⓑ ⓒ ⓓ	191	ⓐ ⓑ ⓒ ⓓ
112	ⓐ ⓑ ⓒ ⓓ	132	ⓐ ⓑ ⓒ ⓓ	152	ⓐ ⓑ ⓒ ⓓ	172	ⓐ ⓑ ⓒ ⓓ	192	ⓐ ⓑ ⓒ ⓓ
113	ⓐ ⓑ ⓒ ⓓ	133	ⓐ ⓑ ⓒ ⓓ	153	ⓐ ⓑ ⓒ ⓓ	173	ⓐ ⓑ ⓒ ⓓ	193	ⓐ ⓑ ⓒ ⓓ
114	ⓐ ⓑ ⓒ ⓓ	134	ⓐ ⓑ ⓒ ⓓ	154	ⓐ ⓑ ⓒ ⓓ	174	ⓐ ⓑ ⓒ ⓓ	194	ⓐ ⓑ ⓒ ⓓ
115	ⓐ ⓑ ⓒ ⓓ	135	ⓐ ⓑ ⓒ ⓓ	155	ⓐ ⓑ ⓒ ⓓ	175	ⓐ ⓑ ⓒ ⓓ	195	ⓐ ⓑ ⓒ ⓓ
116	ⓐ ⓑ ⓒ ⓓ	136	ⓐ ⓑ ⓒ ⓓ	156	ⓐ ⓑ ⓒ ⓓ	176	ⓐ ⓑ ⓒ ⓓ	196	ⓐ ⓑ ⓒ ⓓ
117	ⓐ ⓑ ⓒ ⓓ	137	ⓐ ⓑ ⓒ ⓓ	157	ⓐ ⓑ ⓒ ⓓ	177	ⓐ ⓑ ⓒ ⓓ	197	ⓐ ⓑ ⓒ ⓓ
118	ⓐ ⓑ ⓒ ⓓ	138	ⓐ ⓑ ⓒ ⓓ	158	ⓐ ⓑ ⓒ ⓓ	178	ⓐ ⓑ ⓒ ⓓ	198	ⓐ ⓑ ⓒ ⓓ
119	ⓐ ⓑ ⓒ ⓓ	139	ⓐ ⓑ ⓒ ⓓ	159	ⓐ ⓑ ⓒ ⓓ	179	ⓐ ⓑ ⓒ ⓓ	199	ⓐ ⓑ ⓒ ⓓ
120	ⓐ ⓑ ⓒ ⓓ	140	ⓐ ⓑ ⓒ ⓓ	160	ⓐ ⓑ ⓒ ⓓ	180	ⓐ ⓑ ⓒ ⓓ	200	ⓐ ⓑ ⓒ ⓓ

ANSWER SHEET-RC

ACTUAL TEST

ANSWER SHEET-RC

ACTUAL TEST

지은이

NE능률 영어교육연구소

NE능률 영어교육연구소는 혁신적이며 효율적인 영어교재를 개발하고
영어 학습의 질을 한 단계 높이고자 노력하는 NE능률의 연구조직입니다.

토마토 토익 중급 RC

펴 낸 이	주민홍
펴 낸 곳	서울특별시 마포구 월드컵북로 396(상암동) 누리꿈스퀘어 비즈니스타워 10층
	(주)NE능률 (우편번호 03925)
펴 낸 날	2019년 5월 15일 초판 제1쇄
	2019년 10월 31일 제2쇄
전　　화	02 2014 7114
팩　　스	02 3142 0356
홈페이지	www.tomatoclass.com
등록번호	제1-68호
정　　가	17,000원
I S B N	979-11-253-2797-4

NE 능률

고객센터

교재 내용 문의 www.tomatoclass.com → 토마토교재 → 교재 Q&A
제품 구매, 교환, 불량, 반품 문의 (02-2014-7114)
☎ 전화 문의는 본사 업무 시간 중에만 가능합니다.

DAY 01 문장 구조

FINAL TEST
교재 19쪽

1. (B) 2. (C) 3. (A) 4. (C) 5. (A) 6. (C) 7. (B) 8. (C) 9. (D) 10. (D)
11. (D) 12. (C) 13. (A) 14. (A)

1.
From speaking to singing, presenters and performers can use this powerful microphone for any **occasion**.
(A) occasionally
(B) occasion
(C) occasional
(D) occasioned

어휘 | for any occasion 어떤 상황에서도

해석 | 발표자들과 공연가들은 연설부터 노래까지 어떤 상황에서든 이 강력한 마이크를 사용할 수 있다.
해설 | **전치사의 목적어 자리**
선택지를 보니 알맞은 품사를 고르는 문제이다. 전치사 for의 목적어 역할을 하면서 빈칸 앞 한정사 any의 수식을 받을 수 있는 것은 명사이다. 따라서 (B) occasion이 정답.

2.
Users must **accept** the terms and conditions of the Web site to sign up for a membership.
(A) accepted
(B) are accepting
(C) accept
(D) accepting

어휘 | accept (동의하여) 받아들이다 terms and conditions 조건 sign up for ~을 신청하다

해석 | 사용자들은 회원권을 신청하려면 웹사이트의 조건에 동의해야 한다.
해설 | **조동사 뒤 동사원형 자리**
동사 accept의 알맞은 형태를 고르는 문제이다. 빈칸 앞에 조동사 must가 있으므로 빈칸에는 동사원형이 와야 한다. 따라서 정답은 (C) accept.

3.
The camera was **faulty**, so the customer returned it to the store and asked for an exchange.
(A) faulty
(B) faults
(C) fault
(D) faultless

어휘 | return 반납하다, 돌려주다 ask for ~을 요청하다 exchange 교환

해석 | 카메라에 결함이 있어서, 고객은 매장에 그것을 반납하고 교환을 요구했다.
해설 | **주격 보어 자리**
빈칸은 be동사인 was 뒤에서 주어 The camera를 보충 설명하는 주격 보어 자리이다. 카메라의 교환을 요구하려면 문맥상 '결함이 있는'이란 상태의 의미가 자연스러우므로 형용사인 (A) faulty가 정답이다. 명사 (B)와 (C)는 '카메라 자체가 결함'이라는 동격의 의미가 되므로 오답이다.

4.
Economists **predict** that the rate of unemployment will decrease in the next quarter.
(A) predictably
(B) predicting
(C) predict
(D) predictable

어휘 | economist 경제학자 unemployment 실업 decrease 감소하다 quarter 분기

해석 | 경제학자들은 다음 분기에 실업률이 감소할 것이라고 예측한다.
해설 | **동사 자리**
빈칸은 주어 Economists의 동사 자리이다. 따라서 동사 자리에 올 수 없는 부사인 (A)와 동명사 또는 분사인 (B), 형용사인 (D)는 오답이고 동사 (C) predict가 정답이다.

5.
When you prepare for your hike, please **familiarize** yourself with the map of the mountain and surrounding areas.
(A) familiarize
(B) familiarizes
(C) familiarity
(D) familiarizing

어휘 | prepare for ~을 준비하다 surrounding area 인근 지역

해석 | 도보 여행을 준비하실 때, 산과 인근 지역의 지도에 익숙해지십시오.
해설 | **명령문의 동사원형 자리**
빈칸 앞에 please가 있고 빈칸 뒤에 목적어 역할을 하는 재귀대명사 yourself가 있는 것으로 보아 이 문장은 주어 없이 동사원형으로 시작하는 명령문임을 알 수 있다. 따라서 정답은 (A) familiarize. 참고로 familiarize *oneself* with는 '~에 익숙하게 하다'라는 의미로 자주 쓰인다.

6.

All candidates must wait in the hallway until the personnel manager **calls** them into the interview.

(A) calling
(B) to calling
(C) calls
(D) to call

어휘 | candidate 지원자, 후보자　personnel 인사부

해석 | 모든 지원자는 인사부장이 면접에 들어오라고 호명할 때까지 복도에서 기다려야 한다.

해설 | 접속사절의 동사 자리

접속사 until이 이끄는 접속사절에 동사가 없으므로 빈칸은 동사 자리이다. 따라서 정답은 (C) calls. 분사나 명사 형태인 (A)와 전치사구인 (B), to부정사인 (D)는 동사가 될 수 없으므로 오답.

7.

The fact that a majority of middle-class workers got a raise this year is an **indication** of the economy's recovery.

(A) indications
(B) indication
(C) indicates
(D) indicating

어휘 | a majority of 다수의　middle-class 중산층의　get a raise 급여가 오르다　indication 조짐　recovery 회복

해석 | 다수의 중산층 근로자들이 올해 급여 인상을 받았다는 사실은 경제 회복을 보여주는 조짐이다.

해설 | 주격 보어 자리

빈칸은 be동사 is의 보어 자리이면서 동시에 단수 명사 앞에 쓰이는 관사 an의 수식을 받을 수 있어야 하므로 (B) indication이 정답이다. 주어 The fact를 보충 설명해주며 주어와 동격 관계를 나타내는 주격 보어로 쓰였다.

8.

The **growth** of the automobile industry motivated many corporations to invest in car manufacturing plants.

(A) grow
(B) grown
(C) growth
(D) growingly

어휘 | motivate A to *do* A가 ~하도록 동기를 부여하다　corporation 기업　invest in ~에 투자하다　plant 공장

해석 | 자동차 산업의 성장은 다수의 기업들이 자동차 제조 공장에 투자하도록 동기를 부여했다.

해설 | 주어 자리

전치사구 of the automobile industry는 수식어구로 주어가 될 수 없으므로 빈칸은 주어 자리이다. 선택지 중 주어 자리에 올 수 있는 것은 명사인 growth뿐이므로 정답은 (C).

9.

A guide from A&C Travels will greet you at the airport and provide **directions** to the hotel.

(A) directs
(B) directly
(C) direct
(D) directions

어휘 | greet 맞다, 환영하다　provide 주다, 제공하다　directions 길 안내

해석 | 에이앤씨 여행사에서 나온 안내원이 공항에서 귀하를 맞이하고 호텔로 가는 길 안내를 해줄 것입니다.

해설 | 타동사의 목적어 자리

선택지를 보니 알맞은 품사를 고르는 문제로, 빈칸은 타동사 provide의 목적어 자리이다. 선택지 중에서 목적어 자리에 올 수 있는 것은 명사 directions뿐이므로 정답은 (D).

10.

Crown University's latest research shows that **there** are diverse endangered species living in the jungle of eastern Brazil.

(A) where
(B) it
(C) and
(D) there

어휘 | endangered 멸종 위기의　species (동식물의 그룹을 의미하는) 종

해석 | 크라운 대학의 최신 연구에 따르면, 브라질 동부의 정글에 다양한 멸종 위기의 종들이 살고 있다.

해설 | 〈there+be동사+주어〉 구문

빈칸 뒤에 be동사 are와 명사구 diverse endangered species를 보고 〈there+be동사+주어〉 구문임을 파악하면 문제를 쉽게 풀 수 있다. 정답은 (D) there. (B) it은 대명사로 주어 자리에 올 수 있으나 단수 주어로 복수 동사 are와 어울리지 않으므로 오답이다.

11.

Mr. Simmons finds hands-on marketing workshops very **informative** and tries to organize one every month.

(A) information
(B) informally
(C) informer
(D) informative

어휘 | hands-on 직접 해 보는　informative 유익한　organize 준비하다

해석 | 시몬스 씨는 직접 해 보는 마케팅 워크숍이 매우 유익하다고 생각해서 매달 워크숍을 준비하려고 노력한다.

해설 | 목적격 보어 자리

타동사 find는 〈find+목적어+목적격 보어〉의 구조를 취하는 5문형 동사이다. 빈칸 앞 hands-on marketing workshops가 목적어이고 빈칸이 목적격 보어 자리이므로 보어 자리에 올 수 없는 부사 (B) informally는 오답으로 제외. 문맥상 목적어의 상태를 나타내는 것이 자연스러우므로 형용사 (D) informative가 정답이다. 명사 (A) information과 (C) informer는 목적어와 동격 관계를 나타내므로 오답이다.

12.

Several older staff members were in **attendance** at the event even though the seminar was originally intended for new employees.

(A) absence　　　　　(B) evidence

(C) attendance　　　(D) objective

어휘 | be in attendance (at ~) (~에) 참석 중이다　originally 원래
be intended for ~을 대상으로 하다

해석 | 그 세미나는 원래 신입 사원들 대상임에도 불구하고 몇몇의 고참 직원들이 그 행사에 참석했다.

(A) 부재　　　　　(B) 증거

(C) 참석　　　　　(D) 목적

해설 | **명사 어휘 attendance**
접속사 even though는 '비록 ~이지만'이라는 뜻으로, 주절과 대조되는 내용을 이끈다. 따라서 '신입 사원 대상 세미나'라는 내용과 대조적으로 '고참 직원들이 참석했다'라는 말이 되어야 자연스러우므로 정답은 (C) attendance.

13.

The construction manager mentioned that **completion** of the new building would be delayed due to unforeseen circumstances.

(A) completion　　　(B) completed

(C) completely　　　(D) completes

어휘 | completion 완성　unforeseen 예기치 않은　circumstance 상황

해석 | 건설 현장 소장은 신축 건물의 완공이 예기치 않은 상황으로 인해 연기될 것 같다고 말했다.

해설 | **접속사절의 주어 자리**
빈칸 뒤의 of the new building은 수식어구로 동사 would be delayed의 주어가 될 수 없다. 따라서 빈칸은 that절의 주어 자리이므로 주어 자리에 올 수 있는 명사 (A) completion이 정답이다.

14.

It is one of Mr. Thompson's responsibilities **to review** department reports before the monthly meeting.

(A) to review　　　(B) reviewing

(C) is reviewing　　　(D) is to review

어휘 | responsibility 책무, 책임　monthly 매월의

해석 | 월례 회의 전에 부서 보고서를 검토하는 것이 톰슨 씨의 책무 중 하나이다.

해설 | **가주어 it과 진주어 to부정사**
문장의 형태를 보고 가주어 it을 이용한 구문임을 파악하는 것이 관건이다. to부정사구 주어가 긴 경우 가주어 it을 주어 자리에 쓰고 진주어가 되는 to부정사를 뒤에 쓴다. 따라서 빈칸에는 진주어가 될 수 있는 to부정사가 와야 하므로 정답은 (A) to review.

FINAL TEST

교재 27쪽

1. (C)	2. (B)	3. (A)	4. (A)	5. (D)	6. (C)	7. (C)	8. (B)	9. (B)	10. (A)
11. (B)	12. (A)	13. (B)	14. (C)	15. (C)	16. (D)	17. (A)	18. (A)	19. (C)	20. (D)
21. (B)	22. (A)								

1.

<u>Entries</u> to the Khartoum Film Festival must be submitted before the end of the month.

(A) Entered (B) Entrances
(C) Entries (D) To enter

어휘 | entry 출품작 film festival 영화제 submit 제출하다

해석 | 하르툼 영화제 출품작들은 이 달 말 전에 제출되어야 한다.

해설 | **명사의 역할_주어**
빈칸은 주어 자리로, 주어 역할을 할 수 있는 명사 (B)와 (C), to부정사 (D)가 정답 후보. 문맥상 '출품작들을 제출하는 것'이 자연스러우므로 정답은 (C) Entries. (B) Entrances는 '입구'를 의미하므로 문맥상 어색하고 to부정사 (D) To enter는 뒤에 전치사 없이 목적어를 바로 취하며 '들어가는 것'이란 의미로 문맥상으로도 어색하므로 오답이다.

2.

Dr. Watson's **enthusiasm** helps him overcome challenges that everyone in the medical field faces each day.

(A) enthuse **(B) enthusiasm**
(C) enthusiastic (D) enthusiastically

어휘 | enthusiasm 열정 overcome 극복하다 challenge 어려움, 도전 field 분야 face 직면하다; 얼굴

해석 | 왓슨 박사의 열정은 그가 의학 분야의 모든 사람들이 매일 직면하는 어려움을 극복하도록 도와주었다.

해설 | **명사 자리_소유격＋명사**
빈칸은 소유격 Dr. Watson's의 수식을 받는 동시에 문장의 주어 역할을 해야 하므로 명사 자리이다. 선택지에서 명사는 enthusiasm뿐이므로 정답은 (B). 명사 앞에는 한정사나 형용사가 와서 명사를 수식한다는 것을 기억해 두자.

3.

The retailer offered the customer a voucher as <u>compensation</u> for the late delivery.

(A) compensation (B) compensated
(C) compensates (D) compensatory

어휘 | retailer 소매업체 offer 제공하다 voucher 할인권, 쿠폰 compensation 보상

해석 | 그 소매업체는 배송 지연에 대한 보상으로 고객에게 할인권을 제공했다.

해설 | **명사의 역할_전치사의 목적어**
빈칸은 전치사 as의 목적어이면서 전치사구 for the late delivery의 수식을 받는 명사 자리이므로 명사인 (A) compensation이 정답.

4.

If you have any questions about your itinerary, please contact Ms. Palafox for **assistance**.

(A) assistance (B) assists
(C) assistant (D) assisted

어휘 | itinerary 여행 일정표 contact 연락하다

해석 | 여행 일정표에 대해 질문이 있으시면 팔라폭스 씨에게 연락하여 도움을 받으세요.

해설 | **사람명사 vs. 사물/추상명사**
빈칸은 전치사 for의 목적어 자리이므로 명사 (A)와 (C)가 정답 후보. 문맥상 '담당자에게 연락하여 도움을 받으라'는 의미가 자연스러우므로 '도움, 원조'라는 의미의 (A) assistance가 정답. (C) assistant는 '조수, 보조원'이라는 뜻으로 문맥에 맞지 않아 오답이다.

5.

As part of the expansion plan, administration will order additional office **equipment** next month.

(A) equip (B) equipped
(C) to eqiup **(D) equipment**

어휘 | expansion plan 확장 계획 administration 관리부 additional 추가의

해석 | 확장 계획의 일부로, 관리부에서 다음 달에 사무기기를 추가로 주문할 것이다.

해설 | **복합명사**
빈칸은 동사 will order의 목적어 자리로, 형용사 additional의 수식을 받으며 빈칸 앞의 office와 어울려 '사무기기, 사무용품'이라는 뜻의 복합명사를 만드는 명사가 와야한다. 따라서 정답은 (D). office equipment를 하나의 덩어리로 외워두자.

5

6.

The clients have given their **consent** to change the color of their living room walls.

(A) consented (B) consents

(C) consent (D) consenting

어휘 | client 고객, 의뢰인 give one's consent 승낙하다

해석 | 고객들은 그들의 거실 벽 색상을 변경하는 것을 승낙했다.

해설 | **가산명사 vs. 불가산명사**

빈칸은 소유격 대명사 their의 수식을 받으므로 명사가 들어가야 한다. 따라서 명사 형태인 (B)와 (C)가 정답 후보인데, consent는 불가산명사로 복수형이 존재하지 않는다. 따라서 정답은 (C).

7.

To replace the printer's ink cartridge properly, please follow the detailed **instructions** in the user guide.

(A) instructors (B) instructional

(C) instructions (D) instructs

어휘 | replace 교체하다 properly 제대로, 적절히
detailed 자세한, 상세한 user guide 사용 설명서

해석 | 프린터의 잉크 카트리지를 제대로 교체하기 위해서, 사용 설명서에 있는 자세한 지시 사항을 따라하십시오.

해설 | **사람명사 vs. 사물/추상명사**

빈칸은 앞에서 형용사 detailed의 수식을, 뒤에서 전치사구 in the user guide의 수식을 받는 명사 자리이다. 따라서 (A) instructors (강사)와, (C) instructions(지시 사항)가 정답 후보. 문맥상 '설명서에 있는 지시 사항을 따르라'는 것이 자연스러우므로 정답은 (C).

8.

Please be reminded that the awards **ceremony** for the Young Entrepreneurs of the Year is on Friday at 7 P.M.

(A) winner **(B) ceremony**

(C) selection (D) presenter

어휘 | remind 기억나게 하다 entrepreneur 기업가, 사업가

해석 | 올해의 젊은 기업가 시상식이 금요일 저녁 7시에 있다는 것을 기억하십시오.

(A) 우승자 (B) 의식

(C) 선택 (D) 진행자

해설 | **명사 어휘 ceremony**

명사 awards와 함께 어울리며 문맥에 적절한 명사 어휘를 찾는 문제. awards ceremony는 복합명사로 하나의 명사처럼 쓰여 '시상식'을 의미한다. 따라서 정답은 (B).

9.

Davis Inc. decided to stop manufacturing printers, as **these** products are the company's worst-selling items.

(A) theirs **(B) these**

(C) them (D) this

어휘 | decide to do ~하기로 결정하다 manufacture 생산하다

해석 | 데이비스 주식회사는 프린터 생산을 중단하기로 결정했는데, 그 이유는 이 제품들이 회사에서 제일 안 팔리는 품목이기 때문이다.

해설 | **한정사_지시형용사**

빈칸은 명사 products를 수식하는 한정사 자리로 명사를 수식할 수 있는 지시형용사 (B) these와 (D) this가 정답 후보. 수식을 받는 명사가 가산명사의 복수형이므로 (B)가 정답이다. 소유대명사 (A) theirs와 목적격 인칭대명사 (C) them은 명사를 수식할 수 없으므로 오답이다.

10.

Employees must apply for travel **reimbursement** at the finance department immediately after they return from any business trip.

(A) reimbursement (B) reimburse

(C) reimbursing (D) reimbursed

어휘 | apply for ~을 신청하다 immediately after ~ 직후에

해석 | 직원들은 모든 출장에서 돌아온 직후에 재무부에 출장비 환급을 신청해야 한다.

해설 | **복합명사**

선택지에 reimburse의 다양한 파생어들이 있는 것으로 보아 알맞은 품사를 선택해야 하는 문제임을 알 수 있다. 빈칸은 앞의 travel과 어울리면서 전치사 for의 목적어 역할을 해야 한다. 문맥상으로도 '출장비 환급'이라는 의미인 복합명사 travel reimbursement가 적절하므로 정답은 명사 (A).

11.

The executive chef suggested acquiring cooking ingredients and other **necessities** from local shops to save on costs.

(A) necessity **(B) necessities**

(C) necessitating (D) necessitated

어휘 | executive chef 총주방장 acquire 얻다, 획득하다
necessity 필수품 save on ~을 아끼다, 절약하다

해석 | 총주방장은 비용을 아끼기 위해 현지 상점에서 요리 재료와 기타 필수품들을 구입하자고 제안했다.

해설 | **한정사와 명사의 수일치**

빈칸은 앞의 한정사 other의 수식을 받으며 뒤의 from이 이끄는 전치사구의 수식을 받는 명사 자리이다. 따라서 명사인 (A)와 (B)가 정답 후보. 빈칸 앞에 복수 명사 또는 불가산명사를 수식하는 other가 있으므로 빈칸에는 가산명사인 necessity의 복수형이 와야 한다. 따라서 정답은 (B) necessities.

12.

The chief safety officer visited the factory to discuss the scheduled **inspections** of machinery.

(A) inspections (B) inspector

(C) inspects (D) inspect

어휘 | schedule 예정하다 machinery 기계(류)

해석 | 안전 담당 책임자는 예정된 기계 점검에 대해서 논의하기 위해 공장에 방문했다.

해설 | 사람명사 vs. 사물/추상명사

빈칸은 형용사 scheduled의 수식을 받는 자리이므로 명사인 (A) 와 (B)가 정답이 될 수 있다. 문맥상 '예정될' 수 있는 것은 사람명사 inspector(조사관)가 아닌 추상명사 inspection(점검)이므로 정답은 (A).

13.

All marketing managers need to **attend** several trade shows a year to expand their client base.

(A) examine (B) attend

(C) consider (D) participate

어휘 | manager 관리자 trade show 무역 박람회 expand 확장시키다

해석 | 모든 마케팅 관리자들은 그들의 고객층을 확장시키기 위해 일 년에 몇 개의 무역 박람회에 참석해야 한다.

(A) 검토하다 (B) 참석하다

(C) 고려하다 (D) 참가하다

해설 | 동사 어휘 attend

문맥상 trade show와 가장 잘 어울리는 동사는 회의나 행사 등에 '참석하다'는 뜻의 attend이므로 정답은 (B). (D) 또한 '참가하다'라는 의미이지만, 전치사 in과 함께 participate in(~에 참가하다)의 형태로 쓰여야 하므로 오답.

14.

You may hire a licensed broker to assess the value of your **residence** so that it may be sold at the best price.

(A) reside (B) resident

(C) residence (D) residential

어휘 | hire 고용하다 licensed 자격증이 있는 broker 중개인; 중개하다 assess 평가하다, 재다

해석 | 주택이 가장 좋은 가격에 팔릴 수 있도록 자격증이 있는 중개인을 고용해서 당신의 주택 가치를 평가하게 할 수 있다.

해설 | 사람명사 vs. 사물/추상명사

빈칸은 소유격 대명사 your의 수식을 받는 명사 자리. 따라서 명사인 (B) resident(거주자)와 (C) residence(주택)가 정답 후보인데, 문맥상 '주택'의 가치를 평가하기 위해 사람을 고용하는 것이 적절하므로 정답은 (C).

[15-18] 공지

Glam.com Refund Policy

Starting August 1, Glam.com will **15 issue** refunds within seven days of receiving notification instead of fourteen days. This change is in response to a request raised by many shoppers in our last customer service survey. **16 According to the results, most shoppers are happy with our ordering system.** However, they found our refund process to be too long. To provide customers with a convenient shopping **17 experience**, our management team has decided to shorten the refund process. If you request a refund after making a **18 purchase** on our Web site, it will now be handled within a week. For further information, please contact our customer service center.

Christine Tirumala
Customer Relations Director
Glam.com

글램닷컴 사 환불 정책

8월 1일부터, 글램닷컴 사는 통고를 받은 후 14일이 아닌 일주일 이내에 환불을 **15 해** 드립니다. 이 변화는 가장 최근의 고객 서비스 설문조사에서 여러 쇼핑객들에 의해 제기된 요청에 응한 것입니다.

16 결과에 따르면, 대부분의 쇼핑객들은 저희의 주문 시스템에 만족하십니다. 하지만, 환불 과정이 너무 길다고 생각하셨습니다. 고객에게 편리한 쇼핑 **17 경험을** 제공하기 위해 저희 경영팀은 환불 과정을 짧게 줄이기로 결정했습니다. 저희 웹사이트에서 **18 구매**하신 후에 환불을 요청하시면, 이제 일주일 이내에 처리될 것입니다. 자세한 정보는 저희 고객 서비스 센터에 문의 주시기 바랍니다.

글램닷컴 사
고객 관리 책임자
크리스틴 티루말라 드림

어휘 | notification 통고, 통지 in response to ~에 응하여 process 과정, 처리 provide A with B A에게 B를 제공하다 shorten 단축하다 handle 처리하다

15.
(A) issues
(B) to issue
(C) issue
(D) issuing

해설 | 조동사 뒤 동사원형 자리
빈칸 앞에 조동사 will이 있으므로 빈칸에는 동사원형이 들어가야 한다. 따라서 정답은 (C) issue. issue refunds는 '환불해주다'라는 의미의 표현으로 한 단어처럼 종종 쓰이므로 알아두자.

16.
(A) The survey was conducted to rate our summer fashion collection.
(B) We are planning to offer a wider selection of products.
(C) Based on their feedback, our Web site is not user-friendly.
(D) According to the results, most shoppers are happy with our ordering system.

해석 |
(A) 저희의 여름 패션 컬렉션을 평가하기 위해 설문 조사가 시행되었습니다.
(B) 저희는 다양한 제품을 제공할 예정입니다.
(C) 그들의 피드백에 근거했을 때, 저희 웹사이트는 사용자 친화적이지 않습니다.
(D) 결과에 따르면, 대부분의 쇼핑객들은 저희의 주문 시스템에 만족하십니다.

해설 | 알맞은 문장 고르기
문맥에 알맞은 문장을 고르는 문제는 빈칸 주변의 내용과 연결어를 잘 파악해야 한다. 빈칸 앞에 고객 서비스 설문 조사가 언급되어 있고 빈칸 다음에 대조를 나타내는 연결어 however를 이용하여 환불 과정이 너무 길다는 부정적인 내용이 나온다. 따라서 빈칸에는 이와 대조되는 설문 조사의 긍정적인 결과가 들어가야 하므로 대다수의 고객이 만족한다는 내용인 (D)가 정답.

17.
(A) experience
(B) permission
(C) familiarity
(D) behavior

해석 | (A) 경험 (B) 허가
 (C) 익숙함 (D) 행동

해설 | 명사 어휘 experience
문맥에 알맞은 명사 어휘를 고르는 문제이다. 문맥상 '편리한 쇼핑 경험을 제공하다'란 의미가 자연스러우므로 정답은 (A) experience.

18.
(A) purchase
(B) purchases
(C) purchased
(D) purchasing

해설 | 한정사와 명사의 수일치
빈칸은 동명사 making의 목적어 자리이므로 명사인 (A)와 (B)가 정답 후보. 부정관사 a와 함께 쓰일 수 있는 것은 가산명사의 단수형이므로 정답은 (A) purchase. make a purchase는 '구매하다'라는 뜻으로 한 단어처럼 자주 쓰이므로 알아두자.

[19-22] 편지

December 2

Roger Williams
Lancelot Boutique Hotel
829 Old Dear Lane
New York, NY 10005

Dear Mr. Williams,

Thank you for writing to express your interest in our company's services. Walters has been a leading **19** <u>distributor</u> of cleaning products in New York for over a decade. In addition to selling our goods at retail stores, we supply products directly to hospitals, major restaurants, and shopping centers. To continue being a successful organization, we **20** <u>expanded</u> our business last year by offering cleaning services to corporate clients.

12월 2일

로저 윌리엄스
랜슬롯 부티크 호텔
올드 디어 가 829번지
뉴욕 시, 뉴욕 주 10005

윌리엄스 씨께,

저희 회사의 서비스에 관심을 보여주셔서 감사합니다. 월터스 사는 10년 넘게 뉴욕의 청소 용품 선두 **19** 판매 업체였습니다. 소매점에 물품을 판매할 뿐 아니라 저희는 병원, 주요 음식점, 그리고 쇼핑 센터에 용품을 직접 공급합니다. 계속해서 성공적인 기업이 되기 위해, 저희는 작년에 기업 고객에게 청소 서비스를 제공하면서 사업을 **20** 확장하였습니다.

While we are relatively new to this field, we are
[21] confident that we can provide high-quality services. We offer professional window washing, carpet vacuuming, and floor polishing to hotels like yours. [22] We can also meet any special needs you may have.
For details on these services, please call 555-1011. Thank you.

Sincerely,

Shannon Cole
Client Representative, Walters

이 분야에서는 비교적 새로운 편이지만, 저희가 양질의 서비스를 제공할 수 있음을 [21] 확신합니다. 귀사와 같은 호텔에 전문적인 창문 청소, 카펫 청소, 그리고 바닥 광택 서비스를 제공합니다. [22] 귀사의 특별 요청 또한 충족시킬 수 있습니다.

이 서비스들의 세부 사항에 대해서는 555-1011로 전화 주시기 바랍니다. 감사합니다.

월터스 사 고객 담당자
섀넌 콜 드림

어휘 | express 나타내다, 표현하다 leading 선두의 decade 10년 in addition to ~일 뿐 아니라 supply 제공하다 successful 성공적인 corporate 기업의 relatively 비교적 vacuum 진공청소기로 청소하다 polish 광을 내다

19. (A) distribute
(B) distribution
(C) distributor
(D) distributing

해설 | 사람명사 vs. 사물/추상명사
빈칸은 앞의 형용사 leading과 뒤의 전치사구 of cleaning products부터 a decade까지의 수식을 받는 명사 자리로 (B)와 (C)가 정답 후보. 문맥상 '선두 판매 업체'라는 것이 자연스럽고 '선두 분배'라는 말은 어색하므로 '판매 업체'라는 의미로 쓰이는 (C) distributor가 정답이다.

20. (A) accepted
(B) arrived
(C) conducted
(D) expanded

해석 | (A) 받아들이다 (B) 도착하다
(C) 시행하다 (D) 확장하다
해설 | 동사 어휘 expand
빈칸 앞에서 회사의 제품 판매 사업에 대해 나열한 후, 기업 고객들에게 청소 서비스도 제공한다고 하였으므로, 문맥상 '사업을 확장했다'라는 의미가 가장 적절하다. 따라서 정답은 (D).

21. (A) confidence
(B) confident
(C) confidently
(D) confidences

해설 | 주격 보어 자리
빈칸은 be동사 are의 보어 자리이다. 보어 자리에는 명사인 (A)와 (D), 형용사인 (B)가 올 수 있는데, 문맥상 주어인 we가 '확신하는'이란 상태의 의미가 되어야 알맞으므로 형용사인 (B) confident가 정답이다. 명사 (A)와 (D)는 '우리가 확신'이라는 동격의 의미가 되므로 오답이다.

22. **(A) We can also meet any special needs you may have.**
(B) We have recently opened a new branch in another city.
(C) However, our services are also available on weekends.
(D) Thank you for being a loyal patron of Walters cleaning.

해석 | (A) 귀사의 특별 요청 또한 충족시킬 수 있습니다.
(B) 최근에 다른 도시에 새로운 지점을 열었습니다.
(C) 하지만, 저희 서비스는 주말에도 이용 가능합니다.
(D) 월터스 사의 단골 고객이 되어주셔서 감사합니다.

해설 | 알맞은 문장 고르기
빈칸 앞에 업체가 제공하는 청소 서비스의 종류를 나열하고 있고 빈칸 뒤에 이 서비스들의 세부 사항이라고 언급된 것으로 보아 빈칸에는 청소 서비스와 관련된 내용이 나와야 한다. 앞서 나열된 서비스 외에, 고객의 특별 요청도 충족시킬 수도 있다고 하며 제공 가능한 서비스를 추가하는 내용이 들어가야 자연스럽다. 따라서 정답은 (A). 편지를 받는 사람이 아직 충성 고객은 아니므로 (D)는 오답이다.

FINAL TEST

교재 37쪽

1. (B)	2. (B)	3. (B)	4. (D)	5. (A)	6. (A)	7. (A)	8. (C)	9. (A)	10. (B)
11. (B)	12. (D)	13. (C)	14. (C)						

1.

During the training, the manager reminded all of the supervisors to update **their** progress charts every week.

(A) they (B) their
(C) themselves (D) them

어휘 | training 교육, 연수 remind A to *do* A가 ~하도록 상기시키다
supervisor 감독관 update 가장 최근의 정보를 알리다

해석 | 교육 중에, 관리자는 모든 감독관들에게 그들의 진척도 관리 차트를 매주 보고할 것을 상기시켰다.

해설 | 인칭대명사_소유격
선택지를 보고 인칭대명사의 알맞은 격을 고르는 문제임을 알 수 있다. 빈칸은 to update의 목적어인 progress charts를 수식해 주는 한정사 자리로, 선택지 중 한정사로 쓰일 수 있는 것은 소유격뿐이다. 따라서 정답은 (B) their. 빈칸 뒤 명사 progress를 동사로 오인하고 주격 (A) they를 정답으로 고르지 않도록 유의하자.

2.

We are out of stock of Decibel headphones as the last **one** on the shelf was sold yesterday.

(A) that (B) one
(C) other (D) another

어휘 | out of stock 재고가 없는 shelf 선반

해석 | 어제 선반에 있던 마지막 하나가 팔렸기 때문에 저희는 데시벨 헤드폰 재고가 없습니다.

해설 | 부정대명사
as가 이끄는 절에 동사 was sold의 주어가 없으므로 빈칸은 주어 자리이다. 따라서 한정사인 (C) other는 오답이고, 대명사인 (A), (B), (D)가 정답 후보이다. 정관사 the의 수식을 받으면서 앞의 Decibel headphones 중 하나를 가리킬 수 있는 대명사는 one밖에 없으므로 정답은 (B). 지시대명사 that이 지칭할 수 있는 단수 명사가 앞에 없으므로 (A)는 오답. 부정대명사 (D) another는 정관사 the와 함께 쓸 수 없으므로 오답이다.

3.

Most motorists avoid the Abenson Boulevard after office hours to keep **themselves** from getting caught in heavy traffic.

(A) yourselves (B) themselves
(C) itself (D) ourselves

어휘 | avoid 피하다 keep A from *doing* A가 ~하는 것을 막다
heavy traffic 교통 체증

해석 | 대부분의 운전자들은 교통 체증에 갇히는 것을 피하기 위해 근무 시간 이후에는 아벤슨 도로를 피해간다.

해설 | 재귀대명사_재귀용법
빈칸은 to부정사 to keep의 목적어 자리인데, 빈칸과 주어 Most motorists가 같은 대상을 가리키므로 재귀용법으로 쓰인 재귀대명사가 와야 한다. 재귀대명사는 주어와 인칭 및 수를 일치시켜야 하므로 (B) themselves가 정답이다.

4.

A security officer checked the passports and boarding passes of **everyone** in line at the boarding gate.

(A) another (B) his own
(C) other (D) everyone

어휘 | security officer 보안 요원 boarding pass 탑승권 boarding gate 탑승구

해석 | 보안 요원이 탑승구에서 줄을 서 있는 모든 사람의 여권과 탑승권을 확인했다.

해설 | 부정대명사
빈칸은 전치사 of의 목적어 자리이므로 명사를 수식하는 한정사 역할을 하는 (C) other는 오답. 문맥상 '줄을 서 있는 모든 사람의 여권과 탑승권'이라고 하는 것이 자연스러우므로 정답은 (D). 사람을 대신하는 경우에 some, any, every에 -one, -body를, 사물을 대신하는 경우는 -thing을 붙여 부정대명사를 만들기도 한다는 것을 알아두자.

5.

Theater enthusiasts may buy the complete soundtrack of the musical *Evergreen* at **any** Beats & Lyrics outlet.

(A) any (B) much
(C) many (D) all

어휘 | enthusiast 열광적인 팬 complete 완전한 outlet 전문 매장

해석 | 연극 열성팬들은 어느 비츠 앤 리릭스 매장에서라도 뮤지컬 〈에버그린〉의 완전한 사운드트랙을 구입할 수 있다.

해설 | 부정형용사
선택지 중 빈칸 뒤의 단수 가산명사(Beats & Lyrics outlet)와 어울릴 수 있는 것은 (A)뿐이다. any는 뒤에 가산명사 단수, 복수와 불가산명사가 모두 올 수 있다. much는 불가산명사와 어울리고 many와 all은 가산명사 복수와 어울리므로 (B), (C), (D) 모두 오답.

6.

According to the Labor Department's survey, **those** who work from home are mostly married women with young children.

(A) those (B) that

(C) ours (D) theirs

어휘 | survey (설문) 조사 mostly 주로 married 기혼의

해석 | 노동부의 조사에 따르면, 재택근무를 하는 사람들은 주로 어린 자녀가 있는 기혼 여성이다.

해설 | those who

빈칸 뒤 who부터 home까지는 앞의 빈칸을 수식하는 관계대명사절이다. 이 관계대명사절의 수식을 받으면서 복수 동사 are와 함께 쓰일 수 있는 것은 지시대명사 those이다. those who는 '~하는 사람들'이란 의미로 쓰이는데 문맥상으로도 '재택근무를 하는 사람들'이란 의미가 적절하므로 정답은 (A).

7.

The Chamber of Commerce hosts monthly gatherings to give an opportunity for members to get to know **one another**.

(A) one another (B) another

(C) other (D) anybody

어휘 | host (행사를) 주최하다 gathering 모임 opportunity 기회 get to know 알게 되다

해석 | 상공회의소는 회원들이 서로 알 수 있는 기회를 주기 위해 매달 모임을 주최한다.

해설 | 부정대명사

빈칸은 to부정사 to know의 목적어로 쓰이면서 문맥상 '서로 알 수 있는 기회'란 의미가 되어야 하므로 정답은 (A). one another와 each other는 '서로'란 뜻의 대명사로 주로 목적어로 쓰인다는 것을 함께 기억해 두자.

8.

Mr. Stevens has turned in his vacation request form to the human resources office, but Ms. Clark has yet to fill out **hers**.

(A) herself (B) she

(C) hers (D) her

어휘 | turn in 제출하다 request form 신청서 fill out 작성하다, 기입하다

해석 | 스티븐스 씨는 자신의 휴가 신청서를 인사부에 제출했지만, 클락 씨는 아직 자신의 것을 작성하지 않았다.

해설 | 소유대명사

문맥상 '클락 씨는 아직 휴가 신청서를 작성하지 않았다'는 의미가 되어야 하므로, 빈칸에는 her vacation request form을 대신하는 소유대명사 hers가 와야 한다. 따라서 정답은 (C).

9.

No one is allowed to stay in the physics laboratory beyond office hours except authorized engineers.

(A) No one (B) Each other

(C) Someone (D) Others

어휘 | be allowed to do ~하는 것이 허용되다 laboratory 실험실 beyond (특정한 시간) 이후 authorize 권한을 부여하다

해석 | 권한을 부여받은 기술자들을 제외하고 아무도 근무 시간 이후에 물리 실험실에 머물러서는 안 된다.

해설 | 부정대명사

선택지가 모두 부정대명사이므로 문맥을 통해 정답을 선택해야 한다. '아무도 허용되지 않는다'라는 의미가 되어야 하므로, '아무도 ~ 않다'는 뜻의 no one이 적절하다. 따라서 정답은 (A). (B) Each other는 주어 자리에 올 수 없으므로 오답이다. (C) Someone은 전치사구 except authorized engineers의 수식을 받을 수 없으므로 오답이다. (D) Others는 단수 동사 is와 수일치가 되지 않아 오답이다.

10.

Because of our advanced equipment, several museums contact **us** to request assistance with moving delicate sculptures.

(A) we (B) us

(C) ours (D) ourselves

어휘 | advanced 첨단의 delicate 깨지기 쉬운 sculpture 조각품

해석 | 우리의 첨단 장비 때문에, 몇몇 박물관들이 깨지기 쉬운 조각품을 옮기는 도움을 요청하기 위해 우리에게 연락한다.

해설 | 인칭대명사_목적격

빈칸은 타동사 contact의 목적어 자리로, 문맥상 '우리에게 연락한다'는 내용이 되어야 한다. 따라서 목적격 인칭대명사 (B) us가 정답이다. (D) ourselves도 목적어로 쓰일 수 있지만 재귀대명사는 주어와 목적어가 동일한 경우에 사용하므로 오답이다.

11.

To encourage more people to come to the fundraiser, the host entered **each** of the guests in a raffle for a trip to Europe.

(A) every (B) each

(C) someone (D) others

어휘 | encourage A to do A가 ~하도록 격려하다 fundraiser 모금 행사 enter (대회 등에) 참가시키다 raffle 추첨

해석 | 더 많은 사람들이 모금 행사에 오도록 격려하기 위해 주최측은 각각의 손님을 유럽 여행권을 받을 수 있는 추첨에 참가시켰다.

해설 | 부정대명사 vs. 형용사

빈칸은 동사 entered의 목적어이면서 뒤에서 of가 이끄는 전치사구의 수식을 받을 수 있어야 한다. 선택지 중에서 이 두 가지를 동시에 할 수 있는 것은 대명사 each뿐이므로 정답은 (B). (A) every는 each와 달리 대명사로 쓰이지 않으므로 오답. 정해지지 않은 막연한 대상을 가리키는 부정대명사 (C) someone과 (D) others는 소속을 나타내는 of가 이끄는 전치사구의 수식을 받을 수 없으므로 오답이다.

12.

Almost all of the delegates are coming from overseas, but there are a few local representatives as well.

(A) Most (B) Much

(C) Any **(D) Almost**

어휘 | delegate 대표 overseas 해외에 representative 대표 as well 또한

해석 | 거의 모든 대표들은 해외에서 왔지만 지역 대표들 또한 조금 있었다.

해설 | **부정대명사 vs. 부사**

빈칸 뒤의 형용사 all을 수식하며 문맥상 '거의 모든'이란 의미로 쓰일 수 있는 것은 부사인 Almost이다. 따라서 정답은 (D). (A), (B), (C)는 모두 부분이나 수량을 나타내는 부정대명사로 all을 수식할 수 없으므로 오답이다.

13.

Since the secretary was sick for a week, Mr. Clements had to prepare the documents for the client meetings **himself**.

(A) he (B) his

(C) himself (D) his own

어휘 | secretary 비서 prepare 준비하다 document 서류 client 고객

해석 | 비서가 일주일 동안 아팠기 때문에, 클레멘츠 씨는 스스로 고객 미팅을 위한 서류를 준비해야만 했다.

해설 | **재귀대명사_강조용법**

빈칸 앞이 〈주어＋동사＋목적어〉로 이루어진 완전한 문장이므로 빈칸을 생략해도 문장이 성립된다. 따라서 빈칸에는 생략 가능한 강조용법으로 쓰인 재귀대명사가 적절하므로 정답은 (C) himself.

14.

Before ordering vaccines, the doctors must determine the amount of supplies that **they** need for the estimated number of patients.

(A) their (B) them

(C) they (D) themselves

어휘 | determine 결정하다 amount 양 estimated number 예상수 patient 환자

해석 | 백신을 주문하기 전에, 의사들은 환자 예상수에 맞춰 필요한 물품의 양을 정해야만 한다.

해설 | **인칭대명사_주격**

선택지를 보니 인칭대명사의 알맞은 격을 고르는 문제. 빈칸은 관계대명사 that이 이끄는 절의 동사 need 앞 주어 자리이므로 주격 인칭대명사 (C) they가 정답이다. need를 명사로 보고 명사와 함께 쓰이는 소유격 (A) their를 답으로 고르지 않도록 주의해야 한다.

FINAL TEST

1. (B)	2. (A)	3. (D)	4. (B)	5. (B)	6. (A)	7. (A)	8. (C)	9. (B)	10. (D)
11. (B)	12. (B)	13. (A)	14. (D)	15. (B)	16. (A)	17. (A)	18. (C)	19. (D)	20. (A)
21. (B)	22. (D)								

1.

The new security measure **restricts** visitors from entering the building without showing an identification card.

(A) restrict　　　　(B) restricts
(C) restrictive　　(D) restriction

어휘 | security measure 보안 조치　restrict A from *doing* A가 ~하지 못하게 하다　identification card 신분증

해석 | 새로운 보안 조치로 방문객들은 신분증을 보여주지 않고는 건물에 들어가지 못한다.

해설 | 단수 주어 + 단수 동사
문장내 동사가 없는 것으로 보아 빈칸은 동사 자리이므로 동사 형태인 (A) restrict와 (B) restricts가 정답 후보이다. 주어 The new security measure가 단수이므로 수일치하여 단수 동사인 (B)가 정답.

2.

Reports of Berry Field's financial problems were strongly denied by the food company's management.

(A) Reports　　(B) Reporting
(C) Reported　　(D) Report

어휘 | report 보도, 보고서　financial 재정의, 금융의　strongly 강하게 deny 부인하다, 부정하다　management 경영진

해석 | 베리 필드 사의 재정 문제 보도는 그 식품 업체의 경영진에 의해 강력히 부인되었다.

해설 | 긴 주어의 수일치
동사 were strongly denied 앞의 of부터 problems까지는 주어가 될 수 없는 수식어구이다. 따라서 빈칸은 주어 자리인데, 동사가 복수 형태이므로 수일치하여 복수 명사인 (A) Reports가 정답.

3.

In the downtown area, each of the establishments **conforms** to business regulations set by the city government.

(A) conformist　　(B) conforming
(C) conform　　　**(D) conforms**

어휘 | downtown 도심　establishment 시설　conform 따르다 regulation 규정

해석 | 도심 지역에서, 각각의 시설은 시 정부가 지정한 사업 규정을 따른다.

해설 | 항상 단수 취급하는 표현
문장의 주어로 쓰인 〈each + of + the + 가산명사의 복수형〉 표현은 항상 단수로 취급하여 단수 동사가 함께 와야 하므로 정답은 (D) conforms. 빈칸 바로 앞의 가산명사의 복수형 establishments만 보고 복수 동사 (C) conform을 정답으로 고르지 않도록 주의하자.

4.

Even though **most** of the desks are not currently in stock, all types will be available next week.

(A) every　　　　**(B) most**
(C) either　　　　(D) neither

어휘 | currently 현재, 지금　be in stock 재고가 있다 available 구할 수 있는, 이용할 수 있는

해석 | 현재 책상 대부분의 재고가 없지만, 다음 주에는 모든 종류가 구입 가능할 것이다.

해설 | 수량 표현의 수일치
접속사 Even though가 이끄는 절에서 동사는 are이고 빈칸은 주어 자리이다. 선택지 중에서 복수 동사 are와 수일치하는 대명사는 most뿐이므로 정답은 (B). (A) every는 한정사로 주어 역할을 할 수 없으므로 오답. (C) either와 (D) neither는 〈of + the + 명사〉의 수식을 받을 때 항상 단수 취급하는 표현으로, 단수 동사가 함께 와야 하므로 오답이다.

5.

Some nurses at the hospital **work** longer hours nowadays due to the large number of patients.

(A) works　　　　**(B) work**
(C) workers　　　(D) working

어휘 | nowadays 요즘　due to ~ 때문에　patient 환자

해석 | 병원에서 일하는 몇몇 간호사들은 요즘 많은 환자들 때문에 더 오랜 시간 근무한다.

해설 | 복수 주어 + 복수 동사
주어와 동사 사이에 전치사구가 삽입되어 있는 문장으로, 빈칸은 동사 자리이다. 주어 nurses가 복수 명사이므로 수일치하여 복수 동사인 (B) work가 정답. 빈칸 바로 앞의 hospital을 보고 단수 동사 (A) works를 답으로 선택하는 함정에 빠지지 않도록 주의하자.

13

6.

Neither the hotel Web site nor the brochures **mention** any complimentary services to regular guests.

(A) mention (B) to mention
(C) mentions (D) mentioning

어휘 | complimentary 무료의 regular guest 단골 고객

해석 | 호텔 웹사이트와 책자들 모두 단골 고객에 대한 어떠한 무료 서비스도 언급하지 않았다.

해설 | **상관접속사의 수일치**
상관접속사 neither A nor B가 사용된 문장으로, 빈칸은 동사 자리이다. neither A nor B는 뒤쪽에 있는 명사의 수에 동사를 일치시켜야 하는데, brochures가 복수 명사이므로 수일치하여 복수 동사인 (A) mention이 정답.

7.

There are a number of **questions** that respondents must answer in the market survey form.

(A) questions (B) questioning
(C) questioned (D) question

어휘 | respondent 응답자 market survey 시장조사

해석 | 시장조사 설문지에 응답자들이 답변해야 하는 질문들이 많이 있다.

해설 | **주의해야 할 수량 표현**
빈칸 앞의 a number of는 형용사처럼 쓰이는 수량 표현으로, 뒤에 가산명사의 복수형이 와야 한다. 따라서 정답은 (A) questions. a number of는 복수 동사와 함께 쓰이므로 be동사의 복수형 are가 쓰였음에 주의하자.

8.

The shipment requested by local customers **was delivered** to the Marks & Vaughn warehouses in Slough yesterday.

(A) delivery (B) delivering
(C) was delivered (D) were delivered

어휘 | shipment 화물, 선적물 warehouse 물류 창고, 저장소

해석 | 현지 고객들이 요청한 화물은 슬로우에 있는 마크스 앤 본 물류 창고로 어제 배송되었다.

해설 | **긴 주어의 수일치**
문장의 주어인 The shipment를 분사구 requested by local customers가 뒤에서 수식하는 구조이므로 빈칸은 동사 자리이다. 따라서 동사 형태인 (C) was delivered와 (D) were delivered가 정답 후보인데, 주어 The shipment가 단수이므로 단수 동사인 (C) 가 정답이다.

9.

Employees arranging conference calls must notify all attendees whenever they **expect** a change in their schedules.

(A) expectation (B) expect
(C) expects (D) expectedly

어휘 | arrange 준비하다 conference call 전화 회의 notify 통보하다 attendee 참석자

해석 | 전화 회의를 준비하는 직원들은 일정 변경이 예상될 때마다 모든 참석자들에게 통보해야 한다.

해설 | **복수 주어 + 복수 동사**
빈칸은 복합관계부사 whenever가 이끄는 부사절의 동사 자리로, 명사 (A) expectation과 부사 (D) expectedly는 오답으로 제외. 주어 they가 복수형이므로 정답은 복수 동사 (B) expect.

10.

Tromso Hardware sells wood in a **variety** of styles, and it makes the store popular among consumers.

(A) priority (B) quotation
(C) limit (D) variety

어휘 | popular 인기있는 consumer 소비자

해석 | 트롬소 하드웨어 사는 여러 가지 스타일의 목재를 판매하는데, 이 덕분에 그 가게는 소비자들 사이에서 인기가 있다.
(A) 우선 사항 (B) 인용구
(C) 한계 (D) 여러 가지

해설 | **명사 어휘 variety**
문맥상 '다양한 스타일의 목재를 판매한다'는 의미가 되어야 하므로 정답은 (D). a variety of는 '여러 가지의'를 의미하는 표현으로 한 단어처럼 쓰이는데, 뒤에 복수 명사가 와야 한다는 것도 참고로 알아두자.

11.

Reading Corner's improved purchasing system immediately **reduced** problems with recording and processing customer orders.

(A) reducing (B) reduced
(C) reduce (D) have reduced

어휘 | improved 개선된 purchasing 구매 immediately 즉시 record 기록하다 process 처리하다

해석 | 리딩 코너스 사의 개선된 구매 시스템으로 고객 주문을 기록하고 처리하는 데에 있어서의 문제점들이 즉시 감소했다.

해설 | **단수 주어 + 단수 동사**
improved는 동사가 아니라 purchasing system을 수식하는 형용사로 쓰였다. 따라서 문장내 동사가 없으므로 빈칸은 동사 자리이다. 주어인 purchasing system이 단수이므로 이와 수일치한 reduce의 과거형 (B) reduced가 정답이다. (C) reduce와 (D) have reduced는 복수 동사이므로 단수 주어와 수가 일치하지 않아 오답.

14

12.

The hallway that **leads** to the fitness gym on the sixth floor has been closed to make way for the renovation.

(A) leading **(B) leads**
(C) lead (D) leader

어휘 | hallway 복도 renovation 개조 공사

해석 | 6층의 헬스클럽으로 이어지는 복도는 개조 공사를 위한 길을 만들기 위해 폐쇄되어 있다.

해설 | **관계사절 내 동사의 수일치**

that부터 floor까지는 주어인 The hallway를 설명하는 관계대명사절이다. 이 관계대명사절에 동사가 없으므로 빈칸은 동사 자리임을 알 수 있다. 이때 동사의 수는 관계대명사 앞 단수 선행사 The hallway와 일치시켜야 하므로 단수 동사인 (B) leads가 정답.

13.

The **changes** to be made on the Web pages strongly suggest that the graphic artists missed some instructions from the client.

(A) changes (B) change
(C) changeable (D) changed

어휘 | strongly 강하게 suggest 암시하다 miss 놓치다
 instruction 《보통 복수형》 지시 client 의뢰인, 고객

해석 | 웹페이지에 적용된 변경 사항은 그래픽 디자이너가 의뢰인의 지시 사항을 놓쳤다는 것을 강하게 암시한다.

해설 | **단수 주어 + 단수 동사**

to부정사구 to be부터 Web pages까지가 빈칸을 수식하는 구조로 빈칸은 문장의 주어 자리이다. 따라서 명사 형태인 (A)와 (B)가 정답 후보이다. 문장의 동사 suggest가 복수 동사이므로 주어도 복수 명사여야 한다. 따라서 정답은 (A) changes.

14.

The use of plastic cutlery and disposable containers **is prohibited** by the Environmental Office.

(A) are prohibited (B) to prohibit
(C) prohibiting **(D) is prohibited**

어휘 | cutlery 식기구, 날붙이류 disposable 일회용의 container 용기

해석 | 플라스틱 식기구와 일회용 용기의 사용은 환경 당국에 의해 금지된다.

해설 | **긴 주어의 수일치**

문장내 동사가 없으므로 빈칸은 동사 자리이다. 따라서 동사 형태인 (A)와 (D)가 정답 후보. 빈칸 앞 전치사구 of부터 containers까지는 수식어구이고 주어는 The use이다. 주어가 단수이므로 수일치하여 단수 동사 (D) is prohibited가 정답.

[15-18] 메모

To: Marketing department employees
From: Heather Gray, Marketing Director
Date: September 2
Subject: Monthly meeting

A luncheon will be held on Friday, September 10, in the sixth-floor cafeteria for all marketing department employees to learn about our latest analysis. **15 Our research team will present the results of their most recent study.** Afterward, we will have time to talk about our future marketing plans.
The new strategies to be implemented in the upcoming quarter **16 are expected** to reflect the team's new findings. In brief, quite surprisingly, a survey conducted by the team showed that customers prefer the black-and-white advertisements to the bright and colorful **17 ones**. To take advantage of this trend, we look forward to hearing **18 your** insights and ideas on September 10.

받는 사람: 마케팅 부서 직원
보내는 사람: 마케팅 부장, 히더 그레이
날짜: 9월 2일
제목: 월례 회의

9월 10일 금요일에 6층의 구내식당에서 모든 마케팅 부서 직원들이 우리의 최근 분석에 대해 알기 위한 오찬이 진행됩니다. **15 우리 연구팀은 그들의 가장 최근 연구 결과를 제시할 것입니다.** 그 후에, 우리는 향후 마케팅 계획에 대해 이야기하는 시간을 가질 것입니다.

다음 분기에 시행될 새로운 전략은 연구팀의 새로운 발견 사항들을 반영할 것으로 **16 예상됩니다.** 간단히 말씀드리면, 꽤 놀랍게도, 그 팀이 수행한 설문 조사는 고객들이 우리의 흑백 광고를 형형색색의 밝은 **17 것**보다 더 선호한다는 것을 보여주었습니다. 이 경향을 이용하기 위해 우리는 9월 10일에 **18 여러분의** 통찰력과 생각을 듣길 기대합니다.

어휘 | analysis 분석 afterward 후에 implement 시행하다 upcoming 다가오는, 곧 있을 reflect 반영하다, 비추다 in brief 간단히 말해서
 conduct (특정한 활동을) 하다 take advantage of ~을 이용하다 look forward to doing ~을 기대하다 insight 통찰력

15.
(A) We will be discussing which intern to hire as a full-time employee.
(B) Our research team will present the results of their most recent study.
(C) We will invite all of our customers to come eat with us.
(D) First, an art organization will show us the recent works of local artists.

해석 |
(A) 우리는 어떤 인턴 사원을 정규직 사원으로 채용할지 논의할 것입니다.
(B) 우리 연구팀은 그들의 가장 최근 연구 결과를 제시할 것입니다.
(C) 우리는 모든 고객들을 초청해서 우리와 함께 식사하도록 할 것입니다.
(D) 우선, 미술 단체에서 우리에게 지역 예술가들의 최근 작품을 보여줄 것입니다.

해설 | 알맞은 문장 고르기
빈칸 앞 문장에서 최근 분석에 대해 알기 위한 오찬이 진행된다는 내용이 나오고 빈칸 뒤에서는 그 후에 향후 마케팅 계획에 대해 이야기하는 시간을 가질 것이라는 내용이 나온다. 따라서 빈칸에는 마케팅 계획에 대해 이야기하기 전에 다루게 될 최근 분석과 관련된 내용이 나오는 것이 알맞으므로 연구팀이 최근 연구 결과를 제시한다는 내용의 (B)가 정답.

16.
(A) are expected
(B) expects
(C) expecting
(D) expectation

해설 | 긴 주어의 수일치
수일치의 핵심은 주어가 단수인지 복수인지 판단하는 것이다. 빈칸은 동사 자리이므로 빈칸 앞 명사구 The new strategies to be implemented in the upcoming quarter에서 수일치와 직접적으로 관련된 주어가 무엇인지 찾는다면 이 문제는 금방 해결할 수 있다. The new strategies가 실질적인 주어이고 나머지는 모두 수식 어구이므로 복수 주어에 맞는 복수 동사인 (A) are expected가 정답이다.

17.
(A) ones
(B) others
(C) most
(D) either

해설 | 부정대명사
문맥상 '고객들이 형형색색의 밝은 광고보다 흑백 광고를 선호한다'라는 의미가 되어야 하므로, 앞에 나온 advertisements를 대신할 수 있는 대명사인 ones가 와야 한다. 따라서 정답은 (A). (B) others, (C) most, (D) either는 형용사의 수식을 받을 수 없고 문맥상으로도 어울리지 않으므로 모두 오답이다.

18.
(A) you
(B) yourself
(C) your
(D) yours

해설 | 인칭대명사_소유격
선택지를 보면 인칭대명사의 알맞은 격을 고르는 문제임을 알 수 있다. 빈칸이 명사구 insights and ideas앞에 위치하므로, 명사구를 수식하는 한정사 역할의 소유격 인칭대명사 (C) your가 정답이다.

[19-22] 편지

June 4

Wetzel Enterprises
507 Palmer Road
Westerville, OH 43081

To Whom It May Concern:

I would like to formally complain about a defective 3-in-1 Emblem printer I bought from your store last week. I'm providing a few **19** remarks on the printer's strange performance. Whenever I produce graphs in color, it prints black in locations that are designated for color ink. Also, I cannot select the "high-resolution" **20** option on the LCD screen when saving a scanned document. However, your manual states

6월 4일

웨첼 엔터프라이즈 사
파머 로 507번지
웨스터빌, 오하이오 주 43081

담당자 분께:

지난주에 귀하의 매장에서 구매한 결함이 있는 3-in-1 엠블럼 프린터에 대해 정식으로 불만을 제기하려고 합니다. 이 프린터의 이상한 작동에 대해 몇 가지 **19** 말씀 드리겠습니다. 제가 그래프를 컬러로 인쇄할 때마다 컬러 잉크가 지정된 곳을 프린터가 흑백으로 인쇄합니다. 또한, 스캔한 서류를 저장할 때 LCD 화면에서 **"고해상도" 20 선택**을 고를 수 없습니다. 하지만, 설명서에는 기계의 선택 패널이 사용자들이 프린터의 설정을 쉽게 조정 **21** 할 수 있게 해준다고 되어있습니다. 제 생각에는 잉크 노즐과 터치 스크린이 손상된 것 같습니다. **22 저는 이 문제들로 매우 불편했습니다.** 이에 대해 빠른 답변 부탁드립니다. 555-0909로 전화해 주십시오.

16

that the device's selection panels easily ²¹ **allow** users to control the printer's settings. I believe that the ink nozzle and touch screen are damaged. ²² **I have been seriously inconvenienced by these problems.** I demand your immediate response to them. Call me at 555-0909.

Sincerely,
Richard Sanghi

리차드 상하이 드림

어휘 | formally 정식으로 complain 불평하다 defective 결함 있는 location 곳, 장소 designate 지정하다 manual 설명서; 수동의 state 명시하다, 말하다 control 조정하다, 제어하다 setting 설정 immediate 빠른, 즉각적인

19.
(A) remark
(B) remarkable
(C) remarkably
(D) remarks

해설 | 수량 표현의 수일치
빈칸은 동사 am providing의 목적어 자리이므로 선택지 중 정답이 될 수 있는 것은 명사형인 (A)와 (D)이다. a few는 복수 가산명사를 수식하는 수량 표현이므로 정답은 복수형인 (D) remarks.

20.
(A) option
(B) favor
(C) concept
(D) cause

해석 | (A) 선택 (B) 호의
 (C) 개념 (D) 원인
해설 | 명사 어휘 option
문맥상 프린터의 LCD 화면상에서 고를 수 있는 것은 "고해상도" '선택'이므로 정답은 (A) option.

21.
(A) allowing
(B) allow
(C) is allowed
(D) to allow

해설 | 복수 주어 + 복수 동사
접속사 that이 이끄는 명사절에 동사가 없으므로 동사 자리에 들어갈 수 있는 (B)와 (C)가 정답 후보이다. 주어 the device's selection panels가 복수이므로 복수 동사인 (B) allow가 정답.

22.
(A) I strongly suggest recalling all your printers.
(B) Thank you for recommending a solution to my concern.
(C) Your shop repaired my scanner within a day.
(D) I have been seriously inconvenienced by these problems.

해석
(A) 귀사의 모든 프린터를 회수할 것을 강력히 제안합니다.
(B) 제 문제에 대해 해결책을 알려주셔서 감사합니다.
(C) 귀하의 가게에서 제 스캐너를 하루 안에 수리해 주셨습니다.
(D) 저는 이 문제들로 매우 불편했습니다.

해설 | 알맞은 문장 고르기
알맞은 문장을 고르는 문제의 단서가 되는 대명사나 지시어, 연결어 등에 주목하여 빈칸 주변 문맥을 확인해 보자. 빈칸 앞에서는 사용자가 구매한 프린터의 오작동에 대해 구체적으로 설명하고 있고, 빈칸 뒤에는 이에 대해 빠른 답변을 부탁한다는 내용이 나온다. 따라서 빈칸에는 사용자가 앞에서 말한 문제점들로 불편을 겪었다는 내용이 나오는 것이 문맥상 자연스러우므로 정답은 (D).

FINAL TEST

교재 55쪽

1. (A)	**2.** (D)	**3.** (A)	**4.** (C)	**5.** (B)	**6.** (B)	**7.** (C)	**8.** (C)	**9.** (A)	**10.** (D)
11. (C)	**12.** (A)	**13.** (B)	**14.** (C)						

1.

An increase in oil price normally **affects** the costs of basic commodities, such as rice and flour.

(A) **affects**　　　　　(B) was affected
(C) is affecting　　　(D) affect

어휘 | increase in (~의) 인상, 증가　normally 보통
commodity 상품, 물품　flour 밀가루

해석 | 유가 상승은 보통 쌀과 밀가루 같은 생필품의 가격에 영향을 미친다.

해설 | **현재 시제**
선택지를 보니 알맞은 동사 형태를 묻는 문제로, normally라는 단서를 통해 답을 고를 수 있어야 한다. 일반적인 사실을 나타낼 때는 현재 시제를 사용하므로 정답은 (A) affects.

2.

Stockholders should call the public relations office to **confirm** their attendance to the general meeting.

(A) remind　　　　　(B) approve
(C) support　　　　(D) **confirm**

어휘 | stockholder 주주　public relations 홍보 (활동)
attendance 참석　general meeting 주주 총회

해석 | 주주들은 주주 총회 참석 확인을 위해 홍보실에 전화해야 한다.
(A) 상기시키다　　　(B) 승인하다
(C) 지지하다　　　　(D) 확인하다

해설 | **동사 어휘 confirm**
문맥상 '참석 확인을 위해 홍보실에 전화해야 한다'는 내용이 되어야 자연스러우므로 정답은 (D) confirm.

3.

Smitty Fashion **is launching** a new marketing campaign next quarter for their latest collection.

(A) **is launching**　　(B) launch
(C) to launch　　　　(D) has launched

어휘 | launch 시작하다, 출시하다　latest 최신의

해석 | 스미티 패션 사는 다음 분기에 그들의 최신 컬렉션에 대한 새로운 마케팅 캠페인을 시작할 것이다.

해설 | **미래를 의미하는 현재진행**
미래를 나타내는 부사구 next quarter로 미루어 보아 빈칸은 미래를 나타내는 동사여야 한다. 가까운 미래의 일은 현재진행형으로도 나타낼 수 있으므로 정답은 (A) is launching. 이처럼 시제 문제에서는 일반적으로 시간을 나타내는 부사(구)가 단서가 된다.

4.

Two years ago, Swiss Pharma **obtained** an exclusive license to manufacture vaccines for newborns.

(A) obtains　　　　　(B) has obtained
(C) **obtained**　　　(D) obtaining

어휘 | exclusive 독점적인　manufacture 제조하다
newborn 신생아; 갓 태어난

해석 | 2년 전에, 스위스 제약은 신생아를 위한 백신을 제조할 수 있는 독점권을 획득하였다.

해설 | **과거 시제**
빈칸은 문장의 동사 자리이므로 (D) obtaining은 오답으로 제외. 문장 앞부분에 과거를 나타내는 표현인 Two years ago가 있으므로 과거 시제인 (C) obtained가 정답이다. 현재완료인 (B) has obtained는 Two years ago처럼 명백한 과거를 나타내는 표현과 함께 쓰이지 않으므로 오답.

5.

Over the past thirty years, Wilcon Crystals **has set** a high standard of excellence in jewelry making.

(A) will be setting　　(B) **has set**
(C) is being set　　　(D) sets

어휘 | standard 수준　excellence 우수성, 뛰어남

해석 | 지난 30년 동안, 윌콘 크리스탈 사는 보석 제작에서 높은 수준의 우수성을 유지해왔다.

해설 | **현재완료**
단서로 기간을 나타내는 부사구 Over the past thirty years를 빠르게 찾아야 한다. 문맥상 '지난 30년간 수준을 유지해왔다'는 내용이 되어야 하므로, 현재완료 시제가 적절하다. 따라서 정답은 (B) has set. 이처럼 기간을 나타내는 표현은 현재까지 지속되는 상태를 나타내는 완료 시제와 잘 어울려 쓰인다는 점을 기억하자.

6.

Mr. Mullahy's team **will have completed** its proposed Web design by the end of the week.

(A) is completing **(B) will have completed**

(C) completes (D) was completed

어휘 I proposed 제안된

해석 I 물라히 씨의 팀은 제안된 웹 디자인을 이번 주말까지 완료할 것이다.

해설 I **미래완료**

미래를 나타내는 부사구 by the end of the week이 결정적인 단서이다. 이번 주말까지 디자인을 완료할 것이란 내용으로 보아 미래의 특정 시점까지 상태가 완료될 것임을 알 수 있다. 따라서 미래완료인 (B) will have completed가 정답이다.

7.

Due to the heavy snow, the tour guide suggested that the fishing trip **be postponed** until tomorrow.

(A) will postpone (B) to postpone

(C) be postponed (D) are postponed

어휘 I suggest 제안하다 postpone 미루다, 연기하다

해석 I 폭설 때문에, 여행 가이드는 낚시 여행을 내일까지 미루자고 제안했다.

해설 I **시제 일치의 예외**

빈칸은 that절의 동사 자리이므로 to부정사인 (B)는 오답으로 제외. 주절의 동사 suggest는 제안을 나타내는 동사로, 뒤의 that절의 동사는 〈(should)+동사원형〉의 형태여야 한다. 따라서 동사원형인 (C) be postponed가 정답.

8.

The new train station on Libby Street **will begin** operating next month in time for the holidays.

(A) has begun (B) had begun

(C) will begin (D) was beginning

어휘 I operate 영업하다, 작동하다 in time for ~에 시간 맞춰 holiday 휴일

해석 I 리비 가에 있는 새로운 기차역은 휴일에 맞춰 다음 달에 영업을 시작할 것이다.

해설 I **미래 시제**

선택지가 모두 동사인 것을 통해 동사의 시제를 묻는 문제임을 알 수 있다. 따라서 문장 안에 시제를 나타내는 단서부터 찾아야 한다. 미래를 나타내는 부사구 next month를 통해 미래 시제가 와야 함을 알 수 있으므로 정답은 (C) will begin.

9.

If the factory director **develops** stricter quality assurance requirements, he will reduce the number of defective products.

(A) develops (B) developed

(C) will develop (D) develop

어휘 I strict 엄격한 quality assurance 품질 보증 requirement 《보통 복수형》 요건, 필요조건 defective 결함이 있는

해석 I 공장 관리자가 더 엄격한 품질 보증 요건을 개발한다면, 그는 불량품의 수를 줄일 것이다.

해설 I **시제 일치의 예외**

접속사 if가 이끄는 조건의 부사절이 쓰인 문장으로, 시간이나 조건의 부사절에서는 미래 시제 대신 현재 시제를 쓴다. 따라서 현재 시제인 (A), (D)가 정답 후보인데 주어 the factory director가 단수이므로 수일치하여 단수 동사인 (A) develops가 정답. 주절의 동사가 미래 시제(will reduce)라고 해서 미래 시제인 (C) will develop를 정답으로 고르는 함정에 빠져선 안 된다.

10.

Last month's budget cut has **already** influenced several departments in a significant way.

(A) yet (B) currently

(C) soon **(D) already**

어휘 I budget cut 예산 삭감 influence 영향을 미치다 significant 상당한, 중요한

해석 I 지난달의 예산 삭감은 이미 여러 부서에 상당한 영향을 미쳤다.

(A) 아직 (B) 현재

(D) 곧 (D) 이미

해설 I **부사 어휘 already**

문맥상 '예산 삭감이 이미 상당한 영향을 미쳤다'라는 의미가 자연스러우므로 정답은 (D) already. (A) yet도 현재완료 시제에 자주 쓰이나 주로 부정문에서 쓰이므로 오답. (B) currently는 현재 시제, (C) soon은 미래 시제와 주로 쓰이므로 오답이다.

11.

According to the quality inspector, some of the dairy items **have been sitting** on display for over two weeks now.

(A) sit (B) to sit

(C) have been sitting (D) were sitting

어휘 I according to ~에 의하면 inspector 검사관 dairy 유제품의 on display 진열 중인

해석 I 품질 검사관에 의하면, 일부 유제품이 현재 2주가 넘는 동안 진열되어 있다고 한다.

해설 I **현재완료 진행**

계속되는 기간을 나타내는 for over two weeks를 통해 빈칸에 완료 시제가 와야 한다는 것을 유추해 볼 수 있다. 2주 전부터 지금까지 계속 진열되어 있다는 의미이므로 현재완료 진행형인 (C) have been sitting이 정답.

12.
It is important that all motorists **be** aware of potential risks and hazards on the road.

(A) be (B) were
(C) is being (D) to be

어휘 | motorist 자동차 운전자 be aware of ~을 알다
potential 잠재적인 hazard 위험

해석 | 모든 자동차 운전자들이 도로에서의 잠재적 위험에 대해 알고 있어야 하는 것은 중요하다.

해설 | **시제 일치의 예외**
의무나 필수의 의미를 가진 형용사가 뒤에 that절을 이끌 때 that절의 동사는 〈should + 동사원형〉의 형태이며 조동사 should는 보통 생략된다. 따라서 형용사 important가 이끄는 that절의 동사는 동사원형인 (A) be가 가장 적절하다.

13.
Drivers must continue to use the detour because heavy rains **have delayed** the completion of the highway expansion.

(A) were delaying **(B) have delayed**
(C) delaying (D) delays

어휘 | detour 우회로 completion 완공 expansion 확장

해석 | 폭우가 고속도로 확장 작업의 완공을 지연시켰기 때문에 운전자들은 계속 우회로를 이용해야 한다.

해설 | **현재완료**
문장에 직접적인 시간 표현 단서가 없으므로 오답을 제거하며 정답을 찾는 것이 효과적이다. 문맥상 because절의 원인으로 현재 우회로를 이용해야 하는 상황이므로 빈칸은 과거의 의미가 있는 시제가 와야 한다. 따라서 과거의 의미가 있는 과거진행형 (A)와 현재완료 (B)가 정답 후보. 과거진행형은 과거의 특정 시점에 한정한 사실을 나타내므로 주절에 주로 과거 시제가 오기 때문에 (A)는 오답. 따라서 과거부터 현재까지 영향을 미치는 것을 나타내는 시제인 현재완료 (B) have delayed가 정답이다.

14.
Companies in the region **had been** unable to find affordable office supplies before OfficeBlock started to sell inexpensive goods.

(A) have been (B) would be
(C) had been (D) are being

어휘 | region 지역 be unable to *do* ~할 수 없다 affordable (가격이)
알맞은 inexpensive 저렴한, 비싸지 않은

해석 | 오피스블록 사가 저렴한 제품들을 판매하기 전에 그 지역 기업들은 가격이 알맞은 사무용품을 구할 수가 없었다.

해설 | **과거완료**
접속사 before로 연결된 문장이므로 주절의 내용은 오피스블록 사에서 값싼 제품을 판매하기 시작하기 이전의 과거 상황을 의미한다. 따라서 접속사절의 과거 시제 started보다 앞선 시제를 의미하는 과거완료 (C) had been이 정답.

FINAL TEST

교재 63쪽

1. (A)	2. (A)	3. (C)	4. (D)	5. (A)	6. (A)	7. (B)	8. (C)	9. (D)	10. (C)
11. (D)	12. (D)	13. (A)	14. (C)	15. (B)	16. (B)	17. (D)	18. (B)	19. (B)	20. (D)
21. (A)	22. (D)								

1.

Crime rates in the city **declined** after several strict measures were taken.

(A) declined　　　　(B) declining
(C) was declined　　(D) has been declined

어휘 | crime rates 범죄 발생률　measure 조치

해석 | 여러 엄격한 조치들이 취해진 후 시의 범죄 발생률이 감소했다.
해설 | **수동태로 쓸 수 없는 자동사**
빈칸은 동사 자리이므로 (B) declining은 오답으로 제외. decline은 '감소하다'라는 의미의 자동사로 수동태로 쓸 수 없으므로 수동태 형태인 (C) was declined와 (D) has been declined는 오답. 따라서 (A) declined가 정답이다.

2.

The human resources department formed a committee **dedicated** to the preparations for the Engineering Masters Conference.

(A) dedicated　　(B) interested
(C) registered　　(D) concerned

어휘 | form 구성하다　committee 위원회　preparation 준비

해석 | 인사부는 엔지니어링 마스터스 학회 준비에 전념할 위원회를 구성했다.
(A) 전념하는　　(B) 관심 있는
(C) 등록한　　　(D) 걱정하는

해설 | **형용사 어휘 dedicated**
빈칸 앞의 명사 committee를 수식하는 형용사 어휘를 고르는 문제이다. 문맥상 '학회 준비에 전념할 위원회를 구성했다'는 의미가 되어야 하므로 '전념하는'의 의미로 쓰이는 (A) dedicated가 정답이다. dedicated는 보통 to와 함께 쓰여 '~에 전념하는, 헌신하는'의 의미로 빈출되므로 기억해 두도록 하자.

3.

All container vans must be **inspected** by a Customs Division official as soon as they arrive at the port.

(A) inspecting　　(B) inspect
(C) inspected　　(D) inspection

어휘 | van 화물차　customs 세관　official 공무원　port 항구

해석 | 모든 컨테이너 화물차는 항구에 도착하자마자 세관 공무원에게 점검받아야 한다.
해설 | **3문형 동사의 수동태**
컨테이너 화물차는 점검을 받는 대상이며 빈칸 뒤의 〈by + 행위자〉를 통해서 빈칸은 수동태 형태여야 함을 알 수 있다. 따라서 정답은 빈칸 앞의 be동사와 함께 수동태를 만드는 (C) inspected.

4.

Managers **are advised** to make advance reservations to ensure they may attend the leadership training.

(A) advised　　(B) has been advised
(C) is advising　(D) are advised

어휘 | advance reservation 사전 예약　ensure 반드시 ~하게 하다

해석 | 관리자들은 리더십 교육에 반드시 참석할 수 있도록 사전 예약을 할 것을 권유받았다.
해설 | **목적격 보어가 to부정사구인 5문형의 수동태**
advise는 목적어와 함께 목적격 보어로 to부정사를 취하는 5문형 동사인데, 빈칸 앞에는 주어, 뒤에는 목적어 없이 to부정사가 있는 것으로 보아 수동태가 사용된 문장임을 알 수 있다. 수동태 형태인 (B) has been advised와 (D) are advised가 정답 후보인데 주어 Managers가 복수 명사이므로 복수 동사를 써야 한다. 따라서 정답은 (D).

5.

The customer service department was understaffed today, so the volume of work was **overwhelming** all the employees.

(A) overwhelming　　(B) overwhelmed
(C) overwhelm　　　(D) overwhelmingly

어휘 | understaffed 인원이 부족한　volume ~의 양, 음량　overwhelm 압도하다

해석 | 오늘 고객 서비스 부서의 인원이 부족해서 업무량이 모든 직원들을 압도했다.
해설 | **감정 동사의 능동태**
선택지들을 통해 감정 동사 overwhelm의 알맞은 형태를 고르는 문제임을 알 수 있다. 사물 주어 the volume of work는 직원들로 하여금 감정을 느끼게 하는 원인이므로 능동태를 사용해야 한다. 따라서 정답은 (A) overwhelming.

6.

Next January, artist James Cornice **will exhibit** his latest collection of ceramic pots and vases at the art museum.

(A) will exhibit (B) will be exhibited

(C) was exhibiting (D) have been exhibited

어휘 | exhibit 전시하다 collection 소장품, 수집품 ceramic pot 도자기 vase 꽃병

해석 | 내년 1월에, 예술가 제임스 코니스 씨는 미술관에 자신의 최신 소장품인 도자기와 꽃병들을 전시할 예정이다.

해설 | **3문형 동사의 능동태**

James Cornice는 동사 exhibit의 행위자이므로 빈칸은 능동태여야 한다. 따라서 (A)와 (C)가 정답 후보이다. 문장 앞부분의 Next January는 미래를 나타내는 단서 표현이므로 미래 시제 (A) will exhibit이 정답이다.

7.

At the communication meeting, the company president mentioned that he **is satisfied** with the company's performance in the third quarter.

(A) satisfies (B) is satisfied

(C) satisfy (D) will have satisfied

어휘 | mention 말하다, 언급하다 performance 실적 quarter 분기

해석 | 커뮤니케이션 회의에서, 그 회사 회장은 회사의 3분기 실적에 만족한다고 말했다.

해설 | **감정 동사의 수동태**

감정 동사가 선택지로 나온 경우, 먼저 주어와 감정 동사와의 관계를 파악해야 한다. 사람 주어 he는 만족스러운 감정을 느끼는 주체이므로 빈칸은 수동태가 알맞다. 따라서 정답은 (B) is satisfied.

8.

According to the finance team, part of the operations' budget **has been reserved** for the sports festival and software training in August.

(A) were being reserved (B) will reserve

(C) has been reserved (D) is reserving

어휘 | finance 재무 operation 운영, 영업 budget 예산 training 교육, 연수

해석 | 재무팀에 따르면, 운영 예산의 일부를 8월에 있을 체육대회와 소프트웨어 교육을 위해 남겨 두었다고 한다.

해설 | **3문형 동사의 수동태**

주어인 part of the operations' budget은 '따로 남겨진' 것이라는 수동의 의미이므로 (A) were being reserved와 (C) has been reserved가 정답 후보이다. 이때 주어가 단수이므로 수일치하여 정답은 단수 동사인 (C).

9.

The security guards contacted Mr. Brown because they noticed that his car **was left** unlocked in the office parking lot.

(A) leave (B) were left

(C) left (D) was left

어휘 | contact 연락하다 notice ~을 알다, 주목하다 unlock 열다 parking lot 주차장

해석 | 경비원들은 브라운 씨의 차가 사무실 주차장에 열린 채로 있는 것을 알았기 때문에 그에게 연락하였다.

해설 | **목적격 보어가 명사/형용사인 5문형의 수동태**

that절의 주어 his car는 열린 채 '남겨 진' 것이므로 수동태가 쓰여야 한다. 따라서 수동태 형태인 (B)와 (D)가 정답 후보인데, 주어가 단수이므로 단수 동사를 써야 한다. 따라서 정답은 (D) was left. 빈칸 뒤의 unlocked는 목적격 보어인 형용사가 그대로 남아있는 것이므로 2문형 동사의 능동태로 착각하지 않도록 하자.

10.

Upon expiration, one of the magazine's staff members **told** Ms. Wilson that she needed to renew her annual subscription.

(A) was told (B) tell

(C) told (D) will be told

어휘 | expiration 만료, 만기 renew 갱신하다 annual 연간의 subscription 구독권

해석 | 구독이 만료되자마자, 잡지사 직원 중 한 명이 윌슨 씨에게 그녀가 연간 구독권을 갱신해야 한다고 말했다.

해설 | **4문형 동사의 능동태**

동사 tell의 형태를 묻는 문제로, 문맥상 잡지사 직원이 윌슨 씨에게 직접 '말하는' 것이므로 능동태가 되어야 자연스럽다. 따라서 (B) tell과 (C) told가 정답 후보인데, 주어 one of the magazine's staff members는 단수이므로 복수 동사 (B)는 오답이고 (C)가 정답이다.

11.

The order form was **submitted** to the supplier last week, so the tools should arrive today.

(A) submission (B) submitting

(C) submits (D) submitted

어휘 | order form 주문서 supplier 공급 회사, 공급자 tool 공구, 도구 arrive (물건이) 배달되다, 도착하다

해석 | 주문서가 지난주에 공급 업체에게 제출되었으므로, 공구는 오늘 배달되어야 한다.

해설 | **〈수동태＋전치사〉 구문**

동사 submit은 '(서류 등을) 제출하다'라는 의미의 타동사로 뒤에 목적어가 와야 하는데 빈칸 뒤에는 목적어 없이 전치사구가 나오므로 〈수동태＋전치사〉 구문인 be submitted to(~에게 제출되다)를 떠올릴 수 있어야 한다. 문맥상으로도 주문서가 '제출된' 것이므로 수동태가 오는 것이 맞다. 따라서 정답은 (D) submitted.

12. Anyone who was on the guest list **was sent** an invitation to the furniture auction yesterday.

(A) will be sent (B) sends

(C) was sending **(D) was sent**

어휘 | guest list 손님 명단 invitation 초대장 furniture 가구 auction 경매

해석 | 손님 명단에 있는 사람은 누구나 어제 가구 경매 초대장을 받았다.

해설 | 4문형 동사의 수동태

문맥상 손님 명단에 있는 사람들이 초대장을 '받는' 것이므로, 수동태가 되어야 자연스럽다. 따라서 (A) will be sent와 (D) was sent가 정답 후보. 시간 부사 yesterday를 통해 과거 시제임을 알 수 있으므로 (D)가 정답이다. send는 4문형 동사이므로 수동태에서도 동사 뒤에 직접목적어(an invitation)가 남아 있다는 것에 주의하자.

13. Entries to all categories of the costume design competition **are being accepted** at the Fashion Society Office until June 30 only.

(A) are being accepted (B) are accepting

(C) is accepted (D) have accepted

어휘 | entry 출품작 costume 의상, 복장 competition 대회

해석 | 의상 디자인 대회의 모든 부문에 대한 출품작들은 패션 협회 사무소에서 6월 30일까지만 받고 있다.

해설 | 3문형 동사의 수동태

주어 Entries는 '받아들이는(accept)' 대상이므로 수동태가 쓰여야 한다. 따라서 (A)와 (C)가 정답 후보인데, 주어가 복수 명사이므로 복수 동사 (A) are being accepted가 정답이다.

14. Any issues raised by our clients regarding our kitchen products **are dealt** with carefully by our experienced consumer support team.

(A) dealt (B) is being dealt

(C) are dealt (D) deal

어휘 | issue 문제, 쟁점 raise (문제 등을) 제기하다 regarding ~에 대하여 carefully 신중히 experienced 경험이 풍부한

해석 | 자사의 주방용품에 대해 고객들이 제기한 모든 문제들은 경험이 풍부한 고객 지원팀이 신중히 처리할 것이다.

해설 | 〈자동사 + 전치사〉의 수동태

자동사 deal은 전치사 with와 함께 deal with(~을 처리하다)의 형태로 타동사처럼 뒤에 목적어가 올 수 있기 때문에 수동태로 쓰일 수 있다. 문맥상 주어 Any issues는 '처리되는' 것이므로 수동태가 알맞다. 정답 후보 (B)와 (C)중 복수 주어와 어울리는 것은 복수 동사이므로 정답은 (C) are dealt.

[15-18] 공지

NOTICE TO ALL EMPLOYEES

Management **15 is pleased** to announce a new benefit for all Bells Cargo staff members. By presenting your employee ID cards, you and your families may enjoy exclusive discounts from popular restaurants in Florida.

On our employee Web site, you will find a link with promotions for **16 designated** restaurants. Particularly interesting offers **17 will be announced** every month. This June, you can enjoy a 10 percent discount when you dine in any branch of Pizza Plaza, Amigo, or Chandler Burgers.

18 We strongly encourage everyone to take advantage of this benefit. For questions and feedback, please e-mail hr@bellscargo.com.

어휘 | announce 알리다 benefit 혜택 present 보여주다, 제시하다 exclusive 독점적인, 전용의 discount 할인 promotion 할인 행사 particularly 특별히, 특히 dine 식사를 하다 branch 지점, 지사

전직원에게 알림

경영진은 모든 벨스 카고 직원들에게 새로운 혜택을 알리게 되어 **15 기쁩니다.** 사원증을 보여주시면, 여러분과 여러분의 가족들은 플로리다의 인기 있는 음식점에서 독점적인 할인을 받으실 수 있습니다.

직원 웹사이트에서, **16 지정된** 음식점에서 제공하는 할인 행사들이 있는 링크를 발견하실 것입니다. 특별히 흥미로운 할인들은 매달 **17 발표될 것입니다.** 이번 6월에는 피자 플라자, 아미고, 혹은 챈들러 버거의 어느 지점에서라도 식사하실 때 10퍼센트 할인을 받으실 수 있습니다.

18 여러분 모두가 이 혜택을 누리시길 적극 권장합니다. 질문이나 의견이 있으시면 hr@bellscargo.com으로 메일을 보내주시기 바랍니다.

23

15. (A) pleases
(B) is pleased
(C) pleasing
(D) to please

해설 | 감정 동사의 수동태
please는 감정을 나타내는 동사로, 감정 동사는 주어가 감정을 느끼게 하는 원인이면 능동태, 주어가 감정을 느끼는 주체이면 수동태를 사용한다. Management는 기쁜 감정을 느끼는 주체이므로 수동태가 쓰여야 한다. 따라서 정답은 (B) is pleased.

16. (A) appointed
(B) designated
(C) instructed
(D) determined

해석 | (A) 임명된 (B) 지정된
(C) 교육을 받은 (D) 단단히 결심한

해설 | 형용사 어휘 designated
문맥상 '지정된 음식점들의 할인 행사들이 있는 링크'라는 의미가 자연스러우므로 정답은 (B) designated. (A) appointed는 주로 time(시간), date(날짜), 또는 사람명사를 수식하므로 오답이다.

17. (A) has been announced
(B) announce
(C) are announcing
(D) will be announced

해설 | 3문형 동사의 수동태
3문형 동사인 announce의 적절한 형태를 찾는 문제로 빈칸 뒤에 목적어가 없는 것으로 보아 수동태가 쓰였음을 알 수 있다. 문맥상으로도 주어 offers가 '발표되는' 것이므로 수동태 (A)와 (D)가 정답 후보. 이때 주어가 복수이므로 3인칭 단수 동사인 (A)는 오답이고 (D) will be announced가 정답이다.

18. (A) You may claim your ID cards from the human resources office.
(B) We strongly encourage everyone to take advantage of this benefit.
(C) This is a great investment opportunity for all employees.
(D) The discount coupons are available on our Web site.

해석 |
(A) 사원증은 인사팀에서 찾아오시면 됩니다.
(B) 여러분 모두가 이 혜택을 누리시길 적극 권장합니다.
(C) 이것은 모든 직원들에게 좋은 투자 기회가 될 것입니다.
(D) 할인 쿠폰은 저희 웹사이트에서 사용 가능합니다.

해설 | 알맞은 문장 고르기
빈칸이 공지 마무리 부분에 있고 공지에서는 회사의 새로운 혜택에 대해 설명하고 있으므로 지문 구조상 빈칸에는 설명을 마무리하는 내용이 적절하다. 빈칸 앞 부분에 설명된 혜택 이용을 장려하며 빈칸 뒤에서 이와 관련해서 질문이 있으면 연락하라는 내용으로 자연스럽게 이어지므로 (B)가 정답이다. 지문 전체 내용이 할인 혜택과 관련된 설명이므로 이 내용과 무관한 (A)와 (C)는 오답이다. 할인 쿠폰이 아니라 사원증을 제시하면 할인을 받을 수 있으므로 (D)도 오답이다.

[19-22] 광고

Experience the coolness of the South Pole with Antarctica refrigerator!

The latest addition to Evergreen's no-frost refrigerators, Antarctica is stylish and functional, yet affordable. Our new model is equipped with a bottom freezer and icemaker, and it comes in two-door and three-door units. [19] In addition, it is one of the cheapest on the market today.
Antarctica is further proof of Evergreen's capacity for creating excellent technology. [20] Since its launch in England three months ago, Antarctica has received many positive reviews for its advanced features.
In fact, it [21] was named Innovation of the Year by Europe's Consumer Union.
Right now, we [22] are giving a 15 percent discount and extended warranty to customers who purchase Antarctica refrigerators. This offer ends on June 30,

안타티카 냉장고로 남극의 시원함을 느껴보세요!

에버그린 사의 최신 기종인, 자동 서리 제거 장치가 달린 냉장고인 안타티카는 세련되고 실용적이지만 가격이 적당합니다. 저희의 새 모델은 아래칸에 냉동고와 제빙기를 갖추고 있으며 문이 두 개와 세 개인 모델로 나옵니다. **[19] 또한, 이는 현재 시장에서 가장 저렴한 모델 중 하나입니다.**

안타티카는 뛰어난 기술을 만드는 에버그린 사의 능력을 추가로 보여주는 증거입니다. 영국에서 세 달 전에 출시된 **[20] 이후로** 안타티카는 그 고급 기능에 대해 긍정적인 의견을 많이 받아왔습니다. 사실, 유럽 소비자 조합에서 올해의 혁신으로 **[21] 선정되었습니다.**

지금 우리는 안타티카 냉장고를 구매한 고객에게 15퍼센트 할인과 연장된 품질 보증서를 **[22] 제공하고 있습니다.** 이 할인은 6월 30일에 종료되니 오늘 가까운 가전제품 매장으로 서둘러 오세요.

so hurry to your nearest appliance store today.

어휘 | experience 느끼다, 겪다 no-frost (자동 서리 제거 장치가 달린) 냉장고 functional 실용적인 affordable (가격이) 적당한, 알맞은
be equipped with ~을 갖추고 있다 proof 증거 launch 출시, 개시 advanced 고급의 feature 특징, 특색 extended 길어진 warranty
품질 보증서

19. (A) It is the first refrigerator manufactured by
Evergreen.
**(B) In addition, it is one of the cheapest on the
market today.**
(C) The Antarctica refrigerator is intended for
personal use.
(D) Our talented designers simplified its features.

해석 |
(A) 이것은 에버그린 사에서 만든 첫 냉장고입니다.
(B) 또한, 이는 현재 시장에서 가장 저렴한 모델 중 하나입니다.
(C) 안타티카 냉장고는 개인용으로 만들어졌습니다.
(D) 저희의 재능 있는 디자이너들이 기능을 간소화했습니다.

해설 | 알맞은 문장 고르기
회사의 최신 기종 냉장고를 홍보하는 광고로, 맨 앞 문장에서 냉장고의
기능성과 적당한 가격에 대해 언급하고 있다. 그리고 빈칸 앞에서 냉장
고의 기능성에 대한 구체적인 장점이 나오므로 빈칸에는 가격에 대한
구체적인 장점이 나오는 것이 자연스럽다. 따라서 가장 저렴한 모델 중
하나라며 가격적인 특장점을 언급한 (B)가 정답이다.

20. (A) As
(B) While
(C) Because of
(D) Since

해석 | (A) ~로서 (B) ~하는 동안
(C) ~ 때문에 (D) ~ 이후로

해설 | 시점 전치사
빈칸 뒤에 명사구가 나오므로 빈칸은 전치사 자리이다. 현재완료 시제
(has received)와 함께 쓰이며 문맥상 '출시된 이후로'라는 의미가
되어야 하므로 정답은 시점 전치사인 (D) Since. since는 전치사, 접
속사, 부사 모두 가능하다는 것을 기억해 두자.

21. **(A) was named**
(B) named
(C) is named
(D) names

해설 | 목적격 보어가 명사/형용사인 5문형의 수동태
주어인 it(냉장고)이 유럽 소비자 조합에 의해 '선정된' 것이므로 수동
의 의미가 되어야 한다. 문장은 과거에 있었던 일을 언급하고 있으므로
정답 후보 (A)와 (C) 중 과거 시제가 쓰인 (A) was named가 정답.

22. (A) to give
(B) gave
(C) were given
(D) are giving

해설 | 현재진행
빈칸은 주어 we의 동사 자리로, give의 알맞은 형태를 묻는 문제
이다. 주어인 we가 give의 행위 주체이므로 동사는 능동태여야 한
다. 따라서 (B) gave와 (D) are giving이 정답 후보. 시간 부사구
Right now가 현재를 나타내고 있으므로 정답은 현재진행형인 (D).

FINAL TEST

교재 73쪽

| 1. (D) | 2. (D) | 3. (C) | 4. (D) | 5. (C) | 6. (D) | 7. (C) | 8. (A) | 9. (D) | 10. (B) |
| 11. (B) | 12. (C) | 13. (B) | 14. (D) | | | | | | |

1.

Chattler Life employs certified agents **to assist** clients with their insurance and investment needs.

(A) are assisted (B) assists
(C) assistance (D) to assist

어휘 | employ 고용하다 certified 공인의, 증명된 agent 설계사, 중개인 insurance 보험 investment 투자

해석 | 채틀러 라이프 사는 보험과 투자 요구가 있는 고객들을 돕기 위해 공인 설계사들을 고용한다.

해설 | **to부정사의 부사 역할**
문맥상 '돕기 위해 공인 설계사들을 고용한다'는 의미이므로, 빈칸은 목적을 나타내는 품사가 와야 한다. to부정사는 목적을 의미하는 부사 역할을 하므로 정답은 (D) to assist.

2.

The Public Works Ministry is expected **to create** roads that will connect three cities to the new highway.

(A) creative (B) create
(C) creation (D) to create

어휘 | be expected to *do* ~할 예정이다 connect 연결하다 highway 고속도로

해석 | 공공사업부는 세 도시를 신규 고속도로와 연결할 도로들을 지을 예정이다.

해설 | **to부정사를 목적격 보어로 취하는 동사**
빈칸 앞의 expect는 〈expect + 목적어 + to *do*〉의 형태로 to부정사를 목적격 보어로 취하는 5문형 동사. to부정사를 목적격 보어로 취하는 동사들은 수동의 형태로도 자주 쓰이는데, 이때 목적격 보어인 to부정사가 동사의 바로 뒤에 따라온다. 따라서 정답은 (D) to create. be expected to *do*의 형태로 기억해 두자.

3.

The architect is eager **to begin** the presentation about the new building project, but he has to wait for some late arrivals.

(A) began (B) beginning
(C) to begin (D) begin

어휘 | architect 건축가 wait for ~를 기다리다 arrival 도착한 사람

해석 | 그 건축가는 새 건설 프로젝트에 대해 몹시 발표하고 싶지만, 그는 늦게 도착하는 몇몇 사람들을 기다려야만 한다.

해설 | **〈be동사 + 형용사 + to부정사〉 구문**
빈칸 앞의 is eager를 보고 be eager to *do* 구문을 떠올려 바로 to부정사인 (C) to begin을 정답으로 고를 수 있어야 한다. eager는 to부정사와 함께 '~하고 싶어하는, 몹시 바라는'이란 의미를 만든다. 이 외에도 able, willing, likely와 같이 to부정사와 함께 쓰이는 형용사들은 반드시 기억하자.

4.

Kolp Lifeboats have the ability **to expand** automatically as soon as they are released into the water.

(A) expanding (B) expansion
(C) to have expanded (D) to expand

어휘 | an ability to *do* ~할 능력 expand 팽창되다 automatically 자동적으로 release 풀다, 방출하다

해석 | 콜프 구명보트는 물에 풀어놓자마자 자동적으로 팽창할 능력이 있다.

해설 | **to부정사의 형용사 역할**
빈칸 앞이 완전한 문장이므로 빈칸 이하는 수식어구가 들어가야 한다. 따라서 선택지 중에서 명사 ability를 수식할 수 있는 to부정사 (C) to have expanded와 (D) to expand가 정답 후보. to부정사 완료형인 〈to have *p.p.*〉는 과거의 일을 의미하는데 구명보트가 팽창하는 능력은 과거의 일이 아니라 일반적인 사실을 의미하므로 (D)가 정답이다.

5.

According to the delivery policy, it is important **to send** purchased items to customers within three working days.

(A) to be sent (B) sending
(C) to send (D) will send

어휘 | delivery 배송 purchase 구매하다 working day 근무일

해석 | 배송 정책에 따라, 구매 품목을 근무일 3일 이내로 고객에게 보내는 것은 중요하다.

해설 | **진주어 to부정사**
빈칸 앞 it is important만 보고도 가주어-진주어 구문이 쓰였음을 쉽게 파악할 수 있어야 한다. 진주어 자리에는 to부정사구나 that절이 올 수 있으므로 to부정사인 (A)와 (C)가 정답 후보. 문맥상 구매한 물건을 고객에게 직접 '보내는 것'이므로 능동태를 사용해야 한다. 따라서 정답은 (C) to send.

6.

After meeting with their supervisor, the civil engineers put their requests in a single document **for** him to review.

(A) to (B) as

(C) with **(D) for**

어휘 | supervisor 감독관, 상관 civil engineer 토목 기사

해석 | 감독관과의 회의 후, 토목 기사들은 그가 검토할 수 있게끔 자신들의 요구 사항을 하나의 문서로 작성했다.

해설 | to부정사의 의미상의 주어

빈칸 뒤의 him(=their supervisor)이 바로 뒤에 나오는 to review의 행위자로 문장의 주어 the civil engineers와 다르다. 따라서 to부정사의 의미상의 주어 앞에 쓰는 전치사 (D) for가 정답. to부정사의 의미상의 주어는 〈for+목적격〉으로 표시한다는 것을 기억하자.

7.

The office technician asked Ms. Green **to type** her password on the new laptop after switching on the device.

(A) typed (B) typing

(C) to type (D) would type

어휘 | technician 기술자 switch on 스위치를 켜다 device 기기

해석 | 그 사무 기술자는 새 노트북의 스위치를 켠 후에 그린 씨에게 비밀번호를 입력해 달라고 요청했다.

해설 | to부정사를 목적격 보어로 취하는 동사

빈칸은 동사 asked의 목적어 Ms. Green 뒤에 오는 목적격 보어 자리로, ask가 〈ask+목적어+to do〉의 형태로 목적격 보어 자리에 to부정사를 취하는 동사임을 알아야 풀 수 있는 문제이다. 따라서 정답은 (C) to type.

8.

Many people are happy **to sacrifice** a small amount of their own comfort to make a generous donation to the shelter each year.

(A) to sacrifice (B) sacrificed

(C) to be sacrificed (D) that sacrifice

어휘 | a small amount of 약간의 donation 기부(금) shelter 쉼터

해석 | 많은 사람들이 약간의 불편을 기꺼이 감수하면서 매년 그 쉼터에 아낌없이 기부한다.

해설 | to부정사의 부사 역할

빈칸 앞에 감정을 나타내는 표현이 나오면 감정의 원인을 설명해 주는 to부정사의 부사 역할을 떠올릴 수 있어야 한다. 따라서 happy의 원인을 나타내는 to부정사 (A) to sacrifice와 (C) to be sacrificed가 정답 후보인데, 주어인 Many people이 불편을 감수하는 것이므로 to부정사의 능동태인 (A)가 정답이다. happy 뒤에 that절이 올 수도 있으나 (D) that sacrifice에는 주어가 없으므로 오답이다.

9.

The chairman received a special invitation **to attend** the grand opening of Flayton Hotel this week.

(A) attending (B) is attending

(C) attends **(D) to attend**

어휘 | chairman 의장, 회장 grand opening 개업식

해석 | 의장은 이번 주에 있을 플레이턴 호텔의 개업식에 특별 초대를 받았다.

해설 | to부정사의 형용사 역할

빈칸 앞은 완전한 문장이므로 빈칸 이하는 수식어구가 들어가야 한다. 따라서 동사인 (B)와 (C)는 오답으로 제외. 선택지 중에서 앞의 명사 invitation을 수식할 수 있는 것은 형용사 역할을 하는 to부정사뿐이므로 정답은 (D) to attend.

10.

Because of the reservation system, it is easy to make the staff **notice** the number of visitors.

(A) to be noticed **(B) notice**

(C) notices (D) to notice

어휘 | reservation 예약

해석 | 예약 시스템 덕분에, 직원들이 방문객 수를 알게 하기 쉽다.

해설 | 원형부정사를 목적격 보어로 취하는 동사

빈칸은 〈사역동사(make)+목적어+목적격 보어〉인 5문형 구조의 목적격 보어 자리로, 사역동사는 원형부정사를 목적격 보어로 취한다. 따라서 정답은 (B) notice. 원형부정사는 사역동사(make, let, have), 동사 help, 지각동사(see, watch, hear)의 목적격 보어로 쓰인다는 것을 기억해 두자.

11.

For questions about the new branch of our appliance shop, please do not hesitate **to call** our hotline.

(A) call **(B) to call**

(C) to have called (D) calling

어휘 | branch 지사, 분점 appliance (가정용) 기기 hesitate to do ~하기를 주저하다 hotline 직통 전화

해석 | 저희 가전제품 판매점의 새 지점에 관해 질문이 있으시면, 주저하지 마시고 직통 전화로 전화해 주십시오.

해설 | to부정사를 목적어로 취하는 동사

빈칸은 타동사 hesitate의 목적어 자리이다. hesitate는 목적어로 to부정사를 취하는 동사이므로 (B) to call과 (C) to have called가 정답 후보. 문맥상 '주저하지 말고 전화를 해달라'라는 의미이므로 과거를 나타내는 완료형 (C)는 오답이고 (B)가 정답이다.

27

12.

Venetian Drapes is conducting a big sale **in order to** empty its stockrooms and give space for new products next month.

(A) prior to (B) as long as

(C) in order to (D) because

어휘 | conduct (특정한 활동을) 하다 empty 비우다; 비어 있는 stockroom 창고

해석 | 베니션 드레이프스 사는 창고를 비우고 다음 달에 들어올 신제품을 둘 공간을 만들기 위해 대대적인 할인을 하고 있다.

(A) ~ 전에 (B) ~하는 한

(C) ~하기 위해 (D) ~ 때문에

해설 | **to부정사의 부사 역할**

문맥상 '창고를 비우고 신제품을 둘 공간을 만들기 위해 할인을 하는 것'이므로 목적을 나타내는 to부정사가 와야 한다. 목적의 의미를 분명히 할 때 in order to *do*나 so as to *do*로 바꾸어 쓸 수 있으므로 정답은 (C) in order to.

13.

The popularity of our latest model has helped us **secure** a competitive advantage over the rest of the field.

(A) securities **(B) secure**

(C) for securing (D) be secured

어휘 | secure 얻어 내다; 안심하는 competitive 경쟁력 있는 advantage over ~에 대한 우위(유리한 위치) field 분야, 영역

해석 | 우리 최신 모델의 인기 덕분에 우리가 이 분야 나머지 업체들에 대해 경쟁력 있는 우위를 점할 수 있었다.

해설 | **원형부정사를 목적격 보어로 취하는 동사**

help는 목적격 보어로 to부정사와 원형부정사를 모두 취할 수 있는 동사이다. 따라서 원형부정사인 (B) secure, (D) be secured가 정답 후보인데, 빈칸 뒤에 secure의 목적어가 나오므로 능동태인 (B)가 정답이다.

14.

Please allow around three days for your bulk orders **to be processed** by our sales team.

(A) have been processed (B) are processed

(C) processing **(D) to be processed**

어휘 | around 약, ~쯤 bulk order 대량 주문 process 처리하다

해석 | 영업팀에서 귀하의 대량 주문을 처리하는 데에는 약 3일이 걸린다는 것을 감안해 주십시오.

해설 | **to부정사를 목적격 보어로 취하는 동사**

allow는 〈allow + 목적어 + to *do*〉의 형태로 to부정사를 목적격 보어로 취하는 대표적인 동사이다. 선택지에서 to부정사는 to be processed뿐이므로 정답은 (D). to부정사의 의미상의 주어인 your bulk orders는 '처리되는' 대상이므로 to부정사의 수동태가 쓰였다.

FINAL TEST

교재 81쪽

1. (C)	2. (B)	3. (B)	4. (C)	5. (A)	6. (C)	7. (B)	8. (A)	9. (B)	10. (A)
11. (D)	12. (D)	13. (B)	14. (C)	15. (D)	16. (B)	17. (A)	18. (B)	19. (A)	20. (B)
21. (C)	22. (C)								

1.

The Brazilian sculptor Edwin Pedrosa is best known for **incorporating** patriotic themes into his work.

(A) incorporation　　(B) incorporate
(C) incorporating　　(D) incorporates

어휘 | be known for ~로 알려져 있다　incorporate 포함하다
patriotic 애국적인

해석 | 브라질의 조각가 에드윈 페드로사 씨는 자신의 작품에 애국적인 주제를 포함시키는 것으로 가장 잘 알려져 있다.

해설 | **동명사 vs. 명사**
빈칸은 전치사 for의 목적어 자리로 명사 (A)와 동명사 (C)가 정답 후보. 명사와 달리 동명사는 뒤에 목적어를 취할 수 있으므로 뒤의 목적어 patriotic themes를 취할 수 있는 동명사 (C) incorporating 이 정답이다.

2.

Low unemployment rate and high consumer spending can greatly contribute **to** boosting the economy of a country.

(A) at　　　　　　(B) to
(C) for　　　　　　(D) on

어휘 | unemployment rate 실업률　consumer spending 소비자 지출　greatly 크게, 대단히　boost 신장시키다

해석 | 낮은 실업률과 높은 소비자 지출은 국가의 경제 부양에 크게 기여할 수 있다.

해설 | **〈전치사 to + 동명사〉 관용표현**
빈칸 앞 동사 contribute를 보자마자 contribute to doing(~하는 것에 기여하다)의 관용표현을 바로 떠올릴 수 있어야 한다. 정답은 (B) to. to부정사로 착각하기 쉬운 형태로 전치사 to 뒤의 품사를 묻는 문제로도 자주 출제되니 전치사 to가 쓰인 동명사 관용표현은 반드시 외워두자.

3.

Everyone on the team is looking forward to **working** with Mr. Wilken on another marketing campaign in the future.

(A) worker　　　　(B) working
(C) works　　　　(D) worked

어휘 | look forward to doing ~할 것을 고대하다, 기대하다

해석 | 그 팀의 모든 사람들은 향후 또 다른 마케팅 캠페인에서 윌켄 씨와 함께 일하기를 고대하고 있다.

해설 | **〈전치사 to + 동명사〉 관용표현**
look forward to doing의 관용표현을 알았다면 정답을 쉽게 찾을 수 있는 문제이다. 따라서 정답은 동명사 (B) working. 빈칸 앞의 to를 to부정사로 착각하여 동사원형을 답으로 고르는 실수를 하기 쉬우므로 대표적인 동명사 관용표현들은 평소에 외워두자.

4.

Read and follow the instructions carefully when assembling the dresser to avoid **damaging** the furniture.

(A) damages　　　(B) damaged
(C) damaging　　　(D) to damage

어휘 | assemble 조립하다　dresser 찬장, 드레서

해석 | 찬장을 조립할 때 가구가 손상되지 않도록 지시 사항을 주의 깊게 읽고 따르십시오.

해설 | **동명사를 목적어로 취하는 동사**
동명사를 목적어로 취하는 대표적인 동사 avoid가 빈칸 앞에 나왔으므로 정답을 바로 찾을 수 있어야 한다. 정답은 동명사 (C) damaging. to부정사만을 목적어로 취하는 동사들과 구별하여 알아두자.

5.

After **substantially** improving telecommunication networks around the country, the government has focused on transportation infrastructure.

(A) substantially　　(B) substantial
(C) substance　　　(D) substantive

어휘 | telecommunication network 전기 통신망
infrastructure 기반 시설

해석 | 전국의 전기 통신망을 상당히 개선한 후에, 정부는 교통 기반 시설에 중점을 두었다.

해설 | **부사 자리_동명사 수식**
빈칸 뒤 동명사 improving을 수식해 줄 수 있는 품사를 고르는 문제. 동명사는 동사의 성질을 지니고 있어 부사의 수식을 받을 수 있으므로 정답은 부사 (A) substantially. 형용사 (B) substantial은 명사를 수식하므로 오답이다.

6. Every month, *Runway* editors spend time **discussing** stories that will be published in the next issue of the magazine.

(A) discussion (B) discussed
(C) discussing (D) discuss

어휘 | publish (기사 등을) 게재하다, 출판하다 issue (정기 간행물의) 호

해석 | 매달 〈런웨이〉 지 편집자들은 잡지의 다음 호에 게재될 이야기들에 대해 논의하는데 시간을 보낸다.

해설 | **동명사 관용표현**
빈칸 앞의 spend time을 보자마자 동명사 관용표현인 〈spend 시간[돈] (in) *doing*〉을 떠올렸다면 쉽게 맞출 수 있는 문제. 따라서 정답은 동명사 (C) discussing.

7. The financial advisor did not have time to explain all of the budget details before **being interrupted** by the CEO.

(A) interrupted **(B) being interrupted**
(C) to interrupt (D) having interrupted

어휘 | financial advisor 재정 자문가 interrupt 중단시키다

해석 | 대표이사에 의해 중단되기 전에 그 재정 자문가가 예산 세부 사항 전부를 설명할 시간이 없었다.

해설 | **동명사의 태**
전치사 before의 목적어 자리로 선택지 중 동명사인 (B) being interrupted와 (D) having interrupted가 정답 후보. 문맥상 의미상의 주어(The financial advisor)와 빈칸의 동사 interrupt가 수동의 관계가 되어야 하므로 동명사의 수동형인 (B)가 정답. 능동형인 (D)가 쓰이려면 빈칸 뒤에 목적어가 있어야 하므로 오답이다.

8. During the trade fair, Robin will be busy **demonstrating** the features of the company's latest laser printers.

(A) demonstrating (B) to demonstrate
(C) demonstrate (D) demonstration

어휘 | trade fair 무역 박람회 feature 특징, 특색

해석 | 무역 박람회 동안에 로빈 씨는 회사의 최신 레이저 프린터의 특징을 시연하느라 바쁠 것이다.

해설 | **동명사 관용표현**
be busy *doing*은 '~하느라 바쁘다'라는 의미의 동명사 관용표현으로, 문맥상으로도 '시연하느라 바쁠 것이다'라는 뜻이 자연스럽다. 따라서 정답은 (A) demonstrating. 이와 같이 동명사가 포함된 관용표현을 하나의 표현으로 기억하자.

9. **Gathering** support for the credit card anti-abuse law has been more challenging than the group had expected.

(A) Gather **(B) Gathering**
(C) Gathered (D) Gatherings

어휘 | support 지지, 도움 challenging 어려운, 도전적인

해석 | 신용카드 남용 방지 법안에 대한 지지를 모으는 것은 그 단체가 예상했던 것보다 더욱 어려웠다.

해설 | **동명사 vs. 명사**
빈칸은 주어 자리이므로 동사 (A) Gather와 분사 (C) Gathered는 오답으로 제외. 뒤의 명사 support를 목적어로 취할 수 있는 것은 동사의 성질을 지닌 동명사이므로 정답은 (B) Gathering. 참고로 gathering이 명사로 쓰이면 '모임'이라는 뜻을 의미한다.

10. The book *Talk Wisely*, by Amanda Taylor, teaches readers effective ways of communicating in a formal **setting**.

(A) setting (B) standard
(C) condition (D) preparation

어휘 | effective 효과적인 way 방법, 태도 formal 공식적인

해석 | 아만다 테일러의 책 〈현명하게 말하기〉는 독자들에게 공식적인 장소에서 효과적으로 의사소통하는 방법을 가르쳐준다.
(A) 장소 (B) 기준
(C) 상태 (D) 준비

해설 | **명사 어휘 setting**
형용사 formal과 어울리면서 문맥에 알맞은 명사 어휘를 찾는 문제. 문맥상 '공식적인 장소에서 의사소통하는 방법을 가르쳐준다'는 의미가 가장 적절하므로 정답은 (A) setting.

11. The new intern, Colin Martel, surprised his colleagues and supervisors by **dressing** casually for the year-end office party.

(A) dressy (B) dressed
(C) dress **(D) dressing**

어휘 | colleague 동료 supervisor 상사, 관리자

해석 | 새로운 인턴인 콜린 마르텔 씨는 회사 연말 파티에서 편안하게 옷을 입음으로써 그의 동료들과 상사들을 놀라게 했다.

해설 | **동명사 vs. 명사**
빈칸은 전치사 by의 목적어 자리로 명사 역할을 해야 하는데, 그 중에서도 빈칸 뒤 부사 casually의 수식을 받을 수 있는 것은 동사의 성질을 지닌 동명사뿐이다. 따라서 정답은 (D) dressing. (C) dress를 명사로 보면 부사의 수식을 받을 수 없어 오답이고, 동사로 보더라도 전치사 by의 목적어가 될 수 없어 오답이다.

12.

Lancaster Consultants is **dedicated** to maximizing the profits of its clients through expertise and careful planning.

(A) dedicating (B) dedication
(C) dedicate (D) dedicated

어휘 | expertise 전문 지식 planning 계획

해석 | 랭캐스터 컨설턴트 사는 전문 지식과 세심한 계획을 통해 고객들의 수익을 극대화하는 것에 전념하고 있다.

해설 | 〈전치사 to + 동명사〉 관용표현
빈칸 뒤의 〈to + 동명사〉 형태에 주의하자. be dedicated to *doing*은 '~하는 것에 전념하다'라는 의미의 관용표현으로 문맥상으로도 적절하다. 따라서 (D)가 정답. dedicate는 타동사로 바로 뒤에 전치사를 동반할 수 없으므로 (A) dedicating은 오답이다.

13.

In a press release, Golden Harvest said its action plan includes **resolving** problems that seriously affect its productivity.

(A) resolves (B) **resolving**
(C) to resolve (D) resolved

어휘 | press release 보도 자료 action plan 사업 계획
resolve 해결하다 productivity 생산성

해석 | 보도 자료에서, 골든 하비스트 사는 사업 계획에 그들의 생산성에 심각하게 영향을 주는 문제점들을 해결하는 것을 포함하고 있다고 말했다.

해설 | 동명사를 목적어로 취하는 동사
빈칸은 동사 includes의 목적어 자리이다. 동사 include는 동명사만을 목적어로 취하는 대표적인 동사이므로 정답은 동명사 (B) resolving.

14.

For twenty-five years, Anaya Properties has been striving **to build** cutting-edge residential spaces for families with children.

(A) building (B) builds
(C) **to build** (D) build

어휘 | cutting-edge 최첨단의 residential 주택지의

해석 | 20년 동안 아나야 부동산은 자녀가 있는 가족들을 위한 최첨단 주거 공간을 짓기 위해 노력해왔다.

해설 | to부정사를 목적어로 취하는 동사
빈칸 앞의 동사 strive는 to부정사를 목적어로 취하는 대표적인 동사이다. 따라서 정답은 (C) to build. 동사의 목적어 자리의 알맞은 형태를 묻는 문제들이 자주 등장하므로, 특정 형태만을 목적어로 취하는 동사들은 반드시 기억해 두도록 하자.

[15-18] 이메일

To: Robert Canary <r_canary@heartcakes.com>
From: Alice Walker <a.walker@bakemate.com>
Date: September 15
Subject: Confirmation and delivery update

Dear Mr. Canary,

We appreciate your ¹⁵ considering Bakemate as a regular supplier for your bakery. This is to confirm that we received your orders yesterday.
Your delivery was originally scheduled for Wednesday, May 4. However, we regret to inform you that we are currently having difficulties with our transportation system. ¹⁶ **As a result, delivery of your items will be delayed.** We sincerely apologize for any trouble this issue may cause you. Expediting our delivery process is the primary ¹⁷ concern of our logistics department now. We will update you with the exact date of delivery as soon as we find a solution to the problem.
We thank you for ¹⁸ having chosen us as your supplier for so many years and look forward to continuing to serve you.

받는 사람: 로버트 카나리 <r_canary@heartcakes.com>
보내는 사람: 앨리스 워커 <a.walker@bakemate.com>
날짜: 9월 15일
제목: 확인 및 배송 정보 갱신

카나리 씨께,

귀하의 제과점의 단골 공급 업체로 베이크메이트 사를 ¹⁵ **고려해 주셔서** 감사합니다. 이 메일은 저희가 귀하의 주문을 어제 수령했다는 확인 메일입니다.

귀하의 배송은 원래 5월 4일 수요일로 예정되어 있었습니다. 그러나, 현재 저희의 수송 체계에 문제가 있다는 것을 알려드리게 되어 유감스럽습니다. ¹⁶ **결과적으로, 귀하의 물품 배송이 연기될 것입니다.** 이 문제로 귀하에게 발생할 수 있는 문제에 대해 대단히 죄송합니다. 저희의 배송 과정을 더 신속하게 하는 것이 현재 저희 물류 부서의 주요 ¹⁷ **관심사입니다.** 저희가 문제에 대한 해결책을 찾는 대로 정확한 배송 일자를 귀하께 알려드리도록 하겠습니다.

오랜 시간 동안 저희를 귀사의 공급 업체로 ¹⁸ **선택해 주셔서** 감사드리며 앞으로도 계속 귀사와 거래하기를 고대합니다.

Yours truly,

Alice Walker
Sales Manager, Bakemate

베이크메이트, 영업 관리자
앨리스 워커 드림

어휘 | supplier 공급 업체, 공급자 regret 유감스럽게 생각하다, 후회하다 transportation system 수송 체계 sincerely 진심으로 apologize for ~에 대해 사과하다 expedite 더 신속히 처리하다 primary 주요한, 주된 logistics department 물류 부서 update 가장 최근의 정보를 알려주다 serve (상품·서비스를) 제공하다

15. (A) connecting
(B) informing
(C) communicating
(D) considering

해석 | (A) 연결하다　　(B) 알리다
　　　(C) 의사소통하다　(D) 고려하다

해설 | **동사 어휘 consider**
문맥상 '베이크메이트 사를 단골 공급 업체로 고려해 주셔서 감사하다'라는 내용이 적절하다. 따라서 정답은 (D) considering. 타동사 appreciate의 목적어로 동명사가 쓰인 형태이다.

16. (A) Most of our baking tools are on sale.
(B) As a result, delivery of your items will be delayed.
(C) The local courier has taken responsibility for this issue.
(D) In addition, we have received your returned items.

해석 |
(A) 저희 제빵 기구의 대부분은 판매 중입니다.
(B) 결과적으로, 귀하의 물품 배송이 연기될 것입니다.
(C) 지역의 택배 회사가 이 문제에 대한 책임을 졌습니다.
(D) 게다가, 저희는 귀하의 반송 물품들을 수령했습니다.

해설 | **알맞은 문장 고르기**
알맞은 문장 고르기 문제는 빈칸 주변의 문맥을 잘 파악해야 한다. 빈칸 앞에 수송 체계에 문제가 있다는 것을 알리고 빈칸 뒤에는 그 문제에 대한 사과를 하고 있다. 따라서 빈칸에는 수송 체계의 문제로 인해 발생되는 문제가 언급되는 것이 가장 자연스러우므로 정답은 (B).

17. **(A) concern**
(B) concerning
(C) to concern
(D) concerned

해설 | **동명사 vs. 명사**
빈칸은 주격 보어 자리이므로 명사 (A) concern과 동명사 (B) concerning이 정답 후보이다. 그 중에서 빈칸 앞의 형용사 primary의 수식을 받을 수 있는 것은 명사뿐이므로 정답은 (A).

18. (A) being chosen
(B) having chosen
(C) choice
(D) choose

해설 | **동명사의 시제**
빈칸 뒤 목적어 us를 취하면서 앞의 전치사 for의 목적어로 쓰일 수 있는 것은 동명사뿐이므로 (A)와 (B)가 정답 후보. 그런데 의미상 주어인 you와 선택지의 동사 choose가 능동의 관계이므로 동명사의 수동형인 (A)는 오답이다. 따라서 정답은 (B) having chosen. 동명사의 시점이 주절 동사의 시점보다 이전인 경우에 완료형 〈having p.p.〉를 써서 나타낼 수 있다.

[19-22] 편지

December 5

Melissa Sunders
4522 Clark Street
Patchogue, NY 11772

Dear Ms. Sunders,

We are writing to let you know that we have received your application for the copywriter position. Although our editors have reviewed your [19] qualifications

12월 5일

멜리사 선더스
클라크 가 4522번지
팟처그, 뉴욕 주 11772

선더스 씨께,

저희가 카피라이터 직에 대한 귀하의 지원서를 받았음을 알려드리고자 편지를 씁니다. 저희 편집자들이 공석에 대한 귀하의 [19] **자격**을 검토하고 귀하의 자격이 꽤 인상 깊다고 생각했음에도 불구하고, 귀하께서

for the vacancy and found your credentials rather impressive, you were not selected for this position. However, Ework Publishing International is interested in your professional background. **20 We are in need of talented individuals to join our growing editorial team.** Enclosed is another offering. In addition to **21 writing** news events, this position includes some reporting work. It might be more suited to your interests. You are encouraged **22 to contact** us again if you wish to apply for this job.

Best regards,

Joan Hopkins
HR Specialist, Ework Publishing International

는 이 자리에 선발되지 않으셨습니다.

그러나, 이워크 퍼블리싱 인터내셔널 사는 귀하의 전문적인 배경에 관심이 있습니다. **20 저희는 성장하고 있는 편집팀에 합류할 재능 있는 사람이 필요합니다.** 동봉된 것은 다른 일자리 제안입니다. 뉴스 사건들을 **21 작성하는** 것에 더하여, 이 직책은 일부 보도 업무를 포함합니다. 이것이 귀하의 관심에 더 적합할 것 같습니다. 귀하께서 이 일에 지원하고 싶으시면 저희에게 다시 **22 연락 주시기를** 권해드립니다.

이워크 퍼블리싱 인터내셔널 사, 인사 전문가
조앤 홉킨스 드림

어휘 | application 지원(서) **credentials** 자격, 자격증 **rather** 꽤 **impressive** 인상적인 **be interested in** ~에 관심이 있다 **in addition to** ~에 더하여 **reporting** 보도 **be suited to** ~에 적합하다 **apply for** ~에 지원하다

19. (A) qualifications
(B) establishments
(C) facilities
(D) contributions

해석 | (A) 자격　(B) 기관
　　　(C) 시설　(D) 기부금

해설 | 명사 어휘 qualification
빈칸 뒤에 '자격이 인상적이었다'라는 것으로 보아 문맥상 '지원자의 자격을 검토해 봤다'는 의미가 자연스러우므로 (A) qualifications가 정답이다.

20. (A) We are sending a new résumé for your review.
(B) We are in need of talented individuals to join our growing editorial team.
(C) Please wait for your second interview schedule.
(D) Rest assured that we will notify you about future career opportunities.

해석 |
(A) 귀하께서 검토할 수 있도록 새로운 이력서를 보내드립니다.
(B) 저희는 성장하고 있는 편집팀에 합류할 재능 있는 사람이 필요합니다.
(C) 귀하의 두 번째 면접 일정을 기다려 주십시오.
(D) 미래의 직업 기회에 대해 저희가 귀하께 알려드릴 것을 확신하셔도 좋습니다.

해설 | 알맞은 문장 고르기
빈칸 앞에서 선더스 씨의 전문적인 배경에 관심이 있다고 했고 뒤에서는 다른 일자리를 제안하고 있다. 따라서 지원한 자리 외에도 다른 직책에 대해 추가 모집을 한다는 내용이 문맥상 가장 적절하므로 정답은 (B).

21. (A) write
(B) written
(C) writing
(D) writer

해설 | 동명사 vs. 명사
빈칸은 구전치사 in addition to의 목적어 자리이므로 동명사 (C) writing과 명사 (D) writer가 정답 후보이다. 명사는 뒤에 목적어를 취할 수 없으나 동사의 성질을 가지고 있는 동명사는 뒤에 목적어 us를 취할 수 있으므로 (C)가 정답이다.

22. (A) contacting
(B) contacts
(C) to contact
(D) contact

해설 | to부정사를 목적격 보어로 취하는 동사
빈칸 앞 encourage는 to부정사를 목적격 보어로 취하는 대표적인 동사이다. 수동의 의미로 쓰일 때는 be encouraged to do의 형태로 '~하라고 권장 받다'라는 의미를 나타내므로 정답은 (C) to contact.

FINAL TEST

1. (A)	2. (C)	3. (A)	4. (D)	5. (B)	6. (D)	7. (D)	8. (D)	9. (C)	10. (B)
11. (C)	12. (D)	13. (A)	14. (B)						

1.

The cost of our insurance packages depends on the <u>assessed</u> value of the vehicles.

(A) assessed
(B) assessing
(C) assess
(D) to assess

어휘 | insurance 보험　depend on ~에 달려있다　assess 감정하다
value 값, 가치

해석 | 우리 보험 패키지의 가격은 차량의 감정 가격에 따라 다르다.

해설 | **현재분사 vs. 과거분사**
관사 the와 명사 value 사이에 위치한 것으로 보아 빈칸은 형용사 자리이다. 따라서 선택지 중 형용사로 쓰이는 과거분사 (A) assessed와 현재분사 (B) assessing이 정답 후보. 이때 동사 assess와 명사 value의 관계가 '감정된 가격'이라는 수동의 의미이므로 과거분사 (A)가 정답이다.

2.

Because of his background in the field of architecture, Dave was able to offer **valuable** advice for the project.

(A) valued
(B) values
(C) valuable
(D) value

어휘 | background 학력, 배경　architecture 건축학

해석 | 건축학 분야의 학력 덕분에, 데이브 씨는 그 프로젝트에 귀중한 조언을 해줄 수 있었다.

해설 | **분사 vs. 형용사**
빈칸은 명사 advice를 수식하는 자리로 과거분사 (A)나 형용사 (C)가 정답 후보이다. valued는 '귀중한'이란 뜻으로 형용사 valuable과 의미가 비슷하지만 의미가 유사할 경우 명사 앞에는 형용사가 분사보다 우선하므로 정답은 (C).

3.

The previous leadership seminar conducted by the CEO had a <u>lasting</u> effect on the junior managers.

(A) lasting
(B) lasted
(C) lastly
(D) lasts

어휘 | previous 이전의　conduct (특정한 활동을) 하다

해석 | 대표이사가 진행한 이전의 리더십 세미나는 대리 직급자들에게 지속적인 영향을 미쳤다.

해설 | **분사 형태의 형용사**
빈칸은 뒤의 명사 effect를 수식하는 형용사 역할을 해야 하므로 부사 (C)와 동사 (D)는 오답으로 제외. lasting은 진행 중인 동작의 의미가 내포된 현재분사 형태로 굳어져 사용되는 형용사로, '지속적인'이라는 의미로 문맥에도 알맞다. 따라서 정답은 (A).

4.

<u>Having provided</u> catering services to various events for ten years, Blanc is known for its signature dishes carefully made to perfection.

(A) Provide
(B) To provide
(C) Provided
(D) Having provided

어휘 | catering service 출장요리 서비스　be known for ~로 알려져 있다
perfection 완벽

해석 | 10년간 다양한 행사에 출장요리 서비스를 제공해오면서, 블랑 사는 그들의 대표적인 요리를 정성 들여서 완벽하게 만드는 것으로 알려져 있다.

해설 | **분사구문의 시제**
콤마 뒤에 완전한 문장이 나오므로, 콤마 앞에 수식어구가 쓰였음을 알 수 있다. 따라서 동사원형인 (A)는 오답으로 제외. 문맥상 10년간 서비스를 제공해 온 것이 주절의 현재 시제(is)보다 이전이므로 분사구문의 완료형 (D) Having provided가 정답. to부정사가 문두에 오는 경우, '~하기 위해'라는 목적을 나타내므로 문맥상 어울리지 않아 (B)는 오답이다. (C) Provided는 Having been이 생략된 분사구문의 수동형으로도 생각할 수 있지만 빈칸 뒤에 목적어가 있고 문맥상 능동의 의미이므로 오답.

5.

<u>Founded</u> in 1978, Roadside employs experienced mechanics who specialize in restoring old vehicles.

(A) Founding
(B) Founded
(C) To found
(D) Found

어휘 | mechanic 정비공　specialize in ~을 전문으로 하다　restore 복원하다

해석 | 1978년에 설립된 로드사이드 사는 낡은 차량을 복원하는 일을 전문으로 하는 경험 많은 정비공들을 고용한다.

해설 | **분사구문의 태**
콤마 뒤에 완전한 문장이 나오며, 동사 found의 의미상의 주어가 Roadside로 주절과 일치하므로 분사구문이 쓰였음을 알 수 있다. 의미상의 주어 Roadside와 동사 found가 수동의 관계에 있으므로 정답은 (B) Founded. 분사구문에서 주절의 주어와 동사의 관계가 능동이면 현재분사를, 수동이면 과거분사를 쓴다. 참고로 분사구문의 수동형인 being p.p에서 분사 앞의 being은 생략 가능하다.

6.

Please read the **enclosed** brochure and let us know if you are interested in signing up for the yoga classes.

(A) controlled (B) accepted

(C) extended **(D) enclosed**

어휘 | be interested in ~에 관심이 있다 sign up for ~을 신청하다

해석 | 동봉된 책자를 읽으시고 요가 수업을 신청하는 것에 관심이 있으시다면 저희에게 알려주십시오.
(A) 세심히 관리된 (B) 일반적으로 인정된
(C) 연장된 (D) 동봉된

해설 | **형용사 어휘 enclosed**
선택지를 보니 분사 형태로 굳어진 형용사들이다. 형용사 어휘를 고르는 문제는 수식하는 명사와의 의미 관계를 따져보면 정답을 쉽게 찾을 수 있다. 문맥상 '동봉된 책자'의 의미가 가장 적절하므로 정답은 (D). enclosed는 과거분사 형태로 굳어져 사용되는 대표적인 형용사로 단어의 의미 그대로 기억해 두자.

7.

Many people hire professional accountants to prepare their taxes because the process is so **complicated**.

(A) complicating (B) complicate

(C) complicatedly **(D) complicated**

어휘 | professional 전문적인; 전문가 accountant 회계사

해석 | 절차가 너무 복잡하기 때문에 많은 사람들은 세금 신고를 준비하기 위해서 전문 회계사를 고용한다.

해설 | **분사 형태의 형용사**
빈칸은 주격 보어 자리로 주어 the process의 상태를 보충 설명해 주고 있으므로 형용사 역할을 하는 현재분사 (A) complicating과 과거분사 (D) complicated가 정답 후보이다. complicated는 '복잡한'이라는 의미의 과거분사 형태로 굳어진 형용사이므로 문맥상으로도 알맞다. 따라서 정답은 (D).

8.

Designers at Lily Clothing are always knowledgeable of the strong influences **shaping** the fashion industry.

(A) shaped (B) are shaped

(C) is shaping **(D) shaping**

어휘 | knowledgeable 아는 것이 많은 influence 영향(력)

해석 | 릴리 의류 매장의 디자이너들은 패션 산업을 형성하는 강력한 영향력에 대해 항상 많이 알고 있다.

해설 | **현재분사 vs. 과거분사**
문장 성분이 모두 갖추어져 있으므로 동사 형태인 (B) are shaped와 (C) is shaping은 오답. 타동사 shape는 명사 influences를 뒤에서 수식하는 현재분사일 때 뒤에 목적어 the fashion industry를 취할 수 있으므로 (D) shaping이 정답.

9.

Employing over 20,000 workers across the globe, Cooler Corporation is one of the world's largest beverage manufacturers.

(A) Employment (B) Employ

(C) Employing (D) Employed

어휘 | across the globe 전 세계에서 beverage 음료

해석 | 전 세계에서 20,000명 이상의 근로자를 고용하였고, 그로 인해 쿨러 사는 세계에서 가장 큰 음료 제조사 중 하나이다.

해설 | **분사구문**
빈칸이 포함된 구는 콤마 이하의 절을 수식하는 부사 역할을 하므로 명사 (A)와 동사 (B)는 오답. 전 세계에서 많은 근로자들을 고용하였고 그 결과 가장 큰 음료 제조사가 된 것이므로 결과를 나타내는 분사구문이 쓰였음을 알 수 있다. 주절의 주어 Cooler Corporation과 동사 employ가 능동의 관계이므로 정답은 현재분사 (C) Employing.

10.

We found it extremely **disappointing** that the Southgate Foundation chose to cancel the technology convention.

(A) disappoint **(B) disappointing**

(C) disappointment (D) disappointed

어휘 | extremely 매우, 몹시 cancel 파기하다, 취소하다 convention 협약, 협정

해석 | 우리는 사우스게이트 재단이 기술 협약을 파기하기로 했다는 것에 매우 실망했다.

해설 | **감정 관련 분사**
〈주어 + 타동사 + 목적어 + 목적격 보어〉의 5문형으로, 긴 목적어인 that절을 문장의 뒤로 보내고 대신 가목적어 it을 쓴 구조. 따라서 빈칸은 목적어의 성질, 상태를 나타내는 목적격 보어 자리이므로 형용사 역할을 하는 분사 (B) disappointing과 (D) disappointed가 정답 후보이다. 문맥상 진목적어 that절의 내용은 그 자체가 실망스러운 감정을 일으키는 원인이므로 정답은 현재분사 (B). 목적어와 목적격 보어가 동격의 관계가 아니므로 명사 (C)는 오답이다.

11.

As **specified** in the contract, the completion date for the office renovation project is August 31.

(A) specifies (B) specifying

(C) **specified** (D) specification

어휘 | specify 명시하다 contract 계약서 renovation 개조, 수선

해석 | 계약서에 명시된 대로, 사무실 개조 프로젝트의 완료 날짜는 8월 31일이다.

해설 | **분사구문의 태**

접속사 as가 이끄는 절에 주어와 동사가 모두 없는 것으로 보아 접속사가 남아있는 분사구문이 쓰였다는 것을 알 수 있다. 따라서 빈칸에 분사가 와야 하는데, 동사 specify와 생략된 주어 the completion date와의 관계가 수동이므로 정답은 과거분사인 (C) specified이다. 이처럼 접속사가 남아있는 분사구문의 분사 자리를 묻는 문제가 자주 출제되고 있으니 현재분사와 과거분사의 구별법을 반드시 알아두자.

12.

Popular among cooks all over the world, Abdullah Old Market is home to stores selling spices **imported** from Iran and India.

(A) importing (B) imports

(C) import (D) **imported**

어휘 | among ~ 사이에 spice 향신료, 양념

해석 | 전 세계의 요리사들 사이에서 유명한 압둘라 올드 마켓은 이란과 인도에서 수입된 향신료를 판매하는 매장들의 본고장이다.

해설 | **현재분사 vs. 과거분사**

빈칸 이하가 명사 spices를 수식하는 구조로, 형용사 역할을 할 수 있는 현재분사 (A) importing과 과거분사 (D) imported가 정답 후보. 수식하는 명사 spices와 동사 import의 관계가 '수입된 향신료'라는 수동의 관계이므로 과거분사가 적절하다. 따라서 정답은 (D). 빈칸 뒤에 목적어가 없는 것을 보고 과거분사를 정답으로 고를 수도 있다.

13.

The **growing** number of foreign visitors in the country proves that the Tourism Ministry's marketing campaign is a complete success.

(A) **growing** (B) closed

(C) experienced (D) decreasing

어휘 | prove 증명하다, 입증하다 complete 완벽한

해석 | 국가의 증가하는 외국인 방문자의 수는 관광청 마케팅 캠페인의 완벽한 성공을 증명한다.

(A) 증가하는 (B) 닫힌

(C) 경험이 있는 (D) 감소하는

해설 | **형용사 어휘 growing**

뒤의 명사 number를 수식하면서 문맥에 맞는 형용사 어휘를 찾는 문제. 문맥상 '증가하는 외국인 방문자의 수가 마케팅 캠페인의 성공을 증명한다'는 의미이므로 정답은 (A). growing은 '증가하는'이란 의미의 현재분사 형태로 굳어진 형용사로 기억하자.

14.

After **having been** registered as a premium member for five years, you are entitled to a free phone and a plan upgrade.

(A) had been (B) **having been**

(C) has been (D) will be

어휘 | register A as B A를 B로 등록하다 be entitled to ~할 자격이 있다

해석 | 프리미엄 회원으로 등록되고 5년 뒤에, 귀하께서는 무료 휴대폰과 요금제 업그레이드를 받으실 자격이 됩니다.

해설 | **분사구문의 시제**

접속사 after 뒤에 절이 와야 하는데 주어와 동사가 없는 것으로 보아 접속사가 남아있는 분사구문인 것을 알 수 있다. 주절의 현재 시제 (are)보다 프리미엄 회원 등록이 먼저 일어난 일이므로 분사구문의 완료형을 사용한 (B) having been이 정답.

FINAL TEST

교재 99쪽

1. (C)	2. (D)	3. (A)	4. (D)	5. (B)	6. (B)	7. (A)	8. (A)	9. (C)	10. (A)
11. (B)	12. (D)	13. (A)	14. (A)	15. (D)	16. (A)	17. (C)	18. (B)	19. (A)	20. (A)
21. (B)	22. (B)								

1.

The cabin crew received recognition for its **skillful** management of a medical emergency during a flight.

(A) skillfully (B) skill

(C) skillful (D) skills

어휘 | cabin crew 승무원 recognition for ~에 대한 인정
emergency 응급, 비상사태

해석 | 그 승무원들은 비행 중 응급 의료 상황을 다루는 숙련된 솜씨에 대해 인정받았다.

해설 | **형용사 자리_한정사 + 형용사 + 명사**
한정사인 소유격 its의 수식을 받으면서 뒤의 명사 management를 수식하는 품사가 빈칸에 와야 한다. 선택지 중에서 명사를 수식할 수 있는 것은 형용사인 skillful뿐이므로 정답은 (C).

2.

Clothing purchased at the Pink Closet is **refundable** for seven days based on the shop's return policy.

(A) refunding (B) refunds

(C) refund **(D) refundable**

어휘 | based on ~에 근거하여 refundable 환불이 가능한
return policy 환불 정책

해석 | 핑크 클로젯에서 구매한 옷은 매장의 환불 정책에 근거하여 7일 동안 환불이 가능하다.

해설 | **형용사 자리_주격 보어**
빈칸은 주어인 Clothing의 성질을 나타낼 수 있는 주격 보어 자리이다. 문맥상 '7일 동안 환불이 가능하다'는 의미가 자연스러우므로 (D) refundable이 정답이다. (A) refunding은 '옷이 환불한다'는 의미가 되어 문맥상 어색하므로 오답. 명사 (B)와 (C)는 주어인 옷과 환불이 동격 관계가 될 수 없으므로 오답.

3.

Opening a second location on Sixth Street will be favorable to **several** clients of Super Laundry.

(A) several (B) less

(C) each (D) one

어휘 | second location 2호점 favorable 편리한, 유리한

해석 | 6번 가에 2호점을 개업하는 것은 슈퍼 세탁소의 몇몇 고객들에게 편리할 것이다.

해설 | **수량 표현**
빈칸 뒤 가산명사 복수형인 clients를 수식하는 수량 표현을 고르는 문제이다. 선택지 중에서 가산명사 복수형과 어울려 쓰는 수량 표현은 several뿐이므로 정답은 (A). (C) each와 (D) one은 가산명사의 단수형과 쓰이고 (B) less는 불가산명사와 쓰이는 수량형용사이므로 모두 오답이다.

4.

The advisor has **a little** influence on the mayor's decision, but not enough to make a difference.

(A) various (B) much

(C) few **(D) a little**

어휘 | advisor 고문 have influence on ~에 영향을 미치다 mayor 시장 make a difference 차이를 만들다

해석 | 그 고문은 시장의 결정에 조금 영향을 미쳤지만 차이를 만들 만큼 충분하지는 않았다.

해설 | **수량형용사**
빈칸 뒤의 불가산명사 influence와 어울려 쓸 수 있는 수량형용사는 (B) much와 (D) a little. 문맥상 '영향이 적었다'는 것이 자연스러우므로 정답은 (D). (A) various와 (C) few는 가산명사의 복수형과 어울리는 수량 표현들이므로 오답.

5.

Researchers at the Animal Institute were able **to explain** all the probable causes of the disease affecting livestock in Wales.

(A) to be explained **(B) to explain**

(C) have explained (D) being explained

어휘 | probable 개연성 있는 disease 질병 affect 영향을 미치다
livestock 가축

해석 | 동물 협회 연구가들은 웨일즈 지역에서 가축에게 영향을 주는 질병의 개연성 있는 원인 모두를 설명할 수 있었다.

해설 | **〈be동사 + 형용사 + to부정사〉 구문**
형용사 able은 be able to do 형태로 to부정사를 동반하는 구문으로 사용된다. 따라서 to부정사인 (A) to be explained와 (B) to explain이 정답 후보. 주어 Researchers가 '설명할 수 있는' 것이므로 능동태인 (B)가 정답이다.

6.

Some information about the fire will remain **confidential** until the investigation is finished.

(A) confident
(B) **confidential**
(C) confidentially
(D) confidence

어휘 | remain 계속 ~이다 investigation 수사, 조사 confidential 기밀의

해석 | 그 화재에 대한 몇몇 정보는 수사가 끝날 때까지 기밀로 유지될 것이다.

해설 | 혼동하기 쉬운 형용사
remain은 대표적인 2문형 동사로 목적어 없이 보어를 취한다. 따라서 빈칸은 Some information을 보충 설명하는 주격 보어 자리로, 형용사 (A) confident와 (B) confidential, 명사 (D) confidence가 정답 후보. 문맥상 '정보가 기밀로 유지될 것이다'라는 의미가 자연스러우므로 정답은 (B). (A) confident는 '확신하는'이라는 의미로 문맥에 맞지 않아 오답이다. (D) confidence는 주어 Some information과 동격 관계가 될 수 없으므로 오답이다.

7.

Moseby Office Solutions is looking for account executives who are **capable** of working on multiple projects at a time.

(A) **capable**
(B) capability
(C) capably
(D) capabilities

어휘 | look for ~을 찾다 multiple 다양한, 다수의 at a time 한 번에

해석 | 모스비 오피스 솔루션즈 사는 한 번에 다양한 프로젝트에 근무할 수 있는 회계 담당자를 찾고 있다.

해설 | 〈be동사＋형용사＋전치사〉 구문
특정 전치사를 동반하는 형용사 관용표현 중 '~에 유능하다'라는 뜻의 be capable of를 알고 있었다면 쉽게 풀 수 있는 문제. 따라서 정답은 (A) capable. 주격 보어 자리에 명사도 올 수 있지만 보충 설명하는 대상인 account executives가 capability와 동격 관계가 될 수 없으므로 명사인 (B) capability와 (D) capabilities는 오답이다.

8.

Ms. Gladwell is a busy sales manager, but she is always **willing** to help her staff members meet their targets.

(A) **willing**
(B) subjective
(C) necessary
(D) essential

어휘 | meet *one's* target 목표를 달성하다

해석 | 글래드웰 씨는 바쁜 영업 관리자이지만, 그녀는 항상 직원들의 목표 달성을 위해 그들을 기꺼이 돕는다.
(A) 기꺼이 하는
(B) 주관적인
(C) 필요한
(D) 필수적인

해설 | 형용사 어휘 willing
빈칸에 어울리는 형용사 어휘를 고르는 문제. 형용사 자리 뒤에 to부정사가 나온다면 관용표현을 묻는 문제는 아닌지 의심해 보자. be willing to *do*는 '기꺼이 ~하다'라는 의미로 문맥에 가장 알맞으므로 정답은 (A).

9.

Dorothy Mayer makes her software reviews **educational** for readers with limited knowledge of Illustrador's graphic design programs.

(A) educated
(B) educate
(C) **educational**
(D) education

어휘 | review 보고서, 검토 limited 한정된, 제한된 knowledge 지식

해석 | 도로시 메이어 씨는 일러스트레이더 사의 그래픽 디자인 프로그램에 대한 지식이 빈약한 독자들을 위해 자신의 소프트웨어 보고서를 교육적으로 만든다.

해설 | 형용사 자리_목적격 보어
〈make＋목적어＋목적격 보어〉의 5문형 구조로 목적격 보어 자리에 알맞은 품사를 고르는 문제이다. 명사, 형용사, 동사원형이 동사 make의 목적격 보어로 쓰일 수 있으므로 목적어와의 의미 관계를 파악하여 정답을 찾아야 한다. 문맥상 목적어 her software reviews가 '교육적'이라는 성질을 설명하는 것이 가장 적절하므로 정답은 형용사 (C) educational.

10.

For security purposes, high-definition cameras are strategically installed on **every** floor of the commercial building.

(A) **every**
(B) all
(C) some
(D) many

어휘 | strategically 전략적으로 commercial building 상업용 건물

해석 | 보안 목적으로, 고화질 카메라들이 전략적으로 상업용 건물의 모든 층에 설치되어있다.

해설 | 부정형용사
명사 floor를 수식하는 부정형용사를 고르는 문제. 선택지 중에서 가산명사의 단수형 floor를 수식할 수 있는 부정형용사는 every뿐이므로 정답은 (A). (B) all과 (C) some은 가산명사 복수형과 불가산명사와 함께 쓰이고, (D) many는 가산명사의 복수형만 수식할 수 있으므로 모두 오답이다.

11.

The personnel manager is responsible **for** updating the training curriculum regularly to include any changes in office rules.

(A) of (B) for

(C) on (D) at

어휘 | update 갱신하다 curriculum 교육과정

해석 | 인사부장은 회사 규정의 모든 변경 사항을 포함시키기 위해 정기적으로 연수 교육과정을 갱신하는 일을 담당하고 있다.

해설 | 〈be동사 + 형용사 + 전치사〉 구문

빈칸 앞 형용사 responsible을 보자마자 be responsible for(~을 담당하다) 표현을 바로 떠올릴 수 있어야 한다. 따라서 정답은 (B) for. be responsible for는 토익에 자주 출제되는 전치사 동반 형용사 관용표현으로 반드시 기억해 두자.

12.

For the annual management lecture series, the advertising director did his presentation on **successful** marketing methods.

(A) success (B) successfully

(C) successive (D) successful

어휘 | annual 연례의, 매년의 method 방법

해석 | 일련의 연례 경영 강의로, 광고 이사는 성공적인 마케팅 방법들에 대한 발표를 했다.

해설 | 혼동하기 쉬운 형용사

빈칸은 전치사 on의 목적어인 복합명사 marketing methods를 수식하는 형용사 자리이다. 따라서 명사 (A) success와 부사 (B) successfully는 오답으로 제외. 문맥상 '성공적인 마케팅 방법들'이라는 뜻이 적절하므로 정답은 (D) successful. (C) successive는 '연속적인, 연이은'이라는 뜻이므로 문맥에 맞지 않아 오답이다.

13.

Qatar is set to become a perfect place for foreign investment in the **foreseeable** future because of its relaxed business regulations.

(A) foreseeable (B) foreseen

(C) foreseeably (D) foreseeing

어휘 | be set to *do* ~할 예정이다 investment 투자 regulation 규제

해석 | 카타르는 완화된 기업규제 때문에 가까운 미래에 외국인 투자의 완벽한 장소가 될 것이다.

해설 | 형용사 자리_한정사 + 형용사 + 명사

명사 future 앞에 빈칸이 있는 것으로 보아 명사를 수식하는 품사를 고르는 문제이므로 부사 (C) foreseeably는 오답으로 제외. '예측할 수 있는'이라는 뜻의 형용사 foreseeable이 future와 함께 '가까운 미래, 예측할 수 있는 미래'의 뜻으로 문맥에 가장 적절하므로 정답은 (A). 현재분사 형태의 형용사 (D) foreseeing은 '선견지명이 있는'이라는 뜻으로 문맥상 어울리지 않아 오답.

14.

The CEO is worried that the company is becoming increasingly **dependent** on a few key markets in Asia and Europe.

(A) dependent (B) depending

(C) dependable (D) dependence

어휘 | increasingly 점점, 더욱 더

해석 | 대표이사는 회사가 아시아와 유럽의 몇몇 주요 시장에만 점점 의존하게 되는 것을 우려하고 있다.

해설 | 혼동하기 쉬운 형용사

빈칸은 2문형 동사 become의 보어이면서 부사 increasingly의 수식을 받는 형용사 자리이다. 따라서 선택지 중 (A)와 (C)가 정답 후보. dependent(의존하는)와 dependable(믿을 수 있는)은 형태는 비슷하지만 의미가 다른 형용사로 문맥상 (A) dependent가 자연스럽다.

[15-18] 기사

AUGUSTA, June 2—Augusta mayor Alfred Bates announced the approval for the construction of the Gilmore Shopping Mall, a project proposed by Gilmore Estates a month ago. <u>**15** The mayor believes the project will help to boost the town's economy.</u> "Thanks to this new shopping mall, our city will earn more than $20 million in taxes and tourism revenue **16** <u>each</u> year," Bates explained.

Despite these benefits, the announcement received a mixed response and has become **17** <u>controversial</u>. Local residents, who are used to the quiet area, are concerned that they will now be **18** <u>subject</u> to noise and pollution from the traffic increase. However, Bates said he was confident that the opponents will

오거스타, 6월 2일—오거스타 시장 알프레드 베이츠는 길모어 이스테이츠 사가 한 달 전 제안한 프로젝트인 길모어 쇼핑몰 건설에 대한 승인을 발표했다. **15** 시장은 이 프로젝트가 도시의 경기를 신장시키는 데 도움이 될 것이라고 믿는다. "이 새로운 쇼핑몰 덕분에, 우리 시는 세금과 관광 수입으로 **16** 매년 2천만 달러 이상을 벌어들일 것입니다,"라고 베이츠는 설명했다.

이러한 혜택들에도 불구하고, 그 발표는 엇갈리는 반응을 얻었고 **17** 논란이 많아졌다. 조용한 지역이 익숙한 지역 주민들은 교통량의 증가로 인한 소음과 공해를 **18** 받기 쉬워질 것이라고 우려했다. 그러나, 베이츠는 반대자들이 길모어 쇼핑몰의 긍정적인 효과들을 본다면 그들의 마음을 바꿀 것이라는 것을 확신한다고 말했다.

change their minds once they see the positive effects of the Gilmore Shopping Mall.

어휘 | approval 승인, 찬성 propose 제안하다 boost 신장시키다, 북돋우다 mixed (의견, 생각 등이) 엇갈리는, 뒤섞인 controversial 논란이 많은 resident 거주자 pollution 공해, 오염 confident 확신하는 opponent (~에 대한) 반대자

15. (A) Environmentalists immediately expressed their disapproval of the decision.
(B) The building is expected to cost the town a lot of money.
(C) However, the project has already posed many unforeseen problems.
(D) The mayor believes the project will help to boost the town's economy.

해석 |
(A) 환경운동가들은 즉시 그 결정에 대한 반감을 드러냈다.
(B) 그 건물로 인해 시에서 많은 비용을 치를 것으로 예상된다.
(C) 그러나, 그 프로젝트는 이미 예상치 못한 많은 문제들을 제기해왔다.
(D) 시장은 이 프로젝트가 도시의 경기를 신장시키는 데 도움이 될 것이라고 믿는다.

해설 | 알맞은 문장 고르기
빈칸 앞에 시장의 건설 승인 발표에 대한 내용이 나오고 빈칸 뒤에서 시장의 기대감이 직접적으로 인용되고 있으므로 그 사이에는 쇼핑몰 건축에 대한 시장의 긍정적인 생각이 나오는 것이 자연스럽다. 따라서 정답은 (D). (A), (B), (C) 모두 해당 건설 프로젝트에 대한 부정적인 내용으로 빈칸 뒤의 긍정적인 내용과 대조되므로 오답이다.

16. **(A) each**
(B) other
(C) much
(D) few

해설 | 부정형용사
빈칸 뒤 가산명사 year와 어울려 쓸 수 있는 형용사를 찾는 문제로, 가산명사 단수형과 쓰이는 (A) each가 정답. (B) other와 (D) few는 가산명사의 복수형을, (C) much는 불가산명사를 수식하므로 모두 오답이다.

17. (A) controversially
(B) controversies
(C) controversial
(D) controversy

해설 | 형용사 자리_주격 보어
빈칸은 2문형 동사 become의 뒤에서 주어 the announcement를 보충 설명하는 주격 보어 자리이다. 문맥상 '그 발표가 논란이 많아졌다'라는 의미가 자연스러우므로 주어의 상태를 서술해주는 형용사 (C) controversial이 정답이다. 명사 (B)와 (D)가 보어로 쓰이면 '발표 자체가 논란'이라는 동격의 의미가 되어 어색하므로 오답이다.

18. (A) submissive
(B) subject
(C) confirmed
(D) required

해석 | (A) 순종적인 (B) ~될 수 있는 (C) 확고부동한 (D) 필수의

해설 | 형용사 어휘 subject
문맥에 어울리는 형용사 어휘를 고르는 문제. 빈칸 뒤 전치사 to를 보고 특정 전치사를 동반하는 형용사 관용표현을 떠올렸다면 더 쉽게 답을 찾을 수 있다. '~을 받기 쉽다'라는 뜻의 be subject to가 문맥상 가장 알맞다. 따라서 정답은 (B) subject.

[19-22] 이메일

To: Department Heads
<deptheads@venusmobile.com>
From: Jason Franco <j.franco@venusmobile.com>
Date: March 2
Subject: Emergency Meeting Schedule

Hello everyone,

As you all know, we've recently received ¹⁹ **many** complaints about our latest smartphone, the HB-1011. Customers claim that the colors on the phone's LCD screen change when it is being charged. To deal

받는 사람: 부서장들 〈deptheads@venusmobile.com〉
보내는 사람: 제이슨 프랑코 〈j.franco@venusmobile.com〉
날짜: 3월 2일
제목: 긴급 회의 일정

안녕하세요 여러분,

모두 알고 계시다시피, 우리는 최근 우리의 최신 스마트폰 HB-1011에 대한 ¹⁹ **많은** 불만 사항을 받아왔습니다. 고객들은 스마트폰이 충전 중일 때 LCD 화면 색상이 변한다고 주장합니다. 이 문제를 처리하기 위해, 경영진은 오늘 오후에 ²⁰ **긴급회의**를 소집했습니다. 그러나, 우리 터치 스크린 공급업체의 영업 관리자인 올드린 로페즈 씨가 우리

with this issue, management called for an ²⁰ **urgent** meeting this afternoon. However, this meeting will be postponed until tomorrow at 9 A.M. so that Mr. Aldrin Lopez, the sales director of our touch-screen supplier, may join us. ²¹ <u>I believe it is important to include him in the discussion.</u> We need his explanation on the defective LCD screens. Problems related to ²² **damaged** products are usually manageable, provided that we immediately identify their root cause. Therefore, I request that you prioritize this meeting over any other engagements.

Sincerely,

Jason Franco
Vice-President for External Affairs, Venus Mobile

와 함께하실 수 있도록 이번 회의는 내일 오전 9시로 연기될 것입니다. ²¹ 저는 그분을 토론에 포함시키는 것이 중요하다고 생각합니다. 우리는 결함이 있는 LCD 스크린에 대한 그분의 설명이 필요합니다.

우리가 즉시 근본 원인을 파악한다면 ²² 손상된 제품과 관련된 문제들은 보통 처리하기 쉽습니다. 그러므로, 저는 이번 회의를 어느 다른 업무보다 우선적으로 처리하기를 요청드립니다.

비너스 모바일, 대외업무 부사장
제이슨 프랑코 드림

어휘 | charge 충전하다 postpone 연기하다, 미루다 supplier 공급업체, 공급자 defective 결함이 있는 related to ~와 관련 있는 manageable 처리할 수 있는, 관리할 수 있는 root cause 근본 원인 prioritize 우선적으로 처리하다, 우선순위를 매기다 engagement 업무, (공적인) 약속

19. (A) many
(B) another
(C) no
(D) any

해설 | 수량형용사
빈칸 뒤 복수 가산명사 complaints를 수식하는 수량형용사를 고르는 문제. (A) many, (C) no, (D) any 모두 복수 가산명사를 수식할 수 있지만 문맥상 '많은 불만 사항을 받았다'라고 하는 것이 자연스러우므로 정답은 (A).

20. **(A) urgent**
(B) urgently
(C) urgency
(D) urges

해설 | 형용사 자리_한정사＋형용사＋명사
빈칸 뒤 명사 meeting을 수식할 수 있는 것은 형용사이므로 선택지에서 형용사를 찾으면 된다. 정답은 (A) urgent. urgent meeting(긴급회의)은 자주 쓰이는 표현이므로 함께 묶어서 알아두자.

21. (A) Mr. Lopez has been with our company for three years.
(B) I believe it is important to include him in the discussion.
(C) He was one of the clients who returned a defective phone.
(D) This calls for an expert in crisis management.

해석 |
(A) 로페즈 씨는 우리 회사와 3년 동안 함께 해왔습니다.
(B) 저는 그분을 토론에 포함시키는 것이 중요하다고 생각합니다.
(C) 그분은 결함 있는 핸드폰을 반납한 고객 중 한 분입니다.
(D) 이는 위기 관리 전문가를 필요로 합니다.

해설 | 알맞은 문장 고르기
빈칸 앞에서 문제가 되었던 LCD 스크린 공급업자가 참석할 수 있도록 회의 시간을 연기했다는 것을 알렸고, 빈칸 뒤에서 결함이 있는 LCD 스크린에 대한 그분의 설명이 필요하다고 했으므로 로페즈 씨의 회의 합류에 대한 필요성을 말해주는 내용이 가장 적절하다. 따라서 정답은 (B).

22. (A) damage
(B) damaged
(C) damaging
(D) damages

해설 | 현재분사 vs. 과거분사
명사 products를 수식하는 품사를 고르는 문제이다. 명사를 수식하는 형용사 역할을 하는 과거분사 (B) damaged와 현재분사 (C) damaging이 정답 후보. 문맥상 이미 완료된 동작의 의미를 내포하며 '손상을 입은'이라는 뜻이 적절하므로 (B) damaged가 정답.

FINAL TEST
교재 109쪽

1. (B)	**2.** (C)	**3.** (D)	**4.** (D)	**5.** (A)	**6.** (A)	**7.** (B)	**8.** (C)	**9.** (C)	**10.** (B)
11. (B)	**12.** (C)	**13.** (A)	**14.** (D)						

1.

Online banking has made it possible to move funds **electronically** from one account to another.

(A) electronics **(B) electronically**

(C) electronic (D) electronical

어휘 | fund 자금, 기금, 돈 account 계좌

해석 | 온라인 뱅킹은 자금을 컴퓨터로 한 계좌에서 다른 계좌로 이체하는 것을 가능하게 만들었다.

해설 | **부사 자리_동사 수식**
빈칸 앞에 문장 성분이 완전하므로 빈칸 이하는 수식어구 자리이다. 빈칸은 동사 move를 수식하는 부사 자리로 '컴퓨터로, 전자적으로'라는 의미인 부사 electronically가 적절하다. 따라서 정답은 (B).

2.

The Ethel Marine Park's management department **closely** monitors the living conditions of all its sea animals.

(A) closing (B) closed

(C) closely (D) close

어휘 | monitor 감시하다, 추적 관찰하다 living conditions 생활 환경

해석 | 에텔 해상 공원의 관리부는 모든 바다 동물들의 생활 환경을 면밀히 감시한다.

해설 | **-ly가 붙어서 뜻이 변하는 부사**
주어 The Ethel Marine Park's management department와 동사 monitors 사이에 위치한 것으로 보아 빈칸은 동사를 수식하는 부사 자리임을 알 수 있다. 따라서 부사인 (C) closely와 (D) close가 정답 후보. 문맥상 '면밀히 감시한다'라는 의미가 적절하므로 정답은 (C) closely. (D) close(가까이)는 물리적 거리를 의미하는 것으로 문맥상 어색하므로 오답이다.

3.

Because winter is coming, the demand for warm clothing is expected to increase **soon**.

(A) already (B) regularly

(C) conversely **(D) soon**

어휘 | demand 수요 be expected to *do* ~할 것으로 예상되다 increase 증가하다

해석 | 겨울이 오고 있기 때문에, 따뜻한 옷에 대한 수요가 곧 증가할 것으로 예상된다.
(A) 이미 (B) 정기적으로
(C) 정반대로 (D) 곧

해설 | **부사 어휘 soon**
문맥에 어울리는 부사 어휘를 고르는 문제. be expected to *do*가 절에 쓰인 것으로 보아 미래에 일어날 일을 암시하는 것을 알 수 있으므로 '곧'을 의미하는 시간 부사 soon이 적절하다. 따라서 정답은 (D).

4.

Kenneth should have been here an hour ago, but he has **still** not arrived, and he is not answering his phone.

(A) only (B) yet

(C) enough **(D) still**

어휘 | should have *p.p.* ~했어야만 했다 answer the phone 전화를 받다

해석 | 케네스 씨는 한 시간 전에는 도착했어야 했으나 아직 도착하지 않았고 전화도 받지 않는다.
(A) 오직 (B) 아직
(C) 충분히 (D) 아직

해설 | **시간 부사**
문맥상 '아직'이란 의미가 자연스러우므로 (B)와 (D)가 정답 후보. 빈칸 뒤의 not이 이 둘의 구별 포인트로 (B) yet은 not 뒤에, (D) still은 not 앞에 쓰인다. 따라서 정답은 (D).

5.

After **considerably** reducing operating costs, Pharmacare Research Center was able to buy advanced laboratory equipment.

(A) considerably (B) considerable

(C) consideration (D) consider

어휘 | operating cost 운영비 advanced 고급의 laboratory 실험실

해석 | 운영비를 상당히 줄인 이후로, 파마케어 리서치 센터는 고급 실험실 설비를 구매할 수 있었다.

해설 | **부사 자리_동명사 수식**
동명사 reducing을 수식하는 품사를 찾는 문제. 동명사는 동사의 성질을 가지고 있기 때문에 동사처럼 부사의 수식을 받을 수 있다. 따라서 정답은 부사 (A) considerably.

6.

Although Ms. Mills passed the exam **once**, her boss wanted her to take it again to get a recent score on record.

(A) once (B) then

(C) ago (D) ever

어휘 | pass an exam 시험에 통과하다 on record 기록상

해석 | 비록 밀스 씨는 한 번 시험에 통과했지만, 그녀의 상사는 기록상 최신 점수를 얻기 위해 그녀가 시험을 다시 보길 원했다.

(A) 한 번 (B) 그때

(C) 이전에 (D) 한때

해설 | **시간 부사**

문맥과 쓰임을 파악하여 알맞은 시간 부사를 고르는 문제. 문맥상 '과거에 한 번 시험에 통과했으나 다시 시험을 보기를 원한다'라는 뜻이 적절하므로 주로 긍정문에서 '한 번'이라는 뜻으로 쓰이는 (A) once 가 정답이다. (B) then은 과거의 특정한 때를 가리키나 문장에서 특정한 때가 언급되지 않았으므로 오답이고, (C) ago는 항상 시간 표현과 함께 쓰이므로 오답이다. (D) ever는 주로 부정문, 의문문, 조건문에 쓰이거나 비교급과 최상급의 의미를 강조하므로 쓰임에 맞지 않아 오답이다.

7.

Thanks to the **newly** introduced strategy, profits have gone up by 10 percent.

(A) new **(B) newly**

(C) news (D) newer

어휘 | strategy 전략 profit 수익 go up by ~까지 오르다

해석 | 새롭게 도입된 전략 덕분에, 수익이 10퍼센트까지 올랐다.

해설 | **부사 자리_형용사 수식**

형용사 introduced를 수식하는 품사를 고르는 문제. 선택지 중 형용사를 수식할 수 있는 것은 부사 newly뿐이므로 정답은 (B). 부사가 형용사를 수식할 때는 형용사 바로 앞에 온다는 것을 기억하자.

DAY 11

8.

The CEO had seen the proposed storyboard **even** before his scheduled meeting with the marketing team.

(A) ever (B) still

(C) even (D) now

어휘 | proposed 제안된

해석 | 그 대표이사는 심지어 마케팅팀과 예정된 회의 전에도 이미 제안된 스토리보드를 봤다.

(A) 한때 (B) 아직

(C) 심지어 ~조차도 (D) 지금

해설 | **부사 어휘 even**

빈칸 뒤에 이어지는 전치사구를 수식하며 그 의미를 강조해 주는 부사 어휘를 찾는 문제. 따라서 전치사구를 수식하며 '심지어 회의 전에도 이미'라고 하는 것이 문맥상 자연스러우므로 (C) even이 정답. (A) ever는 주로 부정문, 의문문에서 '한때, 언젠가'라는 의미로 쓰이거나 비교급이나 최상급의 의미를 강조할 때 쓰이므로 오답이다. (B) still은 동사 앞에 오거나 not 앞에 위치하므로 오답이고, (D) now는 과거완료 시제와는 쓰이지 않으므로 오답이다.

9.

The business forum participants asked questions **shortly** after the speaker presented some profitable investment opportunities.

(A) short (B) shorter

(C) shortly (D) shorten

어휘 | profitable 수익성이 있는 investment 투자

해석 | 비즈니스 포럼 참석자들은 연사가 몇몇 수익성이 있는 투자 기회들을 보여준 직후에 질문했다.

해설 | **-ly가 붙어서 뜻이 변하는 부사**

모든 문장 성분이 갖추어져 있으므로 빈칸은 수식어 자리인데, 빈칸 뒤 접속사절을 수식할 수 있는 것은 부사이다. 따라서 형용사 (B) shorter와 동사 (D) shorten은 오답으로 제외. 문맥상 '보여준 직후에 질문했다'는 의미가 적절하므로 정답은 (C) shortly. shortly after[before](직후[직전]에)는 토익에 자주 등장하는 표현이므로 한 단어처럼 기억해 두자.

10.

The supervisor needs to make sure that all her employees have **adequately** prepared for their upcoming presentations.

(A) adequate **(B) adequately**

(C) adequacy (D) adequateness

어휘 | supervisor 상사, 감독관 make sure 확인하다
 prepare for ~을 준비하다 upcoming 곧 있을, 다가오는

해석 | 그 상사는 모든 직원들이 곧 있을 발표를 적절하게 준비했는지 확인해야 한다.

해설 | **부사 자리_동사 수식**

빈칸이 동사구 have prepared 사이에 위치해 있는 것으로 보아 부사 자리이다. 따라서 부사 (B) adequately(적절하게)가 정답이다. 이처럼 문장의 다양한 위치에 올 수 있는 부사는 동사구와 쓰일 때는 그 사이나 뒤에 위치한다는 것을 기억해 두자.

11.

Place your Marvelous Meals dish in the microwave, and your delicious dinner will be ready in **just** three minutes.

(A) quite **(B) just**

(C) well (D) below

어휘 | dish 요리 microwave 전자레인지

해석 | 마블로우스 밀즈 사의 요리를 전자레인지에 돌리면 맛있는 저녁 식사가 단 3분 안에 준비됩니다.

(A) 꽤 (B) 단지

(C) 매우 (D) 아래에

해설 | **부사 어휘 just**

빈칸 뒤 명사구 three minutes를 수식하는 알맞은 부사를 고르는 문제이다. 선택지 중에서 명사구를 수식할 수 있는 것은 (A) quite와 (B) just이다. 그러나 quite는 숫자 앞에 올 수 없으므로 (B) just가 정답이다. 문맥상으로도 '단 3분 안에'라는 의미로 가장 자연스럽다. 부사 well은 동사 또는 형용사, 전치사구를 수식하므로 (C)는 오답이다. below는 전치사로 쓰일 때 명사구 앞에 올 수 있지만 빈칸 앞 전치사 in과 함께 쓸 수 없고 위치나 수준이 '아래에'라는 의미로 문맥상으로도 어울리지 않아 (D)도 오답이다.

12.

To prolong the life of your digital piano, **simply** follow the product care instructions specified on the last page of the user guide.

(A) simple (B) simplistically

(C) simply (D) simplify

어휘 | prolong 연장하다, 연장시키다 instruction 《보통 복수형》 설명, 지시

해석 | 귀하의 디지털 피아노의 수명을 연장하기 위해, 사용 설명서의 마지막 페이지에 상세하게 설명된 제품 관리 지침을 그저 따르십시오.

해설 | **부사 자리_동사 수식**

콤마 뒤의 문장이 동사원형(follow)으로 시작하는 것으로 보아 명령문임을 알 수 있다. 명령문에서 동사 앞에 올 수 있는 것은 동사를 수식할 수 있는 부사이다. 따라서 (B) simplistically와 (C) simply가 정답 후보인데, 문맥상 '극단적으로 단순화하여'라는 뜻은 적절하지 않으므로 정답은 '그저'라는 뜻의 (C).

13.

The special selection of wine and spirits at the Brown Cellar is **highly** recommended by food critics in New York.

(A) highly (B) merely

(C) instantly (D) generously

어휘 | spirit 증류주, 정신 recommend 추천하다 critic 비평가

해석 | 브라운 셀러 사에서 특별히 선정된 와인과 증류주는 뉴욕의 음식 비평가들에 의해 매우 추천된다.

(A) 매우 (B) 그저

(C) 즉시 (D) 아낌없이

해설 | **부사 어휘 highly**

문맥에 어울리는 부사 어휘를 고르는 문제. 동사 is recommended를 수식하는 부사로는 의미상 '매우'라는 뜻의 highly가 적절하다. 따라서 정답은 (A). highly는 동사 recommend와 함께 자주 출제되는 부사이므로 기억해 두자.

14.

The local government has **yet** to decide where to hold the fireworks display for the founding anniversary of the city.

(A) anyway (B) usually

(C) not **(D) yet**

어휘 | government 정부 firework display 불꽃 놀이 대회
 anniversary 기념일

해석 | 지역 정부는 도시 건립 기념일을 위해 어디에서 불꽃 놀이 대회를 열지 아직 결정하지 못했다.

(A) 게다가 (B) 보통

(C) ~ 않다 (D) 아직

해설 | **have yet to do 구문**

빈칸 앞뒤의 has와 to를 보자마자 have yet to do(아직 ~하지 않았다) 구문을 떠올렸다면 쉽게 풀 수 있는 문제. 시간 부사 yet은 부정문에서 자주 쓰이지만 긍정문에서 쓰일 경우 이처럼 have yet to do의 형태로 쓰인다. 따라서 정답은 (D) yet.

FINAL TEST

교재 117쪽

1. (B) **2.** (A) **3.** (C) **4.** (A) **5.** (B) **6.** (A) **7.** (B) **8.** (B) **9.** (A) **10.** (B)
11. (D) **12.** (D) **13.** (A) **14.** (D) **15.** (C) **16.** (C) **17.** (D) **18.** (C) **19.** (C) **20.** (A)
21. (B) **22.** (A)

1.

Ms. Mendez was given the Customer Representative of the Year Award for **never** ignoring the needs of her clients.

(A) sometimes **(B) never**
(C) fast (D) well

어휘 | ignore 간과하다, 무시하다 need 《보통 복수형》 요구

해석 | 멘데즈 씨는 고객들의 요구를 절대 간과하지 않은 것에 대해 올해의 고객 서비스 직원상을 받았다.
(A) 때때로 (B) 절대 ~않다
(C) 빠르게 (D) 잘

해설 | **부정 부사**
문맥상 '고객들의 요구를 절대 간과하지 않은 것에 대해 상을 받았다'는 것이 적절하다. 따라서 빈칸은 부정의 의미를 포함하는 부정 부사가 와야 알맞으므로 정답은 (B) never.

2.

Mapcat Corp. employees are getting used to the new data entry system, and errors are appearing less **frequently** than before.

(A) frequently (B) frequency
(C) frequents (D) frequented

어휘 | get used to ~에 익숙해지다 frequently 자주

해석 | 맵캣 사 직원들이 신규 정보 입력 시스템에 익숙해지고 있어서, 오류가 이전보다 덜 빈번하게 나타난다.

해설 | **부사 자리_동사 수식**
빈칸 앞 동사 are appearing은 목적어나 보어가 필요 없는 자동사이므로 빈칸에는 동사를 수식하는 부사가 들어가야 한다. 따라서 (A) frequently가 정답이다.

3.

It is **often** profitable for travel companies to offer special promotions during the holidays.

(A) every (B) other
(C) often (D) either

어휘 | profitable 수익성이 있는 promotion 판촉 활동, 홍보

해석 | 여행사들에게 있어 휴가 동안에 특별한 판촉 행사를 제공하는 것이 보통 수익성이 있다.
(A) 모든 (B) 다른
(C) 보통 (D) (둘 중) 어느 하나의

해설 | **빈도 부사**
문맥상 '특별한 판촉 행사를 제공하는 것이 보통 수익이 있다'라는 내용이 적절하므로 정답은 빈도 부사인 (C) often. 형용사인 (A) every와 (B) other는 형용사 profitable을 수식할 수 없으므로 오답이다. 부사인 (D) either는 둘 중에서 하나를 선택할 때 쓰이거나 부정문에서 '~도 그렇다'는 의미로 쓰이므로 문맥에 맞지 않아 오답.

4.

The table's order was taking a long time to prepare, so the waiter offered a **complimentary** side dish to apologize for the wait.

(A) complimentary (B) punctual
(C) fulfilled (D) temporary

어휘 | apologize for ~에 대해 사과하다

해석 | 그 테이블의 주문은 준비하는데 긴 시간이 걸려서, 웨이터는 기다림에 대해 사과하기 위해 무료 곁들임 요리를 제공했다.
(A) 무료의 (B) 시간을 지키는
(C) 성취감을 느끼는 (D) 일시적인

해설 | **형용사 어휘 complimentary**
문맥상 '사과의 의미로 무료 곁들임 요리를 제공했다'는 것이 적절하다. 따라서 '무료의'라는 뜻의 (A) complimentary가 정답.

5.

The office cafeteria was so full this afternoon that there was **hardly** any place to sit.

(A) usually **(B) hardly**
(C) normally (D) occasionally

어휘 | cafeteria 구내식당 so ~ that … 너무 ~해서 …하다

해석 | 사무실 구내식당이 오늘 오후에 너무 붐벼서 앉을 자리가 거의 없었다.
(A) 대개 (B) 거의 ~않다
(C) 대개 (D) 가끔

해설 | **부정 부사**
문맥상 '구내식당이 (사람들로) 너무 붐벼서 앉을 자리가 거의 없었다'라는 뜻이 알맞다. 따라서 '거의 ~않다'는 의미로 쓰이는 부정 부사 (B) hardly가 정답.

45

6.

A loan approval process **typically** requires a thorough investigation into the credit record of a client.

(A) typically (B) familiarly
(C) prominently (D) cautiously

(A) typically

어휘 | loan approval 대출 승인 thorough 철저한, 빈틈없는
investigation 조사 credit record 신용 기록

해석 | 대출 승인 절차는 일반적으로 고객의 신용 기록에 대한 철저한 조사를 필요로 한다.
(A) 일반적으로 (B) 스스럼없이
(C) 두드러지게 (D) 조심스럽게

해설 | **부사 어휘 typically**
문맥에 어울리는 부사 어휘를 고르는 문제. 뒤의 동사 requires를 수식하며 의미가 자연스러운 부사를 고른다. 문맥상 '대출 승인 절차는 일반적으로 철저한 조사를 필요로 한다'는 의미가 적절하므로 정답은 (A) typically. 반복적으로 일어나는 일에 현재 시제 동사와 자주 쓰이는 부사이므로 기억해 두자.

7.

This month, Beauty Box Jewelry had a sudden increase in sales, which is **mostly** due to the holiday season approaching.

(A) nearly **(B) mostly**
(C) quickly (D) slightly

어휘 | sudden 갑작스러운 due to ~때문에 approach 다가오다

해석 | 이번 달 뷰티 박스 보석점에 갑작스러운 매출 상승이 있었는데, 이것은 주로 다가오는 휴일 시즌 때문이다.
(A) 거의 (B) 주로
(C) 빠르게 (D) 약간

해설 | **부사 어휘 mostly**
문맥상 '매출 상승의 원인은 주로 다가오는 휴일 시즌 때문이다'라는 의미가 적절하므로 정답은 (B) mostly. (A) nearly도 '거의'라는 의미로 문맥상 가능할 것 같지만 nearly 뒤에는 주로 숫자나 양, every, all과 같은 형용사가 오기 때문에 오답이다.

8.

The antique clock is broken, but the customer is **nevertheless** interested in buying the item.

(A) thus **(B) nevertheless**
(C) then (D) furthermore

어휘 | antique 골동품인 broken 고장 난, 부러진 be interested in
~에 관심이 있다

해석 | 골동품 시계는 고장이 났지만, 그 고객은 그럼에도 불구하고 그 물품을 구매하는 것에 관심이 있다.
(A) 그러므로 (B) 그럼에도 불구하고
(C) 그때 (D) 뿐만 아니라

해설 | **접속 부사**
'고장이 났음에도 불구하고 구매에 관심이 있다'라는 의미가 문맥상 적절하므로 이에 어울리는 접속 부사인 (B) nevertheless가 정답. 접속 부사 nevertheless는 의미적으로 두 개의 절을 연결해 주지만 혼자서는 두 절을 연결할 수 없어 이와 같이 접속사 but과 함께 쓰인다.

9.

Now that e-mail and other convenient communication means are available, people **seldom** send handwritten letters anymore.

(A) seldom (B) still
(C) ever (D) not

어휘 | now that ~이기 때문에 convenient 편리한 means 수단

해석 | 이메일과 다른 편리한 의사소통 수단들을 사용할 수 있기 때문에 사람들은 요즘은 손으로 쓴 편지를 좀처럼 보내지 않는다.
(A) 좀처럼 ~않다 (B) 아직도
(C) 어느 때고 (D) 아니다

해설 | **부정 부사**
문맥상 알맞은 부사 어휘를 고르는 문제이다. 문맥상 '다른 수단이 있어서 편지를 좀처럼 보내지 않는다'는 부정의 의미가 적절하므로 정답은 '좀처럼 ~않다'는 의미의 (A) seldom. (B) still과 (C) ever는 부정의 의미가 없으므로 오답이고 (D) not은 be동사, do동사나 조동사를 부정할 때 쓰이므로 오답.

10.

Our plumbers will be at your place **approximately** 20 minutes after we send you a text notification.

(A) approximate **(B) approximately**
(C) approximation (D) approximates

어휘 | plumber 배관공 approximately 대략, 거의 notification 알림

해석 | 저희 배관공들은 저희가 귀하에게 문자 알림을 보낸 뒤 대략 20분쯤에 댁에 도착할 것입니다.

해설 | **부사 자리_숫자 수식**
빈칸은 숫자가 포함된 명사구 20 minutes를 수식하는 자리이므로 수식어인 형용사 (A) approximate와 부사 (B) approximately가 정답 후보. 형용사와 부사 중 숫자를 수식할 수 있는 것은 부사이므로 (B) approximately가 정답이다. approximately는 뒤에 시간이나 숫자, 양과 관련된 표현과 함께 자주 출제되므로 기억해 두자.

11.

In November, the Tempus Museum will be **temporarily** closed while its main exhibition hall undergoes renovations.

(A) intensely　　　(B) previously

(C) instantly　　　**(D) temporarily**

어휘 | exhibition 전시　undergo 받다, 겪다　renovation 수리, 혁신

해석 | 11월에 템퍼스 미술관은 주요 전시실이 보수 공사를 하는 동안 일시적으로 문을 닫을 것이다.

(A) 강렬하게　　　(B) 이전에

(C) 즉시　　　　　(D) 일시적으로

해설 | **특정 동사를 수식하는 부사**

빈칸이 수식하는 동사 will be closed와의 관계를 살펴 문맥에 어울리는 부사 어휘를 골라야 한다. 문맥상 '공사 관계로 일시적으로 문을 닫는다'는 의미가 자연스러우므로 정답은 (D) temporarily. 동사 close는 부사 temporarily와 함께 자주 어울려 '일시적으로 문을 닫다'라는 의미로 쓰인다는 것을 기억하자.

12.

Dr. Steve Emerson has **almost** completed his research study on the latest technology used in eye surgeries for old patients.

(A) likewise　　　(B) consequently

(C) near　　　　　**(D) almost**

어휘 | latest 최신의, 최근의　surgery 수술　patient 환자

해석 | 스티브 에머슨 박사는 노령의 환자들의 안과 수술에 사용된 최신 기술에 대한 그의 조사 연구를 거의 끝냈다.

(A) 똑같이　　　(B) 그 결과

(C) 가까이　　　(D) 거의

해설 | **부사 어휘 almost**

동사구 has completed 사이에서 그 의미를 강조해 줄 수 있는 부사 어휘를 찾는다. '조사 연구를 거의 끝냈다'고 하는 것이 문맥상 가장 적절하므로 정답은 '거의'라는 뜻의 (D) almost.

13.

The chef thought that the seafood pasta was the most liked dish on the menu, but restaurant reviews suggest **otherwise**.

(A) otherwise　　(B) accordingly

(C) in contrast　　　(D) therefore

어휘 | seafood 해산물　dish 요리

해석 | 그 요리사는 해산물 파스타가 메뉴에서 가장 사랑받는 요리라고 생각했지만, 음식점 비평들은 다르게 시사한다.

(A) 다르게　　　(B) 부응해서

(C) 그에 반해서　(D) 그러므로

해설 | **주의해야 할 접속 부사**

선택지를 보니 빈칸에 어울리는 부사나 접속 부사를 고르는 문제. 접속사 but은 대조를 나타내는 의미이므로 뒤에는 요리사가 생각한 것과 다른 내용이 나와야 한다. 따라서 정답은 '다르게, 달리'의 의미를 지닌 부사 (A) otherwise. otherwise가 접속 부사로 쓰일 때는 '그렇지 않으면'이라는 의미를 뜻하므로 구별하여 알아두자.

14.

Harrisco's sales are higher this month compared to last month; **however**, they are still nowhere near the original target.

(A) namely　　　(B) specifically

(C) similarly　　　**(D) however**

어휘 | compared to ~와 비교해서　nowhere near ~와 거리가 먼

해석 | 해리스코 사의 매출이 지난달에 비해 이번 달에 더 높다. 하지만 여전히 원래 목표와는 거리가 멀다.

(A) 즉　　　　　(B) 분명히

(C) 유사하게　　(D) 그러나

해설 | **접속 부사**

문맥상 알맞은 접속 부사를 고르는 문제이므로 빈칸 앞과 뒤 절의 의미 관계를 파악해야 한다. 빈칸 앞의 '이번 달 매출이 높다'는 내용과 빈칸 뒤의 '원래 목표와는 거리가 멀다'는 내용은 의미상 대조 관계이므로 대조를 나타내는 접속 부사 (D) however가 정답이다. 접속 부사가 세미콜론(;)과 함께 쓰여 두 절을 연결할 수 있다는 것을 알아두자.

[15-18] 기사

Thai Metal Artist Amazes Netherlands

AMSTERDAM, February 2—Many art enthusiasts gathered at the National Museum last night for the opening of Richard Phraya's Silver Linings metal art exhibit. The twenty-five-year-old Thai artist has impressed the world by turning metal scraps into breathtaking art. **15 His unique works first became popular online.** In September, his friends posted a

태국 금속 예술가, 네덜란드를 놀라게 하다

암스테르담, 2월 2일—많은 예술 열성팬들이 리처드 프라야의 실버 라이닝스 금속 미술 전시회 개장을 위해 지난밤 국립 박물관에 모였다. 그 25세의 태국 예술가는 금속 조각을 숨이 멎을 듯한 예술로 바꾸는 것으로 세계에 깊은 인상을 주고 있다. **15 그의 독특한 작품은 온라인에서 처음 유명해졌다.** 9월에, 그의 친구들은 탄산 음료 캔으로 만들어진 실물 크기의 조형물인 힌두 서사시 속 인물 〈시타〉의 사진을 사진 공유 웹사이트에 게시했다. 그 **16 이미지**는 소셜 미디어에 빠르게 퍼졌다. 그때부터, 프라야는 다른 현대 예술가들이 가졌던 것보다 더 많은 팬들을 얻게 되었다.

picture of *Sita*, a life-size figure of a Hindu epic character made from soft-drink cans, on a photo-sharing Web site. The ¹⁶ **image** quickly spread throughout social media. Since then, Phraya has gained more followers than any contemporary artist has ever had.

This is Phraya's first exhibit in Amsterdam. However, he ¹⁷ **occasionally** displays his work at events in Southeast Asia. "Richard is a brilliant artist, and we want many people in Europe to see his extraordinary talent. ¹⁸ **Therefore**, we are extending his exhibit to April 30," National Museum director James Noir said.

이번이 암스테르담에서의 프라야의 첫 번째 전시회이다. 그러나, 그는 동남아시아의 행사에서 그의 작품들을 ¹⁷ **가끔** 전시하고 있다. "리처드는 훌륭한 예술가이고, 저희는 유럽의 많은 사람들이 그의 놀라운 재능을 봤으면 합니다. ¹⁸ **그러므로**, 저희는 그의 전시를 4월 30일까지 연장할 것입니다," 라고 국립 박물관 관장인 제임스 누아르 씨가 말했다.

어휘 | enthusiast 열광적인 팬 gather 모이다 exhibit 전시회, 전시(품) impress 깊은 인상을 주다, 감동을 주다 turn A into B A를 B로 바꾸다 breathtaking 숨이 멎는 듯한 life-size 실물 크기의 epic 서사시 contemporary 현대의 brilliant 훌륭한, 멋진 extraordinary 놀라운, 비범한 extend 연장하다

15.
(A) He is expected to arrive for the exhibit tomorrow.
(B) He will attend an art school in Amsterdam.
(C) His unique works first became popular online.
(D) His sculptures will be shipped to the Netherlands.

해석 |
(A) 그는 내일 전시회에 도착할 것으로 예상된다.
(B) 그는 암스테르담에 있는 예술 학교에 다닐 것이다.
(C) 그의 독특한 작품은 온라인에서 처음 유명해졌다.
(D) 그의 조각품들은 네덜란드로 발송될 것이다.

해설 | **알맞은 문장 고르기**
빈칸 앞에 태국 예술가를 소개하고 있고, 빈칸 뒤에 리처드의 친구들이 그의 작품 사진을 웹사이트에 게재했다는 내용이 이어진다. 따라서 빈칸에는 이 태국 예술가와 웹사이트를 연결해 주는 내용이 나와야 자연스럽다. 온라인에서 처음 유명해졌다는 일반적인 내용이 나오고 그 뒤로 온라인에서 유명해진 구체적인 과정이 이어지는 것이 자연스러우므로 정답은 (C).

16.
(A) exhibit
(B) description
(C) image
(D) brochure

해석 | (A) 전시회 (B) 서술
　　　 (C) 이미지 (D) 안내 책자

해설 | **명사 어휘 image**
문맥상 알맞은 명사 어휘를 고르는 문제이다. 문맥상 앞에서 언급한 사진 공유 웹사이트에 올린 〈시타〉의 사진을 의미해야 하므로 정답은 (C).

17.
(A) occasioned
(B) occasions
(C) occasional
(D) occasionally

해설 | **부사 자리_동사 수식**
빈칸을 제외한 문장 성분이 완전하므로 빈칸이 수식어 자리임을 알 수 있는데, 뒤의 동사 displays를 수식하므로 빈칸은 부사 자리이다. 따라서 정답은 (D) occasionally.

18.
(A) For example
(B) Meanwhile
(C) Therefore
(D) Moreover

해석 | (A) 예를 들어 (B) 그 동안에
　　　 (C) 그러므로 (D) 게다가

해설 | **접속 부사**
앞 문장과 빈칸이 포함된 문장을 의미적으로 연결해 주는 접속 부사를 고르는 문제. 유럽의 많은 사람들이 프라야의 재능을 봤으면 한다는 것이 원인이 되고 전시 기간을 연장한다는 것이 결과이므로 빈칸에는 결과를 나타내는 접속 부사가 와야 적절하다. 따라서 정답은 (C) Therefore.

Enjoy greater rewards by getting a Prime Card now!

Get more out of your shopping experience with Prime Center account. On top of earning points, you will receive exclusive invitations to fun activities every month. **19 In addition**, we will give you coupons that entitle you to a 10 percent discount on products at our partner stores.

Clients with expired accounts are also eligible for this offer. **20 To take advantage of it, bring your old card to one of our stores.** Simply present it at our customer service desk for instant renewal. We guarantee that your visits to Prime Center **21 will be** considerably more exciting than before.

For information on how to create an account, please call 555-0909 to speak **22 directly** to our customer service representatives.

지금 프라임 카드를 받으셔서 더 많은 보상을 즐기세요!

프라임 센터의 회원 계정으로 여러분의 쇼핑에서 더 많은 것을 얻어보세요. 포인트를 얻는 것 외에도, 여러분께서는 매달 회원에게만 주는 재미있는 활동에 대한 초대권을 받으실 것입니다. **19 게다가**, 저희 제휴 매장의 제품을 10퍼센트 할인받을 수 있는 쿠폰들도 드립니다.

만료된 계정을 지닌 고객들도 이 할인에 대한 자격이 있습니다. **20 이 것을 이용하기 위해서, 여러분의 오래된 카드를 저희 매장 중 한 곳으로 가져오세요.** 그저 여러분의 카드를 고객 서비스 데스크에 제시하시면 즉각적으로 갱신할 수 있습니다. 저희는 여러분의 프라임 센터 방문이 이전보다 상당히 더 신날 **21 것이라는** 것을 보장합니다.

회원 계정을 개설하는 방법에 대한 정보를 원하시면 555-0909로 전화하셔서 고객 서비스 담당자들에게 **22 직접** 말씀해 주세요.

DAY 12

어휘 | reward 보상 **earn** 얻다, 받다 **entitle A to B** A에게 B의 자격을 주다 **expire** 만료되다, 만기가 되다 **be eligible for** ~에 자격이 있다
take advantage of ~을 이용하다 **present** 제시하다 **instant** 즉각적인 **considerably** 상당히

19. (A) By contrast
(B) Otherwise
(C) In addition
(D) Consequently

해석 | (A) 그에 반해서 (B) 그렇지 않으면
(C) 게다가 (D) 그 결과

해설 | 접속 부사
접속 부사를 고르는 문제는 문맥을 파악하는 것이 우선이다. 앞 문장에서 회원 계정으로 얻을 수 있는 혜택을 설명하고 있고 빈칸 이하에도 다른 혜택을 알려주고 있다. 따라서 첨가의 의미를 지닌 접속 부사를 쓰는 것이 적절하므로 정답은 (C) In addition.

20. **(A) To take advantage of it, bring your old card to one of our stores.**
(B) For a limited time only, all renewals are 30 percent off.
(C) Get your first Prime Card by completing a form on our Web site.
(D) Please return any lost cards to Prime Center's administrative office.

해석 |
(A) 이것을 이용하기 위해서, 여러분의 오래된 카드를 저희 매장 중 한 곳으로 가져오세요.
(B) 제한적인 시간 동안만, 모든 갱신은 30퍼센트 할인됩니다.
(C) 저희 웹사이트에서 양식을 완성하셔서 여러분의 첫 번째 프라임 카드를 받으세요.
(D) 어떤 분실 카드라도 프라임 센터의 관리사무소로 돌려주십시오.

해설 | 알맞은 문장 고르기
빈칸 바로 앞 문장에서 만료된 계정이 있는 고객도 혜택을 받을 수 있다는 내용이 언급되고, 다음 문장에서 그 카드의 갱신 방법을 안내하고 있다. 따라서 혜택을 이용하기 위해 오래된 카드를 가져오라는 것이 문맥에 가장 알맞으므로 정답은 (A).

21. (A) being
(B) will be
(C) have been
(D) could have been

해설 | 미래 시제
접속사 that이 이끄는 절에 동사가 없으므로 빈칸은 동사 자리로, (A) being은 오답으로 제외. 계정이 만료된 고객이 계정을 갱신했을 때 받을 수 있는 이익에 대한 내용이므로 미래의 일임을 알 수 있다. 따라서 정답은 미래 시제인 (B) will be.

22. **(A) directly**
(B) basically
(C) thoroughly
(D) formerly

해석 | (A) 직접 (B) 근본적으로
(C) 대단히 (D) 이전에

해설 | 특정 동사를 수식하는 부사
문맥에 어울리는 부사 어휘를 고르는 문제. 빈칸이 수식하는 동사 speak는 부사 directly와 자주 어울려 '직접 말하다'의 의미로 사용된다. 따라서 정답은 (A).

FINAL TEST
교재 127쪽

1. (C) 2. (B) 3. (C) 4. (A) 5. (A) 6. (C) 7. (D) 8. (D) 9. (C) 10. (B)
11. (B) 12. (A) 13. (A) 14. (D)

1.

Customers must hand in their receipts at the client service desk **before** the due date for their refunds.
(A) at
(B) since
(C) before
(D) between

어휘 | hand in 제출하다 due date 만기일 refund 환불

해석 | 고객들은 환불을 받으려면 만기일 전에 고객 서비스 데스크에 그들의 영수증을 제출해야만 한다.
(A) ~에
(B) ~ 이래로
(C) ~ 전에
(D) (둘) 사이에

해설 | 시점 전치사
빈칸 이하의 명사구를 이끌면서 문맥에 어울리는 전치사를 고르는 문제. '만기일 전에 영수증을 제출하라'는 것이 문맥상 적절하므로 정답은 시점 전치사 (C) before. (A) at은 '(특정한 시각)에', (B) since는 '(특정 시점) 이래로'라는 의미이므로 오답이고, (D) between은 둘 사이를 나타내는 장소 전치사이므로 오답이다.

2.

A large year-end bonus was distributed **among** staff members after the company exceeded its targets in the fourth quarter.
(A) unlike
(B) among
(C) besides
(D) above

어휘 | distribute 나누어 주다, 분배하다 exceed 넘다, 초과하다 fourth quarter 4분기

해석 | 회사가 4분기 목표를 넘어선 후에 두둑한 연말 보너스를 직원들에게 나눠주었다.
(A) ~와 달리
(B) (불특정 다수) 사이에
(C) ~ 외에
(D) ~ 위에

해설 | 장소 전치사
빈칸 뒤에 불특정 다수인 staff members가 있고 문맥상 '보너스를 직원들에게 나눠주었다'는 의미가 자연스러우므로 '(다수의 대상) 사이에'를 뜻하는 전치사 (B) among이 정답. 동사 distribute가 among과 함께 쓰여 '~에게 분배하다'라는 뜻으로 쓰인다는 것도 알아두자.

3.

Due to the stormy weather, Old Santorini Port has cancelled all trips that were scheduled to leave today.
(A) In favor of
(B) Notwithstanding
(C) Due to
(D) Barring

어휘 | stormy 폭풍우가 몰아치는 be scheduled to do ~할 예정이다

해석 | 폭풍우가 몰아치는 날씨 때문에, 올드 산토리니 항구는 오늘 떠나기로 예정된 모든 여행을 취소했다.
(A) ~에 찬성하여
(B) ~에도 불구하고
(C) ~ 때문에
(D) ~ 없이

해설 | 이유 전치사
여행을 취소하는 것은 폭풍우 치는 날씨 때문이므로 이유를 나타내는 전치사 (C) Due to가 정답이다.

4.

The streets throughout the business district are always filled with people **during** rush hour.
(A) during
(B) along
(C) down
(D) as of

어휘 | business district 상업 지역 be filled with ~로 가득 차다 rush hour 혼잡 시간대, 러시아워

해석 | 상업 지역 도처의 거리들은 혼잡 시간대 동안 항상 사람들로 가득 차있다.
(A) ~ 동안
(B) ~을 따라
(C) 아래로
(D) ~때로부터

해설 | 기간 전치사
빈칸 뒤에 rush hour라는 기간을 나타내는 명사구가 있으므로 빈칸에는 기간을 나타내는 전치사가 와야 한다. 따라서 '~ 동안'을 의미하는 기간 전치사 (A) during이 정답이다.

5.

Information counters are located **in** the zoo to assist guests with their needs while they are visiting.

(A) in
(B) from
(C) off
(D) on

(A) in

어휘 | information counter 안내 창구 need 《보통 복수형》 요구

해석 | 안내 창구들은 손님들이 방문하는 동안 요구가 있으면 손님들을 돕기 위해 동물원 안에 위치해 있다.
(A) ~에
(B) ~에서
(C) ~에서 떨어져
(D) (접촉해서) ~에

해설 | 장소 전치사
빈칸 앞에 are located를 보자마자 장소 전치사를 떠올릴 수 있어야 한다. be located in은 '~에 위치하다'라는 뜻으로 장소를 나타내는 명사(구)와 함께 쓰인다. 따라서 정답은 (A) in. (D) on은 '(표면에 닿아) ~에'라는 의미로 문맥상 어색하여 오답이다.

6.

Please refer to the city map for directions to various attractions **close** to your hotel.

(A) attentive
(B) short
(C) close
(D) familiar

어휘 | refer to ~을 참조하다, 보다 attraction 명소

해석 | 귀하의 호텔에서 가까운 다양한 명소로 가는 길은 도시 지도를 참조하십시오.
(A) 주의를 기울이는
(B) 짧은
(C) 가까운
(D) 친숙한

해설 | 형용사 어휘 close
빈칸 뒤 전치사 to와 함께 쓰이며 문맥에 어울리는 형용사 어휘를 고르는 문제. close to는 '~에 가까운'이라는 의미로 문맥에 가장 적절하다. 따라서 정답은 (C). (A)와 (D)도 전치사 to와 함께 쓰이는 형용사이지만, attentive to는 '~을 경청하는'이라는 뜻을, familiar to는 '~에게 잘 알려진'이라는 뜻이므로 문맥에 맞지 않아 오답이다.

7.

Athlete's Gear will be gradually relocating its largest factory to China **over** the next decade.

(A) below
(B) at
(C) along
(D) over

어휘 | gradually 서서히 relocate 이전하다 decade 10년

해석 | 애슬레츠 기어 사는 다음 10년 동안 서서히 자사의 가장 큰 공장을 중국으로 이전할 것이다.
(A) ~ 아래에
(B) ~에
(C) ~을 따라
(D) ~ 동안

해설 | 기간 전치사
빈칸 뒤에 the next decade라는 기간을 나타내는 명사구가 나왔으므로 기간 전치사가 쓰여야 함을 알 수 있다. over는 기간 표현과 함께 '~ 동안'이라는 뜻을 의미하므로 정답은 (D).

8.

If you shop at Home Haven this Sunday, you will receive large discounts **plus** free delivery service.

(A) thanks to
(B) throughout
(C) in addition
(D) plus

어휘 | receive 받다 delivery 배송, 배달

해석 | 홈 헤이븐에서 이번 일요일에 쇼핑하시면, 귀하께서는 큰 할인 뿐만 아니라 무료 배송 서비스를 받으실 것입니다.
(A) ~ 덕분에
(B) ~ 내내
(C) 게다가
(D) ~뿐만 아니라

해설 | 추가 전치사
문맥상 '큰 할인을 받으면서 무료 배송 서비스도 받을 수 있다'는 내용이 되어야 알맞다. 따라서 추가의 의미를 지닌 전치사가 와야 하므로 정답은 (D) plus. (C) in addition도 추가의 의미를 가지고 있지만 접속 부사로 뒤에 명사구가 올 수 없어 오답이다.

9.

Mr. Ray decided to open his new restaurant **within** walking distance of the stadium to attract customers from the sporting events.

(A) for
(B) aside from
(C) within
(D) through

어휘 | decide to *do* ~하기로 결정하다 walking distance 도보 거리
attract 끌어들이다 sporting event 스포츠 경기

해석 | 레이 씨는 스포츠 경기를 보러 온 고객들을 끌어들이기 위해 그의 새로운 음식점을 경기장에서 도보 거리 이내에 개업하기로 결정했다.
(A) ~을 위해
(B) ~ 외에는
(C) ~ 이내에
(D) ~을 지나

해설 | 장소 전치사
빈칸 뒤 walking distance를 보자마자 빈출 표현 within walking distance(도보 거리 이내에)를 떠올릴 수 있어야 한다. 전치사 within은 '~ 이내에'라는 뜻으로 기간 전치사 외에 특정 거리를 나타내는 장소 전치사로도 쓰인다는 것을 알아두자. 따라서 정답은 (C).

10.

The training will be delayed **until** next month since there is a conflict in the managers' schedules.
(A) by
(B) **until**
(C) despite
(D) about

어휘 | delay 연기하다 conflict 충돌, 갈등

해석 | 그 교육은 관리자들의 일정과 겹쳐서 다음 달까지 연기될 것이다.
(A) ~까지
(B) ~까지
(C) ~에도 불구하고
(D) ~에 대해서

해설 | 시점 전치사
빈칸 뒤에 next month라는 시점을 나타내는 표현이 쓰였으므로 시점 전치사 (A) by, (B) until이 정답 후보. by는 동작이 일회성으로 끝나는 '완료'의 의미를, until은 상황이 지속되는 '계속'의 의미를 가지고 있다. 다음 달까지 연기되는 상황이 계속되는 것이므로 정답은 (B) until. 빈칸 앞의 동사 delay는 until과 자주 어울려 상황의 지속을 나타내는 대표적인 동사이다.

11.

Tech Computers has established over twenty repair centers **across** the country to provide customer support for its growing client base.
(A) except
(B) **across**
(C) into
(D) ahead

어휘 | establish 설립하다 customer support 고객 지원
grow 늘어나다, 자라다

해석 | 테크 컴퓨터스 사는 늘어나고 있는 그들의 고객 기반에 고객 지원을 제공하기 위해 20개가 넘는 수리 센터를 전국 도처에 설립해왔다.
(A) ~을 제외하고
(B) 도처에
(C) ~ 안으로
(D) 앞에

해설 | 장소 전치사
장소 명사 the country와 함께 쓸 수 있는 장소 전치사를 찾는 문제. across the country는 '전국 도처에'라는 뜻으로 자주 쓰인다는 것을 기억해 두자. 따라서 정답은 (B) across.

12.

To hire the experts, the company will use several methods **apart from** proficiency exams
to test each job applicant's abilities.
(A) **apart from**
(B) in spite of
(C) next to
(D) owing to

어휘 | method 방법 proficiency 능력 job applicant 구직자

해석 | 전문가들을 고용하기 위해, 회사는 각각의 구직자들의 능력을 시험할 능력 시험 외에도 몇 가지 방법들을 사용할 것이다.
(A) ~ 외에도
(B) ~에도 불구하고
(C) ~ 옆에
(D) ~ 때문에

해설 | 제외 전치사
문맥상 '능력 시험 외에도 다른 방법들을 사용할 것'이라는 의미이므로 빈칸은 제외의 의미를 나타내는 전치사가 적절하다. 따라서 정답은 제외의 구전치사 (A) apart from.

13.

Despite the ceramic museum's remote location, it is still being visited by many tourists for its rare pottery collections.
(A) **Despite**
(B) Far from
(C) Even though
(D) Before

어휘 | ceramic 도자기 remote 외진, 외딴 rare 희귀한 pottery 도자기
collection 수집품, 소장품

해석 | 도자기 박물관의 외진 장소에도 불구하고, 희귀한 도자기 수집품을 보기 위해 여전히 많은 관광객들이 방문하고 있다.
(A) ~에도 불구하고
(B) ~로부터 멀리
(C) ~에도 불구하고
(D) ~ 전에

해설 | 양보 전치사
문맥상 '외진 장소에도 불구하고 많은 관광객들이 찾는다'는 것이 자연스러우므로 양보의 의미가 빈칸에 적절하다. 따라서 전치사 (A) Despite와 부사절 접속사 (C) Even though가 정답 후보인데, 빈칸 이하의 명사구를 이끄는 것은 전치사이므로 정답은 (A). 접속사 (C) Even though는 절을 이끄므로 오답이다.

14.

Ms. Mansfield would like to reserve a seat that is **near** the stage so she can be in front of the seminar speakers.
(A) under
(B) instead of
(C) outside
(D) **near**

어휘 | reserve 예약하다 in front of ~의 앞쪽에

해석 | 맨스필드 씨는 세미나 연설가들의 앞쪽에 있을 수 있도록 무대와 가까운 좌석을 예약하고 싶어 한다.
(A) ~ 아래에
(B) ~ 대신에
(C) ~ 밖에
(D) ~ 근처에

해설 | 장소 전치사
'세미나 연설가들의 앞쪽에 있을 수 있도록'이라는 내용으로 보아 문맥상 맨스필드 씨가 예약하고 싶은 좌석은 무대와 가까운 곳이라는 것을 알 수 있다. 따라서 '~ 근처에'라는 뜻의 장소 전치사 (D) near가 정답.

FINAL TEST

교재 135쪽

1. (A)	**2.** (D)	**3.** (D)	**4.** (C)	**5.** (C)	**6.** (B)	**7.** (C)	**8.** (A)	**9.** (B)	**10.** (C)
11. (A)	**12.** (C)	**13.** (C)	**14.** (D)	**15.** (B)	**16.** (B)	**17.** (C)	**18.** (A)	**19.** (B)	**20.** (B)
21. (A)	**22.** (D)								

1.

According to the company president, Aspen Forwarders made record-breaking achievements in the third quarter.

(A) **According to**　　(B) In view of
(C) In addition to　　(D) On behalf of

어휘 | president 회장 record-breaking 전례 없는, 기록을 깨뜨린 achievement 성취, 달성

해석 | 회사 회장에 따르면, 애스펀 포워더스 사는 3분기에 전례 없는 성취를 이루었다.
(A) ~에 따르면　　(B) ~을 고려하여
(C) ~에 더하여　　(D) ~을 대신하여

해설 | 출처 전치사
문맥에 어울리는 구전치사를 고르는 문제. 문맥상 '회사 회장에 따르면'이라는 의미가 가장 적절하므로 정답은 출처를 나타내는 전치사 (A) According to.

2.

Mr. Kingston's lecture **on** Western Graphics' company culture was helpful for all the new hires.

(A) at　　　　　(B) upon
(C) by　　　　　(D) **on**

어휘 | helpful 도움이 되는 hire 신입 사원; 고용하다

해석 | 웨스턴 그래픽스 사의 기업 문화에 대한 킹스턴 씨의 강의는 모든 신입 사원들에게 도움이 되었다.
(A) ~에　　　　(B) ~ 위에
(C) ~에 의하여　　(D) ~에 관하여

해설 | 주제 전치사
빈칸 뒤 명사구 Western Graphics' company culture는 강의의 주제이므로 빈칸은 주제를 나타내는 전치사가 와야 한다. 선택지 중에서 주제 전치사는 on뿐이므로 정답은 (D).

3.

The manager left her phone number so that the employees could reach her **in case of** an emergency.

(A) in front of　　(B) in spite of
(C) on top of　　(D) **in case of**

어휘 | reach (전화로) 연락하다, ~에 이르다 emergency 비상(사태)

해석 | 그 관리자는 비상사태가 발생할 경우 직원들이 그녀에게 연락할 수 있도록 자신의 전화 번호를 남겼다.
(A) ~ 앞에　　(C) ~에도 불구하고
(B) ~ 위에　　(D) ~의 경우

해설 | 구전치사
선택지를 보니 문맥에 알맞은 구전치사를 고르는 문제이다. 문맥상 '비상사태가 발생할 경우'라는 의미가 자연스러우므로 '~의 경우'라는 뜻의 구전치사 in case of가 가장 적절하다. 따라서 정답은 (D). in case of an emergency를 하나의 표현으로 외워두자.

4.

Students who **enroll** in scuba diving classes are requested to submit medical clearance from their physicians.

(A) attend　　　(B) support
(C) **enroll**　　　(D) hand

어휘 | clearance 승인, 허락 physician 의사

해석 | 스쿠버 다이빙 수업에 등록한 학생들은 그들의 의사들로부터 받은 의료 확인증을 제출해야 한다.
(A) 참석하다　　(B) 지지하다
(C) 등록하다　　(D) 넘겨주다

해설 | 동사 어휘 enroll
문맥에 맞는 동사 어휘를 고르는 문제로, 빈칸 뒤 전치사 in이 문제를 푸는 단서가 된다. enroll in은 '~에 등록하다'라는 뜻으로 문맥에 가장 알맞으므로 정답은 (C). (D) hand도 in과 함께 쓰일 수 있지만 '~을 제출하다'는 뜻으로 문맥에 어울리지 않아 오답이다.

5.

Ms. Fenster worked **with** an environmental expert in order to write the grant proposal for the research study.

(A) toward (B) to

(C) with (D) from

어휘 | expert 전문가 grant proposal 보조금 지원서

해석 | 펜스터 씨는 그 조사 연구를 위한 보조금 지원서를 쓰기 위해 환경 전문가와 함께 작업했다.

(A) ~ 쪽으로 (C) ~로

(B) ~와 함께 (D) ~로부터

해설 | 〈동사+전치사〉 관용표현

빈칸 앞 동사 worked가 단서가 된다. 동사 work는 전치사 with와 함께 써서 '~와 함께 일하다'의 의미로 자주 쓰인다. 문맥상으로도 '환경 전문가와 함께 일했다'는 의미가 자연스러우므로 정답은 (C) with.

6.

Stallion Mining has issued a press release **in** response to complaints about its latest excavation projects.

(A) within (B) in

(C) for (D) of

어휘 | issue 발표하다, 공표하다 press release 보도 자료
 excavation 발굴

해석 | 스탈리온 마이닝 사는 자사의 최근 발굴 프로젝트에 대한 불평들에 응하여 보도 자료를 발표했다.

(A) ~ 이내에 (B) ~에서

(C) ~을 위해 (D) ~의

해설 | 구전치사

빈칸 뒤 response to를 보자마자 답을 고를 수 있어야 한다. in response to는 '~에 응하여'라는 의미의 대표적인 구전치사로, '불평들에 응답하여'라는 의미로 문맥에도 적절하다. 따라서 정답은 (B).

7.

Please contact our manager, Ms. Catherine Tan, for any inquiries **regarding** the function room reservation for your company banquet.

(A) regard (B) regarded

(C) regarding (D) to regard

어휘 | inquiry 문의, 질문 function room 대연회장, 대회의장
 banquet 연회, 만찬

해석 | 귀사 연회를 위한 대연회장 예약에 관한 문의 사항은 저희 관리자 캐서린 탄 씨에게 연락하십시오.

해설 | 분사형 전치사

선택지로 보아 알맞은 품사를 고르는 문제임을 알 수 있다. 빈칸 이하는 빈칸 앞 명사 inquiries를 수식하는 수식어구이다. 또한 문맥상 '대연회장 예약에 관한'이라는 뜻이 자연스러우므로 '~에 관하여'라는 뜻을 지닌 전치사 (C) regarding이 정답. regarding은 분사 형태로 굳어져 쓰이는 대표적인 전치사로, 형태에 주의하여 기억해 두자.

8.

Our car service drivers will take customers to any destination within the city **regardless of** the traffic situation.

(A) regardless of (B) along with

(C) because of (D) aside from

어휘 | destination 목적지 traffic 교통(량)

해석 | 우리 자동차 서비스 기사들이 교통 상황에 상관없이 고객들을 시내의 어느 목적지에라도 데려다 줄 것이다.

(A) ~에 상관없이 (B) ~와 마찬가지로

(C) ~ 때문에 (D) ~ 이외에

해설 | 구전치사

문맥에 알맞은 구전치사를 고르는 문제로 '교통 상황에 상관없이'라는 의미가 문맥에 가장 알맞으므로 이에 적절한 구전치사를 찾는다. 따라서 정답은 '~에 상관없이'라는 의미의 구전치사 (A) regardless of.

9.

Chesler Records released additional copies of Amanda Tate's bestselling album, *Freedom*, due to the strong **demand** for her compositions.

(A) reaction (B) demand

(C) struggle (D) efficiency

어휘 | release 풀다, 공개하다 composition 작품

해석 | 체슬러 레코즈 사는 아만다 테이트 씨의 작품에 대한 수요가 많아 그녀의 가장 잘 팔리는 앨범인 〈자유〉의 부수를 추가적으로 배포했다.

(A) 반응 (B) 수요

(C) 분투 (D) 효율

해설 | 명사 어휘 demand

빈칸 앞 형용사 strong의 수식을 받으며 문맥에 적절한 명사 어휘를 고르는 문제이다. 문맥상 '그녀의 작품에 대한 강한 수요 때문에'라는 의미가 가장 적절하므로 정답은 (B) demand. 명사 demand는 전치사 for와 어울려 쓰인다.

10.

Some travel company representatives will be invited to a tour **of** the hotel resort's renovated facilities next week.

(A) as (B) onto
(C) of (D) to

어휘 | representative 대표 tour 방문, 순회 renovate 개조하다
facility 《주로 복수형》 시설, 설비

해석 | 몇몇 여행사 대표들은 다음 주에 호텔 리조트의 개조된 시설 방문에 초대될 것이다.

(A) ~로서 (B) ~로
(C) ~의 (D) ~로

해설 | **소유 전치사**
문맥에 알맞은 전치사를 고르는 문제로 문맥상 '개조된 시설의 방문'이라는 뜻이 적절하므로 빈칸에는 소유를 나타내는 전치사가 들어가야 한다. 따라서 정답은 (C) of.

11.

Within the United States, Flawless Cosmetics charges a standard shipping fee of $8 **for** product purchases below $40.

(A) for (B) to
(C) off (D) like

어휘 | standard 일반의, 보통의 shipping fee 배송비 below 아래에

해석 | 미국 내에서, 플로리스 코스메틱스 사는 40달러 미만 제품 구매에 기본 배송비 8달러를 청구한다.

(A) ~를 위해 (B) ~으로
(C) ~에서 멀리 (D) ~와 같은

해설 | **〈동사＋A＋전치사＋B〉 관용표현**
빈칸 앞 동사 charges를 발견했다면 charge A for B(A를 B에 대해 청구하다)의 형태를 떠올려 답을 찾을 수 있는 문제. 따라서 정답은 (A) for. 이처럼 동사와 목적어 뒤에 특정 전치사를 묻는 문제가 출제되므로 토익에 자주 나오는 관용표현은 정리해 두는 것이 좋다.

12.

Successful applicants for senior positions will receive attractive salary and compensation packages, **including** thirty paid vacation days.

(A) concerning (B) under
(C) including (D) among

어휘 | attractive 매력적인 compensation package 보수
paid vacation 유급 휴가

해석 | 상급직의 합격자들은 30일간의 유급 휴가를 포함하여 매력적인 급여와 보수를 받을 것이다.

(A) ~에 관하여 (B) ~ 아래에
(C) ~을 포함하여 (D) ~ 사이에

해설 | **분사형 전치사**
문맥에 어울리는 전치사를 고르는 문제. (A) concerning과 (C) including은 분사처럼 생겼지만 분사 형태로 굳어져 쓰이는 전치사임에 유의하자. 문맥상 '30일간의 유급 휴가를 포함하여'라는 뜻이 적절하므로 정답은 (C). (A)는 '~에 관하여'라는 뜻으로 문맥에 어울리지 않아 오답이다.

13.

Many interior designers expressed **interest** in several furniture pieces displayed at this year's Home and Garden Fair.

(A) concept (B) inspiration
(C) interest (D) attention

어휘 | express 표현하다, 나타내다 display 전시하다

해석 | 많은 인테리어 디자이너들이 올해의 집과 정원 박람회에 전시된 가구 몇 점에 관심을 표현했다.

(A) 개념 (B) 영감
(C) 관심 (D) 주의

해설 | **명사 어휘 interest**
문맥에 어울리는 명사 어휘를 고르는 문제. '인테리어 디자이너들이 가구에 관심을 표현했다'는 것이 문맥에 가장 적절하므로 정답은 (C) interest. interest in은 '~에 대한 관심'이라는 뜻으로, be interested in는 '~에 관심이 있다'라는 뜻으로 함께 기억해 두자.

14.

Given his extensive experience in aircraft engineering, Dr. Fritz will most likely be hired by the Aeronautics Institute.

(A) Since (B) About
(C) For **(D) Given**

어휘 | extensive 폭넓은, 광범위한 aircraft 항공기

해석 | 그의 항공기 기술 공학에 대한 폭넓은 경험을 고려해 볼 때, 프리츠 박사는 항공 협회에 고용될 것이다.

(A) ~ 이후로 (B) ~에 관하여
(C) ~을 위해 (D) ~을 고려하여

해설 | **분사형 전치사**
문맥을 살펴보면 '그의 폭넓은 경험'은 '고용되는 것'의 전체 조건이다. 따라서 '~을 고려하여'라는 의미로 쓰이는 전치사 (D) Given이 정답이다. Given은 분사형 전치사로 일반적인 전치사의 형태와 달라 오답을 고르기 쉬우므로 주의해서 알아두자.

Get the most out of life at Breeze Tower!	브리즈 타워에서 인생을 최대한 만끽하세요!
Almira Corporation, which provides property development services ¹⁵ **throughout** the Middle East, has built its signature residential towers in Dubai.	중동 지역 ¹⁵ **도처에** 부동산 개발 서비스를 제공하는 알미라 사가 그들의 간판 주택 타워들을 두바이에 건설했습니다.
Situated near Marina Plaza, Breeze Tower gives you everything you need without the hassle. Along with ¹⁶ **its** luxurious amenities, Breeze Tower features spacious one- and two-bedroom units. Breeze Tower also has studio apartments perfect for a sophisticated yet ¹⁷ **practical** lifestyle.	마리나 플라자 근처에 위치한 브리즈 타워는 번거로움 없이 여러분이 필요한 모든 것을 제공합니다. ¹⁶ **이것의** 호화스러운 편의 시설과 함께, 브리즈 타워는 널찍한 침실 하나 짜리와 두 개 짜리 공간이 특징입니다. 또한 브리즈 타워에는 세련되지만 ¹⁷ **실용적인** 생활양식에 안성맞춤인 원룸형 아파트도 있습니다.
¹⁸ <u>Experience the finest city living in our apartments at a good price.</u> If you sign a contract by March 31, you will get a 5 percent discount. Simply present this advertisement to your agent upon visiting our showroom.	¹⁸ 좋은 가격에 저희 아파트에서 제일 좋은 도시 생활을 경험해 보세요. 3월 31일까지 계약서에 서명하시면, 5퍼센트 할인을 받으실 겁니다. 저희 전시실을 방문하자마자 그저 이 광고 유인물을 대리인에게 제출하시면 됩니다.
To learn more, call us at 555-0900 or visit www.breezetower.net.	더 알아보시려면, 555-0900으로 전화하시거나 www.breezetower.net으로 방문해 주세요.

어휘 | property 부동산 **residential** 주택의 **situated** (특정한 장소에) 위치해 있는 **hassle** 번거로운 일, 귀찮은 상황 **along with** ~와 함께 **amenity** 《보통 복수형》 생활 편의 시설 **spacious** 널찍한 **sophisticated** 세련된, 교양 있는

15. (A) between
(B) throughout
(C) before
(D) until

해석 | (A) (둘) 사이에 　(B) ~ 도처에
　　　(C) ~ 앞에 　　(D) ~까지

해설 | 장소 전치사
빈칸 뒤에 장소를 나타내는 명사 the Middle East가 있으므로 장소를 나타내는 전치사 (A), (B), (C)가 정답 후보. 문맥상 '중동 지역 도처에'라는 의미가 적절하므로 정답은 (B) throughout. (A) between은 두 장소 사이를 의미하고 (C) before는 '~ 앞에'를 의미하므로 문맥에 맞지 않아 오답이다.

16. (A) it
(B) its
(C) they
(D) their

해설 | 인칭대명사_소유격
빈칸 앞에 구전치사 Along with가 빈칸 이하의 명사구 luxurious amenities를 목적어로 가진다. 따라서 빈칸은 뒤의 명사구를 수식하는 한정사 역할의 소유격 (B) its와 (D) their가 정답 후보. 빈칸이 가리키는 명사는 Breeze Tower로 단수이므로 정답은 (B).

17. (A) confined
(B) indifferent
(C) practical
(D) usual

해석 | (A) 좁고 사방이 막힌 　(B) 무관심한
　　　(C) 실용적인 　　(D) 보통의

해설 | 형용사 어휘 practical
문맥에 적절한 형용사 어휘를 고르는 문제. 빈칸 앞 yet을 통해 sophisticated의 의미와 대조되는 형용사 어휘가 빈칸에 와야 한다는 것을 알 수 있다. '세련되지만 실용적인 생활양식'이 문맥에 적절하므로 정답은 (C) practical.

18. (A) Experience the finest city living in our apartments at a good price.
(B) Breeze Tower is one of the best resorts in Dubai.
(C) We also offer online reservations and special tour packages.
(D) Our office units are home to Dubai's famed companies.

해석 |
(A) 좋은 가격에 저희 아파트에서 제일 좋은 도시 생활을 경험해 보세요.
(B) 브리즈 타워는 두바이 최고의 리조트 중 하나입니다.
(C) 저희는 또한 온라인 예약과 특별한 여행 패키지를 제공합니다.
(D) 저희 사무실 건물들은 두바이의 저명한 회사들의 발상지입니다.

해석 | 알맞은 문장 고르기
신규 아파트 광고글로, 빈칸 앞 부분에서는 브리즈 타워의 장점과 특징에 대해 설명하고 있다. 그리고 빈칸 뒤에서 할인을 받을 수 있는 구체적인 방법이 언급된다. 따라서 빈칸에는 앞부분에 언급된 브리즈 타워의 장점과 맥락을 같이 하며 할인을 받는 방법으로 내용이 이어지기 위해서는 브리즈 타워 아파트의 가격적인 장점이 언급되는 것이 적절하다. 따라서 좋은 가격을 언급하고 있는 (A)가 정답이다.

DAY 14

[19-22] 공지

PUBLIC NOTICE

The city government has started preparations for this year's Fort Lauderdale Orchid Festival. **19 The schedule for each day has already been decided.** City officials have also formed a committee dedicated to **20 preparing** the activities for the festival. Registration is now open for the following events:

Flower Parade: January 20, 8 A.M. to 11 A.M.
Street Dance: January 21, 2 P.M. to 4 P.M.
Town Games: January 22, 8 A.M. to 12 P.M.
Live Band Contest: January 22, 2 P.M. onwards

Unlike previous years, we are allotting only a half day for town games. This is because many residents wanted a live band competition. Few opposed the idea, so the committee voted **21 in favor of** changing the tradition.
Residents interested in **22 participating** in the activities should sign up at the town office. For questions, please dial 555-8980.

공지

시 당국이 올해의 포트 로더데일 오키드 축제를 위한 준비를 시작했습니다. **19 날짜별 일정이 이미 정해졌습니다.** 시 공무원들은 또한 축제 활동들을 **20 준비하는데** 전념할 위원회를 구성했습니다. 다음의 행사들에 대한 등록이 이제 열렸습니다:

꽃 퍼레이드: 1월 20일, 오전 8시부터 오전 11시
거리 댄스: 1월 21일, 오후 2시부터 오후 4시
마을 게임: 1월 22일, 오전 8시부터 오후 12시
라이브 밴드 콘테스트: 1월 22일, 오후 2시 이후

이전 해와는 달리 저희가 마을 게임에 반나절만 배정했습니다. 이는 많은 주민들이 라이브 밴드 경연 대회를 원했기 때문입니다. 그 계획에 반대하는 사람이 거의 없어서, 의회는 그 전통을 바꾸는 것에 **21 찬성했습니다.**
활동에 **22 참석하는 것에** 관심이 있는 주민들은 마을 사무실에서 등록하셔야 합니다. 질문이 있으시면 555-8980으로 전화 주십시오.

어휘 | form 구성하다 registration 등록 allot 배정하다 resident 주민 oppose 반대하다 vote 투표하다 sign up 등록하다

19. (A) The event will celebrate the arrival of spring.
(B) The schedule for each day has already been decided.
(C) Competing towns have signed up for the activities.
(D) Thank you for your support during the festival.

해석 |
(A) 그 행사는 봄이 온 것을 축하할 것입니다.
(B) 날짜별 일정이 이미 정해졌습니다.
(C) 경쟁하는 마을들은 그 활동에 등록했습니다.
(D) 축제 동안 여러분의 도움에 감사드립니다.

해석 | 알맞은 문장 고르기
빈칸 앞 문장에서 축제 준비가 시작되었다는 내용이 나오고 빈칸 뒤에서 추가를 나타내는 부사 also를 이용하여 축제를 준비하는 위원회도 구성했다는 내용이 나오는 것으로 보아 빈칸에도 축제 준비와 관련된 내용이 나와야 한다. 따라서 축제 일정에 대해 언급한 (B)가 정답이다. (A)는 축제 준비와 관련된 내용이 아니므로 오답이다. 도시간 경쟁하는 축제라는 내용은 없으므로 (C)도 오답이다. (D)는 행사가 끝나고 할 수 있는 인사말이므로 본문 내용에 적절하지 않아 오답이다.

20. (A) preparation
(B) preparing
(C) prepared
(D) prepare

해설 | **동명사 vs. 명사**
선택지를 보니 알맞은 품사를 고르는 문제이다. 빈칸 앞 to는 전치사
이므로 명사 (A)와 동명사 (B)가 정답 후보. 명사는 뒤에 목적어를 취
할 수 없으나 동사의 성질을 가지고 있는 동명사는 뒤에 목적어 the
activities를 취할 수 있으므로 정답은 (B) preparing. 빈칸 앞의 to
는 dedicated to(~에 전념하는) 어구로 쓰이는 전치사인데 이를 to
부정사로 오인하고 동사원형 (D)를 고르지 않도록 주의하자.

21. **(A) in favor of**
(B) ahead of
(C) prior to
(D) against

해석 | (A) ~을 찬성하여 (B) ~ 앞에
　　　(C) ~에 앞서　　　　　　(D) ~에 반대하여

해설 | **구전치사**
문맥에 알맞은 구전치사를 고르는 문제로, '전통을 바꾸는 것에 찬성하
여'라는 의미가 가장 적절하다. in favor of는 '~을 찬성하여'라는 의
미의 구전치사이므로 정답은 (A).

22. (A) registering
(B) accommodating
(C) supporting
(D) participating

해석 | (A) 등록하다 (B) 수용하다
　　　(C) 지지하다　　　　(D) 참여하다

해설 | **동사 어휘 participate**
빈칸 뒤 전치사 in이 결정적인 단서가 된다. participate는 전치사 in
과 함께 participate in의 형태로 '~에 참석하다'를 의미하는 관용표
현으로 쓰인다. 문맥상으로도 '활동에 참석하는 것'이 적절하므로 정답
은 (D).

FINAL TEST

1. (A)	2. (A)	3. (C)	4. (D)	5. (C)	6. (B)	7. (D)	8. (D)	9. (B)	10. (B)
11. (A)	12. (B)	13. (B)	14. (C)						

1.

Neither the laptop's microphone **nor** the speakers are working, so this computer cannot be used in the conference call.

(A) nor　　　　　(B) and

(C) or　　　　　(D) both

어휘 | microphone 마이크　conference call 전화 회의

해석 | 그 노트북의 마이크도 스피커도 작동하지 않아서, 이 컴퓨터는 전화 회의에서 사용할 수 없다.
(A) ~도 아닌　　(B) 그리고
(C) 또는　　　　(D) 둘 다

해설 | **상관접속사**
문두의 Neither를 보자마자 상관접속사 neither A nor B를 떠올릴 수 있어야 한다. 문맥상으로도 '마이크도 스피커도 작동하지 않는다'는 의미가 자연스러우므로 정답은 (A). 이처럼 상관접속사의 짝을 찾는 문제가 자주 출제되므로 상관접속사는 반드시 기억해 두자.

2.

The product labels on the canned food indicate **that** the products were manufactured a few months ago.

(A) that　　　　　(B) while

(C) why　　　　　(D) then

어휘 | label (물건에 대한 정보를 적어 붙여 놓은) 라벨, 표　indicate 나타내다　manufacture 제조하다, 생산하다

해석 | 그 통조림 식품 위의 제품 라벨이 그 제품들이 몇 개월 전에 제조되었다는 것을 나타낸다.
(A) ~하는 것　　(B) ~하는 동안
(C) ~한 이유　　(D) 그 다음에

해설 | **명사절 접속사**
빈칸 이하는 동사 indicate의 목적어 역할을 하므로 선택지에서 명사절 접속사 (A) that과 의문부사 (C) why가 정답 후보. 문맥상 제품 라벨이 나타낼 수 있는 것은 제품이 몇 개월 전에 제조된 이유가 아니라 몇 개월 전에 제조된 사실이므로 정답은 (A). 명사절 접속사 that이 목적어 절을 이끄는 경우에는 생략할 수 있다는 것도 함께 알아두자.

3.

The tenant wants to know **if** the lease can be extended for another month at the end of the year.

(A) yet　　　　　(B) so

(C) if　　　　　(D) what

어휘 | tenant 세입자　lease 임대차 계약　extend 연장하다

해석 | 그 세입자는 연말에 임대차 계약을 한 달 더 연장할 수 있는지 아닌지를 알고 싶어한다.
(A) 그러나　　(B) 그래서
(C) ~인지 아닌지　(D) 무엇

해설 | **명사절 접속사**
빈칸은 to부정사 to know의 목적어가 되는 명사절을 이끄는 접속사 자리로 명사절 접속사 (C) if와 관계대명사 혹은 의문대명사 (D) what이 정답 후보이다. 빈칸 뒤에 완전한 절이 나오고, 문맥상으로도 '연장할 수 있는지 아닌지를 알고 싶은' 것이므로 정답은 (C).

4.

The company is cutting back on operation costs, **but** it will not cancel the year-end party.

(A) so　　　　　(B) or

(C) for　　　　　**(D) but**

어휘 | cut back on ~을 줄이다　operation cost 운영비

해석 | 그 회사는 운영비를 줄이고 있지만, 송년회는 취소하지 않을 것이다.
(A) 그래서　　(B) 또는
(C) 왜냐하면　(D) 그러나

해설 | **등위접속사**
문맥에 어울리는 등위접속사를 찾는 문제. 운영비를 줄이는 것과 송년회를 취소하지 않는 것은 대조 관계이므로 대조의 의미를 지닌 등위접속사가 적절하다. 따라서 정답은 (D) but. (A) so는 결과, (B) or는 선택, (C) for는 원인을 나타내는 의미로 각각 쓰이므로 모두 오답이다.

5.

Speakers must **either** call the event organizer or send an e-mail to reschedule their presentations.

(A) neither (B) both

(C) either (D) not only

어휘 | organizer 주최자 reschedule 일정을 변경하다

해석 | 연사들은 행사 주최측에 전화하거나 이메일을 보내서 그들의 발표 일정을 변경해야 한다.

(A) (둘 중) 어느 것도 ~아니다 (B) 둘 다

(B) (둘 중) 어느 하나 (D) ~뿐만 아니라

해설 | **상관접속사**

선택지를 보고 상관접속사를 고르는 문제임을 알았다면 문장 속에서 단서가 되는 상관접속사 짝이 있는지 찾아본다. 빈칸 뒤에 등위접속사 or가 있는 것으로 보아 either A or B가 쓰였음을 알 수 있다. 문맥 상으로도 '전화하거나 이메일을 보내서'라고 하는 것이 적절하므로 정답은 (C) either.

6.

The reason for the overnight flight's cancelation is **that** a severe snowstorm is expected to start this evening.

(A) while **(B) that**

(C) for (D) what

어휘 | overnight flight 야간 비행 cancelation 취소 severe 심한
be expected to *do* ~할 예정이다

해석 | 그 야간 비행이 취소된 이유는 오늘 저녁에 심한 폭설이 내릴 것으로 예보되었기 때문이다.

(A) ~하는 동안 (B) ~하는 것

(C) 왜냐하면 (D) 무엇

해설 | **명사절 접속사**

빈칸 이하는 동사 is의 보어 역할을 하는 절이다. 따라서 명사절을 이끄는 접속사 (B) that과 의문대명사 (D) what이 정답 후보. 빈칸 이하의 완전한 절을 이끄는 것은 명사절 접속사 that이므로 정답은 (B). (D) what은 뒤에 불완전한 절이 오므로 오답이다.

7.

After hearing from all participants, the client will determine **whose** presentation was the most convincing.

(A) who (B) where

(C) when **(D) whose**

어휘 | client 고객 determine 결정하다 convincing 설득력 있는

해석 | 모든 참석자들의 이야기를 듣고 난 후, 그 고객은 누구의 발표가 가장 설득력이 있었는지 결정할 것이다.

(A) 누구 (B) 어디에서

(C) 언제 (D) 누구의

해설 | **명사절을 이끄는 의문사**

동사 determine의 목적어가 되는 명사절을 이끌면서 빈칸 뒤 명사 presentation을 한정하는 한정사 역할을 할 수 있는 것은 선택지 중에서 의문형용사인 whose 뿐이다. 따라서 정답은 (D).

8.

Soundmatic is not only the most advanced **but also** the largest recording studio in Brooklyn.

(A) in addition to (B) as a result

(C) after all **(D) but also**

어휘 | advanced 선진의, 고급의

해석 | 사운드매틱 사는 브루클린에서 최첨단일 뿐만 아니라 가장 큰 녹음실이다.

(A) ~에 더하여 (B) 결과적으로

(C) 결국 (D) ~도

해설 | **상관접속사**

문장에서 not only를 발견하자마자 상관접속사 not only A but also B(A뿐만 아니라 B도)를 떠올려야 한다. 문맥상으로도 '최첨단일 뿐만 아니라 가장 큰'이라는 의미가 적절하므로 정답은 (D) but also. 이와 같은 뜻으로 B as well as A도 함께 기억해 두자.

9.

For a limited time only, Street Motors customers may receive a special discount **or** a free car accessory of their choice.

(A) if **(B) or**

(C) so (D) yet

어휘 | limited 한정된 receive 받다 accessory 부대용품, 액세서리

해석 | 한정된 시간 동안만, 스트리트 모터스 사의 고객들은 특별한 할인을 받거나 그들이 선택한 무료 자동차 용품을 받을 것이다.

(A) 만약 ~라면 (B) 또는

(C) 그래서 (D) 그러나

해설 | **등위접속사**

빈칸에 알맞은 접속사를 고르는 문제로 빈칸 앞뒤의 요소를 살펴본다. a special discount와 a free car accessory는 같은 명사구로 두 개의 요소를 대등하게 이어주는 등위접속사가 필요하다. 따라서 명사절 접속사 (A) if는 오답으로 제외. 문맥상 '할인 또는 자동차 용품'의 의미가 적절하므로 정답은 (B) or. 참고로 등위접속사 (C) so는 절과 절만 연결할 수 있고 단어나 구는 연결하지 못한다는 것을 알아두자.

10.

If products are defective, they must be **returned** to Oliver Online within thirty days after the date of purchase.

(A) reviewed **(B) returned**

(C) remade (D) realized

어휘 | defective 결함이 있는

해석 | 제품에 결함이 있을 경우, 구매일 이후 30일 이내로 올리버 온라인 사로 제품이 반납되어야 한다.

(A) 검토하다 (B) 반납하다

(C) 다시 만들다 (D) 깨닫다

해설 | **동사 어휘 return**

문맥에 맞는 동사 어휘를 고르는 문제. 수동태로 쓰인 동사 뒤에는 목적어가 없으므로 주어와의 관계를 살펴본다. 주절의 주어인 they는 결함 있는 제품을 말하며 문맥상 '결함 있는 제품이 반납되어야 한다'는 의미가 적절하므로 정답은 (B) returned.

11.

The layout design of the quarterly publication will depend on **how** long the articles are.

(A) how (B) so

(C) if (D) for

어휘 | layout 지면 배치 quarterly 분기별의 publication 발행물 depend on ~에 달려 있다

해석 | 분기별 발행물의 지면 배치 디자인은 기사들이 얼마나 긴지에 달려 있다.

(A) 얼마나 (B) 그래서

(C) 만약 ~라면 (D) 왜냐하면

해설 | **명사절을 이끄는 의문사**

빈칸 이하는 전치사 on의 목적어 역할을 하는 명사절이다. 따라서 명사절을 이끄는 의문부사인 (A) how와 명사절 접속사 (C) if가 정답 후보. 접속사 if는 전치사 뒤에 올 수 없으므로 (A)가 정답이다. 의문부사인 how가 명사절을 이끌 때에는 how 뒤에 형용사나 부사가 나올 수 있다는 것을 알아두자.

12.

Lobbyists have hopes **that** these measures will be implemented nationally within the next few months.

(A) how **(B) that**

(C) which (D) then

어휘 | measure 조치 implement 시행하다 nationally 전국적으로

해석 | 로비스트들은 이러한 조치들이 앞으로 몇 달 이내에 전국적으로 시행될 것이라는 바람을 가지고 있다.

해설 | **동격의 that절**

문맥상 '조치가 시행될 것이라는 바람'이라는 의미로 빈칸은 앞의 명사 hopes의 내용을 서술하는 동격절을 이끌어야 한다. 따라서 명사절 접속사 (B) that이 정답이다. 동격의 that절과 자주 어울려 쓰이는 명사들은 외워두자.

13.

Management has yet to decide **whether** to acquire new vehicles or hire the services of a car rental company.

(A) meanwhile **(B) whether**

(C) neither (D) if

어휘 | acquire 획득하다, 습득하다 hire 빌리다, 고용하다

해석 | 경영진은 새로운 차량을 확보할지, 자동차 대여 회사의 서비스를 임대할지 아직 정하지 않았다.

(A) 그 동안에 (B) ~인지 아닌지

(C) (둘 중) 어느 것도 ~아니다 (D) ~인지 아닌지

해설 | **명사절 접속사**

빈칸 뒤 or를 통해 선택 사항이 있는 문장임을 예측할 수 있다. 문맥상 '새로운 차량을 확보할지 자동차 대여 회사의 서비스를 임대할지 아직 정하지 않았다'는 내용이 적절하므로 '~인지 아닌지'의 뜻을 지닌 명사절 접속사 (B) whether, (D) if가 정답 후보. if는 to부정사와 함께 쓸 수 없으므로 정답은 (B).

14.

A detailed shopping list will allow hardware salespeople to quickly provide **what** customers need for their renovation projects.

(A) also (B) that

(C) what (D) if

어휘 | allow A to B A가 B하는 것을 허락하다 hardware 철물, 하드웨어 renovation 수리, 혁신

해석 | 상세한 쇼핑 목록은 철물 판매원들이 고객들이 수리 계획을 위해 필요로 하는 것을 빠르게 제공해 줄 수 있게 한다.

(A) 또한 (B) ~하는 것

(C) ~하는 것 (D) ~인지 아닌지

해설 | **명사절 접속사 that vs. 관계대명사 what**

빈칸은 동사 provide의 목적어가 되는 명사절을 이끄는 역할을 하며 뒤에 목적어가 없는 불완전한 절이 왔다. 따라서 불완전한 절을 이끌며 명사절을 이끄는 역할을 하는 관계대명사 (C) what이 정답. (A) also는 절을 취할 수 없고 (B) that과 (D) if는 뒤에 완전한 절을 취하므로 모두 오답이다.

FINAL TEST

교재 153쪽

1. (A)	2. (C)	3. (D)	4. (B)	5. (B)	6. (A)	7. (C)	8. (D)	9. (B)	10. (B)
11. (C)	12. (B)	13. (D)	14. (A)	15. (A)	16. (D)	17. (A)	18. (D)	19. (C)	20. (B)
21. (D)	22. (C)								

1.

Mr. Amal took the printer to the service center **since** it was malfunctioning this morning.

(A) since　　　　(B) so that
(C) whether　　　(D) except

어휘 | malfunction (기계 등이) 제대로 작동하지 않다; 고장

해석 | 아말 씨는 오늘 아침에 프린터가 제대로 작동하지 않아서 서비스 센터에 프린터를 가져갔다.
(A) ~ 때문에　　　　(B) ~하기 위해서
(C) ~인지 아닌지　　(D) ~을 제외하고

해설 | 이유 접속사
문맥에 어울리는 접속사를 고르는 문제로 빈칸 앞뒤의 내용을 잘 살펴봐야 한다. '프린터가 제대로 작동하지 않은 것'이 서비스 센터에 프린터를 가져간 이유이므로 정답은 이유를 나타내는 접속사 (A) since.

2.

Even though the glass dealer provided a large discount, the price of the tempered windows is still high.

(A) Rather　　　　　(B) Except that
(C) Even though　　(D) Wherever

어휘 | dealer (특정 상품을 사고파는) 중개인, 딜러　temper 단련하다

해석 | 비록 그 유리 중개인이 큰 할인을 제공했을지라도, 강화유리 창문의 가격은 여전히 높다.
(A) 다소　　　　　(B) ~을 제외하고
(C) 비록 ~일지라도　(D) 어디에나

해설 | 양보 접속사
'비록 큰 할인을 제공했을지라도 가격이 여전히 높다'고 하는 것이 문맥에 가장 적절하다. 따라서 양보의 접속사 (C) Even though가 정답. 양보의 부사절 접속사는 이처럼 예상하지 못한 결과나 기대와 반대되는 내용을 표현할 때 쓰인다.

3.

The price of seasoned turkey is expected to increase **during** the thanksgiving season due to high demand.

(A) while　　　　(B) until
(C) when　　　　**(D) during**

어휘 | seasoned 양념을 한　be expected to *do* ~으로 예상되다

해석 | 양념된 칠면조의 가격은 추수감사절 기간 동안에 높은 수요로 인해 상승할 것으로 예상된다.
(A) ~하는 동안　　(B) ~까지
(C) ~할 때　　　　(D) ~하는 동안

해설 | 접속사 vs. 전치사
문맥상 '추수감사절 기간 동안에'라는 의미가 되어야 적절하다. 따라서 '~하는 동안'의 의미로 쓰이는 접속사 (A) while과 전치사 (D) during이 정답 후보. 빈칸 뒤에 명사구가 왔기 때문에 절을 취하는 접속사 (A)는 정답이 될 수 없다. 따라서 정답은 전치사 (D).

4.

Before the cooking demonstration started, attendees were advised to turn off their mobile devices to avoid any distractions.

(A) So　　　　　**(B) Before**
(C) Unless　　　(D) If

어휘 | demonstration 시범, 설명　be advised to *do* ~하도록 권고 받다　distraction 집중을 방해하는 것

해석 | 조리 시범이 시작되기 전에, 참석자들은 집중에 방해되지 않게 그들의 모바일 기기 전원을 끄도록 권고 받았다.
(A) 그래서　　　　(B) ~ 전에
(C) ~하지 않으면　(D) 만약 ~하면

해설 | 시간 접속사
여러 종류의 접속사가 선택지에 나올 때는 문맥을 파악하는 것이 우선이다. '모바일 기기 전원 끄기를 권고 받은 것'은 '조리 시범이 시작되기 전'이므로 정답은 '~ 전에'라는 뜻의 시간을 나타내는 접속사 (B) Before. 참고로 등위접속사인 (A) So는 문두에 올 수 없다.

5.

Driving to the art museum would take 45 minutes **whereas** taking the subway would only take 20 minutes.

(A) aside from **(B) whereas**
(C) which (D) unless

어휘 | drive to 차를 몰고 ~에 가다 take (시간이) 걸리다, (교통수단 등을) 타다

해석 | 그 미술관에 차를 몰고 가면 45분이 걸리는 반면에 지하철을 타고 가면 단 20분밖에 걸리지 않는다.
(A) ~ 이외에 (B) 반면에
(C) 어느 (D) ~하지 않으면

해설 | **양보 접속사**
빈칸 뒤에 완전한 절이 이어져 나오므로 전치사 (A) aside from과 의문대명사 (C) which는 오답으로 제외. 문맥상 '반면에'라는 의미로 미술관에 가는 두 방법을 비교 및 대조하는 것이 자연스러우므로 정답은 (B) whereas. (D) unless는 '~하지 않으면'이라는 뜻의 조건을 나타내는 접속사이므로 오답.

6.

When **scheduling** your visit to the embassy, you should keep in mind that the average appointment lasts about one hour.

(A) scheduling (B) scheduled
(C) schedule (D) to schedule

어휘 | embassy 대사관 keep in mind that ~을 명심하다
average 일반적인, 보통의 last 지속하다, 계속하다

해석 | 대사관으로의 방문 일정을 잡을 때, 일반적으로 일정은 대략 1시간 가량 걸린다는 것을 명심하십시오.

해설 | **부사절의 생략**
접속사 when이 이끄는 부사절이므로 뒤에 완전한 절이 와야 하지만 〈주어+be동사〉는 생략이 가능하기 때문에 능동과 수동의 의미를 따져 적절한 동사 형태를 정답으로 고른다. 문맥상 '방문 일정을 잡을 때'라는 능동의 의미가 적절하고 뒤에 목적어가 있는 것으로 보아 현재분사 (A) scheduling이 정답임을 알 수 있다. When you are scheduling ~의 문장에서 you are가 생략된 형태이다.

7.

Piota Entertainment will launch its new mobile game on October 20 **provided that** the designers meet all the deadlines.

(A) as (B) whether
(C) provided that (D) in the event

어휘 | launch 출시하다 meet (기한 등을) 지키다, 만나다
deadline 마감 시간, 기한

해석 | 피오타 엔터테인먼트 사는 디자이너들이 모든 마감 시일을 맞춘다면 그들의 새로운 모바일 게임을 10월 20일에 출시할 것이다.
(A) ~ 때문에 (B) ~인지 아닌지
(C) 만약 ~라면 (D) ~할 경우에 대비해서

해설 | **조건 접속사**
문맥에 알맞은 접속사를 고르는 문제로, 문맥상 '디자이너들이 모든 마감 시일을 맞춘다면'이라는 의미가 가장 적절하다. 따라서 정답은 '만약 ~라면'이라는 의미의 조건을 나타내는 접속사 (C) provided that.

8.

While Ms. Summers immediately met her sales target last month, the other managers had difficulty finding clients.

(A) Except for (B) In spite of
(C) In order that **(D) While**

어휘 | sales target 판매목표 have difficulty *doing* ~하는데 어려움을 겪다

해석 | 서머스 씨가 지난달 그녀의 판매목표를 즉시 달성한 반면에, 다른 관리자들은 고객들을 찾는데 어려움을 겪었다.
(A) ~을 제외하고 (B) ~에도 불구하고
(C) ~하기 위해 (D) ~하는 반면에

해설 | **양보 접속사**
'서머스 씨가 즉시 판매목표를 달성한 것'과 '다른 관리자들은 고객을 찾는데 어려움을 겪은 것'은 대조 관계이므로 빈칸에는 '~하는 반면에'라는 의미로 쓰이는 양보의 접속사 while이 와야 한다. 따라서 정답은 (D). 부사절 접속사 while은 '~하는 동안'이라는 의미뿐만 아니라 '~하는 반면에'라는 의미로도 쓰인다는 것을 주의하자.

9.

As long as you subscribe to the Omni newsletter, you will receive regular updates on our products.

(A) In case **(B) As long as**
(C) Even if (D) Rather than

어휘 | subscribe 구독하다 regular 정기적인, 규칙적인

해석 | 귀하께서 옴니 소식지를 구독하시기만 하면, 저희 제품들에 대한 정기적인 최신 정보를 받으실 것입니다.
(A) ~할 경우에 대비해서 (B) ~하기만 하면
(C) 비록 ~일지라도 (D) ~보다는

해설 | **조건 접속사**
빈칸은 '제품들에 대한 정기적인 최신 정보를 받을 것'이라는 주절의 전제가 되는 '소식지를 구독하다'는 절을 이끌어야 하므로 조건을 나타내는 부사절 접속사가 들어가야 알맞다. 따라서 정답은 '~하기만 하면'이라는 뜻의 (B) As long as.

10. Mr. Parson's plan was **so** well designed that the construction project was completed ahead of schedule.

(A) very **(B) so**
(C) too (D) such

어휘 | design 설계하다 ahead of ~보다 빨리

해석 | 파슨 씨의 계획이 매우 잘 설계되어서 그 건설 프로젝트는 일정보다 빨리 완료되었다.

해설 | 결과 접속사
빈칸 뒤 〈형용사+that절〉 구문을 보고 결과를 나타내는 접속사 구문인 〈so+형용사+that〉을 떠올렸으면 쉽게 답을 고를 수 있다. 따라서 정답은 (B) so. (A) very와 (C) too는 that절과 함께 쓰면서 결과를 나타내지 않으므로 오답이고, (D) such는 〈such+(한정사)+(형용사)+명사+that〉 구문으로 쓰이므로 오답이다.

11. **Despite** technical difficulties, the Ministry of Education successfully built multimedia classrooms and computer laboratories.

(A) Through (B) Although
(C) Despite (D) Nevertheless

어휘 | technical 기술적인 laboratory 실험실

해석 | 기술적인 어려움에도 불구하고, 교육부는 멀티미디어 교실과 컴퓨터 연구실을 성공적으로 지었다.

(A) ~을 통해 (B) (비록) ~이지만
(C) ~에도 불구하고 (D) 그럼에도 불구하고

해설 | 접속사 vs. 전치사
문맥상 '어려움에도 불구하고, 성공적으로 지었다'는 의미이므로 양보의 의미가 들어가야 한다. 그런데 빈칸 뒤에 명사구가 나오므로 이를 목적어로 취하는 전치사 (C) Despite가 정답. 접속사인 (B) Although와 접속 부사인 (D) Nevertheless는 뒤에 절을 취해야 하므로 오답이다.

12. The company closed some of its departments last month, yet it continues to operate **as if** nothing had changed.

(A) how **(B) as if**
(C) if only (D) considering that

어휘 | continue to *do* 계속 ~하다 operate 운영하다

해석 | 그 회사는 지난달 몇몇 부서들을 닫았는데, 아무 변화도 없었던 것처럼 계속 운영되고 있다.

(A) 어떻게 (B) 마치 ~인 것처럼
(C) ~이면 좋을 텐데 (D) ~을 고려하면

해설 | 유사/비교 접속사
문맥상 알맞은 접속사를 고르는 문제이다. '아무 변화도 없었던 것처럼 운영된다'는 의미가 문맥에 적절하므로 정답은 '마치 ~인 것처럼'이라는 의미인 (B) as if.

13. The car show can be held this Friday **now that** the vehicles have arrived from Japan.

(A) otherwise (B) due to
(C) therefore **(D) now that**

어휘 | hold (행사 등을) 열다, 개최하다 vehicle 차량

해석 | 자동차 쇼는 이번 주 금요일에 열릴 수 있는데, 일본으로부터 차량들이 도착했기 때문이다.

(A) 그렇지 않으면 (B) ~ 때문에
(C) 그러므로 (D) ~이기 때문에

해설 | 접속사 vs. 전치사
행사가 열릴 수 있는 이유가 빈칸 이후에 설명되어 있으므로 이유를 나타내는 전치사인 (B) due to와 부사절 접속사 (D) now that이 정답 후보. 빈칸 뒤에 절이 오기 때문에 명사(구)를 취하는 전치사 (B)는 오답이고 접속사 (D)가 정답이다.

14. **Given that** several major streets are blocked because of the blizzard, employees probably will not get in trouble for arriving late.

(A) Given that (B) Except that
(C) Unless (D) Notwithstanding

어휘 | blocked 봉쇄된, 막힌 blizzard 눈보라
 get in trouble 곤란에 처하다

해석 | 몇몇 주요 도로가 눈보라로 인해 봉쇄된다는 것을 고려해 직원들은 지각한 것에 대해 곤경에 처하지 않을 것이다.

(A) ~을 고려해 (B) ~을 제외하고
(C) ~하지 않으면 (D) ~에도 불구하고

해설 | 조건 접속사
빈칸은 두 개의 절을 연결하는 접속사 자리이므로 전치사 (D) Notwithstanding은 오답으로 제외. 문맥상 '주요 도로가 봉쇄된 것을 고려해 직원들이 지각한 것에 대해 곤경에 처하지 않을 것이다'는 의미가 가정 적절하므로 정답은 조건을 나타내는 접속사 (A) Given that.

Sky Asia Adds Flights to France

스카이 아시아 프랑스 항공편 추가

SINGAPORE, JANUARY 5—Sky Asia, Singapore's top budget airline, will launch its first direct flight to Paris, France, from Changi Airport at 8 A.M. tomorrow. **15 This means passengers to Europe will no longer have layovers.** Sky Asia chairman Emerson Kong expressed pride in the airline's latest destination. "Becoming the world's best budget carrier is our goal. We have been opening new routes at least every two years **16 since** our airline was established," Kong said. "Through this and other Sky Asia routes, our passengers can **17 access** many parts of the world."

To celebrate its first European route, Sky Asia is offering 20 percent off fares until January 31. Please note **18 that** to get this promotion, ticket purchases must be made on the Sky Asia Web site only.

싱가폴, 1월 5일—싱가폴 최고의 저가 항공사인 스카이 아시아 사가 창이 공항에서 프랑스 파리까지의 첫 번째 직항 노선을 내일 오전 8시에 취항시킬 것이다. **15 이것은 유럽으로 가는 승객들이 더 이상 경유를 하지 않는다는 뜻이다.** 스카이 아시아 사 회장 에머슨 콩은 항공사의 가장 최근의 목적지에 대한 자부심을 표현했다. "세계 최고의 저가 항공사가 되는 것이 저희의 목표입니다. 저희 항공사가 설립된 **16 이래로** 최소 2년마다 새 항로를 취항하고 있습니다,"라고 콩 씨는 말했다. "이 항로와 다른 스카이 아시아 항로를 통해, 저희 승객들은 세계의 많은 곳들에 **17 접근할** 수 있습니다."

첫 번째 유럽 항로를 축하하기 위해, 스카이 아시아 사는 1월 31일까지 20퍼센트의 요금 할인을 제공한다. 이 할인을 받으려면, 스카이 아시아 웹사이트에서만 항공권을 구입해야 **18 된다는 것을** 유념해야 한다.

어휘 | budget airline 저가 항공사 no longer 더 이상 ~하지 않는 layover 도중하차 destination 목적지 carrier 항공사, 운송 회사 establish 설립하다 fare 요금

15. **(A) This means passengers to Europe will no longer have layovers.**

(B) The passenger carrier will return to Paris within the day.

(C) Sky Asia will start selling tickets for its first flight to Europe.

(D) The flight left London an hour after its passengers checked in.

해석 |
(A) 이것은 유럽으로 가는 승객들이 더 이상 경유를 하지 않는다는 뜻이다.
(B) 여객기는 하루 만에 파리로 돌아올 것이다.
(C) 스카이 아시아 사는 그들의 첫 번째 유럽행 항공권을 팔기 시작할 것이다.
(D) 그 비행기는 승객들의 수속 1시간 후 런던을 떠났다.

해설 | **알맞은 문장 고르기**
빈칸 앞 문장의 its first direct flight to Paris, France가 중요한 단서가 된다. 기사에서 다루고 있는 첫 노선은 프랑스 파리로의 직항 노선이기 때문에 '유럽으로 가는 승객들이 더 이상 경유를 하지 않는다'는 문장이 와야 적절하다. 따라서 정답은 (A). 싱가폴에서 출발하는 파리행 노선 광고이므로 프랑스로 돌아온다는 내용은 문맥에 맞지 않아 (B)는 오답이다. 프랑스 파리행 비행기가 유럽행 첫 비행기 취항인지는 알 수 없으므로 (C)도 오답이며, 런던에서 출발하는 비행기는 빈칸 앞에 언급되지 않았으므로 (D)도 오답이다.

16. (A) when
(B) now
(C) before
(D) since

해석 | (A) ~할 때 (B) ~이기 때문에 (C) ~ 전에 (D) ~한 이후로

해설 | **시간 접속사**
문맥상 '저희 항공사가 설립된 이래로'라는 의미가 적절하므로 정답은 시간을 나타내는 접속사 (D) since. (A)는 설립한 때를, (B)는 now that에서 that을 생략한 형태로 설립한 이유를, (C)는 설립 이전의 일을 의미하므로 모두 문맥에 맞지 않아 오답.

17. **(A) access**
(B) aspire
(C) support
(D) arrive

해석 | (A) 접근하다 (B) 열망하다 (C) 지지하다 (D) 도착하다

해설 | **동사 어휘 access**
빈칸 뒤 동사의 목적어로 장소(many parts of the world)가 나오고 있으므로 특정 장소에 '접근하다'라는 의미가 가장 적절하다. 따라서 정답은 (A) access. (D) arrive는 자동사로 전치사 없이 목적어를 바로 취할 수 없어 오답이다.

DAY 16

18.
(A) about
(B) except
(C) during
(D) that

해석 | (A) ~에 관해　　(B) ~을 제외하고
　　　 (C) ~하는 동안　(D) ~하는 것

해설 | **명사절 접속사**
빈칸 앞에 동사 note가 있고 그 뒤에 동사의 목적어 역할을 하는 절이 이어지는 것으로 보아 빈칸은 목적어 역할을 하는 명사절 접속사 that이 들어가야 하는 것을 알 수 있다. 따라서 정답은 (D). please note that(~을 유념하라)이라는 표현은 토익에서 자주 출제되므로 반드시 묶어서 기억해 두자.

[19-22] 편지

Robert Cosby
35 Chestnut Drive
Silvertown, PA 19320

January 15

Dear Mr. Cosby,

Congratulations! Your entry to the Armcore Photo Contest, titled *Even Lights*, has been chosen as the best picture. As the first-prize winner, you will receive $1,000 in cash and a two-year scholarship at the American School of the Arts. The scholarship covers for a maximum of 20 credits every semester **19 until** it expires.
Enclosed is a certificate from our company. It specifies all the prizes and **20 benefits** that you are entitled to. We are holding an awards ceremony on February 25 and hope that you can attend.
21 Otherwise, we will send your prizes to your address.
22 We request that you confirm receipt of this notification. You may call us at 555-0900 or send an e-mail to publicrelations@armcore.com. Thank you.

Sincerely,

Geneva Owens
Armcore Photo Contest Chairman

로버트 코즈비
체스트넛 드라이브 35번지
실버타운, 펜실베니아 주 19320

1월 15일

코즈비 씨께,

축하합니다! 귀하의 〈차분한 빛〉이 암코어 사진 콘테스트 출품작 중 최고의 사진으로 선정되었습니다. 1등 수상자로서, 귀하는 1,000달러의 현금과 미국 예술대학에서 2년간의 장학금을 받으실 것입니다. 장학금은 만료될 때 **19 까지** 매 학기 최대 20학점의 등록비를 댈 것입니다.

동봉된 것은 저희 회사로부터의 증명서입니다. 여기에는 받으실 자격이 있는 모든 상품과 **20 혜택들이** 구체적으로 명시되어 있습니다. 저희는 2월 25일에 시상식을 열 것이고 귀하께서 참석하시길 바랍니다.

21 그렇지 않으면, 저희가 상품들을 귀하의 주소로 보내드리겠습니다.

22 이 통지를 받으셨음을 확인해 주실 것을 요청드립니다. 귀하께서는 555-0900으로 전화 주시거나 publicrelations@armcore.com으로 이메일을 보내주시면 됩니다. 감사합니다.

암코어 사진 콘테스트 회장
제네바 오언스 드림

어휘 | entry 출품작, 참가　title 제목을 붙이다; 제목, 표제　scholarship 장학금　expire 만료되다, 만기가 되다　certificate 증명서, 증서
　　be entitled to A A를 받을 자격이 있다　awards ceremony 시상식　receipt 수령, 영수증　notification 통지

19.
(A) yet
(B) before
(C) until
(D) for

해석 | (A) 그러나　　(B) ~ 전에
　　　 (C) ~까지　　 (D) ~를 위해서

해설 | **시간 접속사**
장학금의 혜택에 대해 설명하고 있는 문장으로, 문맥상 '만료될 때까지'라는 의미가 가장 자연스럽다. 따라서 '~까지'라는 의미인 시간을 나타내는 접속사 (C) until이 정답.

20. (A) beneficiary
(B) benefits
(C) benefitting
(D) beneficial

해설 | **병렬 구조**
빈칸 앞에 등위접속사 and를 보자마자 병렬 구조를 떠올릴 수 있어야 한다. 등위접속사는 문법적 특성이 동등한 요소를 연결해 주므로 and 앞의 표현을 확인한다. the prizes라는 명사가 쓰였으므로 빈칸에도 명사가 와야 한다. 따라서 선택지 중 명사인 (A), (B)가 정답 후보. 문맥상 '혜택들이 명시되어 있다'는 의미가 자연스러우므로 정답은 (B) benefits.

21. (A) Nevertheless
(B) Accordingly
(C) However
(D) Otherwise

해석 | (A) 그럼에도 불구하고 (B) 따라서
 (C) 그러나 (D) 그렇지 않으면

해설 | **접속 부사**
문맥에 어울리는 접속 부사를 찾는 문제. 빈칸 앞 문장에서 시상식에 참여해 달라는 요청을 하고, 빈칸 다음에 상품을 보내겠다는 대조되는 내용이 나오므로 '그렇지 않으면'이라는 의미가 가장 자연스럽다. 따라서 정답은 (D) Otherwise. 나머지 접속 부사들은 문맥에 맞지 않아 오답이다.

22. (A) Please let us know what you plan to name your entry.
(B) We would appreciate receiving your photograph soon.
(C) We request that you confirm receipt of this notification.
(D) You may get your registration form at our office.

해석 |
(A) 귀하의 출품작 이름을 어떻게 지으실 계획인지 알려주십시오.
(B) 귀하의 사진을 곧 받을 수 있으면 감사하겠습니다.
(C) 이 통지를 받으셨음을 확인해 주실 것을 요청드립니다.
(D) 저희 사무실에서 귀하의 등록 양식을 받으실 수 있습니다.

해설 | **알맞은 문장 고르기**
다음 문장에서 전화와 이메일로 연락할 방법에 대한 정보를 제공하고 있다. 따라서 연락할 이유가 빈칸에 나오는 것이 가장 자연스러우므로 상품 안내 통지 수령 확인에 대한 요청을 하는 문장이 가장 적절하다. 정답은 (C). 편지 앞부분에 사진명이 나와 있으므로 (A)는 오답이고, 사진도 이미 출품했기 때문에 (B)와 (D)도 오답이다.

DAY 16

FINAL TEST

교재 163쪽

1. (A)	**2.** (C)	**3.** (A)	**4.** (C)	**5.** (B)	**6.** (B)	**7.** (D)	**8.** (A)	**9.** (A)	**10.** (B)
11. (A)	**12.** (A)	**13.** (C)	**14.** (D)						

1.

A team of experts is reviewing the resolutions **that** contain laws against creating corporate monopolies.

(A) that (B) whom
(C) what (D) where

어휘 | expert 전문가 resolution 결의안 law against ~을 금지하는 법
monopoly 독점

해석 | 한 팀의 전문가들이 기업의 독점 형성을 금지하는 법안을 담은 결의안을 검토 중이다.

해설 | **주격 관계대명사**
뒤에 동사 contain이 나온 것으로 보아 빈칸은 주격 관계대명사 자리. 빈칸 앞에 사물 선행사 the resolutions가 있으므로 (A) that이 정답이다. 목적격 관계대명사 (B) whom은 뒤에 목적어가 생략된 〈주어+타동사〉 구조여야 하고, (C) what은 그 자체가 선행사를 포함하고 있으므로 〈선행사+what〉의 형태로는 쓸 수 없으며, 관계부사 (D) where는 뒤에 완전한 절이 와야 하므로 모두 오답.

2.

Tidal Productions' film directors, **whose** action movies have received numerous recognitions, are working on a new project.

(A) which (B) that
(C) whose (D) when

어휘 | numerous 많은 recognition 인정

해석 | 액션 영화로 인정을 많이 받아 온 타이달 제작사의 영화 감독들이 새로운 영화를 작업 중이다.

해설 | **소유격 관계대명사**
선택지와 앞의 콤마를 보니 계속적 용법으로 쓰인 알맞은 관계사를 고르는 문제이다. 빈칸 앞 선행사 film directors와 빈칸 뒤 action movies는 '영화 감독들의 액션 영화'란 의미로 소유 관계이므로 소유격 관계대명사인 (C) whose가 정답. 참고로 관계사 앞에 콤마를 붙여서 선행사 또는 절 전체를 보충 설명하는 관계사의 계속적 용법으로는 that과 what을 쓸 수 없다.

3.

The hospital is hiring first aiders **experienced** in responding to emergencies.

(A) experienced (B) instructed
(C) compromised (D) completed

어휘 | first aider 응급 처치 요원 respond to ~에 대응하다
emergency 응급 상황

해석 | 그 병원은 응급 상황에 대응하는 데 경험이 있는 응급 처치 요원을 채용 중이다.
(A) 경험이 있는 (B) 교육을 받은
(C) 타협된 (D) 작성한

해설 | **형용사 어휘 experienced**
문맥상 '경험이 있는 응급 처치 요원'이라는 의미가 가장 자연스러우므로 정답은 (A) experienced. 빈칸 앞에 〈주격 관계대명사+be동사〉인 who are가 생략된 구조로 빈칸 이하가 선행사 first aiders를 수식하고 있다.

4.

The art museum **in** which Mr. Stephen's painting exhibit was held is visited by hundreds of tourists every day.

(A) to (B) for
(C) in (D) from

어휘 | exhibit 전시회 be held (행사 등이) 열리다

해석 | 스티븐 씨의 그림 전시회가 열린 그 미술관에는 매일 수백명의 관광객들이 방문한다.

해설 | **〈전치사+관계대명사〉**
빈칸에 알맞은 전치사를 고르는 문제로, 빈칸 뒤에 관계대명사 which가 있는 것으로 보아 관계부사 역할을 하는 〈전치사+관계대명사〉 구조임을 알 수 있다. 빈칸 앞에 장소를 나타내는 선행사 The art museum이 있고 문맥상 '미술관에서 전시회가 열리는 것'이므로 장소 전치사 (C) in이 정답. in which는 관계부사 where로 바꿔 쓸 수 있다.

5.

Workers at Protex Construction are required to take heavy-equipment training courses, which **explain** the proper procedures to follow.

(A) explanation　　　　　**(B) explain**
(C) explaining　　　　　(D) explains

어휘 | be required to *do* ~하도록 요구되다　heavy-equipment 중장비
proper 적절한　procedure 절차

해석 | 프로텍스 건설사의 직원들은 준수해야 할 적절한 절차를 설명하는 중장비 훈련 과정을 듣도록 요구받는다.

해설 | 관계사절 내 동사의 수일치
주격 관계대명사 which가 이끄는 관계사절에 동사가 없으므로 빈칸은 동사 자리이다. 따라서 동사 형태인 (B) explain과 (D) explains가 정답 후보. 관계사절의 동사는 선행사에 수와 태를 일치시켜야 한다. 선행사 training courses가 복수 명사이므로 복수 동사인 (B)가 정답이다.

6.

Lawyers who **regularly** attend seminars on new government policies gain valuable knowledge about their profession.

(A) instantly　　　　　**(B) regularly**
(C) reasonably　　　　(D) comparatively

어휘 | attend 참석하다　valuable 값진, 소중한　profession 직업

해석 | 새로운 정부 정책에 대한 세미나에 정기적으로 참석하는 변호사들은 자신의 직업에 관한 값진 지식을 얻는다.
(A) 즉각　　　　　(B) 정기적으로
(C) 상당히　　　　(D) 비교적

해설 | 부사 어휘 regularly
문맥에 어울리는 부사를 고르는 문제로, 문맥상 '세미나에 정기적으로 참석한다'고 하는 것이 자연스럽다. 따라서 정답은 (B) regularly.

7.

During difficult economic times, lenders conduct more extensive background checks on the people to **whom** they make loans.

(A) whoever　　　　　(B) what
(C) where　　　　　　**(D) whom**

어휘 | lender 대출기관　conduct a check on ~을 조사하다
extensive 광범위한　make a loan 돈을 빌려주다

해석 | 경제가 어려운 시기에는 대출기관들은 그들이 돈을 빌려주는 사람들에 대해 보다 광범위한 신원 조사를 한다.

해설 | 목적격 관계대명사
사람 선행사 the people을 수식하며 전치사 to 뒤에 올 수 있는 것은 목적격 관계대명사뿐이다. 따라서 (D) whom이 정답이다. 복합관계대명사 (A) whoever와 관계대명사 (B) what은 선행사를 이미 포함하고 있으므로 앞에 선행사가 올 수 없고, 관계부사 (C) where는 장소 선행사와 쓰이며 앞에 전치사가 올 수 없어 오답.

8.

My assistant sent the client a map of the building **where** we will discuss the terms of the negotiated contract.

(A) where　　　　　(B) which
(C) who　　　　　　(D) what

어휘 | assistant 비서　client 고객　terms 조건　negotiate 협상하다
contract 계약(서)

해석 | 내 비서가 고객과 내가 협상한 계약 조건에 대해 논의할 건물의 약도를 고객에게 보냈다.

해설 | 관계부사
빈칸 앞의 the building은 장소를 나타내는 선행사이며 빈칸 뒤에 완전한 절이 왔으므로 정답은 관계부사 (A) where. 관계부사는 〈전치사+관계대명사〉로 바꿔 쓸 수 있으며 여기서 where은 in which로 바꿔 쓸 수 있다.

9.

Each section of a contract should be read carefully in order to know exactly **what** the document states.

(A) what　　　　　(B) how
(C) some　　　　　(D) many

어휘 | section 부분　in order to *do* ~하기 위해　state 명시하다

해석 | 서류에 명시된 내용을 정확하게 알기 위해 계약서의 모든 부분을 주의 깊게 읽어야 한다.

해설 | 관계대명사 what
빈칸은 동사 know의 목적어가 되는 명사절을 이끄는 동시에, 명사절 내에서 동사 contains의 목적어 역할을 할 수 있어야 한다. 선택지 중 이 두 가지 역할을 동시에 할 수 있는 것은 관계대명사 what뿐이므로 정답은 (A). what은 그 자체에 선행사를 포함하고 있으며 the thing which[that]로 바꾸어 쓸 수 있다.

10.

Arguel Telecom took many measures to address its financial problems, none of **which** saved the firm from bankruptcy.

(A) whom　　　　　**(B) which**
(C) that　　　　　(D) who

어휘 | measure 조치　address a problem 문제를 처리하다　financial 재정적인　bankruptcy 파산

해석 | 아구엘 통신사는 재정 문제를 처리하기 위해 여러 조치를 취했지만, 그것 중 어떤 것도 그 회사를 파산에서 구하지 못했다.

해설 | 〈부정대명사+of+목적격 관계대명사〉
앞뒤의 두 개의 절을 연결하면서 빈칸 앞 〈부정대명사+of〉인 none of 뒤에 쓰일 수 있는 것은 목적격 관계대명사이다. 따라서 선택지 중 목적격 관계대명사인 (A) whom과 (B) which가 정답 후보. 선행사 many measures가 사물이므로 정답은 사물 선행사를 수식하는 (B). 〈부정대명사+of〉 뒤에 who와 that은 쓸 수 없다는 점을 기억해 두자.

11. Eagle Cargo can deliver your packages anywhere, **however** remote the location is.

(A) however (B) whenever

(C) whatever (D) whichever

어휘 | package 소포 remote 외진

해석 | 이글 화물은 장소가 아무리 외진 곳이라 할지라도 어느 곳이나 귀하의 소포를 배달할 수 있습니다.

해설 | **복합관계부사**

선택지로 보아 적절한 복합관계사를 고르는 문제. 선택지 중 빈칸 뒤의 형용사 remote를 수식할 수 있는 복합관계사는 however(아무리 ~ 하더라도)뿐이므로 정답은 (A). 참고로, 복합관계대명사 whatever와 whichever는 복합관계형용사로 쓰일 때에는 뒤에 명사가 올 수 있다는 점을 기억하자.

12. The sales report for Dreda Tech, **whose** profits have been increasing every month, showed a slowdown of the growth.

(A) whose (B) what

(C) which (D) that

어휘 | profit 이익 slowdown 둔화 growth 성장

해석 | 매달 이익이 증가해 오던 드레다 테크 사의 영업 보고서에 따르면 성장이 둔화되고 있다.

해설 | **소유격 관계대명사**

빈칸 앞 선행사 Dreda Tech를 계속적 용법으로 보충 설명해 주며 빈칸 뒤 명사 profits를 한정시켜줄 수 있는 것은 소유격 관계대명사뿐이므로 정답은 (A) whose. (B) what 앞에는 선행사가 올 수 없고 계속적 용법으로도 쓸 수 없어 오답. 빈칸 뒤의 절에 주어 profits가 있고 목적어도 필요 없으므로 관계대명사 (C) which도 오답이다. (D) that 역시 계속적 용법으로 쓸 수 없으므로 오답이다. 소유격 관계대명사 whose는 사람 선행사뿐만 아니라 사물 선행사에도 쓸 수 있음에 주의하자.

13. **Whoever** leaves the laboratory last has the responsibility of ensuring that the heating equipment has been shut down.

(A) Whatever (B) Whomever

(C) Whoever (D) Whenever

어휘 | laboratory 실험실 responsibility 책임 ensure 반드시 ~하게 하다 shut down 정지시키다

해석 | 실험실을 마지막으로 나가는 사람은 누구든지 반드시 난방 기기 전원이 꺼졌는지 확인해야 한다.

해설 | **복합관계대명사**

빈칸부터 last까지가 문장의 주어로 빈칸은 명사절을 이끄는 동시에 동사 has의 주어 역할을 해야 하므로 복합관계대명사 (A) Whatever와 (C) Whoever가 정답 후보. 문맥상으로 '나가는 사람은 누구든지' 란 뜻이 되어야 하므로 정답은 (C) Whoever. Whatever는 '~하는 것은 무엇이나'라는 의미로 문맥에 맞지 않아 오답이다. 복합관계대명사는 〈관계대명사+-ever〉의 형태로 선행사를 포함하고 있으며 형용사절이 아닌 명사절이나 부사절을 이끈다는 것을 기억하자.

14. Security officers will block access to the main roads this Saturday, **when** Mayor Gustavo will be giving a speech.

(A) then (B) where

(C) which (D) when

어휘 | security officer 경호원, 경비원 block 차단하다 give a speech 연설하다

해석 | 경호원들이 이번 주 토요일에 주요 도로의 통행을 차단할 것인데, 그때에 시장인 구스타보 씨가 연설을 할 것이다.

해설 | **관계부사**

빈칸 앞뒤의 절을 연결하면서 빈칸 뒤에 완전한 절이 나오므로 관계부사 (B) where와 (D) when이 정답 후보이다. 빈칸 바로 앞 선행사 this Saturday가 시간을 나타내므로 정답은 (D). the main roads를 선행사로 착각하여 (B) where를 고르지 않도록 주의하자. (A) then은 부사로 두 개의 절을 연결할 수 없으므로 오답이고 관계대명사 (C) which 뒤에는 불완전한 절이 와야 하므로 오답이다.

FINAL TEST

교재 171쪽

1. (A)	**2.** (B)	**3.** (C)	**4.** (A)	**5.** (A)	**6.** (B)	**7.** (B)	**8.** (C)	**9.** (D)	**10.** (B)
11. (A)	**12.** (C)	**13.** (A)	**14.** (B)	**15.** (B)	**16.** (D)	**17.** (B)	**18.** (A)	**19.** (D)	**20.** (B)
21. (C)	**22.** (A)								

1.

Customers whose pizza deliveries are delayed for more **than** 30 minutes are entitled to a $10 gift certificate.

(A) than (B) as
(C) for (D) over

어휘 | delay 지연시키다 be entitled to A A를 받을 자격이 있다

해석 | 피자 배달이 30분 이상 지연된 손님은 10달러 상당의 상품권을 받을 자격이 있다.

해설 | 비교 구문 관용표현
문맥상 '30분 이상'이라는 의미가 적절하므로 빈칸 앞 more와 함께 '~ 이상'이라는 비교 구문 관용표현을 완성하는 (A) than이 정답. 자주 출제되는 관용표현은 반드시 외워두자.

2.

Finding a job has become **even** more difficult in New York where many companies are affected by the economic crisis.

(A) around **(B) even**
(C) very (D) about

어휘 | affect 영향을 미치다 economic crisis 경제 위기

해석 | 다수의 회사들이 경제 위기에 영향을 받은 뉴욕에서는 일자리를 찾는 것이 훨씬 더 어려워졌다.

해설 | 비교급 강조 부사
빈칸에 적절한 부사를 고르는 문제로, 뒤의 비교급 more difficult를 수식할 수 있는 것을 찾으면 된다. 따라서 정답은 (B) even. (C) very는 원급을 수식하므로 오답이다. 이밖에도 비교급을 강조할 수 있는 부사로는 far, much, a lot, still 등이 있다.

3.

All advanced measures were taken for the maintenance work on the bridge to be as **smooth** as possible.

(A) smoothly (B) smoothest
(C) smooth (D) smoother

어휘 | advanced 선진의 take measures 조치를 취하다 maintenance 유지 보수 smooth (일의 진행이) 순조로운

해석 | 그 다리 위의 유지 보수 업무가 가능한 한 순조로울 수 있도록 모든 선진 조치들이 취해졌다.

해설 | 형용사 vs. 부사
빈칸 앞뒤의 as, as possible을 보자마자 〈as+형용사/부사의 원급+as possible〉 형태의 원급 비교 구문을 떠올릴 수 있어야 한다. 따라서 (A)와 (C)가 정답 후보. 문장이 be동사의 보어가 필요한 불완전한 문장이므로 보어 역할을 하는 형용사 (C) smooth가 정답이다.

4.

The number of foreign tourist arrivals in Bali is typically the **greatest** in July and August.

(A) greatest (B) greatly
(C) greater (D) great

어휘 | arrival 도착한 사람, 도착 typically 일반적으로

해석 | 발리에 도착하는 외국인 관광객 수는 일반적으로 7월과 8월에 가장 많다.

해설 | 최상급 비교 구문
빈칸 앞의 정관사 the와 뒤에 범위를 나타내는 전치사구 in July and August가 빈칸이 형용사 최상급 자리임을 알려주는 단서이다. 문맥상으로도 '7월과 8월에 가장 많다'는 것이 자연스러우므로 정답은 형용사 최상급 (A) greatest.

5.

With the rearranged shelves at Anton Supermarket, the dairy products may now be found **more** easily than other items.

(A) more (B) very
(C) most (D) least

어휘 | rearrange 재배열하다 dairy product 유제품

해석 | 안톤 슈퍼마켓에 재배열된 선반에서, 이제 유제품을 다른 제품보다 더 쉽게 찾을 수 있다.

해설 | 비교급 비교 구문
빈칸 뒤에 than이 있으므로 부사 easily가 비교급으로 쓰인 것을 알 수 있다. 형용사+-ly 부사형의 비교급은 more를 붙인 형태이므로 정답은 (A) more.

6.

Rather than closing some offices, the advertising company offered an early retirement package to senior staff members.

(A) Less **(B) Rather**

(C) More (D) Instead

어휘 | early retirement package 명예퇴직금

해석 | 그 광고 회사는 일부 사무실 문을 닫는 대신에, 고참 직원들에게 명예퇴직금을 제공했다.

해설 | **비교 구문 관용표현**

문맥상 '사무실을 닫는 대신에 명예퇴직금을 제공했다'는 뜻이 적절하다. 비교급 관용표현인 rather than이 '~ 대신에, ~보다는'이라는 뜻으로 쓰이므로 정답은 (B) Rather. than만 보고 비교급 (A) Less나 (C) More를 선택하는 실수를 하지 않도록 하자. (D) Instead는 뒤에 전치사 of와 함께 '~ 대신에'라는 의미로 쓰이므로 오답.

7.

The Wonder induction stove comes with energy-saving features, so it uses **less** electricity than other brands.

(A) few **(B) less**

(C) most (D) least

어휘 | come with ~이 딸려 있다 feature 특징, 특성 electricity 전기

해석 | 원더 전기 레인지에는 에너지 절전 기능이 있어서, 다른 브랜드보다 전기를 덜 이용한다.

해설 | **비교급 비교 구문**

빈칸 뒤 than 이하에 비교의 대상인 other brands가 있는 것으로 보아 비교급 비교 구문이 쓰였음을 알 수 있다. 따라서 비교급 (B) less가 정답.

8.

The director provided **as much** support to the sales team as to the marketing communications group.

(A) as long as (B) so that

(C) as much (D) so many

어휘 | support 지원

해석 | 그 부장은 마케팅 커뮤니케이션 그룹을 지원하는 만큼 영업팀도 많이 지원했다.

해설 | **원급 비교 구문**

빈칸 뒤의 〈명사+as〉를 보고 원급 비교 구문 〈as+much[many] +명사+as〉 구조를 파악하는 것이 관건이다. 빈칸 뒤 명사 support가 불가산명사이므로 much가 수식해야 한다. 따라서 정답은 (C) as much.

9.

The city's **strictest** parking policies have cleared the busy streets in the downtown area.

(A) strictness (B) strictly

(C) more strictly **(D) strictest**

어휘 | strict 엄격한 policy 정책 clear ~을 치우다

해석 | 시의 가장 엄격한 주차 정책으로 도심 지역의 번화한 거리가 뚫렸다.

해설 | **최상급 비교 구문**

빈칸은 명사구 parking policies를 수식하는 형용사 자리이다. 선택지 중에서는 형용사는 최상급 형태인 strictest뿐이므로 정답은 (D). 문맥상으로도 '시의 가장 엄격한 주차 정책'이란 뜻이 자연스럽다. 형용사의 최상급 앞에는 the 이외에 소유격이 올 수도 있다는 점을 기억하자.

10.

Mr. Elliot reacted **more positively** to our latest window design suggestion than to the previous ones.

(A) most positively **(B) more positively**

(C) more positive (D) most positive

어휘 | react to ~에 반응하다 positively 긍정적으로 suggestion 제안 previous 이전의

해석 | 엘리엇 씨는 우리의 최신 창문 디자인 제안에 대해 이전 제안들보다도 더 긍정적으로 반응했다.

해설 | **형용사 vs. 부사**

빈칸 뒤에 than이 있는 것으로 보아 빈칸은 비교급 자리이므로 (B)와 (C)가 정답 후보이다. 동사 react는 보어가 필요 없는 자동사이므로 동사 reacted를 수식하는 부사 비교급 (B) more positively가 정답이다.

11.

In a recent study, automatic trains were found to be safer than those **operated** by human.

(A) operated (B) switched

(C) debated (D) canceled

어휘 | automatic 자동의

해석 | 최근 연구에 따르면, 자동으로 가는 기차가 사람이 작동하는 기차보다 더 안전한 것으로 밝혀졌다.

(A) 작동하다 (B) 바꾸다

(C) 논의하다 (D) 취소하다

해설 | **동사 어휘 operate**

자동으로 가는 기차와 사람에 의해 가는 기차가 비교되고 있으므로 문맥상 '사람이 작동하는 기차'라는 의미가 들어가야 자연스럽다. 따라서 정답은 (A) operated.

12.

This month's anniversary issue of *Business Magazine* features some of the **youngest** billionaires in Washington.

(A) young (B) younger

(C) youngest (D) youth

어휘 | feature 특집으로 다루다; 특집 billionaire 억만장자

해석 | 〈비즈니스 매거진〉의 이번 달 기념호는 워싱턴의 가장 젊은 억만장자 몇 명을 특집으로 다룬다.

해설 | **최상급을 이용한 구문**

빈칸 앞 some of the를 보자마자 '가장 ~한 것 중 일부'라는 의미의 〈some of the + 최상급 + 복수 명사〉 구문을 떠올릴 수 있어야 한다. 이 표현을 몰랐더라도 정관사 the의 수식을 받으며 뒤에 in Washington이라는 범위를 나타내는 전치사구가 있으므로 빈칸은 형용사 최상급 자리임을 알 수 있다. 따라서 정답은 (C) youngest.

13.

Employees who wish to sign up for the badminton league need to notify the HR department no **later** than June 15.

(A) later (B) latest

(C) lately (D) late

어휘 | sign up for ~을 신청하다 notify 알리다

해석 | 배드민턴 리그에 신청하고 싶은 직원들은 늦어도 6월 15일까지 인사부에 알려야 한다.

해설 | **비교 구문 관용표현**

문맥상 '늦어도 6월 15일까지'라는 의미이므로 빈칸 앞뒤의 no와 than과 함께 '늦어도 ~까지'라는 의미를 만드는 비교 구문 관용표현 no later than이 쓰였음을 알 수 있다. 따라서 정답은 (A) later.

14.

The **more** the company invests in the new construction project, the greater its legal liability becomes.

(A) most **(B) more**

(C) mostly (D) moreover

어휘 | invest in ~에 투자하다 liability (부채나 상해에 대한 법적인) 책임, 부담

해석 | 회사가 새로운 건설 프로젝트에 더 많이 투자할수록, 법적 책임도 더 커진다.

해설 | **비교급을 이용한 구문**

빈칸 앞의 정관사 The와 콤마 뒤의 the greater로 보아 '~하면 할수록, 더 …하다'라는 뜻의 비교급을 이용한 구문 〈the + 비교급, the + 비교급〉이 쓰였음을 알 수 있다. 문맥상으로도 '더 많이 투자할수록, 책임도 더 커진다'라는 의미가 되어야 하므로 선택지 중 비교급인 (B) more가 정답.

[15-18] 광고

GreatJobs1.com has come to Malaysia!

We are pleased to inform you that Greatjobs1.com, one of Europe's largest employment firms, is now serving Malaysia. We are in the process of building the new network, through **15 which** companies across the country will be able to find the best candidates.

We specialize in banking and finance placements, and we maintain the **16 most comprehensive** service packages in our field. We provide online recruitment, classified advertisement, and outsourced headhunting services. Through these services, we link **17 at least** 50,000 job seekers to vacancies that best suit their credentials every day.

Register for a free trial of our services and strengthen your workforce now by calling 555-9097. **18 Our recruitment experts are waiting to assist you.**

그레이트잡스1닷컴 사 말레이시아에 오다!

유럽의 가장 큰 고용 알선 회사 중 하나인 그레이트잡스1닷컴 사가 이제 말레이시아에서 서비스를 제공한다는 것을 알리게 되어 기쁩니다. 저희는 신규 네트워크를 만들고 있는데 **15 이 네트워크를** 통해 전국에 있는 회사들은 최적의 후보자를 찾을 수 있을 것입니다.

저희는 은행 및 재무 분야를 전문으로 하고 있는데, 저희 분야에서 **16 가장 포괄적인** 서비스 패키지를 유지하고 있습니다. 저희는 온라인 채용 및 구인 광고와 외주 헤드헌팅 서비스를 제공합니다. 이러한 서비스를 통해서 매일 **17 적어도** 50,000명의 구직자들을 그들의 자격 요건에 가장 잘 맞는 일자리에 연결해줍니다.

지금 555-9097로 전화하셔서 무료로 사용해 볼 수 있는 저희 서비스를 신청하시고 귀사의 인력을 강화시키세요. **18 저희 채용 전문가들이 귀하를 돕기 위해 기다리고 있겠습니다.**

어휘 | in the process of ~의 과정 중에 candidate 후보자 specialize in ~을 전문으로 하다 field 분야 classified advertisement 구인 광고 outsource 외부에 위탁하다 vacancy 공석 credentials 자격 strengthen 강화하다 workforce 인력

15.
(A) whom
(B) which
(C) whose
(D) that

해설 | 〈전치사＋관계대명사〉
선택지를 보니 알맞은 관계대명사를 고르는 문제이다. 빈칸 앞에 전치사 through가 있으므로 목적격 관계대명사 (A) whom과 (B) which가 정답 후보. 선행사가 사람이 아니라 사물인 network이므로 (B)가 정답이다. 소유격 관계대명사 (C) whose와 관계대명사 (D) that은 전치사 뒤에 쓸 수 없으므로 오답이다.

16.
(A) more comprehensively
(B) comprehension
(C) comprehensively
(D) most comprehensive

해설 | 최상급을 이용한 구문
빈칸 앞의 the와 빈칸 뒤에 범위를 나타내는 전치사구 in our field가 있으므로 빈칸은 형용사 최상급 자리이다. 문맥상으로도 '저희 분야에서 가장 포괄적인 서비스 패키지'란 뜻이 자연스러우므로 최상급 (D) most comprehensive가 정답.

17.
(A) more
(B) at least
(C) equal to
(D) less

해설 | 비교 구문 관용표현
빈칸은 50,000 job seekers를 수식하는 부사 자리이다. 문맥상 '적어도 50,000명의 구직자들을 연결시켜준다'는 의미가 자연스러우므로 정답은 '적어도'란 뜻의 (B) at least. 빈칸 뒤에 than이 없으므로 비교급 (A) more와 (D) less는 오답이다. (D) equal to는 형용사구로 보어 역할을 하는데 이 문장에서는 보어가 필요 없으므로 오답이다.

18.
(A) Our recruitment experts are waiting to assist you.
(B) You may extend your subscription anytime this month.
(C) Our staff will provide you with useful financial advice.
(D) We can find you a job you love quickly.

해석 |
(A) 저희 채용 전문가들이 귀하를 돕기 위해 기다리고 있겠습니다.
(B) 이번 달 언제든지 구독권을 연장할 수 있습니다.
(C) 저희 직원이 귀하에게 유용한 재정 관련 조언을 제공할 것입니다.
(D) 저희는 귀하가 원하는 일자리를 빠르게 찾아드릴 수 있습니다.

해설 | 알맞은 문장 고르기
빈칸은 광고글의 가장 마지막 문장으로, 여기에는 주로 look forward to *doing* 또는 wait to *do* 등의 표현과 함께 '고객을 기다리고 있겠다'는 내용이 나온다. 따라서 무료 서비스를 사용해 볼 것을 권장한 다음에 '귀하를 돕기 위해 기다리고 있겠다'라고 광고글을 마무리하는 것이 자연스러우므로 정답은 (A). 구독권 광고가 아니므로 (B)는 오답이다. 재정 관련 자문은 제공하지 않으므로 (C)도 오답이다. (D)는 구직자를 대상으로 하는 광고에서 볼 수 있는 내용이므로 오답이다.

[19-22] 메모

To: All Employees
From: Administrative Office
Date: June 5, Friday
Subject: Repair work

¹⁹ <u>Please be advised that the heating system on the third floor is under repair.</u> During the last inspection, the maintenance team noticed that many heater pipes in the floor's ceiling were ²⁰ <u>severely</u> damaged. We have ordered new pipes, but they will not arrive until next week. Because of this, it might take ²¹ <u>longer</u> than one week for our heating system to be restored.
We understand that the staff members of the finance department are currently affected by the problem. Therefore, they will be temporarily relocated to the fifth floor, ²² <u>where</u> the sales team used to operate.

받는 사람: 전직원
보내는 사람: 총무부
날짜: 6월 5일, 금요일
제목: 보수 공사

¹⁹ 3층 난방 시스템이 수리 중임을 알려드립니다. 지난 점검 중에 관리팀은 3층 천장의 여러 난방기 파이프가 ²⁰ 심각하게 손상되었음을 알아차렸습니다. 새 파이프를 주문했지만 다음 주에나 도착할 것입니다. 이 때문에 난방 시스템이 복구되려면 일주일 ²¹ 이상이 걸릴 것입니다.

우리는 재무 부서 직원들이 현재 이 문제로 영향을 받고 있음을 알고 있습니다. 따라서 그들은 5층에 임시로 자리를 옮길 텐데, ²² 그 층은 영업팀이 작업하던 곳입니다.

인내심을 가지고 이해해 주셔서 감사합니다. 질문이 있으시면 저희에게 알려주십시오.

어휘 | under repair 수리 중인 inspection 점검 notice ~을 알다, 의식하다 restore 복구시키다 currently 현재 affect 영향을 미치다 temporarily 임시로 operate 작업하다

19. (A) As you know, our office building will undergo an inspection.
 (B) We are pleased to inform you that the air conditioning units have been replaced.
 (C) We would like to announce that we are moving to a new building.
 (D) Please be advised that the heating system on the third floor is under repair.

해석 |
(A) 아시다시피, 우리 사무실 건물이 점검을 받을 것입니다.
(B) 에어컨이 교체되었음을 알리게 되어 기쁩니다.
(C) 우리가 새로운 건물로 이사 간다는 것을 알려드리고자 합니다.
(D) 3층 난방 시스템이 수리 중임을 알려드립니다.

해설 | **알맞은 문장 고르기**
빈칸은 메모의 첫 번째 문장으로 메모의 목적이 언급될 확률이 높다. 빈칸 뒤로 난방기 파이프가 손상되어서 새로운 파이프로 교체하여 복구될 것이라는 내용이 이어지고 있으므로 빈칸에는 난방기 수리와 관련해서 알려주는 내용이 들어가야 문맥상 자연스럽다. 따라서 정답은 (D).

20. (A) usually
 (B) severely
 (C) exactly
 (D) toughly

해석 | (A) 보통 (B) 심하게
 (C) 정확하게 (D) 단단하게

해설 | **부사 어휘 severely**
문맥에 어울리는 부사 어휘를 고르는 문제. 뒤 문장에서 새로운 파이프를 주문했다는 내용이 나오므로 '난방기 파이프가 심하게 손상되었다'고 교체 원인을 언급하는 것이 문맥상 자연스럽다. 따라서 정답은 (B) severely.

21. (A) length
 (B) longest
 (C) longer
 (D) long

해설 | **비교급 비교 구문**
빈칸 뒤에 than이 있으므로 빈칸에는 비교급 형태가 들어가야 한다. 선택지에서 비교급은 (C)뿐이므로 정답은 (C). longer than은 '~보다 오래'라는 의미로 자주 쓰이므로 한 단어처럼 외워두자.

22. **(A) where**
 (B) since
 (C) whereas
 (D) then

해설 | **관계부사**
빈칸 앞뒤로 두 개의 절을 연결해야 하므로 빈칸에는 접속사 역할을 할 수 있는 관계부사 (A), 접속사 (B)와 (C)가 정답 후보이다. 빈칸 앞 장소를 나타내는 선행사 the fifth floor를 보충 설명하는 절을 이끄는 관계부사 where가 들어가야 의미가 자연스러우므로 정답은 (A). 이유를 나타내는 since나 비교, 대조를 나타내는 whereas는 문맥에 어울리지 않으므로 오답이다.

DAY 18

FINAL TEST

교재 181쪽

1. (A) **2.** (D) **3.** (B) **4.** (C) **5.** (A) **6.** (D) **7.** (B) **8.** (A) **9.** (B) **10.** (A)
11. (D) **12.** (A) **13.** (C) **14.** (B)

1.

Mr. Tate could submit a suggestion for the new marketing campaign if the manager **extended** the deadline by one week.

(A) extended (B) extension
(C) extending (D) extends

(A) extended

어휘 | suggestion 제안 deadline 마감일

해석 | 부장이 마감일을 한 주 연장해 주면 테이트 씨는 신규 마케팅 캠페인 제안을 제출할 수 있을 텐데.

해설 | **가정법 과거**
if절에 동사가 없으므로 빈칸은 동사 자리로 (A)와 (D)가 정답 후보. 주절의 동사 could submit을 보고 가정법 과거 문장임을 알아채는 것이 관건. 가정법 과거의 if절은 〈if + 주어 + 동사 과거형〉 형태이므로 정답은 (A) extended. 가정법 과거는 현재 사실을 반대로 가정하거나 실현 가능성이 낮은 일을 나타낼 때 쓴다.

2.

If Tucker's Works had informed us of the malfunction earlier, we **would have replaced** the ordered item much sooner.

(A) had replaced (B) would replace
(C) replaced **(D) would have replaced**

어휘 | inform A of B A에게 B를 알리다 malfunction 오작동

해석 | 터커스 웍스 사가 오작동에 관해 좀 더 일찍 알려줬더라면, 우리는 주문한 물품을 훨씬 빨리 교체했을 텐데.

해설 | **가정법 과거완료**
주절 동사 자리에 빈칸이 있으므로 if절의 동사를 잘 살펴봐야 한다. if절의 동사가 had informed이므로 가정법 과거완료가 쓰였음을 알 수 있고 문맥상으로도 '더 일찍 알려줬더라면, 훨씬 빨리 교체했을 텐데'라는 과거 사실과 반대되는 일을 가정하고 있다. 가정법 과거완료의 주절 동사는 〈would[could, should] + have p.p.〉 형태이므로 정답은 (D).

3.

Little could Professor Wiseley have known that his book on personal finance was going to be published in many countries.

(A) A few **(B) Little**
(C) Less (D) Always

어휘 | personal 개인적인 finance 재무 publish 출판하다

해석 | 와이즐리 교수는 개인 재무에 관한 자신의 책이 많은 국가에서 출판될 것이라는 것을 거의 알지 못했다.

해설 | **부정어구 도치**
빈칸 뒤의 〈could + 주어 + have p.p.〉로 도치된 구조를 보고 부정어구 자리인지 의심해봐야 한다. 문맥상으로도 '~을 거의 알지 못했다'라는 부정의 의미가 들어가야 하므로 정답은 '거의 ~않다'를 뜻하는 준부정어 (B) Little. (C) Less도 부정의 뜻은 있지만 도치 구문을 이끌 수 없고 문맥상으로도 비교 대상이 없으므로 오답이다.

4.

If Omsen Freight Services **had insisted** on increasing its corporate rates, we would have signed a contract with another supplier.

(A) have insisted (B) insists
(C) had insisted (D) insist

어휘 | insist on ~을 고집하다 corporate rate 법인 요금
sign a contract 계약하다 supplier 공급 업체, 공급자

해석 | 옴센 화물 서비스 사가 법인 요금을 올리려고 고집했다면, 우리는 다른 공급 업체와 계약했을 텐데.

해설 | **가정법 과거완료**
콤마 이하의 주절의 시제가 would have p.p.이고 문맥상으로도 '법인 요금을 올리려고 고집했다면'이란 과거 사실에 대한 반대의 가정이므로 가정법 과거완료가 쓰였음을 알 수 있다. 따라서 if절에는 had p.p. 형태인 (C) had insisted가 정답.

5.

Enclosed is a detailed plan of the expansion of the Melville Library on Seventh Street.

(A) Enclosed (B) Enclosure
(C) Enclosing (D) Encloses

어휘 | enclosed 동봉된 detailed 상세한 expansion 확장

해석 | 동봉된 것은 7번가 멜빌 도서관 확장에 대한 상세한 계획입니다.

해설 | **보어 도치**
문두가 빈칸이고 뒤에 주어와 be동사가 도치된 구조이므로 보어 도치가 쓰였음을 알 수 있다. 따라서 정답은 (A) Enclosed. (B) Enclosure도 명사로 주어가 될 수 있지만 가산명사이므로 앞에 한정사와 함께 쓰이거나 복수 형태로 쓰여야 하므로 오답.

6.

If vacuum cleaner importers supplied clearer instructions, they **would not receive** so many inquiries from retail clients.

(A) did not received (B) had not received

(C) are not received **(D) would not receive**

어휘 | instructions (제품 등의) 사용 설명서　inquiry 문의　retail 소매(업)

해석 | 청소기 수입 업체들이 좀 더 명확한 제품 사용 설명서를 제공해준다면, 소매점의 고객들로부터 그렇게 많은 문의를 받지 않을 텐데.

해설 | **가정법 과거**

if절의 동사 supplied가 과거형이고 문맥상 현재 사실과 반대되는 상황을 가정하고 있으므로 가정법 과거가 쓰였음을 알 수 있다. 가정법 과거의 주절의 시제는 〈would[could, might, should]＋동사원형〉이 되어야 하므로 정답은 (D) would not receive. 가정법 문제는 if절이나 주절의 시제를 먼저 확인하여 가정법의 종류를 파악하는 것이 핵심이다.

7.

If you should **accept** this offer, we will send a representative to your office next week with the contract to be signed.

(A) receive **(B) accept**

(C) reduce (D) expect

어휘 | offer 제안　representative 직원　contract 계약(서)

해석 | 귀하께서 이 제안을 받아들이신다면, 서명할 계약서와 함께 직원을 다음 주에 귀하의 사무실로 보내겠습니다.

(A) 받다 (B) 받아들이다

(C) 줄이다 (D) 기대하다

해설 | **동사 어휘 accept**

문맥에 알맞은 동사 어휘를 고르는 문제이다. 서명할 계약서를 보내는 것은 제안을 '동의하여 받아들인' 경우에 가능한 일이므로 '(동의하여) 받아들이다'는 의미의 동사 (B) accept가 정답이다. (A) receive는 '(편지나 선물 등 실질적인 물건)을 받다'라는 의미로 제안에 동의한다는 의미가 없으므로 오답이다.

8.

Rarely does Mr. Gunther **stay** past eight o'clock, so Ms. Merica was surprised to see him still in his office at nine.

(A) stay (B) stays

(C) stayed (D) will stay

어휘 | rarely 거의 ~ 않다　past 지나서

해석 | 건서 씨는 8시 이후에는 거의 사무실에 머무르지 않기 때문에 9시에 그가 아직도 사무실에 있는 것을 보고 메리카 씨는 놀랐다.

해설 | **부정어구 도치**

준부정어인 rarely가 문두로 나오면서 〈부정어＋조동사＋주어〉로 도치된 구문이다. 주어 앞에 조동사 does가 있으므로 빈칸에는 동사원형이 들어가야 한다. 따라서 정답은 (A) stay.

9.

If Charles should be promoted to manager, the staff **will work** happily under his leadership.

(A) works **(B) will work**

(C) will have worked (D) worked

어휘 | promote 승진시키다　leadership 지도력

해석 | 찰스 씨가 부장으로 승진한다면, 직원들은 기꺼이 그의 지휘 아래에서 일할 것이다.

해설 | **가정법 미래**

if절에 〈If＋주어＋should＋동사원형〉의 형태가 쓰였고 문맥상으로도 '부장으로 승진한다면, 직원들은 기꺼이 그의 지휘 아래에서 일할 것이다'라고 미래의 일에 대해 가정하므로 가정법 미래가 쓰였음을 알 수 있다. 가정법 미래의 주절은 명령문이나 미래 시제를 사용하므로 정답은 (B) will work.

10.

If the renovations for the function room had not finished last week, Ms. Cosswind **would cancel** today's office party.

(A) would cancel (B) was cancelled

(C) has cancelled (D) are cancelling

어휘 | renovation 보수　function room 대연회장

해석 | 지난주에 대연회장 보수가 끝나지 않았더라면, 코스윈드 씨는 오늘의 회사 파티를 취소할 텐데.

해설 | **혼합가정법**

문맥상 if절은 과거 사실에 반대되는 내용이고, 주절은 현재 사실에 반대되는 내용이면서 주절에 현재를 나타내는 today가 쓰인 것으로 보아 혼합가정법이 쓰였음을 알 수 있다. 〈If＋주어＋had p.p., 주어＋would[could, might, should]＋동사원형〉이 혼합가정법 형태이므로 정답은 (A) would cancel.

11.

During the power failure, the system in the office was not working, and **neither** were the outside surveillance cameras.

(A) which (B) not

(C) whether **(D) neither**

어휘 | power failure 정전 surveillance camera 감시 카메라

해석 | 정전이 된 동안 사무실 시스템은 작동하지 않았고, 외부 감시 카메라들도 마찬가지였다.

해설 | neither가 이끄는 도치

빈칸 뒤가 〈be동사+주어〉로 도치되어 있으며 문맥상 '외부 감시 카메라들도 마찬가지로 작동하지 않았다'는 부정의 의미이므로 (D) neither가 정답이다. (B) not도 부정의 의미이지만 혼자서는 도치 구문을 이끌지 않으므로 오답이다. '~도 역시 …하다'라는 뜻의 〈so+(조)동사+주어〉 형태의 도치 구문도 함께 알아두자.

12.

Only after tonight's client meeting was Mr. Beacon able to answer all the e-mails he received yesterday.

(A) Only (B) Often

(C) None (D) Almost

어휘 | be able to *do* ~을 할 수 있다 receive 받다

해석 | 오늘 저녁 고객과의 회의가 끝난 후에야 비컨 씨는 어제 받은 이메일에 모두 답장을 보낼 수 있었다.

해설 | 〈only+시간 부사(구)〉의 도치

문장에서 주어는 Mr. Beacon으로 be동사 was가 주어 앞에 위치한 것으로 보아 도치 구문임을 알 수 있다. 빈칸 뒤 after부터 meeting까지는 시간을 나타내는 부사구이므로 〈only+시간을 나타내는 부사구〉의 도치가 쓰였음을 알 수 있다. 따라서 정답은 (A) Only.

13.

Had Thompson Corporation not acquired Elsave Plans last year, a strong competitor **would have obtained** ownership of the insurance company.

(A) should obtain (B) will be obtaining

(C) would have obtained (D) has obtained

어휘 | acquire 인수하다 competitor 경쟁사 obtain 획득하다, 얻다 ownership 소유권

해석 | 톰슨 사가 작년에 엘세이브 플랜스 사를 인수하지 않았다면, 강력한 경쟁사가 그 보험 회사의 소유권을 획득했을 것이다.

해설 | 가정법 과거완료

문두에 쓰인 Had를 보고 가정법의 도치 구문임을 파악해야 한다. 가정법 과거완료의 if절에서 if가 생략되고 had와 주어의 어순이 바뀌었다. 가정법 과거완료의 주절은 〈주어+would[could, should]+have *p.p.*〉 형태이므로 정답은 (C) would have obtained.

14.

Should your dental checkup be postponed by Dr. Lucas, we will give you a call the day before your appointment.

(A) So **(B) Should**

(C) If (D) Due to

어휘 | dental checkup 치과 검진 postpone 연기하다 appointment 약속

해석 | 루카스 박사가 귀하의 치과 검진을 연기하게 되면, 저희가 예약일 전날 전화드리겠습니다.

해설 | 가정법 도치

문맥상 '치과 검진을 연기하게 되면, 예약일 전날 전화하겠다'는 내용으로, 빈칸이 속한 절이 가정 혹은 조건의 의미가 되는 것이 적절하다. 그런데 주어 your dental checkup 뒤에 동사원형 be가 있는 것으로 보아 if가 생략되고 조동사와 주어가 도치된 문장임을 알 수 있다. 가정법 미래에서 if가 생략되면서 조동사 should가 문두로 나간 형태이다. 따라서 정답은 (B).

예제 해석

교재 185쪽

[예제 1] 단서 ① 지시어 및 대명사

The end of the summer is approaching, but there's still time to book an unforgettable vacation! To help make your dreams come true, Sansha Travels is having an unbelievable sale!

For bookings made in the month of August, we are giving 10 percent off all of our South American packages. **[1] These include cruises, hiking trips, historical tours, and more.** Check our Web site at www.sanshatravels.com for a detailed description of each option, and find the perfect destination for you. Don't miss out on this great opportunity! Take advantage of this limited-time promotion by calling our agency today.

여름의 끝자락에 와 있지만 여전히 잊지 못할 휴가를 예약할 수 있는 시간이 남았습니다! 귀하의 꿈을 실현시켜 드리기 위해, 산샤 여행사가 믿기 어려울 정도의 할인을 하고 있습니다!

8월에 예약을 하시면, 모든 남미 여행 패키지에 10퍼센트 할인을 제공해 드리고 있습니다. **[1] 여기에는 크루즈 여행과 도보 여행, 역사지 관광, 그리고 그 밖에 많은 것이 포함되어 있습니다.** 저희 웹사이트인 www.sanshatravels.com에서 각각의 옵션에 대한 상세한 설명을 확인해 보시고, 귀하에게 가장 적합한 목적지를 찾으세요.

이 좋은 기회를 놓치지 마십시오! 오늘 저희 대리점에 전화하셔서 한정된 이 프로모션을 이용하세요.

어휘 | approach 다가오다 unforgettable 잊지 못할 come true 실현하다 unbelievable 믿기 어려울 정도인 detailed 상세한 description 설명 destination 목적지 take advantage of ~을 이용하다

1.
(A) Many travel agencies organize trips to that area.
(B) Hotels are already fully booked for the rest of the summer.
(C) These include cruises, hiking trips, historical tours, and more.
(D) We will be closed for that month but will reopen in September.

해석 |
(A) 다수의 여행사들이 그 지역으로의 여행을 준비합니다.
(B) 남은 여름 기간 동안 호텔 예약이 꽉 차있습니다.
(C) 여기에는 크루즈 여행과 도보 여행, 역사지 관광, 그리고 그 밖에 많은 것이 포함되어 있습니다.
(D) 저희는 그 달에 문을 닫고 9월에 다시 열 것입니다.

[예제 2] 단서 ② 연결어

Selmatown, November 11—Propex Mechanics is moving to the outskirts of Selmatown, where it purchased a large area of land. With this space, the car manufacturer plans on expanding its business by producing farming equipment.

According to spokesperson Marie Lucas, Propex Mechanics already started producing a tractor prototype. **[2] However, only Propex cars are currently on the market.** "Thanks to our rapid growth," Ms. Lucas explained, "we are now confident enough to launch a line of high-quality farming equipment." Locals are excited about the manufacturer's expansion, as it is expected to create more than eight hundred new jobs.

셀마타운, 11월 11일—프로펙스 메카닉스 사는 셀마타운 교외 지역으로 이사할 예정인데, 이 곳에 넓은 부지를 구매했다. 이 공간에서 그 자동차 제조사는 농기구를 생산하여 사업을 확장할 계획이다.

대변인 마리 루카스 씨에 따르면, 프로펙스 메카닉스 사는 이미 트랙터 시제품을 생산하기 시작했다고 한다. **[2] 그러나 현재는 프로펙스 자동차만 시장에 나와 있다.** "우리의 급속한 성장 덕분에 이제 양질의 농기구 제품군 출시에 충분히 자신이 있습니다."라고 루카스 씨가 설명했다. 그 제조사의 확장이 새로운 일자리를 800여개 이상 창출할 것으로 예상되어 주민들은 이 확장에 대해 흥분하고 있다.

어휘 | outskirts 교외 expand 확장하다 farming equipment 농기구 according to ~에 따르면 spokesperson 대변인 prototype 시제품 launch 출시하다 local 주민; 지역의 be expected to *do* ~할 것으로 예상되다

2. **(A) However, only Propex cars are currently on the market.**

(B) The manufacturer's original product was not selling.

(C) This is why the organization's facilities are being renovated.

(D) This decision was made after a bid had already been placed.

해석 |
(A) 그러나 현재는 프로펙스 자동차만 시장에 나와 있다.
(B) 제조사의 기존 제품은 팔리지 않았다.
(C) 그래서 그 단체의 시설들이 보수 중이다.
(D) 이것은 이미 응찰이 이루어진 다음에 결정되었다.

[예제 3] 단서 ③ 지문 구조

To: Parks, I. <isaparks@flowernet.com>
From: Marvin, S. <smarvin@tinastalib.edu>
Subject: Librarian Position

Dear Ms. Isabelle Parks,

We are pleased to inform you that you have passed the final stage of the Tinasta University Library interview process. We would thus like to offer you the position of reference librarian.

This position consists in assisting faculty with their research and attending monthly conferences. You would also be expected to organize seminars for fellow librarians.

I've attached a contract with details of the benefits you would be entitled to. <u>³ To accept this offer, please send the signed contract back to me by Friday, August 8.</u>

Sincerely,

Stephen Marvin
Assistant Director, Library Services

받는 사람: 팍스, I. 〈isaparks@flowernet.com〉
보내는 사람: 마빈, S. 〈smarvin@tinastalib.edu〉
제목: 사서직

이사벨 팍스 씨께,

귀하께서 티나스타 대학 도서관 최종 면접에 합격하셨음을 알리게 되어 기쁩니다. 따라서 귀하에게 참고사서직을 제안하고자 합니다.

이 자리는 교수들의 연구를 돕고 월례 학회에 참석하는 일을 합니다. 동료 사서들을 위해 세미나를 준비해야 할 수도 있습니다.

귀하가 받게 될 복지 혜택에 대한 상세한 내용이 담긴 계약서를 첨부했습니다. ³ 이 제안을 받아들이신다면, 서명하신 계약서를 8월 8일 금요일까지 저에게 다시 보내주세요.

도서관 부관장
스티븐 마빈 드림

어휘 | inform 알리다 consist in (주요 특징 등이) ~에 있다 faculty 모든 교수들, 교수단 fellow 동료의 benefit 혜택 be entitled to ~에 권리가 있다

3. (A) The library employs fifteen librarians and twenty library assistants.

(B) The job may entail updating item records in the database.

(C) Conferences are usually organized by national library associations.

(D) To accept this offer, please send the signed contract back to me by Friday, August 8.

해석 |
(A) 도서관은 사서 15명과 사서 보조 20명을 고용하고 있습니다.
(B) 그 일에는 데이터베이스에 품목 기록 정보를 가장 최신의 내용으로 갱신하는 일이 포함될 수 있습니다.
(C) 학회는 보통 전국 도서관 협회가 준비합니다.
(D) 이 제안을 받아들이신다면, 서명하신 계약서를 8월 8일 금요일까지 저에게 다시 보내주세요.

FINAL TEST

교재 188쪽

1. (D)	2. (A)	3. (C)	4. (A)	5. (D)	6. (C)	7. (B)	8. (A)	9. (B)	10. (B)
11. (D)	12. (C)	13. (C)	14. (B)	15. (D)	16. (A)				

[1-4] 편지

Marisa Jacob
3683 Cherry Tree Drive
Holtsville, NY 00501

March 3

Dear Ms. Jacob,

We are writing to remind you to schedule an appointment with Pearly White Dental Clinic. Your last visit was on August 13, and doctors ¹ recommend that patients see a dentist every six months. ² Therefore, you are overdue for your checkup.
We understand that you may not feel any pain at this time. ³ Nevertheless, it is still advisable to visit your dentist. Oral hygiene should be a ⁴ priority for patients your age as treatment becomes increasingly risky.
To make an appointment, please call us at 824-7952. We look forward to helping you keep your beautiful smile!

Regards,

Stanley Jabbards
Pearly White Dental Clinic Receptionist

마리사 제이콥
체리 트리 드라이브 3683번지
홀츠빌, 뉴욕 주 00501

3월 3일

제이콥 씨께,

펄리 화이트 치과에 진료 예약 일정을 잡으실 것을 다시 한 번 알려 드리기 위하여 편지를 씁니다. 귀하께서 마지막으로 방문하신 때는 8월 13일인데, 의사 선생님들은 환자들이 6개월마다 치과 진료를 받을 것을 ¹ 추천합니다. ² 따라서 귀하께서는 검진받으실 시기가 지났습니다.

귀하께서는 현재 아무 통증을 느끼시지 않으실 것이라 생각합니다. ³ 그럼에도 불구하고, 여전히 치과를 방문하는 것이 바람직합니다. 귀하의 연령대의 환자들에게는 치료가 점점 더 위험해지기 때문에 구강 위생이 ⁴ 우선 사항이 되어야 합니다.

진료 예약을 잡으시려면, 824-7952로 전화해 주세요. 저희는 귀하께서 아름다운 미소를 유지할 수 있도록 돕기를 고대합니다.

펄리 화이트 치과 접수 담당자
스탠리 자바즈 드림

어휘 | remind A to *do* ~할 것을 다시 한 번 알리다 **advisable** 바람직한 **oral hygiene** 구강 위생 **treatment** 치료 **increasingly** 점점 더
make an appointment (진료) 약속을 하다 **look forward to *doing*** ~하기를 고대하다

1.
(A) recommended
(B) recommending
(C) is recommended
(D) recommend

해설 | 동사 자리
주어 doctors 뒤에 동사가 없기 때문에 빈칸은 동사 자리이므로 분사 또는 동명사 형태인 (B)는 오답으로 제외. 문맥상 일반적인 사실을 말하고 있으므로 현재 시제여야 한다. 따라서 현재 시제인 (C) is recommended와 (D) recommend가 정답 후보. 주어인 의사들이 추천하는 것이므로 능동태인 (D)가 정답이다.

DAY 20

2. **(A) Therefore, you are overdue for your checkup.**
(B) For this, we require payment in advance.
(C) We are grateful for your patronage.
(D) However, this time slot is no longer available.

해석 |
(A) 따라서 귀하께서는 검진받으실 시기가 지났습니다.
(B) 이를 위해 저희는 선불을 요구하는 바입니다.
(C) 애용해 주셔서 감사드립니다.
(D) 그러나 이 시간대는 더 이상 가능하지 않습니다.

해설 | **알맞은 문장 고르기**
알맞은 문장 고르기 문제는 빈칸 주변의 문맥을 잘 살펴봐야 한다. 빈칸 앞에 마지막 검진일은 8월 13일이고, 의사들은 6개월마다 검진을 받을 것을 추천한다는 내용이 나온다. 그리고 빈칸 뒤에는 현재는 통증이 없겠지만 검진을 받는 것이 바람직하다며 치과 진료를 추천하는 내용이 반복해서 나온다. 따라서 빈칸에는 치과 검진을 받아야 하는 이유가 나오는 것이 자연스러우므로 검진받을 시기가 지났다는 내용의 (A)가 정답이다.

3. (A) Thus
(B) As a result
(C) Nevertheless
(D) On the other hand

해석 | (A) 그러므로 (B) 결과적으로
(C) 그럼에도 불구하고 (D) 반면에

해설 | **접속 부사**
선택지를 보니 문맥상 알맞은 접속 부사를 고르는 문제로, 앞뒤 문장의 의미 관계를 파악해야 한다. 빈칸 앞에는 현재는 통증을 느끼지 않을 것이라는 내용이 나오고 빈칸 뒤에는 치과 검진을 받는 것이 바람직하다는 내용이 나온다. 따라서 문맥상 '아프지 않더라도 검진을 받으라'는 의미가 자연스러우므로 정답은 (C).

4. **(A) priority**
(B) responsibility
(C) demand
(D) damage

해석 | (A) 우선 사항 (B) 책임
(C) 요구 (D) 손상

해설 | **명사 어휘 priority**
문맥에 알맞은 명사 어휘를 고르는 문제. 문맥상 '지금 연령대에는 치료가 점점 더 위험해지기 때문에 구강 위생이 우선 사항이 되어야 한다'는 의미가 자연스러우므로 정답은 (A) priority.

[5-8] 공지

We regret to have to report an error in **⁵ some** of the printed issues of last month's *Hourglass* magazine. An article **⁶ dated** September 12 includes an incorrect job title. The article is a review of the restaurant Tocata. **⁷ In it, Mr. Nicolas Dimaggio is introduced as the restaurant's manager.** In fact, Mr. Dimaggio is Tocata's chef, and Mr. Julian Rose is the manager. Our reporter originally had an appointment to interview Mr. Rose. However, the manager could not make it, so our reporter met with Mr. Dimaggio instead. We apologize for the confusion. Please note that online versions of our updated articles **⁸ can be accessed** on our Web site.

지난달 〈모래시계〉 지의 발행물 **⁵ 일부에** 오류가 있었음을 알리게 되어 유감스럽습니다. 9월 12일에 **⁶ 기입된** 기사에 틀린 직함이 포함되어 있습니다. 그 기사는 토카타 식당에 관한 후기였습니다. **⁷ 거기에는, 니콜라스 디마지오 씨가 식당 관리자로 소개되었습니다.** 사실 디마지오 씨는 토카타 식당의 요리사이고, 줄리언 로세 씨가 관리자입니다. 저희 기자가 원래 로세 씨를 인터뷰하기로 약속을 했었습니다. 그런데 그 관리자가 참석할 수가 없어서 저희 기자는 대신 디마지오 씨를 만났습니다. 혼란을 드려 죄송합니다. 갱신된 기사가 담긴 온라인 판은 저희 웹사이트에서 **⁸ 이용하실 수 있습니다.**

어휘 | regret to *do* ~하게 되어 유감이다 incorrect 틀린, 부정확한 in fact 사실 originally 원래 make it (모임 등에) 참석하다 instead 대신에 apologize for ~에 대해 사과하다 confusion 혼란 update 갱신하다

5. (A) every
(B) less
(C) much
(D) some

해설 | **수량 표현의 수일치**
〈부정대명사+of+the+명사〉 표현은 of 뒤에 오는 명사의 종류와 형태를 기준으로 수일치를 한다. 빈칸 뒤 issues라는 가산명사의 복수형과 함께 쓸 수 있는 것은 선택지 중 some뿐이다. 따라서 정답은 (D).

6.
(A) to date
(B) will be dated
(C) dated
(D) is dating

해설 | **과거분사**
빈칸 뒷 부분에 동사 includes가 있으므로 빈칸부터 September 12까지는 주어 An article을 수식하는 구이다. 따라서 명사를 뒤에서 수식할 수 있는 to부정사 (A) to date와 과거분사 (C) dated가 정답 후보. 주어 An article이 날짜를 기입한 것이 아니라 날짜가 기입된 것이므로 수동의 의미가 있는 과거분사 (C)가 정답이다.

7.
(A) Tocata is a renowned restaurant that specializes in Italian cuisine.
(B) In it, Mr. Nicolas Dimaggio is introduced as the restaurant's manager.
(C) This caused the typo to be printed in our magazine.
(D) These include several mistakes concerning the Italian eatery.

해석 |
(A) 토카타는 이탈리아 음식을 전문으로 하는 유명한 식당입니다.
(B) 거기에는, 니콜라스 디마지오 씨가 식당 관리자로 소개되었습니다.
(C) 이것 때문에 우리 잡지에 오타가 인쇄되었습니다.
(D) 여기에는 이탈리안 식당에 대해 몇 가지 실수가 포함되어 있습니다.

해설 | **알맞은 문장 고르기**
이 공지는 기사의 오류를 알리기 위한 글이다. 빈칸 앞에 음식점 후기 기사가 있었다고 언급하고 있고 빈칸 뒤에는 디마지오 씨가 사실 요리사이고 관리자는 다른 사람이라고 정정하는 내용이 나온다. 따라서 빈칸에는 디마지오 씨가 기사에서 어떻게 잘못 언급되어 있는지에 관한 내용이 나오는 것이 자연스럽다. 따라서 '디마지오 씨가 관리자로 소개되었다'는 내용의 (B)가 가장 자연스럽다. 대명사 it이 앞 문장의 article을 지칭한다는 것을 알면 더 쉽게 풀 수 있다. (D)의 대명사 these가 가리키는 대상이 빈칸 앞에 없으므로 (D)는 오답이다.

8.
(A) can be accessed
(B) have accessed
(C) are accessing
(D) would be accessing

해설 | **3문형 동사의 수동태**
선택지를 보니 알맞은 동사 형태를 고르는 문제이다. 주어 online versions of our updated articles가 '이용하는' 것이 아니라 '이용되는' 것이므로 수동태인 (A) can be accessed가 정답이다.

[9-12] 이메일

To: Heather Garrison <hgarrison@extoppharm.com>
From: Mounir Benidris <mbenidris@extoppharm.com>
Date: April 11
Subject: Promotion

Dear Heather Garrison,

9 I want to congratulate you on your promotion.
I'm so glad you were **10 selected** to be the new team manager for the research and development department.
Working as a manager can be **11 challenging**, but I know you will do a great job. You have a lot of experience with Extop Pharmaceuticals, and I believe you are the best person for this position. I hope you will enjoy your new responsibilities.
We will be seeing each other more often **12 since** you will be in the office next to mine. It will be a pleasure to work more closely with you.

Regards,

Mounir Benidris
Assistant Director

받는 사람: 헤더 개리슨 〈hgarrison@extoppharm.com〉
보내는 사람: 무니르 베니드리스 〈mbenidris@extoppharm.com〉
날짜: 4월 11일
제목: 승진

헤더 개리슨 씨께,

9 당신의 승진을 축하드리고 싶습니다. 당신이 연구개발부서의 새로운 팀장으로 **10 뽑혀서** 매우 기쁩니다.

관리자로 일하는 것은 **11 어려울** 수 있지만, 당신이 잘 해내리라는 걸 압니다. 당신은 엑스탑 제약사와 일한 경험이 풍부하고 저는 당신이 이 자리에 가장 적합한 사람이라고 생각합니다. 당신이 그 새로운 책임을 즐기시길 바랍니다.

당신 사무실이 제 사무실 옆이기 **12 때문에** 우리는 더 자주 볼 수 있겠네요. 당신과 더 가까이에서 일하게 되어 기쁩니다.

이사보
무니르 베니드리스 드림

DAY 20

9. (A) You will be designing new research projects.
(B) I want to congratulate you on your promotion.
(C) Many candidates have applied for the position.
(D) I look forward to hearing back from you soon.

해석 |
(A) 당신은 새로운 연구 프로젝트를 기획할 것입니다.
(B) 당신의 승진을 축하드리고 싶습니다.
(C) 많은 후보자가 그 자리에 지원했습니다.
(D) 곧 당신의 회신을 받기를 고대합니다.

해설 | **알맞은 문장 고르기**
빈칸이 이메일 맨 앞에 위치해 있으므로 빈칸에는 이메일의 목적이 들어갈 확률이 높다. 이메일이 전체적으로 이메일을 받는 사람의 승진과 관련된 내용이므로 승진을 축하하고 싶다는 내용이 들어가는 것이 자연스럽다. 따라서 정답은 (B). (C)는 이메일의 첫 문장으로 오기에는 적합하지 않고 the position이 가리키는 일자리가 빈칸 앞에 없으므로 오답이다.

10. (A) totaled
(B) selected
(C) defined
(D) limited

해석 | (A) 합계를 내다 (B) 뽑다
(C) 정의를 내리다 (D) 제한하다

해설 | **동사 어휘 select**
문맥에 알맞은 동사 어휘를 고르는 문제이다. 문맥상 '연구개발부서 팀장으로 뽑혀서 기쁘다'는 의미가 자연스우므로 정답은 (B) selected.

11. (A) challenged
(B) challenger
(C) challenges
(D) challenging

해설 | **현재분사 vs. 과거분사**
빈칸은 주어 Working as a manager를 보충 설명하는 주격 보어 자리이다. 따라서 형용사 역할을 하는 과거분사 (A) challenged와 현재분사 (D) challenging이 정답 후보. challenging은 '어려운'이라는 의미의 현재분사 형태로 굳어진 형용사이므로 정답은 (D).

12. (A) from
(B) but
(C) since
(D) between

해석 | (A) ~로부터 (B) 그러나
(C) ~ 때문에 (D) (둘) 사이에

해설 | **이유 접속사**
빈칸은 두 절을 연결하는 접속사 자리이다. 따라서 접속사 (B) but과 (C) since가 정답 후보. 문맥상 '사무실이 옆이기 때문에 더 자주 볼 수 있다'는 내용이 적절하므로 정답은 이유의 접속사 (C) since.

[13-16] 기사

Wilmington, January 29—Drivers going through Wilmington are still unable to use Southampton Bridge. The bridge suffered damages last month after a truck driver rode his oversized vehicle over **13 it** without checking the weight requirements. The bridge's supporting columns cracked and now require repairs. These will be conducted using a new **14 innovative** material that allows for a higher weight limit. Wilmington mayor Jennifer Harvest had originally announced that work would be done before January 30. **15 Unfortunately, shipment of materials is taking longer than expected.** The renovation project has therefore been delayed. Repairs should begin on February 1 and are estimated to be finished on February 15. The bridge **16 will reopen** on the very next day.

월밍턴 1월 29일—월밍턴을 지나가는 운전자들은 여전히 사우샘프턴 다리를 이용할 수 없다. 그 다리는 지난달에 한 트럭 운전자가 적정 무게를 확인하지 않고 너무 큰 차량을 **13** 그 위로 몰고 간 뒤에 손상을 입었다. 다리를 지탱하는 기둥에 금이 가서 현재 수리해야 된다. 더 무거운 중량 제한을 허용할 수 있도록 새로운 **14 혁신적인** 자재를 사용해서 수리가 진행될 것이다. 월밍턴 시장 제니퍼 하비스트 씨는 원래 이 작업이 1월 30일 전에 끝날 것이라고 발표했다. **15 유감스럽게도, 자재 배송이 예상했던 것보다 더 오래 걸리고 있다.** 그래서 보수 작업이 지연되었다. 수리는 2월 1일에 시작해서 2월 15일에 끝날 것으로 추정된다. 다리는 그 바로 다음 날 **16 다시 개통될** 것이다.

어휘 | be unable to *do* ~할 수 없다 conduct 시행하다 allow 허용하다 renovation 보수 delay 지연시키다 be estimated do *do* ~할 것으로 추정되다

13. (A) him
(B) himself
(C) it
(D) itself

해설 | **인칭대명사_목적격**
선택지를 보니 알맞은 인칭대명사의 격을 고르는 문제이다. 빈칸이 지칭하는 명사를 빈칸 앞에서 찾아야 한다. 빈칸은 앞의 사물명사 bridge를 지칭하고 있으므로 (C) it과 (D) itself가 정답 후보이다. 주어 a truck driver와 빈칸이 지칭하는 목적어가 다르므로 재귀대명사 itself는 오답이다. 따라서 정답은 목적격 인칭대명사인 (C).

14. (A) typical
(B) innovative
(C) optional
(D) irrelevant

해석 | (A) 전형적인 (B) 혁신적인
(C) 선택적인 (D) 관련이 없는

해설 | **형용사 어휘 innovative**
형용사 어휘 문제는 수식하는 명사와의 관계를 따져야 한다. 문맥상 '더 무거운 중량 제한을 허용하기 위해 새로운 혁신적인 자재를 사용한다'는 의미가 자연스러우므로 정답은 (B) innovative.

15. (A) The mayor is still hesitant about investing in repairs despite the citizens' demands.
(B) Since then, no accidents have been reported on Southampton Bridge.
(C) The driver is expected to pay for part of the project out of his pocket.
(D) Unfortunately, shipment of materials is taking longer than expected.

해석 |
(A) 시장은 시민들의 요구에도 불구하고 수리에 투자하는 것을 여전히 주저한다.
(B) 그 뒤로, 사우샘프턴 다리에 아무런 사고도 보고되지 않고 있다.
(C) 그 운전자는 보수 작업 일부를 자신의 돈으로 지불할 예정이다.
(D) 유감스럽게도, 자재 배송이 예상했던 것보다 더 오래 걸리고 있다.

해설 | **알맞은 문장 고르기**
빈칸 뒤 결과를 나타내는 접속 부사 therefore가 있으므로 빈칸에는 보수 작업이 연기된 이유가 들어가는 것이 알맞다. 따라서 '자재 배송이 늦어져서 작업이 연기됐다'는 이유가 언급되는 것이 자연스러우므로 정답은 (D).

16. **(A) will reopen**
(B) has reopened
(C) to reopen
(D) has been reopening

해설 | **미래 시제**
빈칸은 주어 The bridge의 동사 자리이므로 to부정사 (C) to reopen은 오답으로 제외. 문맥상 다리가 개통되는 것은 미래에 있을 일이므로 미래 시제 (A) will reopen이 정답이다.

DAY 20

85

예제 해석

교재 195쪽

[예제 1] 주제, 목적 문제

TO: Wendy Anderson <wanderson@speedmail.com>
FROM: Lee Conner <leec@jensonlawfirm.com>
DATE: May 29
SUBJECT: Tuesday's appointment

Dear Ms. Anderson,

I just wanted to confirm our appointment for Tuesday to go through the details of the contract with Regency Department Store. I looked through it this morning, and there are some things you may wish to negotiate. I will discuss them in more detail at our meeting.
When you come, could you also bring your current bank account information with you? Regency will need to know where to send payment for your products once an agreement has been reached.
Thanks, and I will see you on Tuesday.

Sincerely,

Lee Conner

받는 사람: 웬디 앤더슨 〈wanderson@speedmail.com〉
보내는 사람: 리 코너 〈leec@jensonlawfirm.com〉
날짜: 5월 29일
제목: 화요일의 약속

앤더슨 씨께,

리전시 백화점과 맺은 계약의 세부 사항을 살펴보기 위해 화요일로 잡은 우리의 약속을 확인하려고 연락드렸습니다. 오늘 오전에 그것을 검토했는데, 당신이 협상하고 싶어 할만한 몇 가지 사항들이 있습니다. 회의에서 그것들을 더 자세히 의논하려고 합니다.

오실 때 현재 은행 계좌 정보도 함께 가져와 주실 수 있을까요? 리전시 측에서는 합의에 도달했을 때 당신의 제품에 대한 대금을 어디로 보내야 할지 알아야 할 것입니다.

감사드리며, 화요일에 뵙겠습니다.

리 코너 드림

어휘 I appointment 약속 go through ~을 살펴보다 contract 계약(서) look through ~을 검토하다 negotiate 협상하다 in more detail 더 자세히 current 현재의 reach an agreement 합의에 도달하다

Why was the e-mail written?
(A) To provide information about an upcoming appointment
(B) To inform Ms. Anderson of a change in schedule
(C) To confirm the acceptance of a contract
(D) To notify Ms. Anderson of an outstanding payment

해석 I 이메일이 쓰여진 이유는?
(A) 다가오는 약속에 관한 정보를 제공하기 위해
(B) 앤더슨 씨에게 일정상의 변경을 알리기 위해
(C) 계약의 수락을 확인하기 위해
(D) 앤더슨 씨에게 미지불 금액을 통지하기 위해

[예제 2] 대상, 출처 문제

MEMO

Date: January 4

Due to a team leaders meeting at 10 A.M. tomorrow, Arnold Wetherell will not be able to lead the safety training for the new equipment on the production floor. The session will be rescheduled for Friday, January 7 at 10 A.M. in the conference room. Please

메모

날짜: 1월 4일

내일 오전 10시에 있을 팀장 회의 때문에, 아놀드 웨더럴 씨는 생산 작업장의 새로운 장비에 관한 안전 교육을 진행할 수 없습니다. 교육 일정이 1월 7일 금요일 오전 10시에 회의실로 변경될 것입니다. 수첩과 펜을 가지고 오세요. 교육을 신청했는데 그 일정에 시간이 안 되는 분들은 약속 날짜를 조정하기 위해 웨더럴 씨나 관리자에게 오늘 말씀해 주셔야 합니다. 불편을 끼쳐드려 죄송합니다.

bring a notebook and pen. Anyone who signed up for the training but is not available at that time should speak to Mr. Wetherell or a manager today in order to make alternative arrangements. We apologize for the inconvenience.

어휘 | due to ~ 때문에 production floor 생산 작업장 session 교육 reschedule 일정을 변경하다 sign up for ~을 신청하다
make arrangements 준비하다 alternative 대안의

To whom is this memo intended?

(A) Team leaders
(B) New employees
(C) Management staff
(D) Training attendees

해석 | 이 메모가 의도하고 있는 대상은?
(A) 팀장
(B) 신입 사원
(C) 관리직 직원
(D) 교육 참가자

패러프레이징

교재 197쪽

예제 (A) / 1. (A) 2. (B) 3. (A) 4. (A) 5. (A)

[예제 3] 패러프레이징

In honor of the city's 150th anniversary, Melville is holding an essay contest for community members. The winner will be awarded a cash prize at the Melville Festival on June 13.

시의 150주년 기념일을 기념하여, 멜빌 시에서는 지역 주민들을 대상으로 백일장을 개최합니다. 우승자는 6월 13일에 열리는 멜빌 축제에서 상금을 받게 됩니다.

What event is being announced?
(A) A writing contest
(B) An award ceremony

해석 | 공지되고 있는 행사는?
(A) 글짓기 대회
(B) 시상식

해설 | 첫 번째 문장을 통해 공지되고 있는 것은 an essay contest 임을 알 수 있다. 따라서 지문의 an essay contest가 상위 개념인 A writing contest로 패러프레이징된 (A)가 정답이다.

1.

We are writing to inform you that you have successfully registered for this year's leadership workshop. Payment has been received, so no further action is needed. Please bring identification to enter the venue. We look forward to seeing you on August 15.

귀하께서 올해 리더십 워크숍에 성공적으로 등록되었음을 알리고자 이 글을 씁니다. 귀하께서 지불하신 금액이 입금되었으므로, 더 이상 다른 조치는 필요하지 않습니다. 행사장 출입을 위하여 신분증을 가져오시기 바랍니다. 8월 15일에 뵙기를 고대하겠습니다.

What is the purpose of the letter?
(A) To confirm registration to an event
(B) To explain an application process

해석 | 편지의 목적은?
(A) 행사 등록을 확인하기 위해
(B) 신청 과정을 설명하기 위해

해설 | 지문 맨 앞에 리더십 워크숍 등록이 성공적으로 이루어졌다는 것을 알리는 편지의 목적이 언급되었다. 따라서 정답은 (A). 지문의 registered for가 다른 품사를 활용하여 registration to로, leadership workshop이 상위 개념인 an event로 패러프레이징 되었다.

DAY 21

87

2.

This weekend is members' weekend at Bird's View Camping! To thank our loyal patrons, we are offering fifty percent off all of our tents and apparel to members only. Come to our store Saturday or Sunday and take advantage of this exceptional event!

이번 주말은 버즈 뷰 캠핑 사의 회원을 위한 주말입니다! 단골 고객분들께 감사드리기 위해, 저희는 저희 텐트와 의류 제품 모두를 회원들에게만 반값에 제공해 드리고 있습니다. 토요일이나 일요일에 저희 매장에 오셔서 이 이례적인 행사를 이용하세요!

To whom is this advertisement addressed?
(A) Store cashiers
(B) Regular customers

해석 | 이 광고의 대상은?
(A) 매장 계산원
(B) 단골 고객

해설 | To thank 이하에 광고의 대상이 명시되어 있다. 단골 고객을 대상으로 하는 할인 행사를 광고하고 있으므로 정답은 (B). 지문의 loyal patrons가 정답에서 유의어인 Regular customers로 패러프레이징되었다.

3.

Mayor Brian Pockter has announced that construction of a new city park will begin at the end of next month. The park will be located between Brandenburg Avenue and Golden Boulevard. Residents will be welcome to enjoy this new green area.

시장 브라이언 포크터 씨가 새로운 시립 공원 건설이 다음 달 말에 시작된다고 발표했습니다. 그 공원은 브란덴부르크 로와 골든 대로 사이에 위치할 것입니다. 주민들은 이 새로운 녹지대를 마음껏 즐기실 수 있습니다.

Where can this article most likely be found?
(A) In a local newspaper
(B) In a campaign pamphlet

해석 | 이 기사를 찾을 수 있는 곳은?
(A) 지역 신문
(B) 캠페인 소책자

해설 | 지문내 Mayor, city park, Residents를 통해 이 기사가 지역 신문에 게재되었음을 유추할 수 있다. 따라서 정답은 (A) In a local newspaper.

4.

My name is Trevor Braton. I am applying for the position of sales representative at your firm. Attached, please find my résumé and a letter of recommendation. I've also included a cover letter explaining my career so far and plans for the future. Thank you for your time.

제 이름은 트레버 브래튼입니다. 저는 귀사의 영업직에 지원하고자 합니다. 첨부된 것은 제 이력서와 추천서입니다. 또한 지금까지의 제 경력과 향후 계획을 설명하는 자기 소개서도 포함시켰습니다. 시간을 내주셔서 감사합니다.

Why was this e-mail written?
(A) To submit a job application
(B) To recommend a candidate

해석 | 이 이메일이 쓰여진 이유는?
(A) 입사 지원서를 제출하기 위해
(B) 후보자를 추천하기 위해

해설 | 지문 앞 부분에 트레버 브래튼이 영업직에 지원하면서 이력서와 추천서, 자기 소개서를 첨부했다고 하였으므로 정답은 (A). 지문의 am applying for the position of sales representative와 résumé and a letter of recommendation이 정답에서 상위 개념인 submit a job application으로 패러프레이징되었다.

5.

A new air conditioner will be installed over the weekend. To protect belongings from dust and debris, employees on the upper floors are asked to put plastic over their possessions and computers on Friday afternoon.

새로운 에어컨이 이번 주말 동안에 설치될 것입니다. 먼지와 쓰레기로부터 소지품을 보호하기 위해, 위층에 있는 직원분들은 금요일 오후에 소지품과 컴퓨터 위에 비닐을 덮으시기 바랍니다.

To whom is this memo intended?

(A) Staff members

(B) Cleaning workers

해석 | 이 메모의 대상은?

(A) 직원

(B) 청소원

해설 | 에어컨 설치를 알리면서 직원들에게 소지품과 컴퓨터 위에 비닐을 덮을 것을 요청하고 있으므로 메모의 대상은 (A) Staff members 임을 알 수 있다. 지문의 employees가 유의어인 staff members 로 패러프레이징되었다.

FINAL TEST

교재 198쪽

1. (B)　　　2. (C)　　　3. (B)　　　4. (B)　　　5. (A)

[1-2] 초대장

¹ Staff members of Levingstone Museum are invited to a reception in honor of Casey Williams. Ms. Williams will be retiring after serving as curator at the museum for ten years. This is an opportunity for all those who worked alongside her to acknowledge her outstanding contribution to this fine institution.

Friday, April 10
6:00–9:00 P.M.
Levingstone Museum Atrium

² Wine, beer, and finger food will be served free of charge. Musical entertainment provided by Foster Folk. Casual attire.
Please reply to Chief Administrator Jacquelyn Corris at 555-8080 at least 24 hours before the event.

¹ 레빙스톤 미술관의 직원들을 케이시 윌리엄스 씨를 축하하는 연회에 초대합니다. 윌리엄스 씨는 지난 10년간 이 미술관에서 큐레이터로 근무한 뒤에 은퇴를 합니다. 이 연회는 그녀와 함께 일했던 모든 사람들이 그녀가 이 훌륭한 기관에 이바지 한 뛰어난 공헌을 인정해 줄 수 있는 기회입니다.

4월 10일 금요일
저녁 6시 – 9시
레빙스톤 미술관 아트리움

² 와인, 맥주, 그리고 간단한 안주가 무료로 제공됩니다. 음악 연주는 포스터 포크가 제공합니다. 편한 복장으로 참석해 주세요.

최고 운영자인 재클린 코리스 씨에게 555-8080번으로 적어도 행사 24시간 전에 회신 주시기 바랍니다.

어휘 | in honor of ~을 축하하여 retire 은퇴하다 serve as ~로 근무하다 alongside ~와 함께 acknowledge 인정하다 outstanding 뛰어난 contribution 공헌 finger food 안주, 손으로 집어 먹을 수 있는 음식 free of charge 무료로 casual attire 편한 복장 chief administrator 최고 운영자

DAY 21

1.　To whom is this invitation intended?

(A) Financial contributors

(B) Current employees

(C) Retired workers

(D) Regular visitors

해석 | 이 초대장이 의도하고 있는 대상은?

(A) 금전적 기부자

(B) 현재 직원

(C) 은퇴한 직원

(D) 단골 방문객

해설 | 대상, 출처 문제

첫 문장에서 직원들을 연회에 초대한다고 했으므로 현재 근무중인 직원들을 대상으로 하는 초대장임을 알 수 있다. 따라서 정답은 (B). 지문의 Staff members가 정답에서 Current employees로 패러프레이징되었다.

2. What will guests be provided with?

(A) Museum memberships

(B) Souvenirs

(C) Light refreshments

(D) Free CDs

해석 | 손님들에게 제공되는 것은?

(A) 미술관 회원권

(B) 기념품

(C) 가벼운 다과

(D) 무료 CD

해설 | **특정 정보 확인 문제**

행사와 관련한 지문에서는 주로 일정 안내 다음에 행사의 세부 정보가 등장한다. 단서 (2)에서 손님들에게 무료로 제공되는 것이 와인, 맥주, 간단한 안주라고 했으므로 지문의 finger food를 상위 개념인 Light refreshments로 패러프레이징한 (C)가 정답.

[3-5] 메모

To: All staff

From: Alicia Wright

Date: July 17

I would like to apologize to employees on the upper floors for the uncomfortable working conditions for the last week or so. [4] The air conditioning unit has been malfunctioning, and because the windows do not fully open on the third, fourth, or fifth floors, it has been very hot and humid.

[3] Please let me reassure you that the management has taken steps to solve the problem. A new air conditioner will be installed over the weekend. [5] To protect belongings from dust and debris, employees on the upper floors are asked to put plastic over their possessions and computers on Friday afternoon.

I hope that this will not cause too much inconvenience. Thank you for your patience.

Kind regards,

Alicia Wright

Maintenance Manager

받는 사람: 전직원

보내는 사람: 알리시아 라이트

날짜: 7월 17일

위층에 있는 직원분들께 지난 한 주동안 불편했던 근무 환경에 대해 사과드리고 싶습니다. [4] 에어컨이 제대로 작동하지 않고 있으며, 3층, 4층 및 5층의 창문은 완전히 열리지 않기 때문에, 매우 습하고 덥습니다.

[3] 관리팀이 이 문제를 해결하기 위해 조치를 취했음을 재차 알려드립니다. 새로운 에어컨이 이번 주말 동안에 설치될 것입니다. [5] 먼지와 쓰레기로부터 소지품을 보호하기 위해, 위층에 있는 직원분들은 금요일 오후에 소지품과 컴퓨터 위에 비닐을 덮으시기 바랍니다. 이것이 너무 많은 불편을 야기하지 않기를 바랍니다. 이해해 주셔서 감사합니다.

관리부장

알리시아 라이트 드림

어휘 | uncomfortable 불편한 malfunction 제대로 작동하지 않다 humid 습한 reassure 재차 알려주다, 안심시키다 take steps 조치를 취하다 install 설치하다 belongings 소지품 debris 쓰레기, 잔해 possession 《보통 복수형》 소지품 inconvenience 불편 patience 이해, 인내심

3. What is the purpose of the memo?

(A) To request employee feedback on a matter

(B) To announce a maintenance upgrade

(C) To inform employees of safety guidelines

(D) To report the results of a recent test

해석 | 메모의 목적은?

(A) 문제에 대한 직원의 피드백을 요청하기 위해

(B) 유지보수의 개선 사항을 알리기 위해

(C) 직원들에게 안전 지침을 알리기 위해

(D) 최근 테스트의 결과를 보고하기 위해

해설 | **주제, 목적 문제**

지문의 첫 문단에서 불편했던 근무 환경에 대해 사과를 한 다음, 두 번째 문단에서 문제에 대한 조치를 이야기하고 있다. 새로운 에어컨을 설치할 것이라고 했으므로 (B)가 정답이다. 지문의 A new airconditioner will be installed가 정답에서 a maintenance upgrade로 패러프레이징 되었다.

4. Why are upstairs workers experiencing difficulties?

(A) Their windows are broken.

(B) The temperature is uncomfortably warm.

(C) The workspace is too crowded.

(D) Their belongings are covered with dust.

해석 | 위층의 직원들이 어려움을 겪는 이유는?

(A) 창문이 깨졌다.

(B) 온도가 불편할 정도로 덥다.

(C) 업무 공간이 너무 빽빽하다.

(D) 소지품이 먼지로 덮여 있다.

해설 | **특정 정보 확인 문제**

지문의 앞부분에서 불편을 겪은 직원들에게 사과를 하고 있으므로 그 뒤에 사과를 하는 이유가 나올 것임을 짐작할 수 있다. 단서 (4)에서 에어컨이 제대로 작동하지 않았고 창문이 완전히 열리지 않아서 매우 습하고 덥다고 했으므로 정답은 (B). 창문이 깨진 것이 아니라 완전히 열리지 않은 것이므로 (A)는 오답이다.

5. What are upstairs workers requested to do on Friday?

(A) Cover their equipment

(B) Stay out of the office

(C) Keep the windows closed

(D) Work on a lower floor

해석 | 위층의 직원들이 금요일에 해달라고 요청받은 것은?

(A) 장비를 덮어두기

(B) 사무실에서 나가있기

(C) 창문을 닫아두기

(D) 아래층에서 일하기

해설 | **특정 정보 확인 문제**

구체적인 시간과 관련된 문제는 시간 표현이 언급된 문장에서 해당 정보를 찾아야 한다. 문제의 on Friday가 그대로 사용된 단서 (5)를 보면, 위층 직원들에게 소지품과 컴퓨터를 비닐로 덮어둘 것을 요청하고 있으므로, 정답은 (A). 지문의 put plastic over their possessions and computers가 정답에서 Cover their equipment로 패러프레이징되었다.

예제 해석

[예제 1] 특정 정보 확인 문제

Flight Attendant Positions Available:

Emerald Isles Air is seeking qualified applicants for flight attendant positions. Due to its upcoming expansion into Spain, Greece, and Italy, the airline is looking to hire 28 additional flight-crew staff members.

DUTIES:
* Ensure safety standards are met throughout the duration of flights
* Serve food and beverages
* Sell duty-free items

REQUIREMENTS:
* One year minimum of experience in the customer service industry
* Fluency in written and verbal English
* Availability to work at any time of the day

Please forward a résumé and cover letter to recruitment@emeraldislesair.com. Only those selected for interviews will be contacted.

승무원 모집:

에메랄드 아일스 항공이 승무원직에 자격을 갖춘 지원자들을 찾고 있습니다. 곧 있을 스페인, 그리스, 이탈리아로의 노선 확장 때문에, 항공사에서는 추가 승무원 28명을 채용하고자 합니다.

직무:
* 비행 동안 안전 기준이 지켜지도록 하기
* 음식과 음료 제공하기
* 면세품 판매하기

자격 요건:
* 최소 1년간의 고객 서비스업 경험
* 유창한 문어체 및 구어체 영어 구사
* 하루 중 아무 때나 근무 가능

이력서와 자기 소개서를 recruitment@emeraldislesair.com으로 보내 주세요. 면접에 선발된 분들께만 연락드리겠습니다.

어휘 | flight attendant 승무원 seek 찾다, 구하다 qualified applicant 자격을 갖춘 지원자 expansion into ~로의 확장 beverage 음료 customer service industry 고객 서비스업 fluency in ~에 있어서의 유창함 forward 보내다 cover letter 자기 소개서

What is a required qualification for all applicants?
(A) Experience in the food service industry
(B) Fluency in at least two languages
(C) Previous work as a flight attendant
(D) **Twenty-four-hour availability**

해석 | 모든 지원자들에게 요구되는 자격은?
(A) 외식업계에서의 경력
(B) 최소 2개 국어의 유창함
(C) 승무원으로서의 경력
(D) 24시간 근무 가능성

[예제 2] Not/True 문제

Wellness Health Club
Helping you reach past your limits!

Wellness Health Club is offering a special promotion to new members for the month of May only. First-time members can purchase an annual membership at half of the original price of $800. The membership includes:
* Use of weight room, aerobic machines, and swimming pools

웰니스 헬스클럽
당신의 한계를 넘어서도록 도와드립니다!

웰니스 헬스클럽이 5월 한 달 동안만 신규 회원들에게 특별 판촉 행사를 제공하고 있습니다. 처음 오시는 회원들은 연간 회원권을 원래 가격인 800달러의 반값에 구입할 수 있습니다. 회원권에 포함되는 것은 다음과 같습니다:
* 체력 단련실, 에어로빅 기구, 수영장 사용
* 매주 60분의 개인 트레이닝
* 탈의실의 개인 사물함

* Weekly personal training sessions of 60 minutes

* Individual locker in changing room

As an additional service free of charge, new members will have access to the tennis courts for the first three months of their membership.

To register for your Wellness Health Club membership, contact one of our knowledgeable staff members at 515-3334.

무료로 제공되는 추가 서비스로, 신규 회원들은 회원권 구입 후 첫 3개월간 테니스 코트를 이용하실 수 있습니다.

웰니스 헬스클럽 회원권을 신청하시려면, 515-3334번으로 풍부한 지식을 갖춘 저희 직원에게 연락하세요.

어휘 | purchase 구입하다 at half of ~의 반값[절반]에 weight room 체력 단련실 individual locker 개인 사물함 free of charge 무료로 access to ~의 이용, ~로의 접근 register for ~을 신청하다 knowledgeable 아는 것이 많은

What is NOT included in the membership?

(A) Access to fitness equipment

(B) Time with personal trainers

(C) Use of a personal locker

(D) A private changing room

해석 | 회원권에 포함되지 않은 것은?

(A) 운동 기구 이용

(B) 개인 트레이너와의 시간

(C) 개인 사물함 이용

(D) 개인 탈의실

패러프레이징

교재 205쪽

예제 (A) / **1. (B)**　　　2. (A)　　　3. (A)　　　4. (A)　　　5. (B)

[예제 3] 패러프레이징

In addition to our spacious rooms and quality customer service, guests at our hotel can enjoy a variety of amenities. We offer complimentary Internet access in all rooms and a free shuttle bus to and from the airport.

넓은 공간과 우수한 고객 서비스 외에, 저희 호텔의 투숙객들은 다양한 편의 시설을 즐기실 수 있습니다. 모든 객실에서 무료 인터넷 접속이 가능하며 공항으로 왕복하는 무료 셔틀 버스를 제공합니다.

(A) Hotel guests are able to use a free transportation service.

(B) Customers have to pay an additional fee to use the Internet.

해석 | (A) 호텔 투숙객들은 무료 교통 서비스를 이용할 수 있다.

(B) 고객들은 인터넷을 사용하기 위해 추가 요금을 내야 한다.

해설 | 무료 셔틀 버스를 제공한다고 했으므로 (A)가 정답. 지문의 a free shuttle bus to and from the airport가 정답에서 상위 개념인 a free transportation service로 패러프레이징되었다.

DAY 22

1.

With Clear Blue, let your message be heard! No matter what industry you work in, we will make your company look great! We use state-of-the-art technology to create today's most appealing advertisements and commercials, which are then strategically placed by our team of experts.

클리어 블루 사와 함께 당신의 메시지를 전달하세요! 귀하께서 어떠한 업종에 종사하시든지, 저희는 귀사를 멋지게 보이도록 해드릴 것입니다! 저희는 최신 기술을 사용해서 오늘날의 가장 매력적인 광고들을 만들며, 전문가들로 구성된 우리 팀이 그 광고들을 전략적으로 배치합니다.

(A) Clear Blue plans to hire experts to analyze commercials.

(B) An agency uses the latest trends in marketing services.

해석 | (A) 클리어 블루 사는 광고를 분석하기 위해 전문가들을 고용할 계획이다.

(B) 대행사는 마케팅 서비스 업계에서 최신 트렌드를 사용한다.

해설 | 최신 기술을 사용해서 오늘날의 가장 매력적인 광고들을 만든다고 하였으므로 (B)가 정답이다. 지문의 state-of-the-art technology to create today's most appealing advertisements and commercials가 정답에서 유의어를 사용하여 the latest trends in marketing services로 바꾸어 표현되었다.

2.

I am writing to report a missing suitcase. I flew from Berlin to Oslo on flight 605 with your airline today, March 17. The flight landed an hour later than scheduled, and when I arrived, my baggage was nowhere to be found. It is a navy-blue Coralia brand suitcase.

(A) A passenger is reporting that a piece of luggage was lost.
(B) A flight attendant is announcing that a bag was left behind.

분실한 여행 가방을 신고하려고 합니다. 저는 3월 17일 오늘 귀사의 605편 항공기로 베를린에서 오슬로까지 갔습니다. 비행기가 예정보다 한 시간 늦게 착륙했고, 제가 도착했을 때 제 수하물을 어디에서도 찾을 수 없었습니다. 그것은 코랄리아 사의 짙은 남색 여행 가방입니다.

해석 | (A) 승객이 수하물 분실을 신고하고 있다.
(B) 승무원이 가방이 남겨져 있었다고 알리고 있다.

해설 | 지문의 맨 앞에서 분실한 여행 가방을 신고한다고 하였으므로 정답은 (A). 지문의 a missing suitcase가 정답에서 유의어를 사용해 a piece of luggage was lost로 패러프레이징되었다.

3.

We invite employees from all departments to take part in our annual company banquet on April 15 from 6 P.M. until 8 P.M. Attendees will be entered into a prize lottery, and winners will be announced at the end of the meal.

(A) Staff members may attend a yearly event and win gifts.
(B) A catering service is being contacted for a company banquet.

4월 15일 저녁 6시부터 8까지 열릴 연례 회사 연회에 전 부서 직원들을 초대합니다. 참석자들은 경품 추첨 행사에 참여할 것이고, 당첨자는 식사가 끝날 무렵 발표될 것입니다.

해석 | (A) 직원들은 연례 행사에 참석하여 상품을 얻어갈 것이다.
(B) 회사 연회를 위해 출장요리 서비스 업체에 연락할 것이다.

해설 | 직원들을 연례 연회에 초대하면서 경품 추첨 행사에 참여하게 될 것이라고 했으므로 (A)가 정답. 지문의 annual company banquet이 정답에서 상위어인 a yearly event로, 지문의 be entered into a prize lottery가 유의어인 win gifts로 패러프레이징되었다.

4.

The Spring music festival will take place at Wood Gardens Park on April 2. The local high school's symphonic orchestra will open at 1 P.M., followed by the Golden Heart Chorus. Finally, special guest Gloria Strandel will perform "Singing Strings" on the harp.

(A) A number of music performances are scheduled for an afternoon.
(B) A special guest will host a seminar on a musical instrument.

스프링 음악 축제가 4월 2일 우드 가든즈 공원에서 열립니다. 현지 고등학교의 교향 오케스트라는 오후 1시에 공연을 시작할 것이며, 골든 하트 합창단이 이어집니다. 마지막으로는, 특별 손님인 글로리아 스트랜델 씨가 하프로 〈노래하는 현〉을 연주할 것입니다.

해석 | (A) 많은 음악 공연이 오후에 예정되어 있다.
(B) 특별 손님이 악기에 대한 세미나를 주최할 것이다.

해설 | 교향 오케스트라, 합창단 공연, 하프 연주가 있을 것이라고 했으므로 정답은 (A). 지문의 symphonic orchestra, Chorus가 상위 개념인 music performances로 패러프레이징되었다. 지문의 special guest가 그대로 쓰인 (B)를 정답으로 혼동하지 않도록 주의하자.

5.

I am contacting you about the possibility of working as a consultant for our company during our transition into Asia through the Taiwanese market. My colleague, Sam Batter, recommended you and spoke highly of your knowledge of East Asian business practices.

저희가 대만 시장을 통해 아시아로 진입하는 동안 저희 회사를 위해 귀하께서 자문 위원으로 근무할 수 있는지 알기 위해 연락드리게 되었습니다. 제 동료인 샘 배터 씨가 당신을 추천하면서 동아시아 사업 관행에 관한 당신의 지식을 크게 칭찬하였습니다.

(A) Colleagues recommended working with a Taiwanese company.

(B) The company requires consulting for opening business in Asia.

해석 | (A) 동료들이 대만 회사와 일하는 것을 추천했다.
(B) 회사는 아시아에서 개업하는 것에 대해 자문을 필요로 한다.

해설 | 대만 시장 진입에 대한 자문 가능성을 알아보고 있으므로 (B)가 정답. 지문의 working as a consultant가 품사를 바꾸어 consulting 으로, our transition into Asia가 유의어를 사용하여 opening business in Asia로 패러프레이징되었다.

FINAL TEST
교재 206쪽

1. (D)	2. (C)	3. (A)	4. (C)	5. (C)	6. (D)	7. (A)	8. (A)	9. (D)	10. (B)
11. (C)	12. (A)								

[1-3] 정보문

¹ Join the Landis Sailing Association!

¹ Enjoy these amazing benefits by becoming a member of the association.
*²ᴬ A free subscription to the *Sail the World* monthly magazine
*²ᴮ A 15% discount on all sailing clothing and equipment at Landis Heads retail store
*²ᴰ Free use of the Landis Sailing Club facilities throughout the year
³ Moreover, sign up to become a member before January 31 and you will receive two complimentary tickets to the Annual Florida Boat Show (valued at $150 each).
Call 555-0982 or visit us at www.landissailing.org.

¹ 랜디스 보트 협회에 가입하세요!

¹ 협회의 회원이 되어 이 놀라운 혜택들을 누려보세요.
*²ᴬ 월간지 〈세계로의 항해〉 무료 구독
*²ᴮ 랜디스 헤즈 대리점에서 항해 의류 및 장비 15퍼센트 할인
*²ᴰ 랜디스 보트 클럽 시설 연중 무료 사용

³ 게다가, 1월 31일 전에 회원 가입을 하시면 연례 플로리다 보트쇼 초대권 2장을 받으실 수 있습니다. (장당 150달러의 가격)

555-0982번으로 전화 주시거나, www.landissailing.org에 방문해 주세요.

어휘 | association 협회 amazing 놀라운 benefit 혜택 subscription 구독 discount 할인 equipment 장비 retail store 대리점, 소매점 facility 《주로 복수형》 시설, 설비 throughout the year 연중 complimentary ticket 초대권, 우대권

DAY 22

1. What is the purpose of the information?
(A) To advertise a local sailing apparel store
(B) To announce a change in subscription fees
(C) To promote a newly renovated yacht club
(D) To recruit new members to an association

해석 | 이 정보문의 목적은?
(A) 지역의 항해 의류 매장을 광고하기 위해
(B) 구독료 변경을 안내하기 위해
(C) 새롭게 개조한 요트 클럽을 홍보하기 위해
(D) 협회에 새로운 회원을 모집하기 위해

해설 | 주제, 목적 문제
글의 목적을 찾는 문제는 지문의 제목에서 단서를 얻을 수 있는 경우가 있으므로 제목을 반드시 읽어보자. 제목에 Join이라는 동사를 써서 협회에 가입할 것을 권하고 있고, 첫 번째 문장에서 회원이 될 경우 받게 되는 혜택을 언급하고 있으므로 정답은 (D).

2. What is NOT offered to members?

(A) A sailing magazine subscription

(B) A discount on sailing gear

(C) Access to free sailing classes

(D) Use of local sailing amenities

해석 | 회원들에게 제공되지 않는 것은?

(A) 항해 잡지 구독

(B) 항해 장비에 대한 할인

(C) 항해 수업 무료 이용

(D) 지역 항해 편의 시설의 사용

해설 | **Not/True 문제**

회원들에게 제공되는 혜택이 리스트로 정리되어 있다. 항해 잡지 무료 구독, 의류 및 장비 할인, 그리고 시설의 무료 이용은 제시되었지만, (C)의 항해 수업은 언급되지 않은 내용이다. 따라서 정답은 (C). 지문의 equipment가 (B)에서는 gear로, facilities가 (D)에서는 amenities로 패러프레이징되었다.

3. How can people get free tickets to a boat show?

(A) By joining a club by a certain date

(B) By subscribing to a journal

(C) By attending a yearly event

(D) By inviting a friend to become a member

해석 | 보트쇼 무료 입장권을 얻을 수 있는 방법은?

(A) 특정일까지 클럽에 가입함으로써

(B) 잡지를 구독함으로써

(C) 연간 행사에 참여함으로써

(D) 회원이 될 친구를 초대함으로써

해설 | **특정 정보 확인 문제**

단서 (3)에 따르면, 1월 31일 전에 회원 가입을 하면 보트쇼 초대권을 준다고 하였으므로 정답은 (A). 지문의 January 31이 정답에서 상위 개념인 a certain date로 패러프레이징되었다.

[4-7] 이메일

TO: Alex Hampton <hampton@xmail.com>

FROM: Samantha Grove <grove@lifebeauty.com>

DATE: May 4

SUBJECT: [4] Consultancy Offer

Dear Mr. Hampton,

My name is Samantha Grove. I am a market analyst at Life Beauty, a natural cosmetics company. [5B] We produce luxury cosmetics for consumers who care about their health. [5D] Our products are available in North America and Europe, and [5C] we are now ready to branch out into the Asian market.
[4] I am contacting you about the possibility of working as a consultant for our company during our transition into Asia through the Taiwanese market. [6] My colleague, Sam Batter, recommended you and spoke highly of your knowledge of East Asian business practices. He told me about [7] your success in introducing health food products to Taiwan's mainstream grocery stores. I was impressed by your reputation.
If you are interested in taking on a freelance consultancy role as we expand our business, please contact us. [5A] We hope to begin talking with retailers in Taipei early next month.
We look forward to hearing from you.

Sincerely,

받는 사람: 알렉스 햄프턴 〈hampton@xmail.com〉

보내는 사람: 사만다 그로브 〈grove@lifebeauty.com〉

날짜: 5월 4일

제목: [4] 자문 제안

햄프턴 씨께,

제 이름은 사만다 그로브입니다. 저는 천연 화장품 회사인 라이프 뷰티사의 시장 분석가입니다. [5B] 저희는 건강에 관심이 있는 소비자를 위해 명품 화장품을 생산합니다. [5D] 저희 제품은 북미와 유럽에서 구입할 수 있으며, [5C] 이제 아시아 시장으로 진출할 준비가 되어 있습니다.

[4] 저희가 대만 시장을 통해 아시아로 진입하는 동안 저희 회사를 위해 귀하께서 자문 위원으로 근무할 수 있는지 알기 위해 연락드리게 되었습니다. [6] 제 동료인 샘 배터 씨가 당신을 추천하면서 동아시아 사업 관행에 관한 당신의 지식을 크게 칭찬했습니다. 그가 [7] 당신이 건강식품 제품을 대만의 주류 식료품점에 도입하는 데 성공했던 것에 관해 말해 주었습니다. 저는 당신의 훌륭한 평판에 깊은 인상을 받았습니다.

저희가 사업을 확장하는 동안 프리랜서 자문 역할을 맡는 데 관심이 있으시면, 연락 주시기 바랍니다. [5A] 저희는 다음 달 초에 타이베이에서 소매업자들과 대화를 시작하고자 합니다.

귀하의 연락을 기다리겠습니다.

Samantha Grove
Market Analyst and Product Specialist, Life Beauty

라이프 뷰티 사, 시장 분석가 겸 제품 전문가
사만다 그로브 드림

어휘 | consultancy 자문, 상담 market analyst 시장 분석가 branch out into ~로 확장하다 transition into ~로의 진입[이행]
speak highly of ~을 크게 칭찬하다 business practice 사업 관행 mainstream 주류 be impressed by ~에 깊은 인상을 받다
retailer 소매업자

4. Why was the e-mail written?

(A) To schedule a business meeting

(B) To inform Mr. Hampton of plans to expand

(C) To request consultation on a project

(D) To offer Mr. Hampton a full-time job

해석 | 이메일이 쓰여진 이유는?

(A) 업무 회의 일정을 잡기 위해

(B) 햄프턴 씨에게 확장 계획을 알리기 위해

(C) 프로젝트에 관해 자문을 요청하기 위해

(D) 햄프턴 씨에게 정규직을 제안하기 위해

해설 | 주제, 목적 문제
이메일의 제목을 보면 Consultancy Offer라고 되어 있다. 그리고 두 번째 문단에서 회사가 아시아에 진입하는 동안 자문 위원으로 근무해 줄 수 있는지 묻고 있으므로 (C)가 정답. 이처럼 글의 목적을 묻는 문제는 I am contacting you about이나 I'm writing to와 같은 표현을 주의 깊게 살펴보자. 정규직이 아니라 프리랜서 자문 역을 제안하고 있으므로 (D)는 오답이다.

5. What is NOT stated about Life Beauty?

(A) It plans to meet with distributors next month.

(B) It produces expensive beauty items.

(C) It has branches across Asia.

(D) It sells products in Europe.

해석 | 라이프 뷰티 사에 대해서 언급되지 않은 것은?

(A) 다음 달에 유통업자들을 만날 계획이다.

(B) 값비싼 미용 제품을 생산한다.

(C) 아시아 전역에 지점이 있다.

(D) 유럽에서 제품을 판매한다.

해설 | Not/True 문제
Not/True 문제의 경우 모든 선택지를 지문과 대조하며 소거하는 방식으로 정답을 찾아야 한다. (A)는 단서 (5A)에서 소매업자들을 만난다고 했고, (B)는 단서 (5B)에서 명품 화장품을 생산한다고 했으며, (D)는 단서 (5D)에서 유럽에서 제품 구매가 가능하다고 했으므로 모두 오답으로 소거한다. 그러나 단서 (5C)에서 이제 아시아 시장으로 진출할 준비가 되어 있다고 했으므로 (C)는 언급된 내용과 다른 내용이다. 따라서 정답은 (C).

6. Who is Mr. Batter?

(A) A Taiwanese language expert

(B) A freelance consultant

(C) A grocery store owner

(D) Mr. Grove's coworker

해석 | 배터 씨는 누구인가?

(A) 대만어 전문가

(B) 프리랜서 자문 위원

(C) 식료품점 점주

(D) 그로브 씨의 동료

해설 | 특정 정보 확인 문제
특정 인물의 정보를 묻는 문제는 해당 인물의 이름이나 그를 지칭하는 대명사가 포함된 문장을 주의 깊게 봐야 한다. 배터 씨 이름이 언급된 단서 (6)에서 편지를 보낸 그로브 씨가 배터 씨를 자신의 동료라고 설명하고 있으므로 정답은 (D). 지문의 colleague가 정답에서 coworker로 바꿔 표현되었다.

7. What is true about Mr. Hampton?

(A) He helped distribute products in East Asia.

(B) He manages the most successful store in Taiwan.

(C) He has done research in healthful ingredients.

(D) He is planning to expand his business overseas.

해석 | 햄프턴 씨에 대해 사실인 것은?

(A) 동아시아에서 제품 유통을 도왔다.

(B) 대만에서 가장 성공적인 가게를 운영한다.

(C) 건강에 좋은 재료에 대해 연구했다.

(D) 사업을 해외로 확장할 계획이다.

해설 | Not/True 문제
단서 (7)에 따르면, 그로브 씨가 자신의 동료로부터 햄프턴 씨가 제품을 대만 식료품점에 도입하는 데 성공했다는 것을 들었다고 했으므로 정답은 (A). 단서의 introducing health food products to Taiwan이 정답에서 상위 개념을 이용하여 distribute products in East Asia로 패러프레이징되었다.

DAY 22

97

Veritas Tour Groups
233 Via Della Spiga, Rome, Italy

The following is the Rome tour schedule for the group from Middleton Incorporated for [9] July 9 to 11. Breakfast and lunch are included for each day, but guests are responsible for their own dinners. All entrance fees are included.

베리타스 관광 그룹
비아 델라 스피가 233번지, 로마, 이탈리아

다음은 [9] 7월 9일 부터 11일까지 미들턴 주식회사에서 오시는 단체의 로마 여행 일정입니다. 아침과 점심 식사는 매일 포함되어 있지만, 손님들이 각자의 저녁 식사비는 부담하셔야 합니다. 모든 입장료는 포함되어 있습니다.

Day 1:

8:00 A.M.	Buffet breakfast at Cesare Hotel
9:00 A.M.–10:30 A.M.	[8] Visit the Coliseum
10:30 A.M.–12:30 P.M.	Visit the Forum Romana
12:30 P.M.	Lunch at Antonio's Ristorante
2:00 P.M.–4:30 P.M.	Visit Trevi Fountain

Day 2:

8:00 A.M.	Buffet breakfast at Cesare Hotel
9:30 A.M.–12:30 P.M.	[8] Visit the Pantheon
12:30 P.M.	Lunch at Delizio Pizzeria
2:00 P.M.–4:30 P.M.	Visit the National Roman Museum
6:30 P.M.	[11-2] Visit the shopping district

Day 3:

8:00 A.M.	Buffet breakfast at Cesare Hotel
9:30 A.M.–10:30 A.M.	Visit Piazza di Spagna (Spanish Steps)
11:00 A.M.–12:30 P.M.	Visit Castello Sant'Angelo (Saint Angelo Castle)
12:30 P.M.	Lunch at Il Lupo
2:00 P.M.–4:00 P.M.	Souvenir shopping at Porta Portese Market
6:00 P.M.– 8:00 P.M	[9] Attend *La Traviata* opera

첫째 날:

오전 8시	체사레 호텔에서 뷔페식 조식
오전 9시-오전 10시 30분	[8] 콜로세움 방문
오전 10시 30분-오후 12시 30분	포럼 로마나 방문
오후 12시 30분	안토니오스 리스토란테에서 중식
오후 2시-오후 4시 30분	트레비 분수 방문

둘째 날:

오전 8시	체사레 호텔에서 뷔페식 조식
오전 9시 30분-오후 12시 30분	[8] 판테온 신전 방문
오후 12시 30분	델리지오 피자 전문점에서 중식
오후 2시-오후 4시 30분	로마 국립 박물관 방문
오후 6시 30분	[11-2] 상점가 방문

셋째 날:

오전 8시	체사레 호텔에서 뷔페식 조식
오전 9시 30분-오전 10시 30분	피아짜 디 스빠냐 (스페인 계단) 방문
오전 11시-오후 12시 30분	카스텔로 산탄젤로 (성 안젤로의 성) 방문
오후 12시 30분	일 루포에서 중식
오후 2시-오후 4시	포르타 포르테스 시장에서 기념품 쇼핑
오후 6시-오후 8시	[9] 〈라 트라비아타〉 오페라 관람

어휘 | incorporated(=Inc.) 주식회사 be responsible for ~을 부담하다, ~에 책임이 있다 entrance fee 입장료 shopping district 상점가 souvenir shopping 기념품 쇼핑

To: Sonia Lorenzo <sonlo@veritastours.com>
From: Gary Martin <gmartin@middletoninc.com>
Date: June 3
Subject: Tour Schedule for Rome

Dear Ms. Lorenzo,

[10] Thank you for sending me the copy of the plans for our group's visit to Rome. Everything looks fine,

받는 사람: 소냐 로렌조 <sonlo@veritastours.com>
보내는 사람: 게리 마틴 <gmartin@middletoninc.com>
날짜: 6월 3일
제목: 로마 관광 일정

로렌조 씨께,

[10] 저희 단체의 로마 방문에 관한 계획표를 보내 주셔서 감사합니다. 모든 것이 좋아 보이지만, 당신께 몇 가지 질문이 있습니다.

but there were just a few questions I had for you. First, **11-1** would it be possible to cancel the last event on Day 2? We are actually planning to do a small awards ceremony for the staff, and I think that would be the best time to do it.

Also, I noticed that not all meals are included in the cost of the tour. How much extra would it cost to have all meals covered?

Finally, as we are quite a large group, **12** I was wondering if you could arrange transport for us from the airport to the Cesare Hotel. We will arrive at 7:20 P.M. at Rome Fiumicino Airport on July 8 on Northstar Airlines flight NA688. Please let me know as soon as possible.

Sincerely,
Gary Martin

먼저, **11-1** 둘째 날의 마지막 행사를 취소하는 것이 가능할까요? 사실 저희가 직원들을 위한 작은 시상식을 열 계획인데, 그때가 행사를 하기에 가장 좋은 시간일 것 같습니다.

또한, 여행 비용에 모든 식사가 포함되어 있지는 않다는 것을 알게 되었습니다. 모든 식사를 포함하려면 얼마의 추가 비용이 들까요?

마지막으로, 저희가 상당히 큰 단체이기 때문에 **12** 저희를 위해 공항에서 체사레 호텔까지의 교통편을 마련해 주실 수 있을지 궁금합니다. 저희는 노스스타 항공 NA688편으로 7월 8일 로마 피우미치노 공항에 저녁 7시 20분에 도착할 예정입니다. 가능한 한 빨리 알려 주시기 바랍니다.

게리 마틴 드림

어휘 | awards ceremony 시상식 cover 포함시키다 arrange transport 교통편을 마련[준비]하다 as soon as possible 가능한 한 빨리

8. What is indicated about the scheduled tour?
 (A) It provides visits to historic sites.
 (B) Its cost includes all food and drinks.
 (C) It takes visitors to several cities.
 (D) Its price does not cover entrance fees.

해석 | 예정된 여행에 관해 시사된 것은?
(A) 유적지 방문을 제공한다.
(B) 모든 식사 비용을 포함한다.
(C) 방문객을 여러 도시에 데리고 갈 것이다.
(D) 입장료를 포함하지 않는다.

해설 | Not/True 문제
여행 일정에 대한 내용은 첫 번째 지문인 일정표에서 확인할 수 있다. 단서 (8)에서 콜로세움과 판테온 신전 등에 방문한다고 했으므로 이를 상위 개념인 historic sites로 바꾸어 표현한 (A)가 정답. 일정표에 언급된 방문지는 모두 로마 도시에 있는 관광지이고 일정표 앞에서도 로마 여행 일정이라고 했으므로 여러 도시에 간다는 (C)는 오답이다.

9. When is Mr. Martin's group scheduled to see a performance?
 (A) July 8
 (B) July 9
 (C) July 10
 (D) July 11

해석 | 마틴 씨의 단체 공연 관람 예정일은?
(A) 7월 8일
(B) 7월 9일
(C) 7월 10일
(D) 7월 11일

해설 | 특정 정보 확인 문제
일정표에서 공연이 언급되어 있는 부분을 찾아보자. Day 3 단서 (9)에 〈라 트라비아타〉 오페라 관람이 예정되어 있다. 일정표 앞부분의 단서 (9)에 따르면 여행 일정은 7월 9일부터이므로 여행 셋째 날은 7월 11일임을 알 수 있다. 따라서 정답은 (D).

10. To whom was the e-mail sent?
 (A) An airline staff member
 (B) A tour agency representative
 (C) A car service driver
 (D) A hotel manager

해석 | 이메일을 받은 사람은?
(A) 항공사 직원
(B) 여행사 직원
(C) 자동차 서비스 기사
(D) 호텔 관리자

해설 | 대상, 출처 문제
이메일을 받는 대상을 묻고 있으므로 이메일의 목적이나 상황 등을 확인해보자. 단서 (10)에서 로마 여행 계획표를 보내줘서 고맙다고 한 것으로 보아 여행 일정표를 보내준 사람이 이메일을 받는 사람임을 알 수 있다. 여행 일정표는 여행사 직원이 보내주는 것이므로 정답은 (B).

11. Which event does Mr. Martin want to cancel?

(A) The tour of the Pantheon

(B) The visit to a museum

(C) The outing to a retail area

(D) The lunch at a pizza restaurant

해석 | 마틴 씨가 취소하길 원하는 행사는?

(A) 판테온 신전 관광

(B) 박물관 방문

(C) 상가 관광

(D) 피자 레스토랑에서의 점심 식사

해설 | 두 지문 연계 문제

두 지문의 내용을 확인해야 하는 연계 문제로, 마틴 씨가 보낸 이메일을 먼저 보도록 한다. 단서 (11-1)에 따르면 마틴 씨가 취소하고 싶어 하는 행사는 둘째 날의 마지막 행사이다. 여행 일정표의 단서 (11-2)에서 둘째 날의 마지막 행사가 Visit the shopping district로 나와 있으므로 the shopping district를 a retail area로, visit를 outing으로 바꾸어 표현한 (C)가 정답이다.

12. What is one of Mr. Martin's requests?

(A) A pickup service

(B) A hotel reservation

(C) A flight upgrade

(D) A group discount

해석 | 마틴 씨가 요청하는 것 중 하나는?

(A) 픽업 서비스

(B) 호텔 예약

(C) 항공편 업그레이드

(D) 단체 할인

해설 | 특정 정보 확인 문제

단서 (12)에서 I was wondering if you could 표현 이하에 요청 사항이 명시되어 있다. 공항에서 호텔까지의 교통편을 마련해 줄 수 있는지 묻고 있으므로 정답은 (A). 단서의 arrange transport ~ the Cesare Hotel이 정답에서 pickup service로 패러프레이징되었다.

예제 해석

교재 213쪽

[예제 1] 다음에 할 일을 묻는 문제

Kim's Dry-Cleaning Expands to Serve Clientele

Boston's leading dry-cleaning company announced this week that it is going to expand its business. Kim's Dry-Cleaning has proudly served the Boston area for over ten years and is known for its quality service and affordable prices. The owner, John Kim, explained that an expansion is necessary to serve the company's ever growing customer base.

A second dry-cleaning shop will open on the city's east side in August and will be twice the size of the original downtown location. In addition, service hours will be extended into the late evening.

Next year, Kim's Dry-Cleaning will further enhance its services. "Eventually we will offer next-day express service and home pick-up as well," said Kim, giving Boston residents a lot to look forward to.

킴스 드라이클리닝 사 모든 고객에게 서비스 제공을 위해 확장하다

보스턴의 선두적인 드라이클리닝 업체가 사업을 확장할 계획이라고 이번 주에 발표했다. 킴스 드라이클리닝 사는 10년 이상 자부심을 갖고 보스턴 지역에 서비스를 제공해 왔으며, 양질의 서비스와 저렴한 가격으로 알려져 있다. 소유주인 존 킴 씨는 계속 늘어나는 회사 고객층에게 서비스를 제공하기 위해 확장이 필요하다고 설명했다.

두 번째 드라이클리닝점은 8월에 시의 동부 지역에 문을 열 것이며, 시내 본점의 두 배 크기가 될 것이다. 또한 운영 시간이 늦은 저녁까지 연장된다.

내년에, 킴스 드라이클리닝 사는 서비스를 더 향상시킬 것이다. 킴 씨는 "궁극적으로 저희는 익일 특급 서비스와 가정 방문 수거 서비스도 제공하려고 합니다."라고 말하며, 보스턴 주민들에게 많은 기대감을 주었다.

어휘 | expand 확장하다 serve (상품, 서비스를) 제공하다 clientele 모든 고객들 be known for ~로 알려져 있다 affordable price 저렴한[알맞은] 가격 ever growing 계속 늘어나는 extend into ~까지 이어지다 enhance 향상시키다 look forward to ~을 기대하다

What will happen next year?
(A) A new store will open.
(B) Service fees will increase.
(C) A store's location will be moved.
(D) Additional services will be offered.

해석 | 내년에 일어날 일은?
(A) 새 매장이 문을 열 것이다.
(B) 서비스 요금이 인상될 것이다.
(C) 가게 위치를 이전할 것이다.
(D) 추가 서비스를 제공할 것이다.

[예제 2] 추론 문제

TO: Derek Houston <dhouston@houstonsteel.com>
FROM: Heather Carlson <heather@sterling.com>
DATE: May 28
SUBJECT: Re: Problem with Delivery Delays

Dear Mr. Houston,

I'm contacting you today regarding your factory's recent shipments of steel pipes to our warehouse. I received each of the last three shipments between two and three days late. The delays in delivery have caused setbacks to our construction schedule. Our clients depend on Sterling Construction to finish the projects on time. Therefore, timely delivery of materials from our suppliers is essential to the

받는 사람: 데릭 휴스턴 <dhouston@houstonsteel.com>
보내는 사람: 헤더 칼슨 <heather@sterling.com>
날짜: 5월 28일
제목: 회신: 배달 지연 문제

휴스턴 씨께,

당신의 공장에서 최근에 저희 창고로 강철 파이프를 배송한 것과 관련하여 오늘 연락 드리게 됐습니다. 지난 세 번의 배송품을 각각 2~3일 정도 늦게 받았습니다. 배달 지연으로 저희 건설 일정에 차질을 빚었습니다. 저희 고객들은 스털링 건설사가 공사를 제시간에 끝낼 것으로 믿습니다. 따라서, 공급 업체에서 자재를 적시에 배달하는 것이 저희 사업의 성공에 필수적입니다.

success of our business.

I am scheduled to visit your factory on June 3. I would like to discuss with you directly how we can ensure that future deliveries will arrive on time. I appreciate your attention to this matter.

Heather Carlson
Warehouse Manager, Sterling Construction

제가 6월 3일에 당신의 공장을 방문할 예정입니다. 향후 배송품이 반드시 제시간에 도착하도록 할 수 있는 방법에 관해 당신과 직접 이야기하고 싶습니다. 이 문제에 주목해 주시면 감사하겠습니다.

스털링 건설, 창고 관리자
헤더 칼슨 드림

어휘 | regarding ~에 관하여 shipment 배송(품), 선적(품) warehouse 창고 cause a setback to ~에 차질을 빚다 depend on ~을 믿다 timely 적시의, 시기적절한 material 자재 be scheduled to *do* ~할 예정이다 ensure that (반드시) ~하도록 하다 attention 주목, 관심

What is suggested about the steel pipes?
(A) They take several days to ship.
(B) They are used in construction projects.
(C) They are sold by Sterling Construction.
(D) They are delivered daily.

해석 | 강철 파이프에 대해 암시된 것은?
(A) 수송하는 데 며칠이 걸린다.
(B) 건설 공사에 사용된다.
(C) 스털링 건설사에서 판매된다.
(D) 매일 배송된다.

패러프레이징
교재 215쪽

예제 (B) / 1. (B) 2. (A) 3. (A) 4. (A) 5. (B)

[예제 3] 패러프레이징

The Fischer Center announced today that the organization has finally raised enough money for its community project to build a park and soccer field. The project will begin in the spring.

피셔 센터는 마침내 공원과 축구장을 건설하는 지역 사회 프로젝트를 위한 돈을 충분히 모았다고 오늘 발표했다. 이 프로젝트는 봄에 착수할 예정이다.

What will the Fischer Center do this spring?
(A) Hold a charity fundraiser
(B) Build a recreational area

해석 | 피셔 센터가 이번 봄에 할 것은?
(A) 자선 기금 모금 행사 개최하기
(B) 오락 구역 건설하기

해설 | 지문에서 spring으로 명시된 곳을 찾아본다. 프로젝트를 봄에 착수할 예정이라고 했는데, 그것은 공원과 축구장을 건설하는 것이므로 정답은 (B). 지문의 a park and soccer field가 정답에서 상위 개념인 a recreational area로 패러프레이징되었다.

1.

Whether you need a quick breakfast early in the morning or a fun snack late at night, Sweet Dreams is there for you! Come check out the newest bakery in Allentown. We specialize in beautiful pastries, but we've got everything from fresh bread to luxury cakes.

아침 일찍 간단한 아침 식사를 원하시든 늦은 밤 가벼운 간식을 원하시든, 스위트 드림스는 여러분을 위해 있습니다! 앨런타운에 새로 생긴 제과점을 보러 오세요. 저희는 훌륭한 페이스트리를 전문으로 하지만, 신선한 빵에서 고급스러운 케이크까지 모든 것이 다 있습니다.

What can be inferred about Sweet Dreams?
(A) It has been in business for many years.
(B) It stays open for long hours.

해석 | 스위트 드림스에 대해 추론할 수 있는 것은?
(A) 수년간 영업해왔다.
(B) 오랜 시간 동안 문을 연다.

해설 | 간단한 아침 식사부터 늦은 밤 가벼운 간식까지 제공한다고 했으므로 오랜 시간 동안 문을 연다는 것을 알 수 있다. 따라서 정답은 (B). 지문의 early in the morning과 late at night이 정답에서 함축 표현을 활용하여 stays open for long hours로 패러프레이징되었다.

2.

Installation of new software will begin on Monday, June 1 at 10 A.M. We expect the process to take about twenty minutes. During this time, your computer may restart itself several times. To avoid losing data, please save all work onto a separate device before 10 A.M.

What is implied about the new software?
(A) Its installation might cause shutdowns.
(B) It allows easy file storage.

해석 | 새 소프트웨어 설치를 6월 1일 월요일 오전 10시에 시작할 것입니다. 저희는 이 과정이 20분 정도 걸릴 것으로 예상하고 있습니다. 이 시간 동안, 여러분의 컴퓨터는 저절로 여러 번 다시 시작될 것입니다. 데이터 손실을 막기 위해서, 오전 10시 전까지 모든 작업물을 별도의 장치에 저장해 주십시오.

해석 | 새로운 소프트웨어에 대해 암시된 것은?
(A) 설치가 종료를 야기할 수도 있다.
(B) 파일 저장을 쉽게 해준다.

해설 | 설치 과정에서 컴퓨터가 저절로 여러 번 다시 시작될 것이라고 했는데, 이는 종료되었다가 일어나는 일이므로 소프트웨어 설치가 종료를 야기한다는 것을 유추할 수 있다. 따라서 정답은 (A).

3.

I booked a room through your Web site for September 3 to September 5. I am a Swan Hotel loyalty cardholder, so I should get 10 percent off; however, my credit card was charged the full amount. Please check my account and call me back as soon as possible.

What is suggested about the hotel?
(A) It offers discounts to loyal customers.
(B) It is fully booked for September.

해석 | 저는 귀사의 웹사이트를 통해 9월 3일부터 5일까지 객실을 예약했습니다. 제가 스완 호텔 고객 카드 소지자여서 10퍼센트 할인을 받아야 합니다. 그런데 제 신용 카드에 전액이 청구되었습니다. 가능한 한 빨리 제 계좌를 확인하시고 저에게 전화 주시기 바랍니다.

해석 | 호텔에 대해 암시된 것은?
(A) 단골 고객에게 할인을 제공한다.
(B) 9월에 예약이 꽉 찼다.

해설 | 고객 카드가 있어서 10퍼센트 할인을 받아야 한다고 언급되어 있는 것으로 보아 호텔이 단골 고객에게 할인을 제공한다는 것을 유추할 수 있다. 따라서 정답은 (A). 지문의 loyalty cardholder가 정답에서 유의어인 loyal customers로, 지문의 get 10 percent off가 정답에서 동의어인 discounts로 패러프레이징되었다.

4.

To make sure your integration into our company goes smoothly, we have prepared an orientation program for new employees, which will begin on February 23. Your department heads will contact you shortly with the location of your specific session.

What will the department heads probably do next?
(A) Provide new hires with further information
(B) Announce the successful candidates

해석 | 귀하께서 저희 회사에 순조롭게 동화될 수 있도록, 신입 사원들을 위한 연수 프로그램을 준비했는데, 이는 2월 23일에 시작될 것입니다. 귀하의 부서장이 곧 구체적인 교육 장소를 알려드리기 위해 연락을 드릴 것입니다.

해석 | 부서장들이 다음에 할 것 같은 일은?
(A) 신입 사원들에게 자세한 정보 제공하기
(B) 합격자 발표하기

해설 | 부서장이 교육 장소를 알려주기 위해 연락한다고 했으므로 정답은 (A). 지문의 the location of your specific session이 정답에서 상위 개념인 further information으로 패러프레이징되었다.

DAY 23

5.

The city council is looking for a company to lead the construction. It will accept proposals from firms in the state starting on April 12. The project is scheduled to start on May 1 and is estimated to last until the end of September.

해석 | 시의회는 그 건설을 주도할 회사를 찾고 있다. 시의회는 4월 12일부터 주 내의 회사들로부터 제안서를 받을 것이다. 사업은 5월 1일에 시작될 예정이고 9월 말까지 지속될 것으로 예상된다.

What will most likely happen on May 1?
(A) A project leader will create a contract.
(B) Construction work will begin.

해석 | 5월 1일에 일어날 것 같은 일은?
(A) 팀장이 계약을 할 것이다.
(B) 건설 공사가 시작될 것이다.

해설 | 사업이 5월 1일에 시작된다고 하였는데 그 사업이 가리키는 것은 건설 공사이므로 정답은 (B). The project is scheduled to start가 정답에서 Construction work will begin으로 패러프레이징되었다.

FINAL TEST

교재 216쪽

1. (D) 2. (B) 3. (D) 4. (A) 5. (C) 6. (C)

[1-2] 광고

Make an ordinary day special!

For over twenty-five years, Fourth Street Flowers has been providing exceptional service to the area. From elegant flower bouquets to plants and gift baskets, you'll be sure to find something that's just right. And if you don't, you can select flowers and make your own unique design! [1] Visit our Web site at www.4thstreetflowers.com and sign up for our monthly newsletter, which tells you about the latest trends and has special discount coupons. You can place orders online for same-day delivery if requested before noon, or stop by the store and see our arrangements for yourself. [2] Right now, we have special Valentine bouquets available for a limited time only. Try us today and turn your special moment into a special memory.

평범한 하루를 특별하게 만들어 보세요!

25년 넘게 4번가 꽃집은 지역에 특별한 서비스를 제공해 왔습니다. 우아한 꽃다발부터 화초와 선물 바구니에 이르기까지, 여러분께 꼭 맞는 것을 반드시 발견하게 될 것입니다. 그게 아니라면, 직접 꽃을 골라서 여러분만의 특별한 디자인을 만들 수 있습니다! [1] 저희 웹사이트 www.4thstreetflowers.com에 방문하셔서 월간 소식지를 신청하세요, 월간 소식지는 최신 경향을 알려드리고 특별 할인 쿠폰도 제공합니다. 오전에 주문하면 당일 배송되는 온라인 주문을 하실 수 있고, 아니면 가게에 들러서 저희가 준비한 것들을 직접 보세요. [2] 바로 지금, 한정된 기간 동안만 구매할 수 있는 특별한 발렌타인 꽃다발을 구비하고 있습니다. 오늘 와서 보시고, 여러분의 특별한 순간을 특별한 추억으로 바꾸세요.

어휘 | exceptional 특별한, 뛰어난 bouquet 꽃다발 sign up for ~을 신청하다 arrangement 준비 turn A into B A를 B로 바꾸다

1. According to the advertisement, how can customers get a reduced price?
 (A) By coming on certain dates
 (B) By ordering online
 (C) By making multiple orders
 (D) By subscribing to a newsletter

해석 | 광고에 따르면, 고객이 할인받을 수 있는 방법은?
(A) 특정한 날에 방문해서
(B) 온라인으로 주문해서
(C) 여러 개를 주문해서
(D) 소식지를 구독해서

해설 | **특정 정보 확인 문제**
할인에 대한 정보는 단서 (1)에서 찾아볼 수 있는데 소식지를 신청하면 소식지에 특별 할인 쿠폰을 제공한다고 했으므로 정답은 (D). 지문의 sign up for our monthly newsletter가 subscribing to a newsletter로 패러프레이징되었다.

2. What can be inferred about Fourth Street Flowers?

(A) It is a new business that opened recently.

(B) It offers holiday-themed products temporarily.

(C) Its most popular item is sold only in the morning.

(D) It charges an additional fee for expedited delivery.

해석 | 4번가 꽃집에 대해 추론할 수 있는 것은?

(A) 최근에 영업을 시작했다.

(B) 휴일을 주제로 한 제품을 일시적으로 제공한다.

(C) 가장 인기있는 제품은 아침에만 판매한다.

(D) 빠른 배송을 이용하려면 추가 요금을 부과한다.

해설 | **추론 문제**

단서 (2)에서 한정 기간 동안만 구매할 수 있는 발렌타인 꽃다발을 구비하고 있다고 했으므로 정답은 (B). 지문의 special Valentine bouquets가 정답에서 holiday-themed products로, 지문의 for a limited time이 정답에서 temporarily로 각각 패러프레이징 되었다.

[3-6] 기사

City Announces Construction of Community Center

During a press conference on Tuesday, ³ city council chairperson Samantha Davies announced plans for the construction of a community center on Chesterton Avenue. The new facility will feature a large event hall, three classrooms, and a conference room. It will also include an art studio and gallery area. "The council felt that such facilities would really improve the quality of life in the city," Davies said. "We will now have a place to hold community events and conduct special courses, such as art classes."
⁴ The city council is looking for a company to lead the construction. ⁵ It will accept proposals from firms in the state starting on April 12. The project is scheduled to start on May 1 and is estimated to last until the end of September. ⁶ Those interested in bidding on the construction project may contact the project manager, Daniel Lewis, at danlew@summerlandcity.org for information on submitting a proposal and application.

For additional information on the plans and features for the new facility, please visit www.summerlandcitycouncil.org/communitycenter.

시에서 지역 문화회관 건설을 발표하다

화요일에 열린 기자 회견에서 ³ 시의회 의장인 사만다 데이비스 씨가 체스터턴 로에 지역 문화회관을 건설하려는 계획을 발표했다. 새 시설은 대규모 행사장과 세 개의 강의실, 그리고 회의실을 특별히 포함할 것이다. 미술실과 미술관 공간도 포함할 것이다. "의회는 그런 시설이 도시 내 삶의 질을 진정으로 향상시킬 것이라고 생각했습니다." 데이비스 씨가 말했다. "우리는 이제 지역 사회 행사를 개최하고 미술 수업과 같은 특별 강좌도 진행할 수 있는 공간을 갖게 될 것입니다."

⁴ 시의회는 그 건설을 주도할 회사를 찾고 있다. ⁵ 4월 12일부터 주 내의 회사들로부터 제안서를 받을 것이다. 공사는 5월 1일에 시작될 예정이고 9월 말까지 지속될 것으로 예상된다. ⁶ 건설 공사에 대한 입찰에 관심 있는 업체들은 danlew@summerlandcity.org로 프로젝트 관리자인 다니엘 루이스 씨에게 연락해서 제안서와 신청서 제출에 관한 정보를 얻을 수 있다.

새로운 시설에 대한 계획과 특징에 관한 추가 정보를 얻으려면, www.summerlandcitycouncil.org/communitycenter를 방문하면 된다.

DAY 23

어휘 | press conference 기자 회견 announce 발표하다 community center 지역 문화회관 feature (특별히) 포함하다; 특징 estimate 추정하다 bid on ~에 입찰하다 submit a proposal 제안서를 제출하다

3. What is the purpose of the article?

(A) To request a town meeting

(B) To raise money for a building

(C) To argue against a proposal

(D) To explain plans for a project

해석 | 기사의 목적은?

(A) 주민 회의를 요청하기 위해

(B) 건물을 위한 돈을 모금하기 위해

(C) 제안에 대해 반대하기 위해

(D) 프로젝트의 계획을 설명하기 위해

해설 | **주제, 목적 문제**

기사의 목적은 지문의 앞부분에 주로 명시되므로 이 부분을 잘 살펴보자. 단서 (3)에서 시의회 의장이 지역 문화회관의 건설 계획을 발표했다는 사실을 알리며 문화회관의 특징에 대해 이야기하고 있으므로 정답은 (D).

4. What does the article suggest about the construction project?

(A) The building contractors have not been chosen yet.

(B) A private company will pay for the expenses.

(C) It was designed by art specialists.

(D) The city council was originally opposed to it.

5. What will most likely happen on April 12?

(A) The facility construction will begin.

(B) Council members will select a winning bid.

(C) Proposals will be submitted to the city council.

(D) The community center will open to the public.

6. How can interested firms get information on submitting a bid for the project?

(A) By calling Samantha Davies

(B) By visiting a Web site

(C) By sending an e-mail

(D) By submitting a form at City Hall

해석 | 기사가 건설 계획에 대해 암시하는 것은?

(A) 아직 건설업체를 선정하지 않았다.

(B) 민간업체에서 비용을 지불할 것이다.

(C) 미술 전문가가 설계하였다.

(D) 시의회는 처음에 이에 반대했다.

해설 | 추론 문제

단서 (4)에서 건설을 주도할 회사를 찾고 있다고 했는데, 이를 통해 아직 건설업체가 선정되지 않았음을 추론할 수 있다. 따라서 정답은 (A).

해석 | 4월 12일에 일어날 것 같은 일은?

(A) 시설 공사가 시작될 것이다.

(B) 의원들이 낙찰업체를 선택할 것이다.

(C) 제안서들이 시의회에 제출될 것이다.

(D) 지역 문화회관이 대중에게 공개될 것이다.

해설 | 다음에 할 일을 묻는 문제

문제에 구체적인 시점이 등장하면 지문에 같은 표현이 있는지 살펴봐야 한다. 단서 (5)에서 4월 12일부터 제안서를 받을 것이라고 했으므로 (C)가 정답이다. 건설이 시작되는 것은 5월 1일이므로 (A)는 오답.

해석 | 관심 있는 회사들이 공사 입찰서 제출에 관한 정보를 얻을 수 있는 방법은?

(A) 사만다 데이비스 씨에게 전화해서

(B) 웹사이트를 방문해서

(C) 이메일을 보내서

(D) 시청에 양식을 제출해서

해설 | 특정 정보 확인 문제

단서 (6)에서 제안서와 신청서 제출에 대한 정보를 얻는 방법에 대해 다니엘 루이스 씨에게 이메일로 연락하라고 했으므로 (C)가 정답이다.

예제 해석

교재 221쪽

[예제 1] 동의어 문제

Eden Lake Public Library Celebrates 100 Years

The Eden Lake Public Library will hold a social on March 13 in honor of its 100 years of service. Valarie Lee, a city council member, is organizing the event. She said the purpose of the event is to celebrate the history of the city as well as bring together members of the community. The library was founded in 1910 with a private donation of $8,000 from Robert Milford, an important figure in Eden Lake's history. The library has since stood as a center for community activity and has expanded its services over the years to include tutoring for students, educational lectures, and Internet access.

에덴 레이크 공공 도서관의 100주년 축하

에덴 레이크 공립 도서관이 개관 100주년을 기념하고자 3월 13일에 친목 파티를 개최할 예정입니다. 시의회 의원인 밸러리 리 씨가 행사를 준비하고 있습니다. 그녀는 본 행사의 목적이 지역 주민들을 한자리에 모으는 것뿐만 아니라 이 도시의 역사를 축하하기 위한 것이라고 말했습니다. 이 도서관은 로버트 밀퍼드 씨가 개인적으로 기부한 8,000달러로 1910년에 설립됐는데, 그는 에덴 레이크의 역사에 있어 중요한 인물입니다. 그때 이후로 도서관은 공동체 활동의 중심으로 존재해왔고, 지난 수년 동안 학생들을 지도하고, 교육 강의와 인터넷 이용 등을 포함하는 것으로 서비스를 확장해왔습니다.

어휘 | social 친목 파티 in honor of ~을 기념하여 bring together 한자리에 모으다 found 설립하다 expand 확장하다 tutor 가르치다

The word "figure" in paragraph 1, line 7 is closest in meaning to
(A) shape
(B) number
(C) amount
(D) person

해석 | 첫째 단락 일곱 번째 줄의 "figure"와 의미상 가장 가까운 단어는?
(A) 모양
(B) 숫자
(C) 양
(D) 사람

[예제 2] 의도 파악 문제

CARL SIMMONS	11:01

Brendon said he submitted a request to have off this Friday but hasn't gotten approval yet. He is wondering if you need him that day.

LINDA HARPER	11:03

Oh, there is a problem with my account. I wasn't able to log into the system this morning, so I didn't see his request.

CARL SIMMONS	11:04

I see. Do you need me to contact Gustavo Quiroz from IT to figure it out?

LINDA HARPER	11:05

No. I've actually already contacted him. He's on it. Just let Brendon know he can take Friday off.

칼 시먼스	11:01

브렌든이 이번 주 금요일 휴가 신청서를 제출했는데 아직 승인을 받지 못했다고 합니다. 당신이 그날에 브렌든이 필요한 것인지 궁금해 하네요.

린다 하퍼	11:03

아, 제 계정에 문제가 있어요. 오늘 아침에 시스템에 로그인할 수 없어서, 그의 요청을 보지 못했어요.

칼 시먼스	11:04

알겠습니다. 제가 IT 부서의 구스타보 퀴로즈 씨에게 연락해서 그것을 알아보라고 할까요?

린다 하퍼	11:05

아니요. 사실 제가 이미 그분에게 연락했어요. 그분이 하고 있어요. 그저 브렌든에게 금요일 휴가를 사용할 수 있다고 알려주세요.

어휘 | submit 제출하다 request 신청, 요청; 요청하다 approval 승인 figure out ~을 알아내다 take off ~(동안)을 쉬다

At 11:05, what does Ms. Harper mean when she writes, "He's on it"?

(A) Mr. Quiroz told her he will not be in the office Friday.

(B) Mr. Quiroz is looking for a solution to her problem.

(C) She is using Mr. Quiroz's account to log on.

(D) She told Mr. Quiroz to approve Brendon's day off.

해석 | 11시 5분에, 하퍼 씨가 "그분이 하고 있어요"라고 한 것에서 그녀가 의도한 것은?

(A) 퀴로즈 씨가 그녀에게 금요일에 사무실에 없을 것이라고 말했다.

(B) 퀴로즈 씨가 그녀의 문제에 대한 해결 방법을 찾고 있다.

(C) 그녀는 퀴로즈 씨의 계정을 이용해서 로그인하고 있다.

(D) 그녀는 퀴로즈 씨에게 브렌든의 휴가를 승인하라고 말했다.

패러프레이징

교재 225쪽

예제 (B) / 1. (A)　　　2. (A)　　　3. (B)　　　4. (B)　　　5. (A)

[예제 3] 패러프레이징

While similar companies are dropping prices to stay competitive, Underwood Electronics continues to thrive. Their loyal customer base is willing to pay more for the quality of Underwood's products, keeping the company's profits steadily on the rise.

동종 업계 회사들이 경쟁력을 유지하기 위해 가격을 내리고 있는 상황에서, 언더우드 전자는 계속 번창하고 있다. 그들의 충성 고객층이 언더우드의 제품들이 가진 품질에 대해 돈을 더 지불할 용의가 있어서, 그 회사의 수익은 꾸준히 상승 중이다.

(A) Some of the customers do not want to pay more for Underwood Electronics products.

(B) Underwood Electronics is able to maintain sales without cutting prices.

해석 | (A) 일부 고객들이 언더우드 전자의 제품들에 돈을 더 지불하고 싶어 하지 않는다.

(B) 언더우드 전자는 가격을 내리지 않고 매출 유지가 가능하다.

해설 | 경쟁사들이 가격을 내리고 있지만 언더우드 전자는 계속 번창한다고 했으므로 가격 변동 없이 매출을 유지하고 있음을 알 수 있다. 따라서 정답은 (B). 지문의 continues to thrive가 정답에서 유의어인 maintain sales로 바뀌어 표현되었다.

1.

Yealy Bakery is opening its doors on July 5! To celebrate, we will have various special deals for our grand opening! Come and check out our various breads, cakes, pastries, and more. For our first day, we will be giving out free samples of our delicious chocolate cake.

일리 베이커리가 7월 5일에 문을 엽니다! 축하하기 위해, 저희의 개업을 위한 다양한 특가 상품들이 있습니다! 오셔서 저희의 다양한 빵, 케이크, 페이스트리와 그 밖의 상품을 확인해 보세요. 저희의 첫째 날에는, 맛있는 초콜릿 케이크의 무료 샘플을 나눠드릴 것입니다.

(A) A new business is having an event.

(B) Chocolate cakes are on sale.

해석 | (A) 새로운 업체가 행사를 준비하고 있다.

(B) 초콜릿 케이크가 할인 중이다.

해설 | 새로 개업한 베이커리에서 개업 첫 날에 무료 샘플을 준다고 했으므로 (A)가 정답이다. 지문의 For our first day, we will be giving out free samples가 정답에서 함축 표현인 A new business is having an event로 바뀌어 표현되었다.

2.

In 2003, Amelia Harrison met chef Paige Jarvis at a food festival in Tucson, Arizona. This fortunate encounter would eventually result in the creation of the largest barbecue sauce producers in Brazos County.

2003년, 아멜리아 해리슨 씨는 요리사인 페이지 자비스 씨를 아리조나 주 투손의 음식 축제에서 만났다. 이 운 좋은 만남으로 결국 브라조스 카운티의 가장 큰 바비큐 소스 제조사를 설립하게 되었다.

(A) After meeting, they started a company together.
(B) They won first place at a contest.

해석 | (A) 만남 후, 그들은 같이 사업을 시작했다.
(B) 그들은 경연 대회에서 우승했다.

해설 | 운 좋은 만남으로 가장 큰 바비큐 소스 제조사를 설립했다고 했으므로 (A)가 정답. 지문의 encounter가 정답에서 유의어인 meeting으로, 지문의 the creation of ~ producers가 정답에서 유의어 started a company로 패러프레이징되었다.

3.

Your interview is scheduled for Thursday, December 8 at 1 P.M. at the Hamelin headquarters. You should arrive at the office at least fifteen minutes early. Please bring four hard copies of your résumé. The interview should last approximately thirty minutes.

(A) An interview needs to be rescheduled.
(B) A candidate should print out a document.

귀하의 면접은 12월 8일 목요일 오후 1시에 하멜린 본사로 일정이 잡혔습니다. 적어도 15분 전에 사무실에 도착하셔야 합니다. 이력서 4부를 출력해서 가져오세요. 면접은 약 30분간 진행될 것입니다.

해석 | (A) 면접 일정을 다시 잡아야 한다.
(B) 후보자는 서류를 출력해야 한다.

해설 | 이력서 4부를 출력해서 가져오라고 했으므로 정답은 (B). 지문의 bring four hard copies of your résumé가 정답에서 상위 개념인 print out a document로 바꿔 표현되었다.

4.

Abstract painter Douglas Flavio is grabbing the attention of art critics all around the city. Flavio, who was unknown just a year ago, has now been featured in several art magazines. Most impressive of all, one of his works will be exhibited at Millwood City's art museum.

(A) A famous critic is opening a new art gallery.
(B) A contemporary artist is rising to fame.

추상파 화가 더글라스 플라비오 씨는 도시 전체의 예술 비평가들의 이목을 끌고 있다. 단 1년 전에는 알려지지 않았던 플라비오 씨는 현재 몇몇 예술 잡지들에 게재되고 있다. 가장 인상 깊게도, 그의 작품 중 하나가 밀우드 시의 미술관에 전시될 것이다.

해석 | (A) 유명한 비평가가 새로운 미술관을 열었다.
(B) 현대 예술가가 명성을 날리고 있다.

해설 | 추상파 화가가 비평가들의 이목을 끌고 예술 잡지, 미술관에서도 집중하는 것으로 보아 명성을 날리고 있다는 (B)가 정답. 지문의 Abstract painter가 정답에서 상위 개념인 A contemporary artist로, 지문의 is grabbing the attention of art critics가 정답에서 함축 표현인 is rising to fame으로 바꿔 표현되었다.

5.

This is to confirm your reservation at Cloud Hotel from March 3 to March 6. You will be staying in a non-smoking twin room. A maximum of two guests are allowed in the room. And breakfast is included for all three mornings for two people.

(A) A booking has successfully been completed.
(B) A reservation was changed to add another person.

이것은 귀하의 3월 3일부터 3월 6일까지 클라우드 호텔에서의 예약을 확인하기 위한 것입니다. 귀하께서는 금연 트윈 침대 객실에 머무르실 것입니다. 객실은 최대 2인까지 허용됩니다. 또한 3일 동안 2인 조식이 포함되어 있습니다.

해석 | (A) 예약이 성공적으로 완료되었다.
(B) 예약은 다른 사람을 추가하기 위해 변경되었다.

해설 | 지문의 첫 줄에 나와있는 글의 목적을 통해 예약이 성공적으로 완료되었음을 알 수 있으므로 정답은 (A). 지문의 your reservation이 정답에서 동의어인 A booking으로 바꾸어 표현되었고, to confirm이 has successfully been completed로 패러프레이징되었다.

FINAL TEST

교재 226쪽

1. (B)	2. (D)	3. (A)	4. (A)	5. (C)	6. (D)	7. (D)	8. (A)	9. (C)	10. (D)

11. (B)

[1-2] 문자 메시지

EDWARD CORSICA ···························· 10:30
Dennis, how is everything going? Do you have a lot left to do for the conference?

DENNIS CALDWELL ···························· 10:32
Not that much. [1] The tables are all ready, and I'm just about finished putting out the cold sandwiches. Then I'll just need to set up the beverage machines, and I'll be done.

EDWARD CORSICA ···························· 10:33
That's all you have left? Good. The presenters will be here soon.

DENNIS CALDWELL ···························· 10:34
Well, it might take a little longer than planned. There is a problem with the coffee machine. The faucet is missing.

EDWARD CORSICA ···························· 10:35
Oh? I thought it was a brand-new machine. [2] How did that happen?

DENNIS CALDWELL ···························· 10:36
Not sure. [2] I think it might have broken off when I took it out of the van. So I'm going to have to go get another one.

에드워드 코르시카 ···························· 10:30
데니스, 어떻게 되고 있어요? 그 회의를 위해 할 일이 많이 남았나요?

데니스 콜드웰 ···························· 10:32
그렇게 많진 않아요. [1] 식탁들은 모두 준비됐고, 방금 막 차가운 샌드위치 꺼내는 것을 끝냈어요. 그 다음에 음료 기계를 설치하면, 끝날 거예요.

에드워드 코르시카 ···························· 10:33
남은 일이 그게 전부인가요? 좋아요. 발표자들이 곧 이곳에 올 거예요.

데니스 콜드웰 ···························· 10:34
음, 아마 계획했던 것보다 조금 더 걸릴 것 같아요. 커피 기계에 문제가 있어요. 꼭지가 사라져서요.

에드워드 코르시카 ···························· 10:35
아? 그것은 완전히 새로운 기계라고 생각했는데요. [2] 어떻게 그런 일이 일어났죠?

데니스 콜드웰 ···························· 10:36
잘 모르겠어요. [2] 제가 화물차에서 꺼낼 때 부러졌을지도 몰라요. 그러니 제가 가서 다른 것을 가져와야 해요.

어휘 | set up 설치하다 beverage 음료 faucet (수도) 꼭지 brand-new 아주 새로운, 신품의 van 화물차, 승합차

1. What type of business does Mr. Caldwell work for?
(A) A coffee shop
(B) A catering service
(C) A restaurant
(D) A moving company

해석 | 콜드웰 씨가 근무하는 업종은?
(A) 커피숍
(B) 출장요리 업체
(C) 음식점
(D) 이삿짐 운송 회사

해설 | 특정 정보 확인 문제
단서 (1)에서 콜드웰 씨가 tables, the cold sandwiches, beverage machines를 준비하는 것이 일이라고 하는 것으로 보아 그가 출장요리 업체에서 근무하는 것을 알 수 있다. 따라서 정답은 (B).

2. At 10:36, what does Mr. Caldwell mean when he writes, "Not sure"?

(A) He can not predict when he will be finished.

(B) He does not have enough food for the event.

(C) He has not thought of a way to fix the problem.

(D) He does not know exactly why the device is damaged.

해석 | 10시 36분에, 콜드웰 씨가 "잘 모르겠어요"라고 한 것에서 그가 의도한 것은?

(A) 언제 끝날지 예상할 수 없다.

(B) 행사 음식이 충분하지 않다.

(C) 문제를 해결한 방법을 생각하지 못했다.

(D) 왜 그 기계가 손상됐는지 정확히 모른다.

해설 | 의도 파악 문제

단서 (2)에 따르면, 코르시카 씨가 왜 꼭지가 사라졌는지 묻는 질문에 대한 응답으로 그 뒤에 콜드웰 씨가 화물차에서 꺼낼 때 부러졌을 것 같다는 추측을 하고 있는 것으로 보아 정확히 커피 기계가 손상된 이유는 모른다는 것을 알 수 있다. 따라서 정답은 (D).

[3-6] 온라인 채팅

Jeremy Finning [15:03]

Bella, can you check the employee description page? ³ It used to have the biographies of all of our personal trainers, and it had pictures of each. Now, everything is gone.

Bella Stanley [15:05]

Oh, they're all blank! Only the list of names is left. When did you notice this?

Jeremy Finning [15:06]

Just now. I got an e-mail from a customer saying she couldn't find any information about our trainers.

Bella Stanley [15:07]

Eric, the employee profiles page seems to have a problem. Can you take a look? ⁴ We updated the Web site earlier today, so there must have been an error in the change.

Eric Gafaga [15:09]

I'm checking now. That's weird. I don't think we've ever had this happen before. I know how to fix it, though.

Bella Stanley [15:10]

⁵ Are we going to have to rewrite the biographies and upload all of the pictures again?

Eric Gafaga [15:11]

That won't be necessary. ⁵ I have the older version of the Web site saved. In the meantime, Jeremy, ⁶ please e-mail the customer with a picture of our brochure. It has an introduction of all of our personal trainers.

[|] [SEND]

제레미 피닝 [15:03]

벨라, 직원 상세 페이지를 확인해 줄 수 있어요? ³ 우리 개인 트레이너 모두의 약력과 각자의 사진들이 있었어요. 그런데 지금은 모두 사라졌네요.

벨라 스탠리 [15:05]

아, 모두 비어있네요! 이름 목록만 남았어요. 언제 이것을 아셨나요?

제레미 피닝 [15:06]

바로 지금이요. 한 고객으로부터 우리 트레이너들에 대한 어떠한 정보도 찾을 수 없다는 이메일을 받았어요.

벨라 스탠리 [15:07]

에릭, 직원 정보 페이지에 문제가 있는 것 같아요. 봐주실 수 있나요? ⁴ 우리가 오늘 일찍 웹사이트를 갱신해서, 그 변경에서 오류가 있었던 것 같아요.

에릭 가파가 [15:09]

지금 확인하고 있어요. 이상하네요. 이전에는 이런 일이 있었던 적이 없는 것 같아요. 그렇지만 제가 고치는 방법을 알아요.

벨라 스탠리 [15:10]

⁵ 우리가 그 약력들을 다시 작성하고 모든 사진들을 다시 업로드해야 하나요?

에릭 가파가 [15:11]

그럴 필요는 없어요. ⁵ 제가 웹사이트의 이전 버전을 저장해 뒀어요. 그 사이에, 제레미, ⁶ 그 고객에게 우리 책자의 사진을 이메일로 보내주세요. 그곳에 우리의 모든 개인 트레이너들의 소개가 있어요.

[|] [보내기]

DAY 24

어휘 | description 서술 biography 약력, 전기 blank 빈 profile 인물 소개 take a look (한 번) 보다 error 오류 weird 이상한, 기묘한 fix 고치다 introduction 소개

111

3. What is mainly being discussed?

(A) **Missing information on a Web site**
(B) Malfunctioning computers
(C) Failed picture uploads
(D) Incorrect names on profiles

해석 | 주로 논의되고 있는 것은?
(A) 웹사이트의 누락된 정보
(B) 오작동하는 컴퓨터
(C) 실패한 사진 업로드
(D) 인물 소개란의 정확하지 않은 이름

해설 | 주제, 목적 문제
단서 (3)에서 원래 있어야 할 트레이너들의 정보가 사라졌다고 말하고 있고, 그 뒤로 이 문제의 원인에 대해 논의하고 있다. 따라서 정답은 (A). 지문의 the biographies와 pictures가 정답에서 상위 개념인 information으로 바꾸어 표현되었다.

4. What is indicated about the Web site?

(A) **It was recently changed.**
(B) It received positive reviews.
(C) It includes several typos.
(D) It has an outdated design.

해석 | 웹사이트에 대해 시사된 것은?
(A) 최근에 변경되었다.
(B) 긍정적인 후기를 받았다.
(C) 몇몇 오자가 포함되어있다.
(D) 디자인이 구식이다.

해설 | Not/True 문제
단서 (4)에서 오늘 일찍 웹사이트를 갱신했다고 말하는 것으로 보아 최근에 웹사이트가 변경되었음을 알 수 있다. 따라서 정답은 (A). 지문의 updated가 정답에서 유의어인 recently changed로 패러프레이징되었다.

5. At 15:11, what does Mr. Gafaga mean when he writes, "That won't be necessary"?

(A) The biographies do not have to be included on the page.
(B) The Web site does not require an update.
(C) **The profiles do not need to be recreated.**
(D) The employee description page is not accessible by customers.

해석 | 15시 11분에, 가파가 씨가 "그럴 필요는 없어요"라고 한 것에서 그가 의도한 것은?
(A) 약력들은 그 페이지에 포함될 필요가 없다.
(B) 웹사이트는 갱신을 요구하지 않는다.
(C) 인물 소개란을 다시 만들 필요가 없다.
(D) 직원 상세 페이지는 고객들이 접근할 수 없다.

해설 | 의도 파악 문제
단서 (5)에서 약력을 다시 작성하고 사진을 다시 업로드해야 하는지 스탠리 씨가 질문을 하고 있고 뒤에 가파가 씨가 웹사이트의 이전 버전을 저장해 뒀다고 대답하는 것을 통해 인물 소개란을 다시 만들 필요는 없다는 것을 알 수 있다. 따라서 정답은 (C).

6. What will Mr. Finning most likely do next?

(A) Update the Web site
(B) Write new biographies
(C) Upload a previous page
(D) **Send a file to a customer**

해석 | 피닝 씨가 다음에 할 것 같은 일은?
(A) 웹사이트 갱신하기
(B) 새로운 약력 작성하기
(C) 이전 페이지 업로드하기
(D) 고객에게 파일 보내기

해설 | 다음에 할 일을 묻는 문제
단서 (6)에서 가파가 씨가 피닝 씨에게 이메일로 고객에게 책자의 사진을 보낼 것을 요청하고 있으므로 정답은 (D). 지문의 a picture of our brochure가 정답에서 상위 개념인 a file로 패러프레이징되었다.

[7-11] 기사, 정보문, 문자 메시지

[7] Smoker's Expands Operations

By Sean Parsons

In 2003, Amelia Harrison met chef Paige Jarvis at a food festival in Tucson, Arizona. This fortunate encounter would eventually result in the creation of the largest barbecue sauce producer in Brazos County.

[7] 스모커스의 사업 확장

숀 파슨스 작성

2003년, 아멜리아 해리슨 씨는 요리사인 페이지 자비스 씨를 아리조나 주 투손의 음식 축제에서 만났다. 이 운 좋은 만남으로 결국 브라조스 카운티의 가장 큰 바비큐 소스 제조사를 설립하게 되었다.

Originally, Harrison was not involved in the recipe-making business at all. She was operating a small grill shop in New Orleans. However, she has always been a fan of quality barbecue, so she joined forces with Jarvis to create one of the country's favorite bottled sauces: Smoker's.

In 2007, Harrison and Jarvis began hosting cooking contests, which have become the most popular attraction of barbecue festivals across the country. This [8] boosted Smoker's success dramatically.

[9-1] They will be the hosts of the contest for the 25th Annual Mid-American Barbecue Convention, too.

[7] Today, Smoker's is moving to a bigger 3,600-square-foot location at 5831 San Felipe St. "We are absolutely thrilled about the move," Amelia Harrison said. "We hoped that this would happen eventually, but never dreamed it would come about so quickly."

원래, 해리슨 씨는 조리법 제조 사업에 전혀 연관되어있지 않았다. 그녀는 뉴올리언스에서 작은 그릴 식당을 운영하고 있었다. 그러나, 그녀는 항상 품질 좋은 바비큐의 팬이었고, 그래서 자비스 씨와 함께 힘을 모아 국민들이 좋아하는 병에 든 소스 중 하나인 스모커스를 만들었다.

2007년, 해리슨 씨와 자비스 씨는 요리 경연 대회를 주최하기 시작했는데, 이 대회들은 전국 곳곳에서 열리는 바비큐 축제의 가장 유명한 관광지가 되었다. 이것은 스모커스의 성공을 극적으로 [8] 신장시켰다. [9-1] 그들은 제25회 연례 미국 중부 바비큐 대회를 위한 경연의 주최자도 될 것이다.

[7] 오늘, 스모커스는 산 펠리페 가 5831번지에 위치한 더 큰 3,600제곱미터의 장소로 이전할 것이다. "우리는 이 이전에 대해 굉장히 흥분해 있습니다,"라고 아멜리아 해리슨 씨가 말했다. "우리는 결국 이것이 이루어지길 바랐지만, 이렇게 빨리 이루어 질 것이라고 꿈에도 생각지 않았습니다."

어휘 | fortunate 운 좋은, 다행한 encounter 만남 eventually 결국, 마침내 creation 창조 involve 관련시키다, 연루시키다 operate 운영하다
bottled 병에 든, 병에 담은 attraction 명소 dramatically 극적으로 absolutely 굉장히, 전적으로 thrilled 아주 흥분한, 황홀해 하는

25TH ANNUAL MID-AMERICAN BARBECUE CONVENTION
Owensboro, Kentucky
Saturday, July 10–Sunday, July 11

제25회 연례 미국 중부 바비큐 대회
오인즈버러, 켄터키 주
7월 10일 토요일 – 7월 11일 일요일

The Annual Mid-American Barbecue Convention has returned! For two days, barbecue lovers can wander around our fair grounds, [10] trying free samples of various foods and drinks served at each booth. On Saturday, [11-3] a private convention will be held indoors for business owners and professionals to learn about various aspects of the barbecue industry while patrons enjoy the fair outside. On Sunday, everyone will be entertained by various events and performances on the main stage outside, including the highly anticipated cook-off competition.

연례 미국 중부 바비큐 대회가 돌아왔습니다! 이틀간, 바비큐를 사랑하는 분들께서는 [10] 각각의 부스에서 제공하는 다양한 무료 음식과 음료를 즐기시면서 우리의 장터를 돌아다니실 수 있습니다. 토요일에는, 고객들이 야외에서 대회를 즐기는 동안 [11-3] 사업주와 전문가들이 바비큐 산업의 다양한 측면들을 배우도록 비공개 대회가 실내에서 열릴 것입니다. 일요일에는, 모두가 야외 중앙 무대에서 몹시 기대되는 요리 경연 대회를 포함하여 다양한 행사와 공연들을 즐기실 것입니다.

TIME	SATURDAY	SUNDAY
10:00 A.M.–11:00 A.M.	[11-2] *From Chef to Sauce Maker*, Paige Jarvis	Pie-Eating Contest
11:00 A.M.–12:00 P.M.	*Branding your Product*, Jake Dyer	Blue Steel Band
12:00 P.M.–2:00 P.M.	Free time for lunch and exploring the festival	Various Children's Games

시간	토요일	일요일
오전 10:00 – 오전 11:00	[11-2] '요리사에서 소스 제조자까지', 페이지 자비스	파이 먹기 대회
오전 11:00 – 오후 12:00	'제품 브랜딩하기', 제이크 다이어	블루 스틸 밴드
오후 12:00 – 오후 2:00	점심과 축제를 돌아보기 위한 자유 시간	다양한 어린이 게임
오후 2:00 – 오후 3:00	'바비큐 사업', 마이클 플레밍	[9-2] 뒷마당 요리 경연 대회
오후 3:00 – 오후 4:00	'장비의 모든 것' 애슐리 제임스	소스 맛 눈가리개 검사

DAY 24

113

2:00 P.M.–3:00 P.M.	*The Business of barbecue*, Michael Flemming	[9-2] Backyard Cook-Off Competition
3:00 P.M.–4:00 P.M.	*It's All in the Equipment*, Ashley James	Blindfolded Sauce Taste Test

어휘 | wander 돌아다니다, 헤매다　private 비공개의, 사적인　business owner 사업주, 경영주　aspect 측면, 양상　industry 산업　patron 고객　entertain 즐겁게 해주다　anticipate 기대하다, 고대하다　cook-off 요리 경연 대회

From: Joel Price
Wednesday, July 14 10:11 A.M.

Hello, Ms. Paige. [11-1] I really enjoyed your presentation at the convention last weekend. Your innovative ideas are truly inspiring. In fact, you have motivated me to design completely new modern menus for my customers. I look forward to seeing you again.

보내는 사람: 조엘 프라이스
7월 14일 수요일 오전 10시 11분

안녕하세요, 페이지 씨. **[11-1] 지난주 대회에서 귀하의 발표가 정말 즐거웠습니다.** 당신의 획기적인 생각들은 진심으로 고무적이었습니다. 사실, 당신은 제 손님들을 위한 완전히 새로운 현대적인 메뉴들을 만들도록 동기를 부여해 주셨습니다. 당신을 다시 뵙기를 고대합니다.

어휘 | enjoy 즐거워하다, 즐기다　innovative 획기적인　truly 진심으로　inspiring 고무하는, 자극하는　motivate 동기를 부여하다, 이유가 되다　look forward to *doing* ~하기를 고대하다

7. Why was the article written?
(A) To report a merger between two companies
(B) To announce the opening of a restaurant
(C) To promote a new line of barbecue products
(D) To describe the growth of a business

해석 | 기사가 작성된 이유는?
(A) 두 회사의 합병을 알리기 위해
(B) 음식점의 개업을 알리기 위해
(C) 바비큐 제품의 새로운 제품군을 홍보하기 위해
(D) 사업의 성장을 서술하기 위해

해설 | **주제, 목적 문제**
'스모커스의 사업 확장'이라는 기사의 제목에 단서가 그대로 나와있다. 지문의 마지막 부분에도 오늘 더 큰 장소로 이전한다고 했으므로, 사업의 성장에 대해 기술하고 있음을 알 수 있다. 따라서 정답은 (D). 이처럼 기사의 제목에 글의 목적이 그대로 명시된 경우가 많으므로 반드시 제목을 확인하자.

8. In the article, the word "boosted" in paragraph 2, line 5, is closest in meaning to
(A) increased
(B) supported
(C) sustained
(D) promoted

해석 | 기사에서, 둘째 단락 다섯 번째 줄의 "boosted"와 의미상 가장 가까운 단어는?
(A) 증가하다
(B) 지지하다
(C) 지속시키다
(D) 촉진하다

해설 | **동의어 문제**
문맥상 '음식 경연 대회를 주최한 것이 이들의 성공을 극적으로 신장시켰다'는 의미이므로 이와 비슷한 의미인 어휘를 고른다. 따라서 정답은 (A) increased.

9. Which event is Smoker's most likely to host?

(A) Pie-Eating Contest

(B) Children's Games

(C) Backyard Cook-Off Competition

(D) Blindfolded Sauce Taste Test

해석 | 스모커스가 주최할 것 같은 행사는?

(A) 파이 먹기 대회

(B) 어린이 게임

(C) 뒷마당 요리 경연 대회

(D) 소스 맛 눈가리개 검사

해설 | **두 지문 연계 문제**

기사와 정보문 두 개의 지문을 함께 봐야 하는 연계 문제. 기사의 단서 (9-1)에서 스모커스가 '제25회 연례 미국 중부 바비큐 대회를 위한 요리 경연의 주최자도 될 것이다'라고 했으므로 정보문의 일정표를 확인해 본다. 단서 (9-2)에서 요리 경연 대회 명칭이 명시되어 있으므로 정답은 (C) Backyard Cook-Off Competition.

10. What is indicated about the convention?

(A) Lectures are open to the general public.

(B) Smoker's will set up a taste-testing booth.

(C) Speakers will give presentations outside.

(D) Food will be available for free.

해석 | 대회에 대해 시사된 것은?

(A) 강연들은 일반 대중에 공개된다.

(B) 스모커스는 시식할 수 있는 부스를 설치할 것이다.

(C) 연사들은 야외에서 발표할 것이다.

(D) 음식은 무료로 이용 가능하다.

해설 | **Not / True 문제**

대회 정보에 대한 것은 정보문에 나와있다. 단서 (10)에서 무료로 음식을 제공한다고 명시되어 있으므로 정답은 (D). 토요일 강연은 사업주와 전문가들에게만 공개된다고 했으므로 (A)는 오답. (B)는 스모커스의 부스에 대해 언급된 것이 없으므로 오답이며 (C)는 비공개 대회가 실내에서 열린다고 했으므로 오답이다.

11. What can be inferred about Mr. Price?

(A) He applied for a job with Smoker's.

(B) He is a business owner.

(C) He organized a competition at the event.

(D) He helped Ms. Jarvis to grow her company.

해석 | 프라이스 씨에 대해 추론할 수 있는 것은?

(A) 스모커스 일자리에 지원했다.

(B) 사업주이다.

(C) 행사에서 경연을 조직했다.

(D) 자비스 씨의 회사가 성장하도록 도왔다.

해설 | **두 지문 연계 문제**

정보문과 문자 메시지 두 개의 지문을 함께 봐야 하는 연계 문제. 문자 메시지의 단서 (11-1)에서 프라이스 씨는 자비스 씨의 강연을 봤다고 했으므로 정보문에서 자비스 씨의 강연 일정을 확인한다. 단서 (11-2)에서 자비스 씨의 강연은 토요일에 있었음을 알 수 있는데, 단서 (11-3)에서 토요일에는 사업주와 전문가 상대로만 비공개 대회가 열릴 것이라고 했으므로 정답은 (B).

예제 해석

교재 233쪽

[예제 1] 문장 위치 찾기 문제 ①

Economic Recession Predicted

Despite attempts by the Reserve Bank to battle persistent inflationary pressure, market conditions continue to worsen. – [1] – With unemployment and inflation rates continuously increasing, leading economists predict the country will fall into a recession before the end of the year. – [2] – Mark Whimsey, a senior economist with the Institute for Economic Stability, says there has been a steady decline in the domestic economy. – [3] – He points to the price of oil, which surged last week to a record high of $1.50 a gallon, and the continuing slump in the real estate market, as major contributors to the downturn. – [4] –

경기 침체가 예측된다

연방 준비 은행에서 지속적인 물가 상승 압력에 대항하고자 노력했음에도 불구하고, 시장 상황은 계속해서 악화되고 있다. – [1] – 실업률과 물가 상승률이 계속 상승하고 있는 가운데, 주요 경제학자들은 연말 전에 국가가 경제 불황 국면에 접어들 것이라고 예측하고 있다. – [2] –

경제안정연구소 수석 경제학자 마크 윔지는 국내 경제가 계속 쇠퇴해 왔다고 말한다. – [3] – 그는 지난주에 갤런 당 1달러 50센트까지 치솟은 유가와 부동산 시장의 계속되는 경기 둔화가 이러한 경기 침체의 주요 요인이라고 지적한다. – [4] –

어휘 | recession 경기 침체 **predict** 예측하다 **persistent** 지속적인, 끈질긴 **inflationary** 물가 상승의 **worsen** (상황 등이) 악화되다 **inflation rate** 물가 상승률 **surge** 치솟다 **slump** 경기 둔화 **contributor to** ~의 요인 **downturn** 경기 침체

In which of the positions marked [1], [2], [3], and [4] does the following sentence best belong?

"He says this is due to the high cost of fuel and housing."

(A) [1]
(B) [2]
(C) [3]
(D) [4]

해석 | [1], [2], [3], [4]번으로 표시된 위치들 중 다음 문장이 들어가기에 가장 적절한 곳은?

"그는 이것이 높은 연료비와 주거비 때문이라고 말한다."

(A) [1]
(B) [2]
(C) [3]
(D) [4]

[예제 2] 문장 위치 찾기 문제 ②

To: Bill Underwood <underwoodbill@lkc.com>
From: Linda Chase <chaselinda@nseducore.com>
Subject: Request for data

Good morning, Bill. I want you to know that we're all excited that your company will be building our new corporate headquarters.
– [1] – He had several questions about the distribution of the budget designated for architectural design.
– [2] – I trust you can supply us with this data, since you have already planned out most of your expenditures. – [3] – I'd like this information, as well as an outline of your budget, as soon as possible.

받는 사람: 빌 언더우드 〈underwoodbill@lkc.com〉
보내는 사람: 린다 체이스 〈chaselinda@nseducore.com〉
제목: 자료 요청

안녕하세요, 빌 씨. 저희 본사의 신사옥 건설을 귀사에서 진행하게 되어 모두 기뻐하고 있음을 알려드리고 싶습니다.

– [1] – 그는 건축 설계에 지정된 예산 분배에 대해 몇 가지 질문이 있었습니다. – [2] – 귀사에서 이미 대부분의 지출 내역에 대한 계획을 세우셨으니 이 정보를 저희에게 주실 수 있으리라 믿습니다. – [3] – 이 정보와 함께 귀사의 예산 개요를 가급적 빨리 받았으면 합니다.

– [4] – Please e-mail this to me and my supervisor, Chris Morrell, at your earliest convenience.

Thank you for your time.
Linda

– [4] – 이를 저와 제 상관인 크리스 모렐 씨에게 형편 닿는 대로 빠른 시일 내에 이메일로 보내주십시오.

시간을 내주셔서 감사합니다.
린다 드림

어휘 | headquarters 본사 distribution 분배 designate 지정하다 expenditure 지출 outline 개요 as soon as possible 가능한 빨리

In which of the positions marked [1], [2], [3], and [4] does the following sentence best belong?

"After the decision was made, I met with one of my colleagues in our accounting department."

(A) [1]
(B) [2]
(C) [3]
(D) [4]

해석 | [1], [2], [3], [4]번으로 표시된 위치들 중 다음 문장이 들어가기에 가장 적절한 곳은?

"결정이 난 뒤에, 저는 저희 회사의 회계 부서에서 근무하는 동료를 만났습니다."

(A) [1]
(B) [2]
(C) [3]
(D) [4]

패러프레이징

교재 235쪽

예제 (A) / 1. (A) 2. (B) 3. (B) 4. (A) 5. (A)

[예제 3] 패러프레이징

For those of you who are attending the company picnic this Friday, please meet in front of the building at 4 P.M. We have decided to rent a shuttle bus so that we can all go together.

이번 주 금요일에 회사 야유회에 참석하시는 분들은, 오후 4시에 건물 앞으로 모여 주십시오. 우리는 모두 함께 갈 수 있도록 셔틀버스를 대여하기로 결정했습니다.

How will employees get to the picnic site?
(A) By riding a bus
(B) By using a car

해석 | 직원들이 야유회 장소에 갈 방법은?
(A) 버스를 타고
(B) 자동차를 이용해서

해설 | 셔틀버스를 대여해서 함께 간다고 했으므로 정답은 (A). 지문의 rent a shuttle bus가 정답에서 riding a bus로 바꾸어 표현되었다.

1.

Starting on September 16, employees will no longer need prior approval from a manager to rent out video equipment from the storage room. Employees who require cameras or other devices may thus go directly to the storage keeper to make their requests.

9월 16일부터, 직원들은 더 이상 창고의 비디오 장비를 대여하기 위해 관리자로부터 사전 승인을 받을 필요가 없을 것이다. 카메라나 다른 장비들이 필요한 직원들은 따라서 곧바로 창고 관리자에게 가서 요청하면 된다.

What is the purpose of the notice?
(A) To inform of a change in policy
(B) To report a missing item

해석 | 공지의 목적은?
(A) 정책의 변경을 알리기 위해
(B) 분실물에 대해 알리기 위해

해설 | 직원들에게 비디오 장비 대여 신청 방법이 변경됐음을 알리고 있으므로 정답은 (A). 지문에서 will no longer need prior approval이 함축 표현을 이용해 a change in policy로 바꾸어 표현되었다.

DAY 25

2.

Train 256 has experienced some mechanical difficulties. As a result, it left Clearsprings ten minutes late, at 5:35 P.M. It is thus now scheduled to arrive at Graston ten minutes late, at 7:21 P.M. instead of 7:11 P.M. Thank you for your patience.

What caused the delay in Train 256?
(A) Mechanics strikes
(B) Technical problems

256 기차는 몇 가지 기계적인 어려움을 겪었습니다. 그 결과, 클리어 스프링스를 10분 늦은 오후 5시 35분에 떠났습니다. 그러하여 현재 그라스톤에 저녁 7시 11분 대신 10분 늦은 저녁 7시 21분에 도착할 예정입니다. 기다려주셔서 감사합니다.

해석 | 256 기차 지연의 원인은?
(A) 기술자들의 파업
(B) 기술상의 문제

해설 | 기계적인 어려움으로 기차의 출발 및 도착 시간이 변경되었음을 알리고 있으므로 정답은 (B). 지문에서 some mechanical difficulties가 유의어 Technical problems로 패러프레이징되었다.

3.

Neurologist Meredith Bowser has dedicated her career to studying the effects of Alzheimer's on memory. Yesterday, Dr. Bowser announced the creation of a foundation to support Alzheimer research. On August 13, the foundation will hold its first fundraiser.

What will happen on August 13?
(A) A new organization will be launched.
(B) An event will take place.

신경학자 메러디스 보우저 씨는 기억에 미치는 알츠하이머의 영향을 연구하는 일에 헌신해왔다. 어제, 보우저 박사는 알츠하이머 연구를 후원하는 재단의 창립을 발표했다. 8월 13일, 재단은 첫 번째 모금 행사를 열 것이다.

해석 | 8월 13일에 일어날 일은?
(A) 새로운 조직이 창설될 것이다.
(B) 행사가 열릴 것이다.

해설 | 8월 13일에 모금 행사를 연다고 했으므로 정답은 (B). 지문의 fundraiser가 정답에서 상위 개념인 An event로 바꾸어 표현되었다.

4.

A new restaurant will be located in the city's West End, miles away from Canneli's original downtown hotspot. The opening date has not been officially set, but Canneli estimates it will be in service before October 1. You can visit the Web site www.agorarestaurant.com for up-to-date information.

What is expected to happen by October 1?
(A) A new restaurant will open for business.
(B) Canneli will relocate his first eatery.

새로운 식당은 도시의 서쪽 끝에 위치하게 되는데, 까넬리 씨의 기존 시내 명소로부터 수 마일 떨어진 곳이다. 개업일은 공식적으로 정해지지 않았지만, 까넬리 씨는 10월 1일 전에 영업을 시작할 것이라고 예상한다. 최신 정보를 보려면 웹사이트 www.agorarestaurant.com을 방문하면 된다.

해석 | 10월 1일까지 일어날 것으로 예상되는 일은?
(A) 새로운 식당이 영업 중일 것이다.
(B) 까넬리 씨가 자신의 첫 번째 식당의 위치를 옮길 것이다.

해설 | 새로운 식당이 10월 1일 전에 영업을 시작할 것으로 예상한다고 했으므로 정답은 (A). 지문의 be in service가 유의어를 이용하여 open for business로 패러프레이징되었다.

5.

We have received your complaint about the defective flashlight you purchased yesterday. We are very sorry about the inconvenience. To get a full refund, please mail the product back along with its receipt to any Night Light retailer.

How can the customer get a refund?
(A) By sending the item to any store branch
(B) By attaching the receipt to an e-mail

어제 구매하신 결함 있는 손전등에 대한 귀하의 불만을 받았습니다. 불편함을 드려 대단히 죄송합니다. 전액 환불을 받기 위해서, 그 제품을 영수증과 함께 아무 나이트 라이트 판매점에 우편으로 다시 보내주십시오.

해석 | 고객이 환불을 받을 수 있는 방법은?
(A) 제품을 어떤 지점에라도 보내서
(B) 이메일에 영수증을 첨부해서

해설 | 결함 있는 제품을 환불받기 위해 제품을 아무 판매점에 보내라고 하였으므로 정답은 (A). 지문의 mail the product back이 유의어를 이용하여 sending the item으로 바꾸어 표현되었다.

FINAL TEST

1. (C)　　2. (A)　　3. (B)　　4. (B)　　5. (D)　　6. (A)　　7. (B)

[1-3] 편지

Anita Brancato
823 Remarque
Quebec City, Quebec

Dear Ms. Brancato,

I work with New England Express Bus Carriers, a full-service express transportation provider operating in the northeastern United States and southeastern Canada. [1] I am contacting you because you are a frequent traveler in the region, and I believe you will enjoy our services. – [1] –
For instance, [3] you can spend your next journey from Montreal to Boston in one of our ultra-comfortable buses. – [2] – Round-trips start at $34.50, which is less than a third of the cost of the average plane ticket, [2] without all the check-in hassles and flight delays. – [3] – And with today's high gas prices, why take your car? Leave the driving to us! – [4] –
So for your next trip, contact New England Express Bus Carriers and let us show you what we can do!

Fred Eldridge, District Manager
New England Express Bus Carriers

아니타 브란카토
르마르크 823번지
퀘백 시, 퀘백 주

브란카토 씨께,

저는 미국 북동부와 캐나다 남동부에서 운영되고 있는 종합 서비스 고속 수송 업체인 뉴 잉글랜드 고속버스 사에서 근무하고 있습니다. [1] 귀하께서 이 지역 내에서 자주 여행하시기 때문에 연락을 드리게 되었는데, 귀하께서는 저희의 서비스에 만족하시리라 믿습니다. – [1] –

예를 들어, [3] 귀하께서는 몬트리올에서 보스턴까지의 다음 여행을 저희 회사의 최고로 안락한 버스 중 하나에서 보내실 수 있습니다. – [2] – 왕복 여행은 [2] 탑승 수속의 번거로움이나 비행편의 지연 없이 보통 비행기표 값의 1/3보다 낮은 가격인 34달러 50센트부터 시작됩니다. – [3] – 그리고 오늘날의 높은 연료비를 고려할 때 굳이 차를 운전해서 갈 이유가 있을까요? 운전은 저희에게 맡겨주십시오! – [4] –

그러므로 귀하의 다음 여행에서는, 뉴 잉글랜드 고속버스 사에 연락하셔서 귀하께 저희 서비스를 보여드릴 기회를 주시기 바랍니다!

뉴 잉글랜드 고속버스 사
지점장, 프레드 엘드리지 드림

어휘 | transportation 수송, 교통편　operate (사업 등을) 운영하다　frequent 자주 ~하는, 빈번한　for instance 예를 들어　hassle 번거로움

1. What is the purpose of this letter?
(A) To introduce a new driver
(B) To describe a vacation
(C) To advertise a company's services
(D) To announce an ongoing sale

해석 | 이 편지의 목적은?
(A) 새로운 운전 기사를 소개하기 위해
(B) 휴가를 설명하기 위해
(C) 회사의 서비스를 광고하기 위해
(D) 진행 중인 할인을 알리기 위해

해설 | 주제, 목적 문제
단서 (1)에서 I am contacting you because 이하에 편지의 목적이 나와있음을 알 수 있다. 지역 내에서 자주 여행을 다니는 고객에게 회사에서 제공하는 서비스를 알려주고 있으므로 정답은 (C). 이처럼 편지의 목적은 대부분 앞부분에 명시되어 있으므로 주의하여 살펴보자.

2. According to the letter, why is bus travel better than air travel?
(A) Airline schedules are not reliable.
(B) Bus travel is less dangerous.
(C) Airplane seats are not comfortable.
(D) Buses run more frequently.

해석 | 편지에 따르면, 버스 여행이 항공 여행보다 나은 이유는?
(A) 항공 일정은 신뢰할 수 없다.
(B) 버스 여행이 덜 위험하다.
(C) 항공기 좌석이 불편하다.
(D) 버스가 더 자주 다닌다.

해설 | 특정 정보 확인 문제
단서 (2)에서 항공 여행의 불편한 점으로 탑승 수속의 번거로움과 비행편의 지연을 지적하고 있다. 따라서 정답은 (A). 지문의 all the check-in hassles and flight delays가 정답에서 함축 표현인 not reliable로 바꾸어 표현되었다.

DAY 25

119

3. In which of the positions marked [1], [2], [3], and [4] does the following sentence best belong?

"These are specially designed to provide a relaxing ride."

(A) [1]
(B) [2]
(C) [3]
(D) [4]

해석 | [1], [2], [3], [4]번으로 표시된 위치들 중 다음 문장이 들어가기에 가장 적절한 곳은?

"이것들은 안락한 탑승을 제공하기 위해 특별히 설계된 것입니다."
(A) [1]
(B) [2]
(C) [3]
(D) [4]

해설 | 문장 위치 찾기 문제
제시된 문장의 대명사 These가 가리키는 대상을 지문에서 찾아야 한다. '안락한 탑승을 제공하기 위해 특별히 설계된 것'은 단서 (3)에서 언급한 이 회사에서 제공하는 버스를 가리키므로, 정답은 (B). 지문의 our ultra-comfortable buses가 제시된 문장에서 These로 받아 표현되었다.

[4-7] 기사

George Canneli Goes for Second Success
Kate Warner

[4, 5B] Renowned chef and restaurant owner George Canneli has announced the upcoming opening of his second restaurant, Agora. Canneli, already well-known for [6] his Italian eatery Il Conto, will try his luck with a Mediterranean fusion restaurant at the end of September. – [1] –
[5A] Canneli was trained in traditional Italian cooking. However, [5C, 7] the chef wishes to move away from the limitations of a single culture's cuisine. – [2] – "Our hope is to combine flavors from across the region and create new tastes," says Andrea Ricardo, who will serve as the new establishment's head chef. [6] The restaurant will be located in the city's West End, miles away from Canneli's original downtown hotspot. – [3] – The opening date has not been officially set, but Canneli estimates it will be in service before October 1. You can visit the Web site www.agorarestaurant.com for up-to-date information. – [4] –

조지 까넬리, 두 번째 성공에 도전하다
케이트 워너

[4, 5B] 유명한 요리사이자 식당 운영자인 조지 까넬리 씨는 그의 두 번째 식당인 아고라가 곧 개업한다고 발표했다. 이미 [6] 그의 이탈리아 식당인 일 꼰또로 잘 알려진 까넬리 씨는 9월 말에 지중해식 퓨전 식당으로 그의 운을 시험해 보게 된다. – [1] –

[5A] 까넬리 씨는 전통적인 이탈리아식 요리를 배웠다. 그러나, [5C, 7] 그 요리사는 단일 문화 요리의 한계로부터 벗어나고 싶어 한다. – [2] – "우리의 바람은 지역 각지의 맛을 결합하여 새로운 맛을 창조하는 것," 이라고 새로운 식당의 주방장으로 근무하게 될 안드레아 리카도 씨는 말한다.

[6] 그 식당은 도시의 서쪽 끝에 위치하게 되는데, 까넬리 씨의 기존 시내 명소로부터 수 마일 떨어진 곳이다. – [3] – 개업일은 공식적으로 정해지지 않았지만, 까넬리 씨는 10월 1일 전에 영업을 시작할 것이라고 예상한다. 최신 정보를 보려면 웹사이트 www.agorarestaurant.com을 방문하면 된다. – [4] –

어휘 | renowned 유명한 well-known for ~로 잘 알려진 eatery 식당 try one's luck ~의 운을 시험해 보다 Mediterranean 지중해의 combine 결합하다 flavor 맛, 풍미 be officially set 공식적으로 정해지다 estimate 예상하다, 추정하다 up-to-date 최신의

4. Why was the article written?
(A) To review a local Italian restaurant
(B) To report the opening of a new restaurant
(C) To introduce a restaurant's new head chef
(D) To give instructions on making reservations

해석 | 기사가 작성된 이유는?
(A) 현지 이탈리아 식당을 평가하기 위해
(B) 새로운 식당의 개업을 알리기 위해
(C) 식당의 새 주방장을 소개하기 위해
(D) 예약하는 것에 관해 설명하기 위해

해설 | 주제, 목적 문제
기사의 첫 문장인 단서 (4)에서 조지 까넬리 씨가 두 번째 식당을 개업한다고 했으므로 정답은 (B). 글의 주제는 지문의 첫 부분을 주의 깊게 살펴보아야 한다.

5. What is NOT indicated about George Canneli?

(A) He got trained in Italian cuisine.

(B) He has a good reputation.

(C) He wants to diversify his menus.

(D) He is from the Mediterranean region.

해석 | 조지 까넬리 씨에 대해 시사되지 않은 것은?
(A) 이탈리아 요리법에 관해 교육받았다.
(B) 평판이 좋다.
(C) 메뉴를 다양하게 만들고 싶어 한다.
(D) 지중해 지역 출신이다.

해설 | **Not / True 문제**
Not/True 문제는 각 선택지와 지문 내용을 대조해서 답을 골라야 한다. 단서 (5A)에서 전통 이탈리아식 요리 교육을 받았음을 알 수 있고, 단서 (5B)에서 Renowned chef로 소개했으므로 명성이 있다는 것도 알 수 있다. 또한 단서 (5C)에서 단일 문화 요리의 한계로부터 벗어나고 싶어 한다고 했으므로 메뉴를 다양하게 만들고 싶어 한다는 것을 알 수 있다. 그러나 그의 출신 지역에 대한 언급은 없으므로 정답은 (D).

6. What can be inferred about Agora?

(A) Its location is far from II Conto.

(B) Its reservation system is not ready.

(C) Its opening event will be held in October.

(D) Its Web site has not launched yet.

해석 | 아고라에 대해 추론할 수 있는 것은?
(A) 일 꼰또에서부터 멀리 떨어져 있다.
(B) 예약 시스템이 아직 준비되지 않았다.
(C) 10월에 개업 행사가 열릴 것이다.
(D) 웹사이트가 아직 개시되지 않았다.

해설 | **추론 문제**
마지막 문단의 단서 (6)에서 '까넬리 씨의 기존 명소로부터 수 마일 떨어진 곳에 위치하게 된다'고 했고, 첫 번째 문단에서 까넬리 씨가 운영하는 식당의 이름이 '일 꼰또'라는 것을 알 수 있으므로 '아고라'는 '일 꼰또'에서부터 멀리 떨어져 있음을 유추할 수 있다. 따라서 정답은 (A).

7. In which of the positions marked [1], [2], [3], and [4] does the following sentence best belong?

"Therefore, Agora will serve dishes that come from a variety of Mediterranean countries."

(A) [1]

(B) [2]

(C) [3]

(D) [4]

해석 | [1], [2], [3], [4]번으로 표시된 위치들 중 다음 문장이 들어가기에 가장 적절한 곳은?
"그러므로 아고라는 다양한 지중해 나라들의 요리를 제공할 것이다."
(A) [1]
(B) [2]
(C) [3]
(D) [4]

해설 | **문장 위치 찾기 문제**
제시된 문장에서 결과를 나타내는 연결어 Therefore에 주목하여 이 문장의 원인을 암시하는 문장을 찾아야 한다. 단서 (7)의 '단일 문화 요리의 한계로부터 벗어나고 싶어 한다'는 문장 뒤에 '그러므로 다양한 지중해 나라들의 요리를 제공할 것이다'라는 내용의 제시된 문장이 오는 것이 자연스럽다. 또한 그 다음의 문장에서도 주방장은 '지역 각지의 맛을 결합하여 새로운 맛을 창조하는 것이 바람'이라고 했으므로 정답은 (B).

DAY 26 이메일/편지 & 메모/공지

예제 해석

교재 241쪽

[예제 1] 이메일/편지

TO: Sara Carlson <orders@oakland.com>
FROM: Gary Folsom <gfolsom@speedmail.com>
DATE: September 22
SUBJECT: Order Refund

Dear Ms. Carlson,

I recently talked with you on the phone. As discussed, I am sending you my bank account details for the refund.
This is in regards to an order I had placed for a dining room table. After paying, I had received notice that the item was out of stock. You explained that your company's policy in this case is to refund the full amount and that the process takes no longer than two days.
If you need any more information from me, you can reach me at 555-3299.
Thank you for your help in this matter.

Regards,

Gary Folsom

받는 사람: 사라 칼슨 〈orders@oakland.com〉
보내는 사람: 게리 폴섬 〈gfolsom@speedmail.com〉
날짜: 9월 22일
제목: 주문품 환불

칼슨 씨께,

저는 최근에 당신과 전화로 이야기했습니다. 논의한대로, 환불을 위해 제 은행 계좌 세부 사항을 당신에게 보냅니다.

이것은 제가 주문한 식탁에 관한 것입니다. 지불한 후에 저는 그 제품이 품절되었다는 공지를 받았습니다. 당신은 귀사의 정책상 이 경우에는 전액 환불을 해주고 환불 과정은 이틀 이상 걸리지 않는다고 설명해 주셨습니다.

제게서 추가 정보가 더 필요하시면, 555-3299번으로 연락하시면 됩니다.

이 문제에 대해 도움을 주셔서 감사합니다.

게리 폴섬 드림

어휘 | refund 환불(금); 환불하다 in regards to ~에 관해서 dining room table 식탁 notice 공지, 통지 out of stock 품절 process 과정 reach ~에게 연락하다

[예제 2] 메모/공지

MEMORANDUM

TO: Design Staff
FROM: Derek White, Director of Marketing
SUBJECT: Practice Meeting

Please be on time for tomorrow's 1 P.M. meeting to review the presentation for the Mullane account. We will practice the presentation for about an hour, so you will be free from 2 P.M. until clients arrive.
They were originally planning to come to the office at 3 P.M., but due to a scheduling conflict, the presentation will be pushed back one hour.
Both the presentation and the meeting will take place in Conference Room A. Mr. Hayes will be responsible for setting up all of the equipment.

메모

받는 사람: 디자인 직원
보내는 사람: 마케팅 팀장, 데릭 화이트
제목: 연습 회의

멀레인 거래처에 대한 발표를 검토하기 위해 내일 오후 1시 회의에 정시에 참석해 주십시오. 연습 시간은 1시간 정도 소요될 것이므로 오후 2시부터 고객들이 도착할 때까지는 자유 시간입니다.

고객들은 원래 사무실에 오후 3시에 올 예정이었으나, 일정이 겹치게 되어 발표가 1시간 뒤로 미루어 졌습니다.

발표와 회의는 모두 회의실 A에서 있을 것입니다. 헤이즈 씨가 모든 장비의 설치를 책임질 것입니다.

| Thank you. | 감사합니다. |

어휘 | account 고객, 단골 scheduling conflict 일정 충돌 push back 뒤로 미루다 take place (일, 행사 등이) 일어나다, 개최되다
be responsible for ~을 책임지다 equipment 장비

패러프레이징

교재 243쪽

예제 (A) / 1. (B)　　2. (B)　　3. (A)　　4. (A)　　5. (A)

[예제 3] 패러프레이징

Although I am registered for the basic phone package, I was charged extra for the premium package on my July statement. I am paying the regular amount and expect this correction to be reflected on my next bill.

(A) **The customer was overcharged in July for a monthly utility service.**

(B) Payment must be made to maintain premium status.

제가 기본 통화 패키지에 가입되어 있음에도 불구하고, 7월 명세서에서 프리미엄 패키지에 대해 추가로 요금을 청구 받았습니다. 저는 평상시 금액을 납부할 것이며 다음 청구서에 정정된 내용이 반영되기를 바랍니다.

해석 | (A) 고객은 7월에 공공 서비스 요금에 대해 과다 청구 받았다.
(B) 프리미엄 패키지를 유지하기 위해 지불해야 한다.

해설 | 7월 명세서에서 추가로 요금을 청구 받았다고 했으므로 정답은 (A). 지문의 was charged extra가 정답에서 유의어인 was overcharged로 패러프레이징되었다.

1.

I ordered a t-shirt on October 30. I chose the blue option in size small. The t-shirt I got had the correct color, but it came in medium. I will send it back. In the meantime, please ship me the correct size.

(A) A customer wishes to order a different-color shirt.

(B) **A customer received a clothing item in the wrong size.**

저는 10월 30일에 티셔츠를 주문했습니다. 작은 사이즈로 파란색을 골랐습니다. 제가 받은 티셔츠는 색상은 맞지만, 중간 사이즈로 왔습니다. 이 티셔츠를 다시 보내겠습니다. 그동안에, 맞는 사이즈로 배송해 주시기 바랍니다.

해석 | (A) 고객은 다른 색상의 셔츠를 주문하고 싶어 한다.
(B) 고객은 잘못된 사이즈의 의류를 받았다.

해설 | 티셔츠의 색상은 제대로 왔지만 처음에 주문한 작은 사이즈가 아닌 중간 사이즈로 받았다고 했으므로 정답은 (B). 지문의 The t-shirt가 정답에서 상위 개념인 a clothing item으로, it came in medium이 received ~ in the wrong size로 패러프레이징되었다.

2.

Business expense refunds no longer require hard copies to be submitted by each department. Claims can now be processed entirely through the company Web site. Please fill out the new online form found at the "Expenses" link to make your requests.

(A) The budget was expanded to update the company Web site.

(B) **The reimbursement procedure is now done online.**

더 이상 각 부서에서 업무 경비 상환을 위해 출력본을 제출하지 않아도 됩니다. 청구는 이제 회사 웹사이트를 통해 모두 처리 가능합니다. 청구 신청을 위해 "비용" 링크에서 새로운 온라인 서식을 작성해 주십시오.

해석 | (A) 예산이 회사의 웹사이트를 갱신하기 위해 확충되었다.
(B) 상환 절차는 이제 온라인으로 처리된다.

해설 | 회사의 웹사이트를 통해 업무 경비 청구가 가능하다고 했으므로 정답은 (B). 지문의 Claims can now be processed가 정답에서 함축 표현을 이용하여 The reimbursement procedure로, company Web site는 상위 개념인 online으로 패러프레이징되었다.

DAY 26

3.

On January 10, a computer and design job fair will be held at the Deniver Convention Center from 2 P.M. until 5 P.M. This event is open to anyone interested in a career in technology. However, registration is required. Apply early at www.deniverjobfair.com.

(A) Job searchers can register for an event online.
(B) Employers are affected by advances in technology.

1월 10일에, 컴퓨터와 디자인 채용 박람회가 오후 2시부터 5시까지 데니버 컨벤션 센터에서 열릴 예정입니다. 이 행사는 기술과 관련된 직업에 관심있는 누구에게나 열려있습니다. 하지만, 등록은 필수입니다. www.deniverjobfair.com에서 빨리 신청하세요.

해석 | (A) 구직자들은 온라인으로 행사에 등록할 수 있다.
(B) 고용주들은 기술 발전의 영향을 받는다.

해설 | 마지막에 웹사이트 주소를 알려주며 행사에 등록하라고 했으므로 정답은 (A). 지문의 웹사이트 주소 www.deniverjobfair.com이 정답에서 상위 개념인 online으로 패러프레이징되었다.

4.

I would like to thank your agency for the wonderful vacation you put together for me and my family. You provided a customized package at a price that was lower than we expected. The trip was wonderful, and we were highly impressed by your service.

(A) A customer paid less than planned for a vacation.
(B) A writer is recommending a travel agency to a colleague.

귀하의 여행사에서 저와 저희 가족을 위해 준비해 주신 훌륭한 휴가에 대해 감사드리고 싶습니다. 저희가 예상했던 것보다 저렴한 가격으로 맞춤형 패키지 여행을 제공해 주셨습니다. 여행은 아주 재미있었고, 저희는 귀사의 서비스에 매우 감명받았습니다.

해석 | (A) 고객은 휴가에 계획한 것보다 적게 지출했다.
(B) 글쓴이는 동료에게 여행사를 추천하고 있다.

해설 | 예상했던 것보다 저렴한 가격으로 휴가를 다녀왔다고 했으므로 정답은 (A). 지문의 at a price that was lower than we expected가 정답에서 유의어를 활용하여 paid less than planned로 패러프레이징되었다.

5.

I have received your voicemail about the late delivery of a Maxwell 24-inch monitor ordered on April 15. The order summary states that you paid an additional fee for express shipping to receive the package on April 18. I am sorry to hear that the item was delivered late.

(A) A customer requested expedited delivery.
(B) An electronic item was delivered damaged.

4월 15일에 주문하신 맥스웰 24인치 컴퓨터 모니터가 늦게 배달되었다는 귀하의 음성 메시지를 받았습니다. 주문서에는 귀하께서 4월 18일에 배송을 받기 위해 특급 배송용 추가 비용을 지불하셨다고 쓰여 있습니다. 물품이 늦게 배송되었다는 것을 듣게 되어 유감입니다.

해석 | (A) 고객이 빠른 배송을 요청했다.
(B) 전자제품이 손상된 채 배송되었다.

해설 | 고객이 빠른 배송을 위해 추가 비용을 지불했지만 물품이 늦게 배송되어 사과하고 있으므로 정답은 (A). 지문의 paid an additional fee for express shipping이 정답에서 requested expedited delivery로 패러프레이징되었다.

[1-2] 메모

To: All Employees

Dupré Manufacturing is currently in the process of updating its employee directory. **[1] We just filled several new positions**, so we think it's important to double-check that our directory is current at this time. Please take a moment to find your listing in the directory and make sure it is up-to-date. You can upload a new picture or add extra information about yourself. If any of the information is wrong, please correct it.

To access your page in the directory, click on "Directory" from the main page of the company Web site and type your name into the search box. **[2] Each page contains an "Update" button and can be accessed by using your ID number and password.** We look forward to seeing everyone's updates!

Iris Turner, Human Resources Director
Dupré Manufacturing Company

받는 사람: 전직원

뒤프레 제조사에서는 현재 직원 명부를 최신의 것으로 갱신하고 있습니다. **[1] 최근 우리는 몇 개의 새로운 자리에 직원을 충원하였으므로,** 이번에 직원 명부가 현재의 상태인지 다시 확인하는 것이 중요하다고 생각합니다. 명부에서 여러분의 목록을 찾아 최신 정보가 되도록 해주십시오. 새로운 사진을 올리거나 여러분에 관한 추가 신상 정보를 더할 수 있습니다. 정보 중 잘못된 것이 있으면, 수정해 주십시오.

명부에서 여러분의 페이지로 들어가기 위해서는, 회사 웹사이트의 메인 화면에서 "직원 명부"를 클릭한 후 검색창에 이름을 입력하십시오. **[2] 각각의 페이지에는 "업데이트"라는 버튼이 있고, 여러분의 ID 번호와 비밀번호로 접속할 수 있습니다.**

전직원의 최신 정보를 보길 기대합니다!

뒤프레 제조사
인사부장 아이리스 터너 드림

어휘 | be in the process of ~하는 중이다 directory (이름, 주소 등의) 명부 up-to-date 최신의 contain 포함하다 access 접속하다, 접근하다

1. What has Dupré Manufacturing recently done?
(A) Upgraded its directory
(B) Issued updated passwords
(C) Hired new employees
(D) Launched a Web site

해석 | 뒤프레 제조사가 최근에 한 일은?
(A) 명부 갱신
(B) 갱신된 비밀번호 발행
(C) 새로운 직원 채용
(D) 웹사이트 개시

해설 | 특정 정보 확인 문제
단서 (1)에서 최근 몇 개의 새로운 자리를 충원했다고 밝히고 있으므로 (C)가 정답. (A) 명부 갱신은 앞으로 예정된 일이므로 오답이다.

2. What is indicated about updating the directory?
(A) It happens automatically.
(B) It can be done only by the director.
(C) It requires entering log-in information.
(D) It affects the design of the main page.

해석 | 명부 갱신에 대해서 시사된 것은?
(A) 자동으로 일어난다.
(B) 부장만이 할 수 있다.
(C) 로그인 정보를 입력해야 한다.
(D) 메인 페이지 디자인에 영향을 미친다.

해설 | Not/True 문제
단서 (2)에서 업데이트를 위해 각각의 페이지에 들어가기 위해서는 ID 번호와 비밀번호를 이용해서 접속할 수 있다고 했으므로 (C)가 정답이다. 지문의 ID number and the password가 정답에서 상위 개념을 활용하여 log-in information으로 패러프레이징되었다.

DAY 26

Joe Scott
4547 Kennedy Court
West Roxbury, MA 02132

April 29

Dear Mr. Scott,

I have received your voicemail about the late delivery of a Maxwell 24-inch monitor ordered on April 15. The order summary states that you paid an additional fee for express shipping to receive the package on April 18. **3** I am sorry to hear that the item was delivered late. **4** The delay was caused by a virus in one of our database programs. We regret that we were not able to solve the problem quickly enough for your package to be delivered on time. As an apology for your inconvenience, I am including **5A** a free USB drive with this letter and **5C** a voucher for 15% off your next order. **5D** We will also be refunding the extra fee you paid for expedited service. I hope you will remain a loyal customer.

Thank you for your understanding,

Alton Phelan
Maxwell Electronics

조 스콧
케네디 코트 4547번지
웨스트록스베리, 메사추세스 주 02132

4월 29일

스콧 씨께,

4월 15일에 주문하신 맥스웰 24인치 컴퓨터 모니터가 늦게 배달되었다는 귀하의 음성 메시지를 받았습니다. 주문서에는 귀하께서 4월 18일에 배송을 받기 위해 특급 배송용 추가 비용을 지불하셨다고 쓰여 있습니다. **3** 물건이 늦게 배송되었다는 것을 듣게 되어 유감입니다. **4** 저희 자료 관리 프로그램 중 하나가 바이러스에 걸려 지연이 발생하였습니다. 제시간에 물건을 배송할 수 있도록 빠르게 문제를 해결하지 못해서 유감스럽게 생각합니다.

귀하께서 겪으신 불편함에 대한 사과의 의미로서, **5A** 무료 USB와 **5C** 다음 구매시에 사용하실 수 있는 15퍼센트 할인 쿠폰을 동봉합니다. 또한 신속한 배송을 위해 지불하신 **5D** 추가 요금을 환불해드릴 것입니다. 귀하께서 저희의 단골 고객으로 남아주시기를 바랍니다.

이해해 주셔서 감사드립니다,

맥스웰 전자
알톤 펠랑 드림

어휘 | state 쓰다, 명시하다 additional 추가의 express shipping 특급 배송 regret 유감스럽게 생각하다 inconvenience 불편 voucher 쿠폰, 할인권 expedite 신속하게 하다

3. What is the purpose of the letter?
(A) To confirm receipt of a package
(B) To modify a shipping option
(C) To advertise a sale event
(D) To apologize for a late delivery

해석 | 편지의 목적은?
(A) 소포의 수령을 확인하기 위해
(B) 배송 옵션을 수정하기 위해
(C) 할인 행사를 광고하기 위해
(D) 배송 지연에 대해 사과하기 위해

해설 | 주제, 목적 문제
단서 (3)에서 모니터가 예정된 날짜보다 늦게 배송되었다는 고객의 음성 메시지에 대해 편지로 사과하고 있으므로 정답은 (D). 지문의 was delivered late가 정답에서 품사를 바꾸어 a late delivery로 패러프레이징되었다.

4. What was the reason for the problem?
(A) An employee error
(B) An out-of-stock item
(C) A damaged delivery vehicle
(D) A software malfunction

해석 | 문제의 원인은?
(A) 직원 실수
(B) 품절된 제품
(C) 손상된 운송 차량
(D) 소프트웨어 오작동

해설 | 특정 정보 확인 문제
지문 중간에 배송 지연 이유에 대해 밝히고 있다. 단서 (4)에 따르면 프로그램이 바이러스에 걸려 지연이 발생한 것이라고 했으므로 정답은 (D). 지문의 a virus in one of our database programs가 A software malfunction으로 패러프레이징되었다.

5. What is NOT offered by Mr. Phelan?

(A) An additional product

(B) Free shipping on a future order

(C) A discount coupon

(D) A partial refund

해석 | 펠랑 씨가 제시한 것이 아닌 것은?

(A) 추가 제품

(B) 나중의 주문에 대한 무료 배송

(C) 할인 쿠폰

(D) 부분 환불

해설 | Not / True 문제

고객 불만에 대한 해결책은 주로 지문 마지막에 나오므로, 이 부분을 주의 깊게 살펴보자. 배송 지연에 대한 사과의 의미로 무료 USB, 할인 쿠폰, 추가 요금 환불을 제시하고 있다. 그러나 나중의 주문에 대한 배송비는 언급되어 있지 않으므로 정답은 (B).

[6-10] 공지 & 이메일

Bernard Dean
876 Jewell Road
Minneapoles, MN 55415

NOTICE: March 15

⁶ We would like to inform you that we are still awaiting payment on services provided by our clinic. Your account is ⁷ outstanding in the amount of $345. Please send a check or make a transfer to our finance offices. A description of the charges for your treatments is provided for your records. Prices indicated include taxes and any related fees. If you have any questions about the charges, please contact our billing department at billing@fountaindentalclinic.com.

Date of Treatment	February 22
Checkup and Cleaning	$90
Dental X-rays	$75
⁹⁻² Teeth Whitening	$180
Total Amount Due	$345

Payment should be received by March 31 in order to prevent late fees. We thank you for taking care of this matter promptly.

Paul Mercer
Accountant Fountain Dental Clinic

Please send payment to:
Fountain Dental Clinic
693 Stratford Park
Minneapolis, MN 55415

Bank: TY Bank
⁸⁻² Account Holder: Carlos Correa
Account Number: 346555

버나드 딘
쥬얼 로 876번지
미니애폴리스, 미네소타 주 55415

공지: 3월 15일

⁶ 저희 병원에서 제공한 서비스에 대한 비용 지불을 아직 기다리고 있음을 알려드리고자 합니다. 귀하의 계정에는 345달러가 ⁷ 미납되어 있습니다. 저희 경리과로 수표를 보내주시거나 금액을 이체해 주십시오. 귀하가 받은 치료에 대한 청구 내역을 귀하께서 보관하실 수 있도록 제공합니다. 표시된 가격에는 세금 및 관련 수수료가 포함되어 있습니다. 요금에 대한 문의 사항이 있으시면 billing@fountaindentalclinic.com으로 저희 청구서 발송 부서에 연락 주십시오.

치료 날짜	2월 22일
검사와 세척	90달러
치아 엑스레이	75달러
⁹⁻² **치아 미백**	**180달러**
총 지불 금액	345달러

연체료를 내지 않으시려면 3월 31일까지 납부해 주십시오. 이 문제를 조속히 해결해 주시면 감사하겠습니다.

파운틴 치과, 회계사
폴 머서 드림

아래 주소로 금액을 납부해 주십시오:
파운틴 치과
스트랫포드 파크 693번지
미니애폴리스, 미네소타 주 55415

은행: 티와이 은행
⁸⁻² **예금주: 카를로스 코레아**
계좌 번호: 346555

DAY 26

어휘 | await 기다리다 **account** 계정 **description** 기술, 묘사 **treatment** 치료, 처리 **indicate** 표시하다 **billing** 청구서 발송 **payment** 지불 **late fee** 연체료 **take care of** ~을 해결하다

To: <billing@fountaindentalclinic.com>
From: Bernard Dean <bernarddean@emailbox.net>
9-1 Date: March 18
Subject: Account payment

To whom it may concern:

I am writing to you about a notice from your billing department regarding a series of treatments I received at your clinic on February 22. The day after I visited your clinic, I immediately submitted my bills to my insurance company and was awaiting a response from them. **8-1** I just talked to one of their representatives, who said they will be transferring a payment to your account on March 19 for all procedures except for the teeth whitening, which is cosmetic. **9-1** I mailed a check this morning to cover the cost of that procedure. **10** Please send me an e-mail when you receive this payment so that I can be sure that it arrived and was applied to the charges on my account. I hope that this will take care of the matter in full.

Thank you,

Bernard Dean

받는 사람: 〈billing@fountaindentalclinic.com〉
보내는 사람: 버나드 딘 〈bernarddean@emailbox.net〉
9-1 날짜: 3월 18일
제목: 계정 납부

관계자분께:

2월 22일에 귀하의 치과에서 받은 일련의 치료들에 관해 청구서 발송 부서로부터 받은 통지서에 대해 메일드립니다. 치과에 방문한 다음 날, 저는 즉시 보험회사에 청구서를 제출했고, 그에 대한 회신을 기다리는 중이었습니다. **8-1** 방금 보험사 직원 중 한 명과 통화를 했는데, 미용과 관련된 치아 미백만 제외하고 모든 치료에 대해 귀하의 계좌로 3월 19일에 지불하겠다고 하였습니다. **9-1** 오늘 아침에 치아 미백에 대한 비용을 지불하는 수표를 발송했습니다. **10** 이 금액을 받으시면 도착했는지와 제 청구서의 요금에 적용되었는지를 알 수 있도록 이메일을 보내 주시기 바랍니다. 저는 이것으로 이 문제가 완전히 처리되기를 바랍니다.

감사합니다,

버나드 딘 드림

어휘 | immediately 즉시 submit 제출하다 bill 청구서 insurance company 보험회사 response 회신, 응답 procedure 치료, 절차 apply 적용하다 in full 전부, 빠짐없이

6. What is the purpose of the notice?
(A) To give an estimate of service costs
(B) To announce an increase in rates
(C) To confirm a medical appointment
(D) To remind of a due payment

해석 | 공지의 목적은?
(A) 서비스 비용에 대한 견적을 제공하기 위해
(B) 요금의 인상을 알리기 위해
(C) 진료 예약을 확인하기 위해
(D) 미결제 금액을 상기시키기 위해

해설 | 주제, 목적 문제
주제, 목적 문제의 단서는 대개 지문의 앞부분에 등장한다. 단서 (6)에서 비용 지불을 기다리고 있다고 했으므로, 이 공지의 목적은 금액이 지불되어야 함을 알리기 위해서임을 알 수 있다. 따라서 정답은 (D).

7. The word "outstanding" in paragraph 1, line 2, of the notice is closest in meaning to
(A) unpaid
(B) noticeable
(C) excellent
(D) essential

해석 | 공지의 첫째 단락 두 번째 줄의 "outstanding"과 의미상 가장 가까운 단어는?
(A) 지불되지 않은
(B) 주목할 만한
(C) 훌륭한
(D) 필수적인

해설 | 동의어 문제
문맥상 345달러가 '미납된 상태'라는 의미이므로 '지불되지 않은'이라는 뜻의 unpaid가 가장 적절하다. 따라서 정답은 (A). outstanding은 '미지불된, 뛰어난'의 두 가지 의미로 자주 쓰인다는 점을 기억하자.

8. What is suggested about the insurance company?

(A) It sent a bill to Fountain Dental Clinic.

(B) It had to pay a late fee.

(C) It does not cover cleaning expenses.

(D) It will make a payment to Carlos Correa.

해석 | 보험 회사에 대해 암시된 것은?

(A) 파운틴 치과에 청구서를 보냈다.

(B) 연체료를 지불해야 했다.

(C) 세척 비용은 보장하지 않는다.

(D) 카를로스 코레아 씨에게 지불할 것이다.

해설 | 두 지문 연계 문제

공지와 이메일 두 개의 지문을 함께 봐야 하는 연계 문제이다. 이메일의 단서 (8-1)에 따르면 보험 회사에서 치료 비용을 이체하겠다고 했는데 공지의 단서 (8-2)를 보면 파운틴 치과의 예금주가 카를로스 코레아 씨이므로 그에게 지불할 것임을 알 수 있다. 따라서 정답은 (D).

9. How much did Mr. Dean send on March 18?

(A) $75

(B) $90

(C) $180

(D) $345

해석 | 딘 씨가 3월 18일에 보낸 금액은?

(A) 75달러

(B) 90달러

(C) 180달러

(D) 345달러

해설 | 두 지문 연계 문제

3월 18일은 딘 씨가 이메일을 보낸 날짜로, 이메일의 단서 (9-1)에서 오늘 아침에 수표를 보냈다고 했다. 이 수표는 보험 적용이 되지 않는 치아 미백 비용에 대해 보낸 것이므로, 공지에서 치아 미백에 대한 비용을 찾아 보면 단서 (9-2)에서 180달러임을 알 수 있다. 따라서 정답은 (C).

10. What is requested by Mr. Dean?

(A) Confirmation of payment

(B) An e-mail with policy information

(C) An extension to a due date

(D) Additional insurance coverage

해석 | 딘 씨가 요구한 것은?

(A) 지불 확인

(B) 규정 정보를 담은 이메일

(C) 만기일의 연장

(D) 추가적인 보험 적용

해설 | 특정 정보 확인 문제

딘 씨가 요구한 사항을 묻고 있으므로 이메일에서 단서를 찾아야 한다. 단서 (10)에서 일부 비용을 납부했으니 이에 대해 확인 이메일을 보내 달라고 요청하고 있으므로 (A)가 정답이다.

DAY 26

예제 해석

교재 251쪽

[예제 1] 문자 메시지

HEATHER OLLIS　　10:04 A.M. Hey, Trevor. I got your e-mail with the market analysis report.	헤더 올리스　　오전 10:04 안녕하세요, 트레버 씨. 당신이 보낸 시장 분석 보고서가 첨부된 이메일을 받았어요.
TREVOR BAXTER　　10:05 A.M. Oh, good. Was it clear?	트레버 박스터　　오전 10:05 오, 잘됐네요. 알아보기 쉽던가요?
HEATHER OLLIS　　10:06 A.M. Actually, I was not able to read it. My computer couldn't open the attachment.	헤더 올리스　　오전 10:06 사실, 그 문서를 읽지 못했어요. 제 컴퓨터에서 첨부 파일을 열 수가 없었어요.
TREVOR BAXTER　　10:08 A.M. That's strange. Don't you have the analysis software installed on your computer?	트레버 박스터　　오전 10:08 이상하네요. 컴퓨터에 분석 소프트웨어를 설치해두지 않았나요?
HEATHER OLLIS　　10:10 A.M. I do have it, but I think I've got an older version. I'll talk to the IT department about it. In the meantime, can we meet in person to discuss the report?	헤더 올리스　　오전 10:10 가지고 있어요, 그런데 예전 버전을 가지고 있나봐요. IT 부서에 그 문제에 대해 이야기해야겠어요. 그동안 직접 만나서 그 보고서에 대해 논의할 수 있을까요?
TREVOR BAXTER　　10:11 A.M. Sure. The best for me would be to meet this afternoon. Can you stop by my office around 2?	트레버 박스터　　오전 10:11 물론이죠. 저는 오늘 오후에 만나는 게 가장 좋을 것 같아요. 제 사무실에 2시쯤 들르실 수 있어요?
HEATHER OLLIS　　10:12 A.M. That works. I'll see you then.	헤더 올리스　　오전 10:12 좋아요. 그때 뵐게요.

어휘 | market analysis 시장 분석　clear 알아보기 쉬운　install 설치하다　in person 직접　stop by (~에) 잠시 들르다

[예제 2] 온라인 채팅

Naomi O'Neill　　11:12 A.M. I invited you to discuss our upcoming Web site launch. The project is coming to an end, so we should talk about the aspects that we have not yet completed.	나오미 오닐　　오전 11:12 다가오는 웹사이트 출시와 관련하여 상의하기 위해 여러분을 초대했어요. 프로젝트가 끝나가고 있어서, 우리가 아직 완료하지 못한 측면들에 대해 이야기해봐야 해요.
Alexander Clark　　11:14 A.M. The site is scheduled to open on July 1. So we need to finish everything a few days earlier to leave us time to check that it all works.	알렉산더 클라크　　오전 11:14 7월 1일에 사이트를 오픈할 예정이에요. 그래서 모든 것이 잘 작동되는지 확인하기 위한 시간을 남겨두려면 우리는 며칠 앞당겨서 모든 것을 끝내야 해요.
Joseph Haynes　　11:18 A.M. So here's what we're missing: photos for the About Our Staff page and the entries for the Customer Reviews section. Is that it?	요세프 헤인즈　　오전 11:18 자 이게 우리가 놓친 것들이에요: 직원 소개 페이지에 들어갈 사진과 고객 후기 코너에 들어갈 항목들. 맞죠?
Alexander Clark　　11:20 A.M. No. I was testing the site earlier this week, and I	알렉산더 클라크　　오전 11:20 아니요. 이번 주 초에 사이트를 확인해 봤는데, 문의 링크를 누를 때마

noticed that every time I click on the Contact Us link, I get a blank page. So that needs to be corrected.

Naomi O'Neill	11:22 A.M.

So to summarize, we have three pages to take care of: About Our Staff, Customer Reviews, and Contact Us.

Joseph Haynes	11:23 A.M.

That's correct. Today, let's focus on the Contact Us page, since that seems to be the most urgent. Naomi, can you take care of the issue?

Naomi O'Neill	11:24 A.M.

Okay, I'll get to that this afternoon. I'll send you a message as soon as it is finished.

나오미 오닐	오전 11:22

다 빈 페이지가 나온다는 걸 알았어요. 그것도 고쳐야 해요.

요약하자면, 우리는 세 개의 페이지를 처리해야 하네요: 직원 소개, 고객 후기, 그리고 문의.

요세프 헤인즈	오전 11:23

맞아요. 문의 페이지가 가장 급한 것 같으니까 오늘은 그것에 집중하도록 해요. 나오미, 이 문제를 처리해 줄 수 있을까요?

나오미 오닐	오전 11:24

알겠어요, 오늘 오후에 그것을 처리할게요. 끝내는 대로 바로 메시지를 보낼게요.

어휘 | upcoming 다가오는, 곧 있을 come to an end 끝나다 aspect 측면, 양상 miss 놓치다, 거르다 entry 항목, 입장 summarize 요약하다 urgent 긴급한 as soon as ~하는 대로, ~하자마자

패러프레이징

교재 253쪽

예제 (A) / 1. (B) 2. (A) 3. (A) 4. (B) 5. (A)

[예제 3] 패러프레이징

The sales figures for May are not ready yet, so I won't be able to present them in Friday's meeting. Would it be possible for me to do it next week?

What is indicated about the writer?
(A) He wants to change a presentation date.
(B) He will not attend the staff meeting.

5월 매출액이 아직 준비되지 않아서, 금요일 회의에서 그것을 발표할 수 없을 것 같습니다. 다음 주에 발표해도 될까요?

해석 | 글쓴이에 대해 시사된 것은?
(A) 발표 날짜를 변경하길 원한다.
(B) 직원 회의에 참석하지 않을 것이다.

해설 | 아직 매출액이 준비되지 않아 다음 주에 발표하고 싶다고 했으므로 정답은 (A). 지문의 Would it be possible for me to do it next week?가 He wants to change a presentation date.로 일반화되어 패러프레이징되었다.

1.

Snippit Hair Salon is adding a new section to its shop! Our redesigned salon will make your hairstyling experience even more special! However, we are closed for one week during construction. Please come back on November 2 to experience the new Snippit!

Why is Snippit Hair Salon closed?
(A) It is preparing for a special holiday event.
(B) It is going through some renovations.

스니핏 미용실이 매장에 새로운 구역을 추가합니다. 재설계한 저희 미용실은 여러분의 미용 경험을 더욱 특별하게 만들어 드릴 것입니다! 하지만, 일주일의 공사 기간 동안은 영업하지 않습니다. 11월 2일에 새로운 스니핏을 경험하러 다시 찾아주세요!

해석 | 스니핏 미용실이 문을 닫는 이유는?
(A) 특별 연휴 행사를 준비 중이다.
(B) 보수공사를 하는 중이다.

해설 | 미용실에 새로운 구역을 추가하는 공사로 일주일간 영업하지 않는다고 했으므로 정답은 (B). 지문의 adding a new section to its shop이 정답에서 함축 표현을 활용하여 going through some renovations로 패러프레이징되었다.

2.

We are writing to inform you that your subscription to *Stardom* magazine will expire on June 30. Unless you renew your subscription, our June issue will be the last that we send you. To ensure that you receive our July edition, please renew by June 15.

What is true about the reader's subscription?
(A) It will end unless it is extended.
(B) It includes the July issue.

해석 | 귀하의 〈스타덤〉 지 정기 구독이 6월 30일에 만료된다는 것을 알려드리기 위해 메일을 드립니다. 구독을 갱신하지 않으시면, 6월호가 저희가 보내드리는 마지막 잡지가 될 것입니다. 7월호를 확실히 받아보시려면, 6월 15일까지 갱신해 주시기 바랍니다.

해석 | 독자의 정기 구독에 대해 사실인 것은?
(A) 연장하지 않으면 끝날 것이다.
(B) 7월호를 포함한다.

해설 | 6월 15일까지 갱신하지 않으면 잡지를 더 받아보지 못할 것이라고 했으므로 정답은 (A). 지문의 expire가 정답에서 유의어인 end로, renew가 유의어인 extended로 패러프레이징되었다.

3.

Mayor Bryan Constance has announced that construction of a new highway will begin at the end of March. The new road is meant to reduce traffic congestion in the Caston City's surrounding streets by allowing commuters to enter and exit the city more easily.

What can be inferred about Caston City?
(A) There are traffic jams during rush hours.
(B) Residents have decided to move out of the city.

해석 | 브라이언 콘스탄스 시장이 새로운 고속도로 건설을 3월 말에 시작할 것이라고 발표했다. 이 새로운 도로는 통근자들이 도시에 더 쉽게 들어오고 나갈 수 있도록 해줌으로써 카스톤 시 인근 도로들의 교통 혼잡을 줄이기 위한 것이다.

해석 | 카스톤 시에 대해 추론할 수 있는 것은?
(A) 출퇴근 시간에 교통 체증이 있다.
(B) 주민들이 도시 밖으로 떠나기로 결심했다.

해설 | 카스톤 시 인근 도로들의 교통 혼잡을 줄여 출퇴근하는 사람들이 쉽게 이동하도록 고속도로를 건설한다고 하였으므로 출퇴근 시간에 교통 체증이 있음을 유추할 수 있다. 따라서 정답은 (A).

4.

Thank you for being a member of the Healthy Habits Association. We are conducting a study on the effects of a new treatment for cancer. Please support us by making a donation. Enclosed, please find a pre-addressed envelope for this purpose.

What is the purpose of this letter?
(A) To survey experts about a new medicine
(B) To ask for contributions for research

해석 | 건강한 습관 협회의 회원이 되어주셔서 감사합니다. 저희는 새로운 암 치료의 효과에 대한 연구를 진행하고 있습니다. 기부로 저희를 후원해주시길 바랍니다. 이를 위해 수신인 주소가 쓰여진 봉투를 동봉했습니다.

해석 | 이 편지의 목적은?
(A) 신약에 대해 전문가를 대상으로 설문 조사하기 위해
(B) 연구에 대한 기부를 요청하기 위해

해설 | 암 치료 연구에 대한 후원을 요청하고 있으므로 정답은 (B). 지문의 making a donation이 정답에서 유의어를 활용하여 contributions로 패러프레이징되었다.

5.

Autumn School offers classes for all ages! Come learn how to draw a portrait, paint a landscape, or create abstract art! Right now, we have a special deal going on. Sign up for a ten-class package and receive an eleventh class at no cost!

What is being advertised?
(A) Art lessons
(B) A gallery exhibition

해석 | 가을 학교는 모든 연령층에게 수업을 제공합니다! 초상화, 풍경화를 어떻게 그리는지, 추상화 작품을 어떻게 만드는지 오셔서 배워보세요! 지금 저희는 특가 상품을 제공하고 있습니다. 10회 수강 패키지를 등록하시고 열한 번째 강의를 무료로 받으세요!

해석 | 광고되는 것은?
(A) 미술 수업
(B) 미술관 전시회

해설 | 가을 학교에서 제공하는 강의들과 신규 수강생을 위한 혜택을 설명하고 있으므로 정답은 (A). 지문의 learn how to ~ art가 함축 표현을 이용하여 정답에서 Art lessons로 패러프레이징되었다.

FINAL TEST

1. (D) 2. (C) 3. (A) 4. (B) 5. (C)

[1-2] 문자 메시지

MARIE RAMOS 16:43

[1] Yessenia, I know you reviewed our monthly order schedule, but there have been some changes that you need to know about.

YESSENIA DUGGAR 16:45

Really? I just submitted that a few days ago. I'm surprised things have changed already.

MARIE RAMOS 16:49

The Des Moines branch just discovered that they still have two boxes of merchandise, so we can ignore its request for more supplies.

MARIE RAMOS 16:51

And because the weather started to get warmer much earlier this year, the Minneapolis branch needs to double its order of bathing suits and sunglasses.

YESSENIA DUGGAR 16:53

Okay, got it. Anything else?

MARIE RAMOS 16:55

Yeah, just one more thing. [2] Richard Kendall from the accounting department asked if he could get the schedule too. So please e-mail him a copy once you update it.

마리 라모스 16:43

[1] 예세니아 씨, 당신이 우리 월간 주문 일정을 검토했다는 것을 알지만, 당신이 알아야 하는 일부 변동 사항들이 있어요.

예세니아 더가 16:45

정말요? 저는 며칠 전에 그것을 제출했어요. 벌써 변동 사항이 있다니 놀랍네요.

마리 라모스 16:49

디모인 지점에서 물품 두 박스가 아직 있다는 것을 발견해서, 그 지점의 추가 물품에 대한 요청은 무시해도 될 것 같아요.

마리 라모스 16:51

그리고 올해 날씨가 훨씬 더 일찍 따뜻해지기 시작해서, 미니애폴리스 지점은 수영복과 선글라스 주문을 두 배로 늘려야 해요.

예세니아 더가 16:53

네, 알겠어요. 또 다른 것은 없나요?

마리 라모스 16:55

네, 딱 하나 더 있어요. [2] 회계 부서의 리처드 켄들 씨가 일정표를 구할 수 있는지 물어봤어요. 그러니 수정하고 나서 그에게 복사본을 이메일로 보내주세요.

어휘 | review 검토하다 submit 제출하다 discover 발견하다 merchandise 물품, 상품 ignore 무시하다 request 요청 supply 물품 bathing suit 수영복 copy 복사본

1. Why did Ms. Ramos send the text message?

(A) To correct a mistake in a shipment
(B) To order new products
(C) To discuss employee performance
(D) To update a work plan

해석 | 라모스 씨가 문자 메시지를 보낸 이유는?
(A) 배송 실수를 정정하기 위해
(B) 신제품을 주문하기 위해
(C) 직원 성과에 대해 논의하기 위해
(D) 업무 계획의 가장 최신 정보를 알려주기 위해

해설 | 주제, 목적 문제
문자 메시지의 주제나 목적은 대부분 메시지 전송자의 메시지 초반에 위치해 있다. 마리 라모스 씨는 첫 문자 메시지에서 월간 주문 일정에 변동 사항이 있음을 알리고 이후에 세부 내용을 전달하고 있으므로 업무 계획에 대한 최신 정보를 알려주기 위해 문자 메시지를 보냈음을 알 수 있다. 따라서 정답은 (D).

2. At 16:55, what does Ms. Ramos mean when she writes, "Yeah, just one more thing"?

(A) A budget needs to be revised.

(B) An order was placed incorrectly.

(C) Another detail needs to be shared.

(D) A delivery is still in the warehouse.

해석 | 16시 55분에 라모스 씨가 "네, 딱 하나 더 있어요"라고 말한 것에서 그녀가 의도한 것은?

(A) 예산이 수정되어야 한다.

(B) 주문품이 잘못 주문되었다.

(C) 다른 세부 사항을 공유해야 한다.

(D) 배송품이 아직 창고에 있다.

해설 | 의도 파악 문제

추가 변동 사항이 없냐는 더가 씨의 질문에 대해 하나 더 있다고 대답하면서 회계 부서의 직장 동료에게 수정된 일정표를 이메일로 보내줄 것을 요청하고 있으므로, 다른 세부 사항을 공유하기 위함임을 알 수 있다. 따라서 정답은 (C).

[3-5] 온라인 채팅

Rosa Hoyt [10:09 A.M.]

Hi. I wanted to talk about the new accountant we are trying to hire. Syd, thank you for e-mailing us those résumés.

Syd Morris [10:11 A.M.]

Sure. Only three candidates have applied so far. ³ It seems that people are reluctant to work for small law offices these days.

Nadine Son [10:13 A.M.]

Well, let's look at what we have. I noticed that Erica Ocello's résumé states that she was an intern here, but I don't remember her. Do either of you?

Syd Morris [10:15 A.M.]

She worked in the finance team, so James Cornish was her supervisor. He said she was diligent, very intelligent, and quite friendly.

Rosa Hoyt [10:17 A.M.]

Unfortunately, ⁴ she's only just graduated from university. We need someone who is more experienced. What about the others?

Nadine Son [10:19 A.M.]

Johan Gibbs had non-negotiable salary expectations that were too high. The third candidate, Norma Scorpio, sounds impressive, but she is currently working for another company and is busy with a project that doesn't end until next month.

Syd Morris [10:21 A.M.]

I see. We need someone who can start right away. Personally, ⁵ I think we should leave the posting up for a few more days.

Rosa Hoyt [10:23 A.M.]

You're right. ⁵ There are other potential candidates out there.

로사 호이트 [오전 10:09]

안녕하세요. 우리가 고용하려고 하는 새로운 회계사에 대해 얘기하고 싶어요. 시드 씨, 그 이력서들을 메일로 보내주셔서 감사해요.

시드 모리스 [오전 10:11]

뭘요. 지금까지 세 명의 후보자만 지원했어요. ³ 요즘엔 사람들이 소규모 법률 회사에서 근무하기를 꺼리는 것 같아요.

네이딘 손 [오전 10:13]

그러게요, 우리 회사에 지원한 지원자를 봅시다. 에리카 오셀로 씨의 이력서에 여기서 인턴을 했었다고 쓰여있는데, 저는 그녀가 기억나지 않아요. 두 분은 어떠세요?

시드 모리스 [오전 10:15]

그녀는 재무팀에서 근무했는데, 제임스 코니시 씨가 그녀의 상사였어요. 그는 그녀가 성실하고, 매우 총명하며 상당히 친절했다고 했어요.

로사 호이트 [오전 10:17]

안타깝지만, ⁴ 그녀는 이제 막 대학을 졸업했어요. 우리는 더 경력이 있는 사람이 필요해요. 다른 지원자들은 어때요?

네이딘 손 [오전 10:19]

요한 기브스 씨는 너무 높은 희망 연봉을 적어서 협상이 불가능해요. 세 번째 지원자인 노마 스콜피오 씨는 인상적이지만, 현재 다른 회사에서 일하고 있고 다음 달이나 돼야 끝날 프로젝트 때문에 바빠요.

시드 모리스 [오전 10:21]

그렇군요. 우리는 당장 일을 시작할 수 있는 사람이 필요해요. 개인적으로는 ⁵ 우리가 게시물을 며칠 더 올려 두어야 한다고 생각해요.

로사 호이트 [오전 10:23]

맞아요. ⁵ 잠재력 있는 다른 후보자들이 있을 거예요.

Nadine Son [10:25 A.M.]
⁵ I feel the same way. So that's settled. Let's continue to advertise the position.

| | | SEND |

네이딘 손 [오전 10:25]
⁵ 저도 그렇게 생각해요. 그럼 정리됐네요. 그 공석을 계속해서 광고하도록 해요.

| | | 보내기 |

어휘 | accountant 회계사 candidate 후보자 apply 지원하다, 적용하다 be reluctant to *do* ~하기를 꺼리다 supervisor 상사, 감독 diligent 성실한 intelligent 총명한 experienced 경력이 있는 non-negotiable 협상 불가의 impressive 인상적인 potential 잠재적인 settle 정리하다, 결정하다

3. At what type of business do the people most likely work?
(A) A legal firm
(B) An education institute
(C) An accounting company
(D) An advertising company

해석 | 대화자들이 근무할 것 같은 회사의 업종은?
(A) 법률 회사
(B) 교육 기관
(C) 회계 법인
(D) 광고 회사

해설 | 특정 정보 확인 문제
새로 고용할 회계사에 대해 대화를 나누고 있는 사람들은 모두 같은 회사의 동료들인데 단서 (3)에서 모리스 씨가 사람들이 소규모 법률 회사에서 근무하기를 꺼리는 것 같다고 하는 것으로 보아 이들이 법률 회사에서 일하는 것을 알 수 있다. 따라서 정답은 (A). 지문의 law offices가 정답에서 유의어를 이용하여 A legal firm으로 패러프레이징되었다.

4. What is indicated about Ms. Ocello?
(A) She has a lot of experience in the field.
(B) She recently completed a degree.
(C) She cannot start working immediately.
(D) She is demanding a high salary.

해석 | 오셀로 씨에 대해 시사된 것은?
(A) 관련 분야의 경험이 많다.
(B) 최근에 학위를 수료했다.
(C) 바로 일을 시작할 수 없다.
(D) 높은 연봉을 요구한다.

해설 | Not / True 문제
특정 인물과 관련된 문제는 지문에서 그 인물의 이름이 언급된 문장에서 단서를 찾는다. 단서 (4)에 따르면 오셀로 씨는 이제 막 대학을 졸업했다고 했다. 따라서 정답은 (B). (C)는 다른 지원자인 스콜피오 씨, (D)는 기브스 씨에 대한 설명이므로 오답이다.

5. At 10:25 A.M., what does Ms. Son mean when she writes, "So that's settled"?
(A) They have chosen a successful candidate.
(B) They have selected a date for interviews.
(C) They have decided to review more applications.
(D) They have agreed to change the requirements.

해석 | 오전 10시 25분에, 손 씨가 "그럼 정리됐네요"라고 한 것에서 그녀가 의도한 것은?
(A) 합격자를 선정했다.
(B) 면접 날짜를 정했다.
(C) 더 많은 지원서를 검토하기로 결정했다.
(D) 필요 요건을 변경하기로 합의했다.

해설 | 의도 파악 문제
게시물을 더 길게 올려두어 다른 지원자들을 고려해보자는 모리스 씨와 호이트 씨의 말에 단서 (5)에서 손 씨는 자신 또한 그렇게 생각한다고 대답하였다. 따라서 그들이 더 많은 지원자들의 지원서를 검토할 것이란 뜻이므로, (C)가 정답이다.

DAY 27

135

예제 해석

교재 259쪽

[예제 1] 광고

Valerio's Lunchtime

If you like Italian food, you'll love the new lunch buffet at Valerio's. Now, the fine dining and quality cuisine you've enjoyed for dinner is available at lunchtime.

Our reasonably priced buffet offers a wide range of pastas with various sauces, pizzas topped with authentic Italian ingredients, and homemade soups and sides. Our new opening time is 11 A.M. instead of 2 P.M., and the buffet is served Monday through Friday from 11 A.M. to 1:30 P.M. Note that ordering from the menu will not be available during the buffet hours. However, you will still be welcomed with our outstanding service that has earned recognition throughout the area.

To celebrate our new service, we are offering $5 off to everyone who comes until April 20. So stop in to Valerio's today for a great meal.

발레리오즈의 점심시간

이탈리아 음식을 좋아하신다면, 발레리오즈의 새로운 점심 뷔페를 좋아하실 것입니다. 이제, 저녁 식사 때에 여러분께서 즐기셨던 훌륭한 만찬과 고품격 요리들을 점심 때에도 드실 수 있습니다.

저희의 합리적인 가격의 뷔페에서는 다양한 소스를 곁들인 많은 종류의 파스타와 정통 이탈리아 재료를 얹은 피자, 그리고 직접 만든 수프와 곁들임 요리를 제공하고 있습니다. 새로운 개점 시각은 오후 2시가 아닌 오전 11시이고, 뷔페는 월요일부터 금요일 오전 11시에서 오후 1시 30분까지 제공됩니다. 뷔페를 운영하는 시간 동안에는 메뉴 주문이 불가능하다는 것에 유의해 주십시오. 하지만 전지역에 걸쳐 인정받아온 저희의 뛰어난 서비스를 여전히 받으실 수 있습니다.

저희의 신규 서비스를 기념하기 위해 4월 20일 전에 오시는 모든 분께 5달러를 할인해 드립니다. 훌륭한 식사를 위해 오늘 발레리오즈를 방문해 주십시오.

어휘 | cuisine 요리　available 이용 가능한　reasonably 합리적으로, 적정하게　a wide range of 다양한　authentic 정통의, 진짜인　ingredient 재료　serve (음식을) 제공하다　outstanding 뛰어난　earn recognition 인정받다　celebrate 기념하다　stop in 들르다

[예제 2] 기사

Rine Industries to Merge with Long-Time Competitor, Lindley Manufacturing

Rine Industries, known for its hair and dental care products, informed the public yesterday of its plans to expand its business. It will be merging with Lindley Manufacturing in an attempt to create one of the largest consumer products companies in the nation. Rine stopped manufacturing products for the skin several years ago because it could not compete with Lindley's loyal customer base. The merger will help fill this gap in Rine's product line.

The merger is scheduled to take place sometime next month. The CEO of Rine will manage this new corporation, and Lindley's CEO has accepted a position as a professor in an MBA program.

라인 산업, 오랜 경쟁사인 린들리 제조사와 합병하다

모발 및 치아 관리 제품으로 잘 알려진 라인 산업은 어제 대중에게 사업을 확장할 계획임을 알렸다. 라인 산업은 국내 최대의 소비 제품 회사로 거듭나기 위한 시도로서 린들리 제조사와 합병할 것이다.

라인 사는 몇 년 전 피부 제품의 제조를 중단했는데, 린들리 사의 충성 고객층과 경쟁이 될 수 없었기 때문이었다. 이번 합병은 이러한 라인 사 제품 라인의 부족한 점을 채워줄 것이다.

이 합병은 다음 달쯤 시행될 예정이다. 라인 사의 대표이사가 이 새로운 회사를 관리할 것이며, 린들리 사의 대표이사는 경영학 석사 프로그램의 교수직을 수락했다.

어휘 | expand 확장하다　merge with ~와 합병하다　in an attempt to do ~하기 위한 시도로　compete with ~와 겨루다　loyal 충실한, 충성하는　customer base 고객층　gap 공백　be scheduled to do ~할 예정이다

패러프레이징

예제 (A) / 1. (A) 2. (B) 3. (A) 4. (B) 5. (B)

[예제 3] 패러프레이징

All employees are expected to attend a safety training workshop on Thursday at 2 P.M. The training will cover basic first aid and the handling of office emergencies.

(A) A safety program will be held for all employees.
(B) Certified workers are invited to a workshop.

모든 직원들은 목요일 오후 2시에 안전 교육 워크숍에 참석하시기 바랍니다. 교육에서는 기본적인 응급 조치와 사무실 긴급 상황 처리에 대해 다룰 예정입니다.

해석 | (A) 모든 직원들을 대상으로 한 안전 프로그램이 열릴 예정이다.
(B) 자격증을 소지한 직원들은 워크숍에 초대되었다.

해설 | 모든 직원들에게 안전 교육 워크숍 참석을 요청하고 있으므로 정답은 (A). 지문의 training workshop이 정답에서 상위 개념인 program으로 패러프레이징되었다.

1.

Mr. Molinka was supposed to lead the meeting about last quarter's performance on Monday, May 7. However, due to an unforeseen situation with a client, he must go on an urgent business trip to Florida. The meeting is therefore postponed to Thursday, May 10.

(A) A meeting will take place later than planned.
(B) An employee has to cancel his travel plans.

몰링카 씨는 5월 7일 월요일에 지난 분기의 실적에 대한 회의를 주도하기로 되어 있었습니다. 하지만, 고객과의 예상치 못한 상황 때문에, 그는 플로리다로 급하게 출장을 가야만 합니다. 따라서 회의는 5월 10일 목요일로 연기되었습니다.

해석 | (A) 회의가 예정보다 늦게 열릴 것이다.
(B) 한 직원은 그의 여행 계획을 취소해야 한다.

해설 | 몰링카 씨의 급한 출장 때문에 회의가 연기되었다고 했으므로 정답은 (A). 지문의 is postponed가 정답에서 유의어를 이용하여 will take place later than planned로 패러프레이징되었다.

2.

In December, we will offer free present wrapping to our customers. Employees who volunteer to wrap presents will be paid ten dollars an hour. If you wish to work overtime at the wrapping station, please e-mail Harry Milter at hmilter@corastore.com.

(A) Overtime work is needed after December.
(B) Volunteers should contact Harry Milter.

12월에, 우리는 고객분들께 무료로 선물 포장 서비스를 제공할 것입니다. 선물을 포장하는 일에 자원하는 직원들은 한 시간에 10달러를 지급받을 것입니다. 선물 포장 코너에서 초과 근무하기를 원하신다면 해리 밀터 씨에게 hmilter@corastore.com으로 이메일을 보내시기 바랍니다.

해석 | (A) 초과 근무는 12월 이후에 필요하다.
(B) 자원자들은 해리 밀터 씨에게 연락해야 한다.

해설 | 초과 근무를 원하는 사람들은 해리 밀터 씨에게 이메일을 보내라고 했으므로 정답은 (B). 지문의 e-mail이 정답에서 상위 개념인 contact로 패러프레이징되었다.

3.

You have been selected to receive the Berenice Meyers Scholarship for Women in the Arts. As a winner of this scholarship, you will receive one thousand dollars a semester for your tuition. You must sustain an average grade of at least B+ to maintain your status.

귀하께서는 예술계 여성을 위한 베레니스 마이어스 장학금을 받는 것에 선정되셨습니다. 이 장학금의 수령자로서, 귀하께서는 학기별 등록금으로 1,000달러를 받게 되실 것입니다. 귀하의 자격을 유지하기 위해 최소 B+의 평균 성적을 유지해야 합니다.

DAY 28

(A) The student should keep a minimum grade for her scholarship.

(B) An organization is donating one thousand dollars to a university.

해석 | (A) 학생은 장학금을 받기 위해 최소 성적을 유지해야 한다.
(B) 한 기관이 대학교에 1,000달러를 기부하고 있다.

해설 | 지문의 마지막에 장학금 수령 조건으로 최소 B⁺의 평균 성적을 유지해야 한다고 했으므로 정답은 (A). 지문의 sustain이 정답에서 동의어인 keep으로, an average grade of at least B⁺가 정답에서 함축 표현인 a minimum grade로 패러프레이징되었다.

4.

The Sanderson Conference Hall has a capacity of two hundred people. The stage features state-of-the-art equipment for showing slideshows and videos in high definition with a surround sound system. Call Mr. Macy at 258-6607 to reserve Sanderson Conference Hall!

샌더슨 컨퍼런스 홀은 200명을 수용할 수 있습니다. 무대에는 슬라이드 쇼와 동영상을 서라운드 음향 시스템과 고화질로 보여주기 위한 최신식 장비를 포함하고 있습니다. 샌더슨 컨퍼런스 홀을 예약하시려면 258-6607로 메이시 씨에게 전화해 주세요!

(A) Mr. Macy has reserved the room for a conference.
(B) The room has enough seating for up to two hundred people.

해석 | (A) 메이시 씨는 회의를 위해 회의실을 예약했다.
(B) 그 공간은 200명까지 앉을 자리가 충분히 있다.

해설 | 지문에서 컨퍼런스 홀이 200명을 수용할 수 있다고 했으므로 (B)가 정답. 지문의 a capacity of two hundred people이 정답에서 유의어인 enough seating for up to two hundred people로 패러프레이징되었다.

5.

Organics Market has initiated a new service that will change the landscape of personal grocery shopping. The program, called Home Harvest, provides customers with weekly deliveries of fresh organic produce at a lower cost than in a store.

오가닉스 마켓은 개인의 식료품 구입의 지형을 변화시킬 새로운 서비스를 개시했다. 가정 수확이라고 불리는 이 프로그램은 매장에서 구매하는 것보다 적은 비용으로 신선한 유기농 제품을 고객들에게 주 1회 배달해 준다.

(A) Home Harvest produces natural food for restaurant.
(B) A store provides a new approach to buying groceries.

해석 | (A) 가정 수확은 식당을 위한 자연 식품을 제조한다.
(B) 가게는 식료품 구매의 새로운 접근법을 제공한다.

해설 | 오가닉스 마켓은 주 1회의 유기농 제품 배달 서비스를 시작했다고 했으므로 정답은 (B). 지문의 a new service that will change the landscape of personal grocery shopping이 정답에서 provides a new approach to buying groceries로 패러프레이징되었다.

FINAL TEST

교재 262쪽

1. (C)	2. (B)	3. (D)	4. (C)	5. (A)	6. (B)	7. (A)	8. (B)	9. (A)	10. (D)

11. (C)

[1-2] 광고

Job Opportunity!

취업 기회!

Sunset Resort, which provides four-star luxury accommodations on Davey Beach, is accepting applications for the position of Housekeeping Manager. This individual will be responsible for

데이비 비치에서 4성급 고급 숙박 시설을 제공하는 선셋 리조트가 객실 관리 부장직에 대한 지원서를 접수합니다. 객실 관리 부장은 **1B 객실 관리 직원의 일상 업무 감독**, **1A 직원 고용 및 교육**, 그리고 **1D 모든 고객 시설의 전반적인 청결함을 보장**하는 책임을 맡게 될 것입니다. 접객업에 대한 지식과 이전에 관리직으로 근무한 경력은 필수입니다.

1B overseeing the day-to-day operations of the housekeeping staff, **1A** hiring and training staff, and **1D** ensuring the overall cleanliness of all guest facilities. Knowledge of the hospitality industry and previous management experience are required. The individual must also possess excellent communication and customer service skills. Preference will be given to candidates with proficiency in at least one foreign language. **2** The work schedule includes some evenings and weekends.

Submit your résumé, cover letter, and salary expectations to:
Sunset Resort, Personnel Office
Attn: Burt Kleffner
11 Palmridge Rd.
Davey Beach, CA

또한 우수한 의사소통 능력과 고객 서비스 기술을 보유해야 합니다. 최소한 하나 이상의 외국어에 능숙한 지원자는 우대할 것입니다. **2** 근무 일정에는 일부 야간 근무와 주말 근무가 포함됩니다.

귀하의 이력서, 자기 소개서 및 희망 연봉을 아래의 주소로 제출하십시오:
선셋 리조트, 인사과
수신: 버트 클레프너
팜리지 로 11번지
데이비 비치, 캘리포니아 주

어휘 | accommodation 숙박 시설 be responsible for *doing* ~하는 것을 책임지다 oversee 감독하다 operation 업무 overall 전반적인 cleanliness 청결 hospitality 접대, 호의 possess 보유하다 preference 선호 candidate 지원자 proficiency 능숙 cover letter 자기 소개서

1. What is NOT mentioned as a duty of this position?
(A) Recruiting housekeeping employees
(B) Supervising cleaning work
(C) Managing hotel room supplies
(D) Maintaining the hotel's appearance

해석 | 이 직위의 업무로 언급되지 않은 것은?
(A) 객실 관리 직원 채용하기
(B) 청소 업무 감독하기
(C) 호텔 객실 비품 관리하기
(D) 호텔 외관 유지하기

해설 | Not/True 문제
구인 광고에서 업무 내용에 대한 것은 지문의 중반부에 나열되므로 이 부분을 유의하여 살펴보자. (A)는 단서 (1A)에서 직원 고용을 한다고 했고, (B)는 단서 (1B)에서 객실 관리 직원의 업무 감독을 한다고 했으며, (D)는 단서 (1D)에서 모든 고객 시설의 청결함을 보장한다고 했다. 그러나 호텔 객실 비품 관리에 대한 내용은 언급되지 않았으므로 정답은 (C).

2. What does this job require?
(A) Knowledge of the Davey Beach area
(B) Availability at flexible times
(C) Fluency in several languages
(D) Experience as a hotel manager

해석 | 이 직업이 요구하는 것은?
(A) 데이비 비치 지역에 대한 지식
(B) 유연 근무 가능성
(C) 몇 가지 언어의 유창함
(D) 호텔 관리자로서의 경력

해설 | 특정 정보 확인 문제
단서 (2)에서 근무 일정에 야간 근무와 주말 근무가 포함된다고 했으므로, 이 직업은 유연 근무를 요구하고 있음을 알 수 있다. 따라서 정답은 (B). 자격 요건으로 관리직 경력을 요구하고 있기는 하나, 이것이 반드시 호텔 관리자로서의 경력을 의미하는 것은 아니므로 (D)는 오답이다.

[3-6] 기사

Organics Market Transforms Grocery Shopping
By Andrew Garner

Health foods retailer Organics Market has initiated a new service that will change the landscape of

오가닉스 마켓, 식료품 구매를 완전히 바꿔 놓다
앤드류 가너 작성

건강 식품 소매업체 오가닉스 마켓은 개인의 식료품 구매의 지형을 변화시킬 새로운 서비스를 개시했다. **3** 가정 수확이라고 불리는 이

personal grocery shopping. **3** The program, called Home Harvest, provides customers with **4C** weekly deliveries of **4D** fresh organic produce **4A** at a lower cost than in a store. – [1] –

Spokesperson Jane Ryder claims that the program will benefit both the local community and the customers. **4B, 6** The company will use only produce from local farmers, increasing revenue for small businesses. – [2] –

5 The region's director of health, Mark Swenson, is giving his support for Organics Market's program. He plans to encourage hospitals to advertise the service, and to educate the public about the importance of choosing healthy local foods. – [3] – People interested in the program can attend one of Organics Market's information sessions, which are held weekly on Wednesdays at 7 P.M. – [4] – Details of the program can be found at www.organicsmarket. net. Registration forms are available at the customer service desk of any Organics Market retailer.

프로그램은 **4A** 매장에서 구매하는 것보다 적은 비용으로 **4D** 신선한 유기농 제품을 고객들에게 **4C** 주 1회 배달해 준다. – [1] –

대변인인 제인 라이더 씨는 이 프로그램이 지역 사회와 고객 모두에게 유익할 것이라고 주장한다. **4B, 6** 회사는 현지 농부들의 농산물만 사용하여 소규모 업체들의 수익을 증가시킬 것이다. – [2] –

5 지역 보건 책임자인 마크 스웬슨 씨는 오가닉스 마켓의 프로그램에 지지를 보내고 있다. 그는 병원들로 하여금 이 서비스를 광고하도록 장려하고, 건강에 좋은 지역 농산물을 선택하는 것의 중요성에 관해 대중을 교육할 계획이다. – [3] – 프로그램에 관심 있는 사람들은 일주일에 한 번씩 수요일 저녁 7시에 열리는 오가닉스 마켓의 설명회에 참석할 수 있다. – [4] – 프로그램에 대한 세부 사항은 www.organicsmarket.net에서 찾을 수 있다. 신청서는 어느 오가닉스 마켓 소매업체의 고객 서비스 창구에서나 구할 수 있다.

어휘 | initiate 개시하다　landscape 지형　organic produce 유기농 제품　spokesperson 대변인　claim 주장하다　benefit 유익하다; 혜택 revenue 수익　encourage A to *do* A가 ~하도록 장려하다　information session 설명회

3. What is the article mainly about?
(A) The organic food market
(B) The local farming industry
(C) A public health campaign
(D) A home delivery service

해석 | 기사의 주제는?
(A) 유기농 식품 시장
(B) 지역 농업
(C) 공중 보건 운동
(D) 가정 배달 서비스

해설 | **주제, 목적 문제**
기사는 보통 첫 문단에 기사 전체의 주제가 드러난다. 단서 (3)에 따르면 고객들에게 주 1회 유기농 제품을 배달하는 서비스를 제공하기 시작했다고 하였으므로 정답은 (D). 식품 시장이 아니라 식료품점에서 제공하는 배달 서비스에 대한 내용이므로 (A)는 오답이다.

4. What is NOT true about the Home Harvest program?
(A) It reduces grocery costs.
(B) It supports farmers in the region.
(C) It delivers produce daily.
(D) It sells fresh produce.

해석 | 가정 수확 프로그램에 관해 사실이 아닌 것은?
(A) 식료품 비용을 줄인다.
(B) 지역 농가를 지원한다.
(C) 농산물을 매일 배달한다.
(D) 신선한 농산물을 판매한다.

해설 | **Not/True 문제**
Not/True 문제는 지문과 선택지를 하나하나 대조해가며 풀어야 한다. (A)는 단서 (4A)에서 비용이 적게 든다고 했고, (B)는 단서 (4B)에서 현지 농부들의 농산물만 사용하여 소규모 업체들의 수익을 증가시킬 것이라 했으며, (D)는 단서 (4D)에서 신선한 유기농 제품을 배달해 준다고 했다. 그러나 (C)는 매일이 아니라 주 1회 배달한다고 했으므로 틀린 내용이다. 따라서 정답은 (C).

5. What is suggested about Mark Swenson?

(A) **He believes healthy eating is important.**
(B) He developed the Home Harvest program.
(C) He works at a regional hospital.
(D) He designed health awareness advertisements.

해석 | 마크 스웬슨 씨에 대해 암시된 것은?
(A) 건강한 식사가 중요하다고 믿는다.
(B) 가정 수확 프로그램을 개발했다.
(C) 지역 병원에서 일한다.
(D) 건강 인식 고취 광고를 고안했다.

해설 | **추론 문제**
문제에 사람 이름이 등장하면, 지문에서 그 이름이 언급된 부분을 찾아보자. 단서 (5)에서 그는 건강에 좋은 지역 농산물을 선택하는 것의 중요성에 대해 대중을 교육할 계획이라고 했으므로 이 말을 패러프레이징한 (A)가 정답이다. 가정 수확 프로그램을 지지한다고 했을 뿐 이를 개발했다고 하지 않았으므로 (B)는 오답.

6. In which of the positions marked [1], [2], [3], and [4] does the following sentence best belong?

"As for customers, they get high-quality organic produce."

(A) [1]
(B) [2]
(C) [3]
(D) [4]

해석 | [1], [2], [3] [4]번으로 표시된 위치들 중 다음 문장이 들어가기에 가장 적절한 곳은?
"고객들의 경우, 좋은 품질의 유기농 제품을 살 수 있다."

(A) [1]
(B) [2]
(C) [3]
(D) [4]

해설 | **문장 위치 찾기 문제**
지문이 전체적으로 유기농 제품 소매점에서 새롭게 도입되는 배달 서비스를 소개하고 있는데, 제시된 문장은 고객에게 유익한 점과 관련된 내용이다. 따라서 해당 서비스의 혜택에 대해서 언급하고 있는 부분을 찾아야 한다. 두 번째 문단에서 지역 사회와 고객 모두에게 유익한 점에 대해서 언급하고 있다. 단서 (6)에서 지역 사회에 주는 혜택이 언급되고 있으므로 고객에게 주는 혜택이 이 문장 뒤에 이어지는 것이 자연스럽다. 따라서 정답은 (B).

[7-11] 광고 & 편지 & 쿠폰

Travel in Comfort!

Rondeau Rides has been providing excellent transportation services to individuals and businesses throughout Ohio since 1977. We offer everything from private limousines for individuals to large buses for groups. **7** We take excellent care of our vehicles by checking them regularly and cleaning them thoroughly after every ride.

10-2 Each Rondeau driver receives sixty hours of training and is required to complete courses in defensive driving. They know the city very well and are able to navigate the best routes—even with heavy traffic—in order to save time.

When you travel with us, you will always feel safe and comfortable. Call Rondeau Rides at 276-2349 today to book a pickup!

편안하게 여행하세요!

론도 라이즈 사는 1977년 이후로 오하이오 주 전역에 걸쳐 개인 및 기업에게 훌륭한 교통 서비스를 제공하고 있습니다. 저희는 개인 손님을 위한 개인용 리무진에서부터 단체 손님을 위한 대형 버스까지 모든 것을 제공합니다. **7** 저희는 차량을 정기적으로 점검하고, 탑승 후 매번 철저히 청소하여 차량들을 매우 잘 관리합니다.

10-2 모든 론도 사의 기사들은 60시간의 훈련을 받아야 하며 안전 운전 과정을 수료해야 합니다. 그들은 도시를 매우 잘 알며 심지어 교통량이 많을 때에도 시간을 절약하기 위한 최적의 경로를 찾을 수 있습니다.

저희와 함께 여행하시면, 항상 편안함과 안전함을 느끼실 수 있을 것입니다. 오늘 론도 라이즈 사에 276-2349로 전화하셔서 픽업을 예약하세요!

어휘 | take care of ~을 돌보다 regularly 정기적으로 thoroughly 철저히 be required to do ~하도록 요구되다 navigate 길을 찾다

DAY 28

Mayra Santiago
11-2 Rondeau Rides, Cheapside
2641 Viking Drive
Worthington, OH 43085

Dear Ms. Santiago,

8 I wanted to commend your employees for their professionalism. I am the general manager of Impala Hotels, and for the last five years, our two companies have worked together. I can always rely on the quality of your service to provide transportation to my guests.
Recently, I've received a number of positive reviews from customers mentioning your drivers, so I wanted to send a small token of my gratitude. Enclosed with this letter are coupons to be given to each of your drivers. **11-3** Since we have a branch near your headquarters, I thought they might like to try that hotel's restaurant. Please accept these coupons with my compliments.

Kind thanks,

Esteban Odell
General Manager, Impala Hotels

마이라 산티아고
11-2 론도 라이즈, 치프사이드
바이킹 드라이브 2641번지
워싱턴, 오하이오 주 43085

산티아고 씨께,

8 귀사 직원분들의 전문성을 칭찬하고 싶습니다. 저는 임팔라 호텔의 총지배인이며, 지난 5년간 저희 두 회사는 함께 일해왔습니다. 저희 고객분들께 교통편을 제공해주시는 귀사 서비스의 품질을 항상 신뢰할 수 있습니다.

최근에, 저는 귀사의 기사분들을 언급하는 고객분들의 긍정적인 평가를 많이 받아서 제 작은 감사의 표시를 보내고 싶었습니다. 이 편지에 동봉된 것은 귀사의 모든 기사분들께 드릴 수 있는 쿠폰입니다. **11-3** 귀사의 본사 근처에 저희 지점이 있기 때문에 기사분들이 그 호텔의 식당에서 드셔보시는 것을 좋아할 것이라고 생각했습니다. 제 칭찬의 말과 함께 이 쿠폰들을 받아 주시기 바랍니다.

임팔라 호텔 총지배인
에스테반 오델 드림

어휘 | commend A for B B에 대해 A를 칭찬하다 **professionalism** 전문성 **general manager** 총지배인 **rely on** ~을 신뢰하다, ~에 의지하다
a number of 많은, 다수의 **a token of gratitude** 감사의 표시로 **headquarters** 본사 **accept** 받아들이다 **compliment** 칭찬, 찬사

* IMPALA HOTELS COUPON *

Issued by: Esteban Odell
9D Holder: **10-1** Jeanie Battochi, Rondeau Rides

The holder of this coupon is entitled to one free sandwich set, which includes the soup of the day and a drink. **9C** This voucher is valid at the following locations: **11-1** Amore in Downtown, Juliano's in Southend, Bella in Cheapside, Napoli in Doonesbury.
9B Please present this voucher to the service staff when placing your order.

Coupon valid until: September 4

* 임팔라 호텔 쿠폰 *

발행인: 에스테반 오델
9D 소지자: **10-1** 론도 라이즈 사, 지니 바토치

이 쿠폰의 소지자에게는 오늘의 수프와 음료수가 포함된 샌드위치 세트 하나가 무료로 주어집니다. **9C** 이 쿠폰은 다음 장소에서 유효합니다: **11-1** 다운타운 지점의 아모레 식당, 사우스엔드 지점의 줄리아노스 식당, 치프사이드 지점의 벨라 식당, 둔즈베리 지점의 나폴리 식당.

9B 주문하실 때 서비스 직원에게 이 쿠폰을 제시하세요.

쿠폰 유효 기한: 9월 4일

어휘 | holder 소지자 **be entitled to A** A의 권리가 있다 **voucher** 쿠폰, 상품권 **present** 제시하다 **place an order** 주문하다 **valid** 유효한

7. What is mentioned about the Rondeau Rides?

 (A) It maintains its vehicles in good condition.

 (B) It recently opened its business.

 (C) It has never gotten into an accident.

 (D) It just repainted its vehicles.

해석 | 론도 라이즈 사에 대해 언급된 것은?

(A) 차량들을 좋은 상태로 유지한다.

(B) 최근에 개업했다.

(C) 한 번도 사고를 내지 않았다.

(D) 차량들을 막 다시 칠했다.

해설 | Not/True 문제

론도 라이즈 사에 대해 묻고 있으므로, 광고의 내용을 살펴본다. 단서 (7)에 따르면, 론도 라이즈 사는 정기적으로 차를 점검하고 청소하여 차량을 매우 잘 관리한다고 했으므로 정답은 (A). 1977부터 회사를 운영하고 있다고 하였으므로 (B)는 오답이다.

8. Why did Mr. Odell write to Ms. Santiago?

 (A) To ask about pricing options

 (B) To express gratitude for a service

 (C) To form a new partnership

 (D) To arrange a pick-up location

해석 | 오델 씨가 산티아고 씨에게 편지를 쓴 이유는?

(A) 가격 옵션에 대해 문의하기 위해

(B) 서비스에 대한 감사를 표현하기 위해

(C) 새로운 협력관계를 구축하기 위해

(D) 픽업 장소를 정하기 위해

해설 | 주제, 목적 문제

편지의 목적은 지문의 초반부에 명시되어 있으므로 이 부분을 살펴본다. 단서 (8)에서 오델 씨가 론도 라이즈 사 직원들의 전문성을 칭찬하고 싶다고 하였으므로 정답은 (B).

9. What is NOT indicated on the voucher?

 (A) When it was issued

 (B) How to use it

 (C) Where it can be used

 (D) Who it belongs to

해석 | 쿠폰에 시사되지 않은 것은?

(A) 언제 발급되었는지

(B) 어떻게 사용하는지

(C) 어디서 사용 가능한지

(D) 누구의 것인지

해설 | Not/True 문제

세 번째 지문인 쿠폰을 살펴봐야 한다. (B)는 단서 (9B)에서 서비스 직원에게 제시하라고 나타나있고, (C)는 단서 (9C)에서 사용처를 명시하고 있으며, (D)는 단서 (9D)에서 소지자를 알 수 있다. 그러나 발급 일자는 알 수 없으므로 정답은 (A).

10. What can be inferred about Ms. Battochi?

 (A) She is planning to reserve a private car.

 (B) She wrote a positive review about Rondeau Rides.

 (C) She often stays at Impala Hotel.

 (D) She has taken a driving class.

해석 | 바토치 씨에 대해 추론할 수 있는 것은?

(A) 개인 차량을 예약할 예정이다.

(B) 론도 라이즈 사에 대한 긍정적인 후기를 썼다.

(C) 임팔라 호텔에서 자주 머무른다.

(D) 운전 교육을 받았다.

해설 | 두 지문 연계 문제

쿠폰과 광고를 함께 보고 연계해서 추론하는 문제. 단서 (10-1)에서 쿠폰의 소지자가 론도 라이즈 사 소속인 지니 바토치 씨임을 알 수 있다. 광고의 단서 (10-2)에 따르면, 회사의 모든 기사들은 60시간의 훈련을 받아야 하고 안전 운전 과정을 수료해야 한다고 했으므로 바토치 씨도 이 운전 교육을 받았음을 추론할 수 있다. 따라서 정답은 (D).

11. At which restaurant will Ms. Battochi most likely use her voucher?

 (A) Amore

 (B) Juliano's

 (C) Bella

 (D) Napoli

해석 | 바토치 씨가 그녀의 쿠폰을 사용할 것 같은 식당은?

(A) 아모레

(B) 줄리아노스

(C) 벨라

(D) 나폴리

해설 | 두 지문 연계 문제

쿠폰과 편지를 함께 봐야하는 연계 문제. 바토치 씨는 쿠폰의 소지자로 론도 라이즈 사 기사이다. 쿠폰의 단서 (11-1)에서 사용 가능한 호텔 지점의 식당 네 군데가 언급되었다. 두 번째 지문인 편지의 단서 (11-2)에서 수신인의 주소를 보면, 론도 라이즈 사가 치프사이드에 위치해 있음을 알 수 있다. 단서 (11-3)에서 론도 라이즈 사의 본사가 임팔라 호텔의 지점 중 한 곳 근처에 있어서 쿠폰을 제공한다고 했으므로 바토치 씨는 치프사이드 지점의 벨라 식당에서 쿠폰을 사용할 것임을 추론할 수 있다. 따라서 정답은 (C).

예제 해석

교재 269쪽

[예제 1] 설명서/지시문

K-MAX90 Blender User's Manual

Package Contents: K-MAX90 motor base, regular blade set, 64 oz. blender jar with lid, interior juice strainer, recipe booklet

Set-up Instructions:

1) Assemble the blender by screwing the blade set into the base of the blender jar.
2) Place the jar on the motor base and turn clockwise until it clicks into place.
3) Plug in the device. Your blender is now ready for use.

Safety Warnings:

– Do not operate the device if it appears to be damaged.
– Only food and beverage items should be placed in the device.
– Unplug the motor when not in use.

For questions or concerns about this product, please contact us at service@kmaxelectronics.com.

K-MAX90 믹서기 사용 설명서

구성 품목: K-MAX90 전동기 받침, 표준 칼날 세트, 뚜껑이 있는 64온스 믹서기 단지, 내부 과즙 여과기, 조리법 소책자

조립 안내:

1) 믹서기 단지의 바닥에 칼날을 돌려서 믹서기를 조립하십시오.
2) 전동기 받침 위에 단지를 올리고, 고정될 때까지 시계 방향으로 돌려주십시오.
3) 전원을 연결하십시오. 이제 믹서기는 사용할 준비가 되었습니다.

안전 경고:

– 손상된 것으로 보이면 기기를 작동시키지 마십시오.
– 음식이나 음료 제품들만 기기 안에 넣으십시오.
– 사용하지 않을 때는 전동기 플러그를 뽑아두십시오.

본 제품에 대한 문의나 기타 용무가 있으시면 service@kmaxelectronics.com으로 연락해 주십시오.

어휘 | blade 칼날 jar 단지 strainer 여과기, 체 recipe 조리법 booklet 소책자 assemble 조립하다 screw 돌려서 조이다 clockwise 시계 방향으로 click into place 딱 들어맞다 operate 작동시키다 unplug 플러그를 뽑다

[예제 2] 웹페이지

Mansion Homes
Live a life of luxury!

HOME	INFORMATION	**VISITATIONS**	PICTURES

If you are interested in viewing some of the units available at the Mansion Homes residential area, we would be more than happy to arrange that for you! Tours of homes are available from Monday through Saturday anytime between 10 A.M. and 1 P.M. Just let us know which time is the most convenient for you. You can choose to see three different units, or simply choose the ones you are most interested in viewing:

■ Palace Unit: A two-bedroom home with a living room, kitchen, dining room, and bathroom
■ Mansion Unit: A two-bedroom home with a living room, kitchen, dining room, and two bathrooms
■ Castle Unit: A three-bedroom home with a living

맨션 홈즈
호화로운 생활을 누리세요!

홈	정보	방문	사진

맨션 홈즈 주택가에서 구입 가능한 주택을 보고 싶으시면, 저희가 기꺼이 일정을 잡아 드리겠습니다!

주택 방문은 월요일부터 토요일까지 오전 10시와 오후 1시 사이에 아무 때나 가능합니다. 어느 때가 가장 편리하신지 정도만 알려 주십시오. 세 개의 다른 주택을 보실 수도 있고, 또는 가장 보시고 싶은 주택들만 선택하셔도 됩니다:

■ 팰리스 주택: 거실, 주방, 식당, 욕실이 있는 방 두 개짜리 주택
■ 맨션 주택: 거실, 주방, 식당, 두 개의 욕실이 있는 방 두 개짜리 주택
■ 캐슬 주택: 거실, 주방, 식당, 두 개의 욕실, 차고가 있는 방 세 개짜리 주택

room, kitchen, dining room, two bathrooms, and garage

Simply send an e-mail to office@mhomes.com, and we can make an appointment for you.

office@mhomes.com으로 이메일만 보내시면 예약을 해드리겠습니다.

어휘 | visitation 방문(권) be interested in *doing* ~하는 데 관심이 있다 residential area 주택가 arrange ~의 일정을 잡다, ~을 준비하다
convenient 편리한 dining room 식당 garage 차고 make an appointment 예약[약속]을 하다

패러프레이징

예제 (A) / 1. (A)　　　2. (B)　　　3. (B)　　　4. (A)　　　5. (A)

[예제 3] 패러프레이징

On behalf of the Social Research Association, I'd like to express my appreciation for your participation in our research project.

사회 조사 협회를 대표하여, 우리의 연구 프로젝트에 참여해 주신 데 대해 감사를 표하고 싶습니다.

Why was the e-mail sent?
(A) To thank the reader for participating in a study
(B) To invite the reader to an upcoming conference

해석 | 이메일이 보내진 이유는?
(A) 연구에 참여해 준 것에 대해 읽는 이에게 감사하기 위해
(B) 곧 있을 회의에 읽는 이를 초대하기 위해

해설 | 연구 참여에 대해 감사를 표하고 있으므로 정답은 (A). 지문의 express my appreciation for your participation in our research project가 정답에서 유의어를 활용해 thank the reader for participating in a study로 패러프레이징되었다.

1.

We are writing to inform you that your February electricity bill was due on March 10. Two weeks have passed since that date, so $5 were added to your balance. You now have a balance of $32. Please make a payment before April 8 to avoid further fees.

귀하의 2월 전기요금의 납부 기한이 3월 10일이었음을 알려드리고자 공지를 드립니다. 그 날로부터 2주가 지나서, 5달러가 귀하의 지불 잔액에 추가되었습니다. 귀하의 현재 지불 잔액은 32달러입니다. 추가 비용을 피하기 위해서 4월 8일 이전까지 지불해 주십시오.

Why was the notice written?
(A) To warn that a bill is overdue
(B) To confirm receipt of a payment

해석 | 이 공지가 작성된 이유는?
(A) 청구서의 납부 기한이 지났음을 경고하기 위해
(B) 지불금 수령을 확인하기 위해

해설 | 요금 납부 기한이 지났음을 알리고 지불 잔액과 추가 납부 기한을 공지하고 있으므로 정답은 (A). 지문의 Two weeks have passed가 정답에서 함축 표현인 overdue로 패러프레이징되었다.

2.

Tomorrow's conference was originally scheduled to start at 8:30 A.M. However, some attendees are coming from far away and asked for a later start. The presentations will therefore be pushed back thirty minutes. Thus, we will begin at 9 A.M. and end at 5:30 P.M.

내일 회의는 원래 오전 8시 30분에 시작하는 것으로 일정이 잡혀있었습니다. 그러나, 몇몇 참석자께서 먼 곳에서 오셔서 조금 더 늦게 시작할 것을 요청했습니다. 그러므로 발표들은 30분씩 뒤로 연기될 것입니다. 따라서, 우리는 오전 9시에 시작하고 오후 5시 30분에 끝날 것입니다.

To whom was this e-mail most likely sent?

(A) Drivers for a transportation service

(B) Guests for an event

해석 | 이 이메일이 보내졌을 대상은?

(A) 교통 서비스의 기사들

(B) 행사의 손님들

해설 | 참석자들이 늦게 시작할 것을 요청하여 회의가 미뤄질 예정임을 알리고 있으므로 이메일이 회의 참석자들에게 보내졌음을 알 수 있다. 따라서 정답은 (B). 지문의 some attendees가 정답에서 상위 개념인 Guests로, conference가 상위 개념인 an event로 패러프레이징되었다.

3.

Next Sunday, the Betista band will give a performance at the outdoor theater of Singsong Gardens. There is no entrance fee, but advanced registration is required. Tickets may be reserved from the Singsong Gardens Web site or by phone at 444-0294.

다음 주 일요일에, 베티스타 밴드가 싱송 가든스의 야외 극장에서 공연을 할 예정이다. 입장료는 없지만, 사전 등록이 요구된다. 표는 싱송 가든스 웹사이트나 444-0294로 전화를 걸어 예약할 수 있다.

What is true about the performance?

(A) Spectators must pay for a ticket.

(B) Reservations can be done online.

해석 | 공연에 대해 사실인 것은?

(A) 관중들은 티켓 요금을 지불해야 한다.

(B) 예약은 온라인으로 할 수 있다.

해설 | 예약은 웹사이트나 전화를 통해 가능하다고 했으므로 정답은 (B). 지문의 be reserved가 정답에서 품사를 바꾸어 Reservations로, Web site가 상위 개념인 online으로 패러프레이징되었다.

4.

On October 22, renovations will begin in our office lobby. Workers will be installing a new reception desk. As a result, the main entrance will be blocked for about three weeks. For the duration of the renovations, please use the back door to enter the building.

10월 22일에, 우리 사무실 로비에서 개조 작업이 시작될 것입니다. 작업자들이 새로운 안내 데스크를 설치할 것입니다. 그 결과, 주 출입구는 약 3주 동안 차단될 것입니다. 개조 기간 동안, 뒷문을 이용해 건물에 출입해주십시오.

What are employees asked to do?

(A) Use a back entrance

(B) Replace some equipment

해석 | 직원들이 하도록 요청받은 것은?

(A) 뒷문을 사용하기

(B) 몇몇 장비를 교체하기

해설 | 개조 기간 동안 건물에 출입하려면 뒷문을 이용해야 한다고 하였으므로 정답은 (A). 지문의 the back door가 정답에서 동의어인 a back entrance로 패러프레이징되었다.

5.

Business class ticket. Two pieces of check-in luggage under 30 kg permitted. One carry-on bag under 8 kg. Ticket is nonrefundable. Changes permitted for a fee of $85. Please confirm flight 24 hours prior to departure. Online check-in available.

비즈니스석 티켓. 30kg 이하의 수하물 2개 허용됨. 8kg 이하의 기내용 가방 1개. 티켓은 환불되지 않음. 변경은 수수료 85달러에 허용됨. 출발 24시간 전에 비행편 확정 요망. 온라인 탑승 수속 가능.

What is indicated about the ticket?

(A) It cannot be reimbursed.

(B) It allows only one suitcase.

해석 | 티켓에 대해 시사된 것은?

(A) 상환받을 수 없다.

(B) 한 개의 여행 가방만 허용한다.

해설 | 티켓 환불은 불가능하며 유료로 변경이 가능하다 했으므로 정답은 (A). 지문의 nonrefundable이 정답에서 유의어인 cannot be reimbursed로 패러프레이징되었다.

FINAL TEST

교재 272쪽

1. (C) 2. (A) 3. (B) 4. (B) 5. (C)

[1-2] 정보문

Thank you for purchasing the Soldo electric piano. ¹ To ensure that your new keyboard lasts as long as possible, please follow the directions below.

· Do not stand the Soldo on its side. ^{2D} Always keep it parallel to the ground.
· ^{2B} Do not install the Soldo near any heat source, such as a stove, fireplace, or radiator.
· After plugging in the Soldo, ^{2C} ensure that all of the cables are safely placed away from any walking path to avoid tripping on a cord.
· For cleaning, use a dry cloth to wipe each part. ^{2A} Do not use water as this will damage the circuits.
· Unplug the Soldo during lightning storms.

Your Soldo electric piano comes with a one year warranty. With proper care, it has a life expectancy of approximately ten years.

솔도 전자 피아노를 구매해 주셔서 감사합니다. ¹ 귀하께서 구매하신 새로운 키보드가 가능한 한 오래 지속될 수 있도록 아래 지시 사항을 따라주세요.

· 솔도 피아노를 옆으로 세워두지 마세요. ^{2D} 항상 지면과 평행하게 유지시켜 주세요.
· ^{2B} 솔도 피아노를 난로나, 벽난로, 난방기와 같은 열원 옆에 설치하지 마세요.
· 솔도 피아노 플러그를 꼽은 후에, ^{2C} 코드에 걸려 넘어지지 않도록 반드시 케이블 선을 걸어다니는 길에서 떨어져 있도록 안전하게 놓아주세요.
· 세척하실 때에는 마른 헝겊으로 각 부분을 닦아주세요. ^{2A} 전기 회로에 손상을 입힐 수 있으므로 물은 사용하지 마세요.
· 번개를 동반하는 폭풍이 치는 동안에는 솔도 피아노 플러그를 뽑아주세요.

귀하께서 구매하신 솔도 전자 피아노는 1년 품질 보증서가 따라 나옵니다. 적절하게 관리하시면, 수명은 약 10년 정도입니다.

어휘 | ensure ~을 보장하다 last 지속하다 on one's side 옆으로 parallel to ~에 평행한 away from ~에서 떨어져 trip on ~에 발이 걸려 넘어지다 damage 손상을 입히다 circuit (전기) 회로 warranty 품질 보증서 life expectancy 수명

1. Where can this information be found?
(A) On a concert program
(B) In a recipe book
(C) In a user manual
(D) In a company policy statement

해석 | 이 정보문을 찾을 수 있는 곳은?
(A) 음악회 프로그램 책
(B) 조리법 책
(C) 사용자 설명서
(D) 회사 정책 설명서

해설 | **대상, 출처 문제**
단서 (1)에서, 제품이 오래 지속될 수 있도록 지시 사항을 따르라고 하고 그 뒤에 여러 지시 사항들이 나온다. 이는 사용자 설명서에 나올 수 있는 내용이므로 정답은 (C).

2. According to the information, what is NOT recommended?
(A) Using water to clean
(B) Keeping the device away from heat
(C) Placing the cables out of reach
(D) Holding the keyboard flat

해석 | 정보문에 따르면, 추천되지 않는 것은?
(A) 물을 이용해서 세척하기
(B) 기기를 열에서 멀리 두기
(C) 케이블 선을 손이 닿지 않는 곳에 두기
(D) 키보드를 평평하게 놓기

해설 | **Not/True 문제**
Not/True 문제는 선택지를 지문과 하나씩 대조해가며 풀어야 한다. (B)는 단서 (2B)에서 열원 옆에 두지 말라고 했고, (C)는 단서 (2C)에서 걸어다니는 길에서 멀리 두라고 했으며, (D)는 단서 (2D)에서 지면과 평행하게 두라고 했으므로 오답이다. 그러나 단서 (2A)에서 물은 사용하지 말라고 했으므로 지시 사항과 다른 (A)가 정답이다.

DAY 29

http://www.falconair.com/bookings

FALCON AIR INTERNATIONAL

Gets you where you want to be!

Home	Flight Schedules	Policies	³ Frequent Fliers	**Bookings**	Contact

Please confirm the following information and itinerary for your planned flight. If everything is accurate, click the PAYMENT button below. If any change is required, click BACK and edit where necessary.

RESERVATION NUMBER: 85590-23782

Passenger(s)	Erica Cavendish	Address	1267-B Queens St. Toronto, Ontario
Frequent flier number	EC-74836758	Phone number	(647)555-5823
Passport number	LF548697	E-mail	ercave@zmail.com
Departure	Flight: FA445, March 11, 7:45 A.M. Toronto Pearson International Airport ⁴ Arrival: Chicago O'Hare International Airport 9:15 A.M.		
Return	Flight: FA443, March 14, 9:30 A.M. Chicago O'Hare International Airport Arrival: Toronto Pearson International Airport 11:00 A.M.		
Details	Business class ticket. ⁵ Two pieces of check-in luggage under 30 kg permitted. One carry-on bag under 8 kg. Ticket is nonrefundable. Changes permitted for a fee of $85. Please confirm flight 24 hours prior to departure. Online check-in available. ***Request for vegetarian meal received.		

BACK	PAYMENT

http://www.falconair.com/bookings

팔콘 에어 인터내셔널

여러분이 가고자 하시는 곳에 모셔다 드립니다!

홈	비행 일정	방침	³ 상용 고객	예약	연락

예정된 비행에 관한 다음 정보와 일정표를 확인해 주시기 바랍니다. 모든 사항이 정확하면, 아래의 '지불' 버튼을 누르세요. 변경이 필요하다면, '뒤로' 버튼을 눌러서 필요한 곳을 수정하세요.

예약 번호: 85590-23782

승객(들)	에리카 캐번디시	주소	퀸즈 가 1267-B번지 토론토, 온타리오 주
상용 고객 번호	EC-74836758	전화번호	(647)555-5823
여권 번호	LF548697	이메일	ercave@zmail.com
출발	비행편: FA445편, 3월 11일 오전 7시 45분, 토론토 피어슨 국제 공항 ⁴ **도착: 시카고 오헤어 국제 공항, 오전 9시 15분**		
복귀	비행편: FA443편, 3월 14일 오전 9시 30분, 시카고 오헤어 국제 공항 도착: 토론토 피어슨 국제 공항, 오전 11시 정각		
세부 사항	비즈니스석 티켓. ⁵ **30kg 이하의 수하물 2개 허용됨.** 8kg 이하의 기내용 가방 1개. 티켓은 환불되지 않음. 변경은 수수료 85달러에 허용됨. 출발 24시간 전에 비행편 확정 요망. 온라인 탑승 수속 가능. ***채식주의 식사 요청 접수됨.		

뒤로	지불

어휘 | frequent flier (항공사의 마일리지 서비스에 가입된) 상용 고객 **itinerary** 일정표 **accurate** 정확한 **departure** 출발 **return** 복귀 **check-in luggage** 수하물, 부칠 짐 **carry-on bag** 기내용 가방 **nonrefundable** 환불되지 않는 **prior to** ~ 전에

3. What is indicated about Falcon Air?

(A) It has flights to Chicago every day.

(B) It has a membership program for frequent users.

(C) It refunds tickets under certain conditions.

(D) It accepts payment only online.

해석 | 팔콘 에어에 관해 시사된 것은?
(A) 매일 시카고 행 비행편이 있다.
(B) 상용 고객들을 위한 회원 프로그램이 있다.
(C) 특정 조건 하에서는 티켓을 환불해 준다.
(D) 온라인 지불만 받는다.

해설 | **Not/True 문제**
지문 상단의 여러 가지 메뉴 중 단서 (3)에 '상용 고객(Frequent Fliers)'이라는 메뉴가 따로 있으므로 (B)가 정답. 이처럼 웹페이지의 메뉴가 단서가 될 수도 있으므로 주의하여 살펴보자. 지문의 Frequent Fliers가 정답에서 frequent users로 바꾸어 표현되었다. (A), (C), (D)는 언급되지 않았으므로 모두 오답이다.

4. At what time will Ms. Cavendish's flight land in Chicago?

(A) 7:45 A.M.

(B) 9:15 A.M.

(C) 9:30 A.M.

(D) 11:00 A.M.

해석 | 캐번디시 씨가 탈 비행기가 시카고에 착륙할 시간은?
(A) 오전 7시 45분
(B) 오전 9시 15분
(C) 오전 9시 30분
(D) 오전 11시 정각

해설 | **특정 정보 확인 문제**
캐번디시 씨는 비행기를 예약한 승객으로, 비행기의 이착륙 정보는 Departure와 Return 부분에서 찾을 수 있다. 단서 (4)에서 시카고 오헤어 국제 공항에 오전 9시 15분에 착륙할 것임을 알 수 있으므로 정답은 (B). 지문의 Arrival이 문제에서 land in으로 바꾸어 표현되었다.

5. What is suggested about Ms. Cavendish?

(A) She chose a meal with meat for her flight.

(B) She can get a full refund for her ticket.

(C) She is allowed to bring more than one baggage.

(D) She should arrive at the airport one day prior to departure.

해석 | 캐번디시 씨에 대해 암시된 것은?
(A) 기내식으로 육류를 선택했다.
(B) 비행기표를 전액 환불받을 수 있다.
(C) 하나 이상의 수하물을 가져올 수 있다.
(D) 공항에 출국일보다 하루 일찍 도착해야 한다.

해설 | **추론 문제**
Details 항목을 통해 답을 찾을 수 있다. 단서 (5)에서 '30kg 이하의 수하물 2개 허용됨'이라고 했으므로 정답은 (C). 지문의 Two pieces of check-in luggage가 정답에서 more than one baggage로 바꾸어 표현되었다.

예제 해석

교재 277쪽

[예제 1] 송장/청구서

Colonial Pottery
Distribution Center
201 Atlantic Drive
Salem, MA 01970

Customer:
Four Seasons Greenhouse
161 North Highway
Lewiston, ME 04240

Statement:

Date	Description	Amount
5/11	Six-inch clay pots, plain (4 dozen)	$36.00
	Sixteen-inch clay pots, ornamental (2 dozen)	$240.00
	Shipping and handling (see below for details)	$59.99
	Discount (see below for details)	$27.60
	Amount due	$308.39

Message:
This shipment was sent by special delivery at the buyer's request. Please return any damaged items, along with the original receipt, within seven working days.
A ten-percent discount applies to all first-time orders placed by retailers. This discount does not apply to shipping and handling charges.

콜로니얼 도기
유통 센터
애틀랜틱 드라이브 201번지
세일럼, 매사추세츠 주 01970

고객:
포 시즌스 그린하우스
노스 하이웨이 161번지
루이스턴, 메인 주 04240

명세서:

날짜	내역	금액
5월 11일	장식 없는 6인치 점토 화분 (48개)	36달러
	장식 있는 16인치 점토 화분 (24개)	240달러
	운송 및 취급 (자세한 사항은 아래 참조)	59달러 99센트
	할인 (자세한 사항은 아래 참조)	27달러 60센트
	지불 금액	308달러 39센트

메시지:
본 화물은 구매자의 요청에 따라 특별 배송으로 배달되었습니다. 파손된 물품이 있는 경우, 영업일 기준 7일 이내에 영수증 원본과 함께 반송해 주십시오.

소매업체의 모든 최초 주문에는 10퍼센트의 할인이 적용됩니다. 본 할인은 운송 및 취급료에는 적용되지 않습니다.

어휘 | statement 명세서 description 내역, 서술 shipping and handling 운송 및 취급 along with ~와 함께 working day 영업일 retailer 소매업체 apply to ~에 적용하다 charge 요금

[예제 2] 일정표

Tampa Annual Realtors Conference
Saturday, November 3
Mesa Convention Center

9:30 A.M.　Welcome speech
Selma Armstrong; President, National Realtor's Association
10 A.M.　Speech: "Using Technology to Maximize Efficiency"
Curtis Nolte; Owner, Small-Tech Solutions

탬파 연례 부동산 중개인 총회
11월 3일 토요일
메사 컨벤션 센터

오전 9시 30분　환영사
전국 부동산 중개인 협회 회장, 셀마 암스트롱

오전 10시　연설: "효율성 극대화를 위한 기술 이용"
스몰-테크 솔루션즈 사 사장, 커티스 놀테

11 A.M.	Presentation: "Marketing for your Business and your Properties" Kenneth Wright; Director, Southside Real Estate		오전 11시	발표: "당신의 사업과 부동산을 위한 마케팅" 사우스사이드 부동산 이사, 케네스 라이트
12 noon	Lunch		정오	점심
1 P.M.	Speech: "The Key to Customer Service" Naomi Lopez; Realtor, Good Neighbors Realty		오후 1시	연설: "고객 서비스의 핵심" 굿 네이버스 부동산 중개인, 나오미 로페즈
2 P.M.	Question and answer session with presenters		오후 2시	발표자들과의 질의응답 시간
3 P.M.	Closing speech Selma Armstrong; President, National Realtor's Association		오후 3시	폐회사 전국 부동산 중개인 협회 회장, 셀마 암스트롱

All events will take place in Meeting Room 103 with the exception of the catered lunch, which will be provided in the ballroom.

연회장에서 제공되는 출장 점심을 제외한 모든 행사는 회의실 103호에서 열립니다.

어휘 | realtor 부동산 중개인 welcome speech 환영사 maximize 극대화하다 with the exception of ~을 제외하고 cater (연회 등의) 음식을 제공하다

패러프레이징

교재 279쪽

예제 (B) / **1. (A)** 2. (A) 3. (B) 4. (B) 5. (A)

[예제 3] 패러프레이징

The IT team will install new software on Friday after 5 P.M. There is a small possibility of data loss during this procedure, so employees should back up all important files before leaving for the day.

(A) The new program can back up all data automatically.
(B) An IT procedure could cause a loss of information.

IT 팀에서 금요일 오후 5시 이후에 신규 소프트웨어를 설치합니다. 이 절차 동안에 데이터 손실의 가능성이 조금 있으므로, 직원 여러분들은 퇴근하시기 전에 중요 파일을 백업해 주시기 바랍니다.

해석 | (A) 신규 프로그램이 모든 데이터를 자동으로 백업할 수 있다.
(B) IT 작업 절차가 정보 손실을 초래할 수 있다.

해설 | 신규 소프트웨어 설치 중 데이터 손실 가능성에 대해 말하고 있으므로 정답은 (B). 지문의 a small possibility of data loss가 정답에서 could cause a loss of information으로 패러프레이징되었다.

1.

Need a new couch? Come to Snooze Furniture to see our new collection of sofas and chairs. Our entire selection of high-quality merchandise is offered at the best prices around. And with nearly endless choices for every size, color, and feature, you're sure to find what you're looking for.

(A) A wide variety of products is available.
(B) The store specializes in a certain style.

새로운 소파가 필요하십니까? 스누즈 가구점으로 오셔서 저희의 새로운 소파와 의자의 소장품을 보십시오. 저희의 엄선된 고품질의 제품 모두 시중에서 가장 좋은 가격에 선보이고 있습니다. 게다가 크기, 색상, 기능별로 거의 무한대로 선택하실 수 있어, 여러분께서 원하시는 것을 반드시 찾게 되실 것입니다.

해석 | (A) 매우 다양한 제품이 이용 가능하다.
(B) 매장은 특정한 스타일을 전문으로 한다.

해설 | 크기, 색상, 기능별로 선택할 수 있는 제품이 많다고 했으므로 정답은 (A). 지문의 nearly endless choices for every size, color, and feature가 정답에서 함축 표현인 A wide variety of products로 패러프레이징되었다.

2.

Adam Hank's retirement party will be held on May 16 at Faustina's, the Italian restaurant by the office. The private party room is reserved for us from 5 P.M. until 8 P.M. Please arrive at 5 P.M. precisely so that we may give Adam his gift with everyone present.

(A) **A gathering is being organized for a retiring employee.**

(B) A restaurant manager is promoting a worker.

아담 행크 씨의 퇴직 기념 파티는 5월 16일 사무실 옆 이탈리아 식당인 파우스티나스에서 열릴 것입니다. 우리를 위한 개별 공간이 오후 5시부터 저녁 8시까지 예약되어있습니다. 모두가 참석하셨을 때 아담 씨에게 선물을 줄 수 있도록 오후 5시에 정확히 도착해주시기 바랍니다.

해석 | (A) 은퇴하는 직원을 위해 모임이 준비되고 있다.
(B) 식당 관리자가 직원을 승진시키고 있다.

해설 | 퇴직 기념 파티의 일정에 대해 알리고 있으므로 정답은 (A). 지문의 retirement party will be held가 정답에서 A gathering is being organized for a retiring employee로 패러프레이징되었다.

3.

Our sales figures for the second quarter of this year are up. Not only are they higher than last quarter's, but this quarter also saw the highest number of sales we've had so far. We hope to continue this upwards movement in the third quarter.

(A) A big sale's event is taking place.

(B) **A company had a successful second quarter.**

우리의 올해 2분기 매출 실적이 상승했습니다. 지난 분기보다 높을 뿐만 아니라 이번 분기가 우리가 지금까지 봐왔던 수치 중에서 가장 높은 숫자를 보여줬습니다. 우리는 3분기에서 이 상승 움직임이 계속되기를 바라고 있습니다.

해석 | (A) 큰 할인 행사가 열리고 있다.
(B) 회사는 성공적인 2분기를 거뒀다.

해설 | 올해 2분기 매출 실적이 상승했다고 했으므로 성공적이었다고 볼 수 있다. 따라서 정답은 (B). 지문의 up이 정답에서 successful로 바꾸어 표현되었다.

4.

Moon Manors Apartments on High Street feature the latest in comfort and style for modern living. We have two-, three-, and four-bedroom apartments. All of these are equipped with state-of-the-art amenities. Call our agents today!

(A) A real estate agent is looking for new landlords.

(B) **The residences have advanced facilities.**

하이 가의 문 매너스 아파트는 현대 생활을 위한 최신식 안락함과 스타일이 특징입니다. 2개, 3개, 4개의 침실이 있는 아파트가 있습니다. 이들 모두는 최신식 생활 편의 시설이 갖추어져 있습니다. 오늘 저희 중개소로 전화해 주세요!

해석 | (A) 부동산 중개인이 새로운 임대주를 찾고 있다.
(B) 주택에 첨단 시설이 있다.

해설 | 아파트에 최신식 생활 편의 시설이 갖추어져 있다고 했으므로 정답은 (B). 지문의 state-of-the-art amenities가 유의어를 이용하여 advanced facilities로 패러프레이징되었다.

5.

The demonstration for our new line of window cleaning products was originally scheduled for Thursday, December 5. However, because a marketing conference is on that day, we've decided to postpone our demonstration gathering until December 12.

(A) **A demonstration date has been changed.**

(B) A product will be launched at a conference.

우리의 새로운 창문 청소 제품 라인에 대한 시연은 원래 12월 5일 목요일로 예정되어 있었습니다. 그러나, 마케팅 회의가 그날이기 때문에, 시연 모임을 12월 12일까지 연기하기로 결정했습니다.

해석 | (A) 시연 날짜가 변경되었다.
(B) 제품이 회의에서 출시될 것이다.

해설 | 마케팅 회의와 일정이 겹쳐서 시연 모임을 연기하기로 결정했다고 했으므로 정답은 (A). 지문의 have decided to postpone이 정답에서 has been changed로 바꾸어 표현되었다.

[1-2] 청구서

Invoice

Ben's Electrical Repairs
Tel: (405) 555-8395 Fax: (405) 555-8396
1681 Blue Spruce Lane; Dundalk, MD 21222

Date: February 12

Invoice Number	INF10-23
Customer	Tara Rivers
Address	781 Turnpike Drive; Dundalk, MD 21222
Date of Service	February 10
Billing Period (in days)	30
¹ Due Date	March 12
Description	Installation of external power outlet near garage door

Description	Quantity	Price per Unit	Subtotal
Tilmann XR power switch	1.0	$4.99	$4.99
Tilmann XR switch cover	1.0	$4.25	$4.25
GFCI protected circuit	1.0	$57.50	$57.50
² Standard labor	1.75 hrs	$60.00	$105.00

Pre-tax Total: $171.74
Tax: $10.31
Amount Paid: -$0.00
Amount Due: **$182.05**

If you will be claiming the above expenses on your taxes, please notify us by March 1 and we will send you additional documentation.

청구서

벤스 전기 수리점
전화: (405) 555-8395 팩스: (405) 555-8396
블루 스프루스 가 1681번지; 던독, 메릴랜드 주 21222

날짜: 2월 12일

청구서 번호	INF10-23
고객명	타라 리버즈
주소	턴파이크 드라이브 781번지; 던독, 메릴랜드 주 21222
서비스 일자	2월 10일
청구 기간 (일 수)	30일
¹ 납부 기한	**3월 12일**
내용	차고 문 근처 외부 전원 콘센트 설치

내역	수량	단가	소계
틸만 XR 전원 스위치	1개	4달러 99센트	4달러 99센트
틸만 XR 스위치 덮개	1개	4달러 25센트	4달러 25센트
GFCI 안전 회로	1개	57달러 50센트	57달러 50센트
² 표준 인건비	1.75시간	60달러	**105달러**

세전 총계: 171달러 74센트
세금: 10달러 31센트
지불된 금액: -0달러
지불할 금액: 182달러 5센트

상기 비용에 대하여 세금에서 공제하실 계획이라면, 3월 1일까지 저희에게 알려주세요. 그러면 추가 서류를 보내드리겠습니다.

어휘 | external 외부의 power outlet 전원 콘센트 garage 차고, 주차장 circuit 회로 claim 청구하다, 요청하다 expense 비용, 돈 documentation 서류

1. When must the bill be settled?
(A) February 10
(B) February 12
(C) March 1
(D) March 12

해석 | 청구서는 언제까지 지불되어야 하는가?
(A) 2월 10일
(B) 2월 12일
(C) 3월 1일
(D) 3월 12일

해설 | 특정 정보 확인 문제
청구서의 각 항목 중 납부 기한을 찾아 날짜를 확인하자. 단서 (1)의 Due Date는 '납부 기한, 만기일'이라는 의미이므로 (D)가 정답.

DAY 30

2. What is the total charge for labor costs?

(A) $60.00

(B) $105.00

(C) $171.74

(D) $182.05

해석 | 인건비 총계는 얼마인가?

(A) 60달러

(B) 105달러

(C) 171달러 74센트

(D) 182달러 5센트

해설 | **특정 정보 확인 문제**

비용 항목 중 Standard labor 부분에 단서가 있다. 인건비 총계를 묻고 있으므로 정답은 표준 인건비의 소계인 (B) 105달러. 60달러는 시간당 인건비이므로 (A)를 고르지 않도록 주의하자.

[3-4] 일정표

New You Fitness Center: Fall Classes

Keep fit at New You Fitness Center! We are happy to introduce the following fall classes:

· [3] Rockin' Aerobics: Monday, Tuesday, Friday/ 8 A.M., 5 P.M.

Enjoy the benefits of aerobics while having fun dancing to pop and rock music and learning genre-specific moves. This one-hour class includes a new routine every week.

· **Water Workout**: Monday, Thursday, Sunday/7 A.M. Start your day with a refreshing workout in the pool. This unique class allows participants an intense workout with minimal stress on the ankles and knees. Great for those recovering from an injury.

· [4D] **Advanced Yoga**: Monday, Thursday/8 P.M. [4A] This advanced class is limited to 6 people per session. The small group allows you to take advantage of the personal attention of a qualified yoga instructor. The workout includes medium to difficult poses. Please sign up in advance.

All classes are free with membership except [4C] Advanced Yoga, which has a $5 fee. Non-gym members can attend classes for $15 per session. All classes are taught by experienced certified instructors.

뉴 유 피트니스 센터: 가을 강좌

뉴 유 피트니스 센터에서 건강을 유지하세요! 아래와 같이 가을 강좌를 소개하게 되어 기쁩니다:

· [3] 록킹 에어로빅: 월, 화, 금/오전 8시, 오후 5시

팝과 록음악에 맞춰 신나게 춤추고 특정한 장르의 동작을 배우면서 에어로빅의 장점을 누리세요. 이 한 시간짜리 수업은 매주 새로운 동작을 포함합니다.

· 수중 운동: 월, 목, 일/오전 7시

수영장에서 활기를 되찾는 운동으로 하루를 시작하세요. 이 특별한 수업은 참가자들이 발목과 무릎에 최소한의 자극을 주면서 집중 운동을 할 수 있도록 합니다. 부상에서 회복 중인 사람들에게 아주 좋습니다.

· [4D] 상급 요가: 월, 목/저녁 8시

[4A] 상급자 수업은 과정 당 6명으로 제한됩니다. 소규모 그룹으로 운영함으로써 유능한 요가 강사가 개개인에 대하여 배려할 수 있는 이점이 있습니다. 이 운동은 중간 단계에서 상급 단계의 동작을 포함하고 있습니다. 미리 신청하여 주십시오.

상급 요가를 제외하고 모든 수업은 회원에게 무료입니다. [4C] 상급 요가는 요금이 5달러입니다. 피트니스 센터 회원이 아닌 분들은 한 과정 당 15달러를 내고 수업에 참가할 수 있습니다. 모든 수업은 경험 많고 자격 있는 강사가 강습합니다.

어휘 | specific 특정한 routine 루틴(공연의 일부로 포함된 동작), 일상 workout 운동 recover 회복하다 injury 부상 advanced 상급의 take advantage of ~을 이용하다 attention 보살핌, 주의 in advance 미리 certify 자격증을 주다

3. How many Rockin' Aerobics classes are offered each week?

(A) Two

(B) Three

(C) Five

(D) Six

해석 | 록킹 에어로빅은 매주 몇 번의 수업이 제공되는가?

(A) 두 번

(B) 세 번

(C) 다섯 번

(D) 여섯 번

해설 | **특정 정보 확인 문제**

단서 (3)에서 월, 화, 금요일 오전 8시와 오후 5시에 수업이 있음을 알 수 있다. 따라서 정답은 (D).

4. What is NOT mentioned about the Advanced Yoga class?

(A) Its class size is restricted.

(B) It is the most popular class.

(C) It has an extra charge.

(D) It is taught in the evening.

해석 | 상급 요가 수업에 대해 언급되지 않은 것은?

(A) 수업의 규모가 제한되어 있다.

(B) 가장 인기 있는 수업이다.

(C) 추가 요금이 있다.

(D) 저녁에 수업한다.

해설 | **Not/True 문제**

Advanced Yoga 부분의 정보와 선택지를 비교해 보자. (A)는 단서 (4A)에서 6명의 인원 제한을 언급하고 있고, (C)는 단서 (4C)에서 수업료가 있음을 알 수 있으며, (D)는 단서 (4D)에서 저녁 8시에 수업이 있음을 밝히고 있다. 그러나 이 수업이 가장 인기 있는지는 언급되지 않았으므로 (B)가 정답.

[5-9] 광고 & 공지 & 청구서

[5] Furniture Land's new four-floor showroom has all the furniture you need to make your home comfortable and inviting. Our entire selection of high-quality merchandise is offered at the best prices around. And with nearly endless choices for every size, color, and feature, you're sure to find what you're looking for.

If you buy from Furniture Land, you can take your furniture home with you right away, or pay for delivery. [8-1] All local orders are guaranteed to arrive the following day, and out-of-town orders may take up to three days. Furniture Land also offers installation and assembly services for a nominal fee. We can send a specially trained employee to [6] assemble your tables, bookcases, dressers, etc. so that you don't have to worry about following written instructions. With our team, you can be sure that the end result will fulfill all your expectations.

Come to Furniture Land today! We look forward to serving you.

[5] 퍼니처 랜드의 4층짜리 새로운 전시장에는 여러분의 집을 편안하고 매력적으로 만드는 데 필요한 모든 가구가 있습니다. 저희의 엄선된 고품질의 제품 모두 시중에서 가장 좋은 가격에 선보이고 있습니다. 게다가 크기, 색상, 기능별로 거의 무한대로 선택하실 수 있어, 여러분께서 원하시는 것을 반드시 찾게 되실 것입니다.

퍼니처 랜드에서 구입하시면, 바로 댁으로 가구를 가져가실 수도 있고, 아니면 배송비를 지불하시면 됩니다. [8-1] 지역 내 모든 주문은 익일 배송을 보장하며, 타지역 주문은 최대 3일까지 걸릴 수 있습니다. 퍼니처 랜드에서는 또한 약간의 수수료를 받고 설치 및 조립 서비스를 제공합니다. 저희는 특별히 훈련된 직원을 보내어 여러분의 탁자, 책장, 서랍장 등을 [6] 조립해 드릴 수 있기 때문에, 서면으로 된 설명서를 따라하는 일에 대해서는 걱정하지 않으셔도 됩니다. 저희 팀과 함께 하시면, 최종 결과가 반드시 여러분의 모든 기대를 충족시켜드릴 것을 믿으셔도 됩니다.

오늘 퍼니처 랜드를 찾아주세요! 여러분을 모시기를 고대하고 있겠습니다.

어휘 | showroom 전시장 inviting 매력적인 merchandise 상품 endless 무한한 feature 기능 guarantee 보장하다 assembly 조립
for a nominal fee 약간의 수수료를 받고 end result 최종 결과 fulfill *one's* expectation ~의 기대를 충족시키다

WELCOME TO FURNITURE LAND!

Getting your purchases home has never been easier! Our flat-pack boxes are easy to carry and [7] trolleys are available to help you transport your larger purchases to your car. Take things with you today and save!

Need help? Just ask.

If you prefer, we will arrange delivery for you at reasonable rates.

Don't know where to go? Look here.

1st Floor: recliners, love seats, sofa sectionals

2nd Floor: carpets, home office, bookcases

퍼니처 랜드에 오신 걸 환영합니다!

구입하신 제품을 댁으로 가져가시는 것은 정말 간단합니다! 저희의 조립용 가구는 운반하기 쉽고 [7] 카트를 이용하여 더 큰 제품을 여러분의 차량까지 운반하실 수 있습니다. 오늘 물건을 직접 가져가셔서 비용을 절약하세요!

도움이 필요하세요? 요청만 하세요.
원하시면, 적정한 가격에 배송을 마련해 드리겠습니다.

어디로 가야 할지 모르시겠다고요? 여기를 보세요.
1층: 리클라이너(등받이가 뒤로 젖혀지는 의자), 2인용 소파, 3인 이상 소파
2층: 카펫, 가정용 사무 가구, 책장

DAY 30

9-2 **3rd Floor**: bedroom sets, mattresses, daybeds
4th Floor: kitchen cabinetry, dining room furniture

9-2 3층: 침실 가구, 매트리스, 소파 침대
4층: 주방 가구, 식당 가구

어휘 | flat-pack box 상자에 부품을 넣어서 파는 조립용 가구 trolley (마트 등에서 쓰는) 카트 transport 운반하다, 나르다 reasonable (가격이) 적정한

FURNITURE LAND
INVOICE
417 South 6th Street, Boise, ID 83616

8-2 Order Date: April 2	**Bill to:**
Shipping Type:	Julio Burns
[X] Local [] Out of Town	3991 Seltice Way
	Boise, ID 83702

Description	Units	Unit Price	Line Total
9-1 Springwell Mattress, King Size	1	$2,449.94	$2,449.94
Willowdoll Headboard, King Size	1	$779.94	$779.94
		Subtotal	$3,229.88
		Tax at 8.6%	$277.77
Call Furniture Land at 555-2876 within 30 days if you wish to have an item returned or replaced. Delivery charges may apply.		**Delivery**	$175.00
		Total	$3,682.65
		Paid	$3,682.65
		Total Due	$0.00

퍼니쳐 랜드
대금 청구서
사우스 6번가 417번지 보이시 시, 아이다호 주 83616

8-2 주문일:4월 2일 배송 유형: [X] 지역 내 [] 지역 외	청구서 발행 대상: 훌리오 번즈 셀티스 웨이 3991번지 보이시 시, 아이다호 주 83702		
상품 내역	수량	단가	제품별 총액
9-1 스프링웰 매트리스, 킹 사이즈	1	2,449달러 94센트	2,449달러 94센트
윌로우달 침대 머리판, 킹 사이즈	1	779달러 94센트	779달러 94센트
		소계	3,229달러 88센트
제품을 반품하거나 교환하기를 원하실 경우 30일 이내에 555-2876번으로 퍼니쳐 랜드에 전화해 주십시오. 배송료가 청구될 수 있습니다.		세금 8.6퍼센트	277달러 77센트
		배송	175달러 00센트
		총액	3,682달러 65센트
		지불	3,682달러 65센트
		미지급 총액	0.00달러

어휘 | invoice (물품) 청구서, 송장 description 서술, 기술 subtotal 소계 return 돌려주다, 반납하다 delivery charge 배송료

5. To whom is the advertisement likely intended?
(A) Homeowners
(B) Crafts people
(C) Interior designers
(D) Delivery workers

해석 | 이 광고의 대상일 것 같은 사람은?
(A) 집 소유주
(B) 공예가
(C) 인테리어 디자이너
(D) 배달 직원

해설 | 대상, 출처 문제
광고의 대상이나 출처를 묻는 문제는 광고하고 있는 제품의 특장점을 살펴보는 것이 좋다. 광고하고 있는 제품은 가정용 가구로 단서 (5)에서 집을 편안하게 만들 수 있다는 것으로 보아 이 광고의 대상은 집을 소유하고 있는 사람임을 알 수 있다. 따라서 정답은 (A).

6. In the advertisement, the word "assemble" in paragraph 2, line 4, is closest in meaning to
(A) build
(B) customize
(C) deliver
(D) refund

해석 | 광고에서, 둘째 단락 네 번째 줄의 "assemble"과 의미상 가장 가까운 단어는?
(A) 조립하다
(B) 주문 제작하다
(C) 배달하다
(D) 환불하다

해설 | 동의어 문제
문맥상 '탁자, 책장, 서랍장 등을 조립해줄 수 있다'는 내용이므로 여기서 assemble은 '조립하다'란 뜻으로 쓰였음을 알 수 있다. 따라서 정답은 '조립하다, 건설하다'란 뜻의 (A) build.

7. What is indicated about Furniture Land?

(A) It does not sell office desks.

(B) Carts are available to move boxes.

(C) Cabinets can be custom-made.

(D) All purchases come with free installation.

해석 | 퍼니쳐 랜드 사에 대해 시사된 것은?

(A) 사무용 책상은 판매하지 않는다.

(B) 상자를 옮기기 위해 카트를 이용할 수 있다.

(C) 캐비닛을 주문 제작할 수 있다.

(D) 모든 구입 제품에 무료 설치가 따라온다.

해설 | **Not/True 문제**

단서 (7)에서 카트를 이용하여 차량까지 큰 조립용 가구를 운반할 수 있다고 했으므로 정답은 (B). 사무용 가구는 판매하고 있지만 주문 제작에 대한 언급은 없으며, 설치 및 조립은 약간의 수수료를 받는다고 했으므로 나머지는 모두 오답이다.

8. When will Mr. Burns' order most likely arrive?

(A) On April 2

(B) On April 3

(C) On April 4

(D) On April 5

해석 | 번즈 씨가 주문한 제품이 도착할 것 같은 때는?

(A) 4월 2일

(B) 4월 3일

(C) 4월 4일

(D) 4월 5일

해설 | **두 지문 연계 문제**

광고와 청구서 두 개의 지문을 함께 봐야 하는 연계 문제. 광고의 단서 (8-1)에서 지역 내 주문은 익일 배송을 보장한다고 했는데, 청구서의 단서 (8-2)를 보니 지역 내 주문에 해당하므로 주문 다음날 제품을 받을 가능성이 높다. 주문일이 4월 2일이라고 나와 있으므로, 정답은 다음날인 (B).

9. What floor did Mr. Burns visit to make his purchase?

(A) First

(B) Second

(C) Third

(D) Fourth

해석 | 번즈 씨가 구입을 하기 위해 방문한 층은?

(A) 1층

(B) 2층

(C) 3층

(D) 4층

해설 | **두 지문 연계 문제**

청구서와 공지를 함께 보고 풀어야 하는 연계 문제. 청구서의 단서 (9-1)을 보니 번즈 씨가 구입한 제품은 매트리스와 침대 머리판인데, 공지의 단서 (9-2)에서 침실 가구와 매트리스는 3층에 있다고 되어 있으므로 정답은 (C).

ACTUAL TEST

ANSWER KEY

교재 286쪽

101. (C)	102. (D)	103. (A)	104. (D)	105. (D)	106. (B)	107. (A)	108. (C)	109. (A)	110. (D)
111. (B)	112. (A)	113. (B)	114. (D)	115. (B)	116. (A)	117. (A)	118. (D)	119. (C)	120. (C)
121. (A)	122. (D)	123. (A)	124. (D)	125. (B)	126. (A)	127. (C)	128. (D)	129. (B)	130. (B)
131. (C)	132. (C)	133. (B)	134. (C)	135. (B)	136. (D)	137. (D)	138. (C)	139. (A)	140. (D)
141. (B)	142. (B)	143. (B)	144. (D)	145. (C)	146. (A)	147. (C)	148. (A)	149. (B)	150. (C)
151. (A)	152. (B)	153. (D)	154. (A)	155. (B)	156. (B)	157. (D)	158. (C)	159. (B)	160. (B)
161. (C)	162. (B)	163. (C)	164. (D)	165. (B)	166. (C)	167. (D)	168. (A)	169. (C)	170. (A)
171. (A)	172. (C)	173. (D)	174. (C)	175. (B)	176. (C)	177. (A)	178. (D)	179. (B)	180. (D)
181. (C)	182. (C)	183. (A)	184. (D)	185. (B)	186. (D)	187. (B)	188. (C)	189. (C)	190. (D)
191. (C)	192. (D)	193. (A)	194. (B)	195. (B)	196. (C)	197. (A)	198. (C)	199. (B)	200. (B)

PART 5

101.

If the team director isn't available, you will interview the final two candidates by **yourself**.

(A) you
(B) your
(C) yourself
(D) yours

어휘 | team director 팀장 available 시간이 되는
candidate 후보자, 지원자

해석 | 만약 팀장이 시간이 되지 않을 경우, 최종 후보 두 명은 당신 혼자서 면접을 보게 되실 것입니다.

해설 | **재귀대명사의 관용표현**
빈칸 앞에 전치사가 있으므로, 전치사의 목적어로 쓰일 수 없는 소유격 (B) your는 오답으로 제외. 문맥상 '혼자서'라는 뜻이 되어야 자연스러우므로 재귀대명사의 관용표현 by *oneself*를 이루는 (C) yourself가 정답이다. 참고로 for *oneself*는 '혼자서, 혼자 힘으로'라는 뜻이다.

102.

Workers at Winny's Burger cannot accept any meal coupons **at** drive-through windows.

(A) in
(B) on
(C) by
(D) at

어휘 | accept 받아들이다 drive-through window 드라이브스루 창구
(차에 탄 채로 음식을 주문해서 받아갈 수 있도록 된 식당 외부 창구)

해석 | 위니스 버거의 직원들은 드라이브스루 창구에서는 어떤 식사 쿠폰도 받지 않는다.
(A) ~에서
(B) ~ 위에
(C) ~ 옆에
(D) ~에서

해설 | **장소 전치사**
빈칸 뒤의 장소를 나타내는 명사 drive-through windows와 어울리는 장소 전치사를 고르는 문제. 선택지 모두 장소를 나타내는 전치사로 쓰이지만, drive-through windows처럼 특정 지점을 나타낼 때는 주로 at을 쓰므로 정답은 (D). (A) in은 넓은 장소에, (B) on은 표면에 접촉하고 있을 때 쓰며, (C) by는 '~ 옆에'라는 뜻이므로 모두 오답이다.

103.

Mr. Hudson is the most **knowledgeable** accountant involved in the project.

(A) knowledgeable
(B) approved
(C) enhanced
(D) accustomed

어휘 | accountant 회계사 involved in ~와 관련된

해석 | 허드슨 씨는 그 프로젝트와 관련된 이들 중에 아는 것이 가장 많은 회계사이다.
(A) 아는 것이 많은 (B) 승인된
(C) 강화된 (D) 익숙한

해설 | **형용사 어휘 knowledgeable**
형용사 어휘를 고르는 문제는 수식하는 명사와의 관계를 파악하는 것이 중요하다. 문맥상 '아는 것이 가장 많은 회계사'라는 의미가 자연스러우므로 (A) knowledgeable이 정답. (B)는 approved accountant만 보면 '공인된 회계사'라는 뜻으로 가능하지만, 빈칸 앞의 the most와 함께 최상급이 되면 의미가 자연스럽지 않으므로 오답이다.

104.

Someone should file all the medical reports and order all the supplies in Dr. Morenci's clinic.

(A) Any
(B) Whoever
(C) The
(D) Someone

어휘 | file (문서 등을 정리하여) 철하다, 보관하다 supply 《항상 복수형》 비품

해석 | 누군가가 모렌시 박사의 병원에서 모든 의료 보고서를 철하고 모든 비품을 주문해야 한다.

해설 | **부정대명사**
빈칸은 주어 자리이므로, 관사 (C) The는 오답으로 제외. (A) Any 는 '어떤 것'이란 뜻으로 사물을 받는 대명사로 문맥상 사람을 뜻하는 빈칸에 올 수 없어 오답. '~하는 사람은 누구나'라는 뜻의 복합 관계대명사 (B) Whoever는 뒤에 절을 수반하는데, 빈칸 뒤에 절이 없으므로 오답이다. 따라서 '누군가, 어떤 사람'이란 뜻의 부정대명사 (D) Someone이 정답.

105.

Ranath Industries **recognizes** hard work from its staff members by giving out generous monthly bonuses.

(A) establishes
(B) rejects
(C) endures
(D) recognizes

어휘 | give out 나누어주다, 배포하다 generous 후한, 넉넉한

해석 | 라나스 산업은 매월 보너스를 후하게 지급하여 직원들의 노고를 인정한다.

(A) 설립하다
(B) 거부하다
(C) 견디다
(D) 인정하다

해설 | **동사 어휘 recognize**
빈칸 뒤의 hard work를 목적어로 취하며 문맥상 가장 자연스러운 동사 어휘를 고르는 문제. '직원들의 노고를 인정한다'는 의미가 자연스러우므로 (D) recognizes가 정답. (C) endures는 '견디다, 인내하다'라는 뜻으로, 회사가 아닌 직원들이 주어가 되어야 어울리므로 오답이다.

106.

Please board through the closest **entrance** to your seat when you get on the train.

(A) entry
(B) entrance
(C) enter
(D) entering

어휘 | board 탑승[승차]하다 get on ~에 타다

해석 | 기차에 오를 때는 좌석에 가장 가까운 입구를 통해 탑승하십시오.

해설 | **명사의 역할_전치사의 목적어**
빈칸은 전치사 through의 목적어이면서 동시에 최상급 형용사 closest의 수식을 받는 명사 자리이므로, 동사 (C) enter는 오답으로 제외. 문맥상 '가장 가까운 입구'라는 뜻이 되어야 자연스러우므로 (B) entrance가 정답이다. 명사 (A) entry는 '입장, 참가'라는 뜻 이고, 동명사 (D) entering은 '들어가기'라는 뜻이므로 둘 다 의미상 어울리지 않아 오답이다.

107.

It is Mr. Marino's job to create a safe working **environment** for all laboratory workers.

(A) environment
(B) foundation
(C) equipment
(D) capacity

어휘 | safe 안전한 laboratory 실험실

해석 | 마리노 씨의 업무는 모든 실험실 직원들을 위해 안전한 작업 환경을 조성하는 것이다.

(A) 환경
(B) 토대
(C) 장비
(D) 용량

해설 | **명사 어휘 environment**
빈칸 앞 working과 자연스럽게 어울리는 명사 어휘를 고르는 문제. working environment가 '작업 환경'이라는 뜻으로 자주 쓰인다는 것을 알았다면 쉽게 답을 고를 수 있다. 형용사 safe의 수식을 받아 '안전한 작업 환경'이란 의미로 문맥에도 자연스러우므로 정답은 (A) environment.

108.

The construction project was delayed, so please check the **updated** work schedule on the city's Web site.

(A) previous
(B) certain
(C) updated
(D) potential

어휘 | construction 건설 delay 연기하다

해석 | 건설 사업이 연기되었으니, 시의 웹사이트에서 최신 근무 일정표를 확인하십시오.

(A) 이전의
(B) 특정한
(C) 최신의
(D) 잠재적인

해설 | **형용사 어휘 updated**
사업이 연기되었다고 했으므로 원래의 일정표도 새롭게 바뀔 것임을 유추할 수 있다. 따라서 '최신의'라는 뜻의 (C) updated가 정답이다. '이전의 근무 일정표'를 구할 필요는 없으므로, (A) previous는 문맥상 알맞지 않아 오답이다.

109.

Some advertisements are **strategically** placed near the middle of the magazine so they are not skipped over easily.

(A) strategically (B) strategy
(C) strategic (D) strategies

(A) strategically

어휘 | strategically 전략적으로 place 놓다, 두다 skip over 건너뛰다

해석 | 몇몇 광고들은 쉽게 건너뛰지 못하도록 잡지 한가운데 근처에 전략적으로 배치된다.

해설 | **부사 자리_동사 수식**
빈칸은 〈be동사+p.p〉 형태인 are placed 사이에 위치하므로, 부사 자리이다. 따라서 정답은 (A) strategically. 부사는 수동태 문장에서 be동사와 과거분사 사이에 놓인다는 것을 기억하자.

110.

F&A Tours **outlines** its various tour packages on its Web site for the peak season.

(A) outline (B) to outline
(C) outlining **(D) outlines**

어휘 | outline 개요를 서술하다 peak season 성수기

해석 | 에프앤에이 여행사는 성수기 동안 자사 웹사이트에 다양한 여행 상품들을 소개한다.

해설 | **단수 주어+단수 동사**
빈칸은 동사 자리이므로 동사 형태인 (A) outline과 (D) outlines 가 정답 후보. 주어인 F&A Tours는 형태상 복수지만, 회사명이므로 단수 취급한다. 따라서 단수 동사인 (D)가 정답.

111.

The contents of the article are not guaranteed to illustrate the **views** of the newspaper editor.

(A) history **(B) views**
(C) conclusions (D) differences

어휘 | contents 내용 guarantee 보장하다, 확신하다 illustrate 분명히 보여주다 editor 편집장, 편집자

해석 | 그 기사 내용이 신문 편집장의 견해를 보여준다고 장담할 수 없다.

(A) 역사 (B) 견해
(C) 결론 (D) 차이점

해설 | **명사 어휘 view**
빈칸은 to부정사 to illustrate의 목적어 자리로, 문맥에 어울리는 명사 어휘를 찾아야 한다. 문맥상 '편집장의 견해를 보여주다'라는 뜻이 되어야 자연스러우므로 (B) views가 정답. 참고로 view는 '견해, 관점'이라는 뜻 외에, '경관, 관람'이라는 뜻으로도 쓰인다.

112.

When employees **routinely** come to work late, they receive a written warning from their department head.

(A) routinely (B) unfortunately
(C) accidentally (D) temporarily

어휘 | receive 받다 written warning 서면 경고

해석 | 직원들이 일상적으로 늦게 출근하면, 그들의 부장으로부터 서면 경고를 받는다.

(A) 일상적으로 (B) 유감스럽게도
(C) 우연히 (D) 일시적으로

해설 | **부사 어휘 routinely**
문맥에 어울리는 부사 어휘를 고르는 문제로 뒤의 동사 come을 수식하면서 의미가 자연스러운 것을 고른다. 부장으로부터 서면 경고를 받는 경우는 일상적으로 늦게 출근할 때이므로 정답은 (A).

113.

The clothing store manager purchased new mannequins **for** its window displays.

(A) during **(B) for**
(C) to (D) beside

어휘 | mannequin 마네킹 display 진열, 전시

해석 | 의류 매장 관리자는 진열창 전시를 위해 마네킹을 새로 구입했다.

(A) ~ 동안 (B) ~을 위해
(C) ~으로 (D) ~ 옆에

해설 | **목적 전치사**
문맥상 빈칸 이하는 마네킹을 새로 구입한 목적 혹은 이유가 되어야 한다. 따라서 '~을 위해'라는 뜻으로 목적을 나타내는 전치사 for가 적절하므로 정답은 (B). (A) during은 기간 전치사, (C) to는 방향 전치사, (D) beside는 장소 전치사로 모두 오답이다.

114.

When applying for a passport, applicants must **provide** a form of identification, such as a driver's license.

(A) protect (B) record
(C) match **(D) provide**

어휘 | apply for ~을 신청하다 applicant 신청자 identification 신분증

해석 | 여권을 신청할 때, 신청자들은 운전면허증 같은 신분증을 제시해야 한다.

(A) 보호하다 (B) 기록하다
(C) 일치하다 (D) 제공하다

해설 | **동사 어휘 provide**
빈칸 뒤 a form of identification을 목적어로 취하며 문맥상 자연스러운 동사 어휘를 고르는 문제. '신분증을 제시해야 한다'라는 의미가 적절하므로 정답은 (D) provide.

115.

Ms. Mendez engaged in an intense **negotiation** with the personnel manager over the specifics of her contract.

(A) negotiated **(B) negotiation**
(C) negotiating (D) negotiator

어휘 | engage in ~에 관여[참여]하다 intense 강렬한, 극심한
 specifics 세부 사항

해석 | 멘데즈 씨는 계약 세부 사항에 대해 인사부장과 열띤 협상을 벌였다.

해설 | **사람명사 vs. 사물/추상명사**
빈칸은 형용사 intense의 수식을 받으며 전치사 with와 어울려 쓰이는 명사 자리이므로 (B) negotiation, (D) negotiator가 정답 후보. 의미상 '열띤 협상'이라는 뜻이 적절하므로 정답은 (B). (D)는 '협상가'라는 뜻이므로 문맥상 어울리지 않아 오답.

116.

No one **except** the payroll administrators will have access to confidential documents.

(A) except (B) after
(C) between (D) over

어휘 | payroll 급여 administrator 관리자 have access to ~에 접근할 수 있다 confidential 기밀의

해석 | 급여를 관리하는 사람들을 제외하고는 아무도 기밀 서류에 접근하지 못할 것이다.
(A) ~을 제외하고 (B) ~ 후에
(C) (둘) 사이에 (D) ~ 동안

해설 | **제외 전치사**
No one이 주어이므로, 빈칸부터 administrators까지는 주어를 수식하는 어구가 된다. 문맥상 '~을 제외하고는'이란 뜻이 되어야 어울리므로 (A) except가 정답이다. (B) after는 시점 전치사이고 (C) between은 장소 전치사, (D) over는 기간 전치사로 문맥상 어울리지 않아 모두 오답.

117.

Along with its other skincare products, Ageless Cosmetics sells a **reasonably** priced anti-aging cream.

(A) reasonably (B) reasonable
(C) reason (D) reasoned

어휘 | along with ~와 함께 skincare 피부 관리 price 값을 매기다
 anti-aging 노화 방지의

해석 | 다른 피부 관리 제품들과 함께, 에이지리스 화장품은 적정 가격의 노화 방지 크림을 판매한다.

해설 | **부사 자리_형용사 수식**
빈칸은 뒤에 오는 과거분사인 priced를 수식하는 자리이므로 부사가 적절하다. 따라서 (A) reasonably가 정답. reasonably는 '적정하게, 합리적으로'라는 뜻으로, reasonably priced는 적정하게 가격이 책정되었다는 뜻이다. high[low] priced(비싼[싼])라는 표현도 함께 알아두자.

118.

The government reviewed the **regulations** created to reduce speeding on highways.

(A) decisions (B) permissions
(C) findings **(D) regulations**

어휘 | review 검토하다 speeding 속도 위반

해석 | 정부는 고속도로상의 속도 위반을 줄이기 위해 만들어진 규정을 검토하였다.
(A) 결정 (B) 허가
(C) 조사 결과 (D) 규정

해설 | **명사 어휘 regulation**
속도 위반을 줄이기 위해 정부에서 만들어 검토하는 대상이므로 '규정, 규제'라는 뜻의 regulations가 어울린다. 따라서 정답은 (D). (C) findings는 주로 복수형으로 써서 조사나 연구의 '결과'를 뜻하므로 오답이다.

119.

Snowball Foundation fundraisers are regularly held to raise money to support **research** in the field of cancer study.

(A) researching (B) researched
(C) research (D) researches

어휘 | fundraiser 모금행사 regularly 정기적으로 field 분야

해석 | 스노우볼 재단의 모금행사는 암 연구 분야의 연구를 지원하기 위한 기금을 모으기 위해 정기적으로 열린다.

해설 | **가산명사 vs. 불가산명사**
빈칸은 to부정사 to support의 목적어 자리이므로 명사인 (C)와 (D)가 정답 후보. research는 불가산명사이므로 복수형으로 쓰지 않기 때문에 (C)가 정답이다. (A) researching을 동명사로 보더라도 빈칸 뒤에 목적어가 없으므로 오답이다.

120.

Using new technology, Howard Inc. developed **markedly** different products from its competitors.

(A) affordably (B) chiefly

(C) markedly (D) rapidly

어휘 | develop 개발하다 competitor 경쟁사, 경쟁자

해석 | 새로운 기술을 이용하여, 하워드 주식회사는 경쟁사들과 현저히 다른 제품들을 개발했다.

(A) 알맞게 (B) 주로

(C) 현저하게 (D) 급격하게

해설 | **부사 어휘 markedly**

빈칸 뒤 형용사 different를 수식하면서 문맥에 어울리는 부사를 고르는 문제. 문맥상 '현저히 다른'이란 뜻이 가장 자연스러우므로 (C) markedly가 정답이다. '현저히 다르다'라는 뜻의 differ markedly라는 표현도 함께 알아두자.

121.

Driving through the British countryside is quite enjoyable **notwithstanding** the unpaved roads and slower speeds.

(A) notwithstanding (B) otherwise

(C) whether (D) whereas

어휘 | countryside 시골 지역 enjoyable 즐거운 unpaved 포장되지 않은

해석 | 영국의 시골 지역을 통과해 운전하는 것은 비포장 도로와 느린 속도에도 불구하고 매우 즐겁다.

(A) ~에도 불구하고 (B) 그렇지 않으면

(C) ~인지 아닌지 (D) ~인 반면

해설 | **양보 전치사**

빈칸 이하는 수식어구인데, 빈칸 다음에 명사구가 나오므로 빈칸은 전치사가 들어갈 자리이다. 선택지 중에서 전치사는 (A) notwithstanding뿐인데, '~에도 불구하고'라는 뜻으로 문맥상으로도 자연스러우므로 정답은 (A). (B) otherwise는 '그렇지 않으면'이란 뜻의 부사이므로 바로 명사와 연결될 수 없고, (C)와 (D)는 접속사이므로 뒤에 절이 나와야 하는데 절이 없으므로 오답이다.

122.

On March 30, professional chef Timothy Bass is opening his fourth restaurant **under** the direction of his son.

(A) either (B) across

(C) within **(D) under**

어휘 | professional 전문적인 chef 요리사 direction 지휘, 통솔

해석 | 3월 30일에, 전문 요리사인 티머시 배스 씨는 그의 아들의 지휘 아래 네 번째 식당을 개점한다.

(A) (둘 중) 하나 (B) ~을 가로질러서

(C) ~ 이내에 (D) ~ 아래에

해설 | **전치사 관용표현**

빈칸 뒤의 the direction of와 어울려 '~의 지휘[지도] 아래'라는 뜻을 이루는 전치사가 적절하므로 정답은 (D) under. under는 '~ 아래에'라는 뜻에서 '어떤 것의 영향력 아래 놓여 있다'는 의미로 확장되어, under the control of(~의 지배[관리]를 받는), under stress(스트레스를 받는) 등의 관용표현으로 자주 쓰인다.

123.

Some companies assign security passes **precisely** to make sure that only employees can enter the building.

(A) precisely (B) relatively

(C) justly (D) quickly

어휘 | assign 배정하다, 할당하다 security pass 보안카드 make sure ~을 확실히 하다

해석 | 몇몇 회사들은 확실하게 직원들만 회사 건물에 출입할 수 있도록 보안카드를 정확하게 배정한다.

(A) 정확하게 (B) 비교적

(C) 공정하게 (D) 빠르게

해설 | **부사 어휘 precisely**

빈칸은 목적어 security passes 뒤에서 동사 assign을 수식한다. 회사 건물에 직원들만 출입할 수 있도록 하려면, 보안카드를 직원들에게만 '정확하게' 배정한다는 것이 문맥상 어울리므로 (A) precisely가 정답이다.

124.

During today's workshop, two software security presentations **will be offered** in Conference Room A.

(A) will offer (B) offering

(C) offer **(D) will be offered**

어휘 | security 보안, 경비

해석 | 오늘 워크숍에서는, 소프트웨어 보안에 관한 두 개의 발표가 회의실 A에서 열린다.

해설 | **3문형 동사의 수동태**

빈칸은 presentations를 주어로 하는 동사 자리이므로 (B) offering은 오답으로 제외. presentations는 동사 offer의 주체가 아니라 대상이므로 수동태가 되어야 한다. 따라서 정답은 (D) will be offered. 3문형 동사인 offer가 능동태로 쓰이려면 뒤에 목적어가 나와야 하므로 (A)와 (C)는 오답.

125.

After meeting with several international clients, Ms. Meyers has developed a global **perspective** on her business affairs.

(A) issue
(B) perspective
(C) concern
(D) selection

어휘 | business affair 업무

해석 | 몇몇 해외 고객들을 만난 후에, 마이어즈 씨는 업무에 관해 국제적 시각을 키웠다.

(A) 문제
(B) 시각
(C) 우려
(D) 선택

해설 | **명사 어휘 perspective**
문맥에 적절한 명사 어휘를 고르는 문제. 문맥상 '국제적 시각을 키우다'라는 뜻이 되어야 자연스러우므로 정답은 (B) perspective. perspective는 '시각, 관점'이란 뜻으로 view와 유사한 의미로 알아두자.

126.

The Springtime Café introduced a stamp-card program last year **in order to** reward loyal customers who come in regularly.

(A) in order to
(B) even if
(C) after all
(D) as a result of

어휘 | introduce 도입하다 reward 보상하다 loyal customer 단골고객

해석 | 스프링타임 카페는 정기적으로 들르는 단골 고객들에게 보상하기 위해 작년에 스탬프 카드 제도를 도입했다.

(A) ~하기 위해
(B) 비록 ~할지라도
(C) 결국에는
(D) ~의 결과로서

해설 | **to부정사의 부사 역할**
빈칸 뒤의 reward는 loyal customers를 목적어로 취하는 동사이다. 선택지 중에서 동사원형 앞에 올 수 있는 것은 (A)뿐으로 정답은 (A) in order to. in order to do는 '~하기 위해'라는 뜻으로 목적의 의미를 분명히 할 때 쓰이는 부사 역할의 to부정사이다. (B)는 접속사로 뒤에 절을 수반하고, (C)는 부사이며, (D)는 전치사로 뒤에 명사가 와야 하므로 모두 오답이다.

127.

The CEO **is addressing** the complaints raised by employees regarding the company's overtime payment policy.

(A) will be addressed
(B) has been addressed
(C) is addressing
(D) to address

어휘 | address 처리하다, 다루다 regarding ~에 대하여 overtime payment 초과근무 수당 지급

해석 | 대표이사가 회사의 초과근무 수당 지급 규정에 대하여 직원들이 제기한 불만을 처리하고 있다.

해설 | **3문형 동사의 능동태**
문장에 동사가 없는 것으로 보아 빈칸은 동사 자리로, to부정사인 (D)는 오답으로 제외. 주어인 The CEO가 동사 address의 주체이므로 능동태가 되어야 한다. 따라서 정답은 (C) is addressing. 3문형의 수동태인 (A)나 (B)는 뒤의 the complaints를 목적어로 가질 수 없으므로 오답이다.

128.

Given the fact that her package was ordered several weeks ago, Ms. Dawson expected it to have arrived by now.

(A) Because
(B) Since
(C) Except
(D) Given

어휘 | given the fact that ~라는 사실을 고려해 볼 때 package 택배 by now 지금쯤은

해석 | 택배를 몇 주 전에 주문했다는 사실을 고려했을 때, 도슨 씨는 그것이 지금쯤은 도착했을 것이라고 예상했다.

(A) ~ 때문에
(B) ~ 이래로
(C) ~을 제외하고
(D) ~을 고려해 볼 때

해설 | **분사형 전치사**
빈칸 뒤에 명사구가 이어지므로, 절을 이끄는 접속사 (A) Because는 오답으로 제외. 문맥상 '~을 고려해 볼 때'라는 뜻이 가장 적절하므로 (D) Given이 정답. (B) Since는 전치사로 쓰이면, '~ 이래로'라는 뜻이므로 문맥상 어울리지 않아 오답이다.

129.

Young adults should put money into a pension fund, **which** ensures them financial security after they retire.

(A) whose
(B) which
(C) that
(D) whatever

어휘 | pension fund 연금 ensure 보장하다 financial 재정의 security 안정성, 보장 retire 은퇴하다

해석 | 젊은 사람들은 연금에 돈을 넣어야 하는데, 이것이 은퇴 후에 그들의 재정적인 안정성을 보장해 주기 때문이다.

해설 | **주격 관계대명사**
빈칸에 알맞은 관계대명사를 고르는 문제이다. 빈칸 다음에 주어 없이 바로 동사가 이어지는 것으로 보아 주격 관계대명사가 들어가야 하므로 (B) which, (C) that, (D) whatever가 정답 후보. 문맥상 빈칸 앞 절을 선행사로 받아 계속적 용법으로 쓰이는 주격 관계대명사가 알맞으므로 정답은 (B). (C) that은 콤마 뒤에 나오는 계속적 용법으로는 쓰이지 않으므로 오답이다. (D) whatever는 '어떤 ~일지라도'의 의미로 쓰이는 복합관계대명사로 문맥상 어울리지 않으므로 오답이다.

130.

Flying to Rome seems faster than taking the train, but it takes the **equivalent** amount of time because of the security check.

(A) profitable　　　　　**(B) equivalent**
(C) massive　　　　　　(D) reliable

어휘 | security check 보안 검색

해석 | 로마에 갈 때 비행기를 타고 가는 것이 기차를 타는 것보다 더 빨라 보이지만, 보안 검색 때문에 동등한 시간이 걸린다.
(A) 수익성이 있는　　　(B) 동등한
(C) 거대한　　　　　　(D) 믿을 수 있는

해설 | **형용사 어휘 equivalent**
빈칸 뒤의 명사구 amount of time을 수식하는 형용사 어휘를 고르는 문제이다. 비행기를 타고 가는 것과 기차를 타고 가는 시간을 비교하고 있는데, 문맥상 '보안 검색 때문에 같은 시간이 걸린다'는 의미가 자연스러우므로 정답은 '동등한'이라는 의미인 (B) equivalent.

PART 6

[131-134] 정보문

Residents of any unit in the Carson Corp. apartment complex are required to purchase parking permits, which are issued by the main offices in the lobby of each building. [131] **In addition**, residents must renew these every year. Expired passes are not acceptable. [132] **Moreover, permits must be displayed visibly to avoid tickets.** Building managers are responsible for [133] **enforcing** these policies and ticket any vehicle that does not have a visible valid permit. Owners of unauthorized vehicles [134] **are charged** large fines.

카슨 사 아파트 단지 내에 모든 가구의 거주민들은 주차 허가증을 구입해야 하는데, 허가증은 각 동 로비에 있는 중앙 사무실에서 발급됩니다. [131] 게다가, 주민들은 이것을 매년 갱신해야 합니다. 만료된 주차 허가증은 허용되지 않습니다. [132] 또한, 위반 딱지를 받지 않으려면 허가증을 눈에 띄게 해두어야 합니다. 건물 관리인들이 이러한 규정을 [133] 시행하는 일을 책임지고 있으며, 눈에 띄는 유효한 허가증이 없으면 어떤 차량이든 위반 딱지를 발부합니다. 승인되지 않은 차량의 소유주들은 고액의 벌금을 [134] 부과받게 됩니다.

어휘 | resident 거주자　unit (공동주택 내의) 한 가구　issue 발급하다　renew 갱신하다　be responsible for ~을 책임지다　ticket (위반) 딱지를 발부하다　visible 눈에 보이는　valid 유효한　unauthorized 승인되지 않은　charge 부과하다, 청구하다　fine 벌금

131.
(A) Similarly
(B) In fact
(C) In addition
(D) However

해석 | (A) 유사하게　　　(B) 사실
　　　(C) 게다가　　　　(D) 그러나

해설 | **접속 부사**
문맥에 맞는 접속 부사를 고르는 문제이다. 빈칸 앞 문장에서는 주차 허가증을 발급해 준다는 내용이 나오고, 빈칸 뒤 문장에서는 주차 허가증을 매년 갱신해야 된다는 내용이 언급되고 있다. 빈칸 앞뒤 문장이 모두 주차 허가증 발급과 관련된 내용이므로 추가를 뜻하는 (C) In addition이 정답이다.

132.
(A) There are no underground parking spots available.
(B) Therefore, residents are not able to choose their spot numbers.
(C) Moreover, permits must be displayed visibly to avoid tickets.
(D) Guest parking spots are limited to four hours at a time.

해석 |
(A) 이용할 수 있는 지하 주차 공간이 없습니다.
(B) 따라서 거주민들은 자신들의 주차 공간 번호를 선택할 수 없습니다.
(C) 또한, 위반 딱지를 받지 않으려면 허가증을 눈에 띄게 해두어야 합니다.
(D) 손님 전용 주차 공간은 한 번에 네 시간으로 제한됩니다.

해설 | **알맞은 문장 고르기**
빈칸 뒤 문장에서 눈에 띄는 허가증이 없으면 위반 딱지를 발부한다는 내용이 나오므로 빈칸에는 위반 딱지를 받지 않으려면 허가증을 눈에 띄게 두라는 내용이 오는 것이 자연스럽다. 따라서 정답은 (C).

133.
(A) inserting
(B) enforcing
(C) eliminating
(D) verifying

해석 | (A) 삽입하다　(B) 시행하다
　　　 (C) 제거하다　(D) 확인하다

해설 | **동사 어휘 enforce**
빈칸 뒤에 these policies를 목적어로 취하면서 의미가 자연스럽게 연결되는 동사 어휘를 찾아야 한다. enforce는 '(법률 등을) 집행하다, 시행하다'라는 뜻으로 주로 law, rule, policy 등을 목적어로 취한다. 따라서 정답은 (B) enforcing.

134.
(A) have charged
(B) are charging
(C) are charged
(D) to charge

해설 | **4문형 동사의 수동태**
빈칸은 동사 자리이다. 주어인 Owners가 동사 charge의 행위를 당하는 대상이므로 수동태가 쓰여야 한다. 따라서 정답은 (C) are charged. 빈칸 뒤에 목적어인 large fines가 있다고 무조건 능동태인 (A)나 (B)를 정답으로 고르는 함정에 빠지지 말아야 한다. 동사 charge와 같이 〈주어＋동사＋간접목적어＋직접목적어〉 구조로 쓰이는 4문형 동사들은 간접목적어가 주어로 쓰이는 수동태에서 동사 뒤에 직접목적어가 그대로 남아있다는 점을 기억하자.

[135-138] 공지

Christmas Holiday Return Policy

Please ¹³⁵ <u>note</u> that items purchased while on sale are not eligible for returns or exchanges. All other items can be returned as long as they are brought back in an unworn condition and with a receipt. ¹³⁶ <u>All items can be returned within thirty days of purchase.</u> However, this period is extended during busy seasons. For instance, the acceptable return period for this Christmas season will last ¹³⁷ <u>longer</u> than at any other time of the year. Thus we ¹³⁸ <u>will accept</u> returns for up to two months after the date of purchase. To qualify for this extension, an item must be purchased between December 1 and January 1.

크리스마스 연휴 반품 규정

할인 중에 구매한 물품은 반품이나 교환이 되지 않음에 ¹³⁵ **주의하시기** 바랍니다. 기타 모든 물품은 사용하지 않은 상태로 영수증을 지참하여 다시 가져오시면 반품 가능합니다.

¹³⁶ **모든 물품은 구입 후 30일 이내에 반품 가능합니다.** 하지만 이 기간은 성수기 동안에는 연장됩니다. 예를 들어, 올해 크리스마스에 허용되는 반품 기간이 일 년 중 다른 어떤 때보다 ¹³⁷ **더 오래** 지속됩니다. 따라서 구매 후 두 달까지 반품을 ¹³⁸ **받을 것입니다.** 이러한 반품 기간 연장에 적용되는 것은 12월 1일과 1월 1일 사이에 구매한 물품만 해당됩니다.

어휘 | return 반품(하다)　be eligible for ~의 자격이 있다　unworn 한 번도 사용하지 않은, 닳지 않은　receipt 영수증　extend 연장하다　busy season 성수기　acceptable 허용할 수 있는　up to ~까지　qualify for ~의 자격을 얻다

135.
(A) prepare
(B) note
(C) determine
(D) address

해석 | (A) 준비하다　(B) 주의하다
　　　 (C) 결정하다　(D) 다루다

해설 | **동사 어휘 note**
빈칸 뒤의 that 이하는 물품 반품 및 교환 규정에 대한 것이므로, 이러한 규정에 '주의하라'는 의미로 (B) note가 들어가야 알맞다. Please note that은 안내문이나 공지 등에 자주 등장하는 표현으로 기억해 두자.

136.
(A) Clothing may be put on hold for forty-eight hours only.
(B) All tags must still be attached to the articles of clothing.
(C) Without a receipt, an exchange cannot be processed.
(D) All items can be returned within thirty days of purchase.

해설 |
(A) 의류는 48시간 동안만 판매가 보류될 수 있습니다.
(B) 의류 품목에는 태그가 모두 부착되어 있어야 합니다.
(C) 영수증이 없으면, 교환이 처리될 수 없습니다.
(D) 모든 물품은 구입 후 30일 이내에 반품 가능합니다.

해설 | **알맞은 문장 고르기**
빈칸 뒤 문장에 this period라는 어구로 보아, 빈칸에는 기간과 관련된 내용이 들어감을 알 수 있다. 기간이 언급된 것은 (A)와 (D)인데, 지문은 반품 정책과 관련된 내용이므로 반품 기한을 안내하는 (D)가 알맞다.

137.
(A) length
(B) long
(C) longest
(D) longer

해설 | 비교급 비교 구문
빈칸 앞의 동사 last는 '지속되다'라는 뜻의 자동사이므로, 빈칸은 이를 수식하는 부사가 들어갈 자리이다. 그런데 빈칸 뒤에 than이 있으므로 부사의 비교급인 (D) longer가 정답.

138.
(A) are accepted
(B) accepting
(C) will accept
(D) have accepted

해설 | 미래 시제
빈칸은 동사 자리이므로 (B)는 오답으로 제외. 주어 we가 받아들이는 동작의 주체이므로 능동태인 (C) will accept와 (D) have accepted가 정답 후보이다. 문맥상 다가오는 크리스마스의 반품 기간에 대해 알리는 내용이므로 동사는 미래를 나타내야 한다. 따라서 정답은 미래 시제인 (C).

[139-142] 이메일

To: Engineering Department
 <engineering@cobasta.com>
From: David Park <dpark@cobasta.com>
Date: August 30
Subject: International Training Fellowship for
 Engineering Professionals

Good afternoon,

I would like to tell you about the International Training Fellowship for Engineering Professionals. This fellowship brings international engineering knowledge into Brazil and South America. It is intended for civil engineers working for Brazilian firms. Applicants with more than five years' experience are **139** eligible to receive company sponsorship to work overseas for half a year.
In addition to a six-month internship at one of several partner organizations, the program for successful **140** candidates will include a variety of training courses. **141** All qualified engineers working in Brazil are able to apply. However, the application review committee gives **142** preference to individuals who speak multiple languages. All applications must be submitted to Mr. Flavio Fela, ffela@itfep.com, by October 1 to be considered.
I hope you will consider applying.

Regards,

David Park
International Team Manager, Cobsta Inc.

받는 사람: 기술부 <engineering@cobasta.com>
보내는 사람: 데이비드 박 <dpark@cobasta.com>
날짜: 8월 30일
제목: 전문 공학자들을 위한 국제 교육 장학금

안녕하세요,

여러분에게 전문 공학자들을 위한 국제 교육 장학금에 대해 말씀드리고자 합니다. 이 장학금은 브라질 및 남아메리카에 국제적인 공학 지식을 가져다 줍니다. 이는 브라질 기업에서 일하는 토목 기사들을 대상으로 합니다. 5년 이상의 경력을 지닌 지원자들은 회사의 후원을 받아 반년 동안 해외에서 근무할 **139** 자격을 얻게 됩니다.

몇몇 제휴 기관들 중 한 곳에서 6개월간의 인턴십 근무 외에도, **140** 합격자들을 위한 프로그램에는 다양한 교육 과정이 포함됩니다. **141** 브라질에서 근무하는 자격 있는 모든 기사들은 지원할 수 있습니다. 하지만 지원서 검토 위원회에서는 여러 가지 언어를 구사하는 사람에게 **142** 우선권을 주고 있습니다. 심사를 받으려면 10월 1일까지 모든 지원서를 ffela@itfep.com으로 플라비오 펠라 씨에게 제출해야 합니다.

여러분께서 지원을 고려해 보시기를 바랍니다.

콥스타 사 국제팀장
데이비드 박 드림

어휘 | fellowship (연구) 장학금 **be intended for** ~을 대상으로 하다 **civil engineer** 토목 기사 **applicant** 지원자 **sponsorship** 후원 **overseas** 해외에서 **in addition to** ~이외에 **organization** 기관, 단체 **a variety of** 다양한 **application** 지원(서) **multiple** 다수의

139. **(A) eligible**
(B) reliable
(C) sustainable
(D) cooperative

해석 | (A) 자격이 있는　　(B) 믿을 수 있는
　　　(C) 지속 가능한　　(D) 협력하는

해설 | **형용사 어휘 eligible**
빈칸은 뒤에 나오는 to부정사의 수식을 받아 의미가 자연스럽게 연결되어야 한다. 문맥상 '회사의 후원을 받아 해외에서 근무할 자격이 있다'는 의미가 적절하므로 정답은 (A) eligible. '~의 자격이 있다'는 의미인 〈be eligible for + 명사〉 형태도 기억해 두자.

140. (A) positions
(B) employers
(C) candidates
(D) occupations

해석 | (A) 자리　　　　(B) 고용주
　　　(C) 지원자　　　 (D) 직업

해설 | **명사 어휘 candidate**
빈칸 앞의 형용사 successful의 수식을 받아 the program의 대상이 될 수 있는 명사 어휘를 찾아야 한다. 문맥상 '지원자'라는 의미의 candidates가 적절하므로 정답은 (C). successful candidate는 '합격자'의 의미로 한 단어처럼 기억해 두자.

141. (A) Only people fluent in Portuguese will be considered.
(B) All qualified engineers working in Brazil are able to apply.
(C) Please bring two reference letters to the interview.
(D) No additional language training will be provided in the program.

해석 |
(A) 포르투갈어가 유창한 사람들만 심사를 받을 것입니다.
(B) 브라질에서 근무하는 자격 있는 모든 기사들은 지원할 수 있습니다.
(C) 면접에 두 통의 추천서를 가져오십시오.
(D) 프로그램에서 추가적인 어학 연수는 제공되지 않을 것입니다.

해설 | **알맞은 문장 고르기**
빈칸 뒤 문장에서 대조의 의미를 나타내는 연결어 However가 나오며, 우선권을 주는 조건을 언급하고 있다. 따라서 빈칸에는 우선권과 대조되는 일반적인 지원 조건이 언급되는 것이 자연스러우므로 자격 있는 모든 기사들은 지원하라는 (B)가 정답이다.

142. (A) preferring
(B) preference
(C) preferential
(D) preferred

해설 | **명사의 역할_타동사의 목적어**
빈칸은 타동사 gives의 목적어 자리이므로 명사가 들어가야 한다. 선택지 중 명사인 preference가 '선호, 우선권'이란 뜻으로 문맥에도 어울리므로 정답은 (B).

[143-146] 회의 요약본

Tuesday, March 29 Marketing Meeting Notes

The meeting discussed moving Mojo Enterprises business operations from South Carolina to Tennessee. Unfortunately, no decision was reached. [143] **Currently, management remains divided on the best course of action.** According to the opposition, despite being an extremely prominent [144] **distributor** of fine china in South Carolina, Mojo will lose existing customers by moving to Tennessee. Conversely, those supporting the move argued that property taxes are too high in South Carolina and pointed out the benefit of [145] **relocating** to a state with lower costs. In response, a manager claimed that one of Mojo's competitors tried to take advantage of a state with lower taxes and failed. [146] **Since** it moved its headquarters, it has been losing customer interest.

3월 29일 화요일 마케팅 회의 기록

회의에서는 모조 엔터프라이즈 사의 사업을 사우스 캐롤라이나 주에서 테네시 주로 이전하는 것에 대해 논의했다. 안타깝게도, 어떤 결정에도 이르지 못했다. [143] **현재, 경영진은 최선책을 두고 의견이 나뉘어진 상태이다.** 반대 의견에 따르면, 모조 사는 대단히 유명한 사우스 캐롤라이나 주의 정교한 도자기 [144] **유통 업체임에도** 불구하고, 테네시 주로 이전하면 기존 고객들을 잃게 될 것이라고 한다. 반대로, 이전을 지지하는 사람들은 사우스 캐롤라이나 주는 재산세가 너무 높다고 주장하며 비용이 더 적게 드는 주로 [145] **이전하는 것의** 이점을 지적했다. 이에 대응하여, 한 부장이 모조 사의 경쟁사 중 하나가 세금이 더 낮은 주를 이용하려고 했다가 실패했다고 주장했다. 그 회사는 본사를 이전한 [146] **이래로**, 고객의 관심을 잃고 있다.

어휘 | opposition 반대측, 반대 extremely 매우 prominent 유명한 china 도자기 existing 기존의 conversely 정반대로 property tax 재산세 point out 지적하다 in response 이에 대응하여 take advantage of ~을 이용하다 headquarters 본사

143.
(A) Correspondingly, a decision must be reached unanimously.
(B) Currently, management remains divided on the best course of action.
(C) Therefore, the meeting was determined to be productive.
(D) This is why Tennessee has fewer government regulations to follow.

해석 |
(A) 따라서, 결정은 만장일치로 이루어져야 한다.
(B) 현재, 경영진은 최선책을 두고 의견이 나뉘어진 상태이다.
(C) 그러므로, 회의는 생산적인 것으로 판명되었다.
(D) 그러한 이유로 테네시 주에는 따라야 하는 정부 규제가 더 적다.

해설 | 알맞은 문장 고르기
빈칸 앞 문장에서 어떤 결정에도 이르지 못했다고 했고, 빈칸 뒤로 사업 이전에 반대하는 의견과 지지하는 의견을 교대로 열거하고 있으므로, 결정권을 가지고 있는 경영진의 의견이 나뉘어진 상태라는 (B)가 들어가야 문맥이 자연스럽게 연결된다. 따라서 정답은 (B).

144.
(A) distribute
(B) distributing
(C) distribution
(D) distributor

해설 | 사람명사 vs. 사물/추상명사
빈칸은 an extremely prominent의 수식을 받으면서 being의 보어가 되는 명사 자리이다. being의 의미상 주어는 주절의 Mojo로, 문맥상 '유통 업체'가 적절하므로 정답은 (D) distributor. (C) distribution도 명사이기는 하지만, '유통, 배급'이라는 뜻이므로 의미상 적절하지 않아 오답이다.

145.
(A) connecting
(B) adjusting
(C) relocating
(D) joining

해석 | (A) 연결하다 (B) 적응하다
 (C) 이전하다 (D) 가입하다

해설 | 동사 어휘 relocate
빈칸 뒤의 전치사 to와 호응하여, '비용이 더 적게 드는 주로 이전하다'라는 뜻이 되어야 문맥상 어울린다. 따라서 (C) relocating이 정답이다.

146.
(A) Since
(B) Unless
(C) Not only
(D) No sooner

해석 | (A) ~ 이래로 (B) ~하지 않는 한
 (C) ~뿐만 아니라 (D) ~하자마자

해설 | 시간 접속사
빈칸은 뒤의 절을 이끄는 접속사가 들어갈 자리인데, 문맥상 '본사 이전 이래로 고객의 관심을 잃고 있다'는 뜻이 자연스러우므로 '~ 이래로'라는 뜻의 (A) Since가 정답이다.

PART 7

[147-148] 웹페이지

www.carpages.com/sales
For sale: 2014 green, four-door Campri Sedan
[147] **Sale price**: $8,500 (negotiable)
Vehicle description:
- Used car in very good condition (never been in an accident)
- Car mileage is 100,000 km ([148C] mostly highway driving), gets great gas mileage
- [148D] Two full sets of tires included (summer and all-season)
- [148A] Manufacturing warranty has expired, but [148B] vehicle has been safety tested
- Oil changes and maintenance checks performed regularly

www.carpages.com/sales
팝니다: 2014년형 초록색, 문 4개짜리 캄프리 세단
[147] 판매 가격: 8,500달러 (협상 가능)

차량 상세내역:
- 상태가 매우 양호한 중고차 (한 번도 사고 난 적 없음)
- 주행거리는 100,000km ([148C] 주로 고속도로에서 주행), 연비가 뛰어남
- [148D] 완벽히 갖춰진 타이어 두 세트 포함 (하절기용과 사계절용)
- [148A] 제조사 보증서는 기한이 만료되었지만, [148B] 차량 안전검사는 받았음
- 오일 교환 및 정비 점검은 정기적으로 시행했음
- 널찍한 트렁크 공간

· Spacious trunk space

Contact: Call Jerrold at 342-6587 to schedule a test drive.

연락: 시운전 일정을 잡으시려면 제럴드 씨에게 342-6587로 전화 주세요.

어휘 | negotiable 협상의 여지가 있는 description 서술, 설명 mostly 주로 car mileage 자동차 주행거리 gas mileage 연비 warranty 보증서 expire 만료되다 maintenance check 정비 점검 spacious 널찍한

147. What is suggested about the seller?

(A) He has only owned one vehicle.

(B) He performs his own oil changes.

(C) He is willing to lower the posted price.

(D) He pays a lot for fuel.

해석 | 판매자에 대해 암시된 것은?

(A) 소유하고 있는 차량이 한 대뿐이다.

(B) 오일 교환을 직접 한다.

(C) 게시한 가격을 낮출 용의가 있다.

(D) 연료비로 많은 돈을 지불한다.

해설 | **추론 문제**

단서 (147)의 판매 가격 옆에 negotiable이라는 단서를 덧붙였으므로, 협상을 통해 제시한 가격을 조정해 줄 의향이 있음을 알 수 있다. 따라서 정답은 (C). (A)와 (B)의 여부는 확인할 수 없으며, (D)는 연비가 뛰어나다는 내용과 맞지 않으므로 오답.

148. What is NOT true about the vehicle?

(A) It has time remaining on the warranty.

(B) It has passed official safety checks.

(C) It was driven on the highway regularly.

(D) It comes with an additional set of tires.

해석 | 차량에 대해 사실이 아닌 것은?

(A) 보증서 기한이 남아 있다.

(B) 공식적인 안전점검을 통과했다.

(C) 고속도로에서 자주 운행되었다.

(D) 추가로 타이어 세트가 따라온다.

해설 | **Not/True 문제**

Not/True 문제는 모든 선택지를 지문과 대조해가며 풀어야 한다. 차량 상세내역에서 (B), (C), (D)는 모두 확인할 수 있지만 단서 (148A)에서 제조사 보증서의 기한이 만료되었다고 했으므로 (A)는 지문의 내용과 일치하지 않는다. 따라서 정답은 (A).

[149-151] 기사

BGI Welcomes New CEO!

[149] BGI Enterprises welcomes Ada Strickland as its new Chief Executive Officer. Ada is an experienced executive with thirty years in executive management and business leadership.

Ada was born right here in Boston, Massachusetts, in 1943. [150A, 150C] She later moved to New York to complete her undergraduate degree in business. [150B] She then relocated a second time to London [150A] to get a master's in administration at Cambridge University. Ada started her career as a mortgage broker before becoming a financial analyst and moving back to her hometown.

[150D] Ada has been an officer and senior leader for many consulting firms. She has a solid track record of strong corporate leadership and is known for her understanding of tactical business strategies. She has demonstrated an ability to discover, mentor, and lead action-oriented teams of talented individuals. These skills will help her at [151] BGI Enterprises, which is still recovering from a series of aggressive layoffs that took place last year.

비지아이 사, 신임 대표이사를 맞이하다!

[149] 비지아이 엔터프라이즈 사는 신임 대표이사로 아다 스트릭랜드 씨를 맞이한다. 아다 씨는 30년간 경영진 및 업계 리더로서 경험이 많은 임원이다.

아다 씨는 1943년에 바로 이곳, 매사추세츠 주, 보스톤에서 태어났다. [150A, 150C] 그녀는 나중에 뉴욕으로 옮겨가 경영학 학위를 이수했다. [150B] 그리고 나서 다시 런던으로 옮겨 [150A] 케임브리지 대학에서 행정학 석사 학위를 받았다. 아다 씨는 금융 분석가가 되어 고향으로 돌아오기 전에 모기지 브로커로 직장 생활을 시작했다.

[150D] 아다 씨는 많은 컨설팅 회사에서 실무 담당자 및 임원으로 재직했다. 그녀는 강한 기업 리더십면에서 탄탄한 경력을 가지고 있으며 전술적인 사업 전략에 정통한 것으로 잘 알려져 있다. 그녀는 행동 지향적인 재능 있는 인재들을 발견하고 조언하며 지휘하는 능력을 보여주었다. 이러한 능력이 [151] 작년에 있었던 일련의 공격적인 정리해고에서 아직도 회복 중에 있는 비지아이 엔터프라이즈 사에서 그녀에게 도움이 되어줄 것이다.

어휘 I undergraduate degree 학사 학위　master's (degree) 석사 학위　administration 행정　solid 탄탄한, 실속 있는　track record 경력, 실적　tactical 전술[전략]적인　demonstrate 보여주다　mentor 조언하다, 지도하다　action-oriented 행동 지향적인　aggressive 공격적인　layoff 정리해고

149. What is the purpose of the article?

(A) To outline the qualifications needed for a role

(B) To provide the profile of a new executive

(C) To describe a business program

(D) To publicize a job opening

해석 I 기사의 목적은?

(A) 역할에 필요한 자격을 간략히 설명하기 위해

(B) 신임 임원의 약력을 알려주기 위해

(C) 비즈니스 프로그램을 설명하기 위해

(D) 채용 공고를 광고하기 위해

해설 I 주제, 목적 문제

글의 주제나 목적을 묻는 문제의 단서는 대개 지문의 앞부분에 등장한다. 첫 문장에서 신임 대표이사를 맞이한다는 내용을 밝히고 나서, 이어지는 내용은 모두 신임 대표이사의 경력 및 실적에 관한 것이다. 따라서 정답은 (B).

150. What is NOT stated about Ada Strickland?

(A) She earned two university degrees.

(B) She lived in London temporarily.

(C) She grew up in New York City.

(D) She has worked for multiple companies.

해석 I 아다 스트릭랜드 씨에 대해 언급되지 않은 것은?

(A) 두 개의 대학에서 학위를 받았다.

(B) 잠시 런던에서 살았다.

(C) 뉴욕 시에서 자랐다.

(D) 여러 회사에서 근무했다.

해설 I Not/True 문제

(A)는 단서 (150A)에서 각각 다른 대학교에서 경영학과 행정학 두 개의 학위를 받았음을 알 수 있고, (B)는 단서 (150B)에서 런던에 잠시 살았음을 알 수 있으며, (D)는 단서 (150D)에서 많은 회사에서 근무했음을 알 수 있다. 그러나 아다 씨는 대학을 다니기 위해 나중에 뉴욕으로 옮겨갔다고 했으므로, 뉴욕은 자란 곳이 아님을 알 수 있다. 따라서 정답은 (C).

151. What is implied about BGI Enterprises?

(A) It recently reduced its work force.

(B) It completed a merger with another firm.

(C) It plans to lay off staff members soon.

(D) It has not had a CEO for several months.

해석 I 비지아이 엔터프라이즈 사에 대해 암시된 것은?

(A) 최근에 직원 수를 줄였다.

(B) 다른 회사와 합병을 마쳤다.

(C) 조만간 직원을 정리해고 할 계획이다.

(D) 몇 달간 대표이사 자리가 비어 있었다.

해설 I 추론 문제

단서 (151)에서 작년에 정리해고가 있었다고 했으므로 이를 통해 직원 수를 줄였음을 추론할 수 있다. 따라서 정답은 (A).

[152-154] 기사

Hammett Builders Appointed as New Community Builder

By Jennifer Brashears

[154] Mitchell Construction will no longer be responsible for designing and installing the city's new water pipe in Charlton Square. — [1] — Prior to the move-in dates for new residents, a water pipe needs to be installed to provide them all with water service.

Earlier last year, the city council accepted a proposal to install a new water pipe in this location. — [2] — Afterwards, it hired Mitchell Construction to head up the project. Unfortunately, Mitchell Construction had to cancel the agreement, [152] as another project

해밋 건설사, 새로운 지역 건설사로 지정되다

제니퍼 브래셔스 작성

[154] 미첼 건설사는 더 이상 시에서 맡긴 찰턴 스퀘어에 새로운 수도관 설계 및 설치를 담당하지 않는다. —[1]— 새로운 입주민들의 입주 날짜 이전에, 그들 모두에게 수도 서비스를 제공하기 위해서 수도관이 설치되어야 한다.

작년 초에, 시의회는 이 지역에 새로운 수도관을 설치하자는 제안을 받아들였다. —[2]— 그 후에, 공사를 추진하기 위해 미첼 건설사를 고용하였다. 유감스럽게도, 미첼 건설사는 계약을 취소해야 했는데, [152] 다른 공사가 예상보다 훨씬 길어지고 있기 때문이다. —[3]—

has gone on much longer than expected. — [3] — Hammett Builders submitted a very cost-effective proposal, and has been selected to replace Mitchell Construction. Its appointment was a decision that Mayor Tara Buzbee is quite pleased with. She stated, "Hammett Builders was the perfect candidate for the job. — [4] — **153** The best part is that, through Hammett, the work is expected to be completed within six weeks, which is much faster than we originally anticipated."

해밋 건설사는 비용 효율이 매우 높은 제안서를 제출했고, 미첼 건설사를 대신할 곳으로 선정되었다. 이 지명은 타라 버즈비 시장이 매우 만족해 하는 결정이었다. 그녀는 "해밋 건설사는 그 일에 완벽한 후보였습니다. — [4] — **153** 가장 좋은 점은 해밋 건설사를 통하면 공사가 6주 이내에 끝날 것으로 예상된다는 것인데, 이는 우리가 처음에 예상했던 것보다 훨씬 빠른 것입니다."라고 말했다.

어휘 | install 설치하다 prior to ~ 이전에 move-in 전입 afterwards 그 뒤에 agreement 계약, 합의 go on 계속되다 cost-effective 비용 효율이 높은 replace 대신하다 appointment 지명 be pleased with ~에 만족하다 candidate 후보 anticipate 예상하다

152. What is suggested about Mitchell Construction?
(A) It proposed a project to the city.
(B) It is currently engaged in a project.
(C) It can complete the work within six weeks.
(D) It nominated Hammett Builders to be its replacement.

해석 | 미첼 건설사에 대해 암시된 것은?
(A) 시에 공사를 제안했다.
(B) 현재 공사에 참여하고 있다.
(C) 6주 안에 작업을 끝마칠 수 있다.
(D) 자사를 대신할 곳으로 해밋 건설사를 추천했다.

해설 | 추론 문제
단서 (152)에서 미첼 건설사가 계약을 취소해야 하는 이유가 다른 공사가 예상보다 길어지고 있기 때문이라고 했으므로, 현재 다른 공사를 진행하고 있음을 알 수 있다. 따라서 정답은 (B).

153. What aspect of Hammett Builders is Ms. Buzbee most satisfied with?
(A) Its safety practices
(B) Its unique design ideas
(C) Its experienced workers
(D) Its time-saving plan

해석 | 해밋 건설사에 대해서 버즈비 씨가 가장 만족스러워하는 점은?
(A) 안전 실무
(B) 독특한 설계 아이디어
(C) 경험 많은 인부들
(D) 시간 절약 계획

해설 | 특정 정보 확인 문제
버즈비 씨는 시장으로, 기사의 마지막에 그녀의 말을 인용한 것에 주의하며 살펴봐야 한다. 단서 (153)에 따르면 버즈비 씨는 공사가 예상보다 훨씬 짧은 기간 내에 끝날 것으로 예상되는 것이 가장 좋은 점이라고 말했으므로, 정답은 (D). 지문의 be completed within six weeks, which is much faster than we originally anticipated가 정답에서 함축 표현을 활용하여 time-saving plan으로 패러프레이징되었다.

154. In which of the positions marked [1], [2], [3], and [4] does the following sentence best belong?

"This brand-new residential neighborhood was only recently constructed."

(A) [1]
(B) [2]
(C) [3]
(D) [4]

해석 | [1], [2], [3], [4]로 표시된 위치들 중, 다음 문장이 들어가기에 가장 적절한 곳은?

"이 새로운 주거 지역은 최근에서야 건설된 곳이다."

(A) [1]
(B) [2]
(C) [3]
(D) [4]

해설 | 문장 위치 찾기 문제
문장 위치 찾기 문제는 제시된 문장에 this, that 같은 지시대명사가 있으면 이것이 가리키는 것이 무엇인지 문맥을 통해 파악해야 한다. 따라서 This brand-new residential neighborhood가 지칭할 만한 것을 지문에서 찾아야 하는데, [1]번 앞 문장에 나온 in Charlton Square라는 지명이 이에 해당한다. 이 지역에 건설된 새로운 주거 지역을 언급하고 다음 문장에서 새로운 입주민들의 입주 날짜에 관한 내용이 이어지는 것이 자연스러우므로, 정답은 (A).

Richardson Electronics Shipping and Delivery Policies

- Items will be shipped immediately after credit card payments are processed in full.
- Shipping is free on all domestic orders.
- The cost for international shipping is calculated based on location. ¹⁵⁵ The price will be displayed on the check-out page before you complete your order.
- Deliveries are made between 9 A.M. and 4 P.M. on weekdays.
- ¹⁵⁶ If our drivers are unable to deliver your purchase, your package will be taken to the nearest postal center, where you may retrieve it in person.

리처드슨 가전매장 발송 및 배송 규정

- 물품은 신용카드 결제가 완전히 처리된 직후 바로 발송됩니다.
- 모든 국내 주문에 대해서는 배송이 무료입니다.
- 해외 배송 비용은 지역에 따라 계산됩니다. ¹⁵⁵ 배송 가격은 주문을 끝내기 전에 확인 페이지에서 보여집니다.
- 배송은 주중에 오전 9시부터 오후 4시 사이에 이루어집니다.
- ¹⁵⁶ 배송 기사가 귀하의 주문품을 배달할 수 없을 경우, 귀하의 물품은 직접 되찾을 수 있는 가장 가까운 우편 취급소로 보내집니다.

어휘 | shipping 발송, 선적 delivery 배송, 배달 process 처리하다 domestic 국내의 display 보여주다 postal center 우편 취급소 retrieve 되찾아오다, 회수하다 in person 직접

155. For whom is the notice most likely intended?
(A) Delivery drivers
(B) Online shoppers
(C) Customer service agents
(D) Retail clerks

해석 | 공지의 대상일 것 같은 사람은?
(A) 배송 기사
(B) 온라인 구매자
(C) 고객서비스 담당 직원
(D) 판매점 직원

해설 | 대상, 출처 문제
공지가 주문한 물품의 배송 비용, 배송 시간, 수령 방법 등을 다루고 있으므로, 기본적으로 물건을 구입한 사람들을 대상으로 하는 것임을 알 수 있다. 특히 단서 (155)에서 가격이 확인 페이지에서 보여진다는 것을 통해 이 공지는 온라인으로 주문하는 사람들을 대상으로 한다는 것을 알 수 있으므로, 정답은 (B).

156. What is mentioned about the delivery process?
(A) Shoppers can track deliveries.
(B) Failed deliveries must be picked up.
(C) The fees are the same regardless of the destination.
(D) Drivers can drop off packages on the weekend.

해석 | 배송 절차에 대해서 언급된 것은?
(A) 구매자는 배송을 추적할 수 있다.
(B) 배달에 실패한 물품은 수령해야 한다.
(C) 요금은 배송지에 상관없이 동일하다.
(D) 기사가 주말에 물품을 갖다줄 수 있다.

해설 | Not/True 문제
마지막 배송 규정인 단서 (156)에서, 기사가 물품을 배달할 수 없는 경우에는 고객이 우편 취급소에 가서 직접 수령할 수 있다고 했으므로 정답은 (B). (A)는 전혀 언급되지 않은 내용이고, (C)와 (D)는 지문의 내용과 일치하지 않으므로 오답.

Eudora Vineyards Starts Annual Summer Photo Contest

CALIFORNIA, June 30—Every summer for the last five years, local winery Eudora Vineyards has asked California residents to show their Californian pride by taking pictures of themselves at, or adjacent to,

유도라 빈야즈 사, 연례 하계 사진 경연대회를 시작하다

캘리포니아, 6월 30일—지난 5년 동안 매년 여름, 지역 와인 양조장인 유도라 빈야즈는 캘리포니아 주민들에게 골든 게이트 브릿지같은 캘리포니아 주의 유명한 랜드마크 및 그 인근에서 자신의 사진을 찍어서 캘리포니아인의 자부심을 보여줄 것을 요청해왔다. 캘리포니아 주의 어떤 풍경이 배경에 있는지와는 상관없이, ^{158D} 유도라 빈야

prominent state landmarks like the Golden Gate Bridge. Regardless of what piece of state scenery is in the backdrop, **158D** a bottle or glass of wine from Eudora Vineyards must be situated somewhere in the photo.

All photos are posted to the company's social media page, where **158A** fans will get to vote for their favorite pictures **158B** from July 1 to July 31. Votes are limited to one per person, but each photo typically receives thousands of votes each year. **157** The first-place winner is invited to take a free tour of the winery. Second- and third-place winners are given smaller prizes that vary from souvenirs to vouchers. The competition has successfully raised the profile of Eudora Vineyards in the community, and helped to increase its annual sales by nearly 15 percent.

즈에서 생산한 와인 한 병 또는 한 잔이 사진 어딘가에 반드시 있어야 한다.

모든 사진은 회사의 소셜 미디어 페이지에 게재되며, 이곳에서 **158B** 7월 1일부터 7월 31일까지 **158A** 팬들은 자신이 가장 마음에 드는 사진에 **투표**를 할 것이다. 투표는 한 사람당 한 번으로 제한되지만, 각각의 사진은 보통 매년 수천 개의 표를 받는다.

157 1등 수상자는 와인 양조장을 무료로 둘러볼 수 있도록 초대된다. 2등과 3등 수상자에게는 기념품부터 상품권까지 다양하게 소정의 상품이 주어진다. 경연대회는 지역에서 유도라 빈야즈의 인지도를 성공적으로 높여주었고, 연간 매출을 거의 15퍼센트 증가시키는 데 도움을 주었다.

어휘 | winery 와인 양조장 adjacent to ~에 인접한 prominent 유명한 landmark 랜드마크, 눈에 띄는 대표적 건물이나 장소 regardless of ~에 상관 없이 backdrop 배경 be situated 위치해 있다 take a tour of ~을 둘러보다 vary 다양하다 souvenir 기념품 voucher 상품권 profile 인지도, 관심

157. What is suggested about Eudora Vineyards?
(A) It is located near the Golden Gate Bridge.
(B) It opened five years ago.
(C) It holds regular wine-tasting events.
(D) It gives tours of its winery.

해석 | 유도라 빈야즈에 대해 암시된 것은?
(A) 골든 게이트 브릿지 근처에 위치해 있다.
(B) 5년 전에 개장했다.
(C) 정기적인 와인 시음 행사를 개최한다.
(D) 자사의 와인 양조장 투어를 제공한다.

해설 | 추론 문제
단서 (157)에서 1등 수상자는 와인 양조장을 무료로 둘러볼 수 있다고 했으므로 유도라 빈야즈가 양조장 투어를 제공함을 추론할 수 있다. 따라서 정답은 (D). 양조장이 5년 전에 개장한 것이 아니라 5년 동안 사진 경연대회를 주최한 것이므로 (B)는 오답.

158. What is NOT true about the photo contest?
(A) Fans get to select the winner.
(B) The voting period is a month long.
(C) Winners receive free bottles of wine.
(D) Photos must be related to the winery.

해석 | 사진 경연대회에 대해 사실이 아닌 것은?
(A) 팬들이 수상자를 선정할 수 있다.
(B) 투표 기간은 한 달 동안이다.
(C) 수상자들은 무료로 와인을 받는다.
(D) 사진은 와인 양조장과 관련이 있어야 한다.

해설 | Not/True 문제
(A)는 단서 (158A)에서 팬들이 직접 사진에 투표한다고 했고, (B)는 단서 (158B)에서 투표는 7월 1일부터 31일 한 달간이라고 했으며, (D)는 단서 (158D)에서 유도라 빈야즈에서 생산한 와인이 사진 속에 있어야 한다고 했으므로 지문과 일치한다. 하지만 수상자들에게 무료로 와인을 준다는 내용은 없으므로 (C)가 정답.

[159-161] 공지

Tony's Catering Service

Tony's Catering provides upscale catering services to clients. We cook meals in our facility and deliver prepared food to clients, or we can make meals at external locations.

Server Responsibilities

토니스 케이터링 서비스

토니스 케이터링에서는 고객들에게 고품격의 출장 요리 서비스를 제공합니다. 우리 시설에서 음식을 조리하여 고객에게 준비된 음식을 배달하거나, 외부 장소에서 음식을 만들 수도 있습니다.

서빙하는 사람의 업무

- Offer menus to guests, explain entrée and drink specials, fill water glasses
- Provide perfect service to every table by paying close attention to the needs of patrons
- Process payments

Food Purchaser Responsibilities
- Build relationships with nearby farmers and producers
- Order meat, produce, and dairy products according to client needs
- [160] Conduct regular on-site visits to local partner vendors

Kitchen Staff Responsibilities
- Confirm menu specials and prepare ingredients every day
- Assure the cleanliness and sanitization of all work areas
- [161] Thoroughly clean all fridges, freezers, and other food storage areas monthly

[159] If you would like additional information about your expected duties, please contact your area manager.

손님에게 메뉴 제공하기, 주요리 및 특별 음료 설명하기, 물잔 채우기
- 고객의 요구에 세심한 주의를 기울여 모든 테이블에 완벽한 서비스 제공하기
- 계산 처리하기

식품 구매자의 업무
- 인근의 농부 및 생산자들과 인맥 쌓기
- 고객의 요구에 따라 고기, 농산물, 유제품 주문하기
- [160] 제휴를 맺은 현지 판매처들을 정기적으로 현장 방문하기

주방 직원의 업무
- 특별 메뉴를 확인하고 매일 재료 준비하기
- 모든 작업 구역의 청결 및 위생을 확실히 하기
- [161] 모든 냉장고 및 냉동고, 기타 식품 보관 장소를 매달 철저히 청소하기

[159] 여러분의 예상 업무에 대해 추가 정보를 원하신다면, 담당 구역의 관리자에게 연락하십시오.

어휘 | catering 출장 요리, 행사 음식 공급 upscale 고급의 external 외부의 entrée 주요리 patron 고객 nearby 인근의 produce 농산물 dairy product 유제품 on-site 현장의 assure 확실히 하다 sanitization 위생 처리 thoroughly 철저하게 storage 저장(고), 보관

159. Who is the notice intended for?
(A) Dairy producers
(B) Food-service workers
(C) Catering clients
(D) Produce farmers

해석 | 공지가 의도하고 있는 대상은?
(A) 유제품 생산자
(B) 요식업계 직원
(C) 출장 요리 고객
(D) 농산물 생산자

해설 | 대상, 출처 문제
출장 음식을 공급하는 업체에서 각 담당 직원들의 업무를 구체적으로 설명하고 있다. 특히 단서 (159)에서 업무와 관련하여 구역 관리자에게 연락하라는 내용으로 보아, 업체 직원들을 대상으로 한 공지임을 알 수 있으므로 (B)가 정답이다.

160. What is suggested about the ingredients used by Tony's Catering?
(A) They are purchased directly by the client.
(B) They are locally sourced.
(C) They are organically farmed.
(D) They are heavily discounted.

해석 | 토니스 케이터링에서 사용하는 요리 재료에 대해 암시된 것은?
(A) 고객이 직접 구매한 것이다.
(B) 현지에서 생산된 것이다.
(C) 유기농으로 재배된 것이다.
(D) 많이 할인된 것이다.

해설 | 추론 문제
단서 (160)에서 식품 구매자의 업무로 제휴를 맺은 현지 판매처들을 정기적으로 방문한다는 것으로 보아, 이 업체는 현지에서 생산된 재료를 구매한다는 것을 유추할 수 있으므로 (B)가 정답이다.

161. How often are food storage areas cleaned?

(A) Once a day

(B) Once a week

(C) Once a month

(D) Once a year

해석 | 식품 보관 장소는 얼마나 자주 청소하는가?

(A) 하루에 한 번

(B) 일주일에 한 번

(C) 한 달에 한 번

(D) 일 년에 한 번

해설 | **특정 정보 확인 문제**

단서 (161)에서 식품 보관 장소는 매달 청소하라고 나와 있으므로 정답은 (C). 지문의 monthly가 정답에서 Once a month로 패러프레이징되었다.

[162-163] 문자 메시지

JOHN REINHARDT	09:20
I've sent you an e-mail. Have you looked at it yet?	

HAZEL WISEMAN	09:23
Oh, no. I've been traveling the last few days, and I haven't been able to read any e-mails.	

HAZEL WISEMAN	09:24
What did the message say?	

JOHN REINHARDT	09:25
162 I've completed several design proposals for your living-room remodel, and I sent some possible dates for us to meet and discuss them.	

HAZEL WISEMAN	09:26
I'll be back on Friday morning.	

JOHN REINHARDT	09:27
That's perfect. Let's meet at La Cantina at 1 P.M. on Friday.	

JOHN REINHARDT	09:28
I also have a question. 163 Do you want me to purchase the building materials, or do you want confirmation before I buy anything?	

HAZEL WISEMAN	09:29
I prefer the former. As long as you stay within budget, you can have complete control.	

존 라인하르트	09:20
제가 이메일을 보냈는데요. 보셨나요?	

헤이즐 와이즈먼	09:23
아, 아니요. 지난 며칠 동안 여행 중이라서, 이메일을 전혀 읽을 수 없었어요.	

헤이즐 와이즈먼	09:24
무슨 내용이었어요?	

존 라인하르트	09:25
162 댁의 거실 개조를 위해 디자인 제안서를 몇 개 작성해서, 우리가 만나서 그에 대해 의논하기 위한 가능한 날짜들을 보냈어요.	

헤이즐 와이즈먼	09:26
저는 금요일 오전에 돌아갈 거예요.	

존 라인하르트	09:27
그거 정말 잘됐네요. 금요일 오후 1시에 라 칸티나에서 만나죠.	

존 라인하르트	09:28
질문도 하나 있어요. 163 제가 건축 자재를 구입할까요, 아니면 제가 뭔가 구입하기 전에 확인하시겠어요?	

헤이즐 와이즈먼	09:29
저는 전자가 더 좋아요. 예산 범위 내에서 하시는 것이라면, 전적으로 알아서 하시면 돼요.	

어휘 | proposal 제안(서) remodel 개조 building material 건축 자재 confirmation 확인 former (둘 중에서) 전자 stay within budget 예산 범위 내에서 하다 have control 통제권을 갖다 complete 완전한

162. Where most likely does Mr. Reinhardt work?

(A) At a furniture store

(B) At a design firm

(C) At a construction company

(D) At a travel agency

해설 | 라인하르트 씨가 일할 것 같은 곳은?

(A) 가구 매장

(B) 디자인 회사

(C) 건설 회사

(D) 여행사

해설 | **특정 정보 확인 문제**

단서 (162)에서 거실 개조를 위해 디자인 제안서를 작성했다는 라인하르트 씨의 말에서 그의 직업이 인테리어 디자이너임을 알 수 있다. 따라서 정답은 (B).

163. At 09:29, what does Ms. Wiseman mean when she writes, "I prefer the former"?

(A) She needs an itemized list of expenses.

(B) She does not need to buy new furniture.

(C) She does not want to make purchasing decisions.

(D) She would like to have an e-mail sent.

해석 | 9시 29분에, 와이즈먼 씨가 "저는 전자가 더 좋아요"라고 한 것에서 그녀가 의도한 것은?

(A) 지출 경비에 대해 항목별 목록을 원한다.

(B) 새 가구를 살 필요가 없다.

(C) 구매 결정을 내리기를 원하지 않는다.

(D) 이메일을 보내주기를 원한다.

해설 | 의도 파악 문제

인용구 속 the former의 내용이 무엇인지를 앞에 나온 라인하르트 씨의 말에서 찾으면 된다. 단서 (163)에 따르면 라인하르트 씨는 or를 이용해 두 가지 선택권을 제시하고 있는데, '전자'에 해당하는 것은 그가 건축 자재를 구입하는 것이다. 따라서 정답은 (C).

[164-167] 이메일

To: Lonnie Payne <payne@magmail.net>

From: Meredith McGuire
 <meredith@meredithmccguire.com>

Date: April 2

Subject: Your review

Attachment: Taste Testing Event

Dear Ms. Payne,

I just wanted to express my sincere gratitude that you wrote a favorable review of my book in your cooking magazine. As a thank you for your kind words, **166** I'd like to invite you to one of my book promotional tour events. — [1] — **165** I will be visiting a local bakery to sign copies of the book and **164** conduct a taste test with some of the recipes I published.
166 I've attached the schedule details for you.
— [2] — The event is at 2 P.M. on April 14. It is free of charge, but there is limited space, so I have reserved a spot for you in case you wish to drop by. — [3] — **167** Also, you are more than welcome to film the event and upload the video link to your magazine's social media site. — [4] —
Let me know if you are interested in attending.

Meredith McGuire

받는 사람: 로니 페인 〈payne@magmail.net〉

보내는 사람: 메레디스 맥과이어
 〈meredith@meredithmccguire.com〉

날짜: 4월 2일

제목: 귀하의 비평

첨부: 시식 행사

페인 씨께,

귀하의 요리 잡지에 제 책에 대한 호의적인 비평을 써주셔서 진심으로 감사를 드리고 싶습니다. 귀하의 친절한 평가에 대한 감사의 의미로, **166** 제 책의 홍보 투어 행사에 귀하를 초대하고자 합니다. – [1] – **165** 지역의 한 제과점을 방문하여 도서 사인회를 하고 **164** 제가 출판한 요리법 중 몇몇 요리의 시식회를 열 예정입니다.

166 자세한 일정표를 첨부했습니다. –[2]– 행사는 4월 14일 오후 2시에 있습니다. 행사는 무료지만, 공간이 한정되어 있어서, 들르시길 원하실 경우에 대비해서 귀하의 자리를 따로 남겨두었습니다. –[3]– **167** 또한 얼마든지 행사를 촬영하여 귀하의 잡지의 소셜 미디어 사이트에 동영상 링크를 올리셔도 됩니다. –[4]–

참석할 의향이 있으신지 알려주세요.

메레디스 맥과이어 드림

어휘 | taste testing 시식 sincere 진심의 gratitude 감사 favorable 호의적인 promotional 홍보의 free of charge 무료로 spot 자리 in case ~할 경우에 대비해서 drop by 들르다 be more than welcome to *do* 얼마든지 ~해도 좋다 film 촬영하다; 영화 upload 데이터를 올리다, 업로드하다

164. Who is Ms. McGuire?

(A) A publicist

(B) A magazine publisher

(C) A book reviewer

(D) A recipe writer

해석 | 맥과이어 씨는 누구인가?

(A) 홍보 담당자

(B) 잡지 출판자

(C) 도서 비평가

(D) 요리법 저자

해설 | **발신인 신분 문제**

맥과이어 씨는 이메일을 보낸 사람이다. 첫 문장에서 맥과이어 씨가 자신의 책을 출간했음을 알 수 있는데, 단서 (164)에서 그 책의 내용이 요리법에 관한 것이라 하였으므로 맥과이어 씨가 요리법 저자임을 알 수 있다. 따라서 (D)가 정답. (B)는 페인 씨의 직업이므로 오답이다.

165. Where will the event take place?

(A) At a book store

(B) At a bakery

(C) At a magazine publisher

(D) At a cooking school

해석 | 행사가 열릴 장소는?

(A) 서점

(B) 제과점

(C) 잡지 출판사

(D) 요리 학교

해설 | **특정 정보 확인 문제**

책의 홍보 투어 행사에 초대하고 싶다는 문장에 이어, 단서 (165)에서 지역의 한 제과점에서 사인회와 시식회를 한다고 하였으므로, 이곳이 행사 장소임을 알 수 있다. 따라서 정답은 (B).

166. What did Ms. McGuire send to Ms. Payne?

(A) A link to a video

(B) A copy of a recipe

(C) A program for an event

(D) A magazine article

해석 | 맥과이어 씨가 페인 씨에게 보낸 것은?

(A) 동영상 링크

(B) 요리법 책 한 권

(C) 행사 프로그램

(D) 잡지 기사

해설 | **특정 정보 확인 문제**

단서 (166)에 따르면 맥과이어 씨는 친절한 평가에 대한 감사의 의미로 페인 씨를 행사에 초대한다고 했으며, 행사의 자세한 일정표를 첨부했다고 했으므로 첨부한 것이 행사 프로그램임을 알 수 있다. 따라서 (C)가 정답.

167. In which of the positions marked [1], [2], [3], and [4] does the following sentence best belong?

"Perhaps it will help expand your online audience."

(A) [1]

(B) [2]

(C) [3]

(D) [4]

해석 | [1], [2], [3], [4]로 표시된 위치들 중, 다음 문장이 들어가기에 가장 적절한 곳은?

"그렇게 하면 귀하의 온라인 독자를 늘리는 데 도움이 될 것입니다."

(A) [1]

(B) [2]

(C) [3]

(D) [4]

해설 | **문장 위치 찾기 문제**

제시된 문장 속 대명사 it이 가리키는 것이 무엇인지 문맥을 통해 파악해야 한다. '온라인 독자를 늘리는 데 도움이 되는 것'은 단서 (167)의 '소셜 미디어 사이트에 동영상을 올리는 것'을 가리키므로 정답은 (D).

[168-171] 온라인 채팅

Carolyn Lamantia [1:09 P.M.]

I wanted to talk to both of you about ordering some more office supplies for the supply cabinet. **168** I noticed that it's getting fairly empty.

Yvonne Castile [1:11 P.M.]

It's about that time. Orders are due at the end of the month, which is only a couple of days away.

캐럴린 라만티아 [오후 1:09]

비품함에 넣을 사무용품을 더 주문하는 것에 대해 두 사람과 이야기를 하고 싶어요. **168** 비품함이 상당히 비어가고 있는 걸 알았어요.

이본 캐스틸 [오후 1:11]

그럴 때가 됐어요. 주문은 월말에 하기로 되어 있는데, 불과 이삼일 후잖아요.

Wendell Haag [1:13 P.M.]
You'll have to check with Martin. He's responsible for placing those orders each month. Unfortunately, he's on vacation, and he won't be back before the due date.

Carolyn Lamantia [1:17 P.M.]
169 What happens if the order isn't submitted by the deadline?

Wendell Haag [1:19 P.M.]
It's set up on an automatic system. We have a default order that is placed every month. If we want to modify the amounts, then Martin submits an order manually. Otherwise, the default order is processed.

Yvonne Castile [1:21 P.M.]
Martin is really good at caring for these things. 170 If we are lacking supplies, I'm sure he noticed and updated the order.

Wendell Haag [1:23 P.M.]
There's an easy way to find out. 171 On the intranet, you can check to see the invoice history. It'll list all the orders that have been placed.

	SEND

웬들 하그 [오후 1:13]
마틴에게 확인해봐야 할 거예요. 그가 매월 그것을 주문하는 일을 맡고 있으니까요. 공교롭게도 그가 휴가 중이고, 주문 예정일이 지나야 돌아올 텐데요.

캐럴린 라만티아 [오후 1:17]
169 주문서를 기한까지 제출하지 않으면 어떻게 되나요?

웬들 하그 [오후 1:19]
그건 자동 시스템으로 설정되어 있어요. 매월 주문되는 기본 설정 주문이 있어요. 주문량을 바꾸고 싶으면, 마틴이 주문서를 직접 제출해요. 그렇지 않으면, 기본 설정 주문이 처리돼요.

이본 캐스틸 [오후 1:21]
마틴은 그런 일 처리를 정말 잘해요. 170 만약 비품이 부족했다면, 마틴이 알아채서 주문을 업데이트했을 것이라고 확신해요.

웬들 하그 [오후 1:23]
쉽게 알아볼 방법이 있어요. 171 인트라넷에서 거래 명세서 내역을 확인해보면 돼요. 이제까지 주문한 내역이 모두 나와 있을 거예요.

	보내기

어휘 | supply 《보통 복수형》 비품 fairly 상당히, 꽤 due 하기로 되어 있는, 예정된 set up 설정하다 default 기본 설정 상태 modify 고치다, 수정하다 manually 수동으로 be good at ~을 잘하다 care for ~을 처리하다(=sort out) invoice 거래 명세서, 대금 청구서

168. At 1:11 P.M., what does Ms. Castile mean when she writes, "It's about that time"?
(A) Supplies have started to get quite low.
(B) She is prepared for a discussion.
(C) Supplies will be delivered tomorrow.
(D) She is due to take a vacation.

해석 | 오후 1시 11분에, 캐스틸 씨가 "그럴 때가 됐어요"라고 한 것에서 그녀가 의도한 것은?
(A) 비품이 상당히 줄어들기 시작했다.
(B) 논의에 대해 준비가 되어 있다.
(C) 비품은 내일 배달될 것이다.
(D) 휴가를 갈 예정이다.

해설 | 의도 파악 문제
단서 (168)에서 '비품함이 상당히 비어 가고 있다'는 라만티아 씨의 말에 대한 응답으로 '그럴 때가 됐다'고 한 것이므로, (A)가 정답이다.

169. What is Ms. Lamantia concerned about?
(A) Contacting Martin
(B) Coordinating vacations
(C) Missing a deadline
(D) Moving the supply cabinet

해석 | 라만티아 씨가 염려하는 것은?
(A) 마틴에게 연락하는 것
(B) 휴가를 조정하는 것
(C) 기한을 놓치는 것
(D) 비품함을 옮기는 것

해설 | 특정 정보 확인 문제
단서 (169)에서 라만티아 씨가 주문서를 기한까지 제출하지 않을 경우 어떻게 될지 묻는 것으로 보아 그녀가 주문서 제출 기한을 놓칠까 염려하고 있음을 알 수 있으므로 (C)가 정답이다.

170. What does Ms. Castile imply about Martin?

(A) **He has likely already arranged an order.**

(B) He is the only person who can access invoices.

(C) He returned from his vacation early.

(D) He should be given the due date.

171. According to Mr. Haag, what is stored on the intranet?

(A) **Order histories**

(B) Employee phone numbers

(C) Pricing charts

(D) Supplier contact information

[172-175] 정보문

SALEM CORP. COMPANY MONTHLY NEWSLETTER

From January 1 to March 30, [172] we experimented with the use of video conferences to enable all staff members from remote offices to be visibly present at all meetings, both small and large. These video conferences were highly informative.

What was the purpose of these video conferences?

The goal was to determine whether there are better ways to facilitate interaction between project members in different offices.

What are the advantages of video conferences?

First of all, [173B] purchasing video conference software is cheaper than continuing to send employees overseas for meetings.

Second, [173C] it avoids the misunderstandings that occur through phone calls, e-mails, or instant messages. The lack of face-to-face interaction in these types of meetings prevents people from using facial expressions, gestures, and other forms of communication. [173A] Being able to see the people we interact with is [174] critical to ensuring clarity in meetings.

When are video conferences inappropriate?

It is NOT recommended that we use video conferences as a replacement for all in-person meetings, [175] such as our yearly meeting with the board of directors. We believe it is beneficial to

have all board members physically present at this time.

어휘 | experiment with ~을 실험하다 video conference 화상 회의 remote 멀리 떨어진 visibly 눈에 보이게 informative 유익한 facilitate 용이하게 하다 lack 부족 critical 대단히 중요한 clarity 명확성 inappropriate 부적절한 replacement 대체 in-person 직접의 board of directors 이사회

172. What is this information mainly about?
(A) The results of a staff meeting
(B) The cost of business travel
(C) A new method of interaction
(D) A problem with e-mail communication

해석 | 이 정보문의 주된 내용은?
(A) 직원 회의 결과
(B) 출장 비용
(C) 상호 작용의 새로운 방법
(D) 이메일 의사소통의 문제점

해설 | **주제, 목적 문제**
지문의 주제는 대부분 앞에 위치하고 있다. 단서 (172)에서 회사가 실험적으로 화상 회의를 이용했다고 한 다음에 전반적으로 이에 대해 다루고 있다. 따라서 정답은 (C)이다. 지문의 conferences와 meetings가 정답에서 interaction으로 바꾸어 표현되었다.

173. What is NOT mentioned as an advantage of video conferences?
(A) They allow for visual communication.
(B) They save on travel expenses.
(C) They prevent misunderstandings.
(D) They shorten meeting lengths.

해석 | 화상 회의의 이점으로 언급되지 않은 것은?
(A) 보면서 의사소통을 할 수 있게 해준다.
(B) 출장 경비를 절약해준다.
(C) 오해를 방지한다.
(D) 회의 시간을 줄여준다.

해설 | **Not/True 문제**
화상 회의의 이점을 묻는 질문에 대한 답변에서 언급되지 않은 내용을 찾으면 된다. (A)는 단서 (173A)에서 의사소통하는 사람들을 볼 수 있다고 했고, (B)는 단서 (173B)에서 직접 회의에 가는 것보다 비용이 적게 든다고 했으며, (C)는 단서 (173C)에서 오해를 방지해 준다고 했다. 그러나 회의 시간을 줄여준다는 내용은 없으므로 (D)가 정답이다.

174. The word "critical" in paragraph 4, line 4, is closest in meaning to
(A) hazardous
(B) analytical
(C) essential
(D) negative

해석 | 넷째 단락 네 번째 줄의 "critical"과 의미상 가장 가까운 단어는?
(A) 위험한
(B) 분석적인
(C) 극히 중요한
(D) 부정적인

해설 | **동의어 문제**
문맥상 '회의에서 소통하는 사람들을 볼 수 있다는 것이 대단히 중요하다'는 의미이므로 이와 비슷한 의미의 어휘를 고른다. 따라서 정답은 (C). critical은 '위태로운, 비판적인'이란 뜻도 있지만, 지문에서는 '대단히 중요한'이란 뜻으로 쓰였다.

175. What is indicated about the annual board meeting?
(A) It would be easier to do as a video conference.
(B) It is usually held in the first quarter.
(C) It should deal with the topic of communication.
(D) The entire board should attend it.

해석 | 연례 이사회 회의에 대해 시사된 것은?
(A) 화상 회의로 하는 것이 더 간편할 것이다.
(B) 주로 1분기에 열린다.
(C) 의사소통의 주제를 다루어야 한다.
(D) 이사진 전원이 참석해야 한다.

해설 | **Not/True 문제**
단서 (175)에 따르면 이사회의 연례 회의에는 모든 이사진이 직접 참석하는 것이 좋다고 하였으므로 정답은 (D). 연례 이사회 회의가 화상 회의가 부적절한 사례로 언급되고 있으므로 (A)는 지문 내용에 어긋나며, (B), (C)는 언급되지 않았으므로 오답이다.

[176-180] 이메일 & 이메일

To: Sheryl Payan <sheryl@umail.org>
From: David Wolfe <wolfe@coteta.net>
Date: January 21
Subject: Your upcoming trip

Hello Ms. Payan,

176 I'm pleased to say that I've been able to make your travel arrangements to Costa Rica at a special rate. The total travel package will cost you $3,050. I found you some plane tickets with Air Americana for a cheaper rate than the standard ticket fares. **178-2** Your arrival date in Costa Rica will be March 2, at 5 P.M., and your departure date from the Juan Santamaria Airport in Alajuela will be March 15, on a 6 A.M. flight.
I've booked the Traveler's Hotel in Tibás and arranged for a car to take you from the airport to the hotel. I've also reserved the activities you requested, including **177** a walk up a volcano and a boat ride to Quepos. You will also get a tour of **179-2** the capital, Heredia.
If any changes are needed, just e-mail me.

Sincerely,

David Wolfe,
Corners of the Earth Travel Agency

받는 사람: 쉐릴 파얀 〈sheryl@umail.org〉
보내는 사람: 데이비드 울프 〈wolfe@coteta.net〉
날짜: 1월 21일
제목: 귀하의 다가오는 여행

안녕하세요, 파얀 씨,

176 특별가로 귀하의 코스타리카 여행 준비를 할 수 있었다는 것을 알리게 되어 기쁩니다. 패키지 여행 총 비용은 3,050달러입니다.

평균 비행기 요금보다 더 저렴하게 에어 아메리카나의 항공권을 찾아냈습니다. **178-2** 귀하의 코스타리카 도착 날짜는 3월 2일 오후 5시이며, 알라후엘라의 후안 산타마리아 공항에서 출발 날짜는 3월 15일로 오전 6시 비행편입니다.

티바스의 트레블러스 호텔을 예약했으며, 공항에서 호텔까지 귀하를 모실 차를 준비했습니다. **177** 화산에 걸어 올라가는 것과 케포스 해변행 보트 타기를 비롯해서 요청하신 활동들도 예약했습니다. **179-2** 주도인 에레디아 관광도 하시게 될 것입니다.

변경이 필요하시면, 제게 이메일을 보내주세요.

코너스 오브 디 어스 여행사
데이비드 울프 드림

어휘 | upcoming 다가오는　make arrangements 준비하다　fare (교통) 요금　reserve 예약하다　volcano 화산　capital 주도, 수도

To: David Wolfe <wolfe@coteta.net>
From: Sheryl Payan <sheryl@umail.org>
Date: January 22
Subject: RE: Your upcoming trip

Dear Mr. Wolfe,

Thank you for your e-mail. I appreciate all the work that you've put into my trip, but there are a few things I would like to clarify. First of all, my arrival date is a bit earlier than I desired. **178-1** I would like to arrive two days later than you've proposed. There is no need to modify the return date. Is this possible to adjust?
Secondly, **179-1** could I stay in a hotel in the capital city instead of Tibás? I'll travel from there to the other surrounding cities.

받는 사람: 데이비드 울프 〈wolfe@coteta.net〉
보내는 사람: 쉐릴 파얀 〈sheryl@umail.org〉
날짜: 1월 22일
제목: 회신: 귀하의 다가오는 여행

울프 씨께,

이메일을 보내주셔서 감사드립니다. 제 여행에 쏟으신 노고에 감사드리지만, 그런데 분명히 하고 싶은 것이 몇 가지 있습니다. 우선, 제 도착 날짜가 제가 원했던 것보다 약간 이릅니다. **178-1** 제안하신 날짜보다 이틀 늦게 도착했으면 합니다. 돌아오는 날짜를 바꿀 필요는 없습니다. 조정이 가능할까요?

두 번째로, **179-1** 티바스 대신에 주도에 있는 호텔에 묵을 수 있을까요? 그곳에서 주변의 다른 도시들로 여행을 할 것입니다.

Please let me know once these [180] matters have been dealt with and my trip plans have been finalized.

Thank you,
Sheryl Payan

이 [180] 문제들이 해결되고 제 여행 계획이 마무리되면 알려주세요.

감사합니다,
쉐릴 파얀 드림

어휘 | appreciate 감사히 여기다 clarify 명확하게 하다 modify 바꾸다, 수정하다 adjust 조정하다 surrounding 주변의 deal with 해결하다
finalize 마무리짓다

176. Why did Mr. Wolfe write the first e-mail?
(A) To outline travel warnings to Costa Rica
(B) To send electronic copies of plane tickets
(C) To provide updates on travel arrangements
(D) To request a payment to be processed

해석 | 울프 씨가 첫 번째 이메일을 쓴 이유는?
(A) 코스타리카로의 여행 경보를 간략히 설명하기 위해
(B) 전자 항공권을 보내기 위해
(C) 여행 준비의 최신 상황을 알리기 위해
(D) 결제 처리를 요청하기 위해

해설 | 주제, 목적 문제
이메일을 보낸 목적이나 이유는 주로 첫 문장에서 언급된다. 단서 (176)에서 파얀 씨의 여행에 대한 조사를 마치고 저렴한 비용으로 여행 준비를 했다고 알리고 있으므로, 여행 준비의 최신 상황을 알리기 위해 이메일을 보냈음을 알 수 있다. 따라서 정답은 (C).

177. According to Mr. Wolfe, what activity will Ms. Payan do?
(A) Hiking a mountain
(B) Observing animals
(C) Fishing in the sea
(D) Camping in a park

해석 | 울프 씨에 따르면, 파얀 씨가 할 활동은?
(A) 등산하기
(B) 동물 관찰하기
(C) 바다 낚시하기
(D) 공원에서 야영하기

해설 | 특정 정보 확인 문제
첫 번째 이메일에서 울프 씨가 파얀 씨의 여행을 위해 예약한 활동을 확인해 본다. 단서 (177)에서 화산에 걸어 올라가는 것을 예약했다고 했으므로 정답은 (A). 지문의 a walk up a volcano가 정답에서 Hiking a mountain으로 패러프레이징되었다.

178. What is true about Ms. Payan?
(A) She has visited Costa Rica before.
(B) She is a loyalty member with Air Americana.
(C) She wants arrive on March 4.
(D) She plans to rent a car from the airport.

해석 | 파얀 씨에 대해 사실인 것은?
(A) 코스타리카에 이전에 방문한 적 있다.
(B) 에어 아메리카나의 단골 회원이다.
(C) 3월 4일에 도착하기를 원한다.
(D) 공항에서 차를 빌릴 계획이다.

해설 | 두 지문 연계 문제
두 번째 이메일의 단서 (178-1)에서 도착 날짜를 제시한 날보다 이틀 늦췄으면 했는데, 첫 번째 이메일의 단서 (178-2)를 보니 제시한 날짜가 3월 2일이다. 따라서 정답은 (C).

179. In what city does Ms. Payan want to stay?
(A) Alajuela
(B) Heredia
(C) Quepos
(D) Tibás

해석 | 파얀 씨가 머물기를 원하는 도시는?
(A) 알라후엘라
(B) 에레디아
(C) 케포스
(D) 티바스

해설 | 두 지문 연계 문제
두 이메일을 함께 보고 풀어야 하는 연계 문제이다. 두 번째 이메일의 단서 (179-1)에서 파얀 씨는 티바스 대신에 주도에 있는 호텔에 머물고 싶다는 의사를 밝혔는데, 울프 씨가 보낸 이메일의 단서 (179-2)에서 주도가 에레디아임을 확인할 수 있다. 따라서 (B)가 정답.

180.
In the second e-mail, the word "matters" in paragraph 3, line 1, is closest in meaning to
(A) substances
(B) meanings
(C) amounts
(D) situations

해석 | 두 번째 이메일에서, 셋째 단락, 첫 번째 줄의 "matters"와 의미상 가장 가까운 단어는?
(A) 물질
(B) 의미
(C) 양
(D) 상황

해설 | **동의어 문제**
matters 앞에 지시대명사 these가 있으므로 앞부분에서 가리키는 내용을 찾아봐야 한다. 돌아오는 날짜를 바꾸기를 원하고 숙소를 옮기고 싶다는 내용이 나오므로 these matters는 앞에서 언급된 두 문제를 뜻한다. 따라서 가장 유사한 의미의 '상황'을 뜻하는 (D) situations가 정답이다.

[181-185] 메모 & 이메일

Attention Drake Corp. Employees

181 Starting February 1, we will be introducing a new inventory software program here at Drake Corp. With this system, you should be able to log in to our company inventory records remotely. This means that **182** regardless of where you work, you will have access to the inventory records. While all records are viewable for any employee, only relevant personnel have authorization to edit the inventory database. This is both to ensure accuracy, and to protect sensitive information.

To sign in as an editor, you must enter one of these assigned codes followed by your four-digit individual employee number. The department codes are:

Warehouse: 03
Shipment: 05
Production: 07
184-2 **Returns:** 09

드레이크 사 직원들에게 알립니다

181 2월 1일부터, 이곳 드레이크 사에서는 새로운 재고 목록 소프트웨어 프로그램을 도입하게 됩니다. 이 시스템을 이용하면, 회사 재고 목록 기록에 원격으로 로그인할 수 있을 것입니다. 즉 **182** 여러분이 어디서 근무하는지에 상관 없이, 재고 목록 기록에 접속할 수 있다는 것을 의미합니다. 모든 기록은 어떤 직원이든 열람할 수 있지만, 재고 목록 데이터베이스를 수정하는 권한은 오직 관련 직원에게만 있습니다. 이는 정확성을 보장하고 민감한 정보를 보호하기 위해서입니다.

편집자로 로그인하기 위해서는, 네 자리 숫자로 된 여러분 개개인의 직원번호에 이어 아래 배정된 코드 중 하나를 입력해야 합니다. 부서별 코드는 다음과 같습니다:
물류부: 03
배송부: 05
생산부: 07
184-2 반품부: 09

어휘 | inventory 재고[물품] 목록 remotely 원격으로, 멀리서 regardless of ~와 상관 없이 have access to ~에 접속[접근]할 수 있다 viewable 볼 수 있는 relevant 관련 있는 personnel 직원 authorization 권한, 허가 accuracy 정확성 sign in 로그인하다 assign 배정하다

To: Clive Redding <redding_c@drakecorp.net>
From: Ebonie Bishop <bishop_e@drakecorp.net>
Date: February 4
Subject: The new system

Dear Clive,

183 I received a returned box today that has ten headphones inside. I'm trying to reflect that in the database, but I can't log on as an editor. However, **184-1** my understanding was that the returns department was one of the departments granted inventory database access. When items are brought

받는 사람: 클라이브 레딩 ⟨redding_c@drakecorp.net⟩
보내는 사람: 에보니 비숍 ⟨bishop_e@drakecorp.net⟩
날짜: 2월 4일
제목: 새로운 시스템

클라이브 씨께,

183 저는 오늘 10개의 헤드폰이 들어 있는 반품 상자를 받았습니다. 데이터베이스에 그것을 반영하려고 하는데, 편집자로 로그인을 할 수 없습니다. 그러나 **184-1** 제가 알기로 반품부는 재고 목록 데이터베이스 접속을 승인 받은 부서 중 하나입니다. 물품이 손상이나 기타 여러 이유로 저희에게 반송되면, 그 숫자를 시스템에서 수정해야 합니다.

back to us because of damage or various other reasons, those numbers need to be corrected in the system.
¹⁸⁵ Can you give me authorization to make this change? I'm also curious whether I'm the only person in my department who has had this problem, or if everyone is experiencing the same frustration.

Thanks in advance,
Ebonie

185 이것을 변경할 수 있는 권한을 주시겠어요? 우리 부서에서 저만 이런 문제를 겪었는지, 아니면 모두 같은 문제를 겪고 있는지도 궁금합니다.

미리 감사드립니다,
에보니 드림

어휘 | reflect 반영하다 grant 승인하다 correct 수정하다 curious 궁금한 frustration 불만, 좌절감 in advance 미리

181. What is the purpose of the memo?
(A) To assign employee identification numbers
(B) To verify the amount of inventory in the warehouse
(C) To announce the use of a new computer program
(D) To outline the record-keeping process

해석 | 메모의 목적은?
(A) 사원번호를 배정하기 위해
(B) 창고에 있는 재고의 양을 확인하기 위해
(C) 새로운 컴퓨터 프로그램의 사용을 알리기 위해
(D) 기록 보관 과정을 간략히 설명하기 위해

해설 | 주제, 목적 문제
메모의 첫 문장인 단서 (181)에서 새로운 프로그램을 도입한다는 내용을 알리고, 이어서 그 프로그램과 관련된 사용방법을 설명하고 있으므로 정답은 (C).

182. According to the memo, what is one of the main features of the new system?
(A) It reduces expenses over time.
(B) It eliminates paper records.
(C) It can be accessed from anywhere.
(D) It increases department efficiency.

해석 | 메모에 따르면, 새로운 시스템의 주요 특징 중 하나는?
(A) 시간이 지남에 따라 비용을 줄여준다.
(B) 문서 기록을 없애준다.
(C) 어디서나 접속할 수 있다.
(D) 부서 효율성을 증가시킨다.

해설 | 특정 정보 확인 문제
단서 (182)에서 근무지가 어디인지에 상관 없이, 새로운 시스템에 접속할 수 있다고 했으므로 정답은 (C). 지문의 regardless of where you work가 정답에서 anywhere로 패러프레이징되었다.

183. What type of company most likely is Drake Corp.?
(A) An electronics manufacturer
(B) A software company
(C) A delivery service
(D) A publication firm

해석 | 드레이크 사의 업종일 것 같은 것은?
(A) 전자 기기 제조 업체
(B) 소프트웨어 회사
(C) 배달 서비스 회사
(D) 출판사

해설 | 특정 정보 확인 문제
이메일을 보낸 에보니 씨는 드레이크 사 직원인데, 단서 (183)에서 에보니 씨가 헤드폰을 반품으로 받았다는 것으로 보아 드레이크 사는 전자 기기 제조 업체임을 알 수 있다. 따라서 정답은 (A).

184. What department code did Ms. Bishop enter into the system?
(A) 03
(B) 05
(C) 07
(D) 09

해석 | 비숍 씨가 시스템에 입력한 부서 코드는?
(A) 03
(B) 05
(C) 07
(D) 09

해설 | 두 지문 연계 문제
메모와 이메일 두 개의 지문을 함께 봐야 하는 연계 문제이다. 이메일의 단서 (184-1)에 따르면 반품 상자를 받은 비숍 씨가 반품부가 시스템 접속을 승인 받은 것으로 알고 있다고 했으므로 그가 반품부서에 근무하고 있음을 알 수 있다. 메모의 단서 (184-2)에서 반품부의 코드는 09라고 나와 있으므로 정답은 (D).

185. What does Ms. Bishop ask Mr. Redding to do?

(A) Go into her office

(B) Grant her access

(C) Turn on her computer

(D) Check her e-mail

해석 | 비숍 씨가 레딩 씨에게 요청한 일은?

(A) 자신의 사무실에 들어가기

(B) 자신의 접속을 승인하기

(C) 자신의 컴퓨터 전원 켜기

(D) 자신의 이메일 확인하기

해설 | 특정 정보 확인 문제

비숍 씨가 보낸 이메일에서 단서 (185)에 따르면 재고 수량을 변경할 수 있는 권한을 달라고 요청하고 있는데, 이는 새 프로그램에 접속을 승인해달라는 말이므로 (B)가 정답이다.

[186-190] 이메일 & 보고서 & 이메일

To: Drew Coleman <coleman@newtonlaw.ca>

From: Shannon Gales <gales@newtonlaw.ca>

Date: June 14

Subject: Lost briefcase

Drew,

As you know, **186** I'm out of town to meet with one of our most important clients this week. Unfortunately, I think I left my briefcase on the train coming here. I am sure I had my briefcase with me both times I transferred. However, shortly after I arrived in Aldersbrook, I realized it was gone. Fortunately, I had my tablet in my purse, or it would be gone too. It's not a nice briefcase or anything, **189-2** but the thing is, it has the flash drive with the files from the Peterson case. I'm really behind, and I have to prepare for the meeting tomorrow morning. Would you mind going to the station to file out a lost item report to trace the location of my item for me?

Thanks so much,

Shannon

받는 사람: 드루 콜먼 〈coleman@newtonlaw.ca〉

보내는 사람: 섀넌 게일즈 〈gales@newtonlaw.ca〉

날짜: 6월 14일

제목: 분실된 서류가방

드루 씨,

아시다시피, **186** 저는 이번 주에 우리 회사의 가장 중요한 고객 중 한 분을 만나기 위해 시외에 나와있어요. 유감스럽게도, 이곳으로 오는 기차에 제 서류가방을 두고 내린 것 같아요. 갈아타는 두 번은 분명히 서류가방을 가지고 있었어요. 그런데 앨더스브룩에 도착한 직후에, 그것이 없어진 걸 알았어요. 다행스럽게도, 태블릿은 핸드백에 가지고 있었는데, 아니었다면 그것 역시 없어졌을 거예요. 좋은 서류가방이나 뭐 그런 건 아니지만, **189-2** 문제는, 거기에 피터슨 사건의 파일을 담은 휴대용 저장 장치가 들어 있다는 거예요. 저는 정말 일이 밀려 있고, 내일 오전 회의를 준비해야 하거든요. 저 대신 역에 가셔서 제 물건의 위치를 추적할 수 있도록 분실물 신고서를 작성해 주실 수 있을까요?

대단히 감사합니다,

섀넌 드림

어휘 | briefcase 서류가방 **transfer** 갈아타다 **fortunately** 다행스럽게도 **flash drive** 휴대용 저장 장치 **be behind** 일이 밀려 있다
fill out 작성하다 **lost item** 분실물 **trace** 추적하다 **location** 위치, 장소

Lost Item Report
Traveler Name: <u>Shannon Gales</u>
Travel Date: <u>June 14</u>
187C **Contact Information:** <u>gales@newtonlaw.ca</u>
Train Number(s): <u>H3AQ, I3WE, N7JD</u>
Departure Station: <u>Milford</u>
190-2 **Arrival Station:** <u>Aldersbrook</u>
187D **Connecting Stations:** First: Ridgeview;
Second: Paddington
Item: <u>briefcase</u>
Brand: <u>Emos</u>

분실물 신고서

여행자 이름: 섀넌 게일즈

여행 날짜: 6월 14일

187C 연락처: gales@newtonlaw.ca

기차 번호: H3AQ, I3WE, N7JD

출발역: 밀포드

190-2 도착역: 앨더스브룩

187D 환승역: 첫 번째: 리지뷰; 두 번째: 패딩턴

물품: 서류가방

브랜드: 이모스

187A Color: navy blue

Size: thin and narrow

Distinguishing features and/or contents:

Inside the briefcase is a flash drive containing a number of confidential files. Therefore, it is particularly important that this specific item be recovered.

Thank you for submitting a lost item report. We will do our best to get your item back to you.

187A 색상: 감청색

크기: 얇고 좁음

특이 사항 및 내용물:

가방 안에 여러 개의 기밀 파일이 담긴 휴대용 저장 장치가 있음. 따라서 이 특정 물품을 회수하는 것이 특히 중요함.

분실물 보고서를 작성해 주셔서 감사합니다. 귀하의 물품을 돌려드리기 위해 최선을 다하겠습니다.

어휘 | connect 연결하다 distinguish 구별하다 feature 특징 contents 내용물 confidential 기밀의 particularly 특히 specific 특정한 recover 되찾다

To: Shannon Gales <gales@newtonlaw.ca>
From: Transit Authority <transport@yaletown.net>
Date: June 16
Subject: Lost Item Report

Dear Ms. Gales,

I am writing in response to the lost item report that you filled. I am pleased to inform you that we have located your briefcase. It was on the third train you took, between your seat and the wall.
188 Unfortunately, as one of our employees was trying to pull it out from beside the seat, part of the side tore. I apologize for the damage.
189-1 However, you'll be pleased to know that we were able to find the item inside that you were concerned about. **190-1** We will keep your briefcase at the lost and found desk of your final destination and you may pick it up anytime.

Kind regards,

Yaletown Transit Authority

받는 사람: 섀넌 게일즈 ⟨gales@newtonlaw.ca⟩
보내는 사람: 교통부 ⟨transport@yaletown.net⟩
날짜: 6월 16일
제목: 분실물 신고서

게일즈 씨께,

귀하께서 작성하신 분실물 신고서에 대하여 답변 메일 드립니다. 귀하의 서류가방을 찾았음을 알려드리게 되어 기쁘게 생각합니다. 귀하가 타신 세 번째 기차의 좌석과 벽 사이에 있었습니다. **188** 유감스럽게도, 저희 직원이 좌석 옆으로 그것을 빼내다가 옆 부분이 찢어졌습니다. 손상에 대해 사과드립니다. **189-1** 하지만 염려하셨던 내용물을 찾을 수 있었다는 것을 아시면 기뻐하실 것입니다. **190-1** 귀하의 최종 도착지의 분실물 센터에 서류가방을 보관하고 있으니, 언제라도 찾아가시면 됩니다.

예일타운 교통부 드림

어휘 | in response to ~에 답하여[응하여] locate ~의 위치를 찾아내다 tear 찢다 be concerned about ~에 대해 걱정하다 lost and found desk 분실물 센터 destination 도착지, 목적지

186. What is indicated about Ms. Gales?

(A) She could not attend the meeting.

(B) She is traveling for business.

(C) She forgot to bring her train ticket.

(D) She left yesterday morning.

해석 | 게일즈 씨에 대해 시사된 것은?
(A) 회의에 참석하지 못했다.
(B) 출장 중이다.
(C) 기차표를 가져오는 것을 잊어버렸다.
(D) 어제 아침에 출발했다.

해설 | Not/True 문제
단서 (186)에서 게일즈 씨는 고객을 만나기 위해 시외에 나와있다고 했으므로 출장 중임을 알 수 있다. 따라서 정답은 (B). 지문의 out of town to부터 clients까지가 함축 표현을 이용하여 정답에서 traveling for business로 패러프레이징되었다.

187. What information is NOT required in the report?

(A) What the item looks like

(B) How the ticket was purchased

(C) How the owner can be contacted

(D) Where the passenger transferred

해석 | 보고서에 필요하지 않은 정보는?
(A) 물품이 어떻게 생겼는지
(B) 표를 어떻게 구매했는지
(C) 물품 주인에게 어떻게 연락해야 하는지
(D) 승객이 어디에서 갈아탔는지

해설 | Not/True 문제
보고서에 기입된 정보를 찾아본다. (A), (C), (D)는 분실물 신고 보고서 단서 (187A), (187C), (187D)에 나와있지만 표를 구매한 방법은 쓰여있지 않으므로 정답은 (B).

188. According to the second e-mail, what is the problem?

(A) The missing property has been claimed.

(B) Ms. Gales's bag could not be located.

(C) The briefcase was damaged.

(D) A fee is charged for lost belongings.

해석 | 두 번째 이메일에 따르면, 문제가 되는 것은?
(A) 분실물을 이미 찾아갔다.
(B) 게일즈 씨의 가방을 찾지 못했다.
(C) 서류가방이 손상되었다.
(D) 분실물에 대해 요금이 청구된다.

해설 | 특정 정보 확인 문제
단서 (188)에 따르면 가방이 찢어졌다는 것을 알리며, 손상된 것에 대해 사과하고 있으므로 정답은 (C). 지문의 part of the side tore가 정답에서 was damaged로 패러프레이징되었다.

189. What did authorities find in Ms. Gales's bag?

(A) An electronic tablet

(B) A copy of a report

(C) A storage device

(D) An ID card

해석 | 교통부가 게일즈 씨의 가방 안에서 찾은 것은?
(A) 전자 태블릿
(B) 보고서 한 부
(C) 저장 장치
(D) 신분증

해설 | 두 지문 연계 문제
두 이메일을 함께 봐야 하는 연계 문제이다. 두 번째 이메일의 단서 (189-1)에서 게일즈 씨가 염려했던 내용물을 찾았음을 알리고 있는데, 첫 번째 이메일의 단서 (189-2)에서 이것이 flash drive, 즉 저장 장치임을 알 수 있다. 따라서 정답은 (C).

190. Where will Ms. Gales most likely go to recover her item?

(A) Milford Station

(B) Ridgeview Station

(C) Paddington Station

(D) Aldersbrook Station

해석 | 게일즈 씨가 자신의 물건을 찾으러 갈 것 같은 곳은?
(A) 밀포드 역
(B) 리지뷰 역
(C) 패딩턴 역
(D) 앨더스브룩 역

해설 | 두 지문 연계 문제
두 번째 이메일과 보고서를 함께 보고 풀어야 하는 연계 문제. 단서 (190-1)에서 게일즈 씨의 가방은 최종 도착지에서 보관하고 있다고 했는데, 보고서의 단서 (190-2)에서 게일즈 씨의 최종 도착지가 앨더스브룩 역임을 확인할 수 있다. 따라서 정답은 (D).

[191-195] 웹사이트 & 영수증 & 후기

www.danvillemuseum.com

191 The Danville Museum has added new rooms for you to enjoy! **193-2** General admission to the museum is still $10.00 per adult and $5 per child, but all special features are only accessible by purchasing additional tickets. The featured films change seasonally and will be replaced with new ones in the fall.

www.danvillemuseum.com

191 댄빌 박물관에서는 여러분이 즐기실 만한 새로운 공간들을 추가했습니다! **193-2** 박물관의 일반 입장료는 그대로 성인 10달러, 아동 5달러이지만, 모든 특별관은 추가 입장권을 구입해야만 입장할 수 있습니다. 특선 영화들은 계절에 따라 바뀌므로, 가을에는 새로운 영화로 대체될 것입니다.

Butterfly Conservatory

This magical attraction features over 1,000 colorful butterflies living in a green and exotic rainforest-like setting. [192] Be prepared for a butterfly to land on you as you walk through the area.

Emerick Theater (two films)

1) [195-3] 2D Film: *Learning to Fly*

This 20-minute documentary covers the history of aviation.

2) [195-3] 3D Film: *Parks and People*

The film will take you on a journey through the country's beautiful national parks.

Desai Planetarium, *Black Universe Show*

This fantastic show will give you a chance to look through the telescope at a replica of the solar system.

나비 온실

이 환상적인 명소는 초록이 무성하고 이국적인 열대우림 같은 환경에서 살고 있는 1,000여 마리 이상의 다채로운 나비들이 특징입니다. [192] 이 곳을 통과해 지나갈 때 나비가 여러분에게 내려앉는 것에 대비하세요.

에머릭 극장 (두 편의 영화)

1) [195-3] 2D 영화: 〈나는 법 배우기〉

이 20분짜리 다큐멘터리는 비행의 역사를 다루고 있습니다.

2) [195-3] 3D 영화: 〈공원과 사람들〉

이 영화는 여러분을 국내의 아름다운 국립 공원들로 여행시켜드릴 것입니다.

데사이 천문관, 〈깜깜한 우주 쇼〉

이 환상적인 쇼는 여러분에게 망원경을 통해 태양계의 모형을 보는 기회를 드릴 것입니다.

어휘 | feature 특징; ~을 특징으로 하다 accessible 입장 가능한 conservatory 온실 attraction 명소 exotic 이국적인 cover 다루다 aviation 항공 planetarium 천문관 telescope 망원경 replica 모형, 복제품 solar system 태양계

Danville Museum Entrance Receipt

Recipient number: 54A632
Name: Philip Scots
Date of purchase: July 15
Credit card number: 4556 XXXX XXXX 3734
Arrival time: 10:04 A.M.

Exhibition	Quantity	Total Cost
[193-1] Museum General Entrance	3	$30.00
Butterfly Conservatory	3	$15.00
[195-2] Emerick Theater, 3D Film	3	$13.50
Desai Planetarium	3	$9.00
	TOTAL	$67.50

Tickets are non-refundable.
This receipt is necessary to access the special exhibits specified above. It must be presented along with your general admission tickets.

댄빌 박물관 입장료 영수증

수령 번호: 54A632
이름: 필립 스콧츠
구매일: 7월 15일
신용카드 번호: 4556 XXXX XXXX 3734
도착 시간: 오전 10:04

전시	수량	총비용
[193-1] 박물관 일반 입장료	3	30달러
나비 온실	3	15달러
[195-2] 에머릭 극장, 3D 영화	3	13달러 50센트
데사이 천문관	3	9달러
	합계	67달러 50센트

입장권은 환불되지 않습니다.

이 영수증은 위에 명시된 특별 전시에 입장하기 위해 필요합니다. 일반 입장권과 함께 제시하셔야 합니다.

어휘 | entrance 입장 recipient 수령인 quantity 수량 non-refundable 환불이 안 되는 access 들어가다, 이용하다 specify 명시하다 present 제시하다 along with ~와 함께

Customer Feedback Form

Name: Philip Scots

Number of visitors: 3

Number of special exhibits seen: 3

What did you like most about the exhibits?

My favorite part was the planetarium. Looking through the telescope was the highlight of my visit.

What didn't you like about the exhibits?

¹⁹⁴ The cost is quite high to pay for each special exhibit separately. Is it possible to bundle all four together for a cheaper price?

How would you rate your experience?

☐ Definitely Disappointed	☐ Disappointed
☐ Satisfied	■ Definitely Satisfied

Further comments:

¹⁹⁵⁻¹ I was upset that my group didn't have enough time to see both films showing in the theater, but I plan to come back and watch the other one next time.

고객 평가 양식

이름: 필립 스콧츠

방문객 수: 3명

관람한 특별 전시 수: 3개

전시들에 대해 가장 마음에 들었던 것은 무엇입니까?

제가 가장 마음에 들었던 것은 천문관이었습니다. 망원경을 통해 보는 것이 이번 방문에서 가장 흥미로운 것이었습니다.

전시들에 대해 마음에 들지 않았던 것은 무엇입니까?

¹⁹⁴ 각각의 특별 전시에 대해 별도로 지불하는 것은 비용이 매우 많이 듭니다. 더 저렴한 가격으로 네 가지 모두를 하나로 묶을 수 있을까요?

관람에 평가를 매긴다면 어떻습니까?

☐ 확실히 실망스럽다	☐ 실망스럽다
☐ 만족스럽다	■ 확실히 만족스럽다

추가 의견:

¹⁹⁵⁻¹ 우리 일행이 극장에서 상영하는 영화 두 편을 다 볼 만큼 충분한 시간이 없어서 안타까웠지만, 다음 번에 다시 와서 다른 것을 볼 계획입니다.

어휘 | separately 별도로, 따로따로 bundle together 하나로 묶다 definitely 확실히 disappointed 실망한 satisfied 만족한

191. What is suggested about the Danville Museum?

(A) It offers membership plans.

(B) It has altered its admission pricing.

(C) It recently set up new facilities.

(D) It will play the same movies until the spring.

해석 | 댄빌 박물관에 대해 암시된 것은?

(A) 회원제 요금을 제공한다.

(B) 입장료 가격을 변동시켰다.

(C) 최근에 새로운 시설들을 설치했다.

(D) 봄까지 같은 영화들을 상영할 것이다.

해설 | 추론 문제

웹사이트의 단서 (191)에서 댄빌 박물관에 새로운 공간들을 추가했다는 내용을 알리고 있으므로 정답은 (C). 지문의 added new rooms가 정답에서 set up new facilities로 패러프레이징되었다.

192. According to the Web site, what can visitors do in the conservatory?

(A) Buy butterfly coloring books

(B) See a magic show

(C) Meet a natural scientist

(D) Observe some insects

해석 | 웹사이트에 따르면, 방문객들이 온실에서 할 수 있는 것은?

(A) 나비 색칠하기 책 구매하기

(B) 마술쇼 관람하기

(C) 자연 과학자 만나기

(D) 몇몇 곤충들 관찰하기

해설 | 특정 정보 확인 문제

웹사이트의 나비 온실 항목을 살펴본다. 단서 (192)에서 나비가 내려앉는 것에 대비하라고 했으므로 나비를 관찰할 수 있음을 알 수 있다. 따라서 (D)가 정답. 지문의 butterfly가 정답에서 some insects로 패러프레이징되었다.

193. What is indicated about Mr. Scots?

(A) **He went to the museum with two other adults.**

(B) He visits the museum frequently.

(C) He paid for his admission in cash.

(D) He chose to watch a documentary about flight.

해석 | 스콧츠 씨에 대해 시사된 것은?
(A) 다른 성인 두 명과 함께 박물관에 갔다.
(B) 박물관에 자주 방문한다.
(C) 현금으로 입장료를 지불했다.
(D) 비행 관련 다큐멘터리를 보는 것을 선택했다.

해설 | 두 지문 연계 문제
웹사이트와 영수증을 함께 보고 푸는 연계 문제이다. 영수증에서 단서 (193-1)을 보면 스콧츠 씨는 3명의 입장료로 30달러를 지불했다. 웹사이트의 단서 (193-2)에서 성인 입장료는 10달러라고 했으므로, 30달러는 성인 3명에 해당하는 것임을 알 수 있다. 따라서 정답은 (A)이다. (B)는 확인할 수 없는 내용이며, (C)는 영수증을 통해 신용카드로 지불했음을 알 수 있고, (D)는 스콧츠 씨가 본 3D 영화는 다큐멘터리가 아니므로 모두 오답이다.

194. What criticism did Mr. Scots provide?

(A) There are too many exhibits to see in one day.

(B) **The prices should be reduced for special elements.**

(C) It is excessive to have two movies shown in the theater.

(D) Museum viewing hours should be extended.

해석 | 스콧츠 씨가 제공한 비판은?
(A) 하루에 보기에 너무 많은 전시들이 있다.
(B) 특별 전시들에 대한 가격을 낮춰야 한다.
(C) 극장에서 두 편의 영화를 상영하는 것은 지나치다.
(D) 박물관 관람 시간을 연장해야 한다.

해설 | 특정 정보 확인 문제
단서 (194)에서 스콧츠 씨는 마음에 들지 않은 점으로 특별 전시들에 비용이 너무 많이 든다는 것을 지적했다. 하나로 묶어서 가격을 낮출 것을 제안하고 있으므로 (B)가 정답이다.

195. What will Mr. Scots probably see on his next visit?

(A) The Butterfly Conservatory

(B) *Learning to Fly*

(C) *Parks and People*

(D) *Black Universe Show*

해석 | 스콧츠 씨가 다음 방문 시에 볼 것 같은 것은?
(A) 나비 온실
(B) 〈나는 법 배우기〉
(C) 〈공원과 사람들〉
(D) 〈깜깜한 우주 쇼〉

해설 | 세 지문 연계 문제
웹사이트, 영수증, 후기를 함께 보고 풀어야 하는 연계 문제. 후기의 단서 (195-1)에 따르면 스콧츠 씨는 영화 두 편을 다 보지 못한 것을 아쉬워하며 다음에 보겠다고 했는데, 영수증의 단서 (195-2)에 따르면 스콧츠 씨가 본 것은 3D 영화이다. 웹사이트의 단서 (195-3)에 따르면 3D 영화는 〈공원과 사람들〉이므로 스콧츠 씨가 다음 방문에 볼 것은 2D 영화인 〈나는 법 배우기〉임을 알 수 있다. 따라서 정답은 (B).

[196-200] 웹사이트 & 온라인 양식 & 이메일

www.twinklecleaners.com

Twinkle Cleaners

Home	Services	Rates	Request	Contact

Twinkle Cleaners provides the most reliable and reputable cleaning services in the Stratford area. We've been in business for nearly two years with a growing client base and a reputation for high standards. ¹⁹⁶We take good care of your home and ¹⁹⁷treat it as if it were our own.

We have several ongoing promotions, which include a 10% discount for seniors, a 15% discount for first-time customers, ¹⁹⁸⁻²20% for existing customers who refer friends, and 25% when you upgrade the frequency of your cleaning schedule.

www.twinklecleaners.com

트윙클 클리너즈

홈	서비스	요금	요청	연락처

트윙클 클리너즈에서는 스트랫퍼드 지역에서 가장 믿을 수 있고 평판 좋은 청소 서비스를 제공합니다. 영업을 시작한 지 거의 2년이 되어가는데, 고객층이 증가하고 있으며 수준 높다는 평판을 얻고 있습니다. ¹⁹⁶저희는 고객님의 집을 잘 관리해 드리며 저희 집처럼 ¹⁹⁷다룹니다.

몇 가지 판촉 행사를 진행 중인데, 노령층에 10퍼센트 할인, 첫 고객에게 15퍼센트 할인, ¹⁹⁸⁻²지인을 추천하는 기존 고객에게 20퍼센트 할인, 청소 일정 횟수를 늘리는 경우 25퍼센트 할인 등이 있습니다.

어휘 | reliable 믿을 수 있는 reputable 평판이 좋은 client base 고객층 ongoing 진행 중인 promotion 판촉 행사 senior 연장자, 노인
refer 추천하다 frequency 빈도

Request Form

Name: Tony Lee
E-mail: tlee@newmail.com
Location of Service: 2359 Clavier Rd.
Phone: 555-239-3495

Type of service (prices are per shift):

	Standard Cleaning	Super Cleaning
One-time service	☐ $200	☐ $230
Once a month	☐ $190	☐ $220
Once a week	☐ **200-2** $180	■ $210
Twice a week	☐ $170	☐ $200

Preferred Day(s):

☐ Monday ☐ Tuesday ■ Wednesday
☐ Thursday ☐ Friday

Additional comments:
198-1 Your company was referred to me by my friend Phoebe Lentz. She highly recommends your service.

어휘 | prefer 선호하다 refer A to B A에게 B를 알아보도록 하다 recommend 추천하다

요청서

이름: 토니 리
이메일: tlee@newmail.com
서비스 장소: 클라비어 로 2359번지
전화: 555-239-3495

서비스 유형 (요금은 서비스 한 회당 가격입니다.):

	기본 청소	특별 청소
1회 서비스	☐ 200달러	☐ 230달러
한 달에 1회	☐ 190달러	☐ 220달러
한 주에 1회	☐ **200-2** 180달러	■ 210달러
한 주에 2회	☐ 170달러	☐ 200달러

선호 요일(들):

☐ 월요일 ☐ 화요일 ■ 수요일
☐ 목요일 ☐ 금요일

추가 의견:
198-1 제 친구인 피비 렌츠 씨가 저에게 귀사에 문의하라고 했습니다. 그녀는 귀사의 서비스를 강력히 추천합니다.

To: Tony Lee <tlee@newmail.com>
From: Leslie Mahlon <leslie@twinkleclean.org>
Date: November 9
Subject: Your request

Dear Mr. Lee,

Thank you so much for your request for Twinkle Cleaners! We would like to do a visit of your home to see the layout and discuss your specific needs. Please confirm that you will be available on November 14 at 9:00 A.M.
Secondly, **199** I regret to inform you that the service you selected is not available on Wednesdays. It is our busiest day of the week and we are currently fully booked. However, **200-1** if you let us come on Fridays instead, we will do a super cleaning for the standard rate.

Kind regards,

Leslie Mahlon

받는 사람: 토니 리 〈tlee@newmail.com〉
보내는 사람: 레슬리 말론 〈leslie@twinkleclean.org〉
날짜: 11월 9일
제목: 귀하의 요청서

리 씨께,

트윙클 클리너즈에 요청을 해주셔서 대단히 감사합니다! 댁을 방문하여 배치를 살펴보고 귀하의 구체적인 요구 사항에 대해 논의하고 싶습니다. 11월 14일 오전 9시에 시간이 되시는지 확인해 주시기 바랍니다.

다음으로, **199** 유감스럽게도 귀하께서 선택하신 서비스는 수요일에는 이용할 수 없음을 알려드립니다. 저희가 가장 바쁜 요일이라서 현재는 예약이 모두 차 있습니다. 그러나 **200-1** 대신 금요일에 갈 수 있도록 해주시면 특별 청소를 기본 요금으로 해드리겠습니다.

레슬리 말론 드림

196. What type of service is being advertised?

(A) Dry cleaning

(B) Carpet repair

(C) House cleaning

(D) Window washing

해석 | 광고하고 있는 서비스의 종류는?

(A) 드라이 클리닝

(B) 카펫 수선

(C) 주택 청소

(D) 창문 청소

해설 | **주제, 목적 문제**

웹사이트의 단서 (196)에서 고객의 집을 잘 관리해 준다고 했으므로 주택 청소 서비스를 제공하는 업체임을 알 수 있다. 따라서 정답은 (C).

197. In the Web site, the word "treat" in paragraph 1, line 3, is closest in meaning to

(A) handle

(B) repair

(C) serve

(D) enter

해석 | 웹사이트에서, 첫째 단락 세 번째 줄의 "treat"와 의미상 가장 가까운 단어는?

(A) 다루다

(B) 수리하다

(C) 서비스를 제공하다

(D) 들어가다

해설 | **동의어 문제**

문맥상 '마치 우리 집인 것처럼 당신의 집을 다루다'라는 의미로, 여기에서 treat는 '다루다, 취급하다'라는 의미로 쓰였다. 따라서 가장 유사한 의미의 (A)가 정답이다.

198. What discount will Ms. Lentz be given?

(A) 10%

(B) 15%

(C) 20%

(D) 25%

해석 | 렌츠 씨가 받게 될 할인율은?

(A) 10퍼센트

(B) 15퍼센트

(C) 20퍼센트

(D) 25퍼센트

해설 | **두 지문 연계 문제**

웹사이트와 온라인 양식을 보고 풀어야 하는 연계 문제. 렌츠라는 이름이 등장하는 부분을 먼저 찾아야 한다. 온라인 양식의 단서 (198-1)에서 렌츠 씨는 청소 업체를 추천한 사람이라고 나왔는데, 웹사이트의 단서 (198-2)에서 지인을 추천한 고객은 20퍼센트의 할인을 받는다고 했으므로 정답은 (C).

199. What is indicated about Twinkle Cleaners?

(A) It does not have a weekly service.

(B) It serves many clients on Wednesdays.

(C) It does not currently offer standard cleaning.

(D) It works mornings only.

해석 | 트윙클 클리너즈 사에 대해 시사된 것은?

(A) 주 단위 서비스는 없다.

(B) 수요일에 많은 고객들에게 서비스를 제공한다.

(C) 현재 기본 청소를 제공하지 않는다.

(D) 아침에만 작업을 한다.

해설 | **Not/True 문제**

이메일은 트윙클 클리너즈 사에서 보낸 것인데 단서 (199)에서 수요일은 가장 바쁜 날이고 예약이 모두 차 있다고 했으므로 수요일에 많은 고객에게 서비스를 제공한다는 것을 알 수 있다. 따라서 정답은 (B).

200. How much will Mr. Mahlon most likely charge Mr. Lee for each shift?

(A) $170

(B) $180

(C) $200

(D) $210

해석 | 말론 씨가 리 씨에게 1회에 청구할 것 같은 금액은?

(A) 170달러

(B) 180달러

(C) 200달러

(D) 210달러

해설 | **두 지문 연계 문제**

말론 씨가 보낸 이메일과 온라인 양식을 연계해서 풀어야 하는 문제. 이메일의 단서 (200-1)에서 말론 씨가 금요일에 가게 해주면 특별 청소를 기본 요금으로 해준다고 하였는데, 온라인 양식의 단서 (200-2)에서 리 씨가 요청한 주 1회 청소 서비스의 기본 요금은 180달러이다. 따라서 정답은 (B).